The Political Portrait

The leader's portrait, produced in a variety of media (statues, coins, billboards, posters, stamps), is a key instrument of propaganda in totalitarian regimes, but increasingly also dominates political communication in democratic countries as a result of the personalization and spectacularization of campaigning.

Written by an international group of contributors, this volume focuses on the last one hundred years, covering a wide range of countries around the globe, and dealing with dictatorial regimes and democratic systems alike. As well as discussing the effigies that are produced by the powers that be for propaganda purposes, it looks at the uses of portraiture by antagonistic groups or movements as forms of resistance, derision, denunciation and demonization.

This volume will be of interest to researchers in visual studies, art history, media studies, cultural studies, politics and contemporary history.

Luciano Cheles is a member of the Laboratoire Universitaire Histoire Cultures Italie Europe of the University of Grenoble Alpes and taught Italian Studies at the University of Poitiers, France.

Alessandro Giacone is Associate Professor of Political Science at the University of Bologna.

Cover image credit: Detail from a poster collectively designed by the People's Fine Arts Publishing House Creative Group, Beijing, 1966. The full poster bears the slogan "Resolutely support the communique of the Eleventh Plenum of the Eighth Party Congress, warmly welcome a new great victory of Mao Zedong Thought". (Collection of the International Institute of Social History / Stefan R. Landsberger Collection, Amsterdam, The Netherlands).

Routledge Research in Art and Politics

Routledge Research in Art and Politics is a new series focusing on politics and government as examined by scholars working in the fields of art history and visual studies. Proposals for monographs and edited collections on this topic are welcomed.

Constructing the Memory of War in Visual Culture since 1914
The Eye on War
Edited by Ann Murray

Socially Engaged Art in Contemporary China
Voices from Below
Meiqin Wang

The Danish Avant-Garde and World War II
The Helhesten Collective
Kerry Greaves

Reframing Migration, Diversity and the Arts
The Postmigrant Condition
Moritz Schramm, Sten Pultz Moslund and Anne Ring Petersen

Social Practice Art in Turbulent Times
The Revolution Will Be Live
Eric J. Schruers and Kristina Olson

Modernity, History, and Politics in Czech Art
Marta Filipová

Italian Modern Art in the Age of Fascism
Anthony White

WPA Posters in an Aesthetic, Social, and Political Context
A New Deal for Design
Cory Pillen

For a full list of titles in this series, please visit https://www.routledge.com/Routledge-Research-in-Art-and-Politics/book-series/RRAP

The Political Portrait

Leadership, Image and Power

Edited by Luciano Cheles and
Alessandro Giacone

Routledge
Taylor & Francis Group

NEW YORK AND LONDON

First published 2020
by Routledge
52 Vanderbilt Avenue, New York, NY 10017

and by Routledge
2 Park Square, Milton Park, Abingdon, Oxon, OX14 4RN

Routledge is an imprint of the Taylor & Francis Group, an informa business

© 2020 Taylor & Francis

Library of Congress Cataloging-in-Publication Data
Names: Cheles, Luciano, editor. | Giacone, Alessandro, editor.
Title: The political portrait: leadership, image and power/edited by Luciano Cheles and Alessandro Giacone.
Description: New York, NY: Routledge, 2020. | Includes bibliographical references and index.
Identifiers: LCCN 2020005863 (print) | LCCN 2020005864 (ebook) | ISBN 9781138054233 (hbk) | ISBN 9781351187152 (ebk)
Subjects: LCSH: Heads of state–Portraits. | Politicians–Portraits. | Art–Political aspects. | Symbolism in politics.
Classification: LCC JF251 .P65 2020 (print) | LCC JF251 (ebook) | DDC 352.23/748–dc23
LC record available at https://lccn.loc.gov/2020005863
LC ebook record available at https://lccn.loc.gov/2020005864

ISBN: 978-1-138-05423-3 (hbk)
ISBN: 978-1-351-18715-2 (ebk)

Typeset in Sabon
by Deanta Global Publishing Services, Chennai, India

Contents

Figures

Contributors

Alessandra Antola Swan is a cultural historian and her PhD on Mussolini and photography was part of the project *The Cult of the Duce. Mussolini and the Italians, 1918–2005* (University of London – Royal Holloway). In 2013 she organized the conference *Iconic Images* (Association for the Study of Modern Italy, London), and in 2016 she was guest editor for the follow-up special issue of *Modern Italy*. Developing her research on photographs as meaningful historical material, her monograph on the composition of Mussolini's public image through photographs is forthcoming.

Luciano Cheles is a member of the Laboratoire Universitaire Histoire Cultures Italie Europe of the University of Grenoble Alpes, France and has taught at the universities of Lancaster, Lyon and Poitiers. His research has focused on Renaissance iconography, as well as on visual propaganda. His publications on the latter topic include *The Far Right in Western and Eastern Europe*, co-edited with R.G. Ferguson and M. Vaughan (Longman, 1995), *The Art of Persuasion. Political Communication in Italy, from 1945 to the 1990s*, co-edited with L. Sponza (Manchester University Press, 2001) and *L'image recyclée*, co-edited with G. Roque (Puppa, 2017). He has an extensive personal collection of Italian and French printed propaganda (posters, leaflets, etc.) and has curated several exhibitions on the subject in Britain and France.

Simon Downs is Lecturer in the School of Design and Creative Arts at Loughborough University, UK, and is a representative of the Universities and Colleges Union. He trained as a painter-illustrator. His working career and research interests have been strongly affected by the digital media revolution. He has worked as a designer and design consultant specializing in "corporate communication", i.e. propaganda, for companies in Europe and the US. He is the Lead Editor of *The Poster* and a Director of the Drawing Research Network.

Lucile Dreidemy is Associate Professor at the Department of German Studies at the University of Toulouse Jean-Jaurès, France. She spent the 2018–2019 academic year as a Visiting Scholar at the Center for European Studies at Harvard University and is currently a Research Fellow in the Department of Contemporary History of the University of Vienna. Her book *Der Dollfuß-Mythos: Eine Biographie des Posthumen* (Böhlau, 2014), which examined the political controversies surrounding Chancellor Engelbert Dollfuss, was awarded Austria's Theodor Körner Prize for Science and the Arts.

Alessandro Giacone is Associate Professor of Political Science at the University of Bologna, Italy. He has also taught at Sciences-Po Paris, the Sorbonne Nouvelle and the University of Grenoble. He was a member of the curatorial committee of the exhibition *Il Quirinale. Dall'unità d'Italia ai nostri giorni* which was held at the Presidential Palace in 2011 in celebration of the 150th anniversary of Italian Unity. He has co-authored with Gilles Bertrand and Jean-Yves Frétigné, *La France et l'Italie: histoire de deux nations sœurs de 1660 à nos jours* (Armand Colin, 2016).

Mary Ginsberg is an international banker turned art historian. She worked for many years at the British Museum, where she curated and wrote the exhibition catalogue for *The Art of Influence: Asian Propaganda*. She edited and contributed to the survey volume, *Communist Posters*. She is curating *Lu Xun's Legacy in Modern Chinese Printmaking*, a travelling exhibition for the Muban Educational Trust (2020–2021). *Folk Art*, a transnational study of the modern in traditional arts, is forthcoming.

Graeme Gill is Professor Emeritus at the University of Sydney and a Fellow of the Academy of Social Sciences, Australia. His main areas of research center on Soviet and Russian politics, but he has also published on the development of the state, democratization, authoritarian politics and the relationship between state and class. His most recent book is entitled *Collective Leadership in Soviet Politics* (Macmillan, 2018) and he is currently working on leadership in authoritarian political systems.

Florian Göttke is a visual artist, researcher and writer based in Amsterdam. He investigates the functioning of public images and their relationship to social memory and politics, combining visual modes of research (collecting, close reading and image montage) with academic research. He completed his PhD dissertation "Burning Images: Performing Effigies as Political Protest" at the University of Amsterdam in 2019. His dissertation, based on over 3,000 effigy-based protests worldwide, combines two discursive narratives: a linear text and a parallel image narrative.

Stefan Landsberger is Olfert Dapper Chair of Contemporary Chinese Culture (Emeritus) at the University of Amsterdam and Associate Professor of Contemporary Chinese History and Social Developments (retired) at the Leiden University Institute of Area Studies. Landsberger has one of the largest private collections of Chinese propaganda posters in the world. He has published widely on topics related to Chinese propaganda, and maintains an extensive website exclusively devoted to this genre of political communications (http://chineseposters.net).

Manuela Marin is an instructor of record and researcher at Babeş-Bolyai University, at Cluj-Napoca, where she received her PhD in Romanian contemporary history in 2008. Her main research interest concerns Nicolae Ceauşescu's regime, on which she has published two books: *Nicolae Ceauşescu: Omul şi Cultul* (Nicolae Ceauşescu: The man and his cult) (Editura Cetatea de Scaun, 2016) and *Între trecut şi prezent: cultul personalităţii lui Nicolae Ceauşescu şi opinia publică românească* (Between past and present: Nicolae Ceauşescu's cult of personality and Romanian public opinion) (Editura Mega, 2014). Other areas of interest include everyday life during communism, national minorities and religion during communism.

Sinan Niyazioğlu is a graphic design historian and Professor at Mimar Sinan Fine Arts University, Istanbul, Turkey. He has been a guest lecturer at the Vienna State Academy of Fine Arts (2010), the Burg Giebichenstein Halle Design Faculty (2013) and the Hochschule Augsburg Design Faculty (2007, 2014, 2019). He is a member of the Advisory Board of the International Conferences on Design History and Design Studies, and has contributed to their colloquia in Averio (2014), Taipei (2016) and Barcelona (2018). He has published on 1930s modernist visual propaganda in Turkey, the Balkans and Western Europe, and has also curated several exhibitions on the subject.

Maurizio Ridolfi is Full Professor of Contemporary History at the Università della Tuscia (Viterbo) and Università Roma Tre. He has co-edited the contemporary history journal *Memoria e Ricerca* since 1993 and is a member of the advisory committee of history journals in France (*Parlement(s)*), Spain (*Pasado y Mémoria*, *Alcores*) and Portugal (*Ler Historia*). He was president of Viterbo's Center for the Study of Mediterranean Europe from 2001 to 2015 and founded the International and European Historical Centre in 2019.

Steven A. Seidman, PhD, is Professor Emeritus of Communication Management and Design in the Department of Strategic Communication, Ithaca College, USA. His main research interests are political communication and visual design. Among his many publications are articles and book chapters on US presidential campaign slogans, election posters, and sex-role stereotyping in the media. His book *Posters, Propaganda, and Persuasion in Election Campaigns Around the World and Through History* was published by Peter Lang.

Pierre Sorlin is Emeritus Professor of the University Paris 3, Sorbonne Nouvelle and fellow of the Istituto storico Ferruccio Parri in Bologna, Italy. His recent publications are *Gli Italiani al cinema. Pubblico e società nel cinema italiano* (Mantua: Tre Lune, 2009); *Ombre passeggere. Cinema e storia* (Venice: Marsilio, 2013); *Introduction à une sociologie du cinéma* (Paris: Klincksieck, 2015).

Manja Wilkens is a freelance exhibition curator and her research focuses on political iconography, outsider art and applied arts. She was born in 1964 in Bremen, Germany. She studied art history in Bonn, Munich, Hamburg and Paris and obtained her Doctorate in Munich in 1993.

Christopher S. Wilson is Professor of Architecture and Design History at Ringling College of Art + Design, Sarasota, Florida, USA. His book, *Beyond Anitkabir: The Construction and Maintenance of National Memory* (Ashgate, 2013), narrates the story of the five architectural constructions that have housed the dead body of Mustafa Kemal Atatürk. He has most recently contributed "The Sarasota Years" chapter to the monograph *Victor Lundy: Artist Architect*, edited by Donna Kacmar (Princeton Architectural Press, 2018).

Foreword

The portrait is a figurative genre that has always played an important role in political communication. Its potential effectiveness resides in its ability to "make absent persons present", to quote the Renaissance art theorist Leon-Battista Alberti (*On Painting*, Book II). This is a feature that politicians much appreciate as it confers them the gift of ubiquity. The powerful have had themselves represented, in idealized form, since time immemorial. Suffice it to mention the monumental sculptures of the pharaohs which were erected throughout Egypt, the effigies on coins of Persian kings and Roman Caesars, which circulated in the most remote regions of their vast empires, and the stamps and banknotes that, in more recent times, played the same function in colonial territories. Portraits can fulfil a propaganda function even when they are conceived as unique works of art to be displayed in private residences. In European courts, effigies of rulers were commissioned from leading artists to exalt their subjects' power, wealth, military exploits, daily life, virtues and connections with other royal households. These "political" messages were addressed to the members of the courts, whose loyal support was sought, as well as to the illustrious visitors. The portraits painted by Giorgio Vasari for the Medici family in Florence, by Diego Velasquez for the Habsburgs in Spain and by Jacques-Louis David for Napoleon, to name but a few, are cases in point.

While there is an extensive scholarly literature on portraits of rulers and other political figures, this has mostly concerned works that are artistically accomplished. The photographic depictions of politicians and aspiring politicians of the twentieth and twenty-first centuries, being rarely of high aesthetic merit, have tended to be neglected. Yet, irrespective of their visual quality, these images are worth investigating because, like commercial advertisements, to which they are closely related, they employ specific techniques to "sell" their "products" (a political ideology, a personality). The portrait's persuasive power rests partly on the commonplace view that "the camera never lies": we are given to understand that it faithfully represents its subject; in fact it is the result of precise choices made by the sitter, the photographer and the political party. The portrait functions as a system of codes: the pose, the facial expression, the sartorial style, the use of colors, the props, the light treatment and the nature of the background are all potential carriers of meaning, and are intended to influence the public subliminally.

The genesis of the present volume is worth telling. In November 2013, we organized an international conference in Paris on the uses of the portrait for propaganda purposes in post-war France and Italy. The event, which benefited from the collaboration of Marie-Anne Matard-Bonucci (Université de Paris 8) and Christian Delporte

(Université de Versailles), was made to coincide with an exhibition of original posters of the French presidential election of 2012 and the Italian parliamentary election of 2013. A selection of papers, as well as a few specially commissioned essays, were published in a volume we edited entitled *Il ritratto e il potere. Immagini della politica in Francia e in Italia nel Novecento* (Pacini: Pisa, 2017). The interest which the conference and exhibition attracted led us to envisage a more ambitious project: a book dealing with political portraiture in several countries, focusing on the last one hundred years. We approached Routledge, who welcomed our proposal enthusiastically. This was eventually fine-tuned in the light of the constructive criticism and helpful suggestions made by our anonymous reviewers. The result is what seems to us a book that is both wider in scope and more detailed than anything that has been produced so far on the subject of political portraiture. The great variety of countries it considers, the equal attention it devotes to democratic countries and to authoritarian/dictatorial ones (a feature permitting comparisons between propaganda approaches of divergent political systems that at times reveal surprising similarities), and the accounts on the uses of portraiture as forms of counter-propaganda are some of the volume's innovative features.

All the essays were specially commissioned for this volume from authors whose academic disciplines range from visual studies, to cultural history, to social and political history, but who all share the view that pictures do not play an ancillary function, but are thoughtfully designed and used for strategic ends. In the light of the new cultural configuration which W. J. Mitchell called "pictorial turn" in his seminal book *Picture Theory* (Chicago: University of Chicago Press, 1994), this volume treats images as valuable documents in their own right conveying beliefs, values, attitudes, identities and loyalties - documents that need to be interpreted cautiously for their reflection of social reality is untrustworthy.

Some words are due regarding the organization of the essays. The introductory text "Faces of Politics" is followed by chapters that are clustered around five thematic areas. The first group deals with the English-speaking world (United States and Great Britain). The second begins with an account of the visual propaganda employed in the elections in Italy that immediately preceded the First World War, the crisis of democracy and the rise of fascism, before examining the role portraiture played in three right-wing regimes: those of Benito Mussolini, of the Austrian Chancellor Engelbert Dollfuss and of the Spanish *Caudillo* Francisco Franco. The volume's third section is devoted to the Communist and ex-Communist world, with chapters dealing with the Soviet Union/Russia, China, North Korea and Romania. The fourth group deals with European countries which have emerged from the dark years of fascism and Nazism: the chapters on Italy, France and Germany focus on the post-war period, and consider the extent to which the personality cults of Mussolini, Marshal Pétain and Hitler have affected the representation of the democratically elected leaders. The last nucleus consists of two essays on the "Greater Middle-East", which approach portraiture from entirely different angles: while the first discusses its use by the early republican leaders of Turkey, Kemal Atatürk and İsmet İnönü, for promotional purposes, the second considers the ways in which the effigies of United States presidents have been employed in Iran, Iraq and Afghanistan as forms of protest.

Though wide-ranging, the present volume is far from comprehensive. We are aware that other important geographical areas could have been covered. It would have been

desirable to feature essays on Scandinavia, on North-African and Sub-Saharan countries, on Latin-America, as well as on such major Asian countries as India, Japan and Thailand. We hope that a future expanded edition of the book will be able to include a wider selection of countries.

We wish to express our sincere thanks to our authors, who, in a collaborative spirit, agreed to revise, and sometimes radically re-write, their texts, in the light of the recommendations we made to ensure that their essays reflected the book's general conception. We are immensely grateful to Pierre Sorlin for reading through the first draft of all the essays and providing helpful remarks. Thanks are also due to Verina Jones (Reading University) for perusing the French and Italian chapters, as well as the introductory essay "Faces of Politics". We owe the greatest debt of gratitude to our commissioning editor Isabella Vitti, editorial assistant Katie Armstrong and senior project manager Rennie Alphonsa for the support and advice they have provided during the various stages of the production of the volume.

Luciano Cheles and Alessandro Giacone
April 2020

1 Introduction

Faces of Politics

Luciano Cheles and Pierre Sorlin

For centuries having one's portrait drawn was a privilege of the mighty. It was not the price, quite high, that prevented well-off people from asking an artist to depict them but rather the fact that they did not feel worthy of having it commissioned. Portraits singled out those of rank, but there was more to it than that; human effigies pertained to an exceptional, almost supernatural realm. The portrait of a sovereign assured his presence in all the provinces of his kingdom, a gallery of ancestors showed the timeless permanency of extremely affluent families such as the wealthy, powerful Dutch and Flemish ship-owners or bankers.

We, moderns, are well aware that an image is nothing but an object, the keepsake of a person, of a moment, of an occurrence now over. Registration techniques, photography, cinema and video recording have progressively de-mythologized the powerful. Initially, the process was rather slow. For ages emperors, kings and princes had exhibited the painted effigy of their predecessors to mark the antiquity and power of their dynasty; photography and cinema did not disrupt the tradition. Until the beginning of the twentieth century, heads of state or government were solemnly represented, seated at their desk or standing in front of the national flag, in public places. Today there are still, in many countries, galleries where the lineages of kings, elected presidents or important leaders are displayed. In the 1960s and 1970s, although television made familiar the faces of influent politicians and followed closely their activities, kings and presidents were usually in control of the choice and put into circulation the sole images that suited them. In the last few decades, the diffusion of individual recording tools, light video, smartphones and other devices has made it easy not only to film at any time, in all circumstances, but also to spread one's pictures throughout the planet.

The great leaders of this world have lost part of their aura: they have come down to our level and talk about their family and daily concerns. Members of royal families such as the Prince of Wales and the Queen of Spain would not object to pose with us on a selfie, if we asked them. Considered in the long term, such evolution evidences a profound transformation in the relationship between the citizens and their leaders. The tempo, forms and depth of the change obviously vary according to the cultures and political systems of the different countries. Any occurrence is interesting in itself, but a comparative study is also necessary to appraise the social implications of political effigies more fully.

The First World War upset the political frameworks in Europe, well-established dynasties collapsed and new powers settled in disorder and instability. A photograph taken in Berlin, on February 24, 1934, on the occasion of the National Day of Remembrance, well exemplifies the dramatic change that was occurring. The President

of the Weimar Republic, Field Marshal von Hindenburg,[1] who features in the foreground standing up straight despite his eighty-seven years, is looking imperious and archaic in his Prussian uniform. Hitler, who had acceded to the Chancellorship, follows him, heedful, a few steps behind. *Der alter* (the old man), as von Hindenburg came to be referred to, died on August 2nd of that year. Within weeks, screaming wildly and gesticulating before his multitudes of fanatics, the *Führer* was to impose a new way of representing leadership in his country.

A map of Europe around 1930 showing the portraits of the different heads of state, here the defenders of the tradition, and there the champions of a great renewal, would be revealing. On one side we would find Miklós Horthy, regent of Hungary, appearing haughty and princely in his uniform studded with medals,[2] Marshal Józef Pilsudski, the Polish dictator, looking fierce and distant, Engelbert Dollfuss,[3] the Chancellor of Catholic Austria, in his officer uniform, praying with profound fervor (Figure 1.1) to recall to his fellow citizens the military tradition of their country and the impossibility of taking sides with Nazi "paganism" – and, on the other side, Lenin, Mussolini and Hitler, the agitators and champions of enthusiastic crowds.

The leaders of mass movements had learned how to arouse popular support before coming to power, while the men of the older generation, accustomed to rule by commanding strict obedience, had trouble in enthralling huge crowds. From the end of the First World War until the late 1920s most photographs of the Turkish leader, Mustafa Kemal, displayed only his facial appearance. Wearing a *schapska* (four-pointed cavalry helmet) that filled one-third of the frame, the general stared coldly at the onlookers who could interpret his gaze in contradictory ways: as a sign of decisiveness or of a state of confusion, of seriousness or hesitation. Such an ambiguous image is revealing of Mustafa Kemal's awkward position. As an officer of the Ottoman Empire, he was, until his election to the presidency of the Turkish Republic, a rebel who clashed with Mehmet VI, the legitimate sultan. In the following years he came up against the violent opposition of Muslims who did not accept the secularization of the country and of notables who were losing their social influence: an ambiguous expression brought less anger than a challenging, bold look. Once his power was stabilized, Atatürk ("father of the Turks"), as he came to be known officially, was represented addressing small groups of people to explain his reforms, visiting families and teaching the new alphabet to schoolboys. Having abandoned the hieratic postures adopted by the Sultan, he chose at the same time not to appear before huge crowds as fascist dictators were doing. His successor, İsmet İnönü, reverted to the classical, formal approach, as his portrait busts show.

The point being made here is that in portraiture apparently minor details may in fact carry important symbolic meanings. By choosing a modest attitude both Mustafa Kemal and İsmet İnönü implicitly took position in a European context dominated by two conflicting iconic models: that of the mob leader *vs.* that of the statesman. In the Second World War Hitler's pictures were intended to galvanize the Germans: he was pictured inspecting military installations and armaments factories, greeting the departing troops, talking to his staff, checking plans of campaign, and encouraging civilians. The leaders of Western democracies, on the other hand, were keen on heartening their

1 Uwe Fleckner, *Handbuch der politischen Ikonographie* (Munich: Beck, 2011), vol. 1, 12.
2 Tibor Dômötörfi, "A Horthy-kultusz elemei," *História*, 5 (1990): 23.
3 *Festschrift zur Feier des zweihundertjährigen Bestandes des Haus* (Vienna: Austria Staatsarchive, 1949), 795.

fellow-citizens by contending that they had the situation under control. Churchill's image dominated the British press and newsreels during the first years of the conflict; his serious, placid countenance and his gaze fixed on the viewer suggested patience and inspired trust. Roosevelt opted for pedagogy: he appeared in the newsreels explaining the scope of the orders he was signing, illustrating the American strategy axes on a wall-map, and talking to officers and privates. In the Soviet Union, throughout the dramatic years 1941–1942, when it seemed impossible to stop the German advance, countless effigies of Stalin were disseminated. The dictator, looking knowing and tranquil, with a hint of a smile on his face, conveyed a confident belief in the future that transcended the worries of the present. Later, when the threat of defeat receded, another Stalin image emerged: that of the architect of victory preparing, late at night, the offensive that was to put an end to the conflict.

The dictators had displayed a determined attitude and firm belief in the future (Hitler's regime was, notably, to last "one thousand years"), which was conveyed by their serious expression. Fascist and Nazi leaders had attended international rallies wearing the uniform of their respective parties. By contrast, the heads of state of the early post-war era appeared attentive and caring, and with a smile on their faces; and everybody, including military officers like general Dwight Eisenhower, wore civilian clothes. Their contact with the crowds took an informal, good-natured turn: they were photographed shaking hands, stroking the heads of children. The assured and imperious stance of the dictators gave way to attitudes that evoked modesty and the difficulty of the tasks confronting politicians after the war. For instance, the portraits of the British Prime Minister Anthony Eden (in office from 1955 to 1957) conveyed the image of an elegant and courteous man who, mindful of public opinion, struggling with the problems of the reconstruction, and gripped by the fear of another international conflict, tried to lead Europe during the difficult times of the Cold War.

Eden and his contemporaries belonged to the inter-war era, and already by the 1950s their language, attire and public behavior looked excessively formal and old-fashioned. Their style of presentation was to be swept away completely by the next decade. The technical advances made during the war, developed in the following decade (automation, jet propulsion, use of atomic energy, synthetic products), transformed the living conditions. Economic growth seemed assured for the long-term; new consumer goods such as cars, domestic appliances and television sets were accessible at fair prices and people got used to going on holidays. There were noticeable improvements in audio-visual recording with Sony's first half-inch portable video and the Kodak Super 8 camera. Thanks to light equipment, television channels multiplied interviews and reports while amateurs were able to film the public appearance of famous people. Conscious of being exposed to the curiosity of any passer-by, most politicians decided to organize their self-representation according to criteria of their choice.

At the same time the Cold War gave way to the "peaceful coexistence" between the capitalist sphere and the communist bloc. Political newcomers such as John Kennedy, the West German Chancellor Willy Brandt and the British Prime Minister Harold Wilson, conscious about the image that television was broadcasting to a rapidly expanding audience, got rid of the formal approach pursued by their predecessors. The following half-century was an extension of the new style that had emerged in the 1960s.

Over the last half-century, momentous developments have taken place in the representation of the political universe. To begin with, the media intrusiveness has blurred the boundaries between the private life of statesmen, their family environment, their

pastimes, and their public activities. This phenomenon has not characterized politicians exclusively: sportsmen, artists and businessmen have also been forced to expose part of their domestic life, but, in the case of political leaders, the balance has often been difficult to establish between personal concerns and the defense of collective interests. Another important development has been the growth of the role of women. Long confined to the margins of governmental decisions, assigned to secondary tasks and weakly represented in elected assemblies, they have managed to impose themselves and occupy key institutional positions, though they are still subjected to caricature and other forms of demeaning representation. Lastly, the intense competition for the exercise of power has brought about an ever-increasing reliance on fanciful and/or down-to-earth imagery and language. Such approaches are supposed to bring the leaders closer to their co-citizens and show that they are ordinary individuals, though the line that separates simplicity from pure demagogy is blurred.

In Western countries, the most radical changes in the depiction of politicians occurred from the 1950s to the 1990s. President Harry Truman, anxious to provide his fellow citizens with a good memory of his years at the White House (1945–1953), was photographed sitting at his desk, pen in hand, with a serious, knowing and benevolent expression, as if he had just stopped writing to direct the gaze toward the camera, which stands for his audience. Meanwhile Chancellor Konrad Adenauer of Germany[4] was involved in an election campaign. Sitting in an armchair, he too stares intensely at the camera – at his constituents. Through the extended exposure of the cliché, the smallest details of his face have been reproduced and his garments appear with great clarity. The portrait radiates self-assurance and strength. Both pictures are meant to reassure the electors that they can manage the country efficiently.

Two examples from the last decade of the past century are worth looking at. A picture taken in 1992, during Bill Clinton's presidential campaign in Cleveland, shows the members of the electoral committee in their shirtsleeves occupying the background while Clinton, his aspiring deputy Al Gore and the organizer of the meeting, wearing a dark suit, feature in the foreground. Their eyes flee to the right and their silhouettes are a little fuzzy, but what matters is the general enthusiasm, their raised arms, their unanimous shouting of the final slogan. As for Helmut Kohl, a campaign poster for the Bundestag election of 1994 depicts him smiling, immersed in the crowd. The photographer has focused on the foreground, the head of Kohl and that of the people close to him stand out clearly, while the undifferentiated mass who fill the background are slightly blurred. The image suggests intense excitement, shouts and applause. The program is the show itself and the candidate the manager of the happening: the fervor of the moment guaranties success.

John Kennedy was among the first heads of state to open his official residence to television cameras. His wife, Jackie, guided a few privileged technicians throughout the White House. The photographs that were taken of the Kennedys, parents and children, were carefully framed and slightly conventional: the children appeared between their parents, who occupied the two sides of the pictures; these were family photographs, with no hint at the private life of the couple. Harold Wilson, understanding that an unaffected style would make a political career easier for him, accentuated the fallacious complicity with the onlookers. When photographed with another personality, for example the fellow Labour politician Aneurin Bevan, Lyndon Johnson,

4 Fleckner, *Handbuch der politischen Ikonographie*, vol. 1, 215.

John Kennedy, Richard Nixon and even the Beatles, he always placed himself slightly behind his guest, to honor him or her while underlining his modesty.

The presence of women in political imagery was not always an acknowledgement of the role they played, or were encouraged to play, in society: it was purely perfunctory in countries where women's contribution to the running of institutions was ill tolerated, an attempt to look "Westernized". Mohammed Reza Shah Pahlavi sought to project the image of a "modern" Iran by ensuring that his successive wives wore Western clothes and were unveiled when they attended public events – a sartorial policy that was considered scandalous, "un-Muslim" and contributed to his fall. In reaction, the Muslim republic that substituted Reza Shah in 1979 eliminated women from official portrayal. Iraqi dictator Saddam Hussein, wanting to take advantage of the unrest in neighboring Iran and distinguish himself from it, chose the opposite approach. Countless pictures widely diffused showed him, at home or in public, accompanied by many women dressed in European style who were freely talking with men. It was not so much the presence of women that scandalized many Iraqis – Muslim women could take important offices, as attested by Benazir Bhutto, Pakistani Prime Minister from 1988 to 1990, and from 1993 to 1996 – but rather the elimination of the traditional female dress, the long garment covering the whole body and veil.

Two other notable women who came to power are Indira Gandhi, who served as Prime Minister of India from 1966 to 1977, and from 1980 to 1984, and Margaret Thatcher, who governed Britain from 1979 to 1990. Thatcher was the longest-serving Prime Minister of British history since the eighteenth century, and undoubtedly the most controversial of all. She was imperious, peremptory and uncompromising. After the Falklands War (the 1982 conflict between Argentina and the United Kingdom over two British dependent territories in the South Atlantic), whose outcome she treated as a personal triumph, Thatcher often appeared in the photographs disseminated by the Conservative Party alone and gazing into the distance, i.e. as a far-sighted leader. The Iron Lady, as she was nicknamed, did not seek approbation: she simply wanted to persuade the British that she was always firmly at the helm, whatever the situation. While depicting her as an out-of-the-ordinary personality, her official portraits did not attempt to hide her authoritarian nature. Thatcher's radical policies and bullish attitudes provoked strong reactions that led to her being depicted in exceptionally hostile ways. Cartoons and photo-montages represented her as a spiteful figure, as a ferocious warrior, as a ludicrous Athena figure defending a tiny group of islands, and in the guise of Queen Victoria. Some of Thatcher's public appearances were so over-the-top as to invite mockery. A case in point are the photographs that depict her imitating the Queen's attitudes and outfit, as if she wished to embody both the roles of head of state and Prime Minister.

Despite the uncompromising opposition of the Labour Party and trade unions, Thatcher's ultra-liberal policy – cutting of direct taxes, of State subsidies to the economy and of social security benefits – did not prevent her from winning three successive elections. The aggressiveness of the cartoonists and of part of the press did not result in a total rejection from British public opinion. A comparison with the ways another powerful female leader, the German Chancellor Angela Merkel, has been satirized leads one to consider the question of representation from another angle. Her caricatures have mostly been centered on her physical appearance: her podgy face, her heavy and graceless build have been ceaselessly subjected to malevolent attacks; she has been nastily disfigured, sometimes shown in the traits of a fat sow. Yet, she has never adopted arrogant stances, and enjoyed extreme popularity during her first three terms of office. People seem resigned to tolerate a female Prime Minister, but their

ineradicable and universal sexist attitudes often lead them to "revenge" by resorting to heavy sarcasm. Distorting a woman's features seems to be easier than visually ridiculing a man.

So manifest a contradiction between the popularity of a female leader and the cruelty with which she is represented makes one reflect on the functions of political portraits. Are they barely vehicles of propaganda, criticism and information, or do they serve entirely different purposes? There is no univocal answer to these questions; the role of portraits differs according to the political regimes and the traditions of each cultural area.

The legacy of imperial or royal portraiture such as it had prevailed for centuries is still alive today, notably in North Korea where it is based on the founder's imperishable memory. Kim Il Sung's struggle against the Japanese provides a historical background easy to illustrate and legitimates the giant statues of the "Great Leader", as well as the proliferation of devotional images. His successors have been shown beside their forebear, individual differences between them are unimportant; what matters most is the Kim dynasty whose omnipresence leaves no space for any other representation. Oddly enough, in a time when most dictators have adopted a semblance of democracy and submit to mock elections, the affected adulation that envelops the North Korean leaders proves efficient; secluded from other people, Koreans are loyal to their "guide" while the rest of the world, amazed by such archaism, pay to the country an attention out of proportion with its importance.

Often stereotyped, the portraits and monuments celebrating dictators provide valuable clues about political difficulties when iconography changes. In the first years of Saddam Hussein's dictatorship, myriads of images showed a young, energetic, modern officer who, as we noted earlier, did not hesitate to challenge Muslim traditions. When, in the mid-1980s, it appeared that the war waged against Iran could not be won, was too expensive and plunged many families into mourning, representations changed. The Iraqi leader relinquished his secular attitude and turned into a "sincere believer" in order to rally the support of the popular strata: on countless posters or murals he was depicted kneeling with outspread arms, bowing, reading the Koran. Other portraits, aimed at the middle classes and more highbrow, depicted him fighting under the aegis of Assyrian or Babylonian kings, of Mohamed's companions or of Saladin (Figure 1.2).

The traditional posters of the nineteenth and twentieth centuries, so full of promises, have been replaced in liberal regimes by photographs as colorful and fanciful as tourist flyers. If the propaganda of the dictators dwelled on their alleged strength of character (more rarely, on their physical vigor too, the principal example being Benito Mussolini), the aspiring politicians of today use their physical assets (a youthful appearance, an endearing smile, a beautiful complexion, an athletic build...) and present themselves as informal and approachable people. Tony Blair is a case in point. Aged forty-four in 1997, at the time of his first and triumphant general election, he fought his campaign appearing in shirtsleeves and striving to look friendly, attentive and unassuming – a relaxed approach that was meant to appeal to "ordinary" people. Silvio Berlusconi, whose foray into politics began in 1994, when he was fifty-eight, has been especially aware that good looks and charm are vote-pullers. As well as "rejuvenating" himself (see below), he has frequently chosen female candidates on the basis of their photogenic qualities. He is also known to have demanded that his male aspiring Members of Parliament be beardless, convinced that a "clean" face is aesthetically more pleasing, and hence has a greater electoral appeal. In liberal countries, elections

are generally won at the margin. A floating electorate makes up its mind late, on ill-defined criteria: an attractive figure, an expressive face or a sly look can be enough to orient a vote. Winking at the hesitant can affect their choice and tip the scales of an electoral contest.

Political leaders present themselves according to two different models, one solemn and affirmative, the other familiar and engaging. The images they circulate are revealing of the way they govern. For a long time, hieratic pictures of leaders were meant to inspire awe and persuade the liegemen to comply with their sovereign's wishes. A few decades, from the late 1990s to our days, have been enough to question this age-old tradition, at least in the Western world, and have led rulers to modify their behavior, solicit their electors, try to win their trust.

The heads of despotic and authoritarian regimes have always made a great use of portraiture. To maintain their strongly personalized rule, it is crucial that they should be seen everywhere. Their presence, in the guise of statues, banknotes, coins, murals, posters, etc., attests to their power and contributes to their aura. Hence the reverential attitude toward them that is expected from people. North Korea, where even folding a newspaper that creases the picture of Kim Il Sung on its front page is treated as a serious offense, constitutes an extreme example. The destructive fury that is unleashed against the effigies of leaders when regimes fall is intended to break the rulers' spell.[5]

The downfall of dictatorships also produces long-lasting effects on countries' attitudes to political portraiture. The leaders that come to the fore when democracy is re-established react to the genre in ways that reveal a sense of unease. After the demise of Mussolini, Italian politicians shunned portraiture as a form of propaganda for nearly forty years, out of fear of being accused of personality cult. The apprehension was shared by the presidents of Italy. Despite the importance of their function and the deep respect they are accorded, presidents have always been portrayed in an understated way in their official photographs. No state museums have ever been established to honor their memory, and monuments to them are virtually non-existent. One of the rare exceptions is the monument erected in 1990 in the center of Milan in memory of Sandro Pertini (in office from 1978 to 1985), undoubtedly the most popular of all Italian presidents. Significantly, it is not a statue, but an architectural structure that fulfils a social function: it consists of a hollow marble cube incorporating a staircase that functions as multiple benches. Two rows of mulberry trees have been planted on either side. The architect Aldo Rossi, who conceived the work, intended it as "a little Lombard square, a quiet place to meet, eat a sandwich or take group photographs".[6] Pertini's name only features discretely on a plaque. French politicians showed the same reluctance to use their effigy for campaigning purposes after Marshal Pétain's regime came to an end in 1944 – although this reluctance was short-lived because, unlike fascism, the Vichy state only lasted four years. General de Gaulle, who had led the Resistance against Nazism, never had any qualms about having posters with his effigy plastered on the walls of France, treating the practice as a re-appropriation of the public space that Pétain had usurped. The first two post-war presidents, Vincent Auriol and René Coty (in office from 1947 to 1953 and from 1953 to 1959, respectively) were featured in their official

5 Philip Manon, "Democratic Bodies / Despotic Bodies," in idem, *Under the King's Shadow. The Political Anatomy of Democratic Representation* (Cambridge, UK: Polity, 2010), 90–6, 106–10.
6 Alberto Ferlenga, ed., *Aldo Rossi. Tutte le opere* (Milan: Electa, 1999), 206.

photographs dressed in full regalia. De Gaulle, who succeeded Coty, as well as posing similarly attired, had himself photographed in color (Italians had to wait until 1985 before seeing their president officially portrayed in color – the president in question was Francesco Cossiga). The Germans took a different approach. After the Second World War, instead of proscribing political portraiture altogether, leaders chose to have themselves represented in "humble" or "spontaneous" postures, in deliberate contrast with the imperious ways Hitler and leading Nazi figures liked to present themselves to the public. The paintings were mostly commissioned from modernist artists, whose pictorial styles would have been condemned by the regime as *entartete* (degenerate). The portrait of Konrad Adenauer (Chancellor from 1949 to 1963) provides a particularly eloquent illustration of this policy: it was executed in 1966 by Oskar Kokoschka, an Expressionist artist who had sought refuge abroad in 1943 to avoid persecution. The portraits of the Chancellors therefore fulfilled an educational function, which became more evident when a *Galerie der Bundeskanzler* (Gallery of Chancellors) was established in Bonn in 1976 (later moved to Berlin) to accommodate them.

In the past few decades, the leaders of totalitarian states, like their democratic counterparts, have tended to be represented in informal and friendly attitudes in their propaganda to appear close to their subjects. Having come to realize that it is better to be liked than feared, they now put on a friendly face. Iraq's Saddam Hussein was featured smiling on stamps and banknotes, and even on some billboards and murals depicting him in military gear. The successive leaders of North Korea's Kim dynasty also look affable and approachable in their propaganda; and this is also true of Mao Zedong, Stalin and Romania's Nicolae Ceauşescu. The adoption of an endearing image has clearly been influenced by the manners of presentation of the heads of Western democracies. However, the influence in approaches to propaganda has not been entirely one-way. Umberto Eco noted in an essay on the Italian parliamentary election of 2001 entitled "Vi spiego perché in Berlusconi si nasconde un comunista" (Let me tell you why behind Berlusconi lurks a communist) that the campaign of the mogul-turned-politician, which relied heavily on his charismatic effigy and did not allow other major figures from his party to appear on their publicity, was likely to have been inspired by the triumphant display of the effigies of the Che, Lenin, Stalin and Mao in communist marches and demonstrations.[7] An *Economist* article on the same election remarked wryly that the campaign was so dominated by billboards featuring Berlusconi and other leaders that Italy resembled Saddam Hussein's Iraq.[8]

In democratic states, the degree of informality and "friendliness" in the representation of leaders may depend on their position in the political spectrum. The visual propaganda of the Italian Communist Party and of the left-wing and center-left parties that evolved from it has consistently depicted their chiefs in spontaneous attitudes, to purport that the photographs are casually taken snapshots, therefore suggesting genuineness. These leaders are also more often than not shown together with other political figures (to stress that decisions are taken collectively) or performing militant

7 First published in *La Repubblica*, April 3, 2001, it has appeared in English as "The 2001 Electoral Campaign and Veteran Communist Strategy" in Umberto Eco's own collection of essays *Turning Back the Clock. Hot Wars and Media Populism* (Orlando, FL: Harcourt, 2008), 121–7. Eco was actually referring to the marches of far-left activists in Italy, but the practice of displaying the effigy of Marxist luminaries imitated that commonly pursued in Communist dictatorships.

8 Anon., "That's Italian politics, signori," *The Economist*, February 3, 2001, 38.

activities, such as addressing a rally or discussing everyday issues with ordinary people. It is tempting to relate this approach to the aesthetics of social-realism, and even to Stalin's propensity to be represented as a man of action, a true Bolshevik, rather than as a "sitter".[9] The calculated "roughness" that characterized many of the post-war portraits of the Communist leader Palmiro Togliatti (in office from 1927 to 1964) was in keeping with the warts-and-all aesthetics of Neo-Realism, which his party strongly supported.[10] In Germany too, it is a leader of the left who first had himself portrayed in action: Willy Brandt featured on the campaign poster of the 1969 election in the act of addressing an audience and accompanying his speech with a dramatic gesture – an image that was to serve as a model to the monument that was erected in his party's headquarters in Berlin in 1992. Far-left and protest movements signal their opposition to mainstream parties by rejecting propriety and slick graphic styles. The unorthodox ways in which the leaders of the Italian Lega (League) and Movimento 5 Stelle (5-Star Movement), and of the French Lutte Ouvrière (Workers' Struggle) and Nouveau Parti Anti-Capitaliste (New anti-Capitalist Party) like to appear are cases in point.

The irreverent, eccentric or downright outrageous styles of presentation pursued by some politicians need not be interpreted as expressions of radical, anti-establishment and iconoclastic attitudes. They can be tongue-in-cheek provocations, simple attention-grabbing stunts. In Spain and Italy especially, a number of candidates of all shapes and ages have portrayed themselves in various states of undress in their publicity, allegedly to represent the virtue of transparency or claim that the exorbitant taxes have left them naked.[11]

Male leaders of prominent national movements never bare all, but do not disdain exhibiting pectoral muscles before the cameras. Mussolini featured bare-chested in various official photographs that showed him in a field reaping corn and in a winter resort with his skis on. Recent examples of shirtless leaders include Vladimir Putin and Justin Trudeau (who even performed a mock strip-tease at a charity fund-raiser in Ottawa after his re-election as Liberal Party Member of Parliament in May 2011).[12] Their motives, blatantly narcissistic, are a far cry from those which had led Mahatma Gandhi to shed his barrister attire and adopt a simple loin-cloth: his partial nakedness expressed his solidarity with the millions of poor in India who only wear that

9 Jan Plamper, *The Stalin Cult. A Study in the Alchemy of Power* (New Haven – London: Yale University Press, 2012), 144.

10 Luciano Cheles, "The Faces of Militancy: Palmiro Togliatti's Propaganda Portraits (1948–1964)," in *Words of Power, the Power of Words*, ed. Giulia Bassi (Trieste: Edizioni Università di Trieste, 2019), 115–55.

11 Spanish examples include the swimming champion Albert Rivera, who stood for Catalonia's anti-nationalist party Ciutadans (Citizens) in 2006, Yolanda Couceiro Morin, a member of the far-right Partido por la Libertad – Manos Limpias (Party of Freedom – Clean Hands) who sought to win the mayoralty of the town of Portugalete, in the Bilbao Estuary, in 2015, and the Socialist Luis Alberto Nicolas, who stood in Cantabria in 2015. See Alistair Dawber, "Spanish voters discover naked truth about their politicians," *The Independent*, April 27, 2015, 23. For some Italian examples, see Luciano Cheles, "From Reticence to Excess: Political Portraiture in Italy," 246, in this volume. On the political use of the unclothed body, see: Philip Carr-Gomm, "Naked Rebellion", in idem, *A Brief History of Nakedness* (London: Reaktion, 2010), 89–133, 270–1; Brett Lunceford, *Naked Politics. Nudity, Political Action, and the Rhetoric of the Body* (Lanham, MD: Lexington Books, 2012).

12 Alexander Smith, "Meet Justin Trudeau: Canada's Liberal boxing, strip-teasing new PM," *NBC News*, October 21, 2015. https://www.nbcnews.com/news/world/meet-justin-trudeau-canadas-liberal-boxing-strip-teasing-new-pm-n447636 (This link and the following in this essay were last accessed on December 1, 2019).

garment, as well as his protest against British imperialism which exploited his country's resources; in other words it was a symbol of his mission.[13]

To prove their fitness, energy and endurance, the political personalities of the postwar period also engage themselves in well stage-managed, strenuous physical activities. Swimming is one of their favorites. Chairman Mao's swim in the Yangtze River in 1966 at the age of seventy-two has entered the annals of history. Saddam Hussein, Putin, Kim Jong Un and Beppe Grillo are among the long list of political personalities who performed swims to demonstrate their vigor.[14] Horse-riding is another athletic activity that leaders enjoy to be seen performing. The horse is an animal rich in positive connotations which include strength, loyalty, intelligence, elegance and majesty. It also lends itself to more precise political interpretations that vary depending on the cultural contexts. The portraits of Mussolini and Franco on horseback evoked the equestrian monuments of the Roman Caesars and of Renaissance condottieri, as well as those of such conquerors as Napoleon and Garibaldi. Just after his March on Rome in 1922, Mussolini disseminated 1,000 copies of a lithograph that represented him on horseback, leading the fascist legions.[15] Moreover, in European tradition, the horse, being a wild animal that has been successfully broken, has often served as a metaphor for discipline as a social necessity: the *Duce*'s equestrian portraits were probably also meant to represent him as a gifted rider who controlled an unruly nation.[16] Horses featured frequently in Saddam Hussein's propaganda imagery to allude to Iraq's Bedouin heritage and symbolise male pride (Figure 1.3). If white, the horse carried strong religious associations because Husayn ibn Ali, the Muslim hero and grandson of the Prophet Muhammad, was martyred in 680 riding one.[17] On the other hand, the pictures of Kim Jong Un riding on sacred Mount Paektu which are recurrently released by the authorities refer to Chollima, the winged horse of central Asian mythology, which North Koreans treat as a symbol of rapid progress.

Leaders' preoccupation with their physical appearance and, more generally, with the ways in which their public activities are perceived, prompt them to ensure that their official photographic images are of an "appropriate" nature. Hence the appointment of trusted photographers who understand how they wish to be represented.[18] This is as

13 Emma Tarco, *Clothing and Identity in India* (London: Hurst & Company, 1996), 62–93.
14 On the political symbolism and iconography of swimming, see Horst Bredekamp, *Der schwimmende Souverän* (Berlin: Klaus Wagenbach, 2014).
15 Andrea Giardina, "Retour au futur: la romanité fasciste," in *Rome. L'idée et le mythe. Du moyen âge à nos jours*, eds. André Vauchez and Andrea Giardina (Paris: Fayard, 2001), 163. On Mussolini's equestrian portraits, see Beatrice Sica, "Le anime semplici e il piedistallo: l'immagine del *Duce* condottiero nei libri scolastici e per ragazzi dell'Italia fascista," *Transalpina. Etudes italiennes*, 21 (2018), 191–214.
16 On the horse metaphor, see Pierangelo Schiera, "Socialità e disciplina: la metafora del cavallo nei trattati rinascimentali e barocchi di arte equestre," in *Il potere delle immagini. La metafora politica in prospettiva storica*, eds. Walter Euchner, Francesca Rigotti and Pierangelo Schiera (Bologna – Berlin: Il Mulino – Duncker & Humbolt, 1993), 143–82. This interpretation of Mussolini's equestrian portraits is confirmed by an article which appeared in the popular weekly *La Domenica del Corriere* on August 18, 1923: after informing the reader about the *Duce*'s daily horse-riding exploits, the author notes that his formidable equestrian training began when "he gripped the government of his Country between his vigorous legs".
17 For the symbolism of the horse in Saddam's Iraq, see Kanan Makiya, *The Monument. Art, Vulgarity and Responsibility in Iraq* (London: Tauris, 2004), 11–14, 97.
18 The question of the tension between verisimilitude and idealization in the depiction of rulers is of course age-old. One example from the Renaissance is worth citing. Andrea Mantegna was an artist much sought-after by Italian courts, but the portraits he painted at times displeased his sitters because of his

true of totalitarian regimes, past and present, as it is of democratic states. Pyotr Otsup, who had covered the storming of the Winter Palace and other revolutionary events in the Soviet Union, was the Kremlin's image-maker from 1917 to 1935 (his are some of the most iconic pictures of Lenin and Stalin). The Turkish President Atatürk and his successor İsmet İnönü relied on the services of Etem Tem, who had been an official military photographer during the War of Independence, and Cesmal Isiksel. Mussolini employed both "court" photographers and independent ones, but his propagandists vetted their pictures meticulously before distributing them to the press and commercial organizations. Hitler's official photographs were taken by his long-standing friend Heinrich Hoffmann. Franco's favorite image-maker, especially in the first two decades of the regime, was Jalón Ángel. Marshal Pétain had a photographer named Edé follow him in his travels when he was head of the Vichy government.[19] Though contemporary leaders too have personal photographers,[20] their control over the use made of the pictures taken is considerably limited, given the wide range of independent photographic agencies, whose paparazzi delight in taking snapshots that immortalize political figures in unflattering poses and embarrassing situations, and the eagerness of the media to reproduce them.

Conscious that they are under constant media scrutiny, politicians, female ones in particular, choose their garments with great care to convey the right image.[21] Leaders ensure that they look presentable in the pictures they officially disseminate by resorting to photographic retouching, the extent to which can vary. The Kremlin photographers brightened Nikita Khruschev's smile, brushed up Mikhail Gorbachev's birthmark and removed the bags from Boris Yeltsin's eyes.[22] The pictures of Kim Jong Un have

realism – a realism well attested by the celebrated *Camera degli Sposi* frescoes in the Ducal Palace of Mantua, depicting the members of the Gonzaga family. In 1475 Lodovico Gonzaga remarked in a letter that "Andrea is good at other things, but lacks grace in portraits". From another letter, also written in 1475, we learn that his son-in-law, Galeazzo Maria Sforza, was so dissatisfied with the portraits that Mantegna had made of him that he burnt them. See Lorne Campbell, *Renaissance Portraits* (New Haven – London: Yale University Press, 1990), 150 and 62 respectively.

19 Thérèse Blondet-Bisch, "La photographie," in *La propagande sous Vichy, 1940–1944*, eds. Laurent Gervereau and Denis Peschanski (Nanterre: BDIC, 1990), 160.

20 On American presidents' personal image-makers, see John Bredar, *The President's Photographer. Fifty Years inside the Oval Office* (Washington, DC: National Geographic, 2010). President Obama's Chief Official White House Photographer and Director was Pete Souza. See Petra Bernhardt, "Image-Making, Image-Management: White House Photos and the Political Iconography of the Obama Presidency," *The Poster*, 4, 1–2 (2017): 145–72. President Trump's photographer is Shealah Craighead, who, during George W. Bush's administration, served as photo editor of Vice-President Dick Cheney, as well as Laura Bush's personal photographer. Italian politicians have also relied on personal photographers. See: Guido Quaranta, "Il fotografo del potere. Sì, il Palazzo è tutto un click", *L'Espresso*, January 29, 1990, 60; and anon., "Tiberio Barchielli, da paparazzo a fotografo del premier," *Libero*, May 3, 2014 (on the photographer Matteo Renzi appointed when he became Prime Minister in 2014). https://www.liberoquotidiano.it/news/personaggi/11605207/Tiberio-Barchielli---da-paparazzo.html. President Macron's spectacularly staged photographs are the work of Soazig de la Moissonnière, about whom see Ophélie Ostermann, "Qui est Soazig de La Moissonnière, photographe officielle d'Emmanuel Macron?," *Madame Figaro*, June 29, 2017.

21 Maria Pia Pozzato, "Fashion and Political Communication in the 1980s and 1990s," in *The Art of Persuasion. Political Communication in Italy from 1945 to the 1990s*, eds. Luciano Cheles and Lucio Sponza (Manchester – New York: Manchester University Press, 2001), 287–98; Robb Young, *Power Dressing. First Ladies, Women Politicians & Fashion* (London – New York, Merrell, 2011); and Gaëtane Morin and Elizabeth Pineau, *Le vestiaire des politiques* (Paris: Laffont, 2016), which deals with the sartorial codes of French politicians.

22 Nanette van der Laan, "Retoucher of Kremlin class," *The Independent on Sunday*, August 1, 1993, 10.

also been manipulated. When, in 2016, the North Korean media released an unre-touched high-definition photograph of him, the change caused some surprise and was interpreted as an attempt to project a more natural image that might suggest that the country was "normal".[23] Silvio Berlusconi's photographic rejuvenations are as legend-ary as his numerous facelifts and hair transplants, and he has used his portraits repeat-edly in unchanged form over an extended period. However, he did take the mask off on one occasion: this was when he posed for a photo-reportage that featured in the *Sunday Times Magazine* on January 24, 2014. The photographs, which depicted him with flaccid traits, a somber expression and a granular skin riddled with wrinkles, had an ample international resonance. They were also reproduced in the press owned by Berlusconi himself, for this "aesthetic coming-out" was no more than a shrewd political operation: at a time when the leader was investigated for claims that he gave false testimony and corrupted witnesses to cover up scandals concerning erotic parties involving models and showgirls, he was eager to appear as a wistful old man and rebut his ribald satyr image.[24]

Politicians who strongly personalize their leadership and put extensive effort into their appearance trigger forms of degradation or violence that focus on their physical figures and their depictions when they fall from grace. The once august bodies of all-powerful dictators are displayed to the public and mediatized for all to savor the sight of their humiliation and disfigurement. After Mussolini's execution by the partisans on April 28, 1945, his body was allowed to be physically abused by an angry crowd in Milan, before being hung upside down, and postcards of these scenes were hastily pro-duced to be sold.[25] Footage of the trial of Nicolae Ceaușescu and his wife, and of their corpses, were released to the media immediately after they were shot on December 25, 1989. Photographs of Saddam Hussein in his underwear washing his socks in his Baghdad cell were splashed across the front pages of the tabloids *New York Post* and *The Sun* on May 20, 2005. A few hours after his execution on December 30, 2006, Iraqi television broadcast a video showing the noose being placed around his neck (although not the actual hanging). Just after the Libyan dictator Muammar Gaddafi was shot on October 20, 2011, photos and a video with an offbeat soundtrack were circulated showing him stripped to his waist in a pool of blood and being sodomized with a bayonet. The statues, murals, billboards and posters that glorified these dicta-tors were vandalized or destroyed (Figure 1.4).[26]

The attacks on the effigies of democratically elected politicians who lose favor or are perceived by their opponents as a serious threat, and the visual artefacts that are produced to denigrate them, are at times so brutal, that they cannot be treated as ordi-nary forms of dissent, part and parcel of the freedom of expression of our democracies.

23 AP Seoul, "Kim goes for natural look in official photo," *The Guardian*, May 13, 2016, 22.
24 Dominique Dunglas, "Italie : Berlusconi sans fard," *Le Point*, January 27, 2014, 2. https://www.lepoint.fr/monde/italie-berlusconi-sans-fard-page-2-27-01-2014-1784629_24.php
25 It is alleged that it is precisely to avoid such humiliations that Hitler chose to commit suicide on April 30, 1945 and have his body burned.
26 A particularly good example of the disfigurement and destruction of a dictator's effigy is the toppling of the twelve-meter-high statue of Saddam Hussein in Firdos Square, in the center of Baghdad, on April 8, 2003. The event was broadcast live in Iraq and other countries. See Florian Göttke, *Toppled* (Rotterdam: Post Editions, 2010). On the defacing of Saddam's murals and billboards, see Bernardo Valli's well illus-trated article "Bagdad, il culto sfregiato del Rais," *La Repubblica*, October 23, 2005, 34–5.

The decapitation in 2002 of the marble statue of Margaret Thatcher that was due to be erected in the House of Commons at Westminster is a prime example of "pictorial butchery". Another is provided by the dummy guillotines that the protesters of the *Gilets jaunes* (Yellow vests) movement set up in Paris and elsewhere during the riots of winter 2018 to graphically convey their wish that Emmanuel Macron's head should fall (cut-outs of the president's head were displayed in some places). The Conservative Party literally demonized Tony Blair by picturing him with devil eyes in the campaign for the general election of 1997. The image was so extreme that it caused an uproar. President Barack Obama was portrayed as both Hitler and Lenin in 2010 for "imposing" a scheme that made health care more affordable for everyone, the so-called Obamacare.

The degradation of a leader can take subtler forms. When Berlusconi was struck with a metal souvenir at a political rally in Milan in December 2009, as a result of which he suffered a fractured nose, broken teeth and cuts to a lip, the photographs of his bleeding face that were reproduced on the front pages of many newspapers in Italy and elsewhere[27] were not merely documenting the attack: one could sense an element of glee in the representation of the disfigurement of a statesman who displayed an obsessive concern about his appearance and who had made his broad smile the hallmark of his would-be charm and optimism.[28] It is worth remarking that immediately after the attack, Berlusconi did not cover his blood-spattered face to preserve his decorum. On the contrary, he displayed it: having been hustled into the back of his armored car by his escort, he asked the driver to stop and got out to appear to photoreporters and the crowd as a martyr, an *Ecce Homo* figure.[29] This anecdote shows how the intended meaning of an image can be overturned by the public's perception of it. A classic illustration of this phenomenon is the 1967 photograph of Che Guevara's dead body laid out on a stretcher on top of a trough, which the Bolivian army disseminated to prove that the guerrilla had been captured and executed, but was in fact viewed compassionately by many as it recalled the iconography of Christ's deposition, and in particular Andrea Mantegna's deeply moving *Dead Christ*.[30]

Leaders whose effigies are physically attacked or who are scathingly satirized at times seek to neutralize, attenuate or ridicule these expressions of censure. Albeit belatedly, Thatcher reacted to the decapitation of her statue with characteristic humor. At the unveiling ceremony of the bronze statue that replaced it, in the Houses of Parliament, in February 2007, she declared in her speech: "I might have preferred iron, but bronze will do. It won't rust. And, this time, I hope, the head will stay on."[31] Satire is often re-used by those it is aimed at recuperatively. The German Chancellor Helmut Kohl and Silvio Berlusconi responded to the caricatures that lampooned them in 1987 and 2001 respectively, by appropriating them in order to present them to the public as good, harmless fun, therefore blunting their critical charge. The recuperative use of

27 The foreign newspapers that featured Berlusconi's injured face on their front pages include *The Times*, *The Wall Street Journal*, *El País* and Israel's *Iediot Aharonot*.

28 On this smile, see Stephen Gundle, "Il sorriso di Berlusconi," *Altrochemestre* 3 (1995): 14–17.

29 Filippo Ceccarelli, *Invano. Il potere in Italia da De Gasperi a questi qua* (Milan: Feltrinelli, 2018), 739.

30 John Berger, "'Che' Guevara," in idem, *Selected Essays and Articles. The Look of Things* (Harmondworth: Penguin, 1972), 43–4; Martin Kemp, "Che," in idem, *Christ to Coke. How Image Becomes Icon* (Oxford: Oxford University Press, 2012), 187–9.

31 See: Anon.,"Iron Lady unveils her bronze statue," February 22, 2007. https://uk.reuters.com/article/uk-britain-thatcher/iron-lady-unveils-her-bronze-statue-idUKL2129484920070221

caricatures as a form of counter-propaganda is not a recent phenomenon. A precedent can be found in Nazi Germany. To attempt to exorcise the ferocious satire that was mounted against Hitler by the international press before he came to power, a book featuring the cartoons with translated captions together with comments that replied to the attacks was published in 1933. Entitled *Hitler in der Karikatur der Welt: Tat gegen Tinte* (Worldwide Caricatures of Hitler. Action against Ink) (Berlin: Braune Bücher Carl Rentsch), it was the work of Ernst Hanfstaengl, a Harvard-trained German-American businessman who had helped finance the publication of *Mein Kampf* and was appointed head of the Nazi party's Foreign Press Bureau in 1931.[32]

Caricatures and the vandalizing of statues and other artefacts depicting leaders are not the only portrait-focused forms of protest. Another important genre is that of the photographs of dissidents who have been arrested or abducted by the security forces, which people display during demonstrations. In Argentina, the mothers of the youths who "disappeared" when their country was run by a military junta (1976–1983) converged upon the Plaza de Mayo in Buenos Aires and circled around it with pictures of their children "worn" on their bodies or mounted on placards to demand the truth about what happened to them. Their private photographs were made public to provide indisputable evidence that the missing youths whose bodies were never recovered were alive in their families' minds and hearts. The initiative did not end with the fall of the military regime: the mothers have continued to have weekly vigils in the Plaza: the portraits of the *desaparecidos* serve to keep the memory of past atrocities alive so as to educate the next generations. Hence the *madres'* motto: "Recordar para no repetir" (Remember in order not to repeat). These protests have led to the creation of a centralized archive of photographs and the missing youths' faces have become a vivid collective symbol of a national tragedy.[33] Similar protests have taken place in other countries, including Western democracies. A recent example may be cited: following the imprisonment of separatist leaders in Catalonia in 2018, several thousand people demonstrated in Barcelona to demand their release holding banners that reproduced their effigies.[34] The portraits functioned as a surrogate presence: they were the protesters' answer to what they considered to be the authorities' brutal silencing through physical removal of personalities who represented the views of a large part of the people of the region. Catalan demonstrators have also used portraiture for opposite ends: they have put up posters reproducing the photographs of those who opposed independence in order to denounce and pillory them, and marched with poster-sized

32 A second edition of the book of caricatures appeared in 1938. For an excellent account of this publishing venture and biographical account of its author, see Gianpasquale Santomassimo's introduction to the Italian translation of the volume: *Hitler in caricatura. La satira sul Führer raccolta e commentata dal suo partito* (Rome: Manifestolibri, 2003).

33 Jill Stockwell, *Reframing the Transitional Justice Paradigm. Women's Affective Memories in Post-Dictatorial Argentina* (Cham, Switzerland: Springer, 2014); Sonia M. Tascón, "From Spectres of Horror to 'the Beautiful Death': Re-Corporealising the Desaparecidos of Argentina," in *Spectral Spaces and Hauntings. The Affects of Absence*, ed. Christina Lee (New York – London: Routledge, 2017), 182–94; and Silvia R. Tandeciarz, *Citizens of Memory. Affect, Representation and Human Rights in Post-Dictatorial Argentina* (Lewisburg PA: Bucknell University Press, 2017), especially the chapter "Photography as Art of the Missing," 67–76, which usefully recalls Roland Barthes's study *Camera Lucida* (originally published in 1980) stressing photography's strong capacity to render reality and the past.

34 https://www.devdiscourse.com/article/agency-wire/58258-thousands-protest-in-barcelona-for-release-of-catalan-leaders

portraits of the king, Felipe VI, turned upside down. Another recent example is provided by the anti-immigration campaign launched by the nationalist Prime Minister of Hungary Viktor Orban in February 2019: posters that depicted the laughing faces of the President of the European Commission Jean-Claude Juncker and the Hungarian-American millionaire George Soros were put up around Budapest accusing them of supporting illegal immigration.[35] This form of protest is a contemporary version of the Italian Renaissance genre of *pitture infamanti*, the defamatory paintings depicting traitors, thieves and other offenders that were displayed in the center of cities.[36]

The portraits that are posted on social networks are a recent genre that also deserve some comments. Internet-based media lend themselves to being exploited for propaganda purposes because they enable politicians to address a potentially limitless audience at little or no cost. The iconography and style of the images that are disseminated via these communicative platforms differ from those featuring on printed propaganda and parties' official websites. Political figures do not appear in them posing formally and appealingly: they perform everyday political activities (giving interviews, meeting personalities at home and abroad, attending rallies and protest marches, etc.) wearing everyday clothes. Because these visuals are posted as soon as the events take place, they tend to be aesthetically crude. This "roughness" is not a shortcoming of the genre; on the contrary, it is cultivated to present the protagonists as spontaneous and genuine. The photographs can also be light-hearted self-depictions. Selfies are increasingly being posted on social networks. The phenomenon is closely linked to that of "celebrity politicians". The attention given by the media to politicians' personal lives and their appearances, to the detriment of their policies, has led them to adopt the attitudes of film stars, sportsmen and pop-singers. Political figures share self-generated visuals of chosen moments of their daily lives to promote themselves in familiar terms and be perceived by the general public as accessible, ordinary people. Indeed, to show their proximity to civil society, they allow themselves to pose for selfies with people they encounter while campaigning.[37]

The materials that have been produced in the past one hundred years or so to promote political personalities are extremely varied in terms of iconography, as is to be expected. Some features, however, seem to cut across periods, cultures and ideologies.

A recurrent practice is that of associating a leader to another figure – mythical, allegorical or historical – to suggest allegiance to specific values, indicate continuity with the policies of a predecessor and, by doing so, seek legitimation, or establish a

35 Lili Bayer, "Hungary launches campaign targeting Jean-Claude Juncker," *Politico*, February 18, 2019. https://www.politico.eu/article/hungary-launches-campaign-targeting-jean-claude-juncker-george-soros/

36 Samuel Y. Edgerton, *Pictures and Punishment: Art and Criminal Prosecution during the Florentine Renaissance* (Ithaca, NY: Cornell University Press, 1985).

37 Matthew Wood, Jack Corbett and Matthew Flinders, "Just Like Us: Everyday Celebrity Politicians and the Pursuit of Popularity in an Age of Anti-Politics, *British Journal of Politics and International Relations* 18, 3 (2016): 581–98; Achilleas Karadimitriou and Anastasia Veneti, "Political Selfies: Image Events in the New Media Field," in *The Digital Transformation of the Public Sphere: Conflict, Migration, Crisis, and Culture in Digital Networks*, eds. Athina Karatzogianni, Dennis Nguyen and Elisa Serafinelli (London: Palgrave Macmillan, 2018), 321–40. For interesting comments on the nature of the images of leaders that feature on social networks with reference to Italian politics, see Edoardo Novelli, "Visual Political Communication in Italian Electoral Campaigns," in *Visual Political Communication*, eds. Anastasia Veneti, Daniel Jackson and Darren G. Lilleker (Cham, Switzerland: Palgrave Macmillan, 2019), 145–63.

parallel with the great of the past for aggrandizing purposes.[38] İsmet İnönü had himself portrayed with Atatürk; Stalin with Lenin; Mussolini, who glorified his regime by presenting it as a revival of the Ancient Roman past, liked to be portrayed in association with Julius Caesar or Augustus; the Austrian Chancellor Kurt Schuschnigg posed next to a photograph of Engelbert Dollfuss, whom he succeeded after his assassination in 1934; Ceaușescu was depicted with Burebista, Michael the Brave and Nicolae Balcescu, early rulers of geographical areas corresponding to present-day Romania who shone for their achievements; Saddam Hussein, as noted above, identified with great Muslim figures, as well as with kings of his country's ancient history; Venezuela's president Hugo Chavez exploited the image of Simon Bolivar, the emblematic figure of the emancipation from Spanish colonies in Latin America, and this strategy has been followed by his successor Nicolás Maduro; the "Eternal President" of North Korea Kim Jong Il features in propaganda side by side with the founder of the dynasty, Kim Il Sung; and China's President and Prime Minister, Xi Jinping, is frequently represented in association with Mao, as were his predecessors. Examples abound in democratic states too. In France, Ségolène Royal has personified the allegorical figure of Marianne, while Marine Le Pen likes to portray herself as a contemporary Joan of Arc. In Italy, the leader of the Communist Party Palmiro Togliatti was recurrently portrayed in his publicity with Antonio Gramsci, the party's first General Secretary, and posed for one poster in 1948 modelling himself on two iconic depictions of Lenin and Stalin. The leader of the neo-fascist Movimento Sociale Italiano Giorgio Almirante was consistently represented in attitudes and settings that imitated those of Mussolini, as was to do his young protégé and successor Gianfranco Fini.[39] In America, the Republican President George W. Bush gave a speech before the grandiose setting of Mount Rushmore, in South Dakota, in August 2002, a few months before the Federal election, ensuring that his profile was captured by the cameras in line with the carved portraits of George Washington, Thomas Jefferson, Abraham Lincoln and Theodore Roosevelt, to present himself as their worthy heir.[40]

Leaders also frequently appear in a variety of guises to show that they are polymaths, capable of coping with any contingencies, and also reach a wide range of categories of people. As well as by dictators such as Mussolini, Ceaușescu and Saddam Hussein (whose billboards, murals and posters depicted him in turn as a peasant, an academic,

38 In European visual traditions the practice of celebrating personalities by associating them – usually through assimilation – with mythical or historical figures is well established. Court artists frequently depicted rulers in the guise of Hercules, Jupiter or Caesar. See Friedrich B. Polleross, "From the 'exemplum virtutis' to the Apotheosis: Hercules as an Identification Figure in Portraiture: an Example of the Adoption of Classical Forms of Representation," in *Iconography, Propaganda and Legitimation*, ed. Allan Ellenius (Oxford: Clarendon Press, 1988), 37–62; Jean-Luc Martinez, Patrick Boucheron and Paul Mironneau, *Théâtre du pouvoir* (Paris: Musée du Louvre / Seuil, 2017).

39 It is worth noting that during fascism the imitation of Mussolini was current among his stalwarts. The anti-fascist leader Guido De Ruggiero recalled: "In terms of physical appearance, one could once note that all those who were active in politics strangely resembled the *Duce*, physically: not only his clothes, gestures and style of talking, but even his facial features were modelled on his, his mimicry being at times deliberate, at times unconscious." See "Questo popolo. Gli intellettuali," *La nostra Europa*, April 1, 1945: 13.

40 Burton W. Peretti, *The Leading Man. Hollywood and the Presidential Image* (New Brunswick, NJ: Rutgers University Press, 2012), 261.

a military commander, a pious Muslim, a businessman and a Kalashnikov-carrying soldier [Figure 1.5]), the "universal person" image has also been pursued by leaders in democratic states. To try and correct the hard and uncaring image Margaret Thatcher evoked, the Conservative Party also represented her as a churchgoer, a mother and animal lover. The many portraits that grace Berlusconi's propaganda material depict him not only as a successful businessman and statesman of international standing, but as an affectionate family man, a devout Catholic and even as an anti-fascist. In 2009, as Prime Minister, he surprised everyone by attending the public commemorations of the Liberation from Nazi-fascism for the first time, and wearing the scarf of a partisan brigade around his neck. The gesture was interpreted as an attempt to appear as the country's unifier in view of his possible candidature to the Presidency.[41] The technique of metamorphosing oneself to appeal to a diverse electorate is well-established. Napoleon declared in a speech given at the Council of State on August 1, 1800: "It was by becoming a Catholic that I terminated the Vendéen war. By becoming a Mussulman that I obtained a footing in Egypt. By becoming an Ultramontane that I won over the Italian priests, and had I to govern a nation of Jews I would rebuild Salomon's temple."[42]

Photographic portraits of political figures can be subjected to various types of manipulations that distort reality while claiming that they are merely documenting it since, according to popular opinion, the camera captures what it sees truthfully. Party functionaries who went out of favor during Stalin's reign were excised or cropped out from official photographs. Ceauşescu's face was inserted in a photograph showing a rally that took place in Bucharest on May 1, 1939, when Romania was under a dictatorship, a rally which he never attended, in order to present him as a young Communist revolutionary.[43]

Portraits eulogizing political figures can feature on items that do not necessarily emanate from government agencies, political movements or individual politicians. Millions of postcards featuring the effigy of Mussolini circulated in Italy during fascism; of these a substantial portion were produced and distributed by private printers to be sold by stationers and tobacconists. Theirs was a purely commercial activity that profited from the enthusiasm generated by the *Duce*, especially in the first decade of his rule. The phenomenon is revealing of the impact which the cult of Mussolini masterminded by the regime had on popular culture. Though these artefacts were not, strictly speaking, a form of propaganda, they performed a political function: they helped strengthen people's devotion to their leader. The postcards were not usually sent, but displayed in people's homes like, and often together with, holy images. The reproduction of Mussolini's portraits for profit were officially prohibited; the fact that the authorities

41 Paddy Agnew, "Berlusconi plays politics and marks Liberation Day for the first time," *The Irish Times*, April 28, 2009, 9.

42 The passage was quoted by Gustave Le Bon in his influential book *The Crowd, a Study of the Popular Mind* (New York: Cosimo Classics, 2006 [1895]), 36.

43 For other examples, see: Vicki Goldberg, "Political Persuaders & Photographic Deceits," in idem, *The Power of Photography. How Photographs Changed our Lives* (New York: Abbeville, 1991), 75–101, 257–9; David King, *The Commissar Vanishes. The Falsification of Photographs and Art in Stalin's Russia* (London: Cannongate, 1997); and Mia Fineman, "Politics and Persuasion," in idem, *Faking it. Manipulated Photography Before Photoshop* (New York: The Metropolitan Museum of Art, 2012), 90–115, 261–2.

tolerated it attests that they were well aware of the postcards' propaganda potential.[44] In Franco's Spain, postcards featuring his effigy, which could be purchased from ordinary shops, were equally popular and met with the regime's approval.[45]

Similar practices can be found in post-war democracies. In Britain, ceramic mugs, not unlike those that depict members of the royal family to mark special events (coronations, jubilees, weddings …), have been manufactured privately with the effigies of various political leaders to be sold. In the post-war period this genre has been dominated by the figure of Margaret Thatcher.[46] Her portraits graced the mugs together with short texts such as "Margaret Thatcher Europe's first woman Prime Minister" (Figure 1.6), "M.T. Iron Lady Prime Minister", "M.T. 10 years in power" and "M.T. longest-serving Prime Minister of the country". They vouch for the unusual fervor she aroused among her supporters throughout her terms in office. In America the range of privately produced political collectibles is especially wide and includes clocks, puzzles, letter-openers, watches, jewels and fake banknotes.[47] The latter have been a particularly popular genre in recent years. The Florida-based firm American Art Classics has been producing novelty currency depicting the effigies of American politicians since 2001. Banknotes have been "issued" to celebrate past presidents or support the campaigns of presidential candidates such as Barack Obama and Donald Trump (Figure 1.7). Satirical ones have also been printed to vilify certain figures. The "Nobama 2012 Trillion Dollars" bill featuring a grimacing Obama is a characteristic example. Another is a banknote representing a demented-looking Hillary Clinton behind bars (a reference to Trump's declaration that his contender in the presidential election of 2016 "has to go to jail" for using a private e-mail server for official public communications, rather than the official State Department accounts); it carries the punning slogan "Hillary for prison".[48] Fake currency appears to be especially popular among supporters of the Republican Party, who use them at party rallies.[49]

44 Enrico Sturani, "Analysing Mussolini Postcards," in *The Cult of Mussolini in Twentieth-Century Italy*, eds. Christopher Duggan, Stephen Gundle and Giuliana Pieri, special issue of *Modern Italy*, 18, 2 (2013): 141–56. For numerous reproductions of these postcards, see idem, *Le cartoline per il Duce* (Turin: Edizioni del Capricorno, 2003). The phenomenon of the commodification of Mussolini is investigated more generally, together with that of Hitler, by Bianca Gaudenzi, "Dictators for Sale: the Commercialization of the *Duce* and the *Führer* in Fascist Italy and Nazi Germany," in *Rewriting German History. New Perspectives on Modern Germany*, eds. Jan Rüger and Nikolaus Wachsmann (New York: Palgrave Macmillan, 2015), 267–87.

45 A letter which the chief of the propaganda delegation in Salamanca addressed to the head of the provincial office in Burgos in January 1938 is revealing of the importance which the authorities attributed to postcards in particular: "Although shop owners make a small profit in some cases, it is important to remember that portraits of His Excellency are of value for their own sake and sell to the public automatically, without any effort required. Postcards in particular not only have a patriotic character, they also have a high artistic and lithographic merit for the large number of people that collect and frame them for display." Quoted from Miriam M. Basilio, *Visual Propaganda and the Spanish Civil War* (Farnham, Surrey: Ashgate, 2013), 136.

46 Winston Churchill mugs are actually more numerous than those with Thatcher's effigy, but as a war hero he belongs to a class of his own.

47 Enoch L. Nappen, *Political Collectibles* (Iola, WI: Krause, 2008).

48 See: https://www.americanartclassics.com/all-novelty-money/nobama-2012-trillion-dollar-bill/ and https://www.americanartclassics.com/all-novelty-money/hillary-clinton-for-prison-2016-dollar-bill/

49 Frank Makan, President of American Art Classics, informed us in November 2019 that, with a year to go before the presidential election, the "Trump 2020" bill had sold well over one million units, significantly outstripping all the other political banknotes his firm had produced.

Conclusion

The pictures of emperors, kings and other dignitaries were for centuries imposing and awe-inspiring images which were executed in the presence and under the control of the model, and were meant to be displayed in palaces or public places so that they could be venerated by the population. They were surrounded, Walter Benjamin contended,[50] with an almost mystical atmosphere linked both to the object itself and to the apparent presence of the living personage. Such an aura dissipated when the reverence for the "big" ones declined and when the techniques of mechanical reproduction robbed portraits of their uniqueness. Such trivialization took place differently according to the cultures: the American presidents had long been caricatured when the Japanese still made a deep bow to the Mikado portrayal. The debasement of statespersons' images spread to the entire world when the leaders, obliged to appear every day on television, lost the mysterious qualities that seemed to set them apart.

In a few decades the rulers, modifying their behavior, relinquishing their apparent self-confidence, endeavored to seduce their electors and win their trust. The stiff poses, the intense and reassuring looks that characterized traditional political portraits have given way, in televised meetings, to fun and optimistic faces. Once serious, putting all their strength into making good choices, political leaders now like to be considered benevolent and friendly people. Emotions play a much greater role in electoral contests; it is much simpler to vote for a likeable person than to assess the relevance and applicability of a program.

The present volume follows the evolution in the representation of heads of state and leaders from the end of the nineteenth century to the present. The transformation has been radical: the ceremonious, impressive photographic portraits have led to the fun-loving, apolitical selfies, via newsreels, filmed biographies, multicolored posters, radio and television interviews. What is at stake, in this story, is not merely the chronicle of a relatively quick evolution from the hieraticism of sovereigns whose symbolic strength, evoking the majesty of power, imposed respect to an apparent closeness with the "great" giving the illusion that contemporary leaders are on intimate terms with their constituents. The metamorphosis of political iconography is a syndrome of serious changes that have taken place in the management of contemporary societies. Let us recall that political propaganda is a sector of advertising which allows candidates for a public office to convince the electors that, being the most qualified, they will efficiently fulfil a function and serve common interests. Commercial adverts praise the qualities of a product by playing on drawings, colors and slogans that are as brief as they are enthusiastic. Political propaganda relies equally on brilliance and appearances. Avoiding elaborate projects that voters would not have the time to read, it offers attractive images: cheerful expressions, airy smiles, penetrating glances are more effective than a list of reforms. In marketing schools, pupils learn that advertising does not automatically increase the sales, but that, if it is missing, businesses quickly lose out. The same is true in politics, which is why dictators who, thanks to their police force, do not have to worry about opinion, flood the walls with their portraits: by monopolizing public space

50 *The Work of Art in the Age of Its Technological Reproducibility, and Other Writings on Media* (Cambridge, MA: Belknap, 2008 [1935]).

they prevent others from occupying it. The situation is different in liberal regimes where voters are solicited from many sides. Citizens are generally loyal to a party or a person, but some, usually a minority, a good many in critical periods, change unpredictably their points of view according to the course of events. It is this part of opinion that must be won and, since it lacks firm convictions, it is easily impressed by external appearances.

State power rests on two pillars: the enforcement of law and the need to win the confidence of individuals and maintain the cohesion of the group. For a long time, hieratic pictures of leaders were used to call for dutifulness. Law and strength: the pillars of political authority remain what they have always been – but their use has become much more problematic. On the one hand, economic and technical growth has diversified the professional structure of contemporary populations; instead of facing relatively homogeneous and law-abiding masses, the rulers must take into account divergent and often incompatible interests; cheerful pictures exuding good-will and nearness free the candidates from taking a stand on tricky problems. On the other hand, the development of education has made workers aware of their rights and capable of defending them; instead of debating with protesting trade-unionists, election candidates prefer the broadcast of a walkabout among crowds of ordinary people, of a few words addressed to a family and of a photograph taken with kids.

The daily practice of the web has created among the surfers a remote familiarity between people who will never meet, but regard one other as close friends. This feeling of remote intimacy extends to politicians. It includes first mayors, town councilors and Members of Parliament, but also, beyond, national leaders, thus compelling these people to create and permanently renew their imagery, making it varied enough to hold the attention of their constituents. Because the images taken during a visit or a meeting are immediately broadcast or posted, it is necessary to record other events constantly, with different participants. Many people ask for autographs, for photographs taken next to a president or minister, for signed portraits, and it is impossible to refuse. Producing images in all conceivable forms has become a sure duty of every official much in the public eye.

Photographs, videos and selfies interpose a screen between the citizens and the concrete activities of the power – the word "screen" being understood in its double sense, as surface on which images are projected and as a framework preventing one from seeing. The relational policy of the leaders is subjected to continuous attention, but the decisions engaging present and future do not appear on the screens. The governance of societies tends therefore to divide. Their first task being the institution, then the perpetuation of a fragile, ephemeral connivance with public opinion, politicians must leave it to technicians to solve the compelling or minor economic, financial, diplomatic problems any government has to face.

The representation of State leaders partakes fully of today's "culture of images" and should be seen in this context as ephemeral and constantly renewed. At the same time, it replaces any debate about concrete problems that must be resolved with the face and features of those who should make the decisions. Oddly enough, in a hyper-connected world, where means of communication link people more than ever, the "politics show" puts the spotlight on individuals playing a role as if communities did not matter.

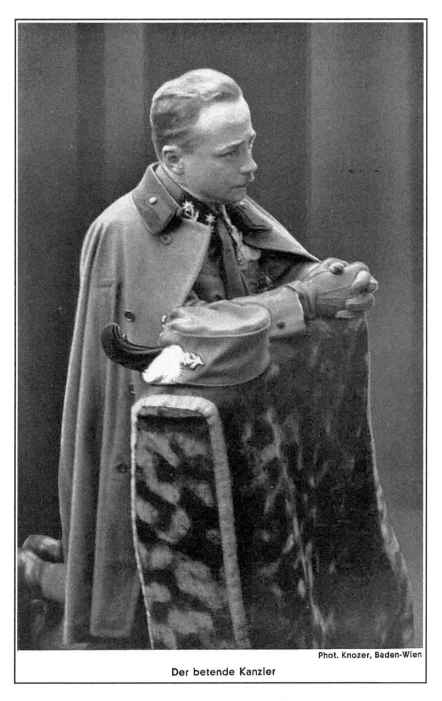

Phot. Knozer, Baden-Wien

Der betende Kanzler

Figure 1.1 "The praying Chancellor". Engelbert Dollfuss, photographed by Friedrich Knozer, 1934. Postcard produced in 1935, just after the Chancellor's death. On the reverse is a prayer in his honor. Following an attempt on his life in 1933, a bass-relief based on the photograph was commissioned for the *Michaelerkirche* in Vienna with his agreement. Inaugurated in 1936, it is still in place.

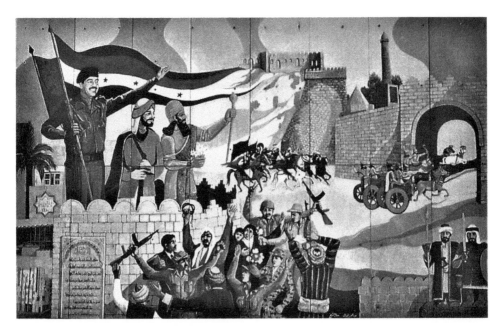

Figure 1.2 Billboard near the ruins of Nineveh showing Saddam Hussein with Nebuchadnezzar and Saladin, 1990. (Photo: Stevan Beverly).

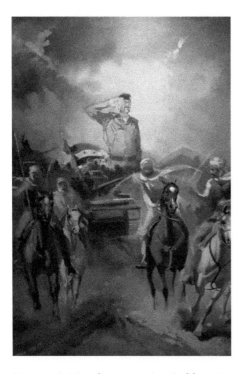

Figure 1.3 Mural representing Saddam Hussein as a warrior returning in triumph from the Iraq–Iran War, 1987. (Photo: José Nicolas, Paris).

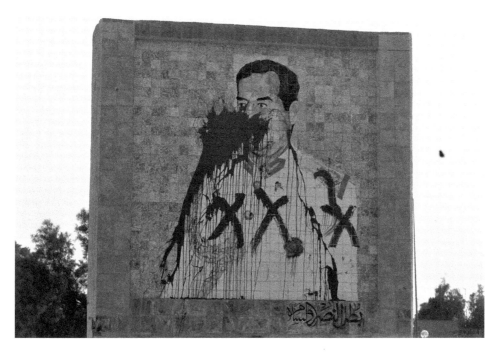

Figure 1.4 A degraded billboard featuring Saddam Hussein, Umm Qasr, Iraq, 2003. (Photo: US Marine Corps Lance Cpl. Matthew R. Jones).

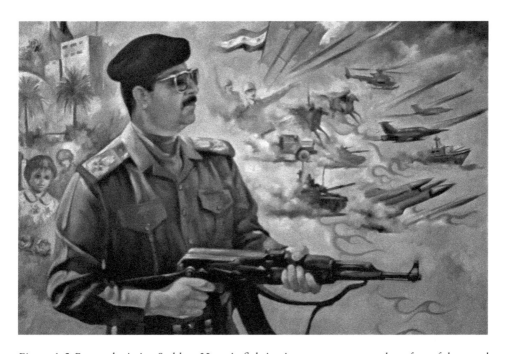

Figure 1.5 Poster depicting Saddam Hussein fighting in person to ensure the safety of the people of his country (symbolised by the women in a tranquil urban setting with palm trees, behind him), 1987. (Photo: José Nicolas, Paris).

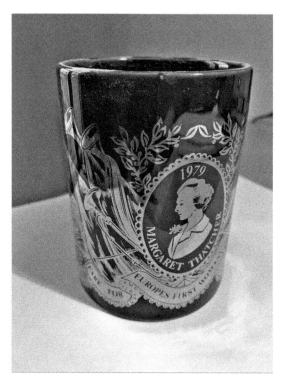

Figure 1.6 Portmeiron Pottery mug celebrating Margaret Thatcher's electoral victory in 1979. The Prime Minister is presented as a queen, as the profile mode and the date placed just above her head crown-fashion indicate.

Figure 1.7 Mock Dollar banknote representing Donald Trump, 2019. Privately produced to be sold to his supporters in view of the American Presidential election of 2020 (American Art Classics, Clearwater, Florida).

Bibliography

Bradburne, James, and Emanuela Di Lallo, *Portraits and Power: People, Politics and Structures*. Milan: Silvana, 2010.

Brändle, Christian, ed. *Head to Head: Political Portraits*. Zurich: Museum für Gestaltung Zürich Plakatsammlung – Lars Müller, 2009.

Brown, David, project manager. *Official Portraits: The Executive Heads of State of 191 Member States of the United Nations Organisation*. London: Berlin Press, 2004.

Burke, Peter. *Eyewitnessing: The Uses of Images as Historical Evidence*. London: Reaktion, 2001.

Chelkowski, Peter, and Hamid Dabashi. *The Art of Persuasion: Staging a Revolution in the Islamic Republic of Iran*. London: Booth-Clibborn, 2000.

Czech, Hans-Jörg, and Nikola Doll, eds. *Kunst und Propaganda im Streit der Nationen, 1930–1945*. Dresden: Sandstein, 2007.

Desmas, Anne-Lise, ed. *Les portraits du pouvoir*. Rome – Paris: Académie de France à Rome – Somogy, 2003.

Gerbaudo, Paolo. *The Digital Party: Political Organisation and Online Democracy*. London: Pluto Press, 2018.

Golomstock, Igor. *Totalitarian Art: In the Soviet Union, the Third Reich, Fascist Italy and the People's Republic of China* (2nd edition). New York: Overlook Duckworth, 2011.

Gruber, Christiane, and Sune Haugbolle, eds. *Visual Culture in the Modern Middle East*. Bloomington-Indianapolis: Indiana University Press, 2013.

Holtz-Bacha, Christina, and Bengt Johansson, eds. *Election Posters Around the Globe: Political Campaigning in the Public Space*. Cham, Switzerland: Springer International Publishing, 2017.

Korkut, Umut et al. *The Aesthetics of Global Protest: Visual Culture and Communication*. Amsterdam: Amsterdam University Press, 2019.

Rapelli, Paola. *Symbols of Power in Art*. Los Angeles: Paul Getty Museum, 2011.

Roberts, Andrew. *Postcards of Political Icons: Leaders of the Twentieth Century*. Oxford: Bodleian, 2008.

Seidman, Steven A. *Posters, Propaganda, and Persuasion in Election Campaigns Around the World and Through History*. New York: Peter Lang, 2008.

Veneti, Anastasia, Daniel Jackson, and Darren G. Lilleker, eds. *Visual Political Communication*. Cham, Switzerland: Palgrave Macmillan, 2019.

Werbner, Pnina, eds. *The Political Aesthetics of Global Protest: The Arab Spring and Beyond*. Edinburgh: Edinburgh University Press, 2014.

2 Portraits of United States Presidents and National Candidates Past and Present

Steven A. Seidman

Political imagery is important. The words in party platforms, campaign speeches and inaugural addresses are soon forgotten generally. But the representations of political leaders in both positive and negative ways in a variety of media, including painting, sculpture, textile, photography, poster, video, television, film and cartoon, make a lasting impression in many cases. "Art provides the images and stereotypes" that can influence perceptions, according to Murray Edelman.[1] Depictions of political candidates can accentuate their personal attractiveness (a factor in image traits that influence voter perceptions and decisions),[2] which might help increase their appeal. Portraits of presidents have been commissioned since the terms of George Washington (in office 1789–1797), with iconic Gilbert Stuart renditions immortalizing the first US president on a multitude of postage stamps, as well as a slightly modified version of his unfinished 1796 "Athenaeum" portrait (National Portrait Gallery, Washington, DC) of the first president appearing on the one-dollar bill. More than two centuries later, a 2008 poster by street artist Shepherd Fairey of an idealized Barack Obama (who was then contending for the Democratic Party's presidential nomination) helped establish him as the first *meme* candidate and president, according to Ryan Teague Beckwith.[3] "Visually speaking, this image lives in the same neighborhood as the engraved likenesses of Washington, [Thomas] Jefferson, [Alexander] Hamilton, [Abraham] Lincoln, and the other archetypical statesmen gracing our currency", wrote Ben McCorkle.[4]

While commissioned oil paintings, and official photographs and sculptures usually are idealized – often literally illuminating subjects in a favorable light – unofficial portraits in many media can be positive or negative. Cartoonists, for example, have captured and defined political figures – especially presidents – since the founding of the American Republic, frequently ridiculing them. Even the venerated Washington was caricatured riding on "an ass" in a 1789 cartoon, and a James Akin cartoon in 1804

1 Murray Edelman, *From Art to Politics: How Artistic Creations Shape Political Conceptions* (Chicago, IL: University of Chicago Press, 1995), 11.
2 Dan Nimmo and Robert L. Savage, *Candidates and Their Images: Concepts, Methods, and Findings* (Pacific Palisades, CA: Goodyear, 1976), 49–53.
3 Ryan Teague Beckwith, "Obama: The First Meme President," *Mercury News* (San Jose, CA), October 23, 2012, http://www.mercurynews.com/2012/10/23/obama-the-first-meme-president/, accessed April 8, 2019 [with all subsequent links accessed and active on this date].
4 Ben McCorkle, "The Annotated Obama Poster," *Harlot* 2 (2009): http://www.harlotofthearts.com/index.php/harlot/article/view/29/18.

rendered President Thomas Jefferson (1801–1809) as a prairie dog vomiting gold coins.[5] In modern times, liberal cartoonists (generally supportive of the Democratic Party) – many of whom had depicted a Democrat, President John F. Kennedy (1961–1963), in a positive light – regularly drew his successors less so. For example, David Levine grossly represented President Lyndon B. Johnson (1963–1969) – also a Democrat – with huge ears and a Pinocchio nose, exhibiting a "scar" map of Vietnam on his stomach in 1966, and Herb Block portrayed President Richard Nixon (1969–1974) – a Republican – with a bag of money replacing his head in 1974 (copying Thomas Nast's image of Boss Tweed from 1871).

Cartoonists have distorted the features of their political targets frequently, and comedians and satirists have exaggerated their looks and mannerisms in television shows and films typically. However, painters, photographers and poster artists have lit their powerful subjects subtly to emphasize their best attributes generally, with poses, patriotic symbols and both formal and casual clothing sometimes used to increase the chances of influencing opinions positively. And sculptors usually have tried to convey a sense of dignity and even nobility for the American leaders represented in their works.

Campaign Poster Images

Increasingly in the last quarter of the twentieth century and beyond, presidential candidates themselves were shown less frequently on their posters (which also often functioned as yard signs). Mostly, these had words and symbols on them, usually a flag – one visual component that continued from the nineteenth century, including at least its colors and/or stars and stripes that suggested that candidates were patriotic. When there *were* portraits of modern politicians on posters, they were presented with smiling or determined facial expressions. Additionally, it became more common for candidates to be depicted from below, with the effect of this perspective being that they seemed more imposing.[6] This low-angle viewpoint makes things perceived as larger than in reality, in general.[7] In a 1973 experimental study, viewers who were shown television news programs rated a supposed political appointee shown at a low angle more favorably and powerful than when he was shown at higher angles.[8] And with dramatic lighting sometimes added, authority can be further enhanced.[9] Furthermore, smiling candidates bathed in warm light and with lower contrast lighting (including

5 On the 1789 cartoon of George Washington, see "Some Early American Caricatures," *The New York Times*, March 8, 1896, 32.

6 See Paul Messaris, "Visual Literacy vs. Visual Manipulation," *Critical Studies in Mass Communication* 11, 2 (1994): 181–203.

7 See Ann Marie Seward Barry, *Visual Intelligence: Perception, Image, and Manipulation in Visual Communication* (Albany, NY: State University of New York Press, 1997), 135–6; and Gunther R. Kress and Theo van Leeuwen, *Reading Images: The Grammar of Visual Design* (New York: Routledge, 1996), 146.

8 Lee M. Mandell and Donald L. Shaw, "Judging People in the News – Unconsciously: Effect of Camera Angle and Bodily Activity," *Journal of Broadcasting* 17 (1973): 353–62. A low angle also is apparent in painted portraits of presidents. For example, Samuel Morse's official portrait of James Monroe (1817–1825) not only idealized that president with the low-angle perspective, but also did so by eliminating a mole on his face; see William Kloss, *Art in the White House: A Nation's Pride* (Washington, DC: White House Historical Association, 1992), 82.

9 See Dan Schill, "The Visual Image and the Political Image: A Review of Visual Communication Research in the Field of Political Communication," *The Review of Communication* 12 (2012): 118–42.

in the background) can be perceived as "friendly", and candidates who exhibit deter-mined facial expressions with harsher spotlighting on them can be viewed as "tough" and "tenacious".[10] A 2014 study of facial portrait paintings revealed that sitters that had high-contrast lighting were rated as significantly more "strong" and "dynamic", and that low-contrast portrait subjects were perceived as more "likable", "attractive" and "cheerful".[11]

The smile in US political portraiture in a variety of media is an interesting topic. Smiling by candidates and elected officials was rare in their campaign and official portraits up until almost the middle of the twentieth century.[12] Even Al Smith (the Democratic Party's presidential nominee in 1928), who was nicknamed "The Happy Warrior", did not smile in many of them. Perhaps this was meant to imply a politi-cian's "seriousness" – or, additionally, as has been speculated, people into the twentieth century often had bad teeth, which they did not want to show and that in artworks, portrait subjects with broad smiles were commonly perceived as buffoons, insane, obscene or at least unbecoming.[13] Subsequently, people were more frequently captured in amateur photographs with smiles, dental work improved, and smiles of models and film stars in promotional and advertising photographs were seen, and eventually this carried over to other media,[14] including the political poster, button and painted por-trait. Smiling *broadly* seemed to be a mostly American trend, at least initially.[15]

By 1944, a poster showed a grinning President Franklin D. Roosevelt (1933–1945) looking out at viewers, accompanied by the slogan "Rain or Shine". And by 1952, both major party presidential candidates – Republican Dwight Eisenhower (who was elected and then served 1953–1961) and Democrat Adlai Stevenson – displayed huge smiles in their promotions. The political marketers for the former politician realized that he could be "sold" as being in touch with the "common folk" and that a folksy, smiling image would help his electoral chances. The slogan they chose for Eisenhower – "I Like Ike" – conveyed much of this feeling.[16] A poster for Stevenson shows him with probably the broadest grin ever included on an American election poster in a likely attempt to compete with Eisenhower's persona. After 1952, most candidates – when shown in portraits in their marketing – had fairly broad smiles. Whether or not the presidential candidates are shown smiling, American campaign posters (unlike

10 See Barry, *Visual Intelligence*, 134, 152–3; and Doris A. Graber, "Dissecting the Audio-visual Language of Political Television," *Research in Micropolitics* 5 (1996): 3–31.

11 Yuiko Sakuta, So Kanazawa, and Maasami K. Yamaguchi, "Shedding Light on Painters' Implicit Knowledge: The Effect of Lighting on Recognizing Expression and Facial Impressions of a Depicted Person in Portraits," *Japanese Psychological Research* 56 (2014): 288–95.

12 Steven A. Seidman, *Posters, Propaganda, and Persuasion in Election Campaigns Around the World and Through History* (New York: Peter Lang, 2008), 37.

13 Angus Trumble, *A Brief History of the* Smile (New York: Basic Books, 2004), xxii–xxiii, xxvi–xxviii, 31–48, 85–6.

14 Ibid., xl, 100–1, 149–50, 154–5, 159–60; also see Christina Kotchemidova, "Why We Say 'Cheese': Producing the Smile in Snapshot Photography," *Critical Studies in Mass Communication* 22, 1 (2005): 2–25.

15 Kotchemidova, "Why We Say 'Cheese'," 2–25.

16 Seidman, *Posters, Propaganda, and Persuasion in Election Campaigns Around the World and Through History*, 69, 71–2.

brochures and some other media) usually are advertisements that focus on character, not policies, and facial expressions are a key factor in communicating character.[17]

Attire also has been important. Male candidates sometimes were shown dressed casually (i.e. without a suit and/or tie), and one national female candidate, Hillary Clinton (the Democratic Party's presidential nominee in 2016), was seen mainly in pantsuits in her ads. This carried on an earlier theme of depicting national candidates as being one with the "common man". In the previous century, for example, President Theodore Roosevelt (1901–1909) was dressed as a farmer in a 1904 campaign poster. Later, a Ronald Reagan (1981–1989) poster issued during his 1980 campaign as the Republican Party's nominee for president displayed him in a photograph wearing a cowboy hat and an open blue work shirt (Figure 2.1). The broadly smiling, deeply tanned candidate is shown looking directly at the voters.[18] For many, the American cowboy and frontier symbolized rugged individualism and freedom – the antithesis of a big central government, which is seen by some as imposing regulations on people, taxing them and spending their money in an allegedly wasteful and corrupt manner.[19] Another long-standing approach was to sometimes convey a candidate's military background, if any. For example, a photograph of Reagan's vice president – and his successor as president – George H. W. Bush (1989–1993), clad in a US Navy bomber jacket and an open shirt, was used in a 1988 poster/leaflet to emphasize his record during the Second World War, during which he was awarded the Distinguished Flying Cross for valor.

By the 1984 campaign, posters promoting President Reagan featured a drawing of him (with Vice President Bush) with a suit and tie. Most modern candidates – before and after Reagan – were similarly clothed. Reagan presented the same direct, broad smile in his re-election poster as he did in 1980, when he ran against President Jimmy Carter and Vice President Walter Mondale (both of whom served 1977–1981), each exhibiting an expression that was almost pained that year (at least in one poster), while they gazed into the beyond. Subsequent posters of the major-party candidates included similar poses and smiling facial expressions. but with different graphic approaches. In 1992, for example, the Republicans released one showing a formally attired President George H. W. Bush, with a black-and-white, photo-screened portrait of him, smiling directly, with blue stars and red stripes arrayed patriotically around him (Figure 2.2). An exception was an eye-catching poster in the next decade that merely said "W 2004",

17 See Brooke Gladstone, "Preface," in Library of Congress, *Presidential Campaign Posters* (Philadelphia, PA: Quirk Books, 2012), 4. Also see Lynda Lee Kaid, "Political Advertising," in *Handbook of Political Communication Research*, ed. Lynda Lee Kaid (Mahwah, NJ: Lawrence Erlbaum, 2004), 160–4; and Seidman, *Posters, Propaganda, and Persuasion in Election Campaigns Around the World and Through History*, 55.

18 Reagan (a former film actor) was very aware of how to pose and strike the best facial expression to result in an effective photographic portrait, telling his press secretary, Marlin Fitzwater, "always look directly into the lens and never look down even if someone is tugging on your pants". The photograph used in the 1980 poster was taken by Michael Evans four years earlier. Evans was later appointed Reagan's chief White House photographer. Kenneth T. Walsh, *Ultimate Insiders: White House Photographers and How They Shape History* (New York: Routledge, 2018), 107–9.

19 See Frederick Jackson Turner, *The Significance of the Frontier in American History*, in the Annual Report of the American Historical Association, 1893 (Washington, DC: Government Printing Office, 1894), 197–227, http://www.archive.org/stream/1893annualreport00ameruoft/1893annualreport00am eruoft_djvu.txt.

accompanied by a color photograph of President George W. Bush (2001–2009), displaying a serious facial expression, and spotlighted dramatically in contrast against a black background – all elements appropriate for the post-9/11 political landscape (Figure 2.3). The posters of the two Bushes were quite simplified, compared to many past election posters, with the former one featuring only a direct portrait, a brief slogan and stylized patriotic symbols, and the latter having even fewer details.

In 2008, Fairey's iconic *Hope* poster of Obama (2009–2017) (Figure 2.4) helped create a venerated image of the Democratic presidential candidate, with the effect akin to how paintings of religious personages inspired devotion hundreds of years ago for many. The artist used sharpie pens, stencils and spray paint to portray the Democrat as a striking red, beige and blue graphic figure, with "etched" lines.[20] Fairey portrayed him as a serious, contemplative candidate – a soaring luminary shown from below. The poster somehow was both revolutionary (with some similarity to posters of Che Guevara) and patriotic (with its red-white-and-blue colors).[21] However, the portrait was innovative and inspirational, but in a non-threatening style. Additionally, it was attention-getting in its graphic design: the colors are rich, with red used extensively; the candidate's face (almost looking up to heaven) is illuminated in white light (giving him a vaguely religious glow), with two different shades of blue on the edges; a deeper blue enhances the patriotic message.[22]

While the Fairey poster was the most famous poster portrait of Obama, there were many others, created and distributed in support of his candidacies in both 2008 and 2012. Obama motivated, by far, the most artists and graphic designers to design posters – many of which included portraits of him – in history. Previously, there had been a much less extensive creative outburst for Democrat George McGovern, who ran for president in 1972, with Larry Rivers, Paul Davis, Adrienne Adams, Hans Burkhardt and Alexander Calder putting out pro-McGovern posters, and Andy Warhol and Philip Guston creating an anti-Nixon poster and a series of anti-Nixon caricatures, respectively (as will be noted later). Only Davis and Rivers included portraits of McGovern on posters, with the former artist centering a smiling candidate surrounded by persons of different ethnic groups, and the latter artist including a cut-out photograph of him in a collage with jumbled states of a US map.

Between 1972 and 2008, posters by such artists were lacking. In the latter year, however, a plethora of posters depicted Obama in a positive and creative manner, because they were often innovative in design – simple (often lacking elaborate artistic details), but idealized, and with bold color and imaginative composition – and which

20 McCorkle, "Annotated Obama Poster."

21 Steven A. Seidman, "Election Posters in the United States After World War II," in *Election Posters Around the Globe: Political Campaigning in the Public Space*, eds. Christina Holtz-Bacha and Bengt Johansson (Berlin, Germany: Springer, 2017), 372. Some Democratic Party individuals criticized the *Hope* poster design's "Communist revolutionary style," which they maintained "made Obama look like a dictator pushing the cult of personality"; Hal Elliott Wert, *Hope: A Collection of Obama Posters and Prints* (Minneapolis, MN: Zenith, 2009), 162.

22 Steven A. Seidman, "The Obama Poster Explosion," in *Critically Engaging the Digital Learner in Visual Worlds and Virtual Environments: Selected Readings*, eds. Robert E. Griffin, Maria D. Avgerinou, and Patricia Search (Loretto, PA: International Visual Literacy Association, 2010), 193–4. Also see Warner Todd Huston, "Obama's Propagandistic Iconography: The Making of a Messiah," Publius Forum (blog), June 22, 2008, http://www.publius.com/2008/06/22/obamas-propagandistic-iconography-making-messiah/.

featured portraits of the candidate designed to evoke positive emotions and affect perceptions. Obama was sometimes spotlighted and made to appear commanding due to the perspective and pose. Different poses, such as looking straight into the camera, influence perceptions about candidates (shown in photographs on campaign flyers) and their competence, and candidates with favorable appearance ratings (with smiles seemingly important) do better with voters.[23] The facial appearance of political candidates (presented in head-and-shoulders, black-and-white photographs) influence judgments about their competence and have been positively correlated with election results in races for select US House of Representatives and Senate seats.[24]

There were many more posters that promoted Obama in his two campaigns (sanctioned by his staff or not) that included imaginative, stylized portraits of him. Fairey created three similar posters with "visionary" portraits, including his *Hope* design, which sold more than 300,000 copies.[25] Another artist, Rafael López, designed posters for both campaigns that were bathed in warm colors – red, brown, orange and yellow – which were intended to appeal particularly to Latino voters. The candidate was positioned and clothed similarly to the way he was in Fairey's posters in López's designs. Typical was the latter artist's striking 2008 poster, *Voz Unida* (United Voice), in which López depicted Obama looking serious and upward, and shown from below (Figure 2.5). His face has blue shadows (the color perhaps to subtly emphasize Obama's position as leader of the Democratic Party),[26] and he is positioned in front of a yellow backdrop with multiple sunrays.[27] In 2012, López designed another poster, *Estamos Unidos* (We are United), which was characterized by a comparable facial expression, pose, perspective and background.

Many other artists, graphic designers and amateur supporters (mainly using computer-illustration software) also produced posters with portraits of Obama. One by illustrator Alex Ross in support of the candidate's 2008 campaign was a realistic, comics-type portrait of Obama, tearing off his shirt to reveal a "Super O" outfit. One of the most arresting pro-Obama posters was fashioned in 2006 by another street artist, Ray Noland, whose silkscreened poster, *The Dream,* showed Obama gazing into the distance, with a sun and its rays behind him. The iconography (like Fairey's

23 Shawn W. Rosenberg and Patrick McCafferty, "The Image and the Vote Manipulating Voters' Preferences," *The Public Opinion Quarterly* 51 (1987): 31–47; and Shawn W. Rosenberg, Lisa Bohan, Patrick McCafferty, and Kevin Harris, "The Image and the Vote: The Effect of Candidate Presentation on Voter Preference," *American Journal of Political Science* 30 (1986): 108, 127, http://www.jstor.org/stable/2111296.

24 Alexander Todorov, Anesu N. Mandisodza, Amir Goren, and Crystal C. Hall, "Inferences of Competence from Faces Predict Election Outcomes," *Science* 308 (2005): 1623–6. The authors chose only to use black-and-white photographs for no apparent reason. It also would have been interesting to have tested the effects of color photographs, since modern political propaganda uses these, rather than black-and-white images, generally.

25 Bill Van Siclen, "Shepard Fairey: The Man Behind the Obama Poster," *Providence Journal*, February 1, 2009, http://www.providencejournal.com.

26 The US media gradually settled on blue as the color for the Democrats and red for the Republicans on electoral maps, with these color designations becoming the standard by the presidential election of 2000; see Philip Bump, "Red vs. Blue: A History of How We Use Political Colors," *Washington Post*, November 8, 2016, https://www.washingtonpost.com/news/the-fix/wp/2016/11/08/red-vs-blue-a-brief-history-of-how-we-use-political-colors/?utm_term=.38915819c658.

27 Sunrays appeared in US political campaign posters much earlier. For example, an 1848 poster for the Whig presidential candidate, Zachary Taylor (in office 1849–1850) features sunrays above his head.

Hope design) was religious (albeit less subtle), but also comparable to a Mao poster from China in the use of stylized sunrays and a sun behind the leader. "The image of St. Francis of Assisi speaking to the animals with a 'gold' halo around his head has always resonated with me", stated Noland in his discussion of the creation.[28] Additionally, the artist's sunrays have burlap patterns (to symbolize the candidate's appeal to workers).[29] Obama is dressed in an open-collared, white shirt. Thus, he is portrayed as a figure who is both saintly and to whom the middle and working class can relate. The many posters idealizing Obama with sunrays in 2008 were countered by a poster for Hillary Clinton, who ran against him for the Democratic Party's presidential nomination that year. That poster was designed by Tony Puryear, who placed a blue-tinted photograph of Clinton, with a faint smile, looking off to the side, with orange and yellow rays in the background seeming to emanate from her (Figure 2.6). Although there were those that wrote that Puryear's (and others') use of sunrays was akin to those in Chinese propaganda posters, he denied this, stating that they "were meant to evoke a certain, uniquely American 'heartland' feeling".[30]

Perhaps the most eye-catching poster for Obama in 2008 was concocted by yet another street artist, Ron English, whose design fused the features of a revered US president, Abraham Lincoln (1861–1865), with those of the Democrat. English's multi-city poster, mural and billboard tour brought home the comparison with the admired nineteenth-century leader visually to many Americans, as did coverage of it on the Internet and mass media. In English's painting/poster, "Abraham Obama" looks directly out at the voters, establishing eye contact; he smiles subtly, yet confidently; his eyes seem to show determination and wisdom. An important element used in many political visuals is eye contact, which, according to Paul Messaris, helps gain the attention and interest of viewers, but "is also an attempt to inspire trust".[31] English had taken an American icon from the past and created a new one to promote his candidate effectively. There has been a long tradition of US poster designers attempting to associate venerated presidents – particularly Washington, Jefferson, Franklin D. Roosevelt and Lincoln – with later candidates, but never had an artist combined the features of two of them.[32]

The closest poster phenomenon to the Obama explosion in the past half-century was seen in the designs produced for another "progressive", socialist Bernie Sanders, who contested Hillary Clinton for the Democratic Party's presidential nomination in 2016. One designer, Greg Auerbach, created two posters that were available on the artist's website to download, with his mixed-media design, *We All Deserve a Future*, sold by the Sanders campaign's web store for $50.00 each. The work featured newspaper clippings and headlines such as "Rich-poor gap election focus – maybe not" and "Sanders prompts change", as well as images of the White House, the flag and

28 Ray Noland, quoted in Hal Elliott Wert, "Forward," in Ray Noland, *Street Art Stories and Scenes on the Road for Obama* [Unpublished book], para. 2.

29 Jennifer Swann, "Go Tell SAIC: Ray Noland Shares His Dreams," *fnewsmagazine*, November 12, 2008, http://fnewsmagazine.com/2008/11/go-tell-saic-ray-noland-shares-his-dreams/.

30 Tony Puryear, "Poster for Hillary Clinton's 2008 Presidential Campaign," Tony Puryear Design & Brandbuilding, Worldbuilding (blog), July 29, 2015, https://tonypuryeardesignand.wordpress.com/2015/07/29/poster-for-hillary-clintons-2008-presidential-campaign/.

31 Paul Messaris, *Visual Persuasion: The Role of Images in Advertising* (Thousand Oaks, CA: Sage, 1997), 23.

32 Seidman, "Obama Poster Explosion," 194.

the candidate, holding a placard and making a dramatic gesture, befitting his role as an independent outsider. Another poster was done by two teenage twins, Miguel and Alejandro Vega, and showed Sanders as "Captain America" (a comic-book hero, originally created during the Second World War) smashing Republican Donald Trump (president, 2017–present) (Figure 2.7).

Additionally, the campaign for the Republican Party's 2016 presidential nomination witnessed an early and unusual Republican portrait poster by a street artist named Sabo in 2014. It displayed Texas Senator Ted Cruz, adorned with tattoos of Winston Churchill, and an American flag and seal – a "fighter for liberty" with a cigarette dangling from his mouth (Figure 2.8). The Photoshopped poster was an unauthorized promotion for the candidate's speech at an annual dinner honoring Churchill, one year before Cruz announced a run for the Republican Party's presidential nomination.[33] Later, a slightly revised version was sold on the Cruz campaign's online store after he declared himself to be a candidate for the nomination.

Of course, leaders had been depicted in derogatory terms, including Obama with images that satirized him and even portrayed him in racist terms, including one that depicted him almost nude with an African headdress. His predecessor, George W. Bush, was cast in a 2003 Fairey print as Hitler, and a heavily wrinkled Reagan was shown in a 1988 poster designed by "guerrilla artist" Robbie Conal. Fairey also produced an inflammatory, Orwellian poster of Trump in 2016, titled *Demagogue* (Figure 2.9).[34] The focal point of the poster is Trump's snarling black-and-white mouth, with jagged, diagonal, red lines around it. But probably the most famous disparaging portrait of a presidential candidate was Warhol's rendition of President Nixon, who was running for a second term in 1972. The inspiration for Warhol's poster was a black-and-white caricature by Ben Shahn in support of President Lyndon B. Johnson's campaign eight years earlier, which ridiculed his Republican opponent, Barry Goldwater, depicting him as an almost ghoulish, eyeless, toothy figure with large eyeglasses above the bolded caption of "Vote Johnson".[35] Warhol's poster was similarly captioned "Vote McGovern", and also only showed the opposition candidate (although in a 16-color screen print), described by art critic Hrag Vartanian as a "demonized Nixon" with "his face green and blue" and his eyes orange and mouth yellow.[36] Nixon's infamous

33 Chris Gentilviso, "Ted Cruz has an Incredible Response to these Tattooed Posters of Him," *HuffPost*, March 17, 2014, http://www.huffingtonpost.com/2014/03/15/ted-cruz-tattoo-posters_n_4971355.html.

34 "The poster [was] inspired by [George] Orwell's *Nineteen Eighty-Four* (Fairey also designed a stunning cover for that novel)," according to Cory Doctorow, "Shepard Fairey's Trump Poster: DEMAGOGUE," boingboing (blog), November 7, 2006, https://boingboing.net/2016/11/07/shepard-faireys-trump-poster.html. The book cover is dominated by a large, black-and-white eye.

35 Jane Kinsman, *Workshop: The Kenneth Tyler Collection* (Parkes, Australia: National Gallery of Australia, 2015), 255.

36 Hrag Vartanian, "Before ObamArt: Thoughts on Calder, Warhol & McGovern," Hrag Vartanian (blog), April 1, 2009, hragvartanian.com/2009/04/01/calder-warhol-mcgovern/; also see Ibid. The Vote McGovern committee contacted printer Kenneth Tyler to collaborate with Warhol, who was filming in Los Angeles, and Tyler's screen printer, Jeff Wasserman, produced the prints; *NGA* (National Gallery of Australia), "Kenneth Tyler Printmaking Collection: Andy Warhol," https://nga.gov.au/internationalprints/tyler/artists/default.cfm?mnuid=2&artistirn=12079&list=true&creirn=12079&order_select=13&view_select=5&grpnam=26&tnotes=true&archive=#itm-1. There were 250 copies printed on sheets that were 42 inches square; one copy sold at auction for $22,500 in 2017; *Sotheby's*, "Andy Warhol Vote McGovern," http://www.sothebys.com/en/auctions/ecatalogue/lot.351.html/2017/

"five-o'clock shadow" was colored blue. A 2008 screen print by R. J. Berman and John Calao substituted George W. Bush for Nixon and "Vote Obama" for "Vote McGovern". Three other imitative, deprecating posters were produced during the 2016 campaign. One was merely an updated version of Warhol's anti-Nixon print by Deborah Kass, which showed a snarling, blue-faced Trump, with orange lips, eyebrows and temples, with "Vote Hillary" scrawled beneath him (with the same lettering style used as in the Warhol print). An anti-Hillary Clinton poster by Sabo had a nude drawing of a tight-lipped Clinton, decorated with tattooed slogans such as "No Bras, No Masters" and "Eugenics".

Painted Portraits

Official portraits almost always depict leaders positively. Poses in modern political portraiture can be compared with one in a Gilbert Stuart[37] painting of a full-length George Washington (commonly known as "The Lansdowne Portrait") (National Portrait Gallery, Washington, DC), although the admiration implied by past official portrait artists has become a bit subtler in recent times. Stuart's 1796 work (Figure 2.10) presented a standing Washington, sword at his side, making a dramatic hand gesture, painted in the European classical "Grand Manner" style (often used in state portraiture), which idealized subjects, commonly including classical symbols, plush draperies and carpeting.[38] Stuart depicted the first US president in a pose that

prints-multiples-n09645. It is estimated that the 250 copies raised more than $40,000 (about $238,000 in 2018 dollars) for the Democratic Party in 1972, with the average price per poster being somewhat above $160 (about $950 in 2018); *MCA* (Museum of Contemporary Art Chicago), "Collection: Featured Works; The Devil in the Details," https://mcachicago.org/Collection/Featured-Works.

37 Other well-known artists regularly came after Stuart to execute official portraits. They included John Trumbull (who depicted John Adams, 1797–1801), Rembrandt Peale (who did ones of Washington and Jefferson, the latter while he was John Adams's vice president), John Vanderlyn (of James Madison, 1809–1817), Samuel Morse (of James Monroe), George Caleb Bingham (who painted John Quincy Adams, 1825–1829), Eastman Johnson (who rendered portraits of Grover Cleveland (1885–1889; 1893–1897) and also Benjamin Harrison, 1889–1893), Anders Zorn (who did one of William Howard Taft, 1909–1913) and John Singer Sargent (who painted Theodore Roosevelt). Many of the official American portraitists studied their craft in Europe – Stuart, Rembrandt Peale, Morse, and Trumbull, as well as Ralph E. W. Earl (who painted Andrew Jackson, 1829–1837) in England; and Sargent and Vanderlyn, and also George Peter Alexander Healy (who did official portraits of John Quincy Adams, 1825–1829; Martin Van Buren, 1837–1841; John Tyler, 1841–1845; James Polk, 1845–1849; Millard Fillmore, 1850–1853; and Franklin Pierce, 1853–1857) in France. On many of the artists who studied in Europe, see Dorinda Evans, *Benjamin West and His American Students* (Washington, DC: Smithsonian Institution, 1980). The portraits by Earl and Healy are all in the White House collection.

38 The lavish draperies in some of British artist Joshua Reynolds's portraits done in the second half of the eighteenth century also are evident in some early US presidential portraits, and the standing pose and hand gesture of his full-length portrait of Commodore Augustus Keppel (1752, in the National Maritime Museum, Greenwich, UK) have some similarities to the Stuart portrait of Washington ("The Lansdowne Portrait"). The pose for Washington on which Stuart decided is thought to have been that taken by the president during an address to Congress, which Washington delivered in 1795; see Daniel C. Ward, *America's Presidents: National Portrait Gallery* (Washington, DC: Smithsonian Books, 2018), 54. But the pose also is imitative of that of a statue of Caesar Augustus, along with other classical features in Stuart's work, including Roman-style columns and a table leg with Roman fasces. American

copied full-length portraits of European monarchs, but, as Daniel C. Ward noted, the Stuart piece is "an explicitly antimonarchical work of art" because the American artist clothed Washington in a black suit (rather than in regal robes), and included *The Federalist Papers*, as well as an inkwell molded like Noah's ark and a rainbow bursting forth after some storm clouds (both symbolic of an America renewed and pure, after its revolution).[39] In comparison, John Howard Sanden's official oil painting of George W. Bush (The White House, Washington, DC), unveiled in 2012, also shows a standing president, but with only a hand resting on a chair (Figure 2.11). Bush, like Washington, is seen looking thoughtfully away from the viewers, as well as having carpeting and furnishings around him. The symbolism in the work is understated: a cushion embroidered with the Great Seal of the United States rests on the chair; a corner of the "Resolute Desk" is behind Bush; a painting by William H. D. Koerner, known by the title of a Bush memoir, *A Charge to Keep,* hangs on a background wall. Koerner's piece shows Western horseback riders going up a hill dynamically.[40]

The English and French influence can be seen in some of these presidential portraits, with the use of primary colors, rich tablecloths and drapes, dramatic hand gestures and thoughtful subjects sitting in chairs or standing, with official papers or books nearby. Some poses seem to have been modeled on French official portraiture popular in the seventeenth, eighteenth and early nineteenth century.[41] For example, an 1816 portrait by Jacques Louis David of General Etienne Maurice Gérard (Metropolitan Museum of Art, New York) places the standing, uniformed, decorated general, with a sword at his side, and who is holding an official-looking letter and envelope, on a balcony with lush red curtains in the background.[42] One can find many of these visual elements in Stuart's portrait of Washington (Figure 2.10), but even modern presidential portraits include some of these features. However, many nineteenth-century presidents were depicted rather simply with fairly plain backgrounds and few, if any, trappings. For example, Vanderlyn's 1816 portrait of James Monroe (National Portrait Gallery, Washington, DC) has a dark, brown background like that in David's 1793 *The Death of Marat* (Oldmasters Museum, Brussels, Belgium), and shows the influence of David's "neoclassical" style of painting with its "tight brushwork and subdued palette", according to Frederick S. Voss.[43] Later, in Sargent's early twentieth-century portrait of Theodore Roosevelt, one can see this direct, unadorned, more "democratic" style continue (as well as seeing the influence of his French teacher, Carolus-Duran, with a

features in the work include eagles carved on the leg, as well as the Journal of Congress and a copy of the US Constitution; see Rosalie Blacklock, "Ancient Symbols in an American Classic," *National Portrait Gallery*, February 3, 2017, http://npg.si.edu/blog/ancient-symbols-american-classic, and Kloss, *Art in the White House*, 66.

39 Ward, *America's Presidents*, 14.

40 See Craig Kanalley, "President George W. Bush Official Portrait Unveiled at White House (PHOTO)," *Huffington Post*, May 31, 2012, http://www.huffingtonpost.com/2012/05/31/president-george-w-bush-official-portrait-photo_n_1559961.html.

41 See Anthony Halliday, *Facing the Public: Portraiture in the Aftermath of the French Revolution* (Manchester, UK: Manchester University Press, 1999), 96; and Kloss, *Art in the White House*, 66.

42 See Metropolitan Museum of Art, *Europe in the Age of Enlightenment and Revolution* (New York: Metropolitan Museum of Art, 1987), 64–5.

43 Frederick S. Voss, *Portraits of the Presidents: The National Portrait Gallery* (Washington, DC: Smithsonian Institution, 2000), 33.

similar eye contact by the subject, visible brushstrokes and a relatively simple, dark background).

Almost all presidents were painted in a realistic, traditional style, which generally flattered the office holders, who were characterized as serious, noble leaders, who did not smile (well into the twentieth century), but often looked thoughtfully into the distance, sitting or standing erectly. Around the time of President Gerald Ford (1974–1977) a hint of a smile could be seen in Everett Raymond Kinstler's 1977 portrait of him (The White House, Washington, DC), but 14 years later, in Kinstler's portrait of Reagan (The White House, Washington, DC), a broad smile was evident, with subsequent presidents smiling subtly. In between, the official portrait of disgraced President Nixon by Alexander Clayton gave the ex-president (who sat for it seven years after he resigned) a slight smile. Almost all official portraits have been hung in the White House after presidents leave office, with several now at the National Portrait Gallery.

One controversial official presidential oil portrait was done by Nelson Shanks – 1 of 55 of Bill Clinton (1993–2001) at the National Portrait Gallery (Washington, DC).[44] Shanks claimed that doing the portrait of Clinton was difficult for him, since he "could never get this Monica thing completely out of [his] mind".[45] The "Monica thing" was the president's affair with Monica Lewinsky, a White House intern. What made this portrait notorious was that the artist inserted "a shadow from a blue dress" into the work, stating later that this was "a bit of a metaphor in that it represents a shadow on the office he held, or on him".[46] The blue dress had been worn by Lewinsky when she had sexual relations with Clinton, whose DNA remained on it, and verified that he had lied about the affair. Clinton has not commented publicly on the inclusion of the dress in Shanks's work, but the National Portrait Gallery has not displayed the portrait since 2009.[47]

One unusual official portrait of a president that is displayed in the White House (Washington, DC) is that of Kennedy by Aaron Shikler, who was asked by Jackie Kennedy to memorialize her assassinated husband in 1970 (Figure 2.12). According to the artist, "The only stipulation she made was, 'I don't want him to look the way everybody else makes him look, with the bags under his eyes and that penetrating gaze. I'm tired of that image'".[48] Shikler's portrait featured warm, soft lighting, and a plain, slightly textured, brown background that complemented the president's brown hair. Most striking is Kennedy's lowered head and his folded arms. The most recent – and perhaps the most unconventional – official portrait of a president is of Barack Obama by Kehinde Wiley. It was unveiled and installed at the National Portrait Gallery in

44 See David A. Graham, "In a Bill Clinton Portrait, the Devil's in a Blue Dress," *Atlantic*, March 2, 2015, https://www.theatlantic.com/entertainment/archive/2015/03/the-subtle-satire-of-a-bill-clinton-portrait/386558/.

45 Nelson Shanks, quoted in Ibid.

46 Ibid.

47 Lorena O'Neil, "Bill Clinton Portrait Currently in Storage, Where It Will Remain 'For Quite Some Time,'" *The Hollywood Reporter*, March 4, 2015, https://www.hollywoodreporter.com/news/bill-clinton-portrait-storage-will-779163.

48 Aaron Shikler, quoted in Shirley Clurman, "At $25,000-Plus for a Portrait, Painter Aaron Shikler Can Give Critics the Brush," *People*, May 4, 1981, https://people.com/archive/at-25000-plus-for-a-portrait painter-aaron-shikler-can-give-critics-the-brush-vol-15-no-17/.

Washington, DC in early 2018. A tieless, black-suited Obama sits in a chair (as did many of his predecessors in their portraits), but he hovers in a field of flowers, chosen to symbolize his background (chrysanthemums, jasmine and African blue lilies, which represent his homes in Chicago and Hawaii, and the lilies that suggest his Kenyan heritage).[49] The apparent inclusion of a sperm cell as a symbol of "masculinity" (subtly inserted as a vein on Obama's forehead) makes this portrait unique.[50] And President Obama leans forward intensely, almost scowling directly at the viewers, reminiscent of Sargent's portrait of Theodore Roosevelt, with his "near scowl with narrowed eyes focused on the viewer", according to William Kloss.[51]

In 1977, commissioned painted portraits of US government officials were stopped temporarily by President Carter, who considered them too costly, with color photographs replacing them.[52] Such oil paintings have run from $7,500 to more than $50,000 each.[53] But a few years after the 1977 suspension, the practice started up again, and an official portrait of Carter painted by Herbert E. Abrams (The White House, Washington, DC) was hung after his term in office ended in 1981.

Unofficial portraits of sitters also have been painted, with Shikler's oil painting of Reagan (National Portrait Gallery, Washington, DC), who had just won his first term in 1980, perhaps the best known in the past half-century. Shikler was hired by *Time* that year to do a portrait of President-elect Reagan, to be seen on the cover of the magazine's "Man of the Year" issue. A sitting with the artist was scheduled for only 90 minutes, during which Reagan (informally attired in blue jeans, a wide brown belt with a Western buckle, and, again, a blue work shirt) went to sleep. When Shikler awakened him, he stood up and this pose – with his hands in his back pockets – was sketched quickly.[54] Reagan (flooded with warm light) does appear to be sleepy in the portrait. But probably the most controversial painted portrait was an acrylic work, *The Truth*, by Michael D'Antuono, done in 2009, which showed a crucified Obama, in suit and tie – his face lit softly – with the Presidential Seal as a backdrop (Figure 2.13).

In addition, street artists have illustrated walls with their often-insulting portraits of political leaders. During the 2016 presidential campaign, for instance, Hanksy decorated a New York City building with a portrait of Donald Trump as a pile of feces ("aka Donald Dump"), with flies buzzing around it. And Ron English decorated a wall with "Humpty Trumpty". The several previous election campaigns witnessed outdoor murals of Barack Obama that usually were adoring and those of George W. Bush that were not.

49 Vigilant Citizen, *The Vigilant Citizen*, "Strange Facts About Obama's Portrait and its Painter Kehinde Wiley," February 14, 2018, https://vigilantcitizen.com/latestnews/strange-facts-obamas-portrait-painter-kehinde-wiley/.

50 Ibid.

51 Kloss, *Art in the White House*, 225.

52 Christopher Lee, "Official Portraits Draw Skeptical Gaze," *Washington Post*, October 21, 2008, A1.

53 Ibid.

54 See *Fox News*, "Renowned Painter Aaron Shikler Reveals Stories Behind Famous White House Portraits," December 30, 2011, www.foxnews.com/politics/2011/12/30/renowned-painter-aaron-shikler-reveals-stories-behind-famous-white-house; and William Grimes, "Aaron Shikler, Portrait Artist Known for Images of America's Elite Dies at 93," *The New York Times*, November 16, 2016, B14.

Photographs

Presidents have been photographed for almost 180 years, beginning with William Henry Harrison, who sat for a daguerreotype in 1841 (the year he held office). It did not survive.[55] A typical daguerreotype of a president of that time was of James Polk (1845–1849), taken by Mathew Brady at the end of Polk's term, which shows him sitting stiffly in a chair, looking off to the side, with a serious facial expression.[56] Brady was best known for his Civil War photography and his photographic portraits of President Lincoln (and several other presidents).[57] But a photograph he took of presidential-candidate Lincoln (looking serious and directly at the viewers) before his Cooper Union speech in New York City in early 1860 may have helped elect him later in the year. It showed him as a "sophisticated", smartly dressed orator in woodcuts that were made from the photograph, which appeared in publications such as *Harper's Weekly*.[58] It also helped that Brady retouched it by eliminating facial lines, as well as hiking up Lincoln's collar to have his long neck perceived as shorter.[59] Lincoln himself reportedly said, "Brady and the Cooper Institute made me President".[60]

Kennedy was the first modern president to realize the power of photography to enhance his image. By providing media outlets with almost-romantic photographs of himself and his family, he was able to build his image and promote himself, and – after he was assassinated – his myth was perpetuated.[61] Nowadays, presidential offices routinely disseminate such images taken by official White House photographers, typically on the *Flickr* website.[62] President Kennedy appointed Cecil Stoughton to be the first official White House photographer. Stoughton took numerous candid shots of Kennedy and his family, as well as head-and-shoulder portraits of the president smiling broadly, with curtains and the flag as a backdrop. All of Kennedy's successors, except Carter, have had an official photographer.[63] The official photographic portraits they produced, according to Cara Finnegan, commonly are shot "to communicate a

55 See Megan Garber, "The Oldest Known Photographs of a U.S. President," *Atlantic*, February 5, 2013, https://www.theatlantic.com/technology/archive/2013/02/the-oldest-known-photographs-of-a-us-president/272872/.

56 See Jess Zimmerman, "First (Surviving) Photograph of a Sitting President," *History By Zim* (blog), February 15, 2013, https://www.historybyzim.com/2013/02/first-president-photograph/.

57 Other famous photographers captured images of sitting American presidents in portraits. Those include Edward Curtis (of Theodore Roosevelt), Edward Steichen (of both Theodore and Franklin D. Roosevelt, Taft, and Herbert Hoover [1929–1933]), Alvin Coburn (of Theodore Roosevelt), Margaret Bourke-White (of Franklin D. Roosevelt), Arthur Rothstein (of Franklin D. Roosevelt and Eisenhower), Yousuf Karsh (of all presidents from Harry Truman [1945–1953], to Clinton, except for George H. W. Bush, whom he photographed when Bush was vice president), Arnold Newman (of all presidents from Kennedy to Clinton), Richard Avedon (of Kennedy and Carter), Philippe Halsman (of Nixon), Ansel Adams (of Carter), and Alfred Eisenstaedt and Irving Penn (both of Kennedy).

58 Roger Catlin, "How One Mathew Brady Photograph May Have Helped Elect Abraham Lincoln," *Smithsonian.com*, June 28, 2017, https://www.smithsonianmag.com/smithsonian-institution/how-one-mathew-brady-photograph-may-have-helped-elect-abraham-lincoln-180963839/.

59 Susan Kismaric, *American Politicians: Photographs from 1843 to 1993* (New York: The Museum of Modern Art, 1994), 15.

60 James D. Horan, *Mathew Brady: Historian with a Camera* (New York: Crown, 1955), 32.

61 Kismaric, *American Politicians.* 41.

62 Page views of the White House Flickr site totaled between 30,000 and 1,000,000 a day during Obama's terms. Walsh, *Ultimate Insiders*, 166.

63 Ibid., 103.

sense of authority and confidence", with an American flag included in almost every such work in the past half-century.[64] Eye contact, stance and background can enhance that impression.

A representative official photographic portrait can be seen in Figure 2.14, which shows a smiling President George W. Bush in 2003 looking directly into the camera, clad in a suit and tie, associated with an American flag. The last official portrait of President Obama was shot in December 2012 by Pete Souza, the official White House photographer, who then tweaked it in Photoshop (Figure 2.15).[65] A comparison of Obama's 2008 and 2012 official photographs reveals the same pose, with direct eye contact established, but with the latter portrait showing Obama smiling much more broadly. Both portraits have the American and US Presidential flags in the background. Souza shot both, and the earlier one was the first *official* presidential portrait shot with a digital camera.[66]

Official photographs are hung in courthouses, military bases, post offices, Veterans Affairs medical facilities, embassies and consulates and other government buildings. The official photographic portrait of Obama's successor, Donald Trump, also was shot with a digital camera, and showed him looking sternly at the audience with an American flag and the White House behind him.[67] One professional portrait photographer, Tamzin Smith, offered the following analysis:

> Trump's posture and slight lean forward portray the president as an aggressive figure. The catch lights in the lower part of Trump's eyes – those bright white dots just beneath his pupils – indicate he's being lit from below. For a portrait like this, that's a 'bizarre' lighting choice.[68]

However, it might have been used to accentuate Trump's tough, assertive character.[69]

Of course, there have been too many unofficial photographs of political leaders to mention, some of which have boosted or decreased their electoral chances. Examples include one of Theodore Roosevelt riding a moose in 1900 (reinforcing his "rugged" image); a shot of Kennedy sailing in 1960 (reproduced on the cover of *Sports Illustrated* magazine, which reinforced the untrue of image of him as "healthy" and "vigorous"); and those of Democratic Party presidential nominee John Kerry windsurfing in 2004

64 Cara Finnegan, quoted in Jacob Gardenswartz, "What's So Strange about Trump's White House Portrait? Experts Explain," *Vox*, January 26, 2017, https://www.vox.com/policy-and-politics/2017/1/26/14376784/trump-portrait-white-house-experts-explain.

65 Michael Zhang, "A Closer Look at Obama's New Official Presidential Portrait," *PetaPixel*, January 18, 2013, https://petapixel.com/2013/01/18/a-closer-look-at-obamas-new-official-presidential-portrait/.

66 See Ibid. Obama also was the first president to appoint an official videographer, Arun Chaudhary. Walsh, *Ultimate Insiders*, 8, 166.

67 Michael Zhang, "This is President Trump's Official Portrait," *PetaPixel*, January 21, 2017, https://petapixel.com/2017/01/21/president-trumps-official-portrait/.

68 Tamzin Smith, quoted in Gardenswartz, "What's So Strange about Trump's White House Portrait?"

69 Official presidential portraits are collectible (as is almost everything political): A signed White House photograph of Ford is valued at $75–$100. And a poster of the 1960 Democratic national ticket of John F. Kennedy and Lyndon B. Johnson is worth $75–$125; caricature slippers of George H. W. and Barbara Bush can be obtained for $50–$75; Enoch L. Nappen, *Warman's Political Collectibles: Identification and Price Guide* (Iola, WI: Krause, 2008), 78, 117, 141.

(perhaps showing him as an elitist). Many of these affected the masculine image of these male politicians, either positively or negatively.[70]

One recent development has been cell-phone photos of citizens with candidates (or "selfies"), with the hope that these would go "viral" on Twitter and other social media sites. Accordingly, one promotion by the Hillary Clinton campaign for the 2016 Democratic presidential designation was the "Meet Hillary Clinton Selfie Contest", which was initiated on Facebook in May 2015. Another technological advancement is the three-dimensional printed portrait, created with digital scanners, 3-D cameras, a special printer and a laser. In his second term, Barack Obama was scanned for approximately five minutes – the result being a bust of the president, which looked like "the plaster masks taken of Abraham Lincoln and George Washington", according to officials of the Smithsonian Institution.[71]

Cartoons

Cartoonists have depicted political leaders in ink drawings – often only in black and white, but sometimes with color added. The cartoonist's role typically has been to mock politicians, or, as cartoonist Patrick Oliphant wrote, to provide "a leading vehicle for pointed and savage opinion".[72] As Mark Falkenberg concluded, in his study of two cartoonists' views of Ronald Reagan, "[p]olitical cartooning is an inherently negative, one-sided medium, which is best suited to point out the shortcomings of its subjects".[73] For example, Paul Conrad in 1987, drew a sheepish, nude President Reagan, decorated with tattoos that illustrated the problems that had befallen him during most of his two terms in office, including portraits of the Ayatollah Khomeini (labeled "Moderate Iranian") and Oliver North (labeled a "hero" for his Marine exploits during the Vietnam War, although later he was accused of illegal involvement in the Iran-Contra affair as an officer of the National Security Council), a Jewish star (labeled "Israeli Involvement") and a bag of money (labeled "Contra$"). Conrad's cartoon imitated one by Bernard Gilliam of a tattooed Republican presidential candidate, James G. Blaine, in 1884.

Liberal cartoonists often drew the conservative Reagan negatively. But both pro- and anti-Reagan cartoonists generally emphasized his toothy smile, full head of dark hair, prominent chin, wrinkles and large ears, and positioned a cowboy hat on his head. Even conservative cartoonist Jeff MacNelly gave "Reagan a goofier-than-usual face, by shrinking the forehead, increasing the distance between nose and mouth, pulling the earlobes, and moving the eyes closer together", observed Falkenberg.[74]

70 Aaron J. Moore and David Dewberry, "The Masculine Image of Presidents as Sporting Figures: A Public Relations Perspective," *Sage Open Journal* 2, 3 (2012), https://doi.org/10.1177/2158244012457078.
71 David Ng, "Obama Gets 3-D Printed Portrait at Smithsonian," *Los Angeles Times*, June 23, 2014, https://www.latimes.com/entertainment/arts/culture/la-et-cm-obama-3d-smithsonian-20140623-story.html.
72 Patrick Oliphant, quoted in Stephen Hess and Sandy Northrop, *American Political Cartoons: The Evolution of a National Identity, 1754–2010* (New Brunswick, NJ: Transaction, 2011), 21.
73 Mark Falkenberg, "Where's the Rest of Him? An Analysis of the Political Cartoons of Jeff MacNelly and Pat Oliphant about President Reagan" (master's thesis, University of Montana, 1991), ii, http://scholarworks.umt.edu/cgi/viewcontent.cgi?article=5102&context=etd.
74 Ibid., 74.

Michael Dukakis (the Democratic presidential nominee in 1988) was usually drawn by caricaturists, such as John Pritchett, as a diminutive figure with a huge nose and a shock of dark hair. Noses have been fair game. Guston satirized Nixon in dozens of ink drawings in his 1971 *Poor Richard* series, depicting him as a sullen, tortured soul with a long nose, as well as a stubbly beard.[75]

Although he was a liberal, Block issued cutting cartoons of George H. W. Bush's Democratic successor, Bill Clinton, including one in September 1993, titled *Response to Ethnic Cleansing*, which showed him as a chubby and impassive man, washing his hands in a basin – a protest against the Clinton administration's alleged weakness in opposing genocide in Bosnia. One of the characteristics that political cartoonists like to exaggerate is plumpness. Tom Toles drew President Clinton as a rotund character with a bulbous nose in 1994 (Figure 2.16). And Toles would later draw Trump as a rotund, pig-like human. But neither Block nor Toles was the first to emphasize presidential chubbiness. Edward Tennyson Reed caricatured Theodore Roosevelt with a series of jowls and with a huge belly in the first decade of the twentieth century.

Many cartoonists depicted George W. Bush (who followed Clinton as president) as a dopey fellow, often drawing him smirking, with closed or squinting eyes and bushy eyebrows. Kevin ("KAL") Kallaugher drew him that way, back to back with his Democratic opponent, Al Gore, in the aftermath of the voting in the contentious presidential election of 2000, with Gore drawn taller, with spiked ears and a large, pointed nose. Both candidates held guns, shaped like Florida (the state, whose recount – decided by the Supreme Court – would determine the victor). Kallaugher is known for detailed, crosshatched, pen-and-ink cartoons, in black-and-white and color – his crosshatching technique reminiscent of etchings by Albrecht Dürer and Edward Hopper. And, naturally, he adds exaggeration to his portraits. He, like many cartoonists, drew President Obama as an ultra-thin individual with huge ears.

Kallaugher is an unabashed opponent of the most recent US president, Donald Trump. In fact, according to Thomas Urbain and Aurélie Mayembo, Kal "has in the past depicted the real estate tycoon as a menacing animal".[76] But after Trump won the election, the political cartoonist said that "you have to be more nuanced. You attack his policies; his buffoonery. You try to kill him with a thousand cuts rather than a single axe to the head".[77] In that vein, Kallaugher drew a bloated, angry President-elect Trump with a hairdo that was only slightly exaggerated, tied up with his own tongue, after he had frequently alleged during the campaign that the 2016 presidential election would be rigged (Figure 2.17). As Trump's presidency proceeded, Kal often drew the new American leader as a dense, puffy, pompous figure being hoodwinked and dominated by friends and foes, foreign and domestic, including Russian president Vladimir Putin and White House Chief Strategist Stephen Bannon. Other cartoonists have gone further, depicting President Trump's allegedly dictatorial aims. One cartoonist, John Darkow, drew him as Hitler in one creation, titled "~~Herr~~ Hair Trump", and in another,

75 See Musa Mayer and Sally Radic, eds. *Philip Guston: Nixon Drawings 1971 & 1975* (New York: Hauser & Wirth, 2017).

76 Thomas Urbain and Aurélie Mayembo, "In Trump, Cartoonists Find a Poisonous Gift," *GMA News Online*, December 15, 2016, https://www.gmanetwork.com/news/lifestyle/artandculture/592593/in-trump-cartoonists-find-a-poisonous-gift/story/.

77 Kevin Kallaugher, quoted in Ibid.

Trump is shown sledgehammering the base of the Statue of Liberty. This continued the theme of Americans "fearing power" that was manifested in portrayals by visual caricaturists of past leaders, including Andrew Jackson drawn as Richard III by David Claypool Johnson in 1828; Martin Van Buren (president 1837–1841) shown with a crown on a throne in a lithograph by H. R. Robinson that was published in 1840; and Andrew Johnson (1865–1869) with a royal robe and crown in a Thomas Nast pastel (c. 1876).[78]

Sculptures

Sculptures of American leaders, including presidents, have been executed, beginning in Washington's time. A full-length marble statue of the first American president in his Revolutionary War uniform (Virginia State Capitol, Richmond) was created by the Frenchman, Jean-Antoine Houdon, and unveiled in 1796. Houdon's statue evolved from a life mask and body measurements that he made himself, and combined symbols of America with those of the Roman Republic, including a plowshare, bound rods (known as *fasces*, symbolic of Rome's authority, but the bundle is made from 13 rods, representative of the original 13 states), and Native American arrows.[79] Although Washington was attired in his military uniform, other "neoclassical" sculptors of presidents clothed them in Roman-style garb. For example, Hiram Powers's marble busts of Washington, Jackson and Van Buren (carved several decades after Houdon's work) featured togas and blank eyeballs, both of which were characteristic of the "neoclassical" tradition. However, the works were fairly realistic. For example, Powers carved bags under Van Buren's eyes.[80] Some subsequent statues of venerated presidents have been larger-than-life bronze and marble creations, including two 19-foot statues: one of Jefferson by Rudulph Evans, housed in the 3rd president's Washington, DC memorial right after the Second World War; the other of Lincoln, designed by Daniel Chester French (and completed a year after the First World War ended), which resides in the sixteenth president's memorial in the same city. Although neither sculpture has "neoclassical" features, both memorials do: the Lincoln Memorial structure (modeled after the Greek Parthenon) has 38 Doric columns; the Jefferson Memorial has 54 Roman-style columns.[81] The 1997, 10-foot bronze statue by Neil Estern of a sitting Franklin D. Roosevelt, situated in his Washington, DC memorial, has him looking resolutely into the distance, with a cloak obscuring his wheelchair and his dog at his side.[82] Protests about the statue obscuring Roosevelt's disability ensued, and an additional life-size, bronze work was created by Robert Graham, which placed the former president in a

78 See Amon Carter Museum of Western Art. *The Image of America in Caricature & Cartoon* (Fort Worth, TX: Amon Carter Museum of Western Art, 1976), 3, 63, 68, 87.

79 See Tracy L. Kamerer and Scott W. Nolley, "Rediscovering an American Icon: Houdon's Washington," *Colonial Williamsburg Journal* 25, 3 (2003): 74–9.

80 See Kloss, *Art in the White House*, 101.

81 See National Park Service, "Lincoln Memorial," https://www.nps.gov/linc/learn/historyculture/memorial-features.htm; and *National Park Service*, "Thomas Jefferson Memorial," https://www.nps.gov/thje/learn/historyculture/places.htm.

82 Photographers were instructed never to photograph the paralyzed Roosevelt (who had polio) in a wheelchair during his term of office. Walsh, *Ultimate Insiders*, 6.

wheelchair, with a similar gaze (which was unveiled in 2001).[83] This memorial has no features reminiscent of ancient Greece or Rome.

Many US presidents have been represented in life-size, bronze statues. A series of these reside along the streets of Rapid City, South Dakota, with one of George W. Bush also paired with a dog. Many additional sculptures of American presidents and other leaders have been larger than life (with their size perhaps helping to immortalize some of them) – the most notable being the huge, 60-foot sculptured heads, designed by Gutzon Borglum, of four revered past presidents – Washington, Jefferson, Lincoln and Theodore Roosevelt – at the Mount Rushmore National Memorial, which was completed in 1941. Gigantic 16- to 18-foot, stern-faced busts of post-1980 presidents were among those at the now-dormant Presidents Parks in Williamsburg, Virginia and Lead, South Dakota (both of which opened 2003–2004).[84] Other examples (8- to 10-feet high) can be seen around the country. For example, an 8-foot bronze statue of George H. W. Bush by David Adickes was created in 1990, and can be seen at the George Bush Intercontinental Airport in Houston.[85] The sculpture has a noble, forward-looking Bush holding his jacket over a shoulder with his tie blowing. And there also have been smaller bronze pieces that have glorified and satirized American leaders, including the first president Bush. For example, cartoonist Oliphant transformed him into a withered horseshoe player, with a pointed nose and chin, as he entered office in 1989 (National Gallery, Washington, DC).[86]

In addition, life-size, wax figures of presidents have been produced. In early 2017, the collection of the Hall of Presidents and First Ladies, a wax museum in Gettysburg, Pennsylvania, was auctioned off, with much media attention.[87] The modern presidents were depicted in a realistic fashion, formally attired and standing. Presidential wax creations in other institutions, such as the Hollywood Wax Museum and New York Madame Tussauds, are similar with slight variations, showing a smiling Obama with folded arms, for example, at the latter place.

Other sculptures have been ceramics or made from non-traditional materials. For instance, in 2013, Zach Tate produced humorous painted ceramic sculptures of Carter and Reagan, with their jaws missing. And Stanley Glaubach created a bust of Nixon in 1971 that featured newspaper headlines pasted on fabricated form (National Portrait Gallery, Washington, DC). In 2008, Michael Murphy fashioned an eight-foot-high

83 See National Park Service, "Franklin Delano Roosevelt Memorial," https://www.nps.gov/nr/travel/presidents/fdr_memorial.html; Robert Graham, "Franklin Delano Roosevelt Memorial," https://www.robertgraham-artist.com/civic_monuments/fdr_memorial.html; and Jennifer Rosenberg, "FDR Memorial in Washington D.C.," ThoughtCo., March 7, 2018, https://www.thoughtco.com/fdr-memorial-in-washington-d-c-1779901.

84 Richard H. Saunders, *American Faces: A Cultural History of Portraiture and Identity* (Hanover, NH: University Press of New England, 2016), 156.

85 See *PresidentsUSA.net*, "George Bush 'Winds of Change' Statue – George Bush Airport," 2008, http://www.presidentsusa.net/bushairport.html.

86 See *National Portrait Gallery*, "George Bush," http://npg.si.edu/portraits.

87 The Abraham Lincoln figure drew the top bid, going for $8,500, but of the presidents in the past half-century, the George W. Bush likeness attracted the highest price, going for $3,100, with the lowest bid being for the Obama rendition at $2,000. See *Pa. OnSite Auction*, "Final Sales Prices Including Buyers Premium," January 14, 2017, www.paonsiteauction.com/Jan14/011417prices.pdf. On the auction, see Alyssa Pressler, "Wax Lincoln Sells for $8,500 at Auction in Gettysburg," *York Dispatch* (York, PA), January 15, 2017, www.yorkdispatch.com/story/news/local/2017/01/15/wax-lincoln-sells-8500-auction-gettysburg/96613262/.

sculpture of candidate Obama looking down in profile, which was made from high-tension wire, which he called *Tension* (Figure 2.18).[88] Then there was the sand-sculpture bust of a grinning Bernie Sanders, with huge eyeglasses, created by Dean Arscott in 2015, estimated to be six-feet high.[89]

Video and Film Imagery, Television Shows, Animated Parodies, T-shirts, Mixed Media and Textiles

Presidents and national candidates have been portrayed in practically every form, including medals, buttons, coins, paper currency, banners, textiles, postcards, plates and dolls. Most prominent in the mass-media age have been candidate portrayals in video spot advertisements. Such campaign ads are shown on television, and then posted on Internet sites (including candidate websites and YouTube), as well as being picked up by bloggers. These spots typically are 30 seconds in length, and frequently focus on a key character trait of a candidate. In many US national election campaigns, the majority of advertisements are negative, attacking opponents directly or comparatively.[90] In 2016, for example, almost two-thirds of the ads run by the Hillary Clinton campaign were negative, with overt attacks on Trump or depictions of him being unfit for office, when compared to Clinton's supposed positive qualities.[91] In her ad, "Role Models", as described in a report issued by the Center for Political Communication and Civic Leadership, "Clinton is shown smiling, dressed in white and surrounded by light. Clinton is contrasted to Trump's allegedly backwards and negative comments as a symbol of joy, optimism, and progressive leadership."[92] Additionally, her facial expressions are calm and reassuring, and she ends by placing her hand over her heart, while the Trump clips in the ad show his facial and body language as agitated and aggressive. The Trump campaign ran about 60 percent of negative and comparative ads.[93]

Comparable examples from other campaigns abound, with dark and sunny lighting, in addition to positive and negative facial expressions, body language and poses,

88 See *Perpetual Art* (The Work of Michael Murphy), "Other," http://mmike.com/other.html.

89 See Kate Bradshaw, "Bernie SAND-errs Makes Appearance at Treasure Island Labor Day Event," *Creative Loafing Tampa Bay*, September 8, 2015, www.cltampa.com/news-views/article/20762603/bernie-sand-ers-makes-appearance-at-treasure-island-labor-day-event.

90 During the crucial June 1–October 21 period in 2012, for instance, 59 percent of ads run by the Obama campaign were negative and another 27 percent were contrast ads, while 49 percent of his opponent's (Republican Mitt Romney) campaign ads were negative, with an additional 30 percent presenting contrasts. The negative and contrast percentages were a bit less extreme in 2008, but still high. And while the Bush 2004 campaign's negativity was comparable with the following years, the Kerry campaign that year proved to be an exception, when it ran a mere 3 percent of negative TV spots (and 42 percent contrast ads); see *Wesleyan Media Project*, "2012 Shatters 2004 and 2008 Records for Total Ads Aired," October 24, 2012, http://mediaproject.wesleyan.edu/releases/2012-shatters-2004-and-2008-records-for-total-ads-aired/. Data analyses of 2000–2012 TV ads by the Wesleyan Media Project revealed that such political advertising was more negative with each presidential election year generally; see Denise-Marie Ordway and John Wihbey, "Negative Political Ads and their Effect on Voters: Updated Collection of Research," *Journalist's Resource*, September 25, 2016, https://journalistsresource.org/studies/politics/ads-public-opinion/negative-political-ads-effects-voters-research-roundup/.

91 Center for Political Communication and Civic Leadership, A Report on Presidential Advertising and the 2016 General Election: A Referendum on Character (College Park, MD: Political Advertising Resource Center, University of Maryland, 2016), 6, https://parcumd.files.wordpress.com/2016/11/parc-report-2016-v-21.pdf.

92 Ibid.

93 Ibid., 10.

accentuating candidate "character". The first television campaign advertisements aired in 1952, with Eisenhower looking determined when discussing the issues of the day, and shown triumphant and smiling, with both arms raised, in footage from the party's national convention. By 1960, a negative ad, "Nixon's Experience?", was produced by the Democrats, which included a video shot of Nixon with a downturned mouth and shifty eyes. Of course, Nixon was portrayed quite differently in ads produced by his campaigns, as in a 1972 spot, "Nixon the Man", which had him laughing with Duke Ellington, walking down the aisle while smiling to give away his daughter at her wedding, followed by dancing with her, and telling a joke at a press conference. These techniques have continued.

Another dissemination in the past dozen years has been digitized, animated, musical parodies, with *JibJab* satires of national candidates receiving the most attention.[94] Such animated portraits of politicians, sometimes favored by younger cartoonists (at least those under age 50), began to pop up on .com websites (such as newsday.com and the washingtonpost.com) at the turn of the twenty-first century.[95] Hillary Clinton and Barack Obama were shown with toothy grins, with Obama animations and cartoons giving him ears that rivaled those of Dumbo the elephant.

Comedians and actors also have provided exaggerated imitations of political leaders on American television. The latest has been actor Alec Baldwin, who has lampooned Donald Trump on *Saturday Night Live*, with aggressive gestures and puckered mouth. Hair and makeup artists transformed Baldwin to look like the Republican by crafting "a set of 'huge, arching, over-the-top' eyebrows and us[ing] very orange makeup", as well as constructing a large, blond wig, according to Jodi Mancuso, head of the show's hair department.[96] Other imitators have looked almost like clones of their targets, especially Tina Fey, who played Sarah Palin, who was Republican John McCain's running mate in 2008. Other famous *Saturday Night Live* impressions were Dan Aykroyd's scowling Nixon; Jay Pharoah's gray-haired, big-eared Obama; Larry David's gruff, scruffy Sanders; and Will Ferrell's smirking, simple George W. Bush.[97]

In films, recent presidents have been portrayed both realistically and satirically. Here are a few examples: Reagan was played by Jay Koch, "[w]ith his thatch of thick dark hair, a warm smile and twinkling eyes" in *Back to the Future II, Hot Shots! Part Deux* and in *Panther*, according to Claire Noland; Frank Langella interpreted the desperation of the embattled Nixon in *Frost/Nixon*; George H. W. Bush was portrayed sternly by James Cromwell in *W.*; Tim Walters was a dead ringer for Bill Clinton in *Life or Something Like It*; and James Adomian played George W. Bush as a cursing pot-smoker in *Harold & Kumar Escape from Guantanamo Bay*.

Also, textiles have been created that featured American leaders, particularly Barack Obama. In 2008, one textile designer, Heidi Chisholm, produced an African wax block-print fabric, titled *Hooray for the President*, which placed Obama in a yellow oval surrounded by a wreath with a star above him (Figure 2.19). Obama is looking

94 See Saunders, *American Faces*, 110–11.

95 Hess and Northrop, *American Political Cartoons*, 173.

96 Jodi Mancuso, quoted in Lisa Ryan, "Here's How Kate McKinnon and Alec Baldwin Became Hillary Clinton and Donald Trump on Saturday Night Live," *Vulture*, November 8, 2016, https://www.vulture.com/2016/11/makeup-behind-clinton-and-trump-impressions-kate-mckinnon-alec-baldwin.html.

97 See Anna Silman, Dan Jackson, and John Sellers, "The 21 Best 'Saturday Night Live' Political Impressions Ever," *Thrillist*, February 10, 2016, https://www.thrillist.com/entertainment/nation/saturday-night-live-best-political-impressions-in-snl-history.

upward and smiling, with a star gleaming off his teeth. Additionally, the fabric has a multitude of red roses with yellow leaves, a fist, labeled "HOPE", and an auto-mobile, labeled "Shine Shine" (for the company for which she produced the fabric). And Chuck Close produced a photorealistic tapestry (based on his photographs of the president) in support of Obama's 2012 campaign, with Obama smiling broadly in one portrait and looking more serious in the other.[98] Quilts also have been made to honor Obama, as have dresses, bandanas and T-shirts. Obama's 2008 campaign was the first ever to sell adult T-shirts with a US presidential candidate's portrait on them, with many different designs that featured the candidate's image, often sold independently.[99] Trump's T-shirt design featured a photograph of him wearing a "Make America Great Again" hat, the 2016 Republican candidate looking directly out and giving a "thumbs up", with the stars and stripes splashed behind him.

Finally, there have been mixed-media works. One interesting creation (done with chalk pastel, gouache, acrylic and ink) was made by Beth Consetta Rubel, whose "Saint Obama" carried the implied religious iconography in Fairey's and Noland's posters to its conclusion, depicting the president as a holy figure (as did D'Antuono), bathed in golden light and clad in a red vestment, with a gold halo and birds behind him (Figure 2.20). And there have been countless presidential portraits made from unusual materials by admiring artists. In 1993, the Smithsonian Institution's National Portrait Gallery put on an exhibition with many such portraits, including a carved coconut head of Truman, a postage-stamp collage of Eisenhower, a portrait of Kennedy made of dyed eggshells and cotton thread, a Nixon puppet, a painted rock rendition of Ford, a wooden-nutcracker Carter, a jelly-bean portrait of Reagan and a chair portrait of Clinton.[100]

Conclusions

Generally, official portraits of US presidents and national candidates have been flat-tering, while unofficial ones have ranged from expressions of idolatry to ones of contempt. Facial expressions, poses, gestures and attire have all been important in communicating the artists' intents to capture character. Sculptures and even textiles of political leaders usually have been dignified, inspirational pieces, which most often have depicted the leaders gazing upward with resolute or smiling facial expressions. In addition, the trappings of power have been included in both painted and photographic portraits, as have patriotic symbols. In the mass media age, painted and printed por-traiture undoubtedly have had less impact on voters than previously, although in the past decade, posters and cartoons have reached a much wider audience, due to their dissemination via social media.

Campaign posters in many elections in the past 50 years frequently have not even included portraits. However, there have been some notable exceptions – often created

98 The tapestry was available for purchase for $100,000 to raise funds for the Obama campaign; Julia Halperin, "You Can Buy Chuck Close's Tapestry Portrait of Barack Obama for $100,000," BlouinArtinfo (blog), September 10, 2012, https://web.archive.org/web/20131213044816/http://blogs.artinfo.com/artintheair/2012/09/10/you-can-buy-chuck-closes-tapestry-portrait-of-barack-obama-for-100000/.

99 Steven A. Seidman, "Barack Obama's 2008 Campaign for the U.S. Presidency and Visual Design," *Journal of Visual Literacy*, 29 (2010): 7–8.

100 See James D. Barber, *To the President: Folk Portraits by the People* (Washington, DC: The National Portrait Gallery, Smithsonian Institution, 1993).

by candidates' supporters. In 1980, Ronald Reagan was portrayed as a warm, patriotic cowboy. Eight years later, George H. W. Bush was characterized as a war hero, and, in 2004, his son as a staunch opponent of terrorism. In 2008 and 2012, an abundance of posters portraying Barack Obama as a noble, visionary leader and even a "super-hero", graced (or littered, depending upon one's political leanings) the country, and, four years later, liberal-activist artists depicted Bernie Sanders as a man-of-the-people with similar inspirational qualities. Of course, posters also have been disseminated that have derided presidents and national candidates – some viciously or prejudicially.

Overall, cartoonists' works have been highly critical of American politicians, but largely unseen by most voters, with the occasional cartoon that has been instrumental in defining a president being the rare exception – and that occurred in the 1960s and 1970s, with cartoons by David Levine and Herb Block. Generally, television shows and films have portrayed candidates negatively, both thematically and stylistically, and campaign spot ads have depicted opposition politicians in negative ways in recent years.

Design techniques in a wide variety of media have been used to glorify or malign politicians, lighting them dramatically or pleasingly, or harshly; using grainy, black-and-white footage, or vibrant color stock; making them seem more attractive or distorting their features, using image-manipulation software; and posing them looking upward or downcast. Some of the portraits created in the past half-century have been memorable and influential – even iconic. How many speeches can this be said about? A picture may indeed be worth a thousand words; perhaps more!

Figure 2.1 Ronald Reagan. Poster, Republican Party, presidential election campaign, 1980. (Courtesy of the Ronald Reagan Presidential Foundation & Institute).

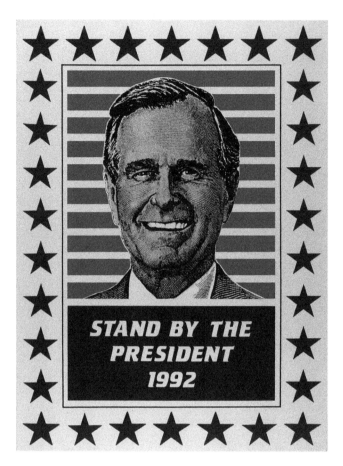

Figure 2.2 President George H. W. Bush. Poster, Republican Party, re-election campaign, 1992. (Used with the permission of the George H. W. Bush Presidential Library Foundation).

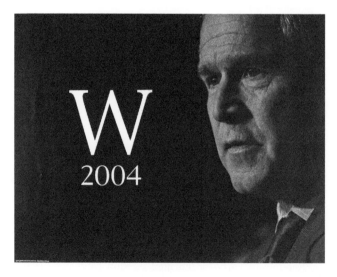

Figure 2.3 President George W. Bush. Poster, Republican Party, re-election campaign, 2004. (Used with the permission of the Republican National Committee).

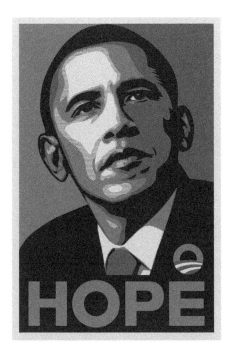

Figure 2.4 Barack Obama. Poster by Shepard Fairey in support of Obama's presidential election campaign, 2008. (Illustration courtesy of Shepard Fairey/Obeygiant.com. Used with the permission of Shepard Fairey/Obeygiant.com).

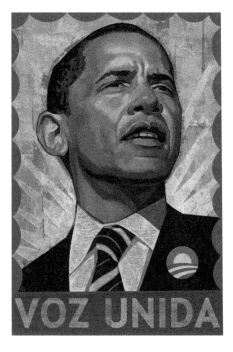

Figure 2.5 Barack Obama. Poster by Rafael López in support of Obama's presidential election campaign, 2008. (Used with the permission of Rafael López Studio).

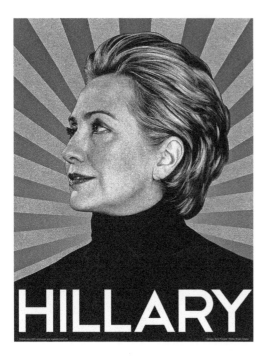

Figure 2.6 Hillary Clinton. Poster by Tony Puryear in support of Clinton's election campaign for the Democratic Party's presidential nomination, 2008. Photo by Brian Adams. (Used with the permission of Tony Puryear).

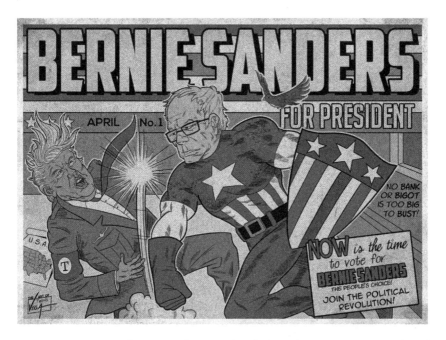

Figure 2.7 Bernie Sanders. Poster by Miguel and Alejandro Vega in support of Sanders's election campaign for the Democratic Party's presidential nomination, 2016. (Used with the permission of Miguel and Alejandro Vega [Art of Twinsvega]).

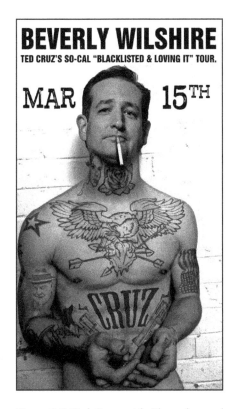

Figure 2.8 Ted Cruz with Photoshopped tattoos. Poster by Sabo promoting a speech by the senator, 2014. (Used with the permission of Sabo/unsavoryagents.com).

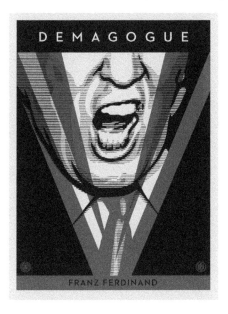

Figure 2.9 Donald Trump. Poster by Shepard Fairey promoting rock song by Franz Ferdinand, 2016. (Illustration courtesy of Shepard Fairey/Obeygiant.com. Used with the permission of Shepard Fairey/Obeygiant.com).

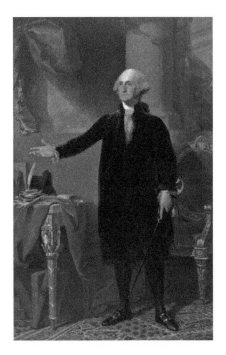

Figure 2.10 George Washington (Lansdowne Portrait). President George Washington. Painting by Gilbert Stuart, 1796. (National Portrait Gallery, Smithsonian Institution; acquired as a gift to the nation through the generosity of the Donald W. Reynolds Foundation).

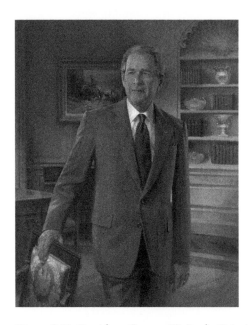

Figure 2.11 President George W. Bush. Painting by John Howard Sanden, 2012. (© [2012] White House Historical Association; Used with the permission of White House Collection/White House Historical Association).

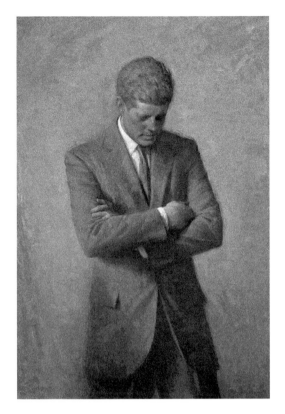

Figure 2.12 President John F. Kennedy. Painting by Aaron Shikler, 1970. (© [1970] White House Historical Association; Used with the permission of White House Collection/ White House Historical Association).

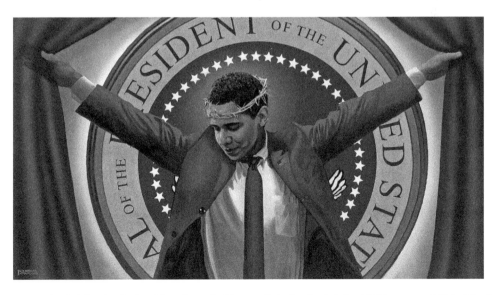

Figure 2.13 *The Truth*. President Barack Obama. Painting by Michael D'Antuono, 2009. (Used with the permission of Michael D'Antuono ArtandResponse.com).

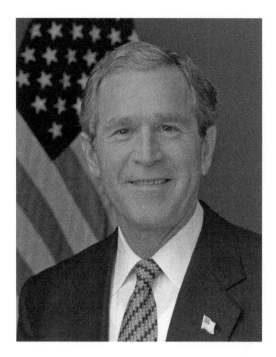

Figure 2.14 Official Portrait of President George W. Bush. Photograph by Eric Draper, 2003. (Public Domain; Library of Congress, Courtesy of the George Bush Presidential Library).

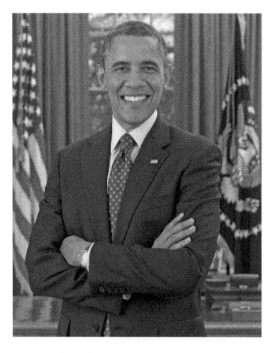

Figure 2.15 Official Portrait of President Barack Obama in Oval Office. Photograph by Pete Souza, 2012. (Public Domain; Library of Congress).

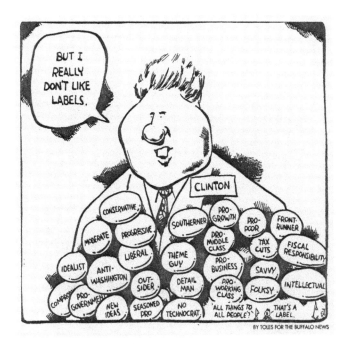

Figure 2.16 "But I Really Don't Like Labels". Cartoon of President Bill Clinton by Tom Toles, 1994. (TOLES © The Washington Post. Reprinted with permission of ANDREWS MCMEEL SYNDICATION. All rights reserved.)

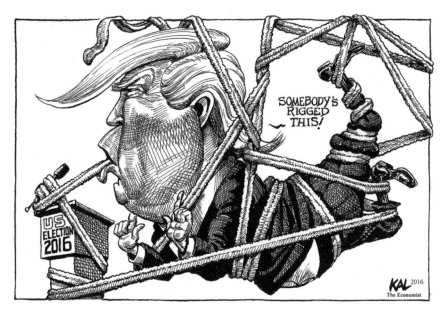

Figure 2.17 "Tongue not in Cheek". Cartoon of President-elect Donald Trump by Kevin KAL Kallaugher 2016. (Used with the permission of Kevin KAL Kallaugher, The Economist, Kaltoons.com).

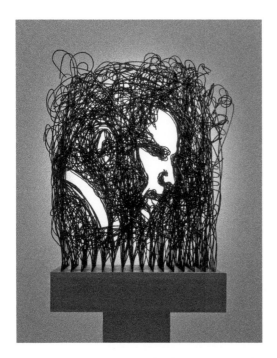

Figure 2.18 Tension. Barack Obama. Wire sculpture by Michael Murphy, 2008. (Used with the permission of Michael Murphy – perceptualart.com).

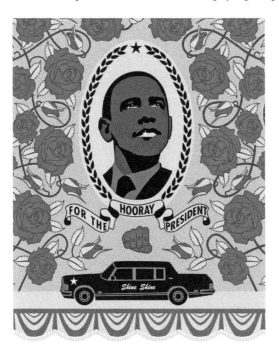

Figure 2.19 Hooray for the President (detail). African wax block-print fabric of President-elect Barack Obama by Heidi Chisholm, 2008. (Used with the permission of Heidi Chisholm for Shine Shine).

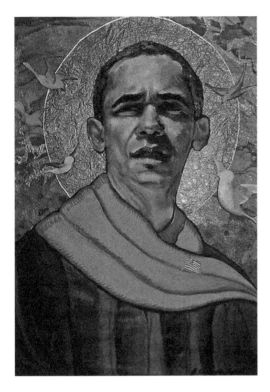

Figure 2.20 Saint Obama. President Barack Obama. Mixed-media work by Beth Consetta Rubel, 2009. (Used with the permission of Beth Consetta Rubel).

Bibliography

Amon Carter Museum of Western Art. *The Image of America in Caricature & Cartoon.* Fort Worth, TX: Amon Carter Museum of Western Art, 1976.

Barber, James D. *To the President: Folk Portraits by the People.* Washington, DC: National Portrait Gallery, Smithsonian Institution, 1993.

Combs, James E., and Dan Nimmo. *The New Propaganda: The Dictatorship of Palaver in Contemporary Politics.* New York: Longman, 1993.

Decker, Juilee. "Paintings and Sculpture." In *The American President in Popular Culture,* edited by John W. Matviko. Westport, CA: Greenwood, 2005.

Fischer, Roger A. *The Damned Pictures: Explorations in American Political Cartoon Art.* New Haven, CT: Archon Books, 1996.

Hess, Stephen, and Sandy Northrop. *American Political Cartoons: The Evolution of a National Identity, 1754–2010.* New Brunswick, NJ: Transaction, 2011.

Kismaric, Susan. *American Politicians: Photographs from 1843 to 1993.* New York: The Museum of Modern Art, 1994.

Kloss, William. *Art in the White House: A Nation's Pride.* Washington, DC: White House Historical Association, 1992.

Library of Congress. *Presidential Campaign Posters.* Philadelphia: Quirk Books, 2012.

Lubin, David M. *Shooting Kennedy: JFK and the Culture of Images.* Berkeley, CA: University of California Press, 2005.

McPherson, James M., ed. *To the Best of My Ability: The American Presidency.* New York: Dorling Kindersley, 2000.

Melder, Keith. *Hail to the Candidate: Presidential Campaigns from Banners to Broadcasts*. Washington, DC: Smithsonian Institution, 1992.

Metzger, Robert. *Reagan: American Icon*. Lewisburg, PA: Bucknell University Press, 1989.

Miles, Ellen G. *George and Martha Washington: Portraits from the Presidential Years*. Washington, DC: Smithsonian Institution, National Portrait Gallery, 1999.

Nappen, Enoch L. *Warman's Political Collectibles: Identification and Price Guide*. Iola, WI: Krause, 2008.

Saunders, Richard H. *American Faces: A Cultural History of Portraiture and Identity*. Hanover, NH: University Press of New England, 2016.

Seidman, Steven A. *Posters, Propaganda, and Persuasion in Election Posters Around the World and Through History*. New York: Peter Lang, 2008.

Seidman, Steven A. "Election Posters in the United States After World War II." In *Election Posters Around the Globe: Political Campaigning in the Public Space*, edited by Christina Holtz-Bacha and Bengt Johansson. Berlin, Germany: Springer, 2017.

Trumble, Angus. *A Brief History of the Smile*. New York: Basic Books, 2004.

Voss, Frederick S. *Portraits of the Presidents: The National Portrait Gallery*. Washington, DC: Smithsonian Institution, 2000.

Walsh, Kenneth T. *Ultimate Insiders: White House Photographers and How They Shape History*. New York: Routledge, 2018.

Ward, Daniel C. *America's Presidents: National Portrait Gallery*. Washington, DC: Smithsonian Books, 2018.

Wert, Hal Elliott. *Hope: A Collection of Obama Posters and Prints*. Minneapolis, MN: Zenith, 2009.

Wert, Hal Elliott. *George McGovern and the Democratic Insurgents: The Best Campaign and Political Posters of the Last Fifty Years*. Lincoln, NE: University of Nebraska Press, 2015.

3 Representing Leaders in Britain

The Portraits of Winston Churchill, Harold Wilson, Margaret Thatcher and Tony Blair

Simon Downs

Churchill – The British Bulldog

Winston Churchill (1874–1965) was Prime Minister from 1940 to 1945 and again from 1951 to 1955. However, before commenting on the portraits that were realized during these years, and later, it is worth drawing attention to an early image: a painting that was commissioned from William Orpen, an official war artist, by the newspaper magnate Lord Rothermere (Figure 3.1). It was realized in 1916, shortly after the disastrous military campaign at Gallipoli, which Churchill had spearheaded as First Lord of the Admiralty, to force Ottoman Turkey (Germany's ally) out of the war, and was shown at the Royal Academy Summer Exhibition, in London, the following year. Churchill is represented with a furrowed brow, a stooped posture and unkempt hair. He wears a coat and clutches a hat, as if he were about to leave the room – a probable allusion to his resignation from Herbert Asquith's wartime cabinet.[1] Churchill treated the painting as something of a public exposure of his personal guilt[2] and hung it in Downing Street during the Second World War. It appears in the background of contemporary photographs as a public reminder of his greatest military failure.

Without giving up politics, Churchill spent the interwar years as a media personality, speaking on the radio and mixing with stars in Hollywood. He published in popular magazines (he had a passion for science and wrote with H. G. Wells), and featured on the cover of the January 1936 issue of *The Strand Magazine*. He even appeared with Charlie Chaplin in 1929 on the set of *City Lights*. The image told a very un-British story of a working-class man (Chaplin) and an upper-class man (Churchill) standing as equals: but this was only on a Hollywood sound stage.

As a wartime prime minister, Churchill became a symbol of defiance and resistance. The Ministry of Information, MOI, plastered Britain with propaganda posters featuring his effigy. A poster of 1940 bearing the slogan "Let Us Go Forward Together" depicted him smiling confidently with tanks and fighting airplanes in the background. Another, issued the following year, represented him stern-eyed pointing his finger at the observer – a posture that echoed Alfred Leete's "Your Country Needs You" propaganda image of 1914 – while the slogan declared "[You] Deserve Victory!"

1 Mark Brown, "'Man of misery' portrait reveals Churchill's angst," *The Guardian*, November 1, 2012, 19.
2 Jonathan Black, *Winston Churchill in British Art, 1900 to the Present Day: the Titan with Many Faces* (London: Bloomsbury, 2017), 43–4.

Churchill was often associated with the image of a bulldog – an old British symbol originating from the sport of bull-baiting and standing for strength and loyalty[3] – on account of his tough attitude, as well as for distinct physical resemblance with the animal. For instance, a cartoon drawn by Sidney Strube, published in the *Daily Mail* on June 8, 1940, depicts him as a giant bulldog guarding the British Isles (represented as a map), ready to attack the enemy (the helmet he wears carries the slogan "Go to it"). The Churchill-bulldog image was also exploited abroad, as the poster "Holding the line!" designed by the American artist Henri Guignon, which was produced in 1940 by the Committee to Save America By Aiding the Allies to call for the United States' intervention, shows (Figure 3.2).[4]

Churchill was omnipresent in the press and in newsreels during the war. The images were wide-ranging. For instance, they showed him in an amphibious armored personal carrier crossing the Rhine, and on the beaches of Normandy with Field Marshal Montgomery to show that the D-Day landings had been successful.[5] His name came to be so inextricably linked to military prowess that a heavy armored vehicle, the Infantry Tank Mk.IV, A22, was generally referred to as "the Churchill". Churchill frequently appeared wearing a military uniform. That public opinion considered perfectly acceptable for him to appear so dressed is an indication of the high esteem he enjoyed: this practice was rarely followed by prime ministers because it was associated with dictators such as Stalin and Mussolini.

Churchill failed to win the first post-war elections in 1945, and his second term of office was less decisive than his wartime one because of his age and ill-health, but his major contribution to the victory against Nazi-fascism established his reputation as a remarkable leader, and many memorials were erected in Britain and other countries to honor him. As early as 1953, a bronze bust, commissioned by the *Rotterdamse Kunststichting* (Rotterdam Art Foundation), was placed in Rotterdam's City Hall. This sculpture, the work of Dutch artist Willem Verbon (1921–2003), depicts him swathed in the regalia and robes he wore when he attended the coronation of Queen Elizabeth II in June 1953. Numerous full-length statues have also been erected to celebrate his political eminence. Oscar Nemon (1906–1985) realized two for the Members' Lobby of the Palace of Westminster (unveiled in 1970) and Toronto's City Hall (1977), respectively, and Ivor Roberts-Jones (1913–1996) completed one for London's Parliament Square (1973). Among the more recent monuments is that created by Jean Cardot (b. 1930), which stands in front of the Petit Palais, in Paris (1998).[6] Only rarely have Churchill's depictions been controversial. A nine-foot sculpture commissioned by the

3 Ibid., 89–91, 101, 102, 105, 123, 140, 155, 199, 231. The bulldog entered the lexicon of nationalist iconology as a shorthand for the British people in the mid-nineteenth century, through the political illustrations which John Leech and John Teniel realized for the weekly satirical magazine *Punch*. See Jeffrey E. Nash, "What's in a Face? The Social Character of the English Bulldog," *Qualitative Sociology* 12, 4 (1989): 357–70.

4 For representations of Churchill in mass culture, see Timothy S. Benson, *Churchill in Caricature* (London: Political Cartoon Society, 2005); and David Welsh, *Persuading the People. British Propaganda in World War II* (London: The British Library, 2016), 8, 185, 190, 215.

5 See the official British Government video of PM Cameron celebrating Churchill's newsreel appearances: https://www.gov.uk/government/history/past-prime-ministers/winston-churchill (last accessed on October 14, 2018).

6 For a fuller survey of Churchill memorials, see Black, *Winston Churchill in British Art*, 205–23, 265–70.

British charity organization Rethink in 2006 that represented him in a straitjacket – a reference to his occasional "black dog" of depression – was roundly condemned and barred from public display by his descendants, despite the fact that it was intended to highlight the hidden stigma of mental health.[7]

Churchill continues to be a living presence in people's minds. His effigy features, for instance, on the new £5 banknote – an honor given to no other twentieth-century politician (Figure 3.3). The portrait is based on a photograph taken in 1941, a choice that was meant to celebrate him as a wartime leader. The background represents Westminster with the parliament clock showing three o'clock, this being the approximate time when Churchill stated in a well-known speech: "I have nothing to offer but blood, toil, tear and sweat" – words that are reproduced along the lower edge of the banknote. In July 2018, Boris Johnson compared his campaign against Britain's membership of the European Union to Churchill's defiance of Hitler in the speech he gave following his resignation as Foreign Secretary, in criticism of Conservative Prime Minister Theresa May's approach to Brexit.[8]

Harold Wilson: A Working-Class Hero?

As the media ecosystem changed, with television replacing print as the focus point for British political life, so did the demands made on politicians. Some rose to the challenge and applied their rhetorical gifts to the new medium; others stumbled in an environment where quick wits and a nippy turn of phrase defeated a considered argument. There is no doubt that Harold Wilson (1916–1995), who ran Britain from 1964 to 1970, and again from 1974 to 1976, thrived.

To many Britons, the image of Prime Minister Harold Wilson is associated with his impersonation by the popular television comic Mike Yarwood. As a media savvy politico, Wilson was more than happy to go along with it in order to connect with a popular television audience. Wilson appeared in public with Yarwood and went as far as allowing the performer to impersonate him, between two genuine policemen, on the steps of 10 Downing Street.

Wilson's embrace of media in all its forms was part of a strategy to project an ordinary, down-to-earth image, one that attempted to connect his politics to his working-class origins. It was a strategy that worked because it was in keeping with the mood of a nation that was experiencing an unprecedented level of social mobility and rise in the standard of living. Wilson was the first British Prime Minister of the television age. He

7 Angela Scriven, and Nimira Lalani, "Sir Winston Churchill: Greatest Briton used as an anti-stigma icon," *Perspectives in Public Health* 126, 4 (2006): 163.

8 Boris Johnson's use of Churchill's name in this context is paradoxical given that the great statesman was a strong promoter of the European communities. Suffice it to recall the speech "The United States of Europe," which he gave at the University of Zurich on September 9, 1946, and that which he delivered at the Council of Europe on August 17, 1949. See David Ramiro Troitiño, "Winston Churchill and the European Union," *Baltic Journal of Law and Politics* 8, 1 (2015): 55–81. Churchill's presence in popular culture also deserves to be mentioned. He is the protagonist of more than ten motion pictures (two produced in 2017 alone), and a major character in nearly fifty on-screen productions, including the long-running British science-fiction television series *Dr. Who*. In the latter he features as a general-purpose symbol of British history and national defiance, linking Britain's past to the country's present and future. Churchill even has the eponymous Doctor's phone number, making him a sign that functions across both time and space.

courted celebrities from working-class backgrounds, such as film stars Roger Moore, Peter Sellers and Peter O'Toole, and the captain of the victorious 1966 England World Cup team Bobby Moore, and sought photo-opportunities with them. He even gave the Beatles their knighthoods. His public image was the complex creation of a man who knew he would be joining the public in their living rooms as an uninvited guest, and who shaped his image to appear ordinary – a far cry from the patrician leaders of the past. The mundane and approachable image he pursued was anticipated by the billboards and posters of his 1964 election campaign: most unusually, these did not merely depict his effigy, but showed him actually canvassing among people.

Wilson carefully constructed for himself an iconography made up of work and family holidays in unglamorous resorts. A characteristic image is that which shows him sitting on a beach in the Scilly Isles, an archipelago off the coast of Cornwall, with his wife Mary, in shorts and sandals, with a mug of tea in one hand, a pipe in the other. What may look like an ordinary family snapshot was of course carefully staged for public consumption: other photographs taken on the same occasion show groups of suited men at the edge of the shot (security or journalists) or news cameras.

The pipe was Wilson's most distinctive visual sign: it was devoid of specific class connotations and suggested a quiet, thoughtful personality. The pipe characterized his public persona to such an extent that it was reproduced on its own, as a synecdoche for his effigy, on the campaign poster of the snap election of 1966. In reality he preferred cigars, which he only smoked in private because they evoked Churchillian plutocracy. Unlike his predecessors, who spoke with an Oxbridge accent, Wilson reveled in his Yorkshire linguistic origins, despite graduating from Oxford. Cartoons and other satirical representations made fun of his pipe and holidays in the Scilly Isles, as well as of his small height, disheveled looks and troll-like appearance.

The monument that Huddersfield, Wilson's home city, dedicated to him, and which Tony Blair unveiled in July 1999, carries on the myth of the "humble and ordinary leader" in every way. The eight-foot statue, the work of the committed socialist sculptor Ian Walters (1930–2006),[9] stands unheroically at street level, barely on a plinth, to invite public interaction. It is located outside the railway station and suggests that Wilson has just stepped off the train and is going home. At the request of Lady Wilson, the portrait, which is based on photographs taken in 1964, does not show him holding the pipe that was his trademark (Figure 3.4).

Margaret Thatcher – The Iron Lady

Tory prime ministers traditionally made little efforts to disguise the upper or aristocratic class they came from. Harold Macmillan, who served from 1957 to 1963, portrayed himself as the last Edwardian. Alec Douglas-Hume, who succeeded him for one year, had an aristocratic demeanor (he was indeed an earl originally; he renounced his title because it was deemed unacceptable for a prime minister to be sitting in the House of Lords). Edward Heath, who ran the country from 1970 to 1974, came from a lower middle-class family, but, though affable, he too failed to convince ordinary people that he was in touch with their problems. The success enjoyed by Wilson's Labour Party

9 On this sculptor, see Tony Benn and Claudia Webbe, "Obituary: Ian Waters, sculptor and socialist whose work included Mandela and Harold Wilson," *The Guardian*, August 18, 2006, 38.

in connecting with the newly socially mobile led the Tory management to position itself in the same way. The election of Margaret Thatcher (1925–2013) to the party leadership in 1975 was a clear break with the past. In selecting her, the Conservatives followed the marketing concept that a product must be adapted to meet the needs of the market.[10]

In many ways Thatcher, who was Prime Minister uninterruptedly from 1979 to 1990, was diametrically opposed to Churchill. Where the wartime premier – an aristocrat, a freebooter and a soldier – was the Tory establishment dream writ large, she was deeply middle-class, suburban in her tastes and religiously non-conformist (she belonged to the Methodist Church, rather than to the Church of England). The Conservative Party was keen to promote her out-of-the ordinary, distinctive features. The strategy it adopted is well exemplified by the widely disseminated photograph depicting her as a young research chemist – an activity that was to lead her to become a member of the Royal Society. The picture indicated that though a female, she had successfully pursued research in a subject that was generally considered to be a male domain; in other words, it attested that she had a strong personality and unswerving determination.[11]

Role-play was to become a recurring feature of her public persona until the end of her first term in office. Her communication adviser was the journalist and television producer Gordon Reece. As Margaret Scammel notes:

> [Reece] carefully designed photo opportunities which set out to create a more warm and womanly image for a leader generally perceived as aloof and rather superior. To this end, for example, Mrs Thatcher infamously cuddled a new-born calf, donned work clothes to coat chocolates, and performed a host of other down-to earth tasks, she shied away from aggressive television interviewers except when unavoidable, such as at election times, and cultivated warmer, "human interest" outlets: women's magazines, chat shows and opportunities to display the softer, family side of her personality.[12]

Thatcher was also photographed wearing garments that suggested power and influence[13] or in hyper-masculine tableaux (e.g. riding in an Abbot Self-Propelled Gun in 1976). The events around the Falklands War of 1982 introduced a subtext of military competence and wartime command to the mythos. She became a modern-day Joan of Arc, a "leader of men". The 1986 portrait of Margaret Thatcher in the command position of a Chieftain main battle tank during a visit to the British Army of the Rhine at Bad Fallingbostel well exemplifies such an image.

10 On the "launching" of Thatcher, see Robert Busby, *Marketing the Populist Politician. The Demotic Democrat* (Basingstoke: Palgrave Macmillan, 2009): 72–4; Sam Delany, *Mad Men & Bad Men. What Happened when British Politics Met Advertising* (London: Faber & Faber, 2015), 123–41.

11 On the appeal of the outsider in politics and the Conservative Party's promotion of Thatcher, see Anthony King, "The Outsider as Political Leader: the Case of Margaret Thatcher," *British Journal of Political Science* 32 (3), 2002: 335–454.

12 Margaret Scammell, "The Odd Couple: Marketing and Maggie," *European Journal of Marketing* 30, 10/11 (1996): 114–26.

13 Jonathan Jones, "Why Thatcher's frocks deserve the same treatment as Bowie's platform heels," and Jess Cartner-Morley, "Tactically tailored for effect not fashion," *The Guardian*, November 4, 2015, 9.

In October 1982, shortly after the recapture of the Falkland Islands, Thatcher appeared at the Conservative Party conference as a triumphant figure. The official photographs of the event depict a setting resembling a Red Square reviewing stand or the Nuremberg rally: the leader appears above the central committee, and the committee above the audience. She is absolute power incarnate. From this time onwards she became The Leader, the politician who ordered the deployment, the commander of the tank, as well as the nanny (that particularly British fetish) about to give you a taste of your medicine.[14]

The hatred Thatcher fueled among those who opposed her policies had no parallel in twentieth-century Britain. Innumerable posters, stickers, placards and newspaper cartoons represented her as a puritanical, dogmatic, spiteful and war-mongering politician (Figure 3.5).[15] The very people Thatcher had so successfully courted to win three consecutive elections eventually abandoned her. If in 1981, polls showed that 43 percent thought her to be "out of touch with ordinary people", by 1990, when she was persuaded to resign, the figure had increased to 62 percent.[16] Toward the end of Thatcher's premiership even the Queen bore animosity toward her. Her antagonism was not so much due to political differences, but rather to the strong perception that the Prime Minister was trying to usurp her role as head of state. Some photographs show that Thatcher modelled her public image on that of Elizabeth II (Figure 3.6).[17]

Margaret Thatcher's divisive nature continued to make the headlines well after the abrupt end of her third term of office. An over-life-size statue of her carved in white Carrara marble by Neil Simmons, which had been on temporary display at the Guildhall Art Gallery in London since February 2002, was decapitated five months later by theatre producer Paul Kelleher (Figure 3.7). The monument, paid for by an anonymous donor, was intended for the Members' Lobby of the House of Commons at Westminster.[18] The repaired statue has remained in the Guildhall building and it is now relegated to a corridor. In 2003 a new full-length statue, this time in tougher silicon bronze, was commissioned for the Palace of Westminster from the sculptor Antony Dufort (b. 1948) and funded by the Works of Art Committee.[19] The figure looks toward the doors of the Commons Chamber, facing the statue of Winston Churchill.

14 For useful surveys of images of Margaret Thatcher, many of which were disseminated or endorsed by her party, see: Lady Olga Maitland, *Margaret Thatcher: the First Ten Years*, with photographs by Srdja Djukanovic (London: Sidgwick & Jackson, 1989); Alex Gover, *Margaret Thatcher: Her Life in Pictures* (London: Go Entertainment, 2009); Elizabeth Roberts ed., *Margaret Thatcher: a Life in Pictures*, with interviews with Ann Widdecombe and Lord Healy (Lewes: Ammonite, 2009). Also of interest is Roland Flamini, *Ten Years at Number 10: Images of a Decade in Office* (London: Aurum, 1989).

15 For a selection of cartoons on Thatcher, see Christopher Miles and Anita O'Brian, eds., *Maggie! Maggie! Maggie! Margaret Thatcher – Mother of the Nation or Monster from the Blue Lagoon* (London: The Cartoon Museum, 2009).

16 Busby, *Marketing the Populist Politician*, 67.

17 Georgina Howell, "The Queening of Mrs Thatcher," *The Sunday Correspondent*, April 22, 1990, 18–19.

18 Michael White, "Thatcher Statue Decapitated," *The Guardian*, July 4, 2002, 1. The statue could not enter the Palace of Westminster just after its completion because the House of Commons did not permit monuments to parliamentarians to be erected there during their lifetimes. This rule was changed later in that year.

19 https://en.wikipedia.org/wiki/Statue_of_Margaret_Thatcher_(Palace_of_Westminster). Last accessed on October 14, 2018.

In January 2018 a proposal for a bronze memorial created by Douglas Jennings (b. 1966) that was originally commissioned to stand, like that of Winton Churchill, in Parliament Square, in central London, was rejected by Westminster Council out of fears that it would be vandalized or serve as a catalyst for civil disobedience. It is to be erected instead in Grantham (Lincolnshire), Thatcher's hometown.[20]

A less controversial portrait of Margaret Thatcher is that painted in 1998 by James Gillick (b. 1972), the son of the Catholic commentator on morality issues Victoria Gillick, for the University of Buckingham (the first private university in the United Kingdom, which the former Prime Minister was instrumental in creating). It depicts Thatcher wearing the robe of Chancellor of the University, a title with purely ceremonial functions she held from 1992 to 1998 (Figure 3.8).

Tony Blair – Too Good to Be True

The expression "media friendly" might almost have been coined for the young Tony Blair (b. 1953), who led the country from 1997 to 2007. It is symbolic of his appeal and of his public appetite for change that the 1997 Labour Party used the hit song "Things Can Only Get Better" by the Northern Irish pop group D:Ream as the campaign theme.[21] Blair's public image, like Thatcher's, was a conscious construct, but taken to a more extreme level. He appeared to be everywhere; framed as new, young and charming. His first election poster depicted him with a grin on his face, wearing a white shirt (a color suggestive of the clean sweep he was making of age-old Labour ideas), with sleeves rolled up to indicate that he was rearing to get on with the job; the loose tie and the hands in his pockets, spelling informality and nonchalance, made him look "cool" (Figure 3.9, Left). The satirists soon began to make fun of him.[22] Confronted with such a dashing young contender, the Conservative Party Central Office resorted to smears to attack him. A general election poster of 1997 depicted Blair with the demonic taint of the socialist past (Figure 3.9, Right).[23] Jeremy Sinclair, the deputy chairman and co-founder of Saatchi & Saatchi, who devised the campaign for the Conservative Party, later remarked:

> In previous elections we had always been able to base our work on facts. We were able to say that every Conservative government had cut tax, every Conservative government had cut unemployment, every Conservative government had cut inflation. But that was no longer the case in 1997, after Black Wednesday. So, we had to go with a broader, less specific approach. "Labour might have changed, but they're still dangerous. Watch out."[24]

20 Peter Walker, "Proposed statue of former PM is rejected," *The Guardian*, January 2018, 12; Ben Quinn, "Rejected by London, statue of Thatcher goes to Granthan," *The Guardian*, February 6, 2019, 1–2.

21 For the campaign video see https://www.youtube.com/watch?v=gi5j7jjhm4M. Accessed on August 15, 2017

22 See, for instance, the cover of the satirical weekly *Private Eye*, No. 920, March 21, 1997; and the December 1997 issue of the comic magazine *2000 AD*, which represented him as the bionic super-agent B.L.A.I.R. Blair also featured recurrently in the satirical television puppet show *Spitting Image*.

23 Andrew Culf, "Demon eye ad wins top award," *The Guardian*, January 10, 1997, 10

24 Quoted from Delany, *Mad Men & Bad Men*, 192. "Black Wednesday" refers to September 16, 1992, when the Pound Sterling collapsed and John Major's Conservative government had to withdraw it from the European Exchange Rate Mechanism.

Blair's election campaign followed the well-established American practice of marketing a politician by presenting him in different settings to suit different audiences.[25] The Labour leader appeared with his adoring wife and children, writing on a private jet, speaking to the people in Uxbridge (a small town near London), meeting school children in Northern Ireland, breathlessly rushing through crowds, etc. There were photographs of him as a moody hipster, as well as a distinguished politician in an expensive suit. Commenting on his official campaign video, Sam Delany has remarked:

> The film's look was almost wilfully low-fi – the perfect riposte to widespread accusations that Blair was a leader surrounded by spin and artful choreography. It opened with the Labour leader in the back of a car, telling [the popular actor John] Dineen (who sat off-camera) that while growing up he wanted to be 'anything but a politician'. He spoke of his childhood ambition to be a professional footballer for Newcastle United. Footage showed him playing football with kids in a park, every bit the young, thrusting and down-to-earth leader. But the key moments were inside the Blair family home in Islington.[26]

Blair and his Chancellor of the Exchequer, Gordon Brown, were engaged in a large-scale redefinition of the party: New Labour presented itself as pro-European, more centrist and globalist – a transformation that succeeded in attracting many new voters, but was disapproved by some of its traditional electorate. The shift to the center could have cost the Labour party some of its core voters. In an attempt to avoid it, the party's publicity frequently depicted Blair with his deputy John Prescott, a former trades-union activist and a strong vocal supporter of traditional Labour politics. Prescott's presence was to serve as a visual buttress holding up Blair's credentials with the left. The strategy, which was masterminded by Blair's campaign manager, Peter Mandleson, proved successful: New Labour managed to attract the support of the downtrodden, the poor and the unemployed, as well as that of the newly affluent middle-classes and of many of the rich.[27]

With his second election victory in 2001 Blair became a touchstone for modern globalist politics. Even President George W. Bush sought photo-opportunities with him to gain some respect. Blair had achieved the status of general purpose sign of political success. His popularity waned dramatically when he backed Bush's intervention in Iraq; he resigned in 2007.

Blair's first official portrait was painted in 2008 by Jonathan Yeo (born in 1970), son of the Conservative Member of Parliament and former minister Timothy Yeo. It was commissioned by Lincoln's Inn, the prestigious London-based society of barristers where Blair had trained. The painting, which represents him clothed in a pale blue suit, surrounded by a halo-like brightness, gives him saintly overtones; however, it also contains references to the Iraq War. The glaringly red poppy, a traditional symbol of military remembrance, which Blair is shown wearing has in fact been interpreted as a sign of his political blemish. As Tim Marlow, Director of the Artistic Programmes at the Royal Academy of Arts, put it: "[It is] a commemoration of the dead from two world

25 Eric Guthey and Brad Jackson, "CEO portraits and authenticity paradox," *Journal of Management Studies* 42, 5 (2005): 1057–82; Busby, *Marketing the Populist Politician*, 117.
26 Delany, *Mad Men & Bad Men*, 198.
27 Ibid, 191.

wars, but equally of those who had died in the Iraq War and Blair and Bush's War on Terror."[28] The portrait hangs in its Great Hall of Lincoln's Inn, a room that contains a number of other paintings, including a portrait of Margaret Thatcher executed by June Mendoza in 1990.

Another work that well exemplifies Blair's post-resignation public image is that painted by Alastair Adams (born in 1969) in 2013 for London's National Portrait Gallery (Figure 3.10). The portrait is uncomfortably confrontational. Sarah Howgate, the gallery's senior curator, remarked:

> The direct gaze of the sitter is uncompromising, but also reflects his considerable skill as a negotiator on the world stage. The strain of the job is apparent on the face of Blair. The portrait is one of an animal prepared to pounce; posed forward, fixated on the viewer and teeth bared.[29]

Adams's painting came under strong attack when it was unveiled: it was perceived as an a-critical celebration of Blair.[30] The work unintentionally tapped into an intense and widespread animosity that Blair had aroused especially when the Chilcot Report, issued in 2016, stated that, contrary to what he had been claiming, no evidence was found that Saddam Hussein had weapons of mass destruction. The newspapers of the day were full of pundits calling for Blair to be prosecuted as a war-criminal. Posters and placards disparaged him by calling him "Bliar" and depicting him as Pinocchio.

Though Blair's political achievements are hard to dispute, he has become a poisoned political brand. The Labour Party has cast off his legacy, as is attested by the absence of his image in the publicity material it has produced during elections since his resignation as Prime Minister.

The present survey spanning a century shows that, while the forms of mediation have changed beyond recognition and the individual points of contention have drifted over time, the fundamental purpose of the British political portrait remains much the same as it ever was. Our four prime ministers faced a multitude of challenges, but all were aware of the need of constructing a public persona that would make them acceptable to the voters. Churchill promoted himself as the heroic defender of his country and the embodiment of national virtue *tout court*. Harold Wilson associated himself with the stars of television, cinema, pop music and sport, and stressed his working-class origins in an effort to appeal to ordinary people. Margaret Thatcher sought the advice of advertising agencies which marketed her as a desirable product. Tony Blair, aided by his spin doctors, projected a modern and inter-classist image that was intended to depart from the gloomy, working-class one the Labour Party was associated with. In the end, the very media that raised Thatcher and Blair to the heights of power delivered the final verdict on their premiership: with their popularity at lowest ebb, both leaders were vigorously persuaded to resign before the end of their terms of office.

28 Marion Gayford et al., *The Many Faces of Jonathan Yeo* (London: Art Book Publishing, 2013), 71. On this portrait see also Mark Brown, "First portrait shows 'mellow, bouncy' Blair," *The Guardian*, January 19, 2008, 21.

29 Mark Brown, "Painting of former PM unveiled," *The Guardian*, December 21, 2013, 10.

30 Following the outcry in the print and electronic media, Alastair Adams, a colleague at Loughborough University, expressed his genuine surprise to me that his portrait of Tony Blair was interpreted as a personal political endorsement.

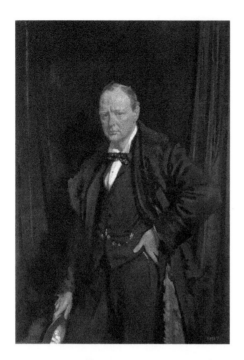

Figure 3.1 William Orpen, portrait of Winston Churchill, 1916. (National Portrait Gallery, London).

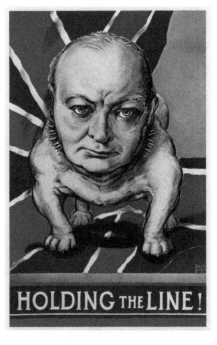

Figure 3.2 Churchill as bulldog. Poster designed by Henri Guignon for the Committee to Save America by Aiding the Allies, 1940. (Imperial War Museum, London).

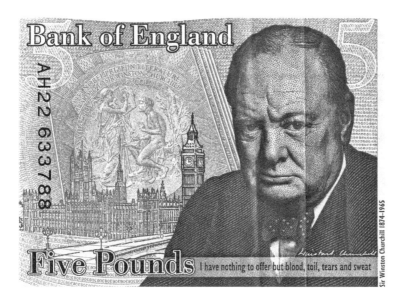

Figure 3.3 Five-Pound banknote featuring Winston Churchill's effigy (detail). In circulation since 2016. (Bank of England).

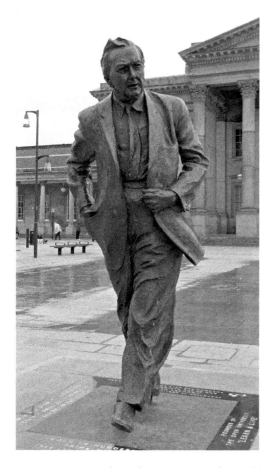

Figure 3.4 Ian Walters, bronze statue of Harold Wilson, 1999, standing outside Huddersfield train station. (Photo: Tony Hisgett, 2010).

Figure 3.5 Ronald Reagan with Margaret Thatcher. Poster designed by Bob Light and John Houston for the Socialist Workers Party, 1983. It parodies the poster of Victor Fleming's film *Gone with the Wind*.

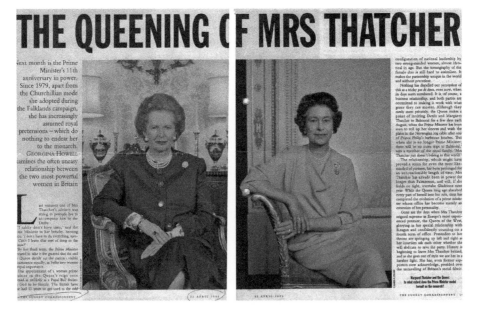

Figure 3.6 Thatcher posing as Queen Elizabeth II. From *The Sunday Correspondent*, April 22, 1990. (Photos: J. Guichard/Gamma/PSP and Camera Press).

Figure 3.7 Neil Simmons's statue of Margaret Thatcher decapitated, July 2002. Guildhall Art
Gallery. (Photo: Peter J. Jordan, PA).

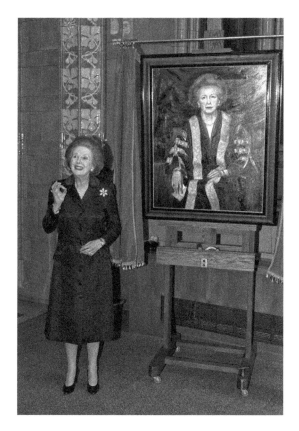

Figure 3.8 Margaret Thatcher unveiling the James Gillick portrait of her as the Chancellor of
the University of Buckingham, 1998. (Press Association).

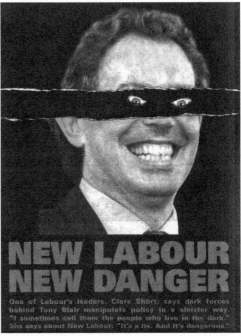

Figure 3.9 (Left) Labour Party poster featuring Tony Blair, general election, 1997. (Right) Conservative Party poster attacking Tony Blair, general election, 1997. (Press Association).

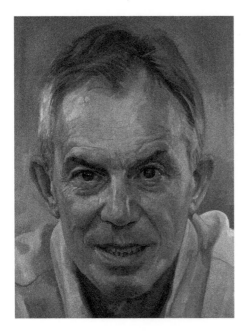

Figure 3.10 Alastair Adams, portrait of Tony Blair, 2013. (National Portrait Gallery, London).

Bibliography

Arthur, Max. *Churchill: A Life. An Authorised Pictorial Biography*. London: Cassell, 2015.

Ball, Stuart. *Dole Queues and Demons: British Election Posters from the Conservative Party Archive*. Oxford: Bodleian Library, 2011.

Burgess, Chris. "From the Political Pipe to the Devil Eyes. A History of the British Election Poster from 1910 to 1997." Unpublished PhD dissertation, University of Nottingham, 2014.

Burgess, Chris, and Dominic Wring. "Framing Politics: The Enduring Appeal of the Poster in British General Election Campaigns." In *Election Posters Around the Globe*, edited by Christina Holtz-Bacha and Bengt Johansson, 339–360. Cham, Switzerland: Springer, 2017.

Cockett, Richard. "The Party, Publicity and the Media." In *The Conservative Party Since 1900*, edited by Anthony Seldon and Stuart Ball, 547–77. Oxford: Oxford University Press, 1994.

Delaney, Sam. *Mad Men & Bad Men: What Happened When British Politics Met Advertising*. London: Faber & Faber, 2015.

Dickason, Renée and Xavier Cervantes, eds. *La Propagande au Royaume-Uni, de la Renaissance à l'Internet*. Paris: Ellipses, 2002.

Dickason, Renée, and Karine Rivière – De Franco, eds. *Image et Communication Politique. La Grande-Bretagne depuis 1980*. Paris: L'Harmattan, 2007.

Negrine, Ralph. "Professionalisation in the British Electoral and Political Context". In *Professionalisation of Political Communication. Changing Media, Changing Europe*, edited by Ralph Negrine et al. Vol. 3, 547–77. Bristol – Chicago: Intellect, 2007.

Rivière – De Franco, Karine. *La Communication électorale en Grande-Bretagne. De M. Thatcher à T. Blair*. Paris: L'Harmattan, 2008.

Schama, Simon. *The Face of Britain. The Nation through Its Portraits*. New York: Oxford University Press, 2016.

Tyler, Rodney. *Campaign! The Selling of the Prime Minister*. London: Grafton Books, 1987.

Vasta, Nicoletta. *Rallying Voters: New Labour's Verbal-Visual Strategies*. Padua: CEDAM, 2001.

Webster, Wendy. *Not a Man to Match Her. The Marketing of a Prime Minister*. London: The Women's Press, 1990.

Welsh, David. *Persuading the People. British Propaganda in World War II*. London: The British Library, 2016.

Wring, Dominic. *The Politics of Marketing the Labour Party*. Basingstoke, Hampshire – New York: Palgrave Macmillan, 2005.

4 The Dawn of Political Portraiture in Italy

Maurizio Ridolfi

The Beginnings

The monarchy was the first political institution in united Italy to use the portrait as a way of communicating with the general public. The House of Savoy had a well-developed publicity machine, which was officially established in 1861 when Victor Emmanuel II became the ruler of the country. The royal court actively encouraged the illustrated press and postcard manufacturers to reproduce the king's effigy.[1] His portrait was also featured on stamps, which, in the words of Federico Zeri, became "the most compact and concise vehicle of visual propaganda – almost a poster reduced to its smallest dimensions, through which a wealth of social and political messages were expressed with great clarity".[2] By their very nature – stamps are meant to "travel" – these images were widely disseminated, both in Italy and abroad. Victor Emmanuel II's successors were also to use stamps to promote themselves, taking full advantage of the latest printing technologies. The effigy of Umberto I, who ruled from 1878 to 1900, was reproduced photographically and that of Victor Emmanuel III, whose reign spanned the period 1900 to 1946, often featured in color.[3]

The Late Nineteenth Century

The end of the nineteenth century saw the rise of two main types of political movements in Italy: the democratic republican ones, supported by the middle classes, and the parties of an anarcho-socialist tradition. The political events of the time and the parties' strongly felt need to stress their identity influenced the nature of electoral propaganda. The Republican supporters of Giuseppe Mazzini (1805–1872), one of the founding fathers of a united Italy, had been using posters since the 1870s.[4] Those they produced for election campaigns were picture-less, but conceived with care to attract the eye of the beholder: texts were printed in black against a grey background

1 For a useful survey of the postcard production, see Domenico Sellitti and Alfredo Turi, *Savoia. Iconografia tra Ottocento e Novecento. Storia della Famiglia Reale attraverso cartoline d'epoca* (Taranto: Edit, 2002).
2 Federico Zeri, *Francobolli italiani* (Milan: Skira, 2006), 10.
3 For the full range of stamps reproducing the effigy of post-Unification monarchs, see www.ibolli.it, *sub vocem* "Vittorio Emanuele II", "Umberto I" and "Vittorio Emanuele III". Last accessed on June 2, 2019.
4 See Maurizio Ridolfi, *Dalla setta al partito. Il "caso" dei repubblicani cesenati dagli anni risorgimentali alla crisi di fine secolo* (Rimini: Maggioli, 1988), 257–77.

and were thoughtfully laid-out. The posters they realized for commemorative pur-
poses featured portraits. They paid homage especially to Mazzini[5] and Giuseppe
Garibaldi (1807–1882) (Figure 4.1), but some posters also honored the "apostles"
of the Democratic and Socialist movements (e.g. Carlo Cattaneo, Enrico Ferri, Anna
Kuliscioff, Carlo Pisacane and Carlo Prampolini). In the mid-1880s leaflets and small
posters printed in color began to appear to celebrate "Republican martyrs". A good
example is the leaflet produced by a Republican workers' organization in Cesena in
1886 that featured Pietro Barsanti, a young soldier who was executed for sedition in
1870 by the government of Prime Minister Giovanni Lanza. Its use of dark red color
and a text glorifying his sacrifice expressed the frustrated ambitions of the Republicans
who yearned for a democratic government.[6]

Illustrated posters were disseminated in the late nineteenth century via the Sunday
edition of *Avanti!*, the Socialist Party daily,[7] and the satirical magazine *L'Asino*; they
were intended to be displayed in party sections and other meeting places[8]. The post-
ers, which usually celebrated May Day[9] and were mostly printed in black and white,[10]
did not feature the effigy of specific personalities, but figures representing various
labor categories. In the same vein, a poster of 1896, designed by Ottavio Rotella
to advertise *Avanti!*, depicted a steel worker – a muscular figure who looked like a
modern-day Prometheus. The portrait of an identifiable personality first appeared on
socialist printed propaganda in 1895: Nicola Barbato, who had been an activist of the
Fasci siciliani dei lavoratori (Sicilian Workers' League), a movement of democratic
and socialist inspiration, featured photographically on a leaflet that was printed to
promote his candidature to the Chamber of Deputies.[11]

The Early Twentieth Century

In the last years of the nineteenth century, printed propaganda became more creative
and its circulation increased. The greater sophistication was the result of technical
advances (the use of linotype, monotype, screen printing and rotogravure). Posters,
newspapers, magazines, postcards and membership cards were increasingly illustrated,
often in color.[12] In an age characterized by a high level of illiteracy, images were an

5 Dino Mengozzi, *La morte e l'immortale. La morte laica da Garibaldi a Costa* (Manduria-Bari-Rome: Lacaita, 2001).

6 Ibid., 270 for a reproduction of the leaflet.

7 Paolo Bolpagni, *L'arte nell"Avanti della domenica, 1903–1907* (Milan: Mazzotta, 2008).

8 Giorgio Candeloro, *L'Asino di Podrecca e Galantara* (Milan: Feltrinelli, 1971). See also Guido D. Neri, *Galantara. Il morso dell'Asino* (Milan: Feltrinelli, 1980) for the artistic techniques employed by this pioneering socialist publication founded in 1892.

9 Giovanna Ginex, "Realismo, simboli e allegorie per il Primo Maggio; le fonti visive," in *Storie e Immagini del 1° Maggio. Problemi della storiografia italiana ed internazionale*, ed., Gianni C. Donno (Manduria-Bari-Rome: Lacaita, 1990), 139–49.

10 Andrea Ragusa, *Il manifesto elettorale. Mezzo secolo di propaganda dai fondi Schiavi di Forlì* (Manduria-Bari- Rome: Lacaita, 2004), esp. 29–34.

11 Ibid., 129, for a reproduction of the leaflet.

12 For a detailed study of color symbolism in late nineteenth century and early twentieth century Italy, see Maurizio Ridolfi, *La politica dei colori. Emozioni e passioni nella storia d'Italia dal Risorgimento al ventennio fascista* (Florence: Le Monnier, 2014), 87ff.

effective way of addressing wider sections of the population.[13] The socialists made a considerable use of these materials to spread their ideas,[14] privileging postcards, which could be produced in bulk at limited costs.[15] The modernization of the postal services and the improved transportation system facilitated their circulation. The postcards often reproduced the effigy of political leaders, in drawn or photographic form. We owe especially to socialist and democratic artists and cartoonists the development of a rich political iconography in Italy.[16]

A particularly interesting example of portrait-based propaganda is the so-called *Album Costa*, preserved in the civic library of Imola (Emilia-Romagna). It consists of a series of postcards relating to Andrea Costa – one of the founders of the Italian Socialist Party – which were collected by a group of activists after his death.[17] As Giovanna Ginex has remarked, the *Album* is an invaluable illustration of socialist activism, a long-lasting memorial to working-class struggle.[18] The first postcard of the series, produced and distributed by *L'Asino*, commemorates the Milan riots of 1898 and the repression that ensued. It depicts some of the illustrious detainees: the socialist Filippo Turati, the democrats Luigi De Andreis and Carlo Ramussi, and the Catholic priest Davide Albertario. The postcard acted as a powerful political instrument, raising awareness and urging the public to demand a general amnesty for the political prisoners (Figure 4.2).[19]

In 1902, *L'Asino* produced a series of postcards that featured the photographic portraits of all the Socialist Members of Parliament. Costa was among them (Figure 4.3).[20] The practice of printing postcards that depicted politicians, singly or in groups, was imitated by other newspapers, political associations and local publishing houses with socialist sympathies. Postcards were issued for commemorative purposes, as well as on the occasion of major political events. When shown in groups, the figures were thoughtfully arranged, usually on two lines or in a pyramidal shape, and were accompanied by symbolic motifs (rosettes, laborers' tools, etc.) and brief texts (slogans and the titles of newspapers) to help identify their political allegiance.

13 Giovanna Ginex, "La comunicazione visiva dell'associazionismo e del movimento operaio e sindacale in Italia (1848–1957)," in *Rossa. Immagine e comunicazione del lavoro 1848–2006*, ed. Luigi Martini (Milan: Skira-Ediesse, 2007), vol. 1, 59–138 for an overview covering an extended period.

14 Dino Mengozzi, "Laicità e sacralizzazione della politica democratica nel "lungo" Ottocento," *Memoria e Ricerca*, 10 (2002): 103–18.

15 Giovanna Ginex, ed., *Cartoline dall'Italia. Il fondo di cartoline fotografiche storiche del "Corriere della Sera"* (Verona: Contrasto Ebs, 2006) for a general bibliography on the subject.

16 Luigi Ganapini and Giovanna Ginex, eds., *Cipputi Communication. Immagini, forme, voci per i lavoratori* (Milan: Mazzotta, 1997).

17 On this document, see esp. Giovanna Ginex, "Sfogliando l'Album Costa. Fotografia e iconografia del socialismo italiano," in *Carte e libri di Andrea Costa*, ed. Paola Mita (Imola: La Mandragola, 2010), 465–85; idem, "Apostoli del socialismo e liberi pensatori: iconografia e monumentalistica celebrativa dei leader," in *L'orizzonte del socialismo. Andrea Costa tra Imola e l'Europa*, ed. Maurizio Ridolfi (Imola: La Mandragola, 2015), 155–92.

18 Ginex, *Sfogliando l'Album Costa*, 467. The postcards are arranged by typologies: Costa's single portraits, group portraits, the monuments to Andrea Costa, caricatures, etc.

19 The portraits are in black and white, while the text is in red.

20 Imola's civic library holds an almost complete set of the postcards.

Costa and other socialist personalities also featured on postcards that were unrelated to the socialist world. Around 1900 the publishers Bossi & Co. marketed an *Album d'Onore delle Famiglie Italiane* (Album of honor of Italian families), which included head-and-shoulders photographic portraits of different categories of professional people, together with detailed biographical notes. One of such series, issued in 1903, was devoted to the "Deputies of the Twenty-First Legislature"[21] and included a portrait of Costa (Figure 4.4) that had been originally featured on a *L'Asino* postcard.

The printed propaganda of the period also represented the founding fathers of international Socialism. A postcard issued in 1905 on the occasion of Labor Day festivities in Altedo, near Bologna, and sold to fund a *casa del popolo* (workers' social center), illustrated the history of Socialism in Romagna allegorically as a tree whose trunk incorporated Marx's portrait, while its main branch was associated with four socialist figures, of whom only Costa is identifiable (Figure 4.5). In another postcard, we find Marx's portrait next to that of the French socialist leader Jean Jaurès. When Jaurès was assassinated in July 1914 he became the subject of a color postcard printed by Rizzoli and distributed by Editrice Avanti.

The Parliamentary Election of 1913

The Italian election of October 26 and November 2, 1913 are a turning point in the history of Italian political activism.[22] The country was riven by social conflict and by the turbulent effects of the war in Libya, which, in an atmosphere of rising nationalism, polarized political opinion. The election were held just after the signing of the Gentiloni Pact,[23] by which the Church allowed Catholics to vote (in 1874 Pope Pius IX had issued a decree known as *Non Expedit* (It is not expedient) that forced them to abstain from the polls because of the Italian State's annexation of Rome in 1870). Thanks to the introduction of an almost universal male suffrage (all men over thirty years of age, regardless of their degree of literacy, could vote)[24] the number of voters increased from just under three million to more than eight million, namely from 8.3 percent to 23.2 percent of the male population. The need to communicate with a larger and more variegated electorate led to major changes in election campaigning at the eve of the First World War.

The use of the candidates' effigies became current. Political communication adopted the approaches that were being pursued by commercial advertising. The photographic portraits of aspiring Members of Parliament appeared on large posters that were affixed on the walls of party headquarters and in places where people congregated. If they so wished, candidates could also reproduce their effigies on the ballot papers, inscribed in small circular, oval or square shapes. To increase their

21 Ginex, *Sfogliando l'Album Costa*, 469.

22 See Pier Luigi Ballini, *Le elezioni nella storia d'Italia dall'Unità al fascismo. Profilo storico-statistico*, (Bologna: Il Mulino, 1988), 400–1 for a bibliography relating to the preparatory work on the electoral reform.

23 The pact is named after Count Vincenzo Gentiloni, whom Pope Pius X had appointed to head the Unione Elettorale Cattolica Italiana.

24 Women were not given the vote until 1946.

visual impact, the figures were at times framed by a red border, or associated with such motifs as a star or the tricolor. The Socialist candidates who had their photographic portraits printed on the ballot papers included Ivanoe Bonomi, who was to serve as Prime Minister from 1921 to 1922, the economist and revolutionary syndicalist Arturo Labriola, and Benito Mussolini, who stood – unsuccessfully – for the Forlì constituency. Most candidates, however, chose to represent themselves through symbolic motifs (a red carnation, a clenched fist brandishing a hammer, etc.).

The election of the autumn of 1913 and the administrative implementation of their results during the following spring, when major cities, such as Bologna and Milan, were won by the socialists, provide an excellent vantage point from which to understand the changes that were taking place in the domain of political communication. As shown above, images, often in color, played a greater role than ever before. Political debates also became current: they were held in party sections and *case del popolo*, as well as in the main squares of villages and towns. Candidates were able to travel more frequently and quickly to meet their constituents thanks to the improved means of transportation. Cars were used for the first time. Moreover, party propaganda, which had been coordinated by small groups of individuals, became more centralized.

The Socialists re-organized themselves into a system of federations and committees that worked beyond a purely local level to fight election campaigns more effectively. They also established closer links with labor organizations. However, the impact these changes had on the outcome of the election of 1913 appear to have been limited.[25] The most significant change was undoubtedly the use of portraits, although the practice of depicting candidates on ballot papers was not widespread and quickly went out of favor. The ballot papers of the elections of 1919 featured the symbols of the various political groups, rather than portraits, as a result of the introduction of proportional representation, which attributed a pivotal role to political parties, to the detriment of the personality of the candidates. The trend was to be consolidated after the Second World War, when, as a reaction against the cult of Mussolini, for decades all personalization of politics was eschewed.[26]

[Translated by Peter Winch]

25 Maria Serena Piretti, *La Giustizia dei numeri. Il proporzionalismo in Italia (1870–1923)* (Bologna: Il Mulino, 1991), 152ff. On the organization of parties at the beginning of the century, see Harthmuth Ullrich, *La classe politica nella crisi di partecipazione dell'Italia giolittiana. Liberali e radicali alla camera dei deputati (1909–1913)* (Rome: Archivio storico della Camera dei Deputati, 1979), vol. 1, 24–6.

26 See Luciano Cheles, "Prima di Berlusconi. Il ritratto politico nell'Italia repubblicana (1946–1994), in *Il Ritratto e il potere. Immagini della politica in Francia e in Italia nel Novecento*, eds. Luciano Cheles and Alessandro Giacone (Pisa: Pacini, 2017), 99–112.

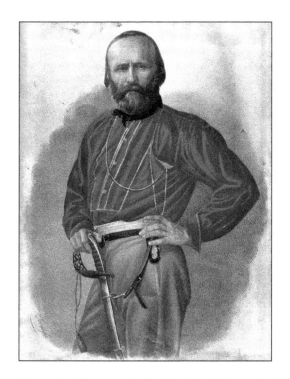

Figure 4.1 Giuseppe Garibaldi. Color lithograph, 1861. (Biblioteca Comunale, Imola)

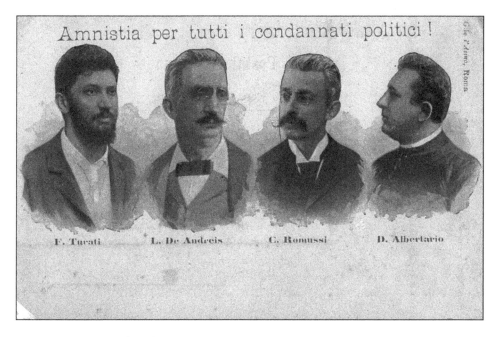

Figure 4.2 "Amnesty for all political prisoners!" Postcard produced and distributed by *L'Asino*, c. 1900. (Biblioteca Comunale, Imola).

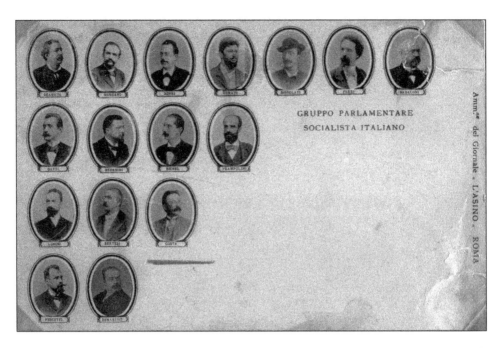

Figure 4.3 Postcard produced by *L'Asino* on behalf of the Socialist Party, 1902, representing the Socialist deputies. (Biblioteca Comunale, Imola).

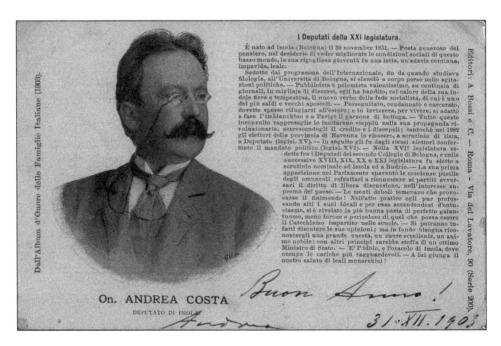

Figure 4.4 Postcard representing the Socialist deputy Andrea Costa, 1903. (Biblioteca Comunale, Imola).

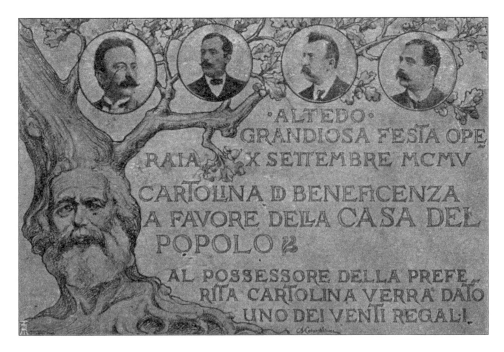

Figure 4.5 Postcard issued on the occasion of a workers fete held in Altedo (Bologna), September 1905, sold in support of a workers' social center. (Biblioteca Comunale, Imola).

Bibliography

Ballini, Pier Luigi. *Le elezioni nella storia d'Italia dall'Unità al fascismo. Profilo storico-statistico*. Bologna: Il Mulino, 1988.

Cheles, Luciano, and Alessandro Giacone, eds. *Il Ritratto e il potere. Immagini della politica in Francia e in Italia nel Novecento*. Pisa: Pacini, 2017.

Ganapini, Luigi, and Giovanna Ginex, eds. *Cipputi Communication. Immagini, forme, voci per i lavoratori*. Milan: Mazzotta, 1997.

Ginex, Giovanna, ed. *Cartoline dall'Italia. Il fondo di cartoline fotografiche storiche del "Corriere della Sera"*. Verona: Contrasto Ebs, 2006.

Martini, Luigi, ed. *Rossa. Immagine e comunicazione del lavoro 1848–2006*. Milan: Skira-Ediesse, 2007.

Mengozzi, Dino. *La morte e l'immortale. La morte laica da Garibaldi a Costa*. Manduria-Bari-Rome: Lacaita, 2001.

Mita, Paola, ed. *Carte e libri di Andrea Costa*. Imola: La Mandragola, 2010.

Neri, Guido D. *Galantara. Il morso dell'Asino*. Milan: Feltrinelli, 1980.

Ragusa, Andrea. *Il manifesto elettorale. Mezzo secolo di propaganda dai fondi Schiavi di Forlì*. Manduria-Bari-Rome: Lacaita, 2004.

Ridolfi, Maurizio. *La politica dei colori. Emozioni e passioni nella storia d'Italia dal Risorgimento al ventennio fascista*. Florence: Le Monnier, 2014.

Zeri, Federico. *Francobolli italiani*. Milan: Skira, 2006.

5 Manufacturing Charisma

Benito Mussolini's Photographic Portraits

Alessandra Antola Swan

Benito Mussolini (1883–1945), who ruled Italy from October 1922 to July 1943, and, after a brief imprisonment, the so-called Repubblica Sociale Italiana (the German-controlled state in Northern Italy) from September 1943 until the downfall of the Nazi-fascist regime in April 1945,[1] was the first modern dictator to be promoted systematically using sophisticated techniques. Although various media were used, photographs played a particularly important role in his propaganda. These depicted him in both official and informal poses, and in public as well as private spaces, so as to reach a diverse audience and make everyone feel that he was part of their world. Mussolini's photographs, accessible, transferable, portable and easily mass-produced, were the principal vehicle for the creation of his cult. His face, enhanced through composition and post-production, was "iconic" in the sense that, like religious icons, it elicited reverence and devotion, and also being all-pervasive, had become so familiar as to be instantly recognizable, like a trademark.[2]

The propagandists and supporters of the regime often dwelled on the facial features of the *Duce*, as Mussolini was generally referred to,[3] seeing in them a reflection of his personal qualities and the values he believed in. The illustrator Sandro Biazzi remarked in an enthusiastic account of the dictator's best known portraits, published in the periodical *L'industria della stampa* in 1941: "It is enough to say 'DUCE' and his unmistakable profile, virile, rugged, iron-willed, Roman, with an unforgettable stare, is conjured up."[4]

The fascist regime disseminated its propaganda at a time when the visual was becoming increasingly central to the construction of social and political life. Visibility

1 Mussolini was deposed in July 1943. Imprisoned, he was rescued by a Nazi commando in September 1943. The Republic was established the following month at Hitler's suggestion. For a recent biography in English, see Richard J. B. Bosworth *Mussolini* (London: Bloomsbury, 2014 [2nd ed.]).

2 On Italian iconic imagery, see *Iconic Images in Modern Italy: Politics, Culture and Society*, eds. Martina Caruso and Alessandra Antola Swan, special issue of *Modern Italy*, 21, 4 (2016); on the concept of iconic, see David Forgacs's article "Gramsci undisabled", 346, in this issue.

3 The term derived from the Latin word *Dux*, meaning "leader". On this title, see Guido Melis, *La macchina imperfetta. Immagine e realtà dello Stato fascista* (Bologna: Il Mulino, 2018).

4 Sandro Biazzi, "Ritratti 'grafici' del Duce," *L'industria della stampa*, 3, 4 (1941), 111.

was gaining importance as a parameter of social redefinition.[5] Through stereotyping, the developing mass culture produced symbolic, spectacular and sometimes self-referential messages.[6] The new elite were those who stood out, those whose images were able to influence a public attracted by the clamors of modern life.[7]

Early Photographic Portraits

Mussolini was conscious of the power of images and their propaganda potential since the Socialist beginnings of his political career.[8] His photographic portraits appeared occasionally in *La Lotta di Classe*, a weekly he founded in 1910 and directed until 1912,[9] and on three postcards where his face appears through the front page of *Avanti!*, whose general editor he was until expelled in 1914 by the Socialist Party, following his support for Italy's intervention in the First World War. The postcards reproduced the front pages of the Socialist Party newspaper torn in the middle to reveal, and exalt (the tear acts as a halo), the smiling figure of Mussolini dressed in a suit (Figure 5.1).[10]

After 1925 when he effectively became a fascist dictator, portraits of Mussolini aged fourteen were disseminated representing him with crossed arms, and a defiant, determined expression, implying that since a tender age he was rebellious and showed a predisposition to lead. The photograph was reproduced as a postcard (Figure 5.2), in books aimed at a young readership, such as Edoardo Bedeschi's *La giovinezza del Duce*,[11] and in the Room T of the *Mostra della Rivoluzione Fascista* in 1933.[12]

One of the earliest photographic portraits of Mussolini as a fascist was taken in 1921 by the photographer G. Caminada. It shows his brightly lit face emerging from a dark background, focusing on his strong jaw, fleshy lips and piercing eyes presenting

5 Earl A. Powell, "Director's Foreword," in Matthew S. Witkovsky and Peter Demetz, eds., *Foto. Modernity in Central Europe, 1918–1945* (New York: Thames & Hudson, 2007), xxiii.

6 Alberto Abruzzese e Davide Borrelli, *L'industria culturale. Tracce e immagini di un privilegio* (Rome: Carocci, 2000), 177.

7 Stephen Gundle and Reka C. V. Buckley, "Flash Trash: Gianni Versace and the theory and practice of glamour," in *Fashion Culture*, eds. Stella Bruzzi and Pamela Church Gibson (London: Routledge, 2000), 335.

8 On Mussolini the Socialist, see Paolo Cortesi, *Quando Mussolini non era fascista. Dal socialismo rivoluzionario alla svolta autoritaria: storia della formazione politica di un dittatore* (Rome: Newton Compton, 2008); and Emilio Gentile, *Mussolini 1883–1915: Triumph and Transformation of a Revolutionary Socialist* (New York: Palgrave Macmillan, 2016).

9 See for instance *La Lotta di Classe*, January 12, 1912.

10 Enrico Sturani notes that this graphic effect on postcards promoting a newspaper was commonplace at the time, except that the tear in the middle of the front page usually afforded a glimpse of a landscape or of a political symbol, rather than the effigy of the general editor. See *Le cartoline per il Duce* (Turin: Edizioni del Capricorno, 2003), 183.

11 Edoardo Bedeschi, *La giovinezza del Duce: libro per la gioventù italiana* (Turin: Società Editrice Internazionale, 1939).

12 The exhibition was mounted in 1933 to celebrate what were then considered achievements of the first fascist decade. See the catalog *Mostra della Rivoluzione Fascista*, eds. Dino Alfieri and Luigi Freddi (Rome: Partito Nazionale Fascista, 1933).

him as a charismatic, Nietzschean character (Figure 5.3). Mussolini seemingly favored this image as a photographic enlargement of it hung above his desk at Milan's new headquarters of *Il Popolo d'Italia*, the daily he founded in 1914 to give voice to his interventionist stance. The replica of this office, which was the highlight of Room T of the commemorative exhibition of 1933, featured this portrait among the accoutrements and wall decorations (Figure 5.4).[13] The photograph acted as a prototype for other portraits of Mussolini.[14] A similar use of dramatic lighting effects can be found, for instance, in the giant portrait that was set up and illuminated at night in front of the Duomo of Milan during the eleventh anniversary of the Fascist revolution in 1933 (Figure 5.5).[15]

A New Media Landscape

As a journalist, Mussolini realized that the press could contribute to the construction and diffusion of his cult, and therefore needed to be controlled. As early as 1922 an *Ufficio Stampa della Presidenza del Consiglio*, renamed *Ufficio Stampa del Capo del Governo* in 1925 (both translate as Head of Government's Press Office), was established to disseminate government bulletins. It was used to combat "anti-fascist propaganda" and provide the press with an official version of events. The Agenzia Stefani, a news agency which had been in existence since 1853, also became a government tool for media control when Mussolini placed Manlio Morgagni, a friend who had supported his interventionist campaign, at its head in 1924. The creation and management of visual depictions of Mussolini were the task of the *Istituto Luce* ("Luce", "light" in Italian, was also the acronym of *L'Unione Cinematografica Educativa*, The Educational Cinema Union), a private company founded in 1924, which the government turned into a state agency in 1925. Although initially *Istituto Luce* realized newsreels that were shown in all cinemas, the Luce Photographic Department was also established in 1927 with the task of producing and distributing images of Mussolini as well as other propaganda material. In 1934 the *Sottosegretariato per la Stampa e la Propaganda* (Undersecretariat for Press and Propaganda), which became a ministry the following year led by Galeazzo Ciano, Mussolini's son-in-law, was set up on the model of Joseph Goebbels's *Propagandaministerium*. A few years later in 1937 it was given the designation *Ministero della Cultura Popolare* (Ministry of Popular Culture), commonly referred to as *MinCulPop*.

All photographs depicting the *Duce* were carefully vetted before they were sent to the press. They were censored if it was felt that they did not meet certain aesthetic

13 *Mostra della Rivoluzione Fascista*, 223–5.

14 Sturani, *Le cartoline*, 116. Caminada's portrait of Mussolini may also have inspired Hitler's strikingly stark election poster of 1932 which depicted his face set against a black background. See Claudia Schmölders, *Hitler's Face: The Biography of an Image* (Philadelphia: University of Pennsylvania Press, 2006), 72–3.

15 The image was reproduced on a postcard and in the press. See, for instance, the popular weekly *La Domenica del Corriere*, November 5, 1933, 3.

criteria or if they did not convey a dignified image of Mussolini.[16] Communiqués known as *veline* were issued to provide information on what was appropriate or ill-appropriate in terms of both content and style. The instructions varied from day to day, and ranged from "Images should be sharp", to "Don't photograph the *Duce* near monks", or "Publish photographs of the *Duce* with the crowd, rather than alone".[17] However, to date, no single official document listing the rules the press should abide by has emerged, and these instructions were communicated on an *ad hoc* basis.[18]

In the 1930s a better distribution system and improved printing techniques led to an increased circulation of illustrated periodicals.[19] Realizing that magazines, such as *L'Illustrazione Italiana,* widely subscribed to by the middle classes,[20] *Il Corriere dei Piccoli,* aimed at children, *La Gazzetta dello Sport* and *La Domenica del Corriere,* which sold over a million copies per week throughout the fascist period,[21] could act as effective vehicles of propaganda, the regime sought to provide them with photographs that suited the different readerships. These images showed Mussolini in close contact with ordinary people, harvesting, inaugurating factories, piloting a plane and similar such activities.

16 Bruno Maida, "La Direzione generale della stampa italiana," in *La stampa del regime 1932–1943. Le veline del Minculpop per orientare l'informazione,* ed. Nicola Tranfaglia (Milan: Bompiani, 2005), 43.

17 Angelo Schwarz, "Fotografia del Duce possibilmente con l'elmetto," in *L'Italia s'è desta! Propaganda politica e mezzi di comunicazione di massa tra fascismo e democrazia,* ed. Adolfo Mignemi (Turin: Gruppo Abele, 1995), 63.

18 On fascism's control of the press, see Giancarlo Ottaviani, *Le veline del MinCulPop. Aspetti della propaganda fascista* (Milan: Todariana, 1999); Romano Canosa, *La voce del Duce. L'agenzia Stefani: l'arma segreta di Mussolini* (Milan: Mondadori, 2002); Nicola Tranfaglia, *La stampa del regime 1932–1943. Le veline del Minculpop per orientare l'informazione* (Milan: Bompiani, 2005); Mauro Forno, *La stampa del Ventennio. Strutture e trasformazioni nello stato totalitario* (Soveria Mannelli: Rubettino, 2005); Albertina Vittoria, "Fascist Censorship and Non-Fascist Literary Circles," in *Culture, Censorship and State in Twentieth-Century Italy,* eds. Guido Bonsaver and Robert Gordon (London: Legenda, 2005), 54–63; Romain H. Rainero, *Propaganda e ordini di stampa. Da Badoglio alla Repubblica Sociale Italiana* (Milan: FrancoAngeli, 2007). On the management of images, see Mimmo Franzinelli and Emanuele Valerio Marino, *Il Duce proibito. Le fotografie di Mussolini che gli italiani non hanno mai visto* (Milan: Mondadori, 2003); Ernesto G. Laura, *Le stagioni dell'aquila. Storia dell'Istituto Luce* (Rome: Istituto Luce, 2004); Gabriele D'Autilia, "Il fascismo senza passione. L'Istituto Luce" and Sergio Luzzatto, "'Niente tubi sulla testa'. L'autoritratto del fascismo," both in *L'Italia del Novecento. Le fotografie e la storia. I. Il potere da Giolitti a Mussolini (1900–1945),* eds. Giovanni De Luna, Gabriele D'Autilia and Luca Criscenti (Turin: Einaudi, 2005), 90–114 and 116–201, respectively.

19 David Forgacs and Stephen Gundle, *Mass Culture and Italian Society from Fascism to the Cold War* (Bloomington: Indiana University Press, 2007), 97–112.

20 Like other illustrated magazines, it was probably passed around from hand to hand, Ibid., 37.

21 The periodical's high points of weekly sales occurred in 1924 (1,281,694 copies), in 1936 (1,451,080 copies) and in 1942 (1,697,495 copies). Archivio Storico *Corriere della Sera,* Diffusione e Vendita, f.21, "Tirature *Domenica del Corriere*".

The *Duce*'s Photographers

Unlike Hitler, whose pictorial propaganda was produced by a single "court photographer", Heinrich Hoffmann,[22] Mussolini posed for numerous photographers. While in the early years of the regime he turned regularly to some independent studio photographers, such as Amerigo Petitti, who signed the pictures they produced, from 1928 he was mostly portrayed by *Istituto Luce* photographers who were not credited, remaining anonymous. The absence of a signature favored concentration on the potency of the subject's magnetic personality rather than the photographers' technique, although Mussolini's photogenic charisma was enhanced by their work.

Luce photographs tended to be straightforwardly illustrative, rather than polished and emotionally charged. They showed the *Duce* visiting factories, inaugurating public buildings, speaking to ordinary people harvesting, and so on.[23] Studio photographers, such as Ghitta Carell and Eva Barrett, who were much favored by the aristocracy and high society, on the other hand dramatized Mussolini's appearance through staging, doctoring and other photographic techniques, often producing a film-star effect. The portraits of Mussolini taken by Ghitta Carell (1899–1972)[24] in the 1930s are a good illustration of this type of photograph.[25] One picture taken in April 1937 and reproduced in various magazines and books (e.g. the biography of Mussolini by Giorgio Pini in 1939) places considerable emphasis on Mussolini's intense somewhat threatening gaze, where the impression of back lighting functions as an aura giving him Hollywood-like glamour (Figure 5.6).

Mussolini was also photographed by independent photo-reporters including the pioneering Adolfo Porry Pastorel and Vincenzo Carrese who respectively founded the photo-agencies VEDO and Publifoto. Most photographers supplied their pictures on a regular basis to these or other photographic agencies, to which newspapers turned when they wanted to illustrate specific events. Once purchased, images became newspaper property and could be cropped, retouched and sequenced by picture editors without the photographers' prior consent.[26] However, in general, photographers knew what sort of portraits the dictator liked and would adjust their style to accommodate.

Throughout the fascist period Mussolini approved various types of representation, such as speaking to an acclaiming crowd from the balcony of a public building or from

22 Rudolf Herz, *Hoffmann & Hitler. Fotografie als Medium des Führer-Mythos* (Munich: Fotomuseum, 1994); Alain Sayag, Johan Chapoutot and Denis Peschanski, *Un Dictateur en images. Photographies de Heinrich Hoffmann* (Paris: Hazan, 2018).

23 For samples of the *Luce* photographs, see Sergio Luzzatto, *L'immagine del Duce. Mussolini nelle fotografie dell'Istituto Luce* (Rome: Editori Riuniti, 2001).

24 Roberto Dulio describes Carell as a photographer "*mondana*" or a photographer known for her society portraits, in *Un ritratto mondano. Fotografie di Ghitta Carell* (Monza: Johan & Levi, 2013), 81.

25 On this prominent photographer, see Eva Nodin, "The Illusions of Ghitta Carell. *Women Photographers* in Italy," in *Women Photographers – European Experience*, eds. Lena Johannesson, Gunilla Knape and Eva Dahlman (Gothenburg: Acta Universitatis Gothoburgensis, 2003), 92–121; R. Dulio, *Un ritratto mondano. Fotografie di Ghitta Carell* (Monza: Johan & Levi, 2013).

26 Mary Warner Marien, *Photography: A Cultural History* (London: Laurence King Publishing, 2010), 167.

a provisional structure that sometimes incorporated the design of a stylized eagle,[27] an iconography meant to attest his immense and enduring popularity.[28] He was also frequently depicted practicing a range of physical activities: fencing, swimming, football, horse-riding. Sport, a sign of his physical vigor, was a key element in the construction of his charisma. Regime propaganda especially emphasized Mussolini's predilection for horse-riding, and photographs that represented him on horseback in uniform were disseminated to evoke the equestrian monuments of the Roman Caesars and of Renaissance condottieri.[29] Mussolini's depictions as action man at times revealed his unclothed body. A much-reproduced picture form 1937 taken at Terminillo, a winter resort in the Apennines, shows him stripped to the waist on the snow holding ski-sticks. The *Duce* also ostentated his naked torso in photos showing him harvesting to promote the so-called *Battaglia del grano* (Battle for grain), a program aimed at achieving self-sufficiency in grain production (Figure 5.7). Functioning as metaphors for firm and dynamic leadership,[30] while celebrating Mussolini's supposed talents, many photographs also depicted him driving sports cars, riding motorbikes, and piloting airplanes.[31]

Portraiture at the time evolved in line with political events. In the late 1930s, when Italy's foreign policy became more aggressive and militarization was intensified, Mussolini was more often than not photographed in uniform,[32] and in the last years of fascism, he was also portrayed wearing a helmet.[33]

Mussolini as a Commodity

We do not know the extent to which commissioned pictures of Mussolini, subsequently sold, were a lucrative source of revenue for the Italian State. A document dated 1937 preserved in the *Luce* archives in Rome mentions that portraits of the *Duce* were available for sale to both government officials and members of the general

27 This bird of prey was especially dear to fascism because it evoked *Romanitas*: it was the attribute of Jupiter and the imperial symbol of Julius Cesar. The eagle clutching the fasces was to feature on the white field of the tricolor of the Italian Social Republic.

28 Nicola Tranfaglia, "Il capo e le masse. L'esempio di Mussolini," in idem, *Labirinto italiano. Il fascismo, l'antifascismo, gli storici* (Florence: La Nuova Italia, 1989), 51; Didier Musiedlack, "Le Duce, le balcon et la foule," in *Rome, 1920–1945. Le modèle fasciste, son Duce, sa mythologie*, ed. François Liffran (Paris: Autrement, 1991), 133–8.

29 Luciano Cheles, "L'animal dans la propagande figurative italienne du fascisme à nos jours," in *L'animal en politique*, eds. Paul Bacot et al. (Paris: l'Harmattan, 2003), 246–52.

30 See Sturani, *Le cartoline* for examples of the different typologies discussed in this paragraph, and the *Luce* brochure (*Bollettino Fotografico*) commented on in this chapter (Figures 5.8–5.9).

31 On representations of the *Duce* as pilot and, more generally, on the fascist cult of flight, see Gerald Silk, "'Il Primo Pilota.' Mussolini, Fascist Aeronautical Symbolism, and Imperial Rome," in *Donatello Among the Blackshirts. History and Modernity in the Visual Culture of Fascist Italy*, eds. Claudia Lazzaro and Roger J. Crum (Ithaca, NY: Cornell University Press, 2005), 67–8, 254–7; and Eric Lehmann, *Le ali del potere. La propaganda aeronautica nell'Italia fascista* (Turin: UTET, 2010).

32 Antonella Mauri, "La 'Domenica del Corriere' e la rappresentazione dei Capi di Stato (1914–1943)," in *Il ritratto e il potere. Immagini della politica in Francia e in Italia nel Novecento*, eds. Luciano Cheles and Alessandro Giacone (Pisa: Pacini, 2017), 71.

33 Schwarz, "Fotografia del Duce," 74.

public.[34] This is confirmed by another document that has recently emerged, a *Luce* brochure (*Bollettino Fotografico*), printed on thick paper, slightly smaller than A3, folded in half and dated January 14, 1942, which reproduced portraits of Mussolini available for sale with the indication of their prices (Figures 5.8–5.9). This is of particular interest because out of the innumerable images produced by the *Luce* Institute, it tells us which were favored by the regime at the time. Mussolini appears in this document in various guises: meeting ordinary people, mounted on horseback, riding a motorbike, saluting Roman-style, kissing a baby, among others, and typical for the date in nearly all photographs he dons a uniform.[35]

The dictator's image was also commercialized by private companies, and as well as on postcards, he featured in biographies,[36] on calendars, posters and in both exercise and children's books.[37] His portrait also appeared alongside a number of commercial advertisements.[38] These artefacts acted as "product placements", a "selling device" with Mussolini as a "profitable subject".[39] Permission had to be sought from the authorities before his effigy could be used for commercial ends,[40] although, unlike Hitler, who became very wealthy thanks to the royalties he earned for the use of the photographs taken by Heinrich Hoffmann,[41] Mussolini does not appear to have benefited personally in monetary terms from the exploitation of his image.

The *Duce*'s distinctive facial traits, on which the propaganda machine of the regime invested so heavily, were bound to attract the stings of caricaturists. In the early stages of fascism, the hugely popular satirical magazines *L'Asino* and *Il Becco Giallo* (the latter sold up to 450,000 copies weekly) fiercely attacked Mussolini. When political opposition was suppressed in 1926, *L'Asino* ceased publication, while *Il Becco Giallo* continued to be produced, albeit in France where it had sought refuge.[42] Artists such as Paolo Garretto, Sergio Tofano (alias Sto), Nino Za and Alvaro Corghi did caricature Mussolini's shiny shaved head, fierce look, frown and protruding jaw in their homeland; however, their satire, being quite good-natured, was not censored.[43] From 1926

34 Archivio di Stato di Forlì - Archivio della famiglia Paulucci di Calboli – Giacomo Barone – Carte relative agli incarichi presso," "*Istituto Luce*," 1925–1940, bb.12.
35 I purchased this document in Italy in 2016 from a dealer specializing in memorabilia.
36 Between 1915 and 1939, 400 biographies of Mussolini were published (a number that gives an idea of the consistent market which existed for this type of publication), despite the fact that the *Duce* was suspicious of the genre, and expressed the wish that no biographies be published before his death. The number of biographies was especially large between 1933 and 1939, when the control of the mass media was especially strong. See Luisa Passerini, *Mussolini immaginario* (Rome-Bari: Laterza, 1991), 154–7.
37 On the literature for children produced during fascism, see Mariella Colin, *I bambini di Mussolini. Letteratura, libri, letture per l'infanzia sotto il fascismo* (Brescia: La Lettura, 2012).
38 Sturani, *Le cartoline*, 182–7; and Stephen Gundle, "Mass Culture and the Cult of Personality," in *The Cult of the Duce. Mussolini and the Italians*, eds. Stephen Gundle, Christopher Duggan and Giuliana Pieri (Manchester – New York: Manchester University Press, 2013), 84–5.
39 Forgacs and Gundle, *Mass Culture*, 216.
40 Gundle, "Mass culture," 85.
41 Stephen Heller, *Iron Fists. Branding the Twentieth-Century Totalitarian State* (London – New York: Phaidon, 2008), 26. The sale of Hitler's photographs on a virtual monopoly basis also made Hoffmann rich. See Schmölders, *Hitler's Face*, 43.
42 Edio Vallini ed., *L'Asino di Podrecca e Galantara* (Milan: Feltrinelli, 1970); Oreste del Buono and Lietta Tornabuoni, eds., *Il Becco Giallo: dinamico di opinione pubblica, 1924–1931* (Milan: Feltrinelli, 1972); and Emanuela Morganti, *Gabriele Galantara: Satira, editoria e grafica (1892–1937)* (Pisa: Pacini, 2019).
43 For some examples of this type of satirical images, see Giorgio Di Genova, ed., *L'uomo della provvidenza. Iconografia del duce 1923–1945* (Bologna: Bora, 1997), 17, 19

to 1945 caricaturists as well as artists could only produce scathing graphic portrayals of the *Duce* clandestinely.[44]

Following Mussolini's removal from power in 1943, and the collapse of the *Repubblica Sociale Italiana* in 1945, the iconoclastic fury which struck all artefacts associated with fascism did not spare the ubiquitous effigies of Mussolini,[45] thus attesting their totemic value.[46] Mussolini's execution by partisans on April 28, 1945, and the ignominious scene that occurred the following day – his corpse was dumped together with those of his lover Clara Petacci and other high-ranking fascists on Milan's Piazzale Loreto, to be subjected to the rage of the crowd, before being hung upside down from the roof of a service station (Figure 5.10)[47] – suggested that Italians would never celebrate him again. Yet, images of Mussolini have continued to circulate in Italy and abroad, widely on the Internet, in historical publications or in various forms for sale. More controversially though, given the Italian constitutional restrictions regarding the political endorsement of fascism, his images have and continue to inform the visual propaganda of the far right.[48]

Conclusion

The propaganda of fascism relied heavily on the portraits of Mussolini to mythologize his public persona. His photographic images were chosen with much care before being made available to the press and commercial organizations. Half-busts and close-ups of the face underwent thorough photographic editing to enhance those features of the *Duce*, the piercing eyes, protruding jaw, the shape of his head, that could evoke strength, determination and sense of leadership. Interestingly his portraits document the iconography of the *Duce* that the regime and its leader wanted the public to see and take away. Mussolini's photographic representation was the result of a selective process which led to an interiorized image of him being formed. While the extent and nature of impact cannot be definitively measured, the communicative role of Mussolini's portraits at the time of original circulation is evident through their continued use, management and censorship by the regime. As political actor, Mussolini was legitimized partially through his portraits appearing in social spaces before an audience who by consuming the image conferred and confirmed the political power of the portrait and therefore,

44 For overviews of satire under fascism, see Luisa Passerini, *Torino operaia e antifascista* (Bari-Rome: Laterza, 1984), 84–113; Stephen Gundle, "Laughter Under Fascism: Humour and Ridicule in Italy, 1922-43," *History Workshop Journal* 79, 1 (2015): 215–32; Sturani, *Le cartoline*, 199–213; and Christopher Duggan et al., *Against Mussolini. Art and the Fall of a Dictator* (London: Estorik Collection Modern Italian Art, 2010), who also deal with the satirical output that followed the collapse of the regime.

45 Stephen Gundle, "The Aftermath of the Mussolini Cult: History, Nostalgia and Popular Culture," in *The Cult of the Duce*, eds. Gundle, Duggan and Pieri, 241–3.

46 Thomas W. J. Mitchell, *What Do Pictures Want? The Lives and Loves of Images* (Chicago: The University of Chicago Press, 2005), 76–106.

47 Sergio Luzzatto, *The Body of the Duce. Mussolini's Corpse and the Fortunes of Italy* (New York: Metropolitan Books, 2005).

48 For a number of examples, see Luciano Cheles, "'Nostalgia dell'Avvenire.' The Propaganda of the Italian Far Right between Tradition and Innovation," in *The Far Right in Western and Eastern Europe*, eds. Luciano Cheles, Ronnie Ferguson and Michalina Vaughan (London; New York: Longman, 1991), 41–90; and idem, "Back to the Future. The Visual Propaganda of Alleanza Nazionale (1994–2009)," *Journal of Modern Italian Studies*, 15 (2010): 232–311.

by association, to Mussolini in person. Although manufactured and composed to maximize charisma and persuade, as portraits of power, images of Mussolini contributed to generating or defining perceptions of the *Duce*'s reality that still resonate with us today.

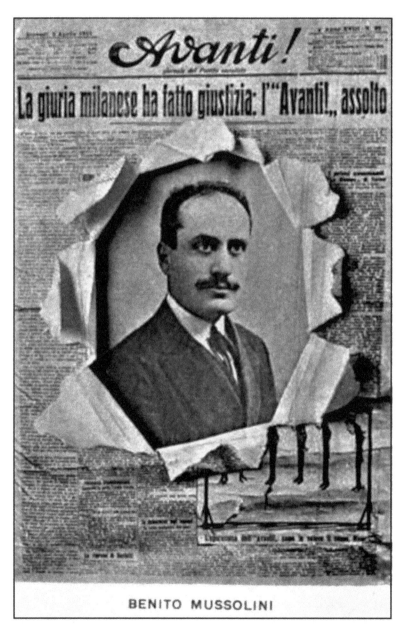

Figure 5.1 Postcard reproducing the front page of the Socialist newspaper *Avanti!*, March 3, 1914, with the portrait of its then editor Mussolini. The photograph originally featured in the January 13, 1912 issue of *La Lotta di Classe*, the newspaper he edited.

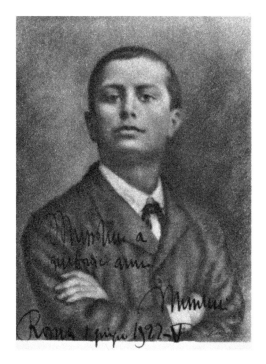

Figure 5.2 Mussolini aged fourteen. Postcard, c. 1923.

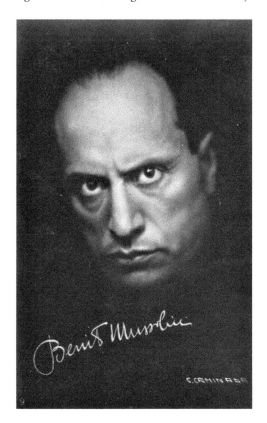

Figure 5.3 Mussolini photographed by G. Caminada. Postcard, 1921.

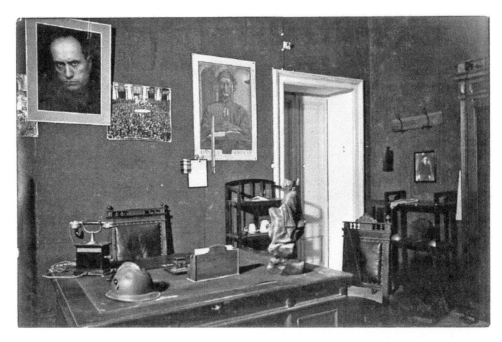

Figure 5.4 Mussolini's office at the Milan headquarters of his daily paper *Il Popolo d'Italia*, as reconstructed for the Mostra della Rivoluzione Fascista, 1933. Caminada's portrait hangs behind his desk. Postcard, 1933.

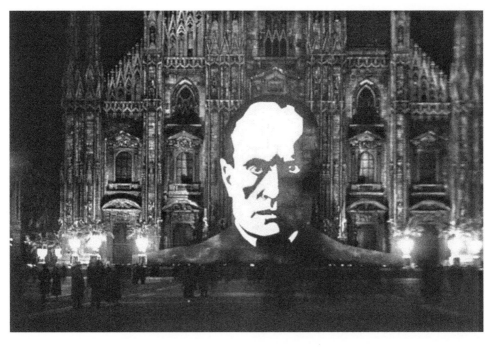

Figure 5.5 Giant portrait of Mussolini placed in front of the Duomo of Milan in 1933. Postcard, 1933.

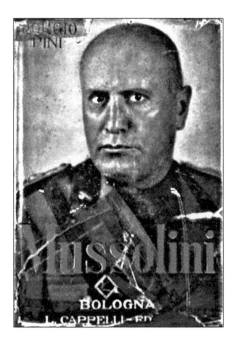

Figure 5.6 Portrait of Mussolini by Ghitta Carell, c. 1937, reproduced on the cover of Giorgio Pini's biography of the *Duce*.

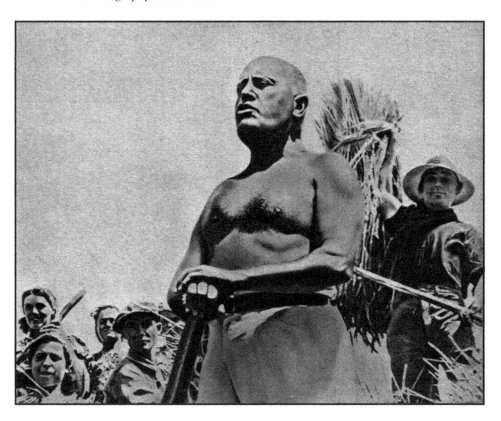

Figure 5.7 Mussolini promoting the "Battle for Grain" in Aprilia (Latium). Postcard, 1938.

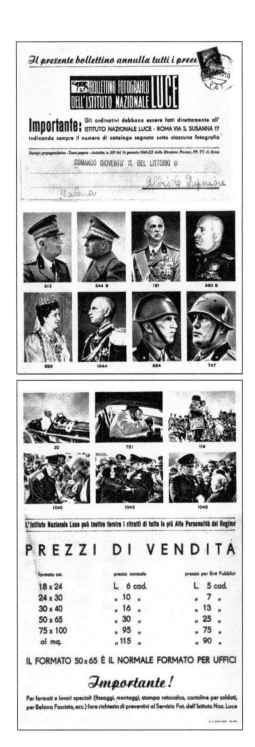

Figures 5.8 Front and back of folding Luce brochure, dated January 14, 1942, featuring the photographic portraits of Mussolini available for sale.

Figures 5.9 Inside picture of the Luce brochure, dated January 14, 1942, featuring the photographic portraits of Mussolini available for sale.

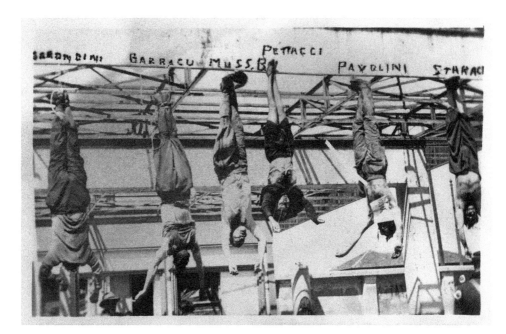

Figure 5.10 The corpses of Mussolini, Clara Petacci and some high-ranking fascists in Piazzale Loreto, Milan, on April 29, 1945. Postcard, one of a series that was privately produced and sold just after the event.

Bibliography

Alinovi, Francesca. "Fotografia." In *Annitrenta. Arte e cultura in Italia*, edited by Nadine Bortolotti, 409–34. Milan: Comune di Milano – Mazzotta, 1982.

Antola Swan, Alessandra. "Photographing Mussolini." In *The Cult of the Duce. Mussolini and the Italians*, edited by Stephen Gundle, Christopher Duggan and Giuliana Pieri, 178–92. Manchester-New York: Manchester University Press, 2013.

Baltzer, Nanni. *Die Fotomontage im Faschistischen Italien. Aspecte der Propaganda under Mussolini*. Berlin-Boston: De Gruyter, 2015.

Bertelli, Carlo, and Giulio Bollati, eds. *Storia d'Italia. Annali 2. L'immagine fotografica, 1845–1945*. Turin: Einaudi, 1979.

Calvino, Italo. "The Dictator's Hats." *Stanford Italian Review* 8, 1–2 (1990): 195–210.

Cannistraro, Philip V. *La fabbrica del consenso. Fascismo e mass media*. Bari-Rome: Laterza, 1975.

D'Autilia, Gabriele. *Storia della fotografia in Italia dal 1839 a oggi*. Torino: Einaudi, 2012.

De Luna, Giovanni, Gabriele D'Autilia and Luca Criscenti, eds. *L'Italia del Novecento. Le fotografie e la storia. I. Il potere da Giolitti a Mussolini (1900–1945)*. Turin: Einaudi, 2005.

Di Genova, Giorgio, ed. *L'uomo della provvidenza. Iconografia del Duce, 1923–1945*. Bologna: Bora, 1997.

Duggan, Christopher, Stephen Gundle and Giuliana Pieri, eds. *The Cult of Mussolini in Twentieth-Century Italy*. Special issue of *Modern Italy* 18, 2 (2013).

Follo, Valentina. "The Power of Images in the Age of Mussolini." PhD Philadelphia: University of Pennsylvania, 2013.

Franzinelli, Mimmo, and Emanuele Valerio Marino. *Il Duce proibito. Le fotografie di Mussolini che gli italiani non hanno mai visto*. Milan: Mondadori, 2003.

Gundle, Stephen, Christopher Duggan, and Giuliana Pieri, eds. *The Cult of the Duce. Mussolini and the Italians*. Manchester - New York: Manchester University Press, 2013.

Lazzaro, Claudia, and Roger J. Crum, eds. *Donatello Among the Blackshirts. History and Modernity in the Visual Culture of Fascist Italy*. Ithaca NY: Cornell University Press, 2005.

Loiperdinge, Martin, Rudolf Herz, and Ulrich Pohlmann, eds. *Führerbilder. Hitler, Mussolini, Roosevelt im fotografie und film*. Munich-Zurich: Piper, 1995.

Luzzatto, Sergio. *L'immagine del Duce. Mussolini nelle fotografie dell'Istituto Luce*. Rome: Editori Riuniti, 2001.

Luzzatto, Sergio. *The Body of the Duce: Mussolini's Corpse and the Fortunes of Italy*. New York: Metropolitan Books, 2005.

Maffei, Terzo, Alessandro Raspagni, and Fausto Sparacino. *Ieri ho visto il Duce. Trilogia dell'iconografia mussoliniana*. 3 vols. Parma: Albertelli, 1999.

Malvano, Laura. *Fascismo e politica dell'immagine*. Turin: Bollati Boringhieri, 1988.

Mignemi, Adolfo. "La costruzione degli strumenti di propaganda." In *Propaganda politica e mezzi di comunicazione di massa tra fascismo e democrazia*, edited by Adolfo Mignemi. Turin: Gruppo Abele, 1995.

Petacco, Arrigo. *Mussolini ritrovato. Storia di una collezione proibita*. Bologna: Minerva, 2009.

Sborgi, Franco. "Ritratti di Mussolini fra identificazione classica e assonanze d'avanguardia." In *Il ritratto storico nel Novecento, 1902–1952*, edited by Francesca Cagianelli, 56–85. Pisa: Pacini, 2003.

Sturani, Enrico. *Le cartoline per il Duce*. Turin: Edizioni del Capricorno, 2003.

Zapponi, Niccolò. *Il fascismo nella caricatura*. Bari – Rome: Laterza, 1981.

Zimmermann, Clemens. "Das Bild Mussolinis. Documentarische Formungen und die Brechungen mediale Wirksamkeit." In *Visual History. Ein Studienbuch*, edited by Gerhard Paul, 225–42. Göttingen: Vandenhoeck & Ruprecht, 2006.

6 A Dictator with a Human Face?

The Portraits of the Austrian Chancellor Engelbert Dollfuss[1]

Lucile Dreidemy

"May his image remain today and forever in the heart of Austria." It was with these words that Kurt Schuschnigg, who took over the chancellorship of Austria in July 1934 following the death of Engelbert Dollfuss, expressed the wish to see his predecessor's memory immortalized. More than eighty years on, Dollfuss, founding father of the Austro-Fascist regime which ruled Austria from 1933 to 1938, remains a controversial historical figure.

Dollfuss came to power in May 1932 as the head of a coalition comprising his Christlichsoziale Partei, CSP (Christian Social Party), the fascist Heimwehr (Home Guard), and the Pan-Germans of the Landbund (Peasants' League). In the autumn of 1932, the government, influenced by the politics established by decree in Germany under the first presidential government of Chancellor Heinrich Brüning (Deutsche Zentrumpartei, DZP, German Centre Party) in 1930, discussed the possibilities of ruling without having to submit to parliamentary oversight. A few months later, in March 1933, it took advantage of a parliamentary crisis to announce the end of the parliamentary system and set about destroying all the pillars of the constitutional First Republic. Independent political parties and trade unions were banned, key civic rights (freedom of expression, and freedom to demonstrate and gather) abolished, censorship and the death sentence were reintroduced and the constitutional court was muzzled. The regime's main enemies were the Sozialdemokratische Arbeiterpartei Österreichs, SDAPÖ (Austrian Social-Democrat Party) and the Kommunistische Partei Österreichs, KPÖ (Austrian Communist Party). After the failure of negotiations with the German Nazis initiated by Dollfuss' government in 1933, which aimed at forming a common anti-Marxist front, tensions and rivalries grew between the two dictatorships and were aggravated by the stepping up of terrorist acts perpetrated by the Nazis in Austria. The increasingly tense political situation came to a head in 1934: in February, an uprising led by the Social Democrats and Communists was violently repressed and nine members of the Schutzbund (Republican protection league, the paramilitary organization of the SDAPÖ) were executed. In July the Nazis attempted a putsch which failed, but during the action at the chancellery Dollfuss was killed. Immediately after his appointment as Chancellor, Kurt Schuschnigg and the propagandists of the regime began to foster a national cult of his predecessor. When the Nazis annexed Austria in 1938,

1 I wish to thank Luciano Cheles, Neil Gwillim and Mike Puleo for their careful editing of this contribution, and the Austrian National Library for generously allowing me to reprint material from their visual archive.

Dollfuss ceased to be officially celebrated, but his memory survives to this day in the form of two competing myths: the heroic Chancellor who resisted Nazism and the dictator.

Relying on a range of visual documents spanning eighty years, this contribution will attempt to show how Dollfuss' portraits have been used, during his term of office and subsequently, to create the myth of the "humble and small dictator" – "small" being used ambiguously to refer to his alleged modesty and to his physical stature (he was only 4'11" tall).

The Portrait as Propaganda Vehicle in 1933–1934

Since the beginning of the dictatorship in 1933, Dollfuss' effigy was greatly exploited for propaganda purposes. It featured on a variety of media ranging from posters to postcards and was intended to create a national plebiscite around the new regime. A 1933 poster inviting Austrians to join the new movement created by the regime, the so-called Vaterländische Front (Patriotic Front), which Dollfuss had just formed on Mussolini's advice and of which he appointed himself *Führer*,[2] provides an illustration of such aspirations (Figure 6.1). Dollfuss' portrait fills two-thirds of the image. Below him are depicted representatives of the country's various professions and social classes holding hands, their faces seemingly expressing admiration for their leader. As well as depicting the corporatist society Dollfuss aspired to, the composition presents him as a unifier of the Austrian people. Above the portrait the slogan reads "Austria above all!" while the text at the bottom of the poster states: "Our Chancellor Dr Dollfuss appeals to you: we urge all those who love Austria and wish to protect it to join the Patriotic Front!" By associating the portrait with the people's representatives, and by making repeated references to Austria, Dollfuss is presented not only as the incarnation of the government, but of the country as a whole.

The strategic use of the leader's portrait to symbolize the transition to autocratic government is also well illustrated by a photograph taken in February 1934 during the uprising. At the very moment when the army was shooting at the workers' houses that sheltered Social-Democratic and Communist fighters, the regime launched an attack on a symbol of Austria's First Republic: in front of the parliament, the statues of the Republic's three founding fathers – Jakob Reumann, Victor Adler, Ferdinand Hanusch, all Social Democrats – were covered up and replaced by a poster of the Patriotic Front displaying the image of the new regime's founding father.[3] Although influenced by fascist and Nazi models, Dollfuss also strived to distinguish himself from them. On September 11, 1933 he delivered a speech at the *Katholikentage* (Catholic Days), a historical festival-like gathering organized by Roman Catholic laity in Vienna, wearing

2 Letter by Dollfuss to Mussolini, July 22, 1933, reproduced in "Der Führer bin ich selbst," *Engelbert Dollfuß Benito Mussolini Briefwechsel*, eds. Wolfgang Maderthaner and Michaela Maier (Vienna: Löcker, 2004), 33.

3 The press reported the event in positive terms. See "Normales Standbild," *Reichspost*, February 15, 1934, 6; "Das Republikdenkmal verhüllt," *Wiener Zeitung*, February 15, 1934, 2. The photograph was also reproduced as a postcard.

the imperial infantryman's uniform he had worn during the First World War.[4] Through this choice of clothes he presented himself as the *Führer* of Austria (Figure 6.2). Like most of the photographs that this contribution will focus on, it was taken by Albert Hilscher (1892–1964), who was one of the main Austrian press photographers at that time.[5] From then on, Dollfuss increasingly appeared in public donning a uniform. However, unlike Mussolini and Hitler, he never assumed an aggressive and intimidating stance, did not try to hide his short stature, and was eager to appear as a modest leader.[6]

A good example of the "ordinary man" image Dollfuss strove to promote is provided by the photograph that featured on the front page of the *Wiener Bilder*, the illustrated supplement of the conservative weekly *Das Interessante Blatt*, on October 4, 1933. It was taken by Hilscher at Dollfuss' house on October 3, 1933, a few hours after the first attempt was made on his life by the young Nazi sympathizer Rudolf Dertil. The Chancellor appears in his pajamas looking toward the camera, with an air of dejection that inspires sympathy, and even commiseration (Figure 6.3). The effect is intensified by the composition of the picture: Dollfuss appears in the picture's middle ground seated, while the tall figure of the journalist, Rudolf Henz, who bends down to speak into the microphone,[7] occupies the foreground. Since the press was strictly controlled by the regime, we can assume that this picture was chosen thoughtfully.[8] The devout Dollfuss presented his survival as a miracle, the sign that he had been assigned the divine mission to lead the fight for Austria's independence. From then on, the themes of Dollfuss' martyrdom and of his heroic resistance to Nazism became central to his propaganda. At the same time his government never ceased to try and persuade the Nazis to create an anti-Marxist front until January 1934.

In the propaganda literature of the time, the motif of the fighter and political martyr was reinforced by recurrent references to the Chancellor's small stature to evoke

4 It was also during this speech that the cross potent, the cross with cross bars at the four ends, was presented for the first time as the regime's new symbol. The choice of this motif reflects the regime's intention to imitate the Nazi aesthetics and at the same time to distinguish itself from the neighboring regime.

5 See Samanta Benito-Sanchez, "Pressefotografen zwischen den Weltkriegen. Eine Biografiensammlung von Pressefotografen, die zwischen 1918 und 1939 in Wien tätig waren" (Master thesis, University of Vienna, 2009), 81–2.

6 Indeed this is how the propaganda literature presented him. For an excellent example see the volume by Attilio R. Bleibtreu, *Der Heldenkanzler. Ein Lied von der Scholle* (Vienna: Jung-Österreich-Verlag, 1934).

7 Henz was one of the leading radio journalists and propagandists for the regime. He is also the author of a song dedicated to the late leader: "Lied der Jugend" (Song of Youth), as illustrated in the song's opening lyrics: "Young people, join our ranks; our late leader is our guide; he gave his blood for Austria; a true German man." These words were inspired by the text of the Nazi *Horst-Wessel-Lied* (The Horst Wessel Song) and the melody by the official anthem of the Italian Fascist party, Giovinezza (Youth). The song became the second, semi-official anthem of the Austro-Fascist regime after Dollfuss' death.

8 On media control under Dollfuss and Schuschnigg, see Elisabeth Spielhofer, "'Der Pressefreiheit würdige Grenzen ziehen …' Theorie und Praxis der Pressepolitik im Österreichischen Ständestaat (1933–1938) unter Berücksichtigung des deutsch-österreichischen Presseabkommens" (Master thesis, University of Vienna, 1992); see also more recently Emmerich Tálos, *Das austrofaschistische Herrschaftssystem Österreich 1933–1938* (Vienna: Lit, 2013), 420–48.

the image of the small but fearless David fighting Goliath.[9] Even satirist Karl Kraus for instance, who had strongly denounced the Christian-Social government's aggressive attitudes toward the Social Democrats in July 1927, started to praise Dollfuss by describing him as "the small savior"[10] or, as the "glittering dwarf" (a reference to Goethe's Faust) who resisted the "German colossus",[11] after Dollfuss' government told the representatives of the Nazi government on visit in Vienna in May 1933 that their presence was "not very welcome".[12]

The Afterlife of Dollfuss' Portrait

Immediately after Dollfuss' death, the government of his successor Kurt Schuschnigg set about building a substantial political liturgy around the "martyred Chancellor" to present him as Austria's "eternal guide". The metaphor of immortality became a key element of the propaganda narrative of the regime and was expressed visually through Dollfuss' ubiquitous portraits. Reproductions of his death mask were used especially for commemorative events, such as the ceremony of remembrance organized on Vienna's Heldenplatz on August 8, 1934 (Figure 6.4). A programme of sculpted portraits, strictly controlled by the party, was launched.[13] Busts and bas-reliefs were displayed in public buildings (governmental offices, offices of the Patriotic Front, administration buildings, town halls, schools), on public squares, as well as in leading private buildings such as the *Österreichische Nationalbank* and churches. They also became a key element in the setting of official ceremonies. For example, on assuming the leadership of the Patriotic Front in May 1936, Schuschnigg delivered his speech next to Dollfuss' bust.[14] A life-size bust of the late chancellor was also placed at the center of the historic hall of the *Bundestag*, overlooking the government members' gallery, when Schuschnigg made his emotional appeal to Austrian patriotism and against Hitler's political pressure on February 24, 1938 (Figure 6.5). Surrounded by a bank of flowers in the colors of the Austrian flag, Dollfuss appeared once again as the immortal embodiment of his country. A similar set-up was adopted a few weeks later, on March 9, 1938, as Schuschnigg officially announced that a referendum for Austria's independence would take place four days later. In the wake of the short referendum campaign, Dollfuss' death mask was reproduced on flyers that simply stated "Auf dass er lebe, stimmen wir mit

9 See Bleibtreu, *Der Heldenkanzler*, 19f.; *Kanzler Dollfuß im Bild. Kalender auf das Jahr 1935* (Innsbruck: Tyrolia, 1934), 28. On the importance of the metaphor of David and Goliath to visualize asymmetric conflicts, see Gerhard Paul, "Das Jahrhundert der Bilder. Die visuelle Geschichte und der Bildkanon des kulturellen Gedächtnisses," in *Das Jahrhundert der Bilder*, ed. Gerhard Paul (Bonn: Bundeszentrale für Politische Bildung, 2008), 14–39: 23.

10 Karl Kraus, *Die Fackel*, Nr. 890–905: "Warum die Fackel nicht erscheint," July 1934, 14.

11 Karl Kraus, *Die Dritte Walpurgisnacht*, ed. Heinrich Fischer (Munich: Kösel, 1967), 291.

12 Ibid. On Kraus' admiration for Dollfuss, see Lucile Dreidemy, "'Ein leuchtend Zwerglein!' Karl Kraus' Bewunderung für Österreichs Diktator Engelbert Dollfuß," in *Pro und Contra Karl Kraus – 1918–2018*, ed. Katharina Prager (Vienna: Böhlau, 2018), 86–99.

13 There were precise directives on how to represent the Chancellor. See Patriotic Front circular no. 48, December 7, 1934, German Federal Archive, Berlin Lichterfelde, BA 901/60433.

14 See Generalsekretariat der Vaterländischen Front: *Kanzler-Schuschnigg-Frontführer*. Propaganda-Broschüre 1936. ÖStA/AVA, Amtliche Nachrichtenstelle, Karton 214: Broschüren und Zeitschriften (Austrian State Archive/ Administrative Archive, Official Intelligence Agency, box 214: brochures and newspapers).

JA" (So that he may live, we vote YES). This referendum was made obsolete by the arrival of German troops on March 12. The *mise-en-scène* of Dollfuss' effigy well-illustrates the concept of the "political survival of dead bodies", which the historian Katherine Verdery has developed in her analysis of the cult of the deceased leaders in former USSR satellite countries.[15]

Kurt Schuschnigg exploited Dollfuss' depictions to reaffirm his legitimacy and off-set his lack of charisma. An official photograph represents him seated at his desk, absorbed in his work, with a portrait of Dollfuss hanging high on the wall behind him to suggest that he is earnestly pursuing the work of his predecessor.[16] The set up clearly evokes the motif of the "immortal leader" as guiding star.[17] Another picture, which was published in the regime-loyal magazine *Wochenpost. Österreichische Illustrierte Hefte* on the first anniversary of Dollfuss' death, shows Schuschnigg posing with his wife and son turned toward the viewer, with a portrait of Dollfuss prominently placed on the piano (Figure 6.6). By playing on the intimacy and informality of the family setting, this *mise-en-scène* hints at the idea of a political lineage and suggests that the Schuschniggs considered Dollfuss as a member of the family. This stage-managed family portrait was an implicit invitation to venerate the founding father of the regime as a father-figure. Dollfuss' effigy was also reproduced on postcards, coins, stamps, calendars and cups – items that depicted him mostly as the nation's humble and zealous public servant or as its soldier.

Although this visual propaganda was not enough to reduce the growing gulf between the population and the regime, it seems to have had some success at the local level. Thus, in the strongly Catholic rural environment from which Dollfuss originated, it was not unusual to find a postcard featuring his portrait in the dining room, often placed next to the crucifix. The cult of the leader had acquired blatant religious connotations: numerous churches and chapels were dedicated to him, and works of art frequently associated him with Christ. For instance, a fresco executed by the academic painter Max Frey (1902–1955) for the church built in Dollfuss' honor in the Hohe Wand region of Lower Austria, depicts him on bended knee at the foot of the Cross next to the apostles.[18]

The interpenetration of the political and the religious reached its height with the likening of Dollfuss to the saint bearing his name. St. Engelbert, a thirteenth-century Cologne bishop, was slain by members of his family following a political rift, but, according to legend, just before dying he had asked God to forgive his killers. Dollfuss deserved to be associated with the martyr because, if the regime's propagandists are to be believed, he had done the same at the time of his death. The political appropriation of St. Engelbert went as far as removing some of his remains from the cathedral

15 Katherine Verdery, *The Political Lives of Dead Bodies, Reburial and Postsocialist Change* (New York: Columbia University Press, 2000).

16 Robert Kriechbaumer, *Vaterländisches Bilderbuch. Propaganda, Selbstinszenierung und Ästhetik der Vaterländischen Front 1933–1938* (Vienna: Böhlau, 2002), 188.

17 This recurrent theme was first used by Schuschnigg at the official announcement of Dollfuss' death: "The Chancellor is dead! But his work lives on, Austria lives on and we ask the world to witness the fact that at this instant we are and will remain the pioneers of German culture, the standard bearers for our country and that Dollfuss' heritage remains the star that will guide us in the future." See "Schuschniggs Rundfunkrede am Abend des 25. Juli 1934," *Reichspost*, July 26, 1934, 4.

18 Lucile Dreidemy, *Der Dollfuß-Mythos. Eine Biographie des Posthumen* (Vienna: Böhlau, 2014), 65.

in Cologne and taking them to Vienna for the inauguration of the parish church of the city's eighteenth district in November 1934 after it was renamed as "Engelbert Dollfuss Memorial Church".[19] The memorial statues and reliefs that featured only the effigy of St. Engelbert survived the waves of destruction that took place after 1938, and again after 1945, better than those depicting Dollfuss. The statue of the Chancellor adorning the facade of the church of St. Peter's in Graz is one of a handful that are still visible. The plaques dedicated to Dollfuss were all removed in 1938. Comparisons with the patron saint nevertheless did not go beyond the symbolic stage. Efforts were made to credit Dollfuss with hypothetical miracles, and attempts were made to canonize him. Though Dollfuss was not officially awarded the status of saint, the sacred character attributed to his words and the pervasiveness of his effigy contributed to turning him into an icon within the Catholic conservative sections of the population.

Portrait of Dollfuss as a "Minor Dictator"

On account of his small size, Dollfuss was nicknamed "Millimetternich"[20] (the Lilliputian Metternich) by political opponents and foreign observers, and became from the beginning of his chancellorship the preferred target of caricaturists. In October 1932 for instance, at a time when the Austrian executive was debating the introduction of a government by decree, the left-wing weekly *Der Morgen* commented on Dollfuss' authoritarian drift with a cartoon depicting the chancellor as a child with an oversized suit and shoes, making his entry into the "club of the dictators" that includes, among others, Stalin, the Turkish leader Kemal Atatürk and Mussolini (Figure 6.7) "But who's this guy coming in with his clodhoppers?" ask the dictators seated around the table, amused by his clown-like appearance. The title "Der kleine Papenheimer" (The Little Papenheimer) is a reference to the then German Chancellor, Franz von Papen, who at that time ruled by emergency decrees in Germany.

The Nazis also played on Dollfuss' short stature in order to ridicule his attempt to compete with the "big men". A caricature featured in the October 1, 1933 issue of the German satirical weekly *Kladderadatsch*, which had strong Nazi sympathies, depicts a gesticulating Dollfuss standing on a chair, under the portraits of Mussolini and Hitler, who look down on him somewhat bemused (Figure 6.8). The caricaturist contrasts the disheveled and silly appearance of the Austrian leader with the solemn postures of the other dictators. The caption beneath Dollfuss' portrait, written in Italian and in German, reads: "I'm a Fascist too!" Published two weeks after the Chancellor's Vienna speech, the satirical drawing was probably intended to ridicule his first public appearance dressed as the new Austrian *Führer*. In a similar vein, a humorous photomontage published in Germany as a propaganda postcard just before the Nazi putsch attempt and republished by the French left-wing photography magazine *Vu* on August 29, 1934 depicts Dollfuss as a child disguised as a dictator, thus prompting the German Führer's amused expression.

19 The church still exists, yet under the name "Parish Church Saint Gertrud"; the remains of St. Engelbert are still kept in the church's treasure room.
20 "Austria: Millimetternich," *Time*, June 12, 1933, 24.

Humorous images of Dollfuss featured repeatedly in other countries, too. For instance, in May 1933, the Swiss satirical newspaper *Nebelspalter* commented on Austria's dependence on its neighbors with a caricature drawn by Emery Kelen and Alois Derso, which represented Dollfuss as a puppet-like child suspended by both arms by Mussolini and Hitler. "Unable to survive on its own, Austria has to rely on its neighbors", states the caption (Figure 6.9). Following the uprising in February 1934, the British cartoonist David Low depicted Dollfuss as a Mickey Mouse attacked by a howling Hitler-cat and seeking protection from a Mussolini-cat (Figure 6.10).

These satirical drawings depicting Dollfuss as a clown, a puppet or a mouse gave a simplistic reading of Austro-Fascism: they presented Dollfuss' politics solely from the point of view of the pressure applied by the two great neighboring powers, instead of questioning his responsibility in Austria's transition to dictatorship. They thus contributed, intentionally or otherwise, to nurture the myth of a Dollfuss at the mercy of his Fascist and Nazi neighbors, and therefore more a victim than a culprit.

After 1945: Dollfuss, Dictator and Victim

The birth of the Second Austrian Republic from the ashes of the war saw the formation of a coalition government made up of the main enemies of the 1930s: the Social Democratic Party, renamed Sozialistische Partei Österreichs, SPÖ (Socialist Party of Austria),[21] and the Christian Social Party, which acquired the name of Österreichische Volkspartei, ÖVP (Austrian People Party). In order to legitimize a political alliance that intrigued political commentators and, above all, their respective electorates, the two parties tacitly agreed to re-write history by officially declaring that the Christian Social Party and the Social Democrats were equally responsible for the collapse of the First Republic in the 1930s. This so-called Theorie der geteilten Schuld (shared-blame thesis) primarily benefited the conservatives who were eager to conceal their direct political lineage to the Austro-Fascist regime. Thus, instead of facilitating reconciliation, these compromises contributed to fuel Socialist resentment toward their conservative partners and perpetuated the antagonism between the two camps. Because the heads of the Austro-Fascist regime were not prosecuted, the ÖVP continued to celebrate Dollfuss as a resistance fighter and a martyr with complete impunity, while the SPÖ denounced the pursuit of this cult by pointing out the anti-democratic and repressive character of the regime. The controversies between the two parties raged especially when the repression of the Social Democrat and Communist uprising of February 1934, and the attempted Nazi putsch of July 1934 were remembered, and during election campaigns and parliamentary debates.

It was only with the arrival of a new generation of historians in the 1960s that the theory of shared blame began to be questioned and the figures of Dollfuss and Schuschnigg critically reassessed. This discursive shift also affected school books, which increasingly addressed Dollfuss' anti-Marxism and anti-parliamentarianism,

21 In 1991, the party changed its name again to Sozialdemokratische Arbeiterpartei Österreichs, but kept the acronym SPÖ.

the repressive character of his regime and the influence that Fascism had on his politics. Despite the advances of critical research, the conservative discourse continued to stick to the theory of shared blame, justified Dollfuss' politics arguing that there were international political pressures over which he had no control, and presented him as a resistance fighter and martyr. The illustrations in schoolbooks also reflected these contradictory interpretations: at least until the late 1990s, the Chancellor was mostly depicted both as a dictator (more often than not in uniform)[22] and as victim. Dollfuss' death was almost always documented with one of the photographs taken just after he was killed, which shows his blood-stained corpse lying on a sofa at the Chancellery (Figure 6.11). These images were taboo in the 1930s, and their origin and history remain obscure. The style of the photographs suggests they were taken by the police, but there is no evidence for that. They appeared for the first time, in the form of a photomontage (which may explain why they were not censored), in the August 1934 issue of the conservative weekly *Wochenpost*.[23] They were republished by the American magazine *Life* on March 28, 1938, following the annexation, again without any mention of their origin. The reappearance of these photographs decades later reflects a radical change in attitude to images in general and, in particular, to images of nudity and death from the 1970s onwards.[24] The pictures of Dollfuss' dead body were very often placed just before the section on the Nazis' seizure of power,[25] thus contributing to perpetuate the conservative myth of Dollfuss as a patriot and victim of Nazism.

Photographs of Dollfuss' corpse repeatedly featured in the press at the occasion of the fortieth anniversary of his death. One was even reproduced in the Socialist paper *Die Arbeiter Zeitung* on July 25, 1974 to illustrate an article entitled "The Late Chancellor is No Longer Our Enemy", signed by the then-Socialist Chancellor Bruno Kreisky, who had been himself a victim of the regime. The close-up of Dollfuss' blood-spattered body was accompanied by a caption stating: "Guilty, but himself a victim: the Chancellor, Engelbert Dollfuss, assassinated."[26] This article is a significant illustration of the conciliatory attitude of Kreisky. When coming into power in 1970, he also

22 The first depiction of Dollfuss in uniform is attributable to Anton Ebner, Anton Kolbabeck, Mattias Laireiter and Hermann Schnell, eds., *Unsere Republik im Wandel der Zeit* (Vienna: Österreichischer Bundesverlag, 1962), 38.

23 *Wochenpost, Österreichische Illustrierte Hefte*, August 26, 1934, 20–1.

24 Dollfuss' corpse was first reproduced after the war, in Franz Göbhart and Erwin Chvojka, eds., *Geschichte und Sozialkunde, Vom Ersten Weltkrieg bis zur Gegenwart, 8. Klasse AHS* (Vienna: Ueberreuter, 1973), 118.

25 See: Oskar Achs, Werner Adelmaier, Edith Loebenstein, Hermann Schnell, eds., *Zeiten, Völker, Kulturen 3, Lehr-und Arbeitsbuch für Geschichte und Sozialkunde, 4. Klasse der Hauptschulen und der allgemeinbildenden höheren Schulen* (Vienna: Jugend und Volk, 1989 and 1995), 81; Felix Riccabona et al., eds., *Geschichte Sozialkunde – Politische Bildung, 4. Klasse Hauptschule* (Linz-Vienna: Veritas, 1984 and 1995), 58; Leopold Rettinger and Friedrich Weissensteiner, eds., *Zeitbilder 4, Geschichte und Sozialkunde* (Vienna: Jugend und Volk 1996), 40.

26 "In Schuld verstrickt und doch selbst zum Opfer geworden: der ermordete Bundeskanzler Engelbert Dollfuss," in Bruno Kreisky, "Der Tote ist uns kein Feind mehr." Interestingly, Kreisky used the term "assassination" rather than the more neutral "death," even though it has never been possible to prove that Dollfuss' death was premeditated.

authorized the continuation of an annual mass for Dollfuss at the Chancellery.[27] This had been established three years earlier under Chancellor Josef Klaus (ÖVP). Over four decades, none of the governments that followed objected to that practice. Finally, in July 2010, a critical account of this tradition published in the daily *Der Standard* led the ÖVP–SPÖ coalition under Werner Faymann (SPÖ) to suppress it for good.

The conciliatory attitude assumed by many prominent Social Democrats was in keeping with the myth of Austria as Nazism's first victim, which became the founding principle of the Second Republic in 1945 and echoed beyond party lines. The "victim theory" was greatly undermined by the scandal about the Nazi past of the presidential candidate Kurt Waldheim, which erupted in 1984. However, instead of disappearing, the myth was transformed into the theory of Austria as both victim and culprit, a scenario into which the Janus figure of Dollfuss as "dictator and victim" fit neatly.

A Portrait Controversy

Until 2017, a portrait of Dollfuss adorned the office of the parliamentary group of the ÖVP (ÖVP–Parlamentsklub) in the Parliament in Vienna. It hung in a gallery of leading figures of the Christian Social movement (Figure 6.12), a gallery that does not include Kurt Schuschnigg, which the ÖVP treated as a persona non grata after 1945. Painted by the renowned Austrian artist Tom Dreger (1868–1948),[28] who completed it on July 18, 1934, a few days before Dollfuss' death,[29] the portrait represents him with a relaxed, almost informal attitude. From the 1970s on, this portrait became the subject of relentless political argument and a political weapon in the hands of ÖVP's opponents, especially the SPÖ, which seized every opportunity during parliamentary debates (even when these dealt with subjects not directly related to Dollfuss) to demand its removal. While members of the SPÖ saw it as proof of the ÖVP's inability to rid itself of its anti-democratic traditions, the conservative leadership remained determined to keep it, arguing that Dollfuss was a complex historical figure having, like everyone else, both qualities and defects. At the beginning of this century, they started to acknowledge the dictatorial nature of his politics, but continued to legitimize the democratic shutdown by stressing that Mussolini's pressure and the Nazi terror had left him no choice. They also continued to praise the martyred chancellor who sacrificed his life to keep Austria independent and resist the rise of Nazism.[30]

27 The non-interference policy of the Social-Democrats is evident in the compromises made over the last few years at the local level on the question of the extant monuments to Dollfuss: instead of removing them from public spaces (and transferring them to a history museum as exhibits, for example), the compromise has consisted in leaving them where they are and adding an explanatory plaque emphasizing the antidemocratic nature of Dollfuss' politics.

28 On Dreger's life and work, see Österreichische Akademie der Wissenschaften, *Österreichisches biographisches Lexikon 1815–1950* (Vienna: Böhlau, 1954), 199.

29 "Das letzte Bildnis Dr. Dollfuß," *Reichspost*, September 20, 1934, 6.

30 See the arguments developed by Andreas Khol (ÖVP) in an interview given to the editor-in-chief of the conservative daily *Die Presse*, Michael Fleischhacker, at the time when Khol was President of the Austrian National Council. "Wer ist schon makellos?," *Die Presse*, March 5, 2005, 2. These views have also been put forward by the conservative Michael Spindelegger, who was President of the National Council from 2006 to 2008. See "Erinnerung und Mahnung," *Falter*, March 5, 2008, 5.

In February 2014, in the course of yet another debate about the painting, which took place during the commemorations for the eightieth anniversary of the uprising in February 1934, ÖVP representatives modified their discourse and started to argue that the portrait should be retained out of a duty of remembrance, and because it documented the party's critical reassessment of its past. "I cannot simply detach myself from a part of my history by side-lining certain persons", declared the chairman of the parliamentary group, Reinhold Lopatka[31]. In the light of this argument, the party decided to place a plaque beneath the portrait explaining that it was not honoring the leader,[32] but that "the good as well as the bad features" of his leadership needed to be told.[33] The transition to dictatorship was once again presented as a response to the rise of Nazism, while other aspects of Dollfuss' personality and political program, such as his anti-parliamentarianism, his negotiations with the Nazis, and his admiration for Mussolini were not even hinted at. The text ended by recalling his death during an attempted Nazi putsch, thereby reviving the old myth of the martyred Chancellor. The decision to keep the portrait and add an explanatory note reaffirmed the legitimacy of the portrait's presence in the office of the conservative parliamentary group, and de facto in the parliament itself – the very parliament that Dollfuss wanted to permanently abolish in 1933.[34]

On July 19, 2017, the ÖVP finally announced that the portrait would be removed. This decision was made following the building's restoration, which forced all parties to temporarily relocate their offices. All twelve portraits that hung in the ÖVP-club were moved for permanent display to the Haus der Geschichte Niederösterreich, a history museum which opened in September 2017 in Sankt Pölten, Lower Austria. Obviously concerned about possible scandals, the curators did not problematize Dollfuss' historic role. Instead, the portrait is displayed together with several small plaques representing a variety of opinions expressed by politicians and academics (all men). Two contrasting statements, by historians Florian Wenninger and Kurt Bauer respectively, are worth quoting: "When dictators are glorified as defenders of the fatherland, tyranny is trivialized and treated as an acceptable sin"; and "Dollfuss [...] was not a mean guy, perhaps a bad politician, probably just a mediocre one. The wrong man at the wrong place at the wrong time."

The removal of the portrait echoes the general change of attitude that the new party-leader Sebastian Kurz announced during the campaign for the parliamentary election of 2017. In the wake of this "makeover", the "Neue ÖVP" also changed its colors from black (the color of the catholic priests, symbol of the historical attachment

31 Herbert Lackner, "Man kann Geschichte nicht verleugnen," Interview of Reinhold Lopatka, *Profil.at*, February 3, 2014. https://www.profil.at/oesterreich/reinhold-lopatka-dollfuss-bild-oevp-klub-372252. Accessed September 29, 2019.

32 On this occasion, the SPÖ leadership reiterated its wish to see the portrait removed from the ÖVP-Parlamentsklub. See the position adopted by the party leader and then chancellor, Werner Faymann, "Dollfuß-Bild gehört nicht ins Parlament," *Kurier*, February 9, 2014, 4.

33 "Dollfuß-Porträt im ÖVP-Klub soll Infotaferl bekommen," *DerStandard.at*, February 5, 2014, accessed September 29, 2019, http://derstandard.at/2000003446272/OeVP-informiert-ueber-Dollfuss-Portraet.

34 In a speech he made on September 11, 1933 he declared: "This parliament is such a poor way of governing our people; it must not, under any circumstances, be allowed to return." Quoted from Weber, *Dollfuß an Österreich*, 26.

to the Christian social tradition) to turquoise blue. Blue happens to be the color of the far-right Freiheitliche Partei Österreichs, FPÖ (Austrian Freedom Party) with which the ÖVP was to enter into a coalition following its election victory. Both "blue" parties share a number of right-wing populist ideas and attitudes, such as a strong anti-Islam discourse, a highly restrictive migration policy and the claim that welfare provision should be reduced to discourage "scroungers". Against this background, it would be rash to interpret the removal of the dictator's portrait as a progressive signal sent by the conservative party.

Conclusion

From the start of the dictatorship in Austria in 1933, portraits of Dollfuss played a decisive role in the propaganda of the Austro-Fascist regime contributing to the personality cult of the new dictator. The idea of humanity and humility was enhanced in the posthumous cult of Dollfuss by the myth of the "martyred Chancellor". At first gaze, Dollfuss' iconography may appear weak when set against the macho and aggressive depictions of other right-wing dictators. However, the two ways of representing Dollfuss, sometimes in uniform, sometimes in civilian clothes, proved to be a winning strategy for they helped convey an acceptable image of the dictator, one that outlasted him by several decades. After 1945, the contrasting images of Dollfuss – the leader in uniform and the bleeding corpse on a sofa – featured concurrently, and perpetuated his Janus-like image.

From the 1930s onwards, political opponents and foreign observers ridiculed Dollfuss in cartoons that exploited his diminutive stature. Ultimately, these satirical images helped reinforce the image of a regime of "lesser evil". Traces of the image of the ridiculous wannabe dictator continue to recur, even in works that are by and large critical of the regime. A good example is the cartoon film *Heldenkanzler* (The Chancellor Hero), which was made in 2011 by the Austrian filmmaker Benjamin Swiczinsky. Though it is based on extensive research and includes archival footage that graphically illustrates Dollfuss' repressive policies, the emphasis on the leader's short stature and on his laughable attempts to imitate the "big" neighbors undermines the filmmaker's intention to denounce the regime.

More than ninety years after Dollfuss' death, and despite recent scholarship on Austro-Fascism laying bare its true nature,[35] the myth of the harmless dictator and victim of Nazism still looms large over the Austrian cultural memory, just as Kurt Schuschnigg had wished in 1935.

35 See, for instance, Ilse Reiter-Zatloukal et al., eds., *Östereich 1933–1938: Interdisziplinäre Annäherungen an das Dollfuß-/Schuschnigg-Regime* (Vienna: Böhlau, 2012); Tálos, *Das austrofaschistische Herrschaftssystem*; Florian Wenninger and Lucile Dreidemy, eds., *Das Dollfuß/Schuschnigg-Regime, 1933–1938. Vermessung eines Forschungsfeldes* (Vienna: Böhlau, 2013); Dreidemy, *Der Dollfuß-Mythos*.

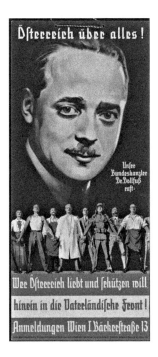

Figure 6.1 "Austria above all". Poster designed by August Schmid, 1933. (Österreichische Nationalbibliothek, ÖNB – Bildarchiv und Grafiksammlung, Plakatarchiv, Sign. PLA16307028).

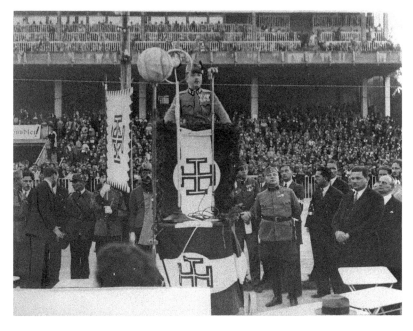

Figure 6.2 Engelbert Dollfuss holding his programmatic speech during a mass rally at the Vienna racing course, on September 11, 1933. Photograph by Albert Hilscher. (ÖNB – Bildarchiv und Grafiksammlung, Sign. NB 524318-B).

Figure 6.3 Engelbert Dollfuss at his home on October 3, 1933, a few hours after the first attempt on his life. Photograph by Albert Hilscher. Front page of the *Wiener Bilder. Illustrierte Wochenschrift*, October 8, 1933, 1.

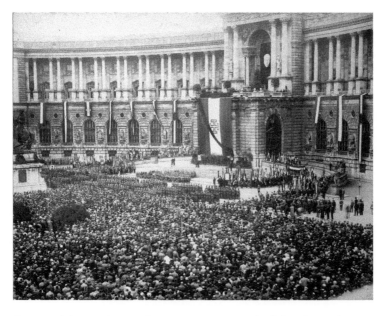

Figure 6.4 Remembrance Day ceremony organized by the regime on Vienna's *Heldenplatz* (Heroes' Square), August 8, 1934. Photographer unknown. (ÖNB – Bildarchiv und Grafiksammlung, Sammlung Zeitgeschichte, Pk 2697/3).

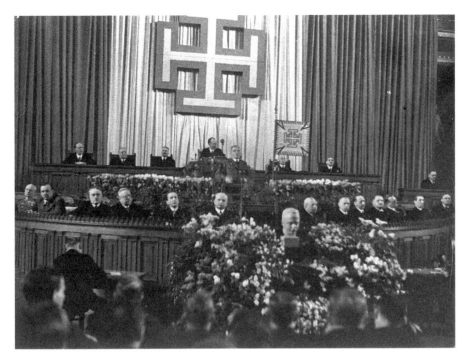

Figure 6.5 Kurt Schuschnigg at the *Bundestag* on February 24, 1938. Photograph by Albert Hilscher. (ÖNB – Bildarchiv und Grafiksammlung, Sammlung Zeitgeschichte, Sign. H 4810/3).

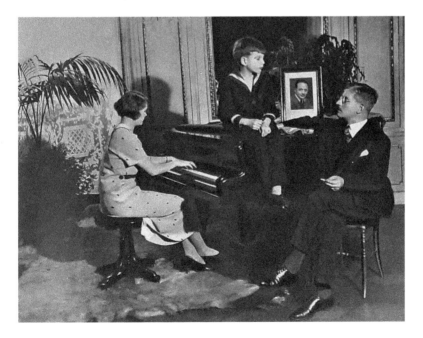

Figure 6.6 Kurt Schuschnigg at home with his family. Picture by an unknown photographer. *Wochenpost. Österreichische Illustrierte Hefte*, July 28, 1935, 11

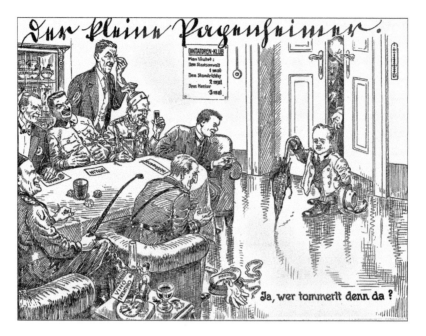

Figure 6.7 "The Little *Papenheimer*". Anonymous cartoon from *Der Morgen*, October 10, 1932. (Tagblattarchiv, Wien, Bibliothek am Rathaus).

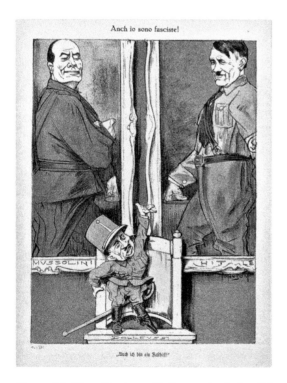

Figure 6.8 "I'm a Fascist too!" Cartoon by Arthur Johnson from *Kladderadatsch*, October 1, 1933.

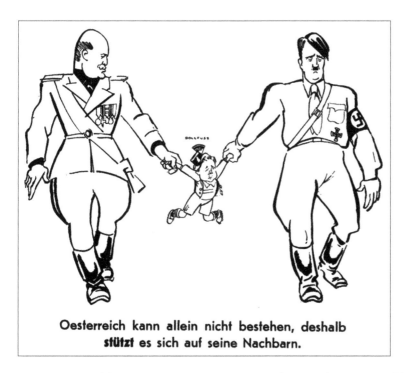

Figure 6.9 "Unable to survive on its own, Austria has to rely on its neighbors". Cartoon by Emery Kelen and Alois Derso, *Nebelspalter*, May 26, 1933.

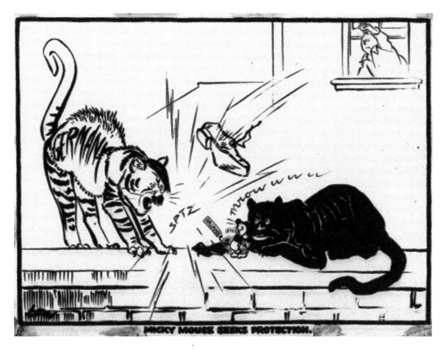

Figure 6.10 "Micky Mouse seeks protection". Cartoon by David Low, *Evening Standard*, February 28, 1934.

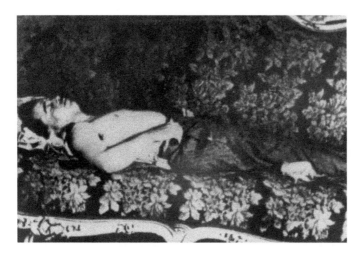

Figure 6.11 Corpse of Dollfuss lying at the Chancellery, July 25, 1934. Photographer unknown. (ÖNB – Bildarchiv und Grafiksammlung, Sammlung Zeitgeschichte, Sign. S 307/28).

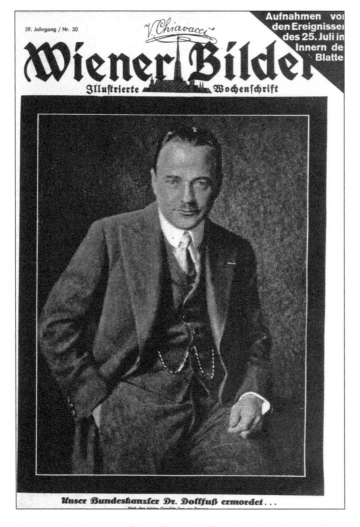

Figure 6.12 Portrait of Engelbert Dollfuss by Tom Dreger. Front page of the *Wiener Bilder. Illustrierte Wochenschrift*, July 29, 1934.

Bibliography

Achs, Oskar, Werner Adelmaier, Edith Loebenstein, and Hermann Schnell, eds. *Zeiten, Völker, Kulturen 3, Lehr-und Arbeitsbuch für Geschichte und Sozialkunde, 4. Klasse der Hauptschulen und der allgemeinbildenden höheren Schulen.* Vienna: Verlag Jugend und Volk, 1989 and 1995.

Benito-Sanchez, Samanta. "Pressefotografen zwischen den Weltkriegen. Eine Biografiensammlung von Pressefotografen, die zwischen 1918 und 1939 in Wien tätig waren." Master thesis, University of Vienna, 2009.

Bleibtreu, Attilio R. *Der Heldenkanzler. Ein Lied von der Scholle.* Vienna: Jung-Österreich-Verlag, 1934.

Dreidemy, Lucile. *Der Dollfuß-Mythos. Eine Biographie des Posthumen.* Vienna: Böhlau, 2014.

Ebner, Anton, Anton Kolbabeck, Mattias Laireiter, and Hermann Schnell, eds. *Unsere Republik Im Wandel der Zeit.* Vienna: Österreichischer Bundesverlag, 1962.

Göbhart, Franz, and Erwin Chvojka, eds. *Geschichte und Sozialkunde, Vom Ersten Weltkrieg bis zur Gegenwart, 8. Klasse AHS.* Vienna: Ueberreuter, 1973.

Kraus, Karl. "Warum die Fackel nicht erscheint." *Die Fackel*, 890–905 (July 1934).

Maderthaner, Wolfgang, and Michaela Maier, eds. *"Der Führer bin ich selbst". Engelbert Dollfuß Benito Mussolini Briefwechsel.* Vienna: Löcker, 2004.

Österreichische Akademie der Wissenschaften, ed. *Österreichisches biographisches Lexikon 1815–1950.* Vienna: Böhlau, 1954.

Paul, Gerhard. "Das Jahrhundert der Bilder. Die Visuelle Geschichte und der Bildkanon des kulturellen Gedächtnisses." In *Das Jahrhundert der Bilder*, edited by Gerhard Paul, 14–39. Bonn: Bundeszentrale für Politische Bildung, 2008.

Reiter-Zatloukal, Ilse, Christiane Rothländer, and Pia Schölnberger, eds. *Östereich 1933–1938: Interdisziplinäre Annäherungen an das Dollfuß-/Schuschnigg-Regime.* Vienna: Böhlau, 2012.

Rettinger, Leopold, and Friedrich Weissensteiner, eds. *Zeitbilder 4, Geschichte und Sozialkunde.* Vienna: Verlag Jugend und Volk, 1996.

Riccabona, Felix, Karl-Heinz Kopeitka, Klaus Markovits, Norbert Riccabona, and Hermine Schuster, eds. *Geschichte Sozialkunde – Politische Bildung, 4. Klasse Hauptschule.* Linz and Vienna: Veritas, 1984 and 1995.

Spielhofer, Elisabeth. "'Der Pressefreiheit würdige Grenzen ziehen...' Theorie und Praxis der Pressepolitik Im Österreichischen Ständestaat (1933–1938) unter Berücksichtigung der deutsch-österreichischen Presseabkommen." Master thesis, University of Vienna, 1992.

Tálos, Emmerich, ed. *'Austrofaschismus'. Beiträge über Politik, Ökonomie und Kultur 1934–1934 (Österreichische Texte zur Gesellschaftskritik)* (2nd edition). Vienna: Verlag für Gesellschaftskritik, 2005.

Tálos, Emmerich. *Das Austrofaschistische Herrschaftssystem. Österreich 1933–1938.* Vienna: Lit, 2013.

Verdery, Katherine. *The Political Lives of Dead Bodies, Reburial and Postsocialist Change.* New York: Columbia University Press, 2000.

Weber, Edmund, ed. *Dollfuß an Österreich. Eines Mannes Wort und Ziel.* Vienna: Reinhold, 1935.

Wenninger, Florian, and Lucile Dreidemy, eds. *Das Dollfuß/Schuschnigg-Regime 1933–1938. Vermessung eines Forschungsfeldes.* Vienna: Böhlau, 2013.

7 Franco

When the Portrait Matters More than the Model

Pierre Sorlin

In the second-third of the twentieth century, "popular" dictatorships, combining collective enthusiasm and severe police control over the population came to power in some European and Latin American countries. Each regime had distinctive features, but most dictators shared a few common characters so much so that we can sketch an "ideal type" of the mid twentieth century autocrat. He (they were all males) believed in his mission and assumed that something or someone – destiny, history, the nation, the people, the ruling group – had entrusted him with inflexibly governing his people. A charismatic individual, he liked and sought his fellow citizens' company. Every meeting was a performance; his speeches enthralled the mob, creating a passionate feeling of togetherness between the chief and his followers. Even Stalin, who was not much fond of informal strolls among the crowd, enjoyed gigantic gatherings in which, from on high, his words made him get through to his audience.

Silent Warrior

Francisco Franco (1892–1975), the Spanish dictator, does not fit in with such a model.[1] He did not think that any authority had mandated him to guide Spain and his title of *Caudillo* (leader, strongman) encapsulates perfectly his peculiar status: a medieval term was opportunely brought out of oblivion to name a man who had gotten his power from nothing but the passive acceptation of his fellow generals. A megalomaniac, who worshiped exclusively his person, Franco conceived of himself as cleverer, more intelligent than anybody else – and that was enough. Shy, unable to spontaneously deliver a cheerful talk, he loathed and avoided public ceremonies. Accredited pictures, such as those of the official, unique, controlled cinema newsreels *Noticiarios y Documentales* (News and Documentaries) known as *NO.DO.* (Figure 7.1) reveal that, being reluctant to appear in public, he did not dare take a glance at those who surrounded him. Unlike other dictators, *el Caudillo* seldom spoke in parades or on radio. Rare issues of *NO.DO.*[2] show him, his eyes riveted on his slip, reading a short address, hesitantly and in a dull tone.

1 While dictatorships, in the last decades of the twentieth century, relied exclusively on constraint.

2 From June 1938 to March 1941 the Francoists had produced a newsreel, *El Noticiario español* [The Spanish newsreel], that was of modest quality because they lacked raw material and technicians. *NO.DO.* was established in January 1938 and shown weekly. See Rafael Tranche and Vicente Sanchez-Biosca,

Dictatorships developed an ideological discourse according to which the present years of hardship prepared a wonderful future, a time when, thanks to economic prosperity, lucky people would overcome any want of the necessity of life. Francoism was devoid of ideology. Half of the country, having won the other half during the Civil War (1936–1939), wanted to be avenged for four years of fear imposed by "the Reds". Until the early 1950s, the aftereffects of the domestic conflict kept Spain in a permanent state of mistrust fostered by Franco who, far from trying to reconcile the adversaries, based his dictatorship on an enduring punishment of the "lawless". The winners dreamed a motionless Spain in which everyone, in their place, would do the best to comply with Franco's guiding principles: *el Caudillo* was fighting "for the country against the anti-country, unity against secession, morality against crime, spirit against materialism, with no other aim than the triumph of plain and eternal principles".[3] There was no need to give a fuller version of so limited a program.

When a few generals rebelled against the Republican government, in July 1936, Franco was simply one of them, and not the most famous. Pulling strings skillfully he managed to have his fellows appoint him *generalísimo* and Head of the State. What State? A monarchy deprived of king? The "nationalist" Spain was, until Franco's death, merely Francoist. *El Caudillo* was its only foundation stone, so that its staff had to make known an unappealing man, reluctant to appear in public and, at least initially, somewhat suspicious about photography or cinema.[4] His name, his reputation and his image were to compensate for his absent person.[5]

Franco himself was the founder of his own imagery. At the outset of the Civil War, the Republic attached much importance to the taking of the Toledo Alcázar, an old fortress transformed in military school that had participated in the uprising. The fortress resisted a long siege and was rescued by the Nationalists on September 27, 1936. Instead of rushing up to congratulate the defenders of the citadel, Franco waited two days, the time necessary to gather a film crew (most filmmakers and technicians were on the loyalist side). He was the center of the cinematic report on his visit, the first visual account of a military event shot in the Nationalist camp, so that most Spaniards considered him the liberator of the Alcázar.

Divided in two irreconcilable parts, Spain was then in a perilous situation, the weak Republic was unable to resolve the crisis and the military uprising, which increased the disorder, met with the effective resistance of popular forces. In difficult occurrences,

NO-DO. El tiempo y la memoria (Madrid: Cátedra, 2000) and idem, *El pasado es el destino. Propaganda y cine del bando nacional en la Guerra Civil* (Madrid: Cátedra/Filmoteca Española, 2011).

3 Franco's statement to the Havas agency, August 23, 1938, quoted from Mathilde Eiroa San Francisco, "Palabra de Franco: Lenguaje político e ideología en los textos doctrinales," in *Coetánea. Actas del III Congreso Internacional de Historia de Nuestro Tiempo*, ed. Diego Iturriaga Barco (Logroño: Universidad de La Rioja, 2017), 75.

4 In Spanish *sacar una foto* (to take a picture) is suggestive of something violent, akin to "to claw". Franco felt ill at ease in the presence of an operator, all the more so because photography, in spite of touching up, unveils the personality of the model.

5 Franco was well aware of such an oddity. In 1941 he wrote a novel, *Raza*, history of a military family from 1898 through 1939, under the pen name Jaime de Andrade. He mentioned, several times, *el generalísimo* (himself), distant, of inaccessible character, an undisputed, powerful leader, dominating the state of affairs from his headquarters. This fiction of an omnipotent, hidden chief suited perfectly his self-esteem.

Max Weber argued, "charismatic" individuals[6] who contend with assurance that, thanks to their exceptional personal qualities, can get people out of their misery, arouse enthusiastic adhesion and entire submission, particularly when they are fighting men. Yet Franco was totally deprived of charisma and did not try to convince the Spaniards that he could save them. Recent research[7] has pointed out that Weber adopted a top-down point of view by which the personality of the leader was the driving force of the charisma, but that there is also, in this concept, a down-top relationship: the desire to give some meaning to muddled circumstances leads distressed or bewildered people to place their confidence in an individual who seems able to guide them. Reliance, in such case, is an abandon driven by enthusiasm, hope or faith: since he had delivered the Alcázar, Franco would also be able to save Spain.[8]

Let us add that many conservative Spaniards admired Mussolini and Hitler who had released their countries from powerless governments and restored their dignity.[9] The hopeless Spanish Republic was unable to maintain law and order, its ceremonies were pitiful crushes of agitated masses; a strong leader must take its place, restore discipline, unite the country and organize huge, fascist-like parades.

In the months that followed the rescue of the Alcázar, Franco turned into a much-liked leader by those living in the Nationalist zone of Spain and they all did their best to demonstrate gratitude and support. Trying to meet the *Caudillo*'s supposed wishes, people put his name everywhere and his portraits mushroomed. Some had an official character. As early as November 1936 the city of Salamanca ordered a bust of Franco to be added to the gallery of statues of Spanish kings placed on the main square of the town[10]. Official stamps of the republic were still in use, but the town councils, in many places, ordered to put on vignettes' inscriptions such as "Long live Franco" or "Our city is with Franco".

A most interesting phenomenon during the Civil War and the post-war period was the flowering of often naïve drawings emanating from ordinary people. The *Delegación de Estado para Prensa y Propaganda* (State Delegation for Press and Propaganda) received dozens of drawings and paintings (as well as poems and thanksgivings) every day: they were sent by ordinary citizens eager to express their admiration (or anxious to get some reward), and represented the man after a photograph or as they imagined him to be, following their personal inspiration. Stationers printed and sold envelopes and writing paper with portraits or sentences in honor of the *Caudillo* and artists

6 "We shall call charisma the exceptional quality of an individual who is, so to say, endowed with powers or supernatural or superhuman qualities [...] or regarded as sent by God, or as an example and, consequently, treated as a leader." Max Weber, *Economy and Society* (Berkeley: University of California Press, 2013), vol. 2, 1111–12.

7 Ian Kershaw, *The Nazi Dictatorship* (London: Edward Arnold, 2000), and idem, *Hitler*, 1991 (London: Routledge, 2001); Michel Dobry, "Charisme et rationalité," in *La politisation*, ed. Jacques Lagroye (Paris: Belin, 2003), 301–23.

8 For the use of the Alcázar episode in Francoist iconography, see Miriam Basilio, *Visual Propaganda, Exhibitions and the Spanish Civil War* (Farnham: Ashgate, 2014), 161–3.

9 "Spain, like Italy, like Germany, [...] is looking for its Führer, its Duce. [Having met Franco], she tells him with one accord 'You are *el Caudillo*. We are behind you and you fill us with enthusiasm. Lead us into the attack.'" See *La Gaceta regional* (Salamanca), January 8, 1937.

10 The town-council was a pioneer in the field. Later portraits or statues of *el Caudillo* often imitated art works representing Spanish kings. See Basilio, *Visual Propaganda*, 165–6.

submitted portraits of *el generalísimo* to the yearly Francoist sculpture and painting exhibitions, hoping that such images would not be refused. One of these works was commissioned by the Burgos town council to thank *el generalísimo* who had set up his headquarters in the city. At that time (early 1937) no directive had been given about the representation of the dictator, but such fanciful, impersonal paintings, with the character's stereotyped teeth, this all-smiles man – a good fellow rather than strong leader – was not likely to reassure a scared population. Such type was never reused afterward.

Many had photographed the *Caudillo* but the pictures were amateurish and clumsy, and concealed neither his smallness nor his stoutness. Extremely precise rules were established: he should be photographed at a low angle to hide his belly and in three-quarters profile, his serious, thoughtful but benevolent face, his penetrating stare turned toward the future, above the heads of the enthusiastic mob.[11]

The official photographer Jalón Ángel[12] succeeded in making him look slim and a bit taller. One of his pictures, which represented him in a military uniform, became a standard official portrait of the dictator. Copies were distributed in Spain and abroad, to be displayed in public offices, town halls, schools and hospitals. The photograph filled the cinema screen until the beginning of the film shows. It was reproduced in newspapers on a daily basis and featured compulsorily in school textbooks. Another widely circulated photograph, possibly taken by Ángel, depicted Franco in a winter military attire (he wears a mantle with a hood lined with fur). Both portraits were also printed in postcard form to be sold (Figures 7.2–7.3). Moreover, huge portraits of Franco painted on canvas were suspended in the streets on the initiative of local authorities or independent institutions – if the censors consented.

El Caudillo's face (not his whole body, or torso) had become an icon, not in the sense of a sacred image, but with the meaning of a self-sufficient representation, efficacious by the very fact of its own existence and necessitating no commentary. Yet, Franco was not only a physiognomy; his name was also a rallying cry. Hundreds of sycophantic poems, published in 1939, immediately after the victory of the Nationalists, celebrated his miraculous powers.[13] One example worth quoting is *La mano de Franco* (Franco's hand), which attributes to *El Caudillo's* hand thaumaturgical properties similar to the power ascribed to the hand of the Spanish kings. The poet, Antonio Guardiola, saw, in Salamanca, "The miraculous hand of the strong General". Although an elegant glove covers it, the witness understands that "such a loyal hand" originated in the people.

11 Alicia Martínez Rivas, "La fotografía durante el franquismo," *Revista de Claseshistoria*, 60 (November 2009): 5–6.

12 Franco met Ángel (Ángel Hilario García de Jalón) in 1928, in Zaragoza when he was Director of the Military Academy, and exceptionally trusted him. The photographer took twenty-two different pictures of *el Caudillo*. There is no scholarly monograph on Ángel, but see Pilar Irala Hortal, "El legado de Juan Ángel y su aportación a la historia de la fotografía en los años 30," *Research Gate*, October 2017. https://www.researchgate.net/publication/321213221_El_legado_de_Jalon_Angel_y_su_aportacion_a_la_his toria_de_la_fotografia_en_los_anos_30 (last accessed on December 1st, 2019).

13 *Lira bélica. Antología de los poetas y la guerra* (Valladolid: Librería Santarén, 1939). The text of Guardolia's poem is taken from José-Carlos Mainer, "La construcción de Franco: primeros años," special issue of *Materiales para una iconografía de Francisco Franco. Archivos de la filmoteca*, ed. Vicente Sanchez Biosca, 42–43 (2003), 37–9.

Nevertheless, "God had inspired him", his hand heals and it belongs to a "skillful navigator" who is also a "high priest" when he "blesses" his people.

On the first anniversary of the uprising, in 1937, two new stamps substituted the Republican ones. As no good graphic artists were prepared to work for the Francoists, the vignettes were rudimentary; they featured an opened hand with the name "Franco" printed prominently. Before the Francoists' victory (March 1939) his name was repeatedly mentioned in the press and on radio, thus reinforcing, and at times replacing, the portrait. Stamps, coins and medals (Figure 7.4) depicting the leader's head, pensive and resolute, began to be issued in 1939 and 1946, respectively.

People who advertised their enterprise in a newspaper were strongly advised to write: "Come and shout with us: *Long live Franco,* then you'll buy what you need." In public celebrations, citizens were ordered to shout three times "Franco". No cheer other than that one, or *Arriba España* (Long live Spain) was permitted, those who shouted different slogans, even favorable to the regime, could be prosecuted. An exceptionally cheerful picture, published by *Vértice,* the propaganda magazine of the Falange, the only political party, in its September–October 1937 issue (that is to say before the adoption of the rules mentioned above), best illustrates the total symbiosis between the visage and the name, "Franco", repeated ad nauseam, the only word worthy of characterizing such outstanding personage.

El Caudillo did not need to talk. Before he appeared, a zealous, strictly supervised mob had long been acclaiming his name. In order to celebrate the victory over "the Reds" there was, in Madrid, on March 28, 1939, a gigantic five-hour parade solemnized by a film, *El gran desfile de la Victoria* (The great parade of victory), later circulated throughout Spain. Franco towered over the ceremony from a huge podium on which his patronymic was inscribed in capital letters. In the movie, his face or bust, taken in long shot, that is to say from afar, reappeared at intervals, so that the military display seemed to converge on him – while in fact it stretched out straight over two miles. Speeches were useless; it was the attractiveness, the magnetism of the icon, that set the ritual in motion.

Knight and Manager

At the time of the Civil War and in the first phase of the Second World War, Franco showed himself in uniform of the *generalísimo*, never on the front but strutting about with Hitler, Mussolini, high diplomats and officers. Max Weber points out[14] that the charismatic relationship, ascribable to a crisis in which many look for a rescuer, turns into a pragmatic management of everyday business once emergency has vanished and that, in this new epoch, "two forms of power initially conflicting, charisma and tradition" interfere with each other. The warrior disappeared slowly in the course of the 1940s in favor of two different characters, an allegoric and a managerial one. A comment, in *NO.DO.*, marked discreetly but clearly the transition: "With the unanimous and fervent adhesion of all Spaniards Franco, every day, wins in the battles for peace and works tirelessly for the liberty and greatness of Spain"[15].

14 *Economy and Society*, 146–7.
15 *NO.DO.*, n° 59, January 5, 1944.

Stabilized, Franco's Spain adopted the mass ceremonies of totalitarian regimes. Dates marking a milestone in recent history, such as the anniversaries of the uprising or of the victory, were marked by a gigantic military parade attended, willingly or not, by the population. Speechless as usual, the dictator followed the march-past from the balcony of the Madrid Palacio Nacional (National Palace) and delighted in receiving the "impressive homage" of the crowd. The voiceover remarked: "the square resonates with the unanimous clamor of a frenzied audience, *el Caudillo* was obliged to come back eight times without the mob tiring of calling for his presence",[16] "All throats cheer up to going hoarse. ... Thousands of flame-like hankies ... show the feeling of the whole nation unshakably united with Franco."[17]

These were exceptional events. In everyday life, thanks to portraits displayed in public buildings, on city walls and in the press, the leader's features were always fresh in Spanish minds. In the war, photography had been the favorite medium. Stuck to current events it had shown a *Caudillo* permanently vigilant, intent on anticipating the future. Peaceful times required a different image better conveyed by works of art, paintings or statues, and by newsreels. With the first it was easy to adjust Franco's features to his self-image. More interestingly, portraits gave a feeling of firmness, of durability absent from photography, and conveyed an indirect ideological message.

Countless portraits were made in that period and mentioning them all would be tedious, all the more so because they were of poor aesthetic quality. Two examples will suffice.

The first portrait we shall focus on was painted in 1940 by Ignacio Zuloaga, a renowned artist and early supporter of Franco. It was first displayed in 1941.[18] At first glance, its meaning is straightforward. The dark clouds, at the background, refer to the difficult situation of Spain, to the scarcity of food, clothes, fuels and transportation equipment resulting from a disastrous domestic conflict and a World War that would later interrupt international trade. An athletic Franco, firm on his feet, wrapped in the red and yellow flag, the royal banner opposed to the Republican violet, yellow and red one, contains the storm and looks toward the days to come.

But there is much more than meets the eye. In 1936, two main political forces had joined the troops and revolted against the Republic. There were first the Conservatives, hardline Catholics and monarchists, who wore a red beret as a rallying sign.[19] The members of La Falange española (The Spanish Phalange), a political party founded in 1933, which advocated a national worker control over industrial production – an idea vaguely inspired by national socialism –, were recognizable for their navy blue shirts and the emblem of an arrow, the symbol of war, and a yoke, the symbol of labor. By executing the Falange leader, José Antonio Primo de Rivera, the Republicans

16 *NO.DO.*, n° 179, April 1, 1946.
17 *NO.DO.*, special issue, December 9, 1946.
18 The portrait cannot be reproduced here, but can be accessed by googling "Ignacio Zuloaga retrato de Franco". The painting is now owned by the heirs of the dictator's wife, Carmen Polo, who preserve it in their home at el Pazo de Meirás, in the province of la Coruña. See "Francisco Franco, el retrato más problemático e inaccessibile de Ignacio Zuloaga," *ABC*, November 25, 2018.
19 The red beret was the rallying sign of the Catholic, monarchist Navarros, who were among the best soldiers of the Nationalist army.

turned an insignificant young man into a martyr and a saint. Franco, jumping at the opportunity, declared himself heir to José Antonio and despite the reluctance of the above-mentioned organizations, which did not share the same ideal, merged all political forces into one party, La Falange, placed under his personal authority. The painting in question was much more than a mere portrait, it brought to the fore Franco's exclusive direction of the party and the army by associating various emblems, the red beret (which he often wore [Figure 7.1]), the blue shirt, the military trousers and the boots. The picture made *el Caudillo* an iconographic symbol of Nationalist Spain and did it much better than the dictator's person would have done.

There were, at the beginning, many *falangistas* in Franco's staff, but he appreciated neither their activism, nor their claims to social reforms. Members of *Opus Dei*,[20] a congregation of rigid, dedicated believers, progressively replaced them. Franco has signed a Concordat with the Vatican granting him political control over the Spanish church, provided he would conspicuously demonstrate his assent to Divine revelation.[21]

The second allegorical work we shall discuss is a triptych which was painted in oil in 1946–1947. At the end of the Civil War, Franco had decided to build the *Valle de los Caídos* (Valley of the Fallen), an underground memorial consecrated to those who had scarified their life for the Nationalist cause. A well-known Bolivian painter, Arturo Reque Meruvia, was asked to decorate the choir of the monument. Since the building was making slow progress, the artist executed *Cruzados del siglo veinte* (Twentieth-century Crusaders) in his studio. The monument was not completed before 1959, a time when the idea of a "Crusade" against the "godless forces of communism" was no longer the order of the day, as we shall see. The work was put in the Ávila *Archivo General Milita.*[22]

The structure and arrangement of the characters, inspired by a long tradition of Catholic imagery, recalls the homage to God paid by a faithful warrior, among a crowd of companions-in-arms and devout believers. During the Civil War some bishops had called the *Crusades* the fight against the "godless". Franco reveled in playing the crusader; this placed him in the best traditions of legendary or historical Spanish kings and heroes. After the victory, he solemnly handed in his command sword to the bishop of Madrid, as mediaeval knights used to do. A few weeks later he chaired a celebration in Covadonga, a small township where, in 722, the *Reconquista* – the crusade against the Moors – had been launched. A skillful sycophant, Reque Meruvia knew that he would please the dictator by representing him as a crusader with cloak, armor, shield and sword. In the sky Saint James Matamoros (Killer of Moors), riding a white horse, blesses him. At his sides, priests, monks, nuns and soldiers look at the gallant knight. Stylistically, the work is extremely banal, but clerks, ecclesiastics and laymen

20 Founded in Madrid in 1928, the *Opus Dei*, an institution of the Roman Catholic Church, had quickly developed in Spain. The Falange was hostile to its submission to Rome and its conservatism.

21 Before the uprising Franco never showed a deep religious fervor. His comrades said he was "faithless and mass-less". See José Luis Ibáñez Silos, *El Franquismo* (Madrid: Sílex, 2013), 63. From 1936 onwards he went to mass every morning and said rosary with his wife as often as possible. See Julián Casanova, "La religiosidad del *Caudillo*," *El País*, March 17, 2015.

22 This museum cannot provide reproductions of the work. For an old photograph, see zpravy.idnes. cz/foto.aspx?r=zahranicni&foto1=AHA46c3d or https://www.flickr.com/photos/iesluisvelez2006-200 7/8611161396. Last accessed on December 1st, 2019.

delighted in recognizing a classical canon revived in the middle of the twentieth century. What is more, *el Caudillo* enthralled them by posing as a respectful champion of Christian faith. It cost nothing to let the artist draw inspiration from a traditional, worn-out model – and the political profit was noticeable.

Equestrian statues were another of Franco's portrait genre. More than twenty of them were erected in various cities. Bareheaded, in military uniform, with the Falange badge on his coat, *el generalísimo* raised his right arm to show the way, or ordered to attack with his baton of command. These massive structures (the one in Madrid measured eight-by-nine meters), trite imitations of antique or Renaissance sculptures, were deprived or artistic interest and more or less identical. They served to impose the impressive, overwhelming presence of *el Caudillo* on public squares, crossroads and thoroughfares. After the dictator's death posters were torn, pictures were kept in film archives, while statues remained. Polemics burst out when the government decided to take them away, some were even removed secretly, at night. Their long-lasting presence shows that effigies were not ineffective; for a few decades they served to keep alive the nostalgia of those who regretted the bright 1960s.

Such sorrow does not come as a surprise. After the hungry 1940s, years in which Spain struggled against misery and diplomatic isolation, a better period was on its way and, instead of the crusader, another Franco was put to the fore by newsreels or documentaries. The Spaniards were fond of films; in the 1960s, cinema attendance was higher in Spain than in Germany, France or the United Kingdom. Contrary to a widespread practice, the newsreels were projected at the end of the show so that spectators could not elude them, any early departure would have been noticed by the police. Yet, newsreels did not disseminate one-sided information to promote the ideological values of the regime; the topics dealt with were not much different from those current in other countries: weekly sporting events, industrial and agricultural productivity, fairs and festivals. The only distinctive feature was the recurring apparition of *el Caudillo*.

In the late 1950s and throughout the 1960s Franco was represented as the manager of a country that, taking advantage of the Marshal aid and of a rapid monetary growth provided by foreign tourism, embarked in a process of quick modernization. The dictator did not care for practicalities, he let his ministers decide which projects had priority, but he was intent on chairing the inauguration of the smallest new plant. The press and *NO.DO.* provided accounts of official unveiling and opening ceremonies during which *el generalísimo*, pressing a button, cutting a ribbon or opening a vane, set going a power-station, an assembly-line or a hydraulic-station. *El Caudillo* did not utter a word; a voiceover located the operation, commented on Franco's acts and, seizing the opportunity, set out listing unverifiable statistics that showed the exponential progress of Spanish economy.

Politicians use inaugurations to publicize their programs everywhere in the world, but there were a few Spanish peculiarities. Exceptional elsewhere, the launching ritual had become recurrent in Francoist Spain and people appreciated it because it flattered their sense of national pride. In the nineteenth century, Europe, especially Britain, had massively invested in the peninsula. Nominally, mines or enterprises were Iberian, but interests were paid to foreign banks. Many Spaniards had long lamented the backwardness of their country but, from 1950, *nacional desarrollo* (national development) became the slogan indefinitely repeated in papers, on radio and television. A busy

Spain, freed from foreign influences, was shown spending its own money to manufacture genuine, original Spanish products and Franco was the architect of such a revival.

Most heads of state laid the first stone of a building, dug the first shovelful of a future dam, while Franco took into account and set going ready to use machines. The constructors, technicians or workers did not take part in the ceremony; at best were they vaguely seen at the rear. The starting up of engines was a beginning, a coming into life, linked to the presence and gesture of the dictator whose silent cinematic image was able to put in motion an inanimate matter. Even if Franco took a distant curiosity in his country's expansion, it was none of his concern, since technical innovation did not interest him much; he associated his person with material progress and innovation. His image as a skillful executive persisted in the course of several decades and faded out slowly.

The Benevolent Grandfather

In the mid-1960s it was rumored that the Parkinson disease had affected Franco's mental faculties. The sickness was not yet severe but, obviously, the leader had changed and, understanding that he should contrive a different image, *el generalísimo* offered his admirers another self-representation. The new *Caudillo* appeared in *Franco ese hombre* (Franco, this man), a biopic directed by the filmmaker José Luis Sáenz de Heredia in 1964.[23] The dictator agreed to the making of the picture, gave Sáenz de Heredia an (appalling) interview, inserted in the movie, but was not enthusiastic about the portrait.[24] The film, distributed like an ordinary production, was nevertheless a big hit.

An introductory sequence, a montage of archival pictures, which does not refer clearly to the Civil War, recalls the black years of hardship and destructions and the return to peace – achieved thanks to the enlightened leadership of *el Caudillo*. A long passage, illustrated with photomontages, is devoted to Franco's bright military career, his campaigns in Morocco and his early promotion to the rank of general. The Civil War is briefly related by an ambassador filmed in the gleaming Spanish pavilion at the New York World Fair of 1964–1965, but no historical documents are shown. The film dwells especially on the new, prosperous, happy Spain, and *el hombre*, the man, an approachable head of state. A new image was launched: from now on Franco was to appear as a good grand-father, a pleasant, unaffected mentor, a modest Sunday-painter, a hunter and a fisherman,[25] who was fond of soccer and television like many of his fellow-citizens.

Franco ese hombre is merely a synthesis of a representation weekly diffused by newspapers, *NO.DO.* and, to a lesser extent, by television in the last decade of Franco's life. Aged, tired, *el Caudillo* went on chairing public celebrations and formal receptions, but did not care much about public affairs. His portrait had become, for

23 On *Franco ese hombre*, see Nancy Berthier, *Le Franquisme et son image. Cinéma et propaganda* (Toulouse: Presses Universitaires du Mirail, 1998).

24 He was so lucid that he thought that his interview was startling. See Carlos Prieto, "Franco, ese abuelo entrañable," *El Confidencial*, November 1, 2014.

25 It should be noted that Franco had been shot from behind. The beginning of the sequence shows him strolling hesitantly, supported by one of his bodyguards.

the majority of Spaniards, a faded icon, a touching but anachronistic record of now outdated epochs.

The Portrait, Charisma by Proxy

Some people never part with their fetish, which protects them against evil. They are not convinced that it has the power to shield them but, just in case, never leave it behind. Franco's portrait was Spain's fetish in the two decades that followed the Civil War. Many, not only among the defeated of the domestic conflict, while wishing him dead, feared the after-effects of his disappearance: would there be a second confrontation between irreconcilable factions? In the nineteenth century two royal families had waged an absurd, spasmodic, ruinous war of succession; there had been two royal abdications, two military dictatorships, two republics. An ill-developed industry had created and exploited a miserable proletariat without offering prospects to too many countrymen. The Spaniards were trapped in an atmosphere of exasperation and reciprocal hatred that led to a bloody Civil War. Franco's dictatorship, despite its backwardness and finicky bigotry was given credit for putting an end to a century of chaotic history.

In Francoist Spain, the Head of State was an enigma. One of his fervent admirers, the *falangista* journalist Ernesto Giménez Caballero, described him as "serene, undaunted, as firm as bronze, a mysterious man whom nobody knows well and truly".[26] He was authoritarian, supervised trifling details during the first decades of his dictatorship, but remained distant, inaccessible and silent. Fleeing society, distancing himself from his closer henchmen, he looked mysterious and aroused the curiosity of his contemporaries. Yet, he would have been aloof, inaccessible, had it not been for innumerable, regularly renewed portraits that made him present and relatively approachable. However strange it may seem, the case is characteristic of its epoch, the middle of the twentieth century. It would have been unimaginable before, when newsreels were scarce, technically unsophisticated and deprived of sound, when illustrated papers were extremely expensive and radio in its infancy. Later, it would have survived neither the intrusiveness of television nor the inquisitive nosiness of digital media. During a limited period, some four decades, plenty of excellent images were circulated in the press and in films, but there were not lots of them such that it was easy to control them.

For lack of a familiar, approachable leader, the Spaniards became acquainted with a name and a likeness, an omnipresent and incorporeal portrait. *El Caudillo* was a principle, an image, bearing a simple message: protection for good citizens, punishment for the bad ones. With the passing of time the picture changed, the dictator became pragmatic, came even to be domestic, while remaining disembodied. His immateriality made him reassuring. An image glided over the country, and since images do no harm, Franco's portrait guaranteed a burdensome calmness that, all things considered, was better than a domestic conflict.

26 *Memorias de un dictador* (Barcelona: Planeta, 1979), 13.

Figure 7.1 Screenshot from *NO.DO.*, n. 124, 1945.

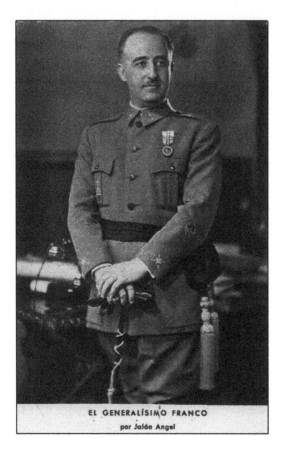

Figure 7.2 Official portrait of Franco by Jalón Ángel, 1939. Postcard.

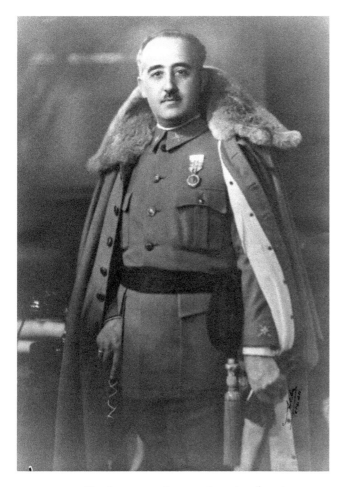

Figure 7.3 Official portrait of Franco by Jalón Ángel, 1939. Postcard.

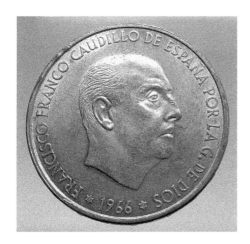

Figure 7.4 Medal with Franco's portrait, 1966.

Bibliography

Basilio, Miriam. *Visual Propaganda, Exhibitions and the Spanish Civil War*. Farnham: Ashgate, 2014.

Bonet Correa, Antonio, and Gabriel Ureña. *Arte del franquismo*. Madrid: Catedra, 1981.

Box, Zita. *España año cero. La construcción simbólica del franquismo*. Madrid: Alianza, 2010.

Cabezuelo Lorenzo, Francisco. "Una mirada mediática a la España franquista a través del cine de Sáenz de Heredia." In *La imagen del franquismo a través de la séptima arte: cine, Franco y posguerra*, edited by Gonzálvez Vallés and Juan Enrique, 21–39. Madrid: Visión Libros, 2012.

Calero, Francisco. "La representación del 'enemigo' en la propaganda escrita de la *España nacional*." *Cultura Escrita y Sociedad* 6 (2009): 79–101.

Di Febo, Giuliana. *Ritos de guerra y Victoria en la España franquista*. Bilbao: Desclée, 2002.

García Sánchez, Jesús. "Sellos y memoria: la construcción de una imagen de España." *Studia Historica: Historia Contemporánea* 25 (2007): 37–86.

Lafuente Ferrari, Enrique. *La vida y el arte de Ignacio Zuloaga*. Barcelona: Planeta, 1990.

Lloriente, Ángel. *Arte e ideología en el franquismo (1936–1951)*. Madrid: Visor, 1995.

Moreno Martin, Francisco J. ed. *El franquismo y la apropiación del pasado. El uso de la historia, de la arqueología y de la historia del arte para la legitimación de la dictatura*. Madrid: Pablo Iglesias, 2017.

Navarro Oltra, Guillermo. "Generalísimo Franco en los sellos postales." In *Autorretratos del estado. El sello postal del franquismo*, edited by Guillermo Navarro Oltra, 20–45. Cuenca: Ediciones de la Universidad de Casuntila-La Mancha, 2013.

Preston, Paul. *Franco: A Biography*. New York: Basic Books, 1994.

Rodríguez Terceño, José. "*Sin novedad en el Alcázar*, El filme de la revolución constructiva." In *La imagen del franquismo a través de la séptima arte: cine, Franco y posguerra*, edited by Juan Enrique Gonzálvez-Vallés et al., 213–61. Madrid: Visión Libros, 2012.

Sanchez, Antonio. *Francisco Franco: una vida en imágenes*. Madrid: Libsa, 2008.

Sanchez-Biosca, Vicente. "Materiales para una iconografía de Francisco Franco." Special issue of *Archivos de la filmoteca* 42–43 (2003).

Sevillano Zenobi, Laura. *La construcción del mito de Franco: de jefe de la Legión a Caudillo de España*. Madrid: Cátedra, 2011.

8 The Face of the Regime

Political Portraiture in the Soviet Union and Russia

Graeme Gill

When the Bolsheviks came to power in 1917, they espoused an ideology that saw the mainspring of historical development to lie in class struggle. Deep material forces were the prime movers of change, with no place in this conception for the "great man" theory of history. Individuals acted only within the constraints of the material environment within which they were found. While this philosophy may have been an appropriate set of ideas animating the professional revolutionaries that frequented the cafes of pre-1917 Western Europe, it was not well suited to a new regime seeking to establish its bona fides with a largely peasant population that showed few signs of welcoming its accession to power. In a society where, traditionally, authority had been personified by the figure of the tsar, personalized symbols of authority were likely to be more effective than appeals to obscure theoretical principles. Furthermore for many of those within the communist party, the events of 1917 had shown the potency of individual agency; they knew that power would not have been gained had it not been for the party leader Vladimir Lenin and his ability to push the party to act in October.

Accordingly, from the outset, they sought to generate personal symbols that would validate the regime. One of the earliest manifestations of this was Lenin's plan to erect monuments to sixty-eight revolutionary forebears along some of Moscow's main thoroughfares, but this plan was never completed, undermined by the poor quality of the initial statues and by a decline in enthusiasm for the project.[1] More important, both at the time and in a continuing sense, was the iconography that occurred on political posters. Posters were a potent form of political propaganda in a society where literacy levels were low, and the new regime spent considerable efforts on the production and dissemination of these visual images. While much of this focused on workers and

1 On this see John E. Bowlt, "Russian Sculpture and Lenin's Plan of Monumental Propaganda" in *Art and Architecture in the Service of Politics*, eds. Henry A. Millon and Linda Nochlin (Cambridge, MA: The MIT Press, 1978); Christina Lodder, "Lenin's Plan of Monumental Propaganda," *Sbornik* 6–7 (1981): 67–82; Brandon Taylor, *Art and Literature Under the Bolsheviks. The Crisis of Renewal 1917–1924* (London: Pluto Press, 1991). Most of Lenin's photographs were taken by Pyotr Otsup (1883–1963), who had covered the Russian Revolution and was, from 1918 to 1935, the Kremlin's photographer. See *Soviet Photography, 1917–40: the New Photo-Journalism*, eds. Sergei Morozov and Valerie Lloyd (London: Orbis, 1984), 16–27; and Evgenii Berezner, Elena. E. Koloskova and Irina Tchmyreva, *Petr Otsup: Prostranstvo revoliutsii: Rossiya, 1917–1941* [Pyotr Otsup: The Space of Revolution: Russia, 1917–1941], (Moscow: Golden-Bi, 2007).

peasants,[2] there was also a focus on the projection of images of the new state's leaders, especially Lenin.

From 1918, Lenin's image was reproduced in a variety of formats, including posters, postcards and leaflets (Figure 8.1).[3] Lenin always appeared wearing a suit and tie; when he was shown with something on his head, this was often a worker's cap, something he had never worn while in exile.[4] For the remainder of his life, Lenin's image was a frequent presence in the press and on posters, banners and other forms of propaganda as the Bolsheviks sought to give a personal face to the regime in these times of military, economic and political crisis. The photographs taken in the late years of his life showed no evidence of his health problems. But it was following his death in January 1924 that the image of Lenin gained significant political potency.[5]

With Lenin's death, his successors made a conscious decision to utilize the former leader as a symbol both for the regime in general and, in a narrower form, as the touchstone of political orthodoxy within the party. The centerpiece of the emergent cult of Lenin was the placing of his preserved body in a specially constructed mausoleum by the Kremlin wall on Red Square. An act with resonance to the treatment of saints in the Orthodox Church, this placing of his body on permanent public display identified the regime and what it stood for with the dead leader.[6] Through posters, pictures, postcards, banners and every other conceivable means of producing the image (including on domestic items like plates, rings, boxes and kerchiefs[7]), portraits of Lenin were to be found throughout the country. His image was also a central factor in the political struggles following his death.

With Lenin's incapacitation in 1922, the struggle to succeed him began among the Bolshevik oligarchs, and the image of Lenin became a vital part of that struggle. Each side in the successive disputes within the party elite during the 1920s sought to present themselves as the closest to Lenin and the truest to his beliefs and ideals. In large part this struggle was carried out at the level of doctrine and ideas, with each of the main protagonists in the struggle professing their adherence to Lenin and trying to show how they were the one most aligned with his thoughts. The whole policy discussion was caught up in this paradigm of Lenin as the source of orthodoxy. But images were also important. The best instance of this was the famous picture showing Stalin sitting with Lenin at Gorky in September 1922 (Figure 8.2). This photograph, taken by Lenin's sister Maria Ulyanova, was published in an illustrated supplement to the

2 For discussions of early posters, see Stephen White, *The Bolshevik Poster* (New Haven: Yale University Press, 1988); Victoria E. Bonnell, *Iconography of Power. Soviet Political Posters under Lenin and Stalin* (Berkeley: University of California Press, 1997); Graeme Gill, *Symbols and Legitimacy in Soviet Politics* (Cambridge: Cambridge University Press, 2011), 33–6.

3 Olga Velikanova, *Making of an Idol: On Uses of Lenin* (Göttingen: Muster-Schmidt Verlag, 1996): 30. For an expanded treatment, see Ol'ga Velikanova, *Obraz Lenina v Massovom Vospriyatii Sovetskikh Lyudei po Arkhivnym Materialam* [The Public Perception of the Cult of Lenin Based on Archival Materials], (Lewiston: The Edwin Mellen Press, 2001).

4 Prior to 1917 he tended to wear a bowler or the sort of hat normally worn by bourgeois men of the time. Velikanova, *Making of an Idol*, 39–40.

5 On its ubiquity in the 1920s, see Gill, *Symbols and Legitimacy*, 82.

6 On the body in the mausoleum, see Velikanova, *Making of an Idol*, 163–253; Nina Tumarkin, *Lenin Lives! The Lenin Cult in Soviet Russia* (Cambridge [Mass]: Harvard University Press, 1983), 207–51.

7 Velikanova, *Making of an Idol*, 30–1.

party newspaper *Pravda* on September 22, 1922[8] and thereby gained national coverage. This image of Stalin being close to Lenin would have been unlikely to persuade members of the Bolshevik elite who knew of the true nature of their pre-revolutionary relationship, but it may have been appealing to those below the elite in the Central Committee and regional party leaderships who were influential in resolving the successive leadership disputes. In any event, Stalin was more successful than his competitors when it came to conjuring up the image of closeness to Lenin. From this time, personal image was central to the projection of authority within the Bolshevik elite.

The Stalin Cult

From the cult's inception until Stalin's death in March 1953, the regime's symbolic message was dominated by the figure of Stalin. This does not mean that he was the only figure to appear in the regime's iconography. Other leaders – like Lazar Kaganovich, Mikhail Kalinin and Vyacheslav Molotov who were all leading figures in the communist party and in the government – had smaller cults of their own, reflected in pictures, excessive praise and the quoting of their words, and in areas outside the capital, local leaders were often also promoted in this way. However, all of these were minor compared with the cult of Stalin, and in large part constituted subordinate strands of the overall leader cult. The figure of Stalin dominated all branches of the mass media, especially from mid-1933. This domination fluctuated over time, but generally the trajectory was upwards in terms of both saturation of the media[9] and the exaggerated nature of the claims being made for him. The chief visual signifiers of the cult were photographs and line drawings in the press, mass-produced posters, paintings, banners, statues and reproductions of his words.

The cult burst onto the scene at the time of the celebration of Stalin's fiftieth birthday in December 1929.[10] As the cult developed, considerable effort was made to present a consistent image of the leader through prescriptive regulations on how he was to be shown in the press.[11] In the depiction of Stalin, the nature of the Soviet press is significant. The media, both printed and spoken, was controlled by the party, which thereby could determine what was printed and said. This means that, in the press, only

8 There has been much discussion about whether this photograph was falsified to insert Stalin when he was not actually present, but this seems to be false. On publication of the picture, see Stephen Kotkin, *Stalin*. Volume 1. *Paradoxes of Power, 1878–1928* (New York: Penguin, 2014), 417.

9 For statistics on the visual representation of Stalin in *Pravda*, see Jan Plamper, *The Stalin Cult. A Study in the Alchemy of Power* (New Haven: Yale University Press, 2012), 227–33. For analysis of how Stalin appeared in *Pravda* 1929–1953, Ibid., 29–86.

10 Robert C. Tucker, "The Rise of Stalin's Personality Cult," *American Historical Review* 84, 2, 1979: 347–66; Graeme Gill, "Political Myth and Stalin's Quest for Authority in the Party," in *Authority, Power and Policy in the USSR. Essays dedicated to Leonard Schapiro*, eds. T. H. Rigby, Archie Brown and Peter Reddaway (London: Macmillan, 1980): 98–117.

11 Benno Ennker, "'Struggling for Stalin's Soul': The Leader Cult and the Balance of Social Power in Stalin's Inner Circle" in *Personality Cults in Stalinism*, eds. Klaus Heller and Jan Plamper (Göttingen: V&R Unipress, 2004), 166. On the organization of the production of the cult, see Plamper, *The Stalin Cult*, 33–4 and Part Two.

images that had been approved by the authorities could be published, and this enabled them to shape the images of which the cult consisted.[12]

The cult sought to present Stalin as the central figure in the regime.[13] Ultimately he was shown as being responsible for everything that happened in the Soviet Union, from the achievement of power in 1917, through the building of socialism and the destruction of enemies, victory in the war over Nazi Germany, and the happy and fruitful lives enjoyed by all Soviet citizens; it was Stalin around whom the Soviet Union turned. The legitimation of the regime stemmed from the figure of Stalin.

An important form of visual imagery was the picture of Stalin as the leader. Sometimes this would just be a formal portrait of Stalin alone. This was the typical representation of Stalin on each tenth anniversary of his birth – 1929, 1939 and 1949. But such portraits, copies of which hung in all Soviet offices, were not restricted to his celebration days; they appeared throughout the year.[14] Unlike Lenin, Stalin was never shown wearing a suit. Prior to the war, he was shown in military-style tunic and breaches, perhaps reflecting the image that he was of humble origin. From 1942 the military-style uniform he wore changed, swapping trousers tucked into high boots for parade trousers and normal shoes.[15] When he became Generalissimo in June 1945, he was sometimes shown in formal military uniform (Figure 8.3), often white to distinguish him from his colleagues.

Generally images were doctored to avoid showing any physical defects. The most important of these was the pock marks on his face, which were usually brushed out of the picture. There were also few signs of aging until the war. However when the war broke out, representations of him began to show signs of the aging process, perhaps to signify maturity, understanding and concern at the danger the country faced; the initial picture following the German attack showed him as having crow's feet around the eyes, while eight months later he developed a deepening wrinkle across his brow.[16] Subsequently he was shown with greying hair and moustache,[17] although he was always shown as upright and there was never a hint of physical weakness.

As well as being shown alone, he was also often shown with other leaders,[18] but he was distinguished from them in a number of ways.[19] In a group, Stalin was normally placed in the middle, with the others ranged on either side. Sometimes his clothing

12 An important instance of this is the way that photographs were doctored to remove people who had fallen into disgrace, been removed or killed. For this see David King, *The Commissar Vanishes. The Falsification of Photographs and Art in Stalin's Russia* (London: Canongate Books, 1997).

13 As well as those sources cited above, on the cult and its images see Jeffrey Brooks, *Thank You, Comrade Stalin. Soviet Public Culture from Revolution to Cold War* (Princeton: Princeton University Press, 2000); *The Leader Cult in Communist Dictatorships. Stalin and the Eastern Bloc*, eds. Balazs Apor et al. (Basingstoke: Palgrave, 2004); Anita Pisch, *The Personality Cult of Stalin in Soviet Posters, 1929–1953. Archetypes, Inventions and Fabrications* (Canberra: ANU Press, 2016).

14 For a study of the pattern across the year, in this case 1947, see Plamper, *The Stalin Cult*, 60–75.

15 For details, see Ibid., 54. Also see the posters reproduced in Pisch, *The Personality Cult*.

16 Respectively, *Pravda* June 23, 1941 and February 15, 1942, Plamper, *The Stalin Cult*, 52–3.

17 For example, see the images by Boris Karpov and Irakli Toidze, respectively *Pravda* May 1, 1945 and May 1, 1946, reproduced in Ibid, 56 and 131.

18 Including as a pall bearer when others died. For example, see *Pravda* December 7, 1934 (Kirov) and June 21, 1936 (Gorky), reproduced in Ibid., 43.

19 Ibid., 38–9.

distinguished him, being either light when the others' was dark or vice versa,[20] and sometimes he appeared larger than his colleagues. In some photographs he appeared motionless while his colleagues were moving, and his gaze was inevitably directed outside the picture, not at his colleagues. When he was represented speaking to groups, the audience was almost invariably shown as giving him their rapt attention.

An important theme in the representation of Stalin was to associate him with Lenin. Over time, this association underwent change, with its most important aspect being the elevation of Stalin into a position of greater importance than Lenin.[21] Visually, when depictions of the two were reproduced, Lenin was usually placed on the left, Stalin on the right, or dominant, side.[22] Stalin was often shown before a background of an image of Lenin on a banner, or of Lenin's head and shoulders ethereally floating in the air behind him.[23] Sometimes Stalin was shown shadowed by Lenin,[24] or both were shown working for victory in October and the achievement of communism.[25] The association with Lenin was an important continuing theme throughout the Stalin period, although it was less prominent than the link between Stalin and success, which was the core theme of the cult.

Stalin was portrayed as the reason for all successes achieved in the building of socialism. This was particularly prominent from the mid-1930s until the war. Stalin was, for example, portrayed with arm outstretched toward the future[26] or carrying out his responsibilities, such as steering the ship of state,[27] working late at night in his office[28] or planning,[29] often with a major achievement (like a dam or a factory) in the background. Posters gave more scope than photographs to directly and immediately associate Stalin with the achievements of the regime and with the mobilization of efforts to achieve particular goals. This was not just because written messages could be included on posters, but through graphic illustration Stalin could be juxtaposed with the particular achievement. Posters were a potent way of linking Stalin with the successful march toward socialism, and could conjure up an imaginary future in the

20 For example, see the picture from *Pravda* June 6, 1924, reproduced in Ibid., 39.

21 On the way in which the relationship between the two was shown over time, see Pisch, *The Personality Cult*, 136–51, 166–89.

22 Plamper, *The Stalin Cult*, 41; Pisch, *The Personality Cult*, 144.

23 For example, respectively, see two posters of the same name by A.I. Madorskii, "Byt' takim, kakim byl VELIKII LENIN" [Be as GREAT as LENIN Was], 1938 and 1939, reproduced in Pisch, *The Personality Cult*, 174–5.

24 For example, Gustav Klutsis, "So znamenem lenina ..." [With the Banner of Lenin ...] 1933, reproduced in Pisch, *The Personality Cult*, 170.

25 For example, Viktor Govorkov, "Vo imya kommunizma" [In the Name of Communism] 1951, reproduced in Aleksandr Snopkov, Pavel Snopkov and Aleksandr Shklyaruk, *Shest'sot plakatov* [Six Hundred Posters] (Moscow: Kontakt-kultura, 2004), 132.

26 For example, see the poster by Irakli Toidze, "Vpered, k novym pobedam sotsialisticheskogo stroitel'stva" [Forward, to New Victories of Socialist Construction], 1946, reproduced in Pisch, *The Personality Cult*, 408.

27 Boris Efimov, "Kapitan Strany Sovetov vedet nas ot pobedy k pobede!" [The Captain of the Country of Soviets Leads Us from Victory to Victory], 1933, reproduced in Snopkov et al., *Shest'sot plakatov*, 34.

28 Viktor Govorkov, "O kazhdom iz nas zabotitsia Stalin v Kremle" [Stalin in the Kremlin Cares about Each of Us], 1940, reproduced in Ibid., 38.

29 Viktor Govorkov, "I zasukhu pobedim!" [And We Will Defeat Drought!], 1949, in Ibid., 42.

way that photographs could not as yet do. A similar message of success was evoked in relation to the war, but only from 1943 when victory seemed assured.[30]

Prior to the war, Stalin was also often shown with groups of adoring people. Arctic explorers, record-breaking aviators, "stakhanovites" (workers who had exceeded their work norms) were all pictured with Stalin,[31] with the message that they owed their achievements to Stalin. In practice, Stalin rarely ventured outside the Kremlin except to go to his dacha. He did not visit factories or farms nor any other places where he might have come into contact with any of the people over whom he ruled, although he was sometimes shown with ordinary delegates at party meetings or with delegations that visited the Kremlin. However, this deficiency could be overcome in posters, where he could be presented in the company of his adoring subjects, and, importantly, the depiction of those subjects could be arranged to send a particular message. Stalin could be shown with children[32] (Figure 8.4), or with shock workers[33] or, with people of Asian ethnicity.[34] In these cases, Stalin generally overshadowed others depicted in the posters. He was truly the "father of his people", working endlessly for their benefit and responsible for the "happy childhood" enjoyed by Soviet youth.[35] Their realization of this was reflected in the love and admiration that they were shown as extending to him.[36]

After the war, Stalin ceased to appear accessible to the people; he was more remote, rarely shown with ordinary people, and an image that involved a kind of "implied presence" became common. Stalin did not physically appear in the image, but his presence was denoted by the appearance or actions of those who were in the picture. An example is Dmitry Mochalsky's painting of 1949 entitled *After the Demonstration (They Saw Stalin)*. This shows people crossing a bridge, with entranced and joyful looks on the faces of the children.[37] Other types of this genre could involve people gathered around a radio set listening to Stalin speak[38] or individuals obviously carried away by what they were reading in something written by Stalin. This sort of image talks to Stalin's power without having to actually show him.

The basic intent of cultist imagery was to project Stalin into the central legitimating structures of the regime: revolution in 1917, Lenin, and the achievement of communism, which involved principally industrialization, improved material conditions for the populace and a comfortable standard of living. The successful move toward

30 Gill, *Symbols and Legitimacy*, 141–53; Pisch, *The Personality Cult*, 312–41.

31 Plamper, *The Stalin Cult*, 39–41.

32 For example, see Nikolai Zhukov, "Thank you comrade Stalin for our happy life!," 1940, reproduced in Pisch, *The Personality Cult*, 281. For some photographs, see Plamper, *The Stalin Cult*, 44–5.

33 For example, Genrikh Futerfas, "Stalintsy! Shire front stakhanovskogo dvizheniya!" [Stalinists! Widen the Front of the Stakhanovite Movement], 1936, reproduced in Pisch, *The Personality Cult*, 83.

34 For example, Vartan Arakelov, "Stalin – the Wisest of People," 1939, reproduced in Ibid., 263. In this case Stalin is represented by a statue.

35 Ibid., 227–37.

36 On Stalin as the father, see Ibid., 225–46.

37 This is reproduced in Plamper, *The Stalin Cult*, 115. It is to be found in the State Tretyakov Gallery, Moscow.

38 For example, the painting *The Voice of the Leader* by Pavel Sokolov-Skalya reproduced in *Sovetskoe iskusstvo* May 21–2, 1948: 1. The first instance of this was a picture in *Pravda* December 12, 1937 entitled "The Whole Country Listened to Stalin," reproduced in Plamper, *The Stalin Cult*, 60.

communism was the central strand of the regime's metanarrative.[39] This was a teleological metanarrative, justifying current action in terms of future achievements and placing Stalin at the center of this. However, by suggesting that all successes and achievements were a result of Stalin's leadership, the message of the cult could be seen to be that Stalin was more important than the teleological aim of communism. It was almost as though the successes achieved in socialist construction were important because they were evidence of the wisdom and knowledge of comrade Stalin rather than being the transcendent purposes for which the system had been created. This sort of displacement created a problem when Stalin died.

After the Stalin Cult

Following the death of Stalin in 1953, the Khrushchev-led leadership sought to address this legitimation problem. There were three strands to the attempt to rework the legitimation narrative: destruction of the Stalin cult, re-energization of the Lenin cult, and the development of a cult around the new leader, Nikita Khrushchev. All involved the manipulation of visual symbols. The process of destalinization began as soon as Stalin died, although its most momentous episodes came in 1956 and 1961 when Khrushchev openly denounced Stalin. From the time of Stalin's death, his picture and name virtually disappeared from the Soviet press.[40] No longer was his name invoked as justification for policies, and the history of the regime was gradually revised to not only reduce his role but by the late 1950s to actually remove it completely from the narrative. Stalin disappeared as the figure that dominated Soviet public space. As the high point of this attack, in 1961 Stalin's body was removed from the Red Square mausoleum it had shared with Lenin since 1953, and was placed in a grave behind the mausoleum and marked by a simple plaque (replaced by a bust on the grave in 1970). After 1956, Stalin's image could no longer play a role in regime legitimation.

In its place, the regime sought to promote the Lenin cult. The earlier focus on Lenin as the state leader remained, but under Khrushchev a new emphasis upon Lenin as a normal man enjoying personal relations with a range of ordinary people appeared. Stimulated by an October 1956 party decision on the promotion of the cult,[41] a wave of books, periodicals, brochures, paintings and posters appeared showing Lenin as a normal human being. He was also shown increasingly as someone who cared for the Soviet people, particularly its youth. Significant emphasis was placed upon images of him with children, a somewhat paradoxical image as he did not have children himself

39 On the metanarrative, see Gill, *Symbols and Legitimacy*.

40 Postage stamps were issued with his image on the first anniversary of his death, and on a few occasions after that. He had appeared on stamps only sparingly during his life, and mostly these were not portraits but either showing him together with Lenin or scenes with him in them. Throughout the Soviet period, there was only one commemorative issue devoted to him, on his seventieth birthday in 1949. In contrast, Lenin appeared on a stamp on many occasions, including anniversaries of his birth and death and of the October revolution. He often was shown in portrait form. *Katalog pochtovykh marok 1857–1960. Rossiya, RSFSR, SSSR* [Catalog of Postage Stamps 1857–1960. Russia, RSFSR, USSR] (St Petersburg: Standart-Kollektsiya, 2004). Also see Alexander Kolchimsky, "Stalin on Stamps and Other Philatelic Materials: Design, Propaganda, Politics," *The Carl Beck Papers in Russian and East European Studies*, no. 2301, August 2013: 1–77.

41 This decision is reprinted in *Spravochnik partiinogo rabotnika* [Handbook of the Party Worker] (Moscow: Gospolitizdat, 1957), 364, cited in Velikanova, *Making of an Idol*, 130.

and did not give them any attention in his writing.[42] He came across not just as the dedicated revolutionary seeking to build a new society for all, but as "uncle Il'ich" the kindly figure who was always concerned for the needs of the youth.[43] This more human image marked a dramatic change from the Stalin cult not only in terms of the identity of the principal (i.e. Lenin rather than Stalin), but also of the nature of the figure portrayed: the distant, aloof state leader dressed in a military-style uniform compared with the kindly, avuncular figure always in a suit, often surrounded by ordinary people.

A cult of Khrushchev the leader also appeared at this time, but it was much more modest than that of Stalin had been in terms of both its saturation of the press and the sort of claims made for its principal. In official pictures, Khrushchev was usually shown in a jacket and tie, often a hat and sometimes bemedaled. No attempt seems to have been made to hide the appearance created by his short, squat stature and ill-fitting clothes. But in a development similar to that noted above with regard to Lenin, the sort of official images concentrating on the leader were now supplemented by a wider range of images. In part this reflects the fact that as a leader, Khrushchev was more outgoing and gregarious than Stalin. Khrushchev travelled abroad to Europe, Asia and America, and he frequently travelled in the Soviet Union; many of these visits were to factories and collective farms where he liberally dispensed advice to the surrounding workers/farmers (Figure 8.5). All of these sorts of trips were captured on film: the leader leaving from or arriving back at the airport in Moscow, meeting foreign leaders,[44] discussing issues with ordinary people.

While these different images reflect the different patterns of the two leaderships, they also show an attempt to project a different image of what it means to be a leader, and one more in tune with the focus in the contemporary metanarrative on the satisfaction of material needs as the touchstone of the move toward communism, and thereby regime legitimation. Khrushchev appeared as the down-to-earth leader who rolled up his sleeves and got on with the job. The aloofness and distance which was such a characteristic of the late Stalin image was replaced by a contrasting earthiness and gregariousness that fitted with the new emphasis on linking regime legitimation with communism defined in terms of material improvement. Indeed, the enduring image of Khrushchev standing in a field of wheat seemed to encapsulate what the leader represented. But this was not necessarily a positive image in the eyes of many; the leader interested and involved in agricultural issues could easily be transformed into the cornstalk or rural hick. And in the eyes of many Soviet citizens, this was how Khrushchev came to be seen.

The overthrow of Khrushchev in 1964 and his replacement by Leonid Brezhnev led to yet another image of leadership. It was also associated with an expansion of the

42 Although his wife Nadezhda Krupskaya was very active in education and children's issues. For this focus on Lenin, see Gill, *Symbols and Legitimacy*, 166–9.

43 On his links with the Young Pioneers movement, see the poster by Maria Marize-Krasnokutskaya, "Torzhestvennoe obeshchanie yunogo pionera sovetskogo soyuza" [Solemn Oath of the Young Pioneer of the Soviet Union], *Soviet Posters. The Sergo Grigorian Collection* (Munich: Prestel Verlag, 2007), 180.

44 Of course Stalin was photographed on occasion with foreign dignitaries, including with some emissaries to Moscow during the war, and with the allied leaders at the wartime summits in Tehran, Yalta and Potsdam, but this was unusual.

Lenin cult, especially leading in to the centenary of his birth in 1971 and stimulated by the fiftieth anniversary of the revolution in 1967, and by a build-up of emphasis upon the Second World War and the Soviet role in its successful prosecution as a source of regime legitimacy.[45] This focus was linked with the emergent leader cult of Brezhnev.

The Brezhnev cult was much less extensive than that of Stalin, but more developed than that of Khrushchev. It was linked with these two foci on Lenin and the war by two mechanisms. The first was by referring to Brezhnev simply by his patronymic, Il'ich. This was the same patronymic as Lenin, and by employing this form of address, it sought resonance with the Lenin cult. Second, significant emphasis was given to Brezhnev's volumes of war memoirs. These slim volumes[46] were accorded lavish praise and were given literary awards, and directly associated Brezhnev with the developing narrative of the war. This was reinforced by the publication at the front of the volumes of an enhanced picture of Brezhnev (by the time of publication he had suffered a stroke and was showing signs of aging, but none of this was registered in the photograph) wearing military-style medals. The depiction of Brezhnev wearing medals became a common theme the longer he ruled. He seemed to have a penchant for these awards, and in some photographs and official portraits toward the end of his life, virtually the whole left side of his chest plus part of the right was covered in medals (Figure 8.6).[47]

On most occasions, Brezhnev was depicted well-groomed and dressed in a suit. This was the case for official portraits, but this was also the style when he was shown working in his office or meeting with foreign leaders. The latter format, meeting with foreign dignitaries, became more prominent over time as Brezhnev became increasingly involved in foreign affairs. Even when he visited factories or farms, and like Khrushchev he was often shown in this way, Brezhnev was usually shown wearing a jacket and a tie. Rarely was he shown informally in the mass media, although in volumes devoted to his life (such as that issued in honor of his seventy-fifth birthday),[48] pictures were reproduced of him relaxing with family and friends.

Brezhnev's image also appeared on some posters as well as on banners hanging from buildings or carried on the annual May Day or celebration of the October Revolution parades through Red Square. The normal form here was a head and shoulders shot of Brezhnev, often delivering a speech or gazing fixedly into the bright future.[49] The image of Brezhnev contrasted with that of Khrushchev; if Khrushchev had seemed like a displaced peasant, Brezhnev appeared as urbane, well-dressed, perhaps even sophisticated. This tapped into the continuing emphasis on regime legitimacy in terms of

45 On this see Nina Tumarkin, *The Living and the Dead. The Rise and Fall of the Cult of World War II in Russia* (New York: Basic Books, 1994); Gregory Carleton, *Russia. The Story of War* (Cambridge MA: The Belknap Press, 2017), esp. 80–113.

46 The works were entitled *Malaya zemlya* [Small Land] (Moscow: Izdatel'stvo politicheskoi literatury, 1978) and *Vozrozhdenie* [Rebirth] (Moscow: Detskaya literatura, 1979).

47 For example see the photograph on May 9, 1981 (i.e. Victory Day), reproduced in V.A. Golikov, *Leonid Il'ich Brezhnev. Stranitsy zhizni i deyatel'nosti (fotodokumenty)* [Leonid Il'ich Brezhnev. Pages from His Life and Activities (Photodocuments)] (Moscow: Izdatel'stva planeta, 1981), 222.

48 See, for instance, Ibid.

49 For one example of him giving a speech, see the poster by Nikolai Popov, "Tak poidem zhe smelo vpered, po puti, bedushchemy k kommunizmu!" [Thus We Walk Boldly Forward, Along the Path to the Future Communism!], 1981, Snopkov et al., *Shest'sot plakatov*, 51.

the creation of a society in the age of the much-heralded "scientific and technological revolution", with Brezhnev seeming to be the epitome of this.

One feature of the image of Brezhnev in the last seven to eight years of his life is that while the still pictures did show Brezhnev as aging, they gave no hint of the illness that afflicted him. From the mid-1970s, Brezhnev was ailing, characterized by, in the words of two scholars, "[A]n inability to work full-time, a tendency to embarrass officials on trips abroad, and the lack of understanding of complex policy matters."[50] None of this was reflected in photographs. However by this time, television had become much more widely used in the Soviet Union, so that many of his activities were shown via this medium, and this could not hide some of these problems. The effect of this was to increase cynicism among the populace about Brezhnev's leadership.

A similar situation applied with the two short-term leaders in 1982–1985, Yuri Andropov and Konstantin Chernenko. Both were elderly and ailing when they came to the leadership; Andropov was actually in hospital for the last eight months of his life and did not appear in public at this time. Nevertheless the official portraits, which had always been modified to show a pure and unblemished image of leadership (Figures 8.7–8.8), were used in the press for both figures, but again the effect of these was undermined by television: the absence of Andropov and the infirmity of Chernenko, especially toward the end, were obvious.

This image of the old and infirm leader disappeared when Mikhail Gorbachev came to the leadership in 1985. Although the official portrait remained the staid sort of representation evident from earlier times (and in at least one case, the picture was re-touched to erase the birthmark on Gorbachev's head) (Figure 8.9), both photographs and television coverage of Gorbachev at work could not fail to give the impression of a vigorous leader actively pursuing a political agenda. Both the printed image and that conveyed by television depicted Gorbachev as in charge and, in his meetings with ordinary people, actively involved in seeking their opinions. Another new aspect of the image of Gorbachev was the way in which his wife, Raisa, was given a prominent place at his side. Previous leaders' wives had little media profile, but Gorbachev's wife did, projecting him as a very different type of leader to his predecessors. This was also evident in Gorbachev's order prohibiting the display of his portrait in government offices,[51] something that had been the norm under all previous leaders. The image of Gorbachev thus chimed with his message of renovating the USSR, while pictures of him relaxed in the company of world leaders were designed to add luster to this image (Figure 8.10).

However, during the Gorbachev period, the state's monopoly on the media disappeared. As time passed, increasing numbers of independent publications began to appear and some established state outlets began to act in ever more independent ways. This meant that the regime lost control over the images that were projected, with the result that both the regime's leading figure and its principal symbolic emblems began to be treated as objects of popular fun and even scorn and derision. The image of Lenin was still evident in some of the regime's visual symbolic discourse (e.g. his statue as a backdrop to speakers at party meetings), but it began to decline in significance as Gorbachev's policies drove the society further away from the established communist

50 Edwin Bacon and Mark Sandle, "Brezhnev Reconsidered" in *Brezhnev Reconsidered*, eds. Edwin Bacon and Mark Sandle (Basingstoke: Palgrave Macmillan, 2002), 206.

51 Anatoly S. Chernyaev, *My Six Years with Gorbachev* (University Park: The Pennsylvania State University Press, 2000), 24.

model.[52] And as elites in the non-Russian republics began to press for greater auton-omy and then independence, the figure of Lenin was used by those people as a symbol against which they sought to mobilize the citizenry. From a positive icon, for many he became a negative signifier of Soviet oppression. The figure of Gorbachev became an object of criticism for his opponents, and as the Soviet Union staggered to its collapse, the authority vested in such symbols drained away.

Independent Russia

With the collapse of the Soviet Union, the landscape changed fundamentally. The icons of Soviet rule, including Lenin, disappeared from the public space.[53] The rise of an independent media meant that management of the images of the president was no longer possible. Official portraits of the successive presidents – Boris Yeltsin (1991–1999), Vladimir Putin (2000–2008 and 2012 to date) (Figure 8.11) and Dmitry Medvedev (2008–2012) – remained in much the same form they had during the Soviet era: a head and shoulders shot of the president wearing a suit and gazing fixedly either into or beside the camera. However, with more independent journalism and active and independent television, the state could not monopolize the way the president was presented. Nevertheless the image that the state sought to project of the two main presidents, Yeltsin and Putin, differed.

Yeltsin's role in the collapse of the coup mounted in an attempt to overthrow Gorbachev in August 1991 provided the basis to present him in charismatic guise, as someone leading his people into a bright future.[54] An instance of this was a poster from the 1996 presidential election which depicted him standing at the microphone with an upraised fist under the slogan "We are together."[55] But in most cases, photographs of Yeltsin showed him dressed in a suit and at work, or meeting with foreign dignitar-ies, Russian officials, or members of the populace. In the first part of the 1990s, there seems to have been a greater attempt to show Yeltsin as in tune with ordinary people and meeting with them than there was later in the decade when he was ailing. His meetings with members of the populace and the shots of him dancing with young go-go dancers during the 1996 campaign (Figure 8.12) were designed to emphasize his youthful vigor. So too were the photographs of him playing tennis, which appeared mainly in the first half of the decade.

The problem was that the television also picked up the deficiencies in this image. With his serious health problems in the second half of the 1990s clearly affecting his capacity to function effectively as a president, and his drinking problem causing his behavior at times to be erratic and embarrassing, the image of the serious, sober states-man that he sought to cultivate was undermined. The official image was undercut by

52 Jutta Scherrer, "L'érosion de l'image de Lenine" *Actes de la Recherche en Sciences Sociales* 85, 1, (1990): 54–69; Velikanova, *Making of an Idol*, 140–4.

53 A qualification is needed here. Much of the Soviet visual symbolism remains in Russian cities, including a number of statues of Lenin in public parts of Moscow. And of course his body remains in the Red Square mausoleum.

54 His role in the clash with the parliament in October 1993 was more problematic in this regard because unlike the earlier event which could be cast in nation-unifying terms, this was clearly divisive.

55 *Vse na vybory prezidenta rossii! (1991, 1996, 2000): albom predvybornykh agitatsionnykh materialov* [All to the Elections of the President of Russia! (1991, 1996, 2000): album of pre-election agitational materials] (Moscow: Gosudarstvennaya publichnaya istoricheskaya biblioteka Rossii, 2006), 30.

the more informal images present in the popular culture; the portrayal of him in the television puppet show *Kukly* was particularly damaging to his image. The portrayal of Yeltsin with his wife or tennis buddies may have done something to soften his image, but they could not eliminate the impression of him as potentially incompetent.

When Putin came to power, steps were taken to avoid the problems experienced by Yeltsin. While the official portrait remained in the same style, and Putin was usually shown hard at work in a suit, the president and the people around him sought to manage his image. One means of doing this was to reassert a degree of central control over the press, with the result that editors became more sensitive to the wishes of the president and his people. Official representations of Putin showed him as a serious man with deep concerns for those over whom he ruled. His official portraits in government offices, embassies and in official publications emphasized his business-like demeanor. The end of the depiction of the president in *Kukly* was another important way in which his image was managed. Another was to stage manage in a more effective fashion the appearances of the president in an official capacity. The visual reporting of presidential inaugurations was designed to lift the gravity and authority of the occasion, while the frequent meetings between president and government ministers were well-reported, always showing the president as decisive and in control. He was also frequently shown with world leaders, emphasizing his standing on the world stage.

They also sought to project a less official image of the president, and they did this by seeking to emphasize his fitness, strength and virility. He was often shown (and referred to) in his judo garb. He was also depicted in a range of rugged outdoor settings: riding a horse or fishing while showing off his muscled and bare torso, scuba diving to find ancient Greek vases, driving trucks in the far countryside, going under the ocean in a submersible (Figure 8.13), guiding cranes that had lost their way in an ultra-lite, and playing ice hockey and skiing; these are some of the images that were designed to evoke this sort of response. These were clearly designed to speak to his sexual, physical and political prowess,[56] and at least in his first term were designed to contrast him with Yeltsin. They clearly convey the message that he has the physical capacity to lead the country, but the absence of a teleological legitimation program like communism meant that this capacity was linked only to the position of leader, not to the legitimation of the system as a whole. Unlike Yeltsin, he was rarely shown with his wife before they were divorced, and after that he did not appear with any other woman in a romantic context. He was sometimes shown with his pet dog, and in many photographs was dressed more informally.

While Yeltsin became an object of derision in much popular culture, a whole unofficial pseudo cult of Putin has grown up within that culture.[57] Books, songs, artwork, kitsch, jokes, websites, T-shirts, even a playgirl calendar have been produced. Portraits of Putin and calendars devoted to him are on sale in leading bookshops (Figure 8.14). Much of this has not been derogatory and, in the eyes of its producers, negative about Putin. It has been a populist expression that probably does not undermine the official

56 On Putin and sexual images in politics, see Valerie Sperling, *Sex, Politics, and Putin. Political Legitimacy in Russia* (Oxford: Oxford University Press, 2015).

57 On this see Julie A. Cassidy and Emily D. Johnston, "Putin, Putiniana and the Question of a Post-Soviet Cult of Personality," *Slavonic and East European Review*, 88, 4 (2010): 681–707; Helena Goscilo, ed., *Putin as Celebrity and Cultural Icon* (London: Routledge, 2013).

image of the president. However there has also been the production of images which have more directly poked fun at Putin, for example diagrams which distort his face, and some of these clearly infringe the presidential sense of propriety.[58] A clear instance of this was representations of Putin as a gay clown that appeared on the internet and were designed to protest against anti-LGBTQ legislation. Such images were banned in April 2017. But while this sort of image may be subversive of presidential dignity, it is less so for the regime as a whole because the image of the leader is no longer central to regime legitimation in the way it was throughout much of the Soviet period.

The 2018 election provided an interesting case of the intersection of official portraiture with images of popular, unofficial, culture. Election posters around the streets of the major cities showed a business-like Vladimir Putin, formally dressed in a suit with the message, to cite a common poster, "Strong President, Strong Russia." The most colorful of Putin's competitors was the former reality TV star, Ksenia Sobchak. The images of her that were most common in Russian society were a polar opposite from the formality of the Putin election poster. They showed her in various poses, from the seductive to the demure, and certainly not in the guise of a serious politician. This encapsulates the problem for those seeking to use images for political purposes: not only can images be produced and wielded for subversive purposes, but even those not intended to have a political effect, may in fact help to shape the course of contemporary political life.

Conclusion

Images of the leader were used extensively in the Soviet period as part of the program of legitimation for the system as a whole. This was particularly evident with the Stalin cult, in which systemic legitimation was meant to be enhanced by the leader cult. The image that cult projected of Stalin as the wise and infallible leader implied that the system was legitimate because it was led by Stalin. With his death, this basis of regime legitimation disappeared, leading to a shift in the function of the leader's imagery. In the post-Stalin period, those images were meant to legitimize the position of the particular leader rather than the regime as a whole, such that the flow of empowerment was reversed: the leader's legitimacy was associated with the legitimacy of the regime and its procedures, not vice versa. This has meant that the image of the leader in each period has changed to reflect the dominant themes in the regime's legitimation program at that time. It has been this later pattern that has prevailed in post-Soviet times, with the image of the leader having immediate political importance for the authority of the leader, but less for systemic legitimation.

Despite this change in function, this highlights the importance the official portraiture has had for the Soviet regime and its successor. In both cases such portraits fulfilled important political functions. In much of the Soviet period, it was part of the broader legitimation program of the regime. In the post-Soviet years, it was a means of seeking to build up the authority of the individual leader in a formally competitive political system. This means that portraiture was not just a reflection of the ego of individual leaders, but a function of the political imperatives of the regime. It was not a superficial add-on, but an intrinsic part of the regime and its persona.

58 For a selection of such images, see Elena Shvets, ed., *V glavnoi roli. Putin v sovremennoi kul'ture* [In the Chief Role. Putin in Contemporary Culture] (Moscow: Internat-portal Gosindex.ru, 2016).

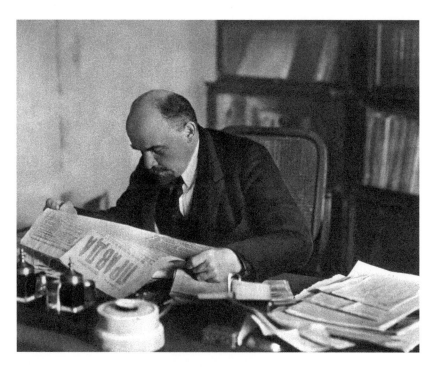

Figure 8.1 Lenin reading the *Pravda*. Photograph by Pyotr Otsup, 1918. (www.russiainphoto.ru and MAMM, Multimedia Art Museum, Moscow).

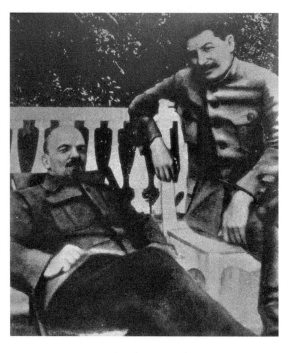

Figure 8.2 Lenin and Stalin at Gorky, 1922. (www.russiainphoto.ru and MAMM).

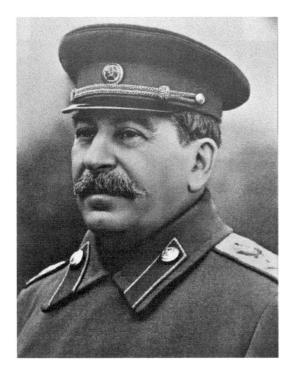

Figure 8.3 Stalin as *Generalissimo*, 1949. (www.russiainphoto.ru and MAMM).

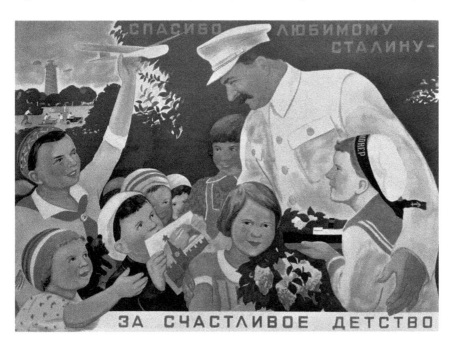

Figure 8.4 Viktor Govorkov, "Thank you beloved Stalin for our happy childhood". Poster, 1936. (Russian State Library, Moscow).

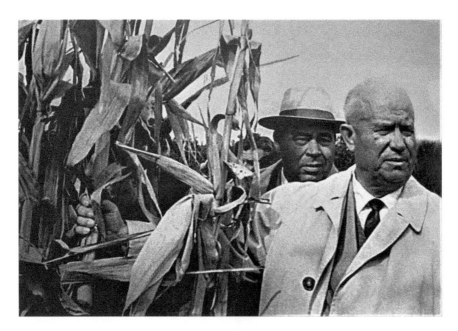

Figure 8.5 Nikita Khrushchev visiting a collective farm and dispensing his wisdom, June 1961. (www.russiainphoto.ru and MAMM).

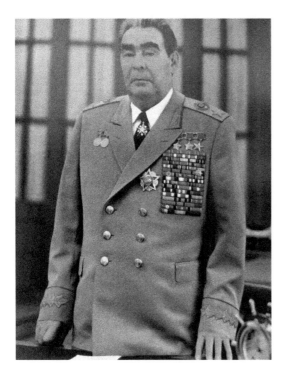

Figure 8.6 Official portrait of Leonid Brezhnev in military-style uniform, late 1970s. (www. russiainphoto.ru and MAMM).

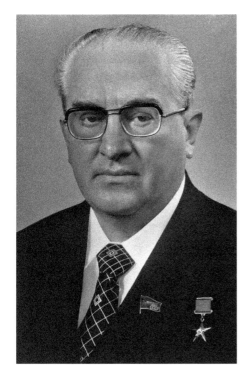

Figure 8.7 Official portrait of Yuri Andropov, 1983.

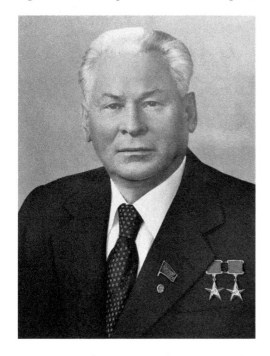

Figure 8.8 Official portrait of Konstantin Chernenko, 1984.

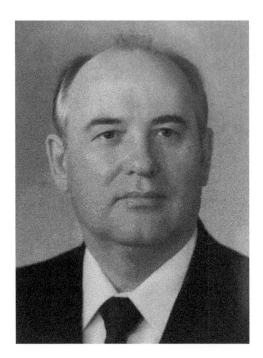

Figure 8.9 Official portrait of Mikhail Gorbachev, 1985.

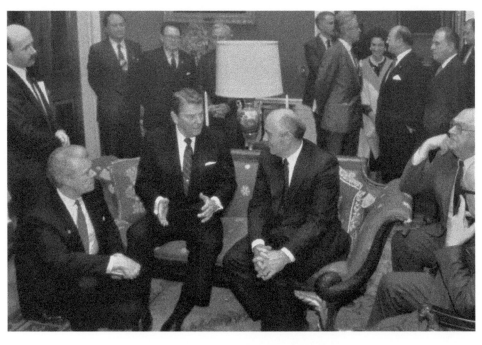

Figure 8.10 Mikhail Gorbachev with President Ronald Reagan and translators, December 1987. (www.russiainphoto.ru and MAMM).

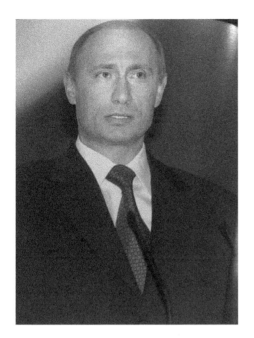

Figure 8.11 Official portrait of Vladimir Putin speaking at the time of his first inauguration, May 1980. (Photo: ITAR-TASS).

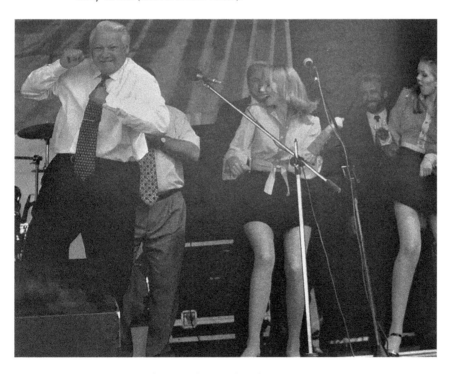

Figure 8.12 Boris Yeltsin dancing during the election campaign, Rostov, June 1996. (www. russiainphoto.ru and MAMM).

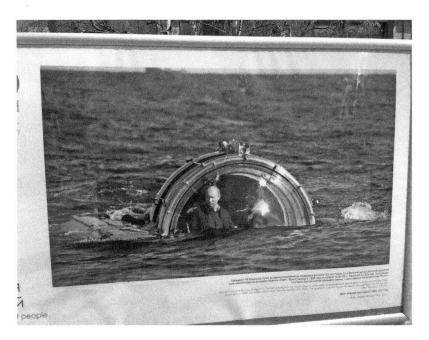

Figure 8.13 Vladimir Putin in a submersible. A poster displayed in front of the ITAR-TASS building. Moscow, May 2017. (Author's photograph).

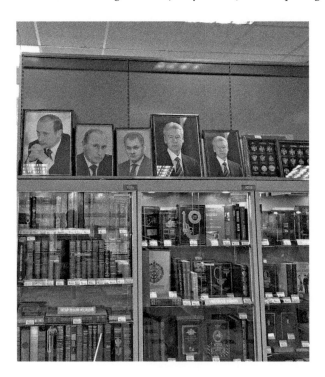

Figure 8.14 Official portrait of Vladimir Putin in a leading Moscow bookstore, May 2017. The other portraits are of Defence Minister Sergei Shoigu and Moscow mayor Sergei Sobyanin. (Author's photograph).

Bibliography

Apor, Balazs, Jan C. Behrends, Polly Jones, and E.A. Rees, eds. *The Leader Cult in Communist Dictatorships: Stalin and the Eastern Bloc*. Basingstoke: Palgrave, 2004.

Baburina, Nina. *The Soviet Political Poster 1917–1980*. Harmondsworth: Penguin, 1985.

Bonnell, Victoria E. *Iconography of Power: Soviet Political Posters under Lenin and Stalin*. Berkeley: University of California Press, 1997.

Bown, Matthew Cullerne. *Art Under Stalin*. New York: Holmes & Meier, 1991.

Bown, Matthew Cullerne, and Brandon Taylor, eds. *Art of the Soviets: Painting, Sculpture and Architecture in a One-Party State*. Manchester: Manchester University Press, 1993.

Brandenberger, David. "Stalin as Symbol: A Case Study of the Personality Cult and Its Construction." In *Stalin: A New History*, edited by Sarah Davies and James Harris, 249–70. Cambridge: Cambridge University Press, 2005.

Cassidy, Julie A., and Emily D. Johnston. "Putin, Putiniana and the Question of a Post-Soviet Cult of Personality." *Slavonic and East European Review* 88(4) (2010): 681–707.

Gill, Graeme. *Symbols and Legitimacy in Soviet Politics*. Cambridge: Cambridge University Press, 2011.

Giusti, Maria Adriana. *Arte di Regime*. Florence: Scala Group, 2014.

Golomstock, Igor. *Totalitarian Art in the Soviet Union, the Third Reich, Fascist Italy and the People's Republic of China*. New York: Overlook, 2011.

Goscilo, Helena, ed. *Putin as Celebrity and Cultural Icon*. London: Routledge, 2013.

Groys, Boris, and Max Hollein, eds. *Dream Factory Communism: The Visual Culture of the Stalin Era*. Frankfurt: Hatje Cantz, 2003.

Heller, Klaus, and Jan Plamper, eds. *Personality Cults in Stalinism*. Gottingen: V&R Unipress, 2004.

Heller, Steven. *Iron Fists: Branding the 20th-Century Totalitarian State*. London: Phaidon Press, 2008.

King, David. *The Commissar Vanishes: The Falsification of Photographs and Art in Stalin's Russia*. London: Cannongate Books, 1997.

Lafont, Maria. *Soviet Posters: The Sergo Grigorian Collection*. Munich: Prestel Verlag, 2007.

Morozov, Sergei, and Valerie Lloyd, eds. *Soviet Photography, 1917–40: The New Photo-Journalism*. London: Orbis, 1984.

Pisch, Anita. *The Personality Cult of Stalin in Soviet Posters, 1929–1953: Archetypes, Inventions and Fabrications*. Canberra: ANU Press, 2016.

Plamper, Jan. *The Stalin Cult: A Study in the Alchemy of Power*. New Haven: Yale University Press, 2012.

Sartori, Rosalinde. "'Als Kind habe ich Stalin gesehen.' Stalin und seine Repräsentationen." In *Kunst und Propaganda im Streit der Nationen, 1930–1945*, edited by Hans-Jorg Czech and Nikola Doll, 172–81. Dresden: Sandstein Verlag, 2007.

Schnapp, Jeffrey T. *Revolutionary Tides: The Art of the Political Poster 1914–1989*. Stanford: Skira, 2005.

Shvets, Elena, ed. *V glavnoi roli: Putin v sovremennoi kul'ture*. [In the chief role: Putin in contemporary culture]. Moscow: Internat-portal Gosindex.ru, 2016.

Snopkov, Aleksandr, Pavel Snopkov, and Aleksandr Shklyaruk. *Shest'sot plakatov*. [Six hundred posters]. Moscow: Kontakt-kultura, 2004.

Taylor, Brandon. *Art and Literature Under the Bolsheviks: The Crisis of Renewal 1917–1924*. London: Pluto Press, 1991.

Tumarkin, Nina. *Lenin Lives! The Lenin Cult in Soviet Russia*. Cambridge: Harvard University Press, 1983.

Velikanova, Olga. *Making of an Idol: Uses of Lenin*. Gottingen: Muster-Schmidt Verlag, 1996.

White, Stephen. *The Bolshevik Poster*. New Haven: Yale University Press, 1988.

Wolf, Erika. *Koretsky: The Soviet Photo Poster: 1930–1984*. New York: The New Press, 2012.

Yampolsky, Mikhail. "The Rhetoric of Representation of Political Leaders in Soviet Culture." *Elementa* 1(1) (1993): 101–13.

9 Faces of Mao

Stefan Landsberger

The likeness of Mao Zedong, the founder of the People's Republic of China, has evolved over time from an image that was used and able to mobilize millions to an icon that signifies and personifies the Chinese Communist Party (CCP) regime. Ever since February 1949, when the city of Beijing – then called Beiping – was liberated from Nationalist rule, several versions of the Mao portrait have looked out over the nation, dominating the symbolic heartland of China – Beijing's Tian'anmen Square. Aside from this official portrait, Mao's face graced millions if not billions of propaganda posters and other media, produced for different audiences, venues, policies, occasions, campaigns and events.

The Tian'anmen Mao

The official Mao portrait, measuring 6.4 by 5 meters and weighing 1.5 tons, was not the first in that particular spot. The first portrait that was installed was a painting that represented Sun Yatsen, a physician, writer and revolutionary, the first president of the Republic of China, who is referred to as "father of the nation". It was hung above the central gate in 1929 and showed Sun's face frontally, flanked by slogans. After recapturing Beiping at the end of the Sino-Japanese War in 1945, the painted portrait of Chiang Kai-shek appeared, the President of the Republic of China. It stood on the balcony rather than hanging on the wall, almost reaching the roof of the gate-building. Mao's first portrait, talking Chiang's portrait's position on the balcony, made its debut on February 12, 1949; it was designed under the leadership of Dong Xiwen (1914–1973).[1] A second portrait appeared in July 1949, again designed by Dong. Eight months later, with the proclamation of the founding of the People's Republic, the third portrait was put up; based on a photograph taken by Zheng Jingkang in Yan'an, it was turned into a 6-by-4.6-meter portrait hanging in the center of the gate-building's front wall by Zhou Lingzhao.[2] By May 1950, it was replaced by a portrait by Xin Mang, who also painted a newer version that would hang from October 1, 1950 until May 1, 1952. Zhang Zhenshi painted the next version, making its first appearance on October 1, 1952 and continuing until 1963. In the period 1964–1967, it was Wang

1 Zhongguo meishuguan, ed., *Zhongguo meishu nianjian 1949–1989* [Chinese Yearbook of Fine Arts 1949–1989] (Guilin: Guangxi meishu chubanshe, 1993); Michael Sullivan, *Modern Chinese Artists – A Biographical Dictionary* (Berkeley: University of California Press, 2006), 31.
2 Ibid., 236.

Guodong's portrait that looked out over the Square. Wang Guodong and his student, Ge Xiaoguang, would continue to paint the version that has been used from 1967 until the present. All of the artists who had and have been involved in painting the iconic Mao image were recognized for their talents and political trustworthiness, as they had demonstrated in earlier commissions.[3]

That Mao's portrait was a painting rather than a photographic representation had technical and symbolic reasons. Photographs of the size needed to dominate Tian'anmen Square were difficult to produce. Moreover, the leaders whose portraits had preceded Mao's all had been paintings, thus setting a precedent.

Aside from different artists applying their talents to rendering the leader, the different versions also show different Maos: the first portrait is frontal (showing "two-ears"); the second shows Mao from the left ("one-ear"); the third also from the left (Figure 9.1); the fourth from the right ("one-ear"); the fifth from the left; the sixth full-frontal ("two-ears"); the seventh from the left; and the final portrait is full-frontal again (Figure 9.2). These different versions and postures, all imbued with different meanings for the intended audience, indicate that there initially was some uncertainty about how to best present the Leader to the people and the world.[4]

After Mao's death in 1976, attempts were made to eradicate the excessive use of his image and influence. Yet this proved to be very difficult. Once Deng Xiaoping took over in 1977, all forms of leadership worship ceased. Deng abhorred the personality cult in all its manifestations and was convinced that leaders should remain in the background.[5] Under Deng a process of de-Maofication was started in the early 1980s, leading to an official reassessment of Mao's contributions. As a result of this reevaluation, Mao's official portrait gradually disappeared from public places, including Chinese embassies abroad. Despite this, Mao continued to be worshipped, reaching a new high with the centenary of his birth in 1993, when a phenomenon also known as the Mao Craze, or Mao Fever, erupted (Figure 9.3). By then it had become clear that the Mao image had become a unifying factor for the nation and a major visual element supporting the party-state. The CCP's involvement in this conscious manipulation of icons can be seen from the ultimate commodification of Mao *and* the Cultural Revolution (1966–1976),[6] a deft negotiation between socialist and consumerist systems of mass

3 Details about these painters can be found in Zhongguo meishuguan, *Chinese Yearbook of Fine Arts*; Sullivan, *Modern Chinese Artists*.

4 Wu Hung, *Remaking Beijing – Tiananmen Square and the Creation of a Political Space* (Chicago, ILL: University of Chicago Press, 2005), 68–84; Chen Lu, "Baci geng xuan, Tian'anmen shang Mao Zedong huaxiangde 'mimi'" [Replaced Eight Times: The 'Secret' of Mao Zedong's Portrait on Tian'anmen], *Xin Jing Bao* September 28, 2016. http://www.bjnews.com.cn/graphic/2016/09/28/418458.html, accessed on September 25, 2019.

5 Liu Jianming, *Deng Xiaoping xuanchuan sixiang yanjiu* [On Deng Xiaoping's Ideas of Propaganda] (Shenyang: Liaoning renmin chubanshe, 1990), 60–5.

6 This was a mass movement engineered by Mao and his followers that set out to return China to the straight path of revolutionary commitment. It is known for its violence and destruction, in particular at the hands of school pupils and university students that had been mobilized to support Mao and his political line. See Guo Jian et al., *Historical Dictionary of the Chinese Cultural Revolution* (Lanham, MD: The Scarecrow Press, 2006); Roderick MacFarquhar and Michael Schoenhals, *Mao's Last Revolution* (Cambridge, MA: Belknap Press of Harvard University Press, 2006).

communications.[7] The trinkets that were available during the short period of the Mao Craze in 1993 included reissues of the *Little Red Book*, watches, alarm clocks with Red Guards waving copies of the *Little Red Book*, medallions, commemorative plates and plaques, etc. Even at present, many karaoke bars still offer popular Maoist songs that are greatly favored and sung with gusto by patrons, old and young; one of the perennial favorites devoted to Mao is "Dong Fang Hong" ("The East is Red") that became the nation's unofficial anthem from the mid-1960s onwards.

The versions of Mao images on posters come in a variety of designs and poses. Chinese poster collectors prize Mao posters the highest; even younger generations of collectors who were not born yet when Mao ruled can criticize or wax poetically over the way in which the Chairman is rendered. According to one (of many) classifications of propaganda posters in circulation, Mao posters are the first category of thirteen, preceding those featuring mass campaigns, the Army, New China, revolutionary models and others.[8]

The Revolutionary Mao

Portraits of Mao had been used prominently for propaganda purposes at least since the Zunyi Conference which took place during the Long March in 1935, where Mao accepted the leadership of the CCP.[9] Presenting Mao as the leader of the revolution echoed the cult that developed around Chiang Kai-shek, which in turn was modelled on the cult that had been formed around Sun Yatsen.[10] For the manifestations of the Mao images in the years following his installation until the founding of the People's Republic of China, we have to depend on photographic evidence. These old photographs, taken during Party meetings and elsewhere, or showing interiors of dwellings, see Mao images appearing regularly in the background. His portrait also is often accompanied by that of Zhu De, Commander-in-Chief of the Red Army, and portraits of Marx, Engels, Lenin and Stalin. The photographs of the victorious Red Army entering large cities on the Eastern seaboard in the late 1940s show Army trucks bearing portraits of Mao and Zhu.

After 1949, during the first three decades of the PRC, the Mao portrait increasingly and actively began to form and guide the revolution as an embodiment of CCP rule (Figure 9.4). As a leader cult developed in the 1950s and 1960s, Mao's image came to dominate all aspects of daily life more and more. By the time the Cultural Revolution started (1966–1976) and the cult reached its climax, Mao's image simply was everywhere. He featured in comic strips chronicling the victory in the war against Japan and the founding of the PRC; his face appeared on bookmarks, biscuit tins and mirrors; a few of the images featuring Mao even were made into postage stamps. However,

7 Francesca Dal Lago, "Personal Mao: Reshaping an Icon in Contemporary Chinese Art," *Art Journal* 58, 2 (1999): 47.

8 Shenzhenshi hongdu wenhua chuanbo youxian gongsi, "Xuanchuan hua zhuyao fenwei shisan lei" [Thirteen Important Categories of Propaganda Posters]. http://mp.weixin.qq.com/s/DPJJUl5N-PmjW-D5r3Y7gg, accessed on September 25, 2019.

9 Barbara Mittler, "Popular Propaganda? Art and Culture in Revolutionary China," *Proceedings of the American Philosophical Society* 152, 4 (2008): 13.

10 Daniel Leese, *Mao Cult – Rhetoric and Ritual in China's Cultural Revolution* (New York: Cambridge University Press, 2011).

using stamps with Mao's likeness could be complicated, in particular during the period when he was venerated like a god.

Prior to the mid-1960s, Mao was showing the Chinese where the Revolution would lead to: he appeared on posters devoted to socialist (re)construction, Five Year Plans, agricultural reform, etc. He was also shown fraternizing with the people, ranging from school children to workers, peasants, soldiers and intellectuals; receiving delegations from ethnic groups, including the Tibetan leader the Dalai Lama; taking stock of the nation. During the Cultural Revolution, politics took precedence. Chairman Mao Zedong, as the Great Teacher, the Great Leader, the Great Helmsman and the Supreme Commander, became the only permissible subject of the era's arts (Figure 9.5). He was "the embodiment and exemplification of the value system supported by the government-maintained ideology".[11] Despite Mao's ambiguous warnings against a personality cult, the intensity of his portrayal in the second half of the 1960s was unparalleled (see cover image). His image was considered more important than the occasion for which a particular work of propaganda art was designed: in a number of cases, identical posters dedicated to Mao were published in different years bearing different slogans, thus serving different propaganda aims.[12] In the few posters where Mao did not feature as prominently, his symbolic presence or blessing was hinted at by the use of symbols like the *Little Red Book*, or his selected works.

Mao was sometimes depicted as a benevolent father surrounded by children, bringing the Confucian mechanisms of popular obedience into play. Or he was portrayed as a wise statesman, an astute military leader or a great teacher. To this end, artists represented him in the vein of the images of Lenin, which had started to appear in the Soviet Union in the early 1920s: towering over the masses, with an outstretched arm suggesting a benediction.[13] Another group of posters visually recounted the more illustrious of his historical deeds. But in each case, he had to be painted *hong, guang, liang* (red, bright and shining); no grey was allowed for shading, and the use of black was interpreted as an indication of an artist's counter-revolutionary intentions.[14] This penchant for using specific colors found its origin in traditional ideas about the symbolic effects they had; it still plays a role of paramount importance in the painted faces in Chinese opera.[15] His face was painted in such a way that it appeared smooth and seemed to radiate as the primary source of light in a composition. In many instances, Mao's head seemed to be surrounded by a halo which emanated a divine light that

11 James T. Myers, "Whatever Happened to Chairman Mao? Myth and Charisma in the Chinese Revolution," in *Chinese Politics from Mao to Deng*, eds. Victor C. Falkenheim and Ilpyong Kim (New York: Paragon House, 1989), 23.
12 Interview with art consultant Yang Peiming, Shanghai, January 17, 1998.
13 Ellen Johnston Laing. *The Winking Owl – Art in the People's Republic of China* (Berkeley, CA: University of California Press, 1988), 65–6; Victoria E. Bonnell, *Iconography of Power—Soviet Political Posters under Lenin and Stalin* (Berkeley: University of California Press, 1999), 142–7.
14 Jerome Silbergeld, *Contradictions: Artistic Life, the Socialist State and the Chinese Painter Li Huasheng* (Seattle, WA: University of Washington Press, 1993), 43; Joan Lebold Cohen, *The New Chinese Painting 1949–1986* (New York: Abrams, 1987), 22; Julia F. Andrews, *Painters and Politics in the People's Republic of China 1949–1979* (Berkeley: University of California Press, 1994), 360.
15 Charles A.S. Williams, *Outlines of Chinese Symbolism & Art Motives* (New York: Dover Publications, 1976 [1941]).

illuminated the faces of the people standing in his presence, a practice that followed the Buddhist tradition (Figure 9.6).[16]

As a supermodel, every detail of his representation had to be preconceived along ideological lines and invested with symbolic meaning. The artist Liu Chunhua, a Red Guard who studied at the Central Academy of Industrial Arts and who in 1967 had painted the famous painting-turned-poster *Mao zhuxi qu Anyuan* (Chairman Mao goes to Anyuan) on the basis of a collective design by a group of students of universities and institutes in Beijing, explained the creative process involved in this work as follows:[17]

> To put him in a focal position, we placed Chairman Mao in the forefront of the painting, advancing towards us like a rising sun bringing hope to the people. Every line of the Chairman's figure embodies the great thought of Mao Zedong and in portraying his journey we strove to give significance to every small detail. His head held high in the act of surveying the scene before him conveys his revolutionary spirit, dauntless before danger and violence and courageous in struggle and in "daring to win"; his clenched fist depicts his revolutionary will, scorning all sacrifice, his determination to surmount every difficulty to emancipate China and mankind and it shows his confidence in victory. The old umbrella under his right arm demonstrates his hard-working style of travelling, in all weather over great distances, across the mountains and rivers, for the revolutionary cause [...] The hair grown long in a very busy life is blown by the autumn wind. His long plain gown, fluttering in the wind, is a harbinger of the approaching revolutionary storm [...] With the arrival of our great leader, blue skies appear over Anyuan. The hills, sky, trees and clouds are the means used artistically to evoke a grand image of the red sun in our hearts. Riotous clouds are drifting swiftly past. They indicate that Chairman Mao is arriving in Anyuan at a critical point of sharp class struggle and show, in contrast how tranquil, confident and firm Chairman Mao is at that moment.[18]

Chairman Mao goes to Anyuan (Figure 9.7) became a *cause célèbre*, "perhaps the most important painting of the Cultural Revolution period",[19] if only because Mao never visited Anyuan. The painting was meant to discredit Liu Shaoqi, Mao's main political opponent at the time, who had played a much more important role in organizing the labor movement in Anyuan in the 1920s than Mao did and did visit. It is believed that more than 900 million copies of the Mao painting were eventually printed; it was displayed at meetings and carried around during demonstrations, mass meetings and processions, and many found their way onto walls, next to the official portrait of the Chairman.[20] It seems as if this poster illustrated the formative and tempering processes

16 Andrews, *Painters and Politics*, 360.

17 Ibid., 338; Liu Chunhua, "Painting Pictures of Chairman Mao Is Our Greatest Happiness," *China Reconstructs*, October 1968, 2–6.

18 Liu Chunhua, "Singing the Praises of Our Great Leader Is Our Greatest Happiness," *Chinese Literature*, September 1968: 32–40.

19 Laing. *The Winking Owl*, 67–70.

20 Andrews, *Painters and Politics*, 339; Robert Benewick, "Facing Left – Power, Terror and Profit in Chinese Iconography," Professorial lecture, University of Sussex, November 26, 1996, published in brochure form, 19.

Mao had gone through, from the young firebrand to the founder of the State to the ultimate Leader of the Cultural Revolution. Seen from this perspective, the poster may also have been disseminated on such a large scale in order to demonstrate that Mao himself had been something of a Red Guard *avant la lettre*. The importance of this painting and its message is proven further by fact that it was meticulously reproduced on a number of posters, thus spreading its message even further.

Nonetheless, when compared with most of the other Mao posters produced during the Cultural Revolution, Liu's painting-turned-poster is remarkably different. The popularity of the Anyuan poster may stem from the fact that its romantic presentation of Mao as a young firebrand appealed to many.

The Domesticated Mao

Even before the Cultural Revolution, Mao had become a regular presence in every home, either in the form of his official portrait, or as a bust or statue (Figure 9.8–9.11).[21] Once the Cultural Revolution started, one could not do without. The official portrait showed the Leader all by himself, in his splendor of *hong, guang, liang*, as

> an idealized benign face done in a near photographic manner, taking advantage of the play of light and shadow over the Chairman's features. It is not a lively portrait; rather, a kind of serenity seems to dwell on the face of the man, gazing into nowhere, almost disinterested in human affairs. On his lips is the shadow of a smile. He is dressed in a bluish grey uniform-like tunic originally introduced as official wear by Sun Yatsen in the early days of the Republic. The background is a celestial blue.[22]

Not having the Mao portrait on display indicated a lack of commitment to the revolutionary flow of the moment, or a counter-revolutionary outlook, and refuted the central role Mao played in politics and the day-to-day affairs of the people. For this reason, those households that were identified as belonging to the landlord class or as bad elements often were not permitted to display Mao's portrait. The formal portrait usually occupied the central place on the family altar. This added to the already god-like stature of Mao as it was created in propaganda posters. The intention was to replace the worship of the "old" gods and superstitious symbols with the worship of Mao by presenting his image and words as sacred symbols.[23]

21 It is estimated that during the Cultural Revolution, some 2.2 billion official Mao portraits were printed, in other words, "three for every person in the nation". Geremie Barmé, *Shades of Mao – The Posthumous Cult of the Great Leader* (Armonk, NY: Sharpe, 1996), 8. The official poster, *Weidade lingxiu he daoshi Mao Zedong zhuxi* [The Great Leader and Teacher Chairman Mao Zedong], published by Renmin meishu chubanshe, print no. 8027.4696, saw its 157th edition in October 1977.

22 Göran Aijmer, "Political Ritual: Aspects of the Mao Cult During the Cultural 'Revolution,'" *China Information* XI: 2/3 (1996): 221. On the origins of the "Sun Yatsen Suit" (*Zhongshan zhuang*), see John Fitzgerald, *Awakening China – Politics, Culture, and Class in the Nationalist Revolution* (Stanford, CA: Stanford University Press, 1998), 23–5.

23 James T. Myers, "Religious Aspects of the Cult of Mao Tse-tung," *Current Scene* 10, 3 (1972): 2; Anita Chan, Richard Madsen, Jonathan Unger, *Chen Village under Mao and Deng* (Expanded and Updated Edition) (Berkeley: University of California Press, 1992), 89; Richard Madsen, *Morality and Power*

Mao's importance as an object of worship was strengthened further by small porcelain tablets—"tablets of loyalty"—bearing his image, often with a golden halo, which replaced the ancestral tablets that earlier had been demolished by "Destroy the Four Olds" teams or by roving Red Guards as the principal objects of family-based worship. These tablets were placed on a "Precious Book Table", which each household had to have. Here, the copies of Mao's works, such as the four volumes of the *Collected Works*, were stacked. In some cases multiple sets were displayed, as free copies were handed out as rewards for diligent labor and other contributions to the revolutionary cause. The presence of the books did not necessarily mean that they were read; they had become sacred, ritual paraphernalia, "the Word made tangible".[24]

The Great Teacher not merely invaded the living quarters, but also the private space of the people. His portrait was carried close to everyone's heart, either in the form of the photograph included in the *Little Red Book*, or in the form of the Mao badges that many wore and collected.[25] Mao even took his rightful place among more traditionally accepted objects of worship. A white bust of Mao was placed in a Protestant church in Beijing (1966), and a sculpted figure of Mao was prominently displayed in a Buddhist temple in Shanghai (1967), before these and other places of religious worship were closed. It is unclear whether these Mao statues were intended for worship or whether they were brought in on account of their protective qualities. Exhibition halls or 'sacred shrines' were built on sites where important events had taken place in Mao's life; organized pilgrimages to these sites—whether under the guise of "revolutionary link-ups" or not—enabled people to pay obeisance.[26] Aside from Beijing, Shanghai and Guangzhou, these places included Mao's native village Shaoshan, the revolutionary base area of Jinggangshan, Yan'an, Zunyi and Ruijin. Presently, these spots play a role in the so-called revolutionary or red tourism, strongly supported by the party-state.[27] Moreover, in many of these destinations, medium- to large-sized (private) museums have been set up by avid collectors, exhibiting paintings, posters and artefacts.

The bestowing of honors on Mao was accompanied by a number of rituals enacted in front of his symbolic presence, which served to further strengthen the belief in the mythical-religious efficacy of his persona. The days were structured around the ritual of "asking for instructions in the morning, thanking Mao for his kindness at noon, and reporting back at night".[28] This involved bowing three times in front of Mao's

in a Chinese Village (Berkeley: University of California Press, 1984), 186; Jonathan Unger, "Cultural Revolution Conflict in the Villages," *The China Quarterly* 153 (1998): 87–8, 93.

24 Dennis Bloodworth, *The Messiah and the Mandarins—Mao Tsetung and the Ironies of Power* (New York: Atheneum, 1982), 258. Chan et al., *Chen Village*, 170.

25 Michael Dutton, *Streetlife China* (Cambridge, UK: Cambridge University Press, 1998), 242–61; Melissa Schrift, *Biography of a Chairman Mao Badge – The Creation and Mass Consumption of a Personality Cult* (New Brunswick, NJ: Rutgers University Press, 2001); Helen Wang, *Chairman Mao Badges – Symbols and Slogans of the Cultural Revolution* (London: British Museum, 2008).

26 Laing. *The Winking Owl*, 67. Maurice Meisner, *Mao's China—A History of the People's Republic* (New York: The Free Press, 1977), 336.

27 Yiping Li, Zhi Yi Hu and Chao Zhi Zhang, "Red tourism: sustaining communist identity in a rapidly changing China," *Journal of Tourism and Cultural Change*, 8, 1–2 (2010): 101–19.

28 Pictures of such rituals taking place in a peasant village in Yunnan can be found in *Wenhua dageming bowuguan* [Museum of the Cultural Revolution], ed. Yang Kelin (Hong Kong: Dongfang chubanshe youxian gongsi, Tiandi tushu youxian gongsi, 1995), 116–17.

picture or bust, or in front of the 'tablets of loyalty,' singing the national anthem, reading passages from the *Little Red Book* and ended with wishing him "ten thousand years". In the mornings, everybody would announce what efforts they would make that day for the revolution. In the evenings, people would report on their accomplishments or failures and announce their resolutions for the next day.[29] Peasants would start and end every workday by reciting a Mao quote, "like an opening and closing prayer", and would spend half an hour on Mao study during their lunch breaks.[30] Moreover, "even the simplest transaction in a shop had to include a recitation from Mao's words".[31] Before every meal, words of thanksgiving had to be intoned, also quite "similar to the pre-dinner grace of the Christian tradition". According to Anita Chan, a standard form of such a recitation went like this:

> We respectfully wish a long life to the reddest, reddest red sun in our hearts, the great leader Chairman Mao. And to Vice-Chairman Lin's health: may he forever be healthy. Having been liberated by the land reform, we will never forget the Communist Party, and in revolution we will forever follow Chairman Mao.[32]

The Mao cult replicated aspects of the traditional cult of the "God of the Stove" or Kitchen God (*Zao wang, Zao jun*), the observance of which can be traced back to the first century BCE.[33] The most important similarities can be found, first, in the power that Mao exerted over daily life by keeping an eye on what went on in the household, noting the virtues and vices of its members in terms of political purity (where the Stove God had monitored moral rectitude). Secondly, certain rituals were enacted in front of Mao's formal portrait, as used to be the case with the portrait of the Stove God. But unlike the Kitchen God, whose effigy was burnt and thus "sent up" to report to the heavenly magistrates on a yearly basis, Mao's image itself was sacrosanct. Furthermore, how could he report to a more high-ranking god, since he himself was the highest authority?

The Divine Mao

In Leiyang County, Hunan Province, local peasants brought together more than 21 million *yuan* of private funds in the 1980s to build the *San Yuan Si* (Three Sources Temple). The construction of the edifice started in 1991 and took a number of years,

29 Scott Minick and Jiao Ping, *Chinese Graphic Design in the Twentieth Century* (London: Thames and Hudson, 1990), 119; Silbergeld, *Contradictions*, 41; Myers, "Religious Aspects," 7; Meisner, *Mao's China*, 336; Bloodworth, *The Messiah and the Mandarins*, 258; Mayfair Yang, *Gifts, Favors & Banquets – The Art of Social Relationships in China* (Ithaca, NY: Cornell University Press, 1994), 250.
30 Chan et al, *Chen Village*, 123; Madsen, *Morality and Power*, 137–8.
31 Li Zhisui, *The Private Life of Chairman Mao: The Memoirs of Mao's Personal Physician* (London: Chatto and Windus, 1996), 507; Yang Xiao-ming, *The Rhetoric of Propaganda – A Tagmemic Analysis of Selected Documents of the Cultural Revolution in China* (New York, NY: Peter Lang, 1994), 30–1.
32 Anita Chan, *Children of Mao – Personality Development & Political Activism in the Red Guard Generation* (London: Macmillan, 1985), 186 and 236–7. Leese, *Mao Cult*, 195–210.
33 Robert L. Chard, "Rituals and Scriptures of the Stove Cult," in *Ritual and Scripture in Chinese Popular Religion: Five Studies*, ed. David Johnson (Berkeley, CA: Institute of East Asian Studies Publications, 1995), 5–6.

with as many as 2,000 people working on the job. The temple, a huge edifice in tra-ditional Buddhist style, was dedicated to the revolutionary Trinity of the CCP: Mao Zedong, Premier Zhou Enlai and Commander-in-Chief Zhu De. The largest of the three idol halls of the complex contained a six-meter-tall statue of Mao; the other two housed the seated images of Zhou and Zhu, each measuring approximately 4.5 meters. At the height of its popularity, in late 1994, the temple attracted 40,000–50,000 mostly elderly worshippers daily. Many came from other parts of the country, and used the traditional methods of burning incense to offer their worship. After hav-ing been forced off the site by outraged pilgrims during an earlier attempt to bring these religious activities to an end, the authorities closed the temple down in May 1995, on the grounds that it encouraged superstition.[34]

The inclusion of Mao in a pantheon of religious-political figures also took place elsewhere. In northern Shaanxi, in temples dedicated to the Three Sage gods (*San Sheng*), Mao, Zhou and Zhu are venerated in a similar manner as in Leiyang. And the China specialist John Gittings tells how visitors to Shaoshan, Mao's birthplace in Jiangxi Province, "burn incense and paper money and set off firecrackers before the statue [a bronze statue of Mao, six meters high, erected in Shaoshan's village square]. Some kowtow to Mao as if he were a god who could grant good fortune".[35]

For those not willing or unable to travel, pictures and talismans were available, which were widely believed to protect against harm and evil.[36] The talismans first appeared in Southern China and spread throughout the country from 1991. These charms, which could often be seen hanging from rear-view mirrors in cars and trucks, showed laminated pictures of Mao as a young man or in his later years, in civilian dress or army uniform, or in the guise of a guardian spirit or a temple god. Many of the pictures came in temple-like frames of gold-colored plastic with red tassels, auspicious characters (such as *fu*, happiness), firecrackers or "gold" ingots dangling from them. Such amulets combined aspects of the Mao persona with elements of folk culture and religion, devoid of any of the political adulation of the past.[37] Some of these amulets from the 1990s had Mao's portrait on one side, and Zhou Enlai's image on the reverse. They were manifestations of a popular longing for a more orderly society and nostalgia for an imaginary golden past, as presented in the propaganda posters of the 1950s, 1960s and 1970s. At the same time, they served as protective symbols against the social upheavals and dislocation that became daily occurrences in the reform period.

34 China Study Journal, "Maoist Temple Closed Down," *China Study Journal* 10, no. 2 (August 1995): 26–7; Barmé, *Shades of Mao*, 23; Dachang Cong, *When Heroes Pass Away – The Invention of a Chinese Communist Pantheon* (Lanham MD.: University Press of America, 1997), 46.

35 John Gittings, *Real China — From Cannibalism to Karaoke* (London: Pocket Books [Simon & Schuster] 1997), 166, 167.

36 Numerous stories testifying to the protective qualities of Mao images and amulets, many of them undoubtedly apocryphal, circulate(d) in China. See also Gittings, *Real China*, 159; Cong, *When Heroes Pass Away*, 64–7.

37 Barmé, *Shades of Mao*, 22.

The Artsy Mao

The Mao image also had traction abroad. Revolutionary students in France, Italy, Germany and elsewhere saw him as the leader of a revolutionary movement that gave agency to the younger generation and opposed global imperialism. They carried his portrait around during anti-establishment demonstrations in the late 1960s, mistakenly interpreting the Cultural Revolution as a mere youth uprising against the establishment.[38] Andy Warhol took much of the political context out of his image and turned him into an icon of the times.[39] In doing so, the Mao portrait, whether in the form of satirical commentary by Warhol or not, became domesticized, a piece of respectable and collectable art. Yet when the *Andy Warhol: 15 Minutes Eternal* exhibitions took place in Beijing and Shanghai in 2013, Mao's Pop Art portraits could not be shown.[40]

In the 1990s and 2000s, young Chinese artists in turn used Mao as an inspiration for satirical works.[41] The painter Wang Guangyi (b. 1957) in particular paved the way for making Mao respectable in Western art collections. Wang is a representative of the artists who paint "political pop", paintings that provide satirical commentary, "trying to use a playful attitude and the forms of capitalism to break open the existing system and ideology".[42] Wang has become best known for his works that combine revolutionary imagery with logos of Western consumer brands.[43] But in one of his first major works, *Mao Zedong – Black Grid* series paintings (1988), first shown at the Beijing *China Avant-Garde* exhibition of 1989 (a few months before the student demonstrations were staged on Tian'anmen Square), Wang applied elements that excited Western art consumers: he combined the official portrait of Mao with the overlay of a grid, suggesting the imprisonment of Mao. In the Western interpretation this could only mean one thing: Wang criticized the authoritarian rule of Mao; he testified that life in China was like living in a prison. In the eyes of Chinese art consumers, however, Wang had faithfully and even expertly rendered the Great Leader, and the grid he used reminded many of the technique needed to enlarge small images for the giant propaganda murals

38 Richard Wolin, *The Wind from the East – French Intellectuals, the Cultural Revolution, and the Legacy of the 1960s* (Princeton, NJ: Princeton University Press, 2010); Sebastian Gehrig, "(Re-)Configuring Mao: Trajectories of a Culturo-Political Trend in West Germany," *Transcultural Studies* 2 (2011): 189–231; Kerry Brown, "The Maoists and Modern China," *China Studies Centre Policy paper Series* 9 (March 2015); Julia Lovell, "The Cultural Revolution and Its Legacies in International Perspective," *The China Quarterly* 227 (2016): 632–52.

39 Warhol made five series of Mao paintings in 1972–73 using the same photographic source. See *The Andy Warhol Catalogue Raisonné. Paintings and Sculpture 1970–1974*, ed. Neil Printz (New York, NY: The Andy Warhol Foundation for the Visual Arts – Phaidon, 2010), 164–263.

40 Kevin Holden Platt, "The artist and the chairman: How Warhol saw China's changing history," *The Japan Times* January 30, 2014. https://www.japantimes.co.jp/culture/2014/01/30/arts/the-artist-and-t he-chairman-how-warhol-saw-chinas-changing-history/. Last accessed on September 25, 2019.

41 Minna Valjakka, "Many Faces of Mao Zedong," unpublished PhD thesis, University of Helsinki 2011, 163–76.

42 R. Orion Martin, "Revisiting Political Pop and Cynical Realism, Discussion with Luo Fei," *The Terms Put Forward*, July 13, 2012. http://www.orionnotes.com/2012/07/revisiting-political-pop-and-cynica l-realism-discussion-with-luo-fei/. Originally accessed August 20, 2013, no longer available.

43 Sullivan, *Modern Chinese Artists*, 154.

that had been produced in many urban and rural areas in the 1960s and 1970s.[44] Moreover, for many Chinese observers, Wang's images coincided with the increased official attention devoted to Mao in the run up to the centenary of his birth in 1993.[45]

Yet not all of the political pop paintings that emerged out of China after Wang Guangyi and that came to define modern Chinese art featured Mao, even though he might make an appearance. Works by other artists who work in the genre of "political pop", such as the sculptor Wang Keping (b. 1949),[46] Zhang Hongtu (b. 1943)[47] and the Gao Brothers (Gao Zhen, born in 1956 and Gao Qiang, from 1962),[48] on the other hand, have explicitly satirized or caricaturized Mao.[49] Even though the value of these artistic products in the trajectory of the development of modern Chinese art is acknowledged, few Chinese have seen these works or appreciate them. For many, whether they have suffered personally at the hands of Mao or his followers or not, turning Mao into a joke is seen as sacrilegious.

Consuming Mao

Putting Mao's portrait on Chinese money surely has been the most efficient and effective way to ensure that he is carried around by everyone. With Mao's likeness gracing the Chinese currency since 1999, "Grandpa Mao", as he is affectionately called, is a more sought after commodity than ever, particularly the red 100 *yuan* bills. In that sense, the present money worship so lamented by commentators in China and abroad can be equated with Mao worship. But aside from enabling Chinese to consume to their hearts' desire, Mao continues to mobilize them for a variety of reasons. The Mao likeness – as well as the occasional Mao impersonator – plays a prominent role during contemporary mass events, ranging from international football meets; the patriotic anti-Japanese demonstrations that took place in 2012; and many smaller, more localized demonstrations where the rights of the people are at stake.[50] Mao has come to personify a more just nation, where the rights and interests of the 'laobaixing' (the One Hundred Names), the ordinary people, are protected and preserved. This is further underlined by the fact that in rural areas, the Mao image is still very much present in the homes of the people; not only in those of his beneficiaries, the elderly who lived through Land Reform (1950) and collectivization (1958–1978), but precisely in the dwellings of the peasantry that has profited from the policies that Mao's successors have enacted.[51] For them, the slogan that without Mao, Modern China would not

44 Zheng Shengtian, "Art and Revolution: Looking Back at Thirty Years of History," in *Art and China's Revolution*, eds. Melissa Chiu and Zheng Shengtian (New Haven, CT: Asia Society/Yale University Press, 2009), 32–4; Ralph Croizier, "The Avant-garde and the Democracy Movement: Reflections on Late Communism in the USSR and China," *Europe-Asia Studies* 51, 3 (1999), 483–513.

45 Michael Dutton, "From Culture Industry to Mao Industry: A Greek Tragedy," *boundary* 32, 2 (2005): 151–67.

46 Cohen, *The New Chinese Painting*; Sullivan, *Modern Chinese Artists*, 158.

47 Ibid., 217.

48 Valjakka, *Many Faces*, 163–76, 298.

49 Minna Valjakka, "Parodying Mao's Image: Caricaturing in Contemporary Chinese Art," *Asian and African Studies* XV, 1 (2011b): 87–114.

50 Timothy Cheek, "The Multiple Maos of Contemporary China," *Harvard Asia Quarterly* 2008, 17: 18–19. See also Ou Ning, *Meishi Street* (New York, NY: dGenerate Films, 2006).

51 Analysis of countless photographs and personal observations, February 1980–May 2017.

exists, rings true. Mao also represents the more assertive attitude China is adopting presently, intent on revenging the national humiliations of the past and reclaiming territories that it sees as rightfully belonging to the nation, and demanding its voice and opinions to be heard and heeded on the international stage (Figure 9.12). In this role, he is used to admonish the CCP that in the eyes of Chinese nationalists, it is not doing enough to defend the nation's interests.

This yearning for days gone by, when Mao was still in power, is widespread, but can be felt particularly among the urbanites who feel disenfranchised by the speed and scope of reform. They are the middle-aged, the men and women who grew up in the waning days of the Cultural Revolution and the exhilarating early Reform period. They were imbued with hope and expectations that the material fruits of the Revolution would finally be delivered and now have to admit that they have lost out on all accounts. Some of them try to earn an income from the same Revolution that sold them out. They are the dealers of (Cultural) revolutionary posters, artefacts and paraphernalia; they run the museums along the revolutionary tourism trail, where the thirty years of High Maoism are venerated that many others try to forget. They have his portrait or his statue prominently on display in their homes; they often say, tongue-in-cheek, that Mao has made them rich, that they owe everything to the Chairman. But I know for a fact that many of them, or their direct families, actually suffered under his rule.[52] What characterizes this group of people is their unquestioning faith in authority, expressed in their admiration for the CCP; their loyalty to and friendship with members of the Army, Armed Police, basically anybody wearing a uniform, with whom they love to rub shoulders and be photographed with; and their ardent support for what many see as the new Mao, the present leader Xi Jinping (affectionately called Xi Dada, Daddy Xi). Posters showing Xi, very much in the style of the official Mao portrait, have emerged. Although some see signs that the popularity of Xi, or that of a cult surrounding him, is reaching the same levels as Mao's, posters certainly will not be the medium of choice. Increasingly, digital media are being employed in China, with developments in technology that make printed images look old-fashioned.

Postscript

Sometimes one still encounters hand-painted faded slogans in the countryside urging peasants to learn from Dazhai, or to energetically study Mao Zedong Thought; a few cities continue to preserve Mao statues. Until a few years ago, Mao's image and his utterances had disappeared from most Chinese public spaces, in particular in urban areas. Yet, China cannot do without the many faces of Mao, as the continued presence of his portrait on Tian'anmen Square testifies. It is illustrated further by his reappearance in the streets in urban areas, where posters showing his countenance, accompanied by those of his successors Deng Xiaoping, Jiang Zemin, Hu Jintao and Xi Jinping, beam down on passers-by as part of the generations of leaders who have brought the nation to where it stands now. Whether Mao's many personae serve as embodiment of the modernized nation and continued Party rule; as mobilizing inspiration where the Chinese identity seems at stake; or on its currency, they have become deeply ingrained in every person's life.

52 Many personal encounters and conversations, February 1980–May 2017.

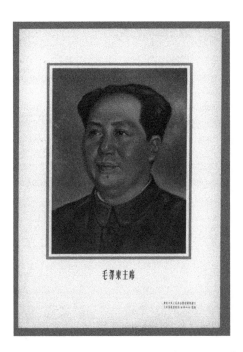

Figure 9.1 "Chairman Mao Zedong – In celebration of the second anniversary of the founding of the People's Republic of China". Poster by Xin Mang; Zuo Hui and Zhang Songhe, Beijing, 1951.

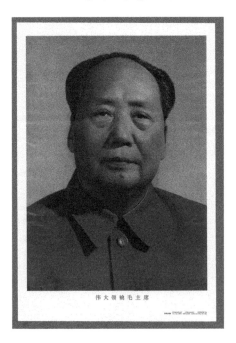

Figure 9.2 "The Great leader Chairman Mao". Poster, collective work of the New China News Agency, Nanjing, 1992.

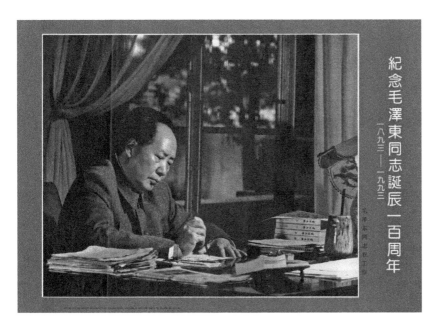

Figure 9.3 "Commemorate the hundredth anniversary of Comrade Mao Zedong's birthday 1893–1993 – Comrade Mao Zedong at work". Poster, collective work of the Editorial Office of the People's Liberation Army Illustrated, Beijing, 1992.

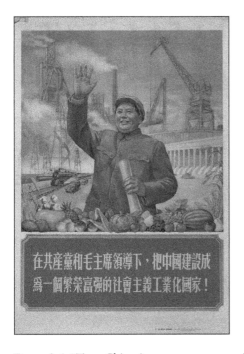

Figure 9.4 "Turn China into a prosperous, rich and powerful industrialized socialist country under the leadership of the Communist Party and Chairman Mao!" Poster by Ding Hao, Zhao Yannian and Cai Zhenhua, Shanghai, 1954.

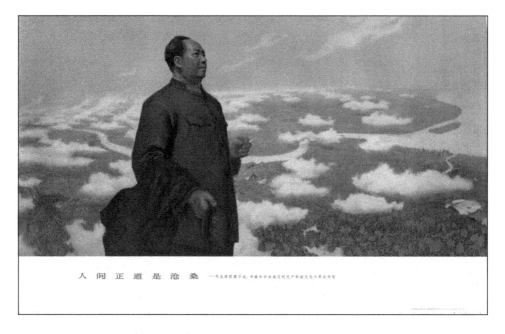

Figure 9.5 "Man's world is mutable, seas become mulberry fields – Chairman Mao inspects the situation of the Great Proletarian Revolution in Northern, South-Central and Eastern China". Poster, collective work of Zheng Shengtian, Zhou Ruiwen, Xu Junxuan and the Zhejiang Worker-Peasant-Soldier Art Academy, Hangzhou, 1967.

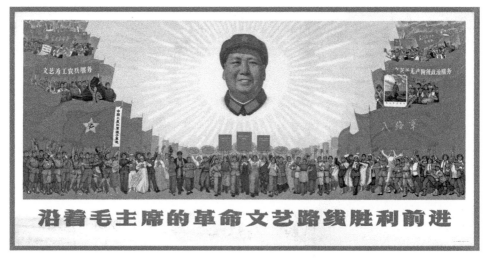

Figure 9.6 "Advance victoriously while following Chairman Mao's revolutionary line in literature and the arts". Poster, collective work of the Central Academy of Industrial Arts, Beijing, ca. 1968.

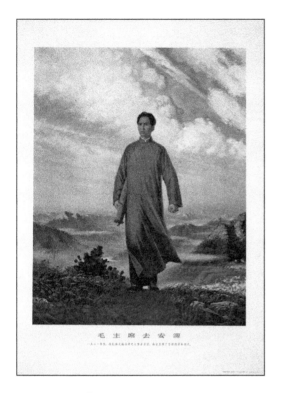

Figure 9.7 "Chairman Mao goes to Anyuan". Poster by Liu Chunhua, Beijing, 1968.

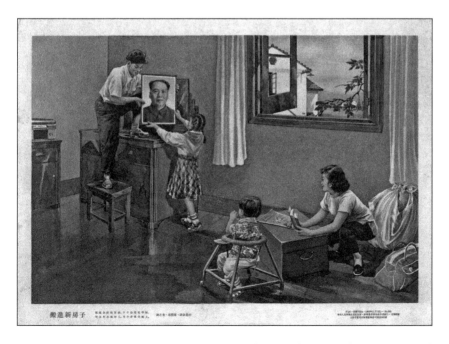

Figure 9.8 "Moving into a new house". Poster by Xie Zhiguang, Shao Jingyun and Xie Mulian, Shanghai, 1953.

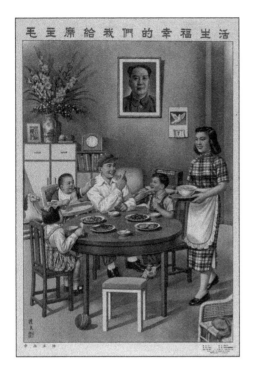

Figure 9.9 "Chairman Mao gives us a happy life". Poster by Xin Liliang, Shanghai, 1954.

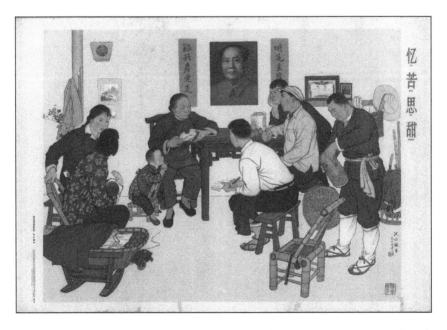

Figure 9.10 "Remembering the bitter, thinking about the sweet". Poster by Sheng Shuifu, Shanghai, 1965.

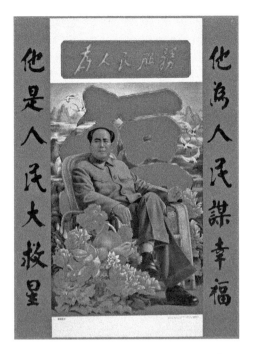

Figure 9.11 "Happy Universe". Poster, designer unknown, Tianjin, 1997.

Figure 9.12 "Glorious new achievements". Poster, designer unknown, place of publication unknown, 2012. It represents Mao surrounded by his successors Deng Xiaoping, Jiang Zemin, Hu Jintao and Xi Jinping. The bottom row depicts the members of the Politbureau, headed by Xi Jinping.

Bibliography

Andrews, Julia F. *Painters and Politics in the People's Republic of China 1949–1979*. Berkeley: University of California Press, 1994.

Barmé, Geremie. *Shades of Mao – The Posthumous Cult of the Great Leader*. Armonk, NY: Sharpe, 1996.

Bloodworth, Dennis. *The Messiah and the Mandarins—Mao Tsetung and the Ironies of Power*. New York: Atheneum, 1982.

Boden, Jeanne. *Chinese Propaganda Seducing the World*. Brussels: Punct, 2019.

Chan, Anita, Richard Madsen, and Jonathan Unger. *Chen Village under Mao and Deng* (Expanded and Updated Edition). Berkeley: University of California Press, 1992.

Chiu, Melissa, and Zheng Shengtian, eds. *Art and China's Revolution*. New Haven, CT: Asia Society/Yale University Press, 2009.

Cohen, Joan Lebold. *The New Chinese Painting 1949–1986*. New York: Abrams, 1987.

Cong, Dachang. *When Heroes Pass Away – The Invention of a Chinese Communist Pantheon*. Lanham, MD: University Press of America, 1997.

Evans, Harriet, and Stephanie Donald, eds. *Picturing Power in the People's Republic of China – Posters of the Cultural Revolution*. Lanham, MD: Rowman and Littlefield Publishers, 1999.

Gallice, Guy, and Claude Hudelot. *Le Mao*. Rodez: Rouergue, 2009.

Gittings, John. Real China — *From Cannibalism to Karaoke*. London: Pocket Books [Simon & Schuster], 1997.

Jian, Guo, Yongyi Song, and Yuan Zhou. *Historical Dictionary of the Chinese Cultural Revolution*. Lanham, MD: The Scarecrow Press, 2006.

Laing, Ellen Johnston. *The Winking Owl – Art in the People's Republic of China*. Berkeley: University of California Press, 1988.

Landsberger, Stefan. *Chinese Propaganda Posters – From Revolution to Reform*. Amsterdam: The Pepin Press, 1995.

Landsberger, Stefan, and Marien van der Heijden, eds. *Chinese Posters – The IISH-Landsberger Collections*. Munich: Prestel Verlag, 2006.

Leese, Daniel. *Mao Cult – Rhetoric and Ritual in China's Cultural Revolution*. New York: Cambridge University Press, 2011.

Minick, Scott, and Jiao Ping. *Chinese Graphic Design in the Twentieth Century*. London: Thames and Hudson, 1990.

Ou, Ning. *Meishi Street*. New York: dGenerate Films, 2006.

Paul, Gerhard. "Mao. Herrscherporträt im globalen Cultural Flow." In *Studien zur 'Visual History' des 20. Und 21. Jahrhunderts*, edited by Gerhard Paul, 319–59. Göttingen: Wallstein, 2013.

Schrift, Melissa. *Biography of a Chairman Mao Badge – The Creation and Mass Consumption of a Personality Cult*. New Brunswick, NJ: Rutgers University Press, 2001.

Sullivan, Michael. *Modern Chinese Artists – A Biographical Dictionary*. Berkeley, CA: University of California Press, 2006.

Valjakka, Minna. "Many Faces of Mao Zedong." Unpublished PhD thesis, University of Helsinki, 2011.

Wu, Hung. *Remaking Beijing – Tiananmen Square and the Creation of a Political Space*. Chicago, IL: University of Chicago Press, 2005.

Zhongguo meishuguan, ed. *Zhongguo meishu nianjian 1949–1989* [Chinese Yearbook of Fine Arts 1949–1989]. Guilin: Guangxi meishu chubanshe, 1993.

10 Monuments in History
Political Portraiture in North Korea

Mary Ginsberg

The political culture of every mobilized nation combines elements of coercion and ritual. The Democratic People's Republic of Korea (DPRK or North Korea[1]) is a highly mobilized society, whose charismatic leadership relies routinely on this admixture to foster appropriate participation and commitment.[2] Established in 1948, the DPRK has been characterized as Confucian, Stalinist, Fascist and Totalitarian, among other regime types.[3] The political system arguably contains elements of all these, on the coercion end, but the uniquely Korean symbolic and ritual aspects of political and social life exert a strong pull on hearts and minds: it's not just behavioral, it's emotional.

Propaganda art plays a crucial role in the development of political culture – particularly in revolutionary and wartime societies. In North Korea, which fought two wars in the twentieth century and is still progressing its "socialist" revolution,[4] all art is state-sanctioned, and nearly all art for domestic display has political content.[5] There is no art for art's sake: if it's art, it's propaganda. The "Dear Leader" Kim Jong Il (1941–2011) wrote the rulebook on the functions and methods of art in his *Misullon* (Treatise on Art). He prescribed the creation of art as the individual expression of correctly interpreted objective reality:

> An artwork can give emotional inspiration [*chŏngsŏjŏk kamhŭng*] to people if it is made on the basis of the ideological impact and the emotional experience which the artist received from reality.[6]

1 "The People's Democratic Republic of Korea," "DPRK" and "North Korea" are used here interchangeably.
2 Kwon and Chung analyze this specifically with respect to North Korea. Their theoretical pole ends are Max Weber, *The Theory of Social and Economic Organization* and Clifford Geertz, Negara: *The Theater State in Nineteenth-Century Bali*. Their resulting formulation is "the modern theater state". Heonik Kwon and Byung-Ho Chung, *North Korea: Beyond Charismatic Politics* (Lanham, MD: Rowman & Littlefield, 2012), 43–6.
3 A useful summary is Charles Armstrong, "Trends in the Study of North Korea," *The Journal of Asian Studies*, 70, 2 (2011): 360–1.
4 The country is officially ruled by the Korean Workers' Party (KWP). "Communism" has been removed from political vocabulary, but North Korea is building its own brand of "socialism".
5 Art for export or international exhibitions is a completely different matter.
6 Kim Jong Il, *Misullon* (Pyongyang: Chosŏn nodongdang ch'ulp'ansa, 1992), 169, translated in Koen de Ceuster, "To Be an Artist in North Korea: Talent and then Some More," in *Exploring North Korean Arts*, ed. Rüdiger Frank (Nuremberg: Verlag für moderne Kunst Nürnberg, 2011), 59.

Misullon goes on at great, empty theoretical length about the individual artist's expression of beauty as reality. More substantively, Kim Jong Il insisted that a work of art must be clearly understood and correctly responded to by the viewer. If people don't understand it, the work is a failure, no matter how technically proficient it is or how pleasant to look at.[7]

In the hierarchy of artistic subject matter, inspirational theme paintings are paramount. (The next type is landscape paintings, which are implicitly political, because they reinforce love of the homeland. Traditional bird and flower subjects are of much less significance.[8]) Within this category, by far the most important are those portraying the leaders' heroic feats, their thoughtful guidance and loving care for the people. They are sublime productions of specific moments, rousing people's emotions by (re)creating "historical truth". As Kim Jong Il put it, "Art leaves monuments in history."[9]

The bringing to life of these "monuments in history" – narrative idolizations of the Kim family leadership – is the most straightforward place to begin a discussion of political portraiture in the DPRK. The personality cult in North Korea is the most all-embracing ever known. Legitimacy of the regime rests fully on the personal legitimacy of the Kim family, continually reinforced by propaganda in its many formats (paintings, posters, prints, mosaics, monuments and statues); parades and pilgrimages to "sacred" sites; and textbooks, magazines, postage stamps and other everyday items. All these strengthen the authority of, and loyalty to, primarily, the founding leader, Kim Il Sung (1912–1994); and by way of rituals and symbols of successorship, the dynastic transitions to Kim Jong Il and then Kim Jong Un (b. 1983?).[10] This paper will consider North Korean political portraiture in its various forms: visual, performative and transactional.

Representations of Kim Il Sung and Kim Jong Il

Briefly, the *dramatis personae*: Kim Il Sung – the "Great Leader", "Parental Leader", "Generalissimo" and "Eternal President" – reigns supreme, omnipresent long after his death. His first son and successor, Kim Jong Il, the Dear Leader,[11] – "Shining Star" and "Sun of the Nation" – ruled until his death in 2011; his image, too is ubiquitous. Kim Jong Un was the second son of the Leader's third wife, so an unusual choice for dynastic succession. He has been in power since 2012 and is fast creating a personality cult of his own, as the "Great Successor" and "Respected and Beloved Leader".

7 This sounds a great deal like Mao Zedong (1893–1976) at the 1942 Yan'an Forum on Literature and Art.

8 De Ceuster, "To Be an Artist," 55–6.

9 Kim Jong Il, *Misullon*: 21. Quoted in Min-Kyung Yoon, "North Korean Art Works: Historical Paintings and the Cult of Personality, *Korean Histories*, 3, 1 (2012): 54. Yoon analyzes four paintings to elucidate the use of history in North Korea's cultural production.

10 The Kim personality cult and its leader symbols are comprehensively analyzed in Jae-Cheon Lim, *Leader Symbols and Personality Cult in north Korea: The Leader State* (New York: Routledge, 2015).

11 The "leader" term used for Kim Il Sung (*suryong*) is different from that used for Jong Il's "leader" title. *Suryong* was originally reserved for Josef Stalin, in the early years of the Soviet-supported DPRK, but from the 1960s, has only been used for only Kim Il Sung.

The leaders' revolutionary pedigree goes back many generations, and most figure in narrative portraiture. Kim Il Sung claimed that his great-grandfather participated in the burning of the American ship, the General Sherman, in 1866. His grandfather is said to have fought in the 1894 Tonghak peasant rebellion, an incipient nationalist and peasant uprising which sparked the first Sino-Japan War over influence in Korea (1994–1995). His father, uncle and brother were all fierce partisans in the long struggle against Japanese colonial rule, which lasted from 1905 to 1945.[12]

The women of the family feature in their own rights. Kim Il Sung's mother, Kang Ban Sok (1892–1932), leader of the revolutionary women's organization, is called "Mother of the Nation" and is honored ceremonially on her birthday every April. His second wife, Kim Jong Suk (1917–1949), served in the guerrilla forces.[13] She was Kim Jong Il's mother and died when he was very young. While not nearly as visible as Kim Il Sung and Kim Jong Il, she appears together with them sometimes ("the Three Generals"), especially since the 1990s.[14]

Images of the Kims are literally everywhere. Side-by-side portraits of Kim Il Sung and Kim Jong Il hang on the wall in every home or apartment; every schoolroom, train and metro car; at the entrance to every factory, office building, gymnasium, hospital and other facilities. The outsides of public buildings display painted large portraits or mosaic murals; murals are permanent, so don't need replacing. Until 2011, only Kim Il Sung adorned many of these spaces, but since Kim Jong Il's death, father and son have appeared together.[15] Mosaic murals decorate metro stations, and freestanding murals are on streets and hilltops. Paintings and murals are often duplicated in other media and display narrative scenes of all kinds – one or both of the Kims giving guidance to farmers or factory workers, inspiring party workers or soldiers or surrounded by adoring children (Figure 10.1).

Far and away the most important is Kim Il Sung. The Eternal President, he is supreme – and yet always at one with the people, caring for them, working tirelessly for them. He was the great emancipator in the anti-Japanese struggle (1910–1945) and the Fatherland Liberation War (Korean War, 1950–1953). He led the economic re-construction that made North Korea "the happiest country in the world". His revolutionary vision and achievements guide all successors.

There is a prescriptive picture book called *Images of the Immortal*, which makes clear the inseparable intertwining of Kim Il Sung's life and North Korea's national history.[16] The book divides Kim's life into ten periods, illustrating each with select paintings. Each section begins with a quote – the first by Kim Jong Il about his father's greatness, the rest by Kim Il Sung locating himself in the various stages of revolutionary

12 Sheila Miyoshi Jager, *Narratives of Nation-Building in Korea: A Genealogy of Patriotism* (London: Routledge, 2003), 109.
13 Kim Hye Sun (d. 1940) is believed to have been Kim Il Sung's first wife.
14 Andrei Lankov states that Kim Jong Il joined his father in standardized portraits form the late 1970s. Andrei Lankov, *The Real North Korea: Life and Politics in the Failed Stalinist Utopia* (Oxford: Oxford University Press, 2013), 32.
15 Ibid. However, photograph collections published in the 2000's mostly show Kim Il Sung alone. See, for example, Mark Edward Harris, *Inside North Korea* (San Francisco, CA: Chronicle Books), 207.
16 Yoon, "North Korean Art Works," especially 57–8. Yoon analyzes four specific paintings by reference to officially approved reviews: 58–71.

struggle and national development. The first five sections cover the years to 1945 and then the end of Japanese colonial rule. This is the foundation on which the Kim Il Sung supremacy rests.[17]

The history begins early. Kim first witnessed Japanese brutalities at the age of six in his birthplace at Man'gyŏngdae (now a place of pilgrimage near the capital).[18] When he was thirteen, he vowed not to return to Pyongyang until it was liberated.[19] An iconic painting of the early years shows his steadfast mother passing on his father's pistols (Figure 10.2), and with this legacy, Kim went off in 1925 to lead the struggle against the Japanese aggressors. His mother the revolutionary appears entirely traditional here – women generally do, regardless of their actions – and he looks rather like a Japanese schoolboy. There is no fire at all in his eyes, but already his head seems surrounded by a super-natural light.

According to "the Text", as one scholar refers to the body of national myths,[20] Kim organized underground revolutionary youth groups for armed resistance in the 1920s and 1930s. One of the earliest recorded revolutionary paintings illustrates Kim's rousing victory speech at Poch'ŏnbo in 1937. Kim Il Sung's forces attacked a Japanese outpost, caused some damage and occupied it for one day. This was a minor event which has an exaggerated place in North Korean history, symbolizing Kim's heroic feats in the struggle for liberation. Like many paintings, as cultural policy changed over time, it was revised by the artist to meet new guidelines with respect to materials, coloring and placement of the main characters.[21]

A clear example of re-working Kim portraiture was produced over three decades, in several media.[22] It celebrates Kim Il Sung's triumphant return to Pyongyang after the Japanese departure at the end of Second World War. The official story is that Kim spent the years 1939–1945 near Mount Paektu (Baekdu), inside the border between Korea and Manchuria. In fact, he returned to Korea from the Soviet Union, where he was a Captain in the Army.[23] The official, widely displayed color photograph shows Kim Il Sung alone at the podium against a blue sky, speaking at a mass rally on October 14,

17 Kim's memoir, *With the Century*, was meant to be thirty volumes, but he died after writing six, and two were published posthumously; they only got as far as 1945. Full of dramatic narrative, *With the Century* is the most popular of the many, many books (claimed to be) written by Kim Il Sung.

18 There is some question as to whether he was actually born there.

19 The Arch of Triumph in Pyongyang, built in 1982 – Kim's seventieth birthday – celebrates this promise: the dates 1925 and 1945 are prominent on the monument – which looks very much like the one in Paris, but intentionally bigger.

20 Brian R. Myers, *The Cleanest Race: How North Koreans See Themselves and Why It Matters* (New York: Melville House, 2010), 18.

21 Two versions are shown in Charlotte Horlyck, *Korean Art from the 19th Century to the Present* (London: Reaktion Books, 2017), figs. 66–7.

22 For two versions of the painting (1953 and 1961) and a 2010 postage stamp, see Frank Hoffman, "Brush, Ink and Props," in Frank, *Exploring North Korean Arts*, figs. 9–11. For a photo of the actual event, see "Korean Leaders in 1945". http://www.endofempire.asia/1010–2-korean-leaders-in–1945–3/. Last accessed April 2, 2018.

23 After the war, Korea was divided by the Allies at the thirty-eighth parallel, with the Soviets effectively in charge in the North, and Kim Il Sung was their chosen leader. The extent to which the Soviets actually managed post-war politics, economics and culture from 1945 until their departure in 1948 remains hotly debated.

1945. The real photo is black and white, and behind Kim stand two Soviet generals, commanders of the Soviet armed forces in Korea.

Influential artist Mun Haksu (1916–1988) painted this event at least three times. In the 1953 and 1961 versions, Kim stands at the left of the painting, with prominent portraits of Lenin and Stalin behind him (although these get reversed between versions). In a later undated version, which appeared as a commemorative postage stamp in 2010, Lenin and Stalin are gone, emphasizing Kim's authority. Painted in the bright colors of *Chosonhwa* (Korean painting),[24] as required from the mid-1960s, Kim speaks to a joyous crowd of workers and farmers, but he is still way over on the left, with the crowd taking up most of the picture. Finally, in an enormous mosaic mural installed in the square where the speech took place, Kim stands alone, front and center, cheered by an ecstatic crowd, waving flags, banners and flowers (Figure 10.3).[25]

Many of the endlessly portrayed Kim Il Sung episodes have some basis in fact: they more or less occurred. He did have a success at Poch'ŏnbo, though its importance to the revolution is wildly over-stated. Other depictions are fabrications. The Victorious Fatherland Liberation War Museum has room after room of paintings, dioramas, photographs and documents from the Anti-Japanese Revolutionary Struggle (1910–1945) and the Fatherland Liberation War (1953). In one display case, Emperor Hirohito is shown delivering his famous recorded surrender speech.[26] In the photograph, he is positioned facing a portrait of Kim Il Sung – as though he is surrendering to Kim, who achieved this sacred victory. There is no mention of any other country in this display (Figure 10.4).

Similarly, every child is taught that South Korea started the Fatherland Liberation War, and that the United Nations surrendered to North Korea in 1953: neither is true.[27] Following the Korean War, the DPRK achieved rapid economic reconstruction – faster than South Korea, albeit with much help from communist bloc nations. Gradually Kim Il Sung distanced himself from the USSR and Marxism-Leninism, declaring a new ideology known as *Juche* (generally translated as self-reliance, but literally "subject").[28] The main points of *Juche* are that (1) man is the master of all things and can accomplish anything; and (2) the people of the DPRK will realize the

24 *Chosonhwa* was the preferred medium over oil painting, since it represented a national form. Painting must be national in form, socialist in content, according to Kim Il Sung (actually Mao Zedong said it long before). In the 2010s, oil painting made a major comeback, but with colors and style very similar to *Chosonhwa*. They can be difficult to differentiate if looking at a published copy, rather than the actual work.

25 Dated 1987, it is made of finely cut, varied tile pieces, with strong colors and clear outlines. Later mosaic murals are made with standard-size tile pieces, resulting in less clear and appealing works. For the best analysis of mosaic murals, see Marsha Haufler, "Mosaic Murals in North Korea," in Frank, *Exploring North Korean Arts*, 241–75.

26 "The war situation has developed not necessarily to Japan's advantage …"

27 An Armistice was signed on the site of the Demilitarized Zone (DMZ) between North and South. No peace treaty has ever been signed. However, in a surprising development at a landmark meeting between Kim Jong Un and ROK President Moon Jae-In in April 2018, both leaders declared their intention to do so.

28 References to Lenin and Stalin disappeared by the end of the 1950s, and the last publicly displayed portrait of Marx was removed in 2012. Lankov, *The Real North Korea*, 49–50.

socialist revolution according to Korea's own circumstances, under the banner of the Korean Workers Party. *Juche* theory is hailed as Kim Il Sung's creative contribution to socialism and revolutionary development, and it is invoked in all areas of politics, economics, culture and social relations. In 1972, *Juche* was declared the country's official ideology.[29]

Kim Il Sung turned sixty in 1972. According to traditional calendars, sixty completes the sexagenary zodiac cycle, so is a milestone of great importance. In that year, badges were distributed to the masses with a picture a Kim Il Sung. People wear these on their left side, close to their heart. Badges were produced and distributed for particular occasions before this time, but from 1972, became compulsory.[30] Some people wear a badge only with Kim Il Sung; others with both Kim Il Sung and Kim Jong Il. Relatively few wear only Kim Jong Il. The system for distribution of the badges is unclear, and people wear different ones as they progress or change units. Foreigners cannot buy these badges – unlike in China, where Mao Zedong badges are readily available in markets and shops.[31] A few special foreign friends have been given them, and they wear them on formal occasions.

Another commemoration of Kim's sixtieth birthday was an enormous statue of him – sixty-six feet tall (twenty meters) – built on the site of the Korean Revolution Museum on Mansu Hill, Pyongyang. He stands in front of a mosaic mural of Mount Paektu, sacred mountain of the revolution (and more of which below). Two vast bronze friezes of revolutionary figures form part of the monument complex. Originally Kim Il Sung's statue was covered in gold leaf, but it was later modified to bronze (Figure 10.5).

After Kim Jong Il died in 2011, a statue of him was added next to his father. The statue of Kim Jong Il originally showed him similarly dressed in a long coat, but this was quickly changed to his signature parka over his usual khaki tunic and trousers. The most notable thing about the Kim Jong Il statue is his resemblance to Kim Il Sung, which simply wasn't the case in real life. Among other differences, he was much shorter than his father – at 5'3", he wore lifts or platform shoes. His face was thinner and less round than his father's, particularly in his last years; his whole manner was less accessible. Like the statues, however, many paintings and mosaics of them together show a strong family likeness.

Mansu Hill is a requisite site of pilgrimage for both citizens and visitors. Not only on special occasions, but early every morning, groups line up row by row, moving ahead to greet the leaders, bowing respectfully. North Koreans offer flowers and dress formally – men in suits, women in the traditional costume. Every foreign group has a minder, who stands by tensely until this ceremony is completed without incident (foreign tourists have been known to behave disrespectfully, laughing or refusing to bow). Photography is permitted; even encouraged, with the proviso that one never takes

29 It is difficult to pinpoint concrete measures inspired by *Juche*. Brian Myers calls it, "a sham doctrine with no bearing on Pyongyang's policy-making". Myers, *The Cleanest Race*, 12.

30 James E. Hoare, *Historical Dictionary of Democratic People's Republic of Korea* (Historical Dictionaries of Asia, Oceania, and the Middle East), 2nd edition (Lanham, MD: Scarecrow, 2012), 57.

31 Mao badges were ubiquitous during the Cultural Revolution, but it is unclear whether foreigners were allowed to have them in those days.

only part of Kim Il Sung's face, but must capture the whole. Nor may one photograph the statues from behind or take only Kim's feet (which someone might do to show the relative size of the statue).

Even more strictly regulated is the paying of respect to the Leaders at the Kumsusan Palace of the Sun, which served as Kim Il Sung's official residence. Following his father's death in 1994, Kim Jong Il had it renovated as an enormous mausoleum, and this is now also his resting place. A visit to this sacred place for foreign groups is by invitation and is not part of the usual tourist itinerary. Again, all is formal and reverent behavior. One moves silently along on a slow travellator for about twenty minutes (being moved, not walking). Near the end of this ride, on the way in, is a long wall of chronologically themed paintings of Kim Il Sung's life and work. In paintings of his later life, he is rarely in military uniform or "people's" clothes (khaki or dark Mao suits), and most often in suit and tie. The gray streak in his hair becomes prominent, and he always wears glasses, which he did not in paintings of the revolutionary years. He appears part distinguished statesman, part benevolent grandfather.

Many include Kim Jong Il – episodes where they gave on the spot guidance together to workers or military personnel, or visited special places together. In these, Kim Jong Il looks more like his photographs, less artificially like Kim Il Sung. Perhaps this is because the viewer is shortly to see the actual body and face of Kim Jong Il, so a strong mis-representation would be unconvincing.[32] From the end of the portrait gallery, one passes through a chamber like a metal detector, whose function is a disinfecting fan-blower. Only then may one enter the large room where the Eternal President lies in state, embalmed in a glass case. Groups of four advance in a row, bowing to the case on each side and at the feet-end, but not at the head-end; this is not explained. From there, the group goes into a hall of medals, awards and other decorations that were bestowed upon Kim Il Sung. A third room holds the Mercedes Benz and train carriage that Kim Il Sung traveled the country in, tirelessly inspecting, guiding and inspiring. A huge wall map shows all the places he went at home and abroad, working indefatigably for his people.

This ritual is repeated for Kim Jong Il. His train carriage is particularly important, because he is said to have died in it, working late into the night. His transport room also contains the boat in which he traveled the country. On the travellator back toward the mausoleum's exit, the visitor views a chronological gallery of Kim Jong Il portraits. Some show him young and round-faced: Kim Il Sung-like. The ones of his later years are more true-to-life: short and thin, not at all robust like his father, usually wearing sunglasses. The large spot of discoloration on his face is never shown, just as the tumor on the back-right side of Kim Il Sung's neck is never visible in paintings or official photographs (though foreign news agencies caught it in photographs).

Kim Jong Il's story is less straightforward than his father's, and his career more complicated to portray convincingly. The official version is that the Sun of the Nation was born in 1942 in a cabin on Mount Paektu, where Kim Il Sung was leading the anti-Japanese struggle. Mount Paektu is sacred as the legendary birthplace of Korea's

32 Photography is prohibited inside – phones and cameras deposited at the door – so no example is available here.

first leader, Tan'gun (Dangun), who founded the nation in 2333 BC. Both Koreas accept the Tan'gun myth, so Mount Paektu's location in the DPRK adds weight to its legitimacy and unification claims.

Kim Jong Il's birth was heralded by a double rainbow and glowing star. The local partisans were so happy, they carved his name into thousands of trees. Images related to the birth – the cabin, mountain village and carved trees, which have been preserved – merit a full room at the Fatherland Liberation War Museum (Figure 10.6).

The facts are different. The boy was born in 1941, Yuri Irsenovich Kim, in a refugee camp near Khabarovsk, Siberia, USSR. The spurious 1942 date auspiciously puts his seventieth birthday in the year of Kim Il Sung's hundredth. Unlike his father's portrayed heroics, which have a whiff of plausibility to them, Kim Jong Il is said to have walked at three weeks of age, and talked at eight weeks. He wrote 1,500 books while at university. When he played his first-ever round of golf, he got eleven holes-in-one. He could change the weather.

Kim Il Sung started laying the groundwork for Kim Jong Il's succession in the early 1960s, and this escalated visibly a decade later.[33] His official title was "Party Center", so his rising importance could be described without naming him. He first appeared in portraits beside Kim Il Sung in 1975.[34] His titles became grander through the 1970s, and finally in 1980, the intended hereditary succession was formally acknowledged to foreign journalists.[35] Propaganda in the 1980s witnessed a return to traditional Confucian principles, which emphasized loyalty in relationships and most particularly, filial piety.[36] These virtues were conflated to mean filial loyalty to the parental supreme leader: the people were all Kim Il Sung's children.

A great many published paintings and open-air murals show father and son together. In Kim Il Sung's lifetime, the father took center stage in these themed portraits (Figure 10.7).

Paintings in the 2010s sometimes focus on the younger Kim. Published collections of contemporary paintings now have more paintings of Kim Jong Il than of his father. The first section of every such volume is reserved for portraits or themed narratives of the Leaders. A 2010 (year 99 of the *Juche* calendar)[37] collection commemorates the sixty-fifth anniversary of the KWP. Its section on the Kims contains six portraits of Kim Il Sung, but thirteen of Kim Jong Il, plus a painting of the cabin in which he was born.

Many of the Kim Jong Il paintings show him with military personnel, as this is the era of *Songun* (military first) politics. In a painting chosen as a national treasure, he is shown greeting sailors on Navy Day. His presence fills them with joy: a sailor is actually in tears (Figure 10.8). Kim's demeanor is warm and caring in these paintings – fussing with a soldier's hat to make sure he is warm, celebrating the harvest with hardworking farmers or hugging a group of schoolchildren. "Loving",

33 Bradley K. Martin, *Under the Loving Care of the Fatherly Leader: North Korea and the Kim Dynasty* (New York: Thomas Dunne, 2004), 236.

34 Ibid., 271.

35 Ibid., 286.

36 Lim, *Leader Symbols*, 23.

37 After Kim Il Sung's death, Kim Jung Il changed year-counting to the *Juche* calendar. 1912, the year of Kim Il Sung's birthday, is *Juche* 1.

"caring" and "affectionate" are common words in the titles of these paintings. He has taken on the fatherly leader persona that was so effective in the portraiture of Kim Il Sung.[38]

There is no reason to doubt that Kim Il Sung was beloved by the people of North Korea. From 1948–1994, he was the only leader they knew. He was the revered emancipator and rebuilder. His passing was truly traumatic to the nation. During the years following his death, the country suffered numerous economic and political setbacks (collapse of the USSR and its accompanying economic support on which the DPRK depended), as well as natural disasters – all of which combined resulted in a catastrophic famine.

Kim Jong Il, having securely achieved the hereditary succession, called this terrible period the "Arduous March".[39] The United States and its "puppet", South Korea, were blamed for all the North's ills. The Dear Leader's public persona was the self-sacrificing protector of the nation – eating just one rice ball a day as he worked tirelessly to keep the foreign enemies at bay. He was never portrayed looking thin and hungry, however. He was sometimes painted against a dark sky, "Stand[ing] guard as the waves of a hostile world crash ineffectually against the rocks".[40]

The worst of the famine was over by 1998, and the country tried to reconstruct. Much had changed forever, though: state failure resulted in entrepreneurial activity unknown for decades. The Public Distribution System had broken down completely, and unofficial private markets were the nation's lifeline. Many more would have starved to death without them. Families had been separated in the search for food, schools had been abandoned and children were roaming the streets. Transport, electric power and production had been disrupted. In practical terms, this meant people's lives were less completely bound to party and state; in political and emotional terms, they had lost faith.[41]

Although the country began to recover, the terrible circumstances of the 1990s were still strong in people's minds when the Dear Leader died in 2011. He had not been revered in nearly the same way as Kim Il Sung, but the mourning performances were similarly histrionic. As one writer put it,

> For a leader who ruled with an iron fist and had few accomplishments, images of a grief-stricken public were puzzling to most foreign observers. To what extent the tears were sincere or crocodile was the source of considerable speculation.[42]

38 Brian Myers insists that the parental role played by the Leaders is maternal. Myers, *The Cleanest Race*, 105–7. Most other scholars emphasize "parental" or "fatherly".

39 He used the term to hark back to Kim Il Sung's "Arduous March" during the anti-Japanese struggle in the 1930s.

40 Myers, *The Cleanest Race*, plate 16, 96–7.

41 Barbara Demick, *Nothing to Envy: Real Lives in North Korea* (New York: Spiegel and Grau, 2010) relates stories of individuals who lived through the famine in Chongjin, the DPRK's third largest city. Everyone suffered, but life outside Pyongyang was very much worse than for the privileged residents of the capital and for military service personnel.

42 Peter M. Beck, "North Korea in 2011 The Next Kim Takes the Helm," *Asian Survey*, 52, 1 (2012): 66.

Notwithstanding all those images of the Dear Leader giving tender guidance and revolutionary inspiration, Kim Jong Il was a distant and unknown figure to most. He was self-conscious about his voice – he never gave a public speech during his seventeen years as Leader – as well as his height and looks (shoe lifts, sunglasses). Of course, no one dared to deride him within North Korea, but defectors and foreigners produced many caricatures and insulting images. Song Byeok is a defector who made propaganda paintings and posters in the DPRK, but now critiques the regime from South Korea. His best-known work is *Take Your Clothes Off* (2010), a caricature of Kim Jong Il's head on Marilyn Monroe's body.[43] In the US, Kim Jong Il's death was parodied in a Paramount film directed in 2004 by Trey Parker, *Team America: World Police*.

Kim Jong Un Era

Kim Jong Il had decades preparing to assume the top leadership role, but Kim Jong Un had only started publicly appearing a year or so before he took over,[44] garnering a few important titles here and there. He led all Kim Jong Il's funeral arrangements and ceremonies, making it clear that he was in charge as the rightful hereditary successor. Since 2012, he has greatly expanded the personality cult of his father – as noted above, Kim Jong Il's portrait is now everywhere beside Kim Il Sung's. Dual statues are made even for occasions specifically honoring Kim Il Sung, such as the spectacular extravaganza honoring his 105th birthday.

The Kim Jong Un propaganda machine revved up immediately. The new leader appeared on a stamp, standing with Kim Jong Il, a mere eighteen days after his father died.[45] He is very media-savvy, meeting the population in a personable way, appearing with his wife both at home and abroad. He bears a remarkable resemblance to his grandfather – facial features, haircut, tone of voice, dressed in "people's" clothing in the style Kim Il Sung wore when young. Rumors spread early on of cosmetic surgeries to enhance the similarity, which the North Korean news agency vehemently denied.[46] In late 2019, he moved away from the Kim Il Sung sartorial look, by adopting a personal wardrobe of leather trench coats. However, he is holding fast to the revolutionary traditions that legitimize his rule. He has been photographed several times riding a white horse up on sacred Mount Paektu (where Kim Il Sung supposedly spent the War of Liberation war fighting Japanese, and where Kim Jong Il is claimed to have been born). There are paintings of both earlier Kims astride a white horse, and Kim Il Sung was riding a horse on the first bronze statue made to honor him. Moreover, the horse

43 Ju-min Park, "From Dear Leader to Marilyn Monroe, defector mocks Kim" – Reuters UK. https://uk.reuters.com/article/us-korea-north-painting-idUKTRE7BP06B20111226. Last accessed May 10, 2018.

44 His first publicized appearance was September 2011. Kim Jong Il died the following December. BBC News, "Keeping up with the Kims: North Korea's elusive first family" February 7, 2018. http://www.bbc.co.uk/news/world-asia–41081356. Last accessed May 10, 2018.

45 Willem van der Bijl, private communication, April 2018.

46 "North Korea hits out at 'sordid' Kim Jong-un plastic surgery rumours," January 24, 2013. https://www.telegraph.co.uk/news/worldnews/asia/northkorea/9822936/North-Korea-hits-out-at-sordid-Kim-Jong-un-plastic-surgery-rumours.html. Last accessed May 10, 2018.

carries special meaning in Korean mythology: the winged Chollima was so fast that only immortals could ride him.[47]

The outside world has seen two versions of Kim Jong Un. In his first years in power, he often appeared the buffoon, laughing irrationally and threatening to obliterate all enemies. This early persona has been the object of much lampooning and ridicule outside the DPRK. There have been toys, posters, cartoons and T-shirts, and even a full-length feature film: *The Interview*, directed in 2014 by Seth Rogen and produced by Sony Pictures.[48] In 2018, however, he made numerous diplomatic overtures to both South Korea and the United States, presenting a mature, executive image.

Within North Korea he is endlessly photographed and filmed for daily news media, but as of early 2018, his painted portrait had not begun appearing with the other Kims in public spaces. Nor, at that time, were badges of Kim Jong Un being worn by citizens.[49] The Beloved and Respected Leader is, however, still very young (mid-30s?), and his image may well be elevated with his predecessors'.

Availability of the Leaders' Portraits

All official images of the Leaders are produced at the Mansudae Art Studio in Pyongyang. Founded in 1959, this is the premier establishment for cultural production, responsible for paintings, portraits, sculptures, graphics and badges of the Kims, as well as national monuments honoring the KWP and *Juche* Thought. Mansudae has a staff of roughly 4,000, of whom 1,000 are artists, chosen from the best art academies. Much of Mansudae's production is made specifically for export, by the Overseas Project Group of Companies. This unit's published catalog of available works includes paintings, murals, sculptures, ceramics, badges and other items – none bearing the image of Kim Il Sung, Kim Jong Il or Kim Jong Un. The works for export include traditional bird and flower paintings, landscapes, scenes of productive families and workplaces and other themes with explicit or implied political content – but no Leaders. Foreign tourists may visit the Mansudae Art Studio and meet some artists, but apparently not in the areas where Leader pictures are produced.

A puzzling exception with respect to Leader imagery seems to be made for transactional items like money and stamps. Kim Il Sung is on the face of banknotes for domestic circulation as well as souvenir packs urged on foreigners and paid for with hard currency.[50] Moreover, foreigners are allowed to visit at least one Pyongyang department store where purchases are made only with local currency, which they obtain in

47 Chollima remains the national symbol of rapid development, invoked in every major economic campaign.

48 North Korean computer experts hacked Sony's email system and leaked a batch of embarrassing material. Sony cancelled the theatrical release, but the film was available through other outlets.

49 Daniel Levitsky, private communication, April 2018. In 2012, it was reported that Kim Jong Un badges had been distributed to some staff in the Ministry for State Security. Luke Herman, "Brace Yourselves, the Kim Jong Un Badges are coming." https://www.nknews.org/2012/11/brace-yourselves-the-kim-jong-un-badges-are-coming/. Last accessed April 23, 2018.

50 Kim Il Sung first appeared on banknotes issued in 1978, and again in 1992, 2002 and 2006. Neither of the other Kim leaders appears on banknotes.

exchange for hard currency.[51] This is strange, given the great emphasis on respecting the Leaders' complete images. It is a major offense to fold a newspaper, if Kim Il Sung's face goes across the page and would be dissected. Tourists are warned to ensure that they photograph his whole face on any mural or monument. No one would dare to tear or otherwise deface an image of any of the Kims, but a banknote is always subject to folding and general wear-and-tear, and the image could easily be damaged (Figure 10.9).

Leader portraits on postage stamps are for domestic use, but special covers are easily obtained by tourists and collectors, both in official stores and through many international outlets.[52] The International Year of the Child was commemorated in 1979 with five stamps that reproduced narrative paintings of Kim Il Sung. The stamps all appear to have been cancelled, but this is part of the production printing process for international/collectors' stamps.[53] Domestic stamps are actually cancelled, but never near the Leader's face.

Portraiture by Reference

There is nothing unusual about these images of Kim and children – only that foreigners can obtain them on stamps, but not on paintings, prints, posters or other permitted purchases. Children are important in the propaganda of all countries, but particularly when the leader's persona is explicitly paternal and protective.[54] A famous painting shows a girl asleep in bed, holding a gift-wrapped package in her arms. The present is from President Kim Il Sung, and all children receive gifts on his birthday, April 15. The painting is entitled *Happiness*, and the message is that all good things come from Kim's parental love.

Another painting of Kim Il Sung – also by reference – has a sacred air to it. The scene is an ordinary farm house during wartime. A young girl cleans away snow from the front of the house. On the porch are boots, which a visitor has removed before entering. Golden light shines from within the house: the Great Leader has come (Figure 10.10).

Kim Il Sung was raised in a Christian household. He repudiated the religion: it didn't solve Korea's problems,[55] and communism prescribes atheism. This painting,

51 Some elite shops accept only foreign currency or North Korean won which have an official exchange rate linked to foreign currencies. The People's Republic of China had a similar two-currency system in the 1980s. China today prohibits the export of Mao Zedong's image, but people take money out all the time.

52 For a comprehensive discussion of DPRK stamps, see Ross King, "Monuments Writ Small: Postage Stamps, Philatelic Iconography, and the Commercialization of State Sovereignty in North Korea," in Frank, *Exploring North Korean Arts*, 192–240. The DPRK ranks among world's most prolific stamp "panderers," issuing special covers honoring all sorts of unlikely people (Princess Diana, Elvis Presley) and occasions (one hundredth anniversary of the Orient Express). Stamp pandering refers to the commercial targeting of collectors.

53 Willem van der Bijl, private communication, April 2018. All the Kim leaders have appeared on stamps.

54 For example, Stalin was frequently portrayed with children during the Second World War, but not Lenin during the Bolshevik Revolution.

55 Kim rejected Christianity for himself, but permitted citizens to believe in their "superstitions", as long as they did not harm the state. He famously remarked, "I maintain that if one had to believe in a God

however, is unmistakably reverential. The setting and light within invoke Christian iconography. Scholars point to other paintings with similar Christian connotations.[56]

Another way to portray the Kims by reference is with flowers. In 1964, an Indonesian botanist created a light purple orchid in honor of Kim Il Sung ("Kimilsungia"). In 1988, a red begonia ("Kimjongilia") was produced in Japan as a mark of respect for the Dear Leader. These flowers symbolize the Leaders on posters and other media just as surely as if their faces are in the image. A 2017 issue of *Korea* magazine dedicated to the seventy-fifth (official) anniversary of Kim Jong Il's birthday has only a single Kimjongilia flower on the cover (Figure 10.11, Left).[57]

The Leaders are glorified by symbolic reference on posters, because they almost never appear on them. This is another puzzling fact about North Korean portraiture. The Kims' images are on paintings and mosaic murals in all kinds of public spaces. Posters are also everywhere – inside every building, on hoardings or in freestanding cases on the street – but the Leaders' images are not on them. Is it because posters are ephemera and might get torn? That is possible, but newspapers with the Kims' photographs are displayed on the street, made of even less sturdy paper. Furthermore, as noted above, money and stamps – both destructible – have Kim portraits. Is it because poster campaigns change regularly, so are only meant to last a short time before being stored or thrown away? That doesn't make sense either, because Kim glorification is not subject to short-term campaigns or policy changes. This writer has found no reasonable explanation.

A rare poster, *Long Live the Glorious Workers' Party of Korea!*, with a Leader portrait, has as its subject Kim Jong Il – looking very much more like his father than in real life – standing beside the symbol of the KWP.[58] Behind him is the tower to the *Juche* ideology, with its eternally glowing light, and the tall silhouette of a worker. In front of him are Kimilsungia and Kimjongilia blooms, as well as white magnolias, which are the national flower (Figure 10.11, Right).

Other Systematized Portrayals

Far more typical are posters with standard types: soldier, factory worker, miner, farmer, party worker, intellectual. These figures are "all represented through the habitual personifications in appropriate attire and holding the right props"[59] (Figure 10.12).

The cast of characters changes, depending upon the campaign being promoted, or the segment of the economy or government that is the subject of the poster. The slogan

he should believe in the God of Korea. It is laudable to cherish the God of Korea in one's heart and not do things harmful to the state. Do you believe in heaven? Has anyone been there?" Quoted in "The Surprising Reason Kim Il Sung Rejected Christianity". http://dotheword.org/2014/05/19/the-surprisin g-reason-kim-il-sung-rejected-christianity-and-what-christians-should-do-about-it/. Last accessed April 23, 2018.

56 Hoffman, "Brush, Ink and Props," 161.

57 *Korea* is a foreign language propaganda magazine issued in English, Arabic, Chinese, French, Russian, Spanish.

58 Unlike most communist parties whose symbol was the hammer (worker) and sickle (farmer), North Korea added the calligraphy brush to symbolize the inclusion of the intellectual class.

59 De Ceuster, "Democratic People's Republic of Korea," 229.

generally comes first; then the imagery gets assigned. The slogan in Figure 10.12 refers to "the single-hearted unity of the entire Party, the whole Army and all the people". Hence, at least one of each stereotype: female farmer carrying grain; Party worker with megaphone and important text, usually by Kim Il Sung; intellectual wearing glasses, and so on.

Women, too, display similar traits, regardless of the situation. Unlike the tough, unisex women of early Bolshevik propaganda or the radical years of China's Cultural Revolution, North Korean women are presented as demure and feminine. Even resolute revolutionaries often wear traditional clothing. This includes Kim Jong Suk, Kim Il Sung's second wife (Figure 10.13). Sometimes she appears in uniform with the other Kims, as one of the Three Generals. However, in one painting, Kim Jong Suk is the only one out of uniform among the female corps of pilots.[60] One of her colleagues is picking flowers, a distinctly unmilitary activity. Women in construction and factory jobs are similarly portrayed with ladylike attire and hairstyles.

A final stereotype is the presentation of foreigners, particularly enemies. Americans are shown acting cruelly and violently, stabbing babies to death in scenes of the Korean War. They are usually very thin with exaggerated or pointy features. A painting of the violent-looking, crazed Americans hangs on the DPRK side at Panmunjom (the Demilitarized Zone between North and South), where the Korean War Armistice was signed in 1953. Kim Jong Un met South Korea's President, Moon Jae-In in April 2018 on the ROK's side.

In posters, tiny American soldiers are shown being smashed by larger-than-life North Korean military personnel or just a huge fist. Sometimes, Americans appear as dogs wrapped in American flags. DPRK propaganda artists have been very imaginative in the portrayal of Donald Trump, the "mentally deranged American dotard", as Kim Jong Un calls him. American cartoonists have had their fun, too, with "Rocket Man" Kim. These portrayals may soften, depending on progress toward normalized relations; only time will tell.

Conclusion

The political portraiture of North Korea is overwhelmingly dominated by Kim Il Sung and Kim Jong Il. This is likely to remain so, although Kim Jong Un, the Great Successor, will be more visibly venerated as his tenure extends. The dynastic regime's authority rests on continually reinforced loyalty to the Kims, so this imagery is critical to the system. It is, of course, impossible to measure the internalization of performative devotion, and the coercion-emotional commitment mix will vary with economic and political conditions. Because the regime tries so hard to maintain its monopoly on information, both within and without, this essay has raised more questions than it has answered.

60 The red ribbon, however, distinguishes her special status. Thanks to Ginny Choi for noting this.

Figure 10.1 Putting Forward the Workers as the Master of the Hwanghae Iron and Steel Works. Painting by Rim Chol Ho, 2010 depicting Kim Il Sung, current whereabouts unknown. (From: Mansudae Overseas Project Group of Companies, *National Fine Arts Show for Celebration of the WPK Conference and the 65th Anniversary of the WPK*, Pyongyang: Foreign Languages Publishing House, 2010).

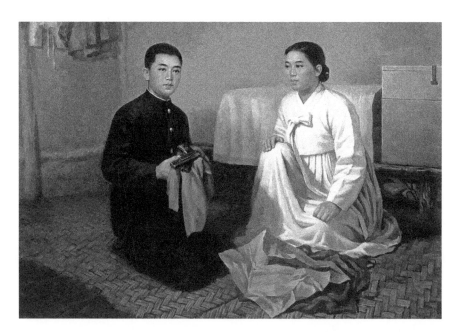

Figure 10.2 Kim Il Sung takes over two pistols, valuable inheritance left by his father, from his mother. Painting by unknown artist, date unknown, Victorious Fatherland Liberation War Museum, Pyongyang. (From: *Victorious Fatherland Liberation War Museum*, Pyongyang: Foreign Languages Publishing House, 2014).

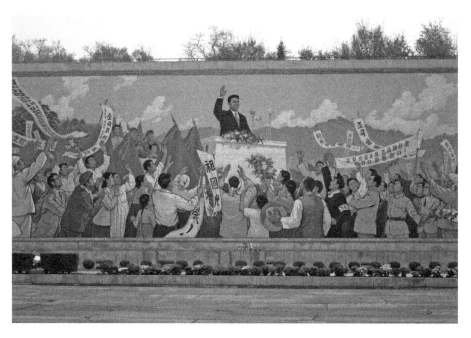

Figure 10.3 Cheers of the Whole Nation. Mosaic Mural celebrating Kim Il Sung, 1987, Pyongyang. (Author's photograph).

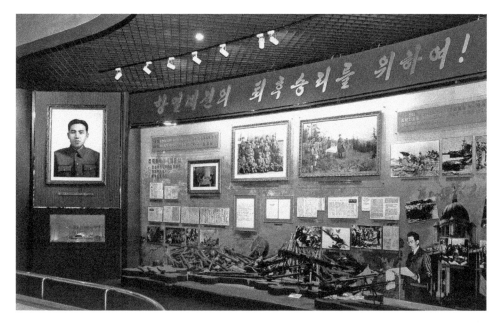

Figure 10.4 Victorious Fatherland Liberation War Museum, Pyongyang. (Author's photograph).

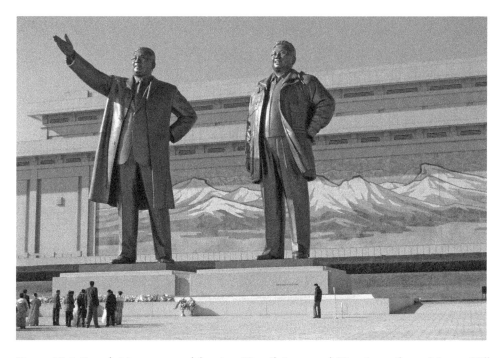

Figure 10.5 Grand Monument celebrating Kim Il Sung and Kim Jong Il. on Mansu Hill, Pyonggyan, (Author's photograph).

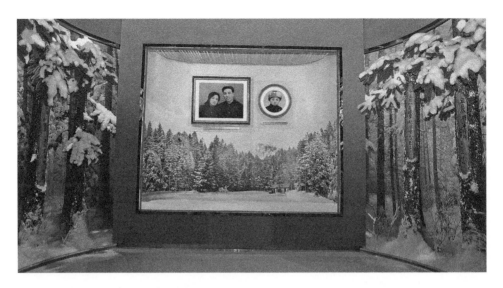

Figure 10.6 Victorious Fatherland Liberation War Museum, Pyongyang. (Author's photograph).

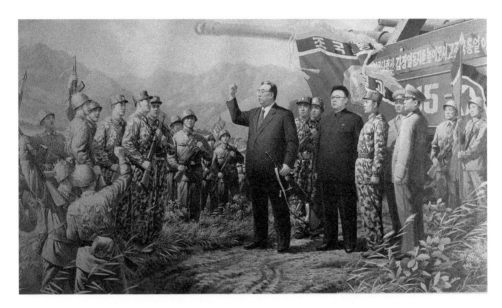

Figure 10.7 *The Victory of the Korean Revolution Relies on Guns in Our Hands.* Painting by Chong Dong-hyok and Cho Yun featuring Kim Il Sung and Kim Jong Il, undated, current whereabouts unknown. (From: Kim Sang Son ed., *Brilliant Paintings of Juche Art*, Pyongyang: The General Publisher of Literature and Art, 2001).

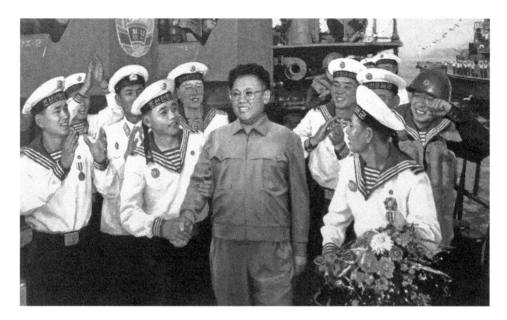

Figure 10.8 On the Morning of Navy Day. Painting by Ra Kang Chol, Pak Yong Chol, Kim Hyon Guk and Ri Kum Hyok, 2010, celebrating Kim Jong Il, current whereabouts unknown. (From: Mansudae Overseas Project Group of Companies, *National Fine Arts Show for Celebration of the WPK Conference and the 65th Anniversary of the WPK*, Pyongyang: Foreign Languages Publishing House, 2010).

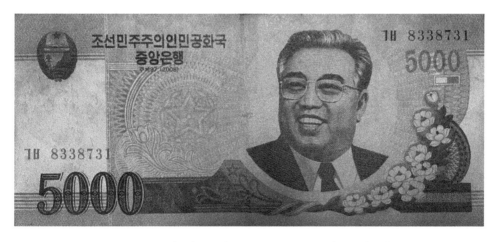

Figure 10.9 5000 won Korean banknote featuring a portrait of Kim Il Sung, 2008.

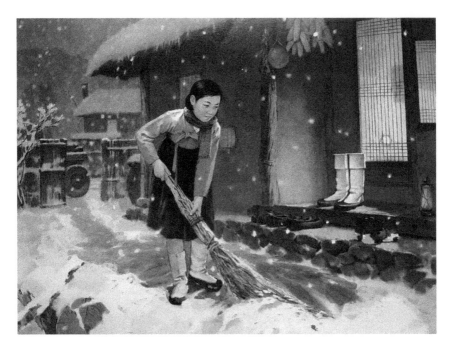

Figure 10.10 The Night When Dear Leader Has Come. Painting by Sok Rye Jin, 1979, current whereabouts unknown. (From *Korean Paintings of Today*, Pyongyang: Foreign Languages Publishing House, 1980).

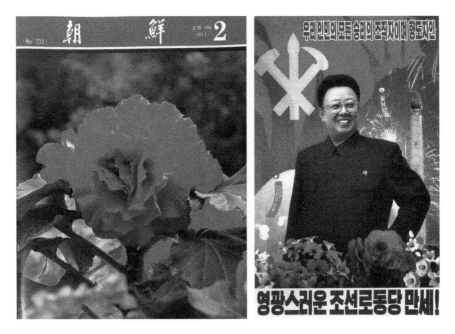

Figure 10.11 (Left) Cover, *Chosŏn* pictorial, February 2017. (Right) "Long Live the Glorious Workers' Party of Korea!" Poster designed by Pak Chol Hyon, Chon Sung Thaek and Yu Il Ho, 2010, celebrating Kim Jong Il (From: Mansudae Overseas Project Group of Companies, *National Fine Arts Show for Celebration of the WPK Conference and the 65th Anniversary of the WPK*, Pyongyang: Foreign Languages Publishing House, 2010).

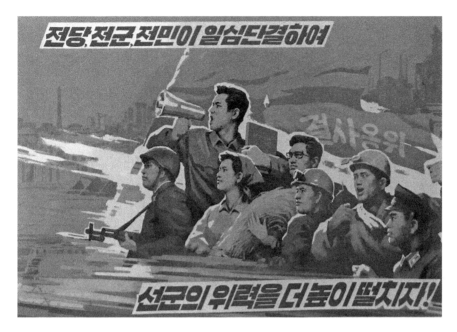

Figure 10.12 "Let Us Exalt the Might of the Songun Revolution through the Single-Hearted Unity of the Entire Party, the Whole Army and All the People!" Poster designed by Chon Sung Thaek and Hwang Myong Hyok, 2005. (Courtesy of Willem van der Bijl).

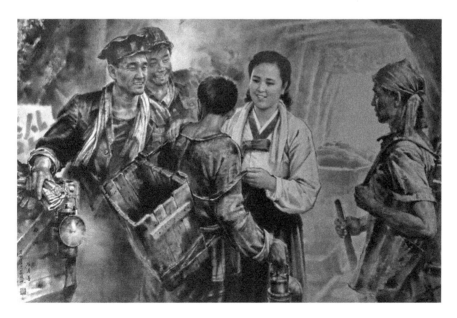

Figure 10.13 Telling Coal Miners to Be Masters of a New Korea. Painting by Kim Du Song, 2010, current whereabouts unknown. (From: Mansudae Overseas Project Group of Companies, *National Fine Arts Show for Celebration of the WPK Conference and the 65th Anniversary of the WPK*, Pyongyang: Foreign Languages Publishing House, 2010).

Bibliography

Cumings, Bruce. *North Korea: Another Country*. New York: New Press, 2003.

de Ceuster, Koen. "To Be an Artist in North Korea: Talent and then Some More." In *Exploring North Korean Arts*, edited by Rüdiger Frank, 51–71. Nürnberg: Verlag für moderne Kunst Nuremberg, 2011.

de Ceuster, Koen. "Democratic People's Republic of Korea, 1948-." In *Communist Posters*, edited by Mary Ginsberg, 225–74. London: Reaktion Books, 2017.

Delisle, Guy. *Pyongyang: A Journey in North Korea*. Montreal, Canada: Drawn and Quarterly, 2007.

Demick, Barbara. *Nothing to Envy: Real Lives in North Korea*. New York: Spiegel and Grau, 2010.

Harris, Mark Edward, and Bruce Cummings. *Inside North Korea*. San Francisco: Chronicle Books, 2007.

Hassig, Ralph, and Kongdan Oh. *The Hidden People of North Korea: Everyday Life in the Hermit Kingdom* (2nd edition). Lanham, MD: Rowman and Littlefield, 2015.

Haufler, Marsha. "Mosaic Murals in North Korea." In *Exploring North Korean Arts*, edited by Rüdiger Frank, 241–75. Nürnberg: Verlag für moderne Kunst Nürnberg, 2011.

Hoffman, Frank. "Brush, Ink and Props." In *Exploring North Korean Arts*, edited by Rüdiger Frank, 145–80. Nuremberg: Verlag für moderne Kunst Nürnberg, 2011.

Horlyck, Charlotte. *Korean Art from the 19th Century to the Present*. London: Reaktion Books, 2017.

Kang, Ik-Joong et al., *The 70th Anniversary of Liberation Day: NK Project 20.7.21–2015.9.29*, exhibition catalogue, Seoul: Seoul Museum of Art, 2015.

King, Ross. "Monuments Writ Small; Postage Stamps, Philatelic Iconography, and the Commercialization of State Sovereignty in North Korea." In *Exploring North Korean Arts*, edited by Rüdiger Frank, 192–240. Nuremberg: Verlag für moderne Kunst Nürnberg, 2011.

Kwon, Heonik, and Byung-Ho Chung. *North Korea: Beyond Charismatic Politics*. Lanham, MD: Rowman & Littlefield, 2012.

Lankov, Andrei. *The Real North Korea: Life and Politics in the Failed Soviet Stalinist Utopia*. Oxford: Oxford University Press, 2013.

Lim, Jae-Cheon. *Leader Symbols and Personality Cult in North Korea: The Leader State*. New York: Routledge, 2015.

Mansudae Overseas Project Group of Companies. *National Fine Arts Show for Celebration of the WPK Conference and the 65th Anniversary of the WPK*. Pyongyang: Foreign Languages Publishing House, 2010.

Meuser, Philipp, ed. *Architectural and Cultural Guide: Pyongyang*. Berlin: Dom Publishers, 2012.

Myers, B.R. *The Cleanest Race: How North Koreans See Themselves and Why It Matters*. New York: Melville House, 2010.

Portal, Jane. *Art Under Control*. London: Reaktion Books, 2005.

Shim, David. *Visual Politics and North Korea. Seeing Is Believing*. New York and London: Routledge, 2015.

Wainwright, Oliver. *Inside North Korea*. Cologne: Taschen, 2018.

Yoon, Min-Kyung. "North Korean Art Works: Historical Paintings and the Cult of Personality." *Korean Histories* 3, 1 (2012): 53–72.

11 "For Our Beloved Leader"

Nicolae Ceauşescu's Propaganda Portraits

Manuela Marin

Introduction

The overthrow of Nicolae Ceauşescu's personal regime in December 1989 was followed by a purification of the public space of all its material remains. The protesters who forced their way into official buildings removed the Communist Party's flag, destroyed documents, and tore down the portraits of the Romanian leader from the walls. Thrown into the streets, burned or vandalized, the images depicting the supreme leader became the crowd's favorite way of expressing their demonic fury. The destruction of the images of the man who ruled Romania for almost twenty-five years meant the end of the "tyrant". It attested not only that Nicolae Ceauşescu was seen as the incarnation of the communist regime that ruled Romania for almost twenty-five years, but also that his person had become indissolubly linked to his official portraits.

The present study aims to highlight how Nicolae Ceauşescu's portrait was used in the fabrication of his cult of personality. Although the present analysis will focus mostly on the period of his rule, it will also look at the uses of Ceauşescu's image following the fall of his regime. Using the visual studies approach, the images will be examined as cultural constructions, artefacts that should be treated as historical documents, because they are the expression of the aesthetic concerns, dominant ideological views and power relations of a given period.[1] Moreover, when considering the images, special attention will be paid to what the specialist of Soviet iconography Victoria E. Bonnell has defined as visual syntax, namely "the positioning of figures and objects in relation to each other and the environment" in order to show how the association of the Romanian leader with such elements as slogans, newspaper headlines, statistical data, symbolic motifs and historical characters, was used for celebratory purposes.[2]

In the present analysis, the term "image" will be employed to designate a wide range of artefacts, such as paintings, posters, stamps and sculptures. Particular attention will be devoted to photographic portraits in view of their ubiquitous presence. As

1 Elizabeth Sears, "Reading Images," in *Reading Medieval Images. The Art Historian and the Object*, eds. Elizabeth Sears et al. (Ann Arbor, MI: The University of Michigan Press, 2002), 1–7; Iritt Rogoff, "Studying Visual Culture," in *The Visual Culture Reader*, ed. Nicholas Mirzoeff (London: Routledge, 1998), 14–26.

2 Victoria Bonnell, *Iconography of Power: Soviet Political Posters under Lenin and Stalin* (Berkeley, CA: University of California Press, 1997), 10.

well as being used to illustrate press articles and anniversary volumes, and displayed during mass rallies, Ceaușescu's official portraits adorned every classroom, workplace and office. Even the textbooks, starting with that used by primary school children, had on their frontispiece the smiling picture of the Romanian leader. Photographs were also given great importance because Ceaușescu, probably sharing Stalin's belief that a real Bolshevik must not pose, never sat for a painter.[3] Artists had to rely on the pictures provided to them by a special photo laboratory, which was commissioned to execute the Romanian leader's portraits. These photographs were heavily retouched so that Ceaușescu would look younger and even taller than he really was. Photographs as a medium also merit special attention because, being much more numerous and accessible than paintings and sculptures, most of which were housed in museums and official buildings, they became an easy target for vandalism and destruction, and they were used in protest actions directed against the leader. After the collapse of the regime, Ceaușescu's portrait was used not only to ridicule him or to underline his maleficent character, but also as a way of expressing nostalgia for his rule.

Before analyzing the various forms Ceaușescu's image took, a few remarks are necessary to illustrate the Romanian context during his leadership, and explain how Ceaușescu's political decisions influenced not only the development of his cult of personality, but also the way in which he was represented using various media.

Nicolae Ceaușescu and His Regime

Nicolae Ceaușescu (1918–1989) was the head of the Romanian Communist Party and of his country between March 1965 and December 1989. He was elected Secretary General of the party in March 1965, after the death of Gheorghe Gheorghiu-Dej, who had led Romania since 1947. He was the youngest party leader in the Soviet bloc. The beginning of his rule was marked by a promise of liberalization as he strove to present himself as an open-minded and reformist leader willing to leave behind the dark times of the country's blind subordination to the Soviet Union and open Romania to the West.[4] Ceaușescu's moment of glory was the public condemnation of the Warsaw Pact's invasion of Czechoslovakia on August 22, 1968. Ironically, although his courageous anti-Soviet stance made him popular among Romanians and Western leaders, it also signaled the end of the hopes for liberalization and reform nurtured by

3 Jan Plamper explains the reasons for this: "Stalin had to remain true to his image of the quintessential Bolshevik, who was modest and who acted rather than sitting for painters"; moreover the social realist aesthetics required that portraits be based on "existing depictions of Stalin or photographic and cinematographic templates". Jan Plamper, *The Stalin Cult. A Study in the Alchemy of Power* (New Haven, CT: Yale University Press, 2011), 144.

4 Dennis Deletant, *Romania under Communist Rule* (Bucharest: Civic Academy Foundation, 1998), 146–69. On the post-war history of Romania, see also: Robert R. King, *A History of the Romanian Communist Party* (Stanford, CA: Hoover Institution Press, 1980); Michael Shafir, *Romania. Politics, Economics and Society* (Boulder, CO: Lynne Rienner Publishers, 1985); Stephen A. Fischer-Galați, *Twentieth Century Rumania* (New York: Columbia University Press, 1991); Keith Hitchins, *Rumania: 1966–1947* (Oxford: Claredon Press, 1994).

the population and the cultural elites alike.[5] In this regard, the so-called July Thesis of 1971 drafted with the purpose of "raising the political-ideological and cultural-educational" level of the Romanians marked a return to the Soviet-inspired model of building of the "New Socialist Man" through mass mobilization and political and ideological education. The arts and literature with a "firm political orientation" were supposed to bring an important contribution to the political and ideological education of the people by focusing exclusively on Romanian-inspired productions and socialist realities.[6]

The end of the liberalization period was also evident in what was soon to become the unmistakable trait of the regime: Ceaușescu's cult of personality. This found expression in an ever-growing number of celebratory artworks and publications featuring his portrait. Not only did Ceaușescu concentrate both the Party and the state apparatus in his hands, but he also created a new position to reaffirm his authority. In March 1974 he was officially invested as the first President of Romania during a ceremony that recalled a royal ritual.[7]

The use of national symbols in the investiture ceremony in March 1974 signaled the regime's nationalistic turn. Apart from supporting the questionable view that cultural developments in Romania anticipated or even surpassed those in the Western cultures, the exacerbated nationalism led to a reinterpretation of the national history in terms of the Romanians' ceaseless fight for unity and independence.[8] As a result of this reassessment, past Romanian rulers who helped forge the country were resurrected, and Nicolae Ceaușescu and the Romanian Communist Party (founded in 1921) were made to appear as their rightful heirs. Ceaușescu presented himself as the leading communist militant who coordinated the party's fight against an allegedly fascist regime intent on destroying national independence.[9] These claims could not have been further from the truth. During the interwar period, Romania was a constitutional monarchy in which the rules of democratic game were observed by the king and political parties. Everything changed after Carol II was crowned in 1930. An authoritarian figure, he aimed at consolidating his personal power by undermining the democratic institutions and by weakening the main political parties. In the wake of the growing number of totalitarian regimes that had been establishing themselves in Europe, in February 1938 Carol II set up his own dictatorship, tailoring it after the fascist model. He pursued close economic relations with Germany and also favored political collaboration with

5 Manuela Marin, *Nicolae Ceaușescu: Omul și cultul* [Nicolae Ceaușescu: The Man and His Cult] (Târgoviște, Romania: Cetatea de Scaun, 2016), 63–87.

6 Caterina Preda, *Art and Politics under Modern Dictatorships: A Comparison of Chile and Romania* (New York: Palgrave Macmillan, 2017), 144–5.

7 Anneli Ute Gabanyi, *The Ceaușescu Cult* (Bucharest: The Romanian Cultural Foundation, 2000), 45. The ceremony of investiture will be discussed in detail below.

8 Katherine Verdery, *National Ideology under Socialism. Identity and Cultural Politics in Ceaușescu's Romania* (Berkeley, CA: University of California Press, 1991), 167–301.

9 Manuela Marin, "The Nationalistic Discourse in Communist Romania: A General Perspective," *Studia Universitatis Babeș-Bolyai, Historia* 56 (2011): 80–104 and "Nationalism and Socialism in Romania: The Case of Nicolae Ceaușescu's Cult of Personality," in *Empires and Nations from the Eighteenth to the Twentieth Century.* vol. 2, eds. Antonello Biagini et al. (Cambridge: Cambridge Scholars Publishing, 2014), 427–36.

the Garda de Fier (Iron Guard), Corneliu Zelea Codreanu's fascist organization, in an attempt to please the Nazis and shelter Romania from its neighbors' territorial claims. Hungary, Bulgaria and the Soviet Union were in fact seeking to obtain the historical provinces of Transylvania, Southern Dobrudja and Bessarabia that had joined the Romanian Kingdom at the end of the First World War. Despite the king's efforts, Romania was dismembered and lost a third of its territory in the summer of 1940.[10]

During the interwar period the Communist Party remained on the margins of Romanian politics and lacked any popular support because it passively accepted the demands of the Comintern (the international communist organization that advocated world communism) for the return of Bessarabia, historically a Romanian province, to the Soviet Union – an acceptance that would have led to the dismantling of the newly created Romanian state. As the result, the government banned the party in April 1924. This interdiction was to remain in force for the following twenty years.[11] Deprived of any popular support, the communists' alleged involvement in the organization of a national resistance movement against the Romanian fascist government was nothing more than an ideologically convenient invention. The false claim was meant to obscure not only the party's insignificant role during the interwar period, but also its anti-nationalist stand. Ceauşescu's record as a young communist militant who distinguished himself in the fight for the unity of Romania was a propagandistic invention meant to embellish his image.

Nicolae Ceauşescu's cult of personality began after August 1968 and evolved gradually, reaching its peak in the 1980s. The growth of the cult coincided with a decline in Ceauşescu's popularity as a result of the disappointing results of his domestic policies, which brought Romania on the brink of economic collapse. The Romanian propaganda apparatus transformed Ceauşescu into "Our beloved leader", a multi-faceted idol who could command the popular support that his personality and policies were no longer able to achieve.[12] It manufactured representations of the leader that citizens could identify with.[13] These covered every aspect of his biography and political activity.

Ceauşescu's images told the story of a poor young man from the countryside who, through hard work, courage and total dedication to the communist cause, succeeded in overcoming his modest social origins to become the leader of the Party and of his country. Communist propaganda invented the image of Ceauşescu as a "young revolutionary", or professional revolutionary who, aged fifteen, joined the Communist Party and its struggle against the old regime. Ceauşescu, it was alleged, paid a heavy price for his political activities: he was tried and sentenced to jail more than once. However, he was eventually rewarded for his tireless work and became the supreme leader of the party. From this position, the story goes, Ceauşescu initiated an ambitious program for the country's socialist development. The results were exceptional, and his great achievements made him the "architect of modern Romania". Ceauşescu's concern to

10 Lucian Boia, *Romania: Borderland of Europe* (London: Reaktion Books, 2006), 102–5.

11 Deletant, *Romania under Communist Rule*, 9–40.

12 Mary Ellen Fischer, *Nicolae Ceauşescu. A Study in Political Leadership* (Boulder, CO: Lynne Rienner, 1989), 34, 167–73.

13 Adrian Cioroianu, *Ce Ceauşescu qui hante les Roumains. Le mythe, les représentations et le culte du Dirigeant dans la Roumanie communiste* (2nd edition revised) (Bucarest: Editions Curtea Veche, L'Agence Universitaire de la Francophonie, 2005), 36-8, 182–209.

build a strong and independent socialist Romania was the main argument used by the party propaganda, to describe the leader as a "guarantor of national independence and unity".[14]

The Portrait as Political Practice

Eager to present himself as a new, dynamic leader, and a believer in collective leadership, Ceauşescu began to deal with his public image on the very first month of his rule. In April 1965 the Communist Party agreed upon a set of directives concerning the display of official portraits in the decoration of the party headquarters, cultural institutions and other public buildings. These regulations stipulated the removal of the portraits of the giants of Marxism-Leninism and former Romanian communist leaders from the offices of party secretaries, presidents of popular councils and state activists in general. Portraits of the members of the Political Bureau (later renamed the Permanent Presidium) were to be placed in the hall of festivities of various institutions (party headquarters, educational establishments, etc.) in a predetermined sequence that began with the General Secretary, the President of the State Council, the President of the Council of Ministers, and ended with the other members of the Political Bureau arranged in alphabetical order. These portraits were joined by those of the Marxist-Leninist pantheon, as well as that of Gheorghiu-Dej. The portraits of all the members of the Executive Committee of the party's Central Committee were also to be displayed during mass public events, along with the official emblems of the party and of the Romanian state.[15]

These directives were intended to show that Romanian officials supported the principle of collective leadership and that power was not concentrated in the hands of the party leader. In fact, the regulations concerning the display of portraits were merely a façade that hid the absence of a collective decision-making process.

As a result of Nicolae Ceauşescu's increasing personal hold over the party and state apparatus, new rules on the use of portraits were adopted by the party's Executive Committee in 1972. The effigy of the Head of State was to be displayed in all government buildings, as well as in classrooms. The display of the effigies of all members of the Permanent Presidium, on the other hand, was obligatory only if there was room for them. The portraits of the founding fathers of Marxism-Leninism were to be exhibited only at party institutions or at "international [...] events of a revolutionary character".[16] The party's main decision-making organs, such as the Executive

14 On the creation of Nicolae Ceauşescu's cult of personality by the communist propaganda apparatus, see Marin, *Nicolae Ceauşescu*, 87–153.

15 Arhivele Naţionale Istorice Centrale [The National Historical Central Historical Archives], Bucharest (hereafter ANIC), *Fond CC al PCR–Secţia Cancelarie* [Fund Central Committee of the Romanian Communist Party – The Department of the Chancellery], file 103/1965, folios 2–3. A former close collaborator of Ceauşescu's has attested that from 1967 to 1968 the portrait of the General Secretary appeared in his office alongside those of other senior officials. See Paul Niculescu-Mizil, "Conducerea PCR şi noua orientare ideologică" [The Romanian Communist Party leadership and the New Ideological Orientation], in *Sfârşitul perioadei liberale a regimului Ceauşescu: minirevoluţia culturală din 1971* [The End of the Liberal Period of the Ceauşescu Regime: the Mini-Cultural revolution of 1971], ed. Ana Maria Cătănuş (Bucharest: Institutul Naţional pentru Studiul Totalitarismului, 2005), 50; ANIC, *Fond CC al PCR–Secţia Cancelarie*, file 29/1972, ff. 86–91.

16 Ibid.

Committee, were filled with cadres whose loyalty to the leader was unimpeachable, and who were all too happy to go along with the new policies. The display of Ceauşescu's portrait in the public space marked the end of the short experiment of collective leadership and heralded his consecration as the supreme leader of both party and state.

Portraits in Mass Rallies

Romania's national day, August 23, was celebrated in Bucharest with a mass gathering, which was attended by Romanian officials and foreign dignitaries. The celebration usually included a parade of military men, athletes, school children, youth and workers who walked in front of the gallery where the authorities sat, carrying the portraits of Ceauşescu, Marx, Engels and Lenin, as well as flowers and banners, and shouting slogans that praised the date, the party, and the nation's leaders.[17] As his cult of personality intensified in the late 1970s and in the 1980s, Ceauşescu's effigy was given, both literally and metaphorically speaking, center stage. His portrait, shaped like a giant medallion, was placed at the top of the structure to indicate that the President was the supreme leader of both party and state. It depicted him donning formal garments (jacket and tie). The stage was decorated with such motifs as laurel branches, which traditionally symbolize glory and immortality, and the national and communist flags. Ceauşescu always appeared gazing to his right, in the direction of the flow of the enthusiastic crowd, as if to accompany the people who marched in an orderly pace toward the bright future of communism. His relaxed and smiling expression suggested gratification and self-confidence (Figure 11.1). The marchers who carried yearly "report cards" showing the country's achievements and projects were the very embodiment of Romania's "bright future". Ceauşescu's immobility (the photographic portrait), which contrasted with the crowds on the move, strengthened his image as a hieratic figure. The President was the "unmoved mover",[18] the man who, as well as being the leader who watched the march of people from the heights of his gallery, was the very source of the fundamental changes that Romania was undergoing.

From the late 1970s onwards, the crowd that participated in the National Day rallies only displayed the portraits of Nicolae Ceauşescu and his wife Elena.[19] The image of the President that featured in these events was always the same, and was employed during other public festivities too. It equally featured on magazines and newspapers to mark various special occasions, such as Ceauşescu's birthday.[20] This standardization[21]

17 Marin, *Nicolae Ceauşescu*, 128–40.

18 I borrow the expression from Malte Rolf, "Working toward the Centre: Leader Cults and Spatial Politics in Pre-war Stalinism," in *The Leader Cult in Communist Dictatorships. Stalin and the Eastern Bloc*, ed. Balázs Apor (New York: Palgrave Macmillan, 2004), 148.

19 Marin, *Nicolae Ceauşescu*, 130–40. See, http://stiri.tvr.ro/23-august-semnificatii-majore-in-istoria -romaniei-si-sarbatoare-nationala-comunista-timp-de–45-de-ani_821219.html#view. Last accessed on September 30, 2019.

20 See, for instance, *Scânteia*, January 26, 1978, 1.

21 Commenting on the Romanian leader fixation with his own portrait, Adrian Cioroianu has spoken of "videology," namely "the ideology that tends gradually, but inexorably to resume the exhibition of a single effigy, the display of a single portrait". See "Videologia lui Nicolae Ceauşescu. Conducătorul şi obsesia autoportretului" [Videology of Nicolae Ceauşescu. The leader and the self-portrait obsession],

turned the image of the leader into an icon. However, the portrait varied at times in order to emphasize specific features of the leader.

Portraits in Books

Volumes about Ceaușescu were another vehicle of propaganda. These works were widely accessible: they filled the shelves of libraries and bookshops, were the subject of numerous press reviews, and were also used in political education classes. Their large circulation helped popularize a hagiographic image of the leader. Most of these volumes were collections of his speeches, messages to the nation, reports, interviews and toasts made on official occasions, organized chronologically or thematically. Each chronological or thematic series reproduced the President's portrait on the cover or frontispiece. Although these anthologies were, from 1968 to 1989, constantly reissued, Ceaușescu's image remained the same: he was eternally young. His aging was only hinted at by his greying hair. He appeared dressed in a black suit with a dark tie, greeting the readers with a smile or a beam. The President often gazed into the distance to suggest that he was a leader with a vision.

When depicted on the frontispiece, he turns to the onlooker's right, as if to encourage him/her to read his edifying work. The picture in the anthology *România pe drumul construirii societății socialiste multilateral dezvoltate* (Romania Building the Multilaterally Developed Socialist Society) is a typical example. Ceaușescu's effigy is here printed on glossy paper in stark contrast with the rest of the pages. The portraits featuring on the covers of books, such as those of the series *Din gândirea social-politică/filozofică și economică a Președintelui României, Nicolae Ceaușescu* (Socio-political, Philosophical and Economical Considerations by the President of Romania, Nicolae Ceaușescu), always depict Ceaușescu turning toward the onlooker's left, following a well-established tradition of three-quarter portraiture (Figure 11.2). These volumes tackle the question of the development of a socialist society from different perspectives (social, political, economic, philosophical...). Ceaușescu's smile expresses his satisfaction at the results which of the implementation of his ideas have produced.

Portraits in Press Photography, Paintings and Stamps

Ceaușescu's portraits were rendered in different media and dealt with the favorite themes of his personal mythology: "the young revolutionary", "the architect of modern Romania", and "the guarantor of national independence and unity".

As already noted, Ceaușescu early career as a communist activist was unremarkable. To give luster to a weak revolutionary image the propaganda machine manufactured visual "evidence" to attest to his essential role in the interwar history of the Communist Party.[22] Portraits of young Ceaușescu were used as undisputed evidence

in *Comunism și represiune în România. Istoria tematică a unui fratricid național* [Communism and Repression in Romania. Thematic History of a National Fratricide], ed. Ruxandra Cesereanu (Iași: Polirom, 2006), 251.

22 Manuela Marin, "The Myth of the Young Revolutionary: The Case of Nicolae Ceaușescu," in *Transylvanian Review* 17 (2008): 22–53.

of his involvement in the political activities of the outlawed party and of the persecutions he suffered. They were mostly mugshots (Figure 11.3): they presented young Ceauşescu in a defiant attitude that was meant to suggest his firm determination to fight the old regime and pursue political action despite its repressive interventions; they also suggested his readiness to sacrifice his life to achieve his mission. Ceauşescu's police photographs were usually reproduced in the press to illustrate articles on his early revolutionary activities. Photographs of Ceauşescu as a young man were often manipulated for propaganda purposes. The most eloquent example of this practice is a picture of the May 1, 1939 rally in Bucharest. According to the official version, Ceauşescu was the organizer of this event, during which the participants shouted anti-fascist and pro-Communist slogans. In fact, Nicolae Ceauşescu did not even attend it.[23] In order to prove the opposite, the communist propagandists inserted his face and that of Elena Lenuta Petrescu, his future wife, in to the crowd (Figure 11.4). The collage was crudely executed: Ceauşescu's head looks larger than those of the other participants. Moreover, Ceauşescu's face, unlike the others, is perfectly frontal. The fact that the same photograph had previously appeared in newspapers and other publications without the couple's faces in it proves that it was manipulated.[24]

Numerous paintings also depicted young Ceauşescu as a revolutionary. Two of the best known works are *Demonstraţie comunistă* (Communist Rally) (1986) and *1 Mai 1939* (1986), which were executed by Eugen Palade,[25] both of which hang in the *Muzeul Naţional de Artă Contemporană* (National Museum of Contemporary Art), Bucharest. These were frequently displayed in exhibitions organized on different festive occasions, such as Nicolae Ceauşescu's birthday, at *Sala Dalles* (Dalles Exhibition Hall), the biggest gallery in Bucharest, and also reproduced in newspapers and magazines. As Palade explains in his autobiography, *Communist Rally* was commissioned to him by the Ministry of Culture and was intended to "testify" to the participation of the young Ceauşescu to the May 1, 1939 rally. In the little available time he had at his disposal to finish the painting, the artist visited the *Muzeul de Istorie al Partidului* (History Museum of the Party) to find some images of Ceauşescu dating from the 1930s. The deputy director of the museum advised him to go somewhere else, since he did not have any authentic photographs: "All are fake, all are counterfeit", he told him. Palade did not give up and turned to the official party photographers, who provided him with some early snapshots of Ceauşescu. He chose the widely circulated mugshot that depicted him as a teenager (Figure 11.3) and painted young Ceauşescu as

23 Pavel Câmpeanu, *Ceauşescu, anii numărătorii inverse* [Ceauşescu, Years of Countdown] (Iaşi: Polirom, 2002), 35.

24 Radio Free Europe, Romanian Broadcasting Department, N. C. Munteanu, Domestic Bloc 13 May 1986, OSA Archivum HU OSA 300–60–1 Box 705; Bujor. T. Râpeanu, "1 Mai 1939, de la realitate la fals" [May 1, 1939, From Reality to Fake], in *Magazin Istoric* 11 (1990): 24–5, 61; Alice Mocănescu, "The Leader Cult in Communist Romania 1965–1989: Constructing Ceauşescu's Uniqueness in Painting" (PhD diss., Durham University, 2007), 248–50.

25 Palade (born in 1927), one of the Romanian regime's best-known artists, began his artistic career in 1954, after a study period in the USSR. See *Dicţionarul artiştilor români contemporani* [Dictionary of Romanian Contemporary Artists] (Bucharest: Meridiane, 1976), 376. He is among the few Romanian painters who have publicly acknowledged to have painted some of Ceauşescu's portraits. https://www.facebook.com/Palade-Eugen-Oficial–880358615335394/. Last accessed on September 30, 2019.

marching with a clenched fist, his eyes fixed toward the onlooker, followed by a group of people. The entire posture betrayed his determination and his unshakable faith in the communist creed and its ultimate triumph. The presence of the national flag alongside the red flat hinted that the young revolutionary would become the leader of the party and of the nation.[26] In Palade's original sketch for the painting, the communist flag featured behind the Romanian leader, but the space behind him needed to be filled with a crowd in order to convey the message that young Ceaușescu was the driving force behind the May 1 rally.[27]

The painting entitled *May 1, 1939* (Figure 11.5) features young Ceaușescu together with Elena. This was in keeping with the promotion of his wife as "first lady" that had begun in the late 1970s. The painting's composition conveys the idea that the couple were the organizers of the gathering: they march forward together, followed by the other participants of the May Day rally, whose faces are indistinct. Nicolae Ceaușescu wears the usual formal attire and his face seems based on the official photographic portraits that were widely circulated during the 1980s (Figure 11.1). In contrast, his wife wears a polka dots dress, a garment copied from her image as a young communist underground fighter (Figure 11.6) that propaganda constantly disseminated during the last two decades of communist rule in Romania in newspapers and magazines. Elena has flowers in her hands – a symbol of the peaceful intentions of the participants for the May 1, 1939 gathering. Together with the flowers, her white dress evoked the idea of "youthfulness and romantic revolutionary ethos".[28]

The Ceaușescus' role in organizing the May 1, 1939 rally was also commemorated by a stamp, produced in 100,000 copies, which was issued on the occasion of the fiftieth anniversary of the event (Figure 11.7).[29] As other artists had done before him, the graphic designer, Aurel Popescu, celebrated the two would-be revolutionaries as the movers and shakers of the rally, a role that the national flag, which functions as a backdrop, emphasizes. The stamp was produced in a typical souvenir format: the sheet's left and right margins featured waving flags and drawings of the achievements of the socialist regime, such as the underground railway in Bucharest and the bridge over the Danube–Black Sea Canal.

One month before the elections for the renewal of the *Marea Adunare Națională* (Grand National Assembly), which took place every five years, the main party newspaper, *Scânteia* (The Spark), always published a full page on the event that acted as an election poster and represented Ceaușescu as the "architect of modern Romania". The picture and texts were intended to convince the Romanians to vote for the Frontul Democrației și Unității Socialiste (Front of Socialist Unity and Democracy), the only organization that was allowed to present candidates in the election. The Front encompassed the Communist Party and other mass movements.[30] The candidates always included the Romanian leader whose status of deputy was a mandatory condition for his re-election as president of the Republic. As well as giving

26 Cioroianu, "Videologia of Nicolae Ceaușescu," 262.
27 Ibid., 261–2.
28 Mocănescu, "The Leader Cult," 250.
29 "Imaginea lui Ceaușescu în timbrele românești" [Ceaușescu's Image in Romanian Stamps]. http://kolector. ro/2010/04/06/imaginea-lui-Ceaușescu-in-timbrele-romanesti/. Last accessed on September 30, 2019.
30 Shafir, *Romania*, 100.

a semblance of legitimacy to the candidates of the only political organization, the poster-sized page enabled Ceauşescu to present himself as a leader who deserved to be reconfirmed as head of state on account of the exceptional results of the mandate that had just ended.

The poster published by *Scânteia* on February 22, 1985 is a good example of this electoral propaganda. Its slogan – "A vote for the socialist achievements of the present. A vote for the bright future of our motherland. New homes for the builders of the new life" – is followed by an extended quote from the leader's speech on the building of new homes. The accompanying photograph, inserted between the list of the achievements of the parliamentary term that had just ended (1981–1985) and the objectives of the new one (1986–1990), shows Nicolae and Elena Ceauşescu in front of a scale model, discussing building plans with the local authorities in the city of Bacău. The suggestive title placed above the image, "File de istorie" (Pages of history), suggests that the event is merely one of a sequence of ambitious, epoch-making projects (Figure 11.8).

Of course photographs depicting Nicolae Ceauşescu, alone or with Elena, as architect were not disseminated by the press only during election time. They were commonplace throughout the years of the regime. Ceauşescu was frequently depicted at building ceremonies pouring the first concrete "with the energetic gesture of the builder [...] and with the traditional tool of the mason"[31] or signing the parchment that was to be inserted into a stainless steel cylinder and buried at the base of official buildings, such as the *Casa Republicii*[32] (The House of the Republic).[33] The text on the parchment identifies Nicolae Ceauşescu as the initiator of the construction works and the building itself as an epitome of the country's development thanks to socialism. These images attest to Ceauşescu's eagerness to achieve immortality through architectural projects.[34]

Paintings too celebrated Nicolae Ceauşescu's as the master builder of socialist Romania. Many depicted him talking to workers, peasants, engineers and other experts in a "fruitful dialogue".[35] *Vizită de lucru* (Working Visit), which was executed by Vasile Pop Negreşteanu in 1987 (*Muzeul Naţional de Artă Contemporană*, Bucharest)[36] (Figure 11.9), is one of the best-known artistic representations of such "dialogues". The painting, which was also shown in various national exhibitions, deals with a visit paid by Ceauşescu to the site of the Danube–Black Sea Canal,

31 *Scânteia*, June 23, 1979, 3.
32 *Casa Republicii*, which now serves as the Romanian Parliament, was supposed to accommodate various state institutions, such as Communist Party's headquarters, the government and the State Council of the Socialist Republic of Romania. It was part of a grandiose Civic Center project and entailed the demolition of an entire Bucharest neighborhood rich in historical buildings.
33 *Scânteia*, June 26, 1984, 1, 3. For other examples of similar photographs, see: *Scânteia*, January 21, 1978, 1; *Flacăra*, January 24, 1980, 5.
34 Marin, *Nicolae Ceauşescu*, 85–6; Mocănescu, "The Leader Cult," 67–8.
35 Marin, *Nicolae Ceauşescu*, 217–28, 244–52.
36 Negreşteanu (born in 1955), a member of the official organization of visual artists, the Union of Visual Artists, produced projects for monuments that were especially appreciated by the regime, as the numerous prizes he was awarded attest. See *Enciclopedia artiştilor români contemporani* [Encyclopedia of Romanian Contemporary Artists], vol. 1 (Bucharest: Arc, 1996), 171. The work he has executed since the fall of the communist regime draws inspiration from Christian iconography and Romanian folklore.

whose construction had begun in the late 1940s with the support of the Soviet Union. This monumental enterprise acted as a forced labor camp for political prisoners until 1953, when it was abandoned at the advice of the new Soviet leader, Nikita Khrushchev. The plan was resurrected in the 1970s and the Danube–Black Sea Canal was finished at last in May 1984. It was frequently exalted as one of the regime's greatest achievements. The Romanian leader features in the painting together with a number of workers wearing their protective helmets, as well as his wife and the youngest of his sons, Nicu, shown holding a small red notebook. Nicu was the Ceauşescu's favorite child, and his presence hints at his status of heir apparent. Nicolae Ceauşescu's raised left arm points toward the canal to draw our attention to the project whose construction he is supervising. His gesture mimics that of medieval rulers who, in votive portraits in churches, were sometimes depicted pointing to a small-scale model of a religious building.[37] The dove flying over the canal symbolizes that the construction is a new beginning that would bring prosperity and peace to Romania.[38]

The theme of Nicolae Ceauşescu as architect was also illustrated in stamps. Of the three that were produced, that which was issued in 1985 as a souvenir sheet with a print run of 150,000 copies to celebrate the recent opening of the Danube–Black Sea Canal[39] is especially worth focusing on. The image, which represents the leader with his spouse in the process of cutting the inaugural ribbon, was executed by Mihai Mănescu, a young artist who, after the fall of the communist regime, became a professor at the University of Arts in Bucharest and a successful painter and graphic designer.[40] The left and right margins of the sheet depict the navigation channel before and after work was completed. Nicolae Ceauşescu is presented as the initiator and supervisor of the project.

Tapestries and bronze statues equally contributed to the exaltation of the leader. Ileana Balotă's twin tapestries entitled *Omagiu* (Homage) (*Muzeul Naţional de Artă Contemporană*, Bucharest), which depict Nicolae Ceauşescu (Figure 11.10) and his consort, respectively, were frequently reproduced in newspapers and magazines and displayed in state-sponsored exhibitions throughout the 1970s and 1980s.[41] The two protagonists appear at the center of their respective compositions, surrounded by blooms. The background of the first tapestry features a multitude of workers. Those on the left wear caps and dark clothes, the typical attire of the communist underground fighters; those on the right side wear protective helmets. The two groups refer to the two historical periods of the country's recent history, united by the presence of the Communist Party (whose initials feature on the banner held by some of the workers) and its supreme leader. The background to the tapestry honoring Elena Ceauşescu shows the outlines of a factory, a high-voltage pole, a dam and a river to suggest

37 Mocănescu, "The Leader Cult," 265–6.
38 The motif alludes to the dove which returns to Noah with an olive branch after the floods.
39 See, http://kolector.ro/2010/04/06/imaginea-lui-Ceauşescu-in-timbrele-romanesti/. Last accessed on September 30, 2019.
40 "Imaginea lui Ceauşescu."
41 On Balotă (1929–1996), who joined the *Uniunea Artiştilor Plastici* [Union of Visual Artists], the main artists' organization in communist Romania, in 1955, see *Dicţionarul artiştilor români contemporani*, 39–40; and *Enciclopedia artiştilor români*, vol. 1, 27.

her involvement in the development of the national industry. The Romanian media portrayed the "first lady" as a successful researcher in chemistry, whose work was highly appreciated worldwide and rewarded with many prizes and distinctions. She led one of the most important research institutes in Romania, the Central Institute of Chemistry, and published numerous articles in prestigious scientific reviews. In reality she lacked even the most basic knowledge of chemistry.

Although no full-length statues of Nicolae Ceaușescu graced the squares of Romania, several busts carved in stone and bronze were commissioned to pay homage to him. A characteristic example is the bronze statue realized by Ion Jalea[42] in the late 1960s (*Muzeul Național de Artă Contemporană*, Bucharest). This statue was invariably shown at the exhibitions, and frequently reproduced in newspapers, magazines and celebratory publications especially during the 1980s. Jalea's bust captured some of Ceaușescu's facial imperfections, such as his big ears and double chin. The leader's physical features were often rendered realistically because artists were reluctant to correct his blemishes.[43]

The image of Ceaușescu as the guarantor of independence and national unity – a stance he embraced in August 1968 when he publicly condemned the Soviet invasion of Czechoslovakia and defended the right of any socialist or communist party to choose its own way of building socialism[44] – was promoted by associating his figure with the national symbols.[45] A number of past Romanian leaders were used to strengthen Ceaușescu's public image. Their deeds were reinterpreted, or their significance accentuated, in order to present the figures as forerunners of the country's patriotic aspirations.

The works of art that depicted Ceaușescu as the champion of Romania's independence and unity were frequently inspired by press photography.[46] One of his most famous pictures was that of his investiture as President of Romania in March 1974.[47] On that occasion, he was photographed wearing a sash with the colors of the national flag over his chest, and holding a scepter in his hand. Being a traditional symbol of a monarch's supreme authority and military power, the scepter was hardly compatible with the office of President of a socialist republic. Ceaușescu retained it to signal that he had full control over the state apparatus and to present himself as the successor of Romania's most illustrious rulers, as their ideological descendant and inheritor of their

42 Ion Jalea (1887–1983), a graduate from Bucharest's *Școala de belle arte*, also trained at the Julian Academy in Paris. He returned to the French capital after the First World War to study with the leading sculptor Antoine Bourdelle. During the interwar period, Jalea achieved fame after carving the effigy of King Carol II, whose dictatorial regime was also characterized by a strong personality cult. After 1945, Jalea executed numerous portraits of Romanian and foreign writers, as well as of workers and peasants. He closely collaborated with the communist regime, which rewarded him with prizes, elected him president of the Union of Visual Artists and made him a Parliamentarian and a member of Romanian Academy. See *Enciclopedia artiștilor români*, vol. 3, 103.

43 Adrian Cioroianu, *Pe umerii lui Marx: O introducere în istoria comunismului românesc* [On Marx's Shoulders: An Introduction to the History of Romanian Communism] (Bucharest: Curtea Veche, 2007), 438–9.

44 *Scânteia*, August 22, 1968, 1.

45 Manuela Marin, *Nicolae Ceaușescu*, 63–5.

46 Drăgușanu, "La commémoration des héros nationaux," 148; Mocănescu, "The Leader Cult," 217–38.

47 See, https://fototeca.iiccr.ro/picdetails.php?picid=33336X154X1968. Last accessed on September 30, 2019.

exceptional qualities.[48] The photograph of the investiture is the source of Constantin Piliuţă's painting *Primul Preşedinte* (The First President, 1977) (*Muzeul Naţional de Artă Contemporană*, Bucharest).[49] This work portrays Ceauşescu similarly attired and with a scepter in his hand making his oath of faith to the country and its people (Figure 11.11). His left hand rests on a sheet of paper "in a gesture of endorsement of his own words and of the party documents in general".[50] Behind him, in the upper half of the image, is a frieze of figures who, allegedly, defended the country and distinguished themselves through their achievements in the fields of foreign and domestic policies: the Thracian king Burebista (?–44 BC), the prince of Vallachia Mircea the Elder (1355–1418), the *de facto* ruler of Transilvania Mihai Viteazul (Michael the Brave, 1558–1601), the prince of Moldavia Stephen the Great (1438/9 –1504), the ruler of the Romanian principalities Alexandru Ioan Cuza (1820–1873) and the leader of the Wallachian 1848 revolution Nicolae Bălcescu (1819–1852). As well as endorsing Ceauşescu's actions, these figures indicated that the "First President" was worthy of a place in the national pantheon. To stress his role as defender of national independence and unity, the painter ignored chronology: Michael the Brave, who in 1600 succeeded in uniting the three Romanian principalities, albeit for a short period, features before Stephen the Great, to permit a visual correspondence with Ceauşescu (the two figures find themselves on the same vertical axis). The association reflected the president's great admiration for the medieval ruler.[51] Stylistically, Piliuţă's picture, with its figures represented flatly in a frieze-like arrangement, is indebted to the medieval paintings that could be seen in Orthodox churches.

Michael the Brave also appeared in a photographic composition that featured in the leading weekly *Flacăra* (The Flame) on December 1, 1983 to commemorate the 1918 unification of Romanian territories. One page reproduced a portrait of Michael the Brave holding the scepter and, beneath it, an illustration of his entry into the city of Alba Iulia in 1599 painted by Dumitrescu Stoica.[52] In perfect symmetry, on the facing page, was a photograph of Ceauşescu with scepter, taken at the ceremony for his investiture, and, directly below, one documenting his recent visit to the same town.[53] Alba Iulia was the place where both the union of 1599 and 1918 had been achieved. These images clearly aimed to parallel the deeds of the two leaders. The accompanying heading – "The entire history of struggles and sacrifices comes

48 Adrian Drăguşanu, "La commémoration des héros nationaux en Roumanie par le régime communiste de Nicolae Ceauşescu (1965–1989)" (PhD diss., Université Laval, Canada, 2002), 127–8, 130, 145–6; Rodica Chelaru, *Culpe care nu se uită. Convorbiri cu Cornel Burtică* [Unforgivable Guilt. Interview with Cornel Burtică] (Bucharest: Curtea Veche, 2001), 79.

49 Piliuţă (1929–2003) was one of the masters of ceremonial portraiture during Ceauşescu's regime. He painted the portraits of medieval rulers and scholars, as well of contemporary Romanian personalities. See *Enciclopedia artiştilor români*, vol. 1, 161.

50 Mocănescu, "The Leader Cult," 225.

51 For Ceauşescu's predilection for Mihai Viteazul, see Mocănescu, "The Leader Cult," 226; Drăguşanu, "La commémoration des héros nationaux," 148.

52 Stoica (1886–1956) specialized in history paintings,http://aman.ro/betawp/wp-content/uploads/pers onalitati/S/stoica%20d.pdf. Last accessed on September 30, 2019.

53 *Flacăra*, December 2, 1983, 4–5.

to life in the union of today!" – celebrates Ceauşescu as the one who completed Michael the Brave's task.

Portraits for Protest

Toward the end of the communist regime, Romanians' exasperation with the omnipresence of Ceauşescu's images led to actions which the *Securitate*, the secret police, termed of "hostile character". These acts involved various forms of vandalism, as well as satirical uses of the leader's effigy, as Romanians considered him to be responsible for the country's economic disaster. Archival documents and oral testimonies provide numerous anecdotes. A young man from Bucharest reported how his aunt Graziela reacted to the invariable presence of the President's effigy on the front page of the newspapers: "She went out to take her paper from the postman, smiled, went into the house, locked herself up, pulled the shutters, tore the newspaper to shreds, trampled on it and then swallowed an Extraveral."[54] Some portraits were also burned. Two inhabitants of the village of Mălăeşti, in Prahova County, are documented to have been arrested and sentenced in 1981 to fifteen and eight years imprisonment respectively, because they had thrown a petard in a shop-window in Ploieşti, thus burning Nicolae Ceauşescu's volumes of speeches, which had his portrait on the cover or on the frontispiece.[55]

When the deterioration of the economic situation in Romania in the 1980s resulted in a generalized shortage of consumer goods, people frequently used Ceauşescu's effigy to attack him. For instance, in 1982 in the towns of Sibiu and Brasov, his photograph was glued on to the "panels of shame" (sorts of large notice boards where pictures of local offenders were displayed), before the eyes of the militia, together with the caption "He stole our bread".[56] On March 10, 1983 Ion Bugan, an electrician, resorted to an unusual form of protest. He crossed the center of Bucharest in a funeral car decorated with the national and communist flags, and two huge banners with anti-Ceauşescu slogans. In front of the car was Ceauşescu's framed portrait with mourning ribbons that featured the words "Executioner, we do not want you as a leader." The mock funeral procession was intended to express a wish-fulfilment: the political death of the usurper who had robbed the country and committed so many crimes against his people.[57] Ion Bugan wore a black suit with a tricolor sash to ridicule Ceauşescu's official image and

54 *LXXX. Mărturii orale. Anii' 80 şi bucureştenii* [LXXX. Oral Testimonies. The 1980s and the People of Bucharest], eds. Şerban Angelescu and Ana Vinea (Bucharest: Paideia, 2003), 169–70. Extraveral is a popular Romanian tranquilizer.

55 Vladimir Socor, "Known Prisoners of Conscience in Romania: An Annotated Checklist," Radio Free Europe Research, RAD Background Report (Romania), August 7, 1987, OSA Archivum, HU OSA 300–60–3 Box 18.

56 Radio Free Europe, Romanian Broadcasting Department, Vlad Georgescu, Listeners' Mail no. 27, August 8, 1982, OSA Archivum, HU OSA 300–6–3 Box 13.

57 Radio Free Europe, Romanian Broadcasting Department, Vlad Georgescu, Editorial no. 190, August 30, 1986, OSA Archivum, HU OSA 300–60–1 Box 431; Radio Free Europe, Romanian Broadcasting Department, Emil Hurezeanu, Domestic Bloc, July 14, 1987, OSA Archivum, HU OSA 300–60–3 Box 4; Mihai Floroiu, "Forme de opoziţie politică în anii' 80: scrisori, inscripţii şi manifeste anti-ceauşiste" [Forms of Political Opposition in the 80s: The Anti-Ceauşescu Letters, Inscriptions and Demonstrations], in *Nesupunere şi contestare în România comunistă* [Disobedience and Contestation in Communist Romania], eds. Clara Mareş et al. (Iaşi, Romania: Polirom 2015), 223–8.

the claim that he enjoyed the unanimous support of all the Romanians. For this, Ion Bugan was sentenced to ten years of hard labor under the charge of "propaganda against the socialist regime".[58]

When the communist regime began to collapse in December 1989 in a bloody revolution, Ceauşescu's official images became the target of the fury of the protesters. In a vindictive act of memory erasure, the Romanians took down his portraits from the walls of classrooms and state institutions, tore the pictures out of the volumes of his works and burned them in squares. As well as destroying Ceauşescu's image, Romanians demonized his person by representing him as a vampire. After the leader's fall from power, these caricatures appeared in the lobby of the Bucharest radio and television station and in other cities.[59] For example, in Timişoara, the city from which the 1989 revolution had originated, graffiti added blood-red eyes, pointed ears, horns and sharp teeth dripping blood to his effigies.[60] These satirical depictions were not entirely fanciful: some journalists claimed in fact that the president and his wife bathed in the blood of children in order to rejuvenate their bodies and extend their rule over the country.[61] Besides, Ceauşescu was a cruel leader who had sucked the blood of his people, i.e. starved them in the 1980s in order to pay for the country's external debt through increased exports of food, and left them without heating and electricity during winters in order to save raw materials for industry. He was also blood-thirsty: he ferociously repressed the protesters who called for his resignation in December 1989.[62]

The last two decades have been marked in Romania by a revival of interest in the communist period. As well as producing critical assessments of the regime, they have led to some forms of nostalgic re-appropriations of the image of Ceauşescu.[63] The *Muzeul Republicii Socialiste România* (Museum of the Socialist Republic of Romania) was founded in 2001 at the initiative of a controversial businessman, Dinel Staicu,

58 Carmen Bugan, "How the secret police tracked my childhood," https://www.bbc.com/news/magazine–26838177. Last accessed on September 30, 2019.

59 Karen Davies, "Dictator Nicolae Ceauşescu was even more terrible than Count," https://www.upi.com/Archives/1990/02/25/Dictator-Nicolae-Ceauşescu-was-even-more-terrible-than-Count/8214635922000/. Last accessed on September 30, 2019.

60 http://www.ceausescu.org/ceausescu_pictures/curiosa/source/200.html. Last accessed on September 30, 2019.

61 Adrian Cioroianu, *Ce Ceauşescu qui hante les Roumains*, 9. The image of Ceauşescu as a vampire and as an avatar of Dracula is not, in fact, a Romanian invention, nor did it originate with the fall of the regime. It began to be diffused by the Western, especially American, media a decade earlier. These drew attention to the ruler's anti-religious stance, (his alleged destruction of churches, fear of crosses and avoidance of Christian services), the charisma he enjoyed despite his unattractive looks, his blood disease (he suffered from diabetes), Romania's high rates of HIV infection, as well as his celebration of Vlad the Impaler as a national hero (the 500th anniversary of his death was commemorated in 1976 in great pomp). The circumstances surrounding Ceauşescu's death added sinister overtones to his figure: he was assassinated on Christmas Day in the town Târgovişte, where Dracula spent the early part of his life, and it was rumored that his corpse and that of his wife were spirited off by supporters and replaced in the grave with those of anonymous people. See Constantin Dobrilă, *Entre Dracula et Ceauşescu. Le tyrannie chez les Roumains* (Bucharest: Fundaţia Culturală Română, 2006); Hank Willow, "Undead Red Dictator Returns as Vampire." http://www.hollywoodinvestigator.com/Ceauşescu.htm. Last accessed on September 30, 2019. See also Davies, "Dictator".

62 Dobrilă, *Entre Dracula et Ceauşescu*, 329–30.

63 On this subject, see Manuela Marin, "Assessing Communist Nostalgia in Romania: Chronological Framework and Opinion Pools," in *Twentieth Century Communism* 11 (2016): 10–26.

in the village of Podari, in the south-eastern part of Romania, to display paintings, busts, flags and other artefacts of the Ceauşescu's era. A huge notice at the entrance of the museum greets the visitors with the message: "Welcome Comrades!" The way from the building's entrance to the museum itself is paved with quotations from the disgraced President's speeches. The curious visitor can admire the effigies of past Romanian rulers such as Michael the Brave, Vlad the Impaler, Alexandru Ioan Cuza, as well as busts of the communist dictator.[64] One of these busts rests, guarded by two sculpted lions, on a pedestal outside the building. Ceauşescu is represented wearing the characteristic sash across his chest. In his right hand, he holds the coat of arms of the Socialist Republic of Romania.[65]

The house in Scorniceşti where Ceauşescu was born is another place dedicated to his memory. The building, which was opened in January 2007, does not accommodate a museum. Only the bust resting on a pedestal, 1.8 meters high altogether, which was erected in front of the building in 2010, (Figure 11.12) reminds visitors that this was the former leader's birthplace.[66] The portrait was carved in white marble by Dediu Georgescu, a Romanian artist who lived in France and realized the sculpture for free, allegedly out of devotion for Ceauşescu's personality.[67] It is a totally uninspiring work: Ceauşescu's head is too small for the massive torso and turns the bust into an unintentional caricature.

A combination of nostalgia, irony and a sense of "coolness" are to be found in the street art stencils that have been appearing on the walls of Bucharest and other cities since the beginning of the century. They reproduce Ceauşescu's state portrait with tags such as "Vin în 5 minute" (Back in 5 minutes)[68] or "I'll be back".[69] They should be treated as yet another expressive way of coming to terms with Romania's tormented past and the legacy of the disgraced communist leader.[70]

64 Veronica Micu, Ovidiu Ciutescu, "Noul Ceauşescu- face bani din brandul *celui mai iubit fiu*" [The New Ceauşescu-Dinel Makes Money from the Brand of *the Most Beloved Son*], *Jurnalul Naţional*, January 25, 2007; Cristian Preda, "De la Ceauşescu la muzeul RSR" [From Ceauşescu to the Museum of the SRR], *Revista 22*, July 28, 2004.

65 See http://www.wowbiz.ro/foto-exclusiv-cum-cum-arata-astazi-muzeul-sinistru-al-republicii-socialist e-romania-facut-de-dinel-staicu-ansamblul-de-la-podari-a-fost-vandut-de-afaceristul-aflat-de-cativa-ani-la-inchisoare–16245884. Last accessed on September 30, 2019.

66 For other pictures from the Scorniceşti museum, see https://www.dcnews.ro/casa-memoriala-nicolae-Ceauşescu-de-la-scornicesti-olt-galerie-foto_67441.html. Last accessed on September 30, 2019.

67 "Prima statuie a lui Ceauşescu, amplasată în Scorniceşti în ziua deshumării" [The First Statue of Ceauşescu, Unveiled in Scorniceşti on the Day of Exhumation], *Adevărul*, June 22, 2010.

68 http://www.b365.ro/stencilurile-cu-ceausescu-vin-in-cinci-minute-sunt-facute-de-un-celebru-artist-ro man_183326.html. Last accessed on September 30, 2019.

69 http://artspolitics.blogspot.ro/2010/07/in-fact-he-never-left.html. Last accessed on September 30, 2019.

70 Caterina Preda, "Looking at the Past through an Artistic Lens: Art of Memorization," in *History of Communism in Europe* 1 (2010): 145.

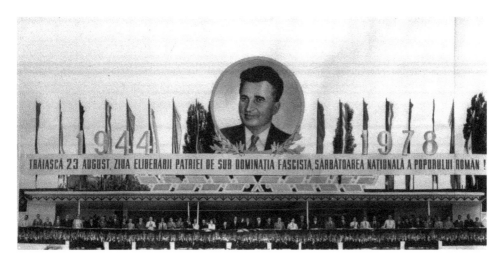

Figure 11.1 The main tribune, party rally in Aviatorilor Square, Bucharest, August 23, 1978. (*Fototeca online a comunismului românesc, Cota 279/1978*).

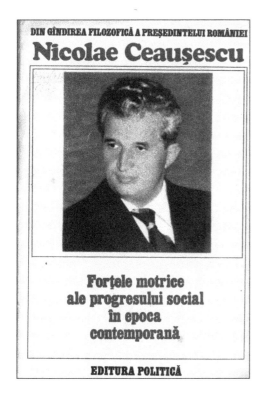

Figure 11.2 Nicolae Ceauşescu's portrait on the cover of one of the many volumes that collected his pronouncements.

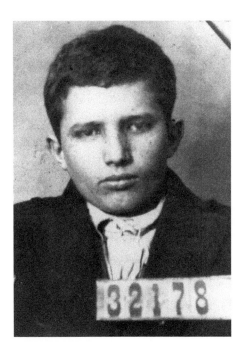

Figure 11.3 Mugshot of fifteen-year-old Nicolae Ceaușescu at Doftana prison, 1933. (*Fototeca online a comunismului românesc, Cota 1/1933*)

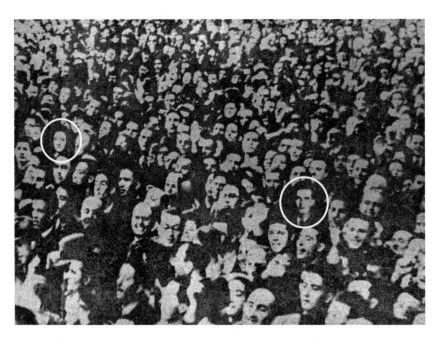

Figure 11.4 The forged image of the May Day rally in 1939 showing Nicolae and Elena Ceaușescu among the participants. National History Museum of Romania, Bucharest.

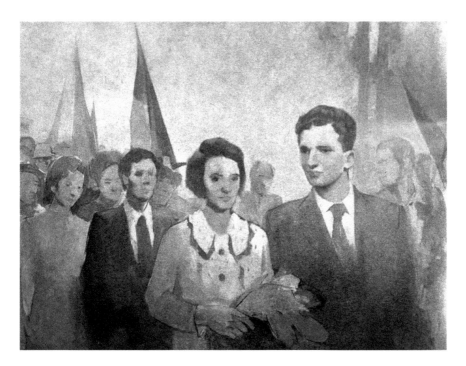

Figure 11.5 Eugen Palade, *May 1, 1939*. Painting, 1986, National Museum of Contemporary Art, Bucharest. (Courtesy of the Museum).

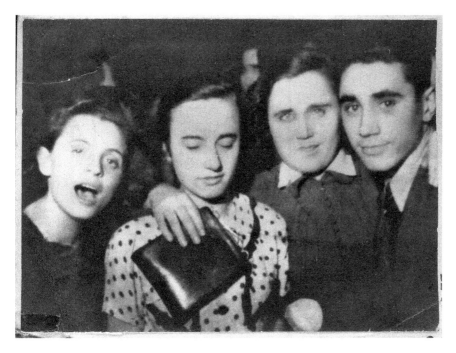

Figure 11.6 Elena Ceaușescu wearing the polka dress at a ball organized by the youth organization of the Communist Party. (*Fototeca online a comunismului românesc, Cota 2/1939*)

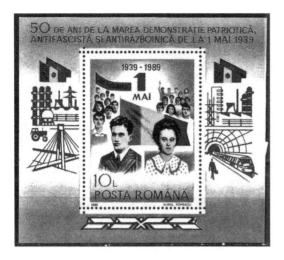

Figure 11.7 Souvenir sheet stamp depicting Nicolae and Elena Ceauşescu, issued on the occasion of the fiftieth anniversary of the May 1, 1939 mass rally.

Figure 11.8 Election poster, part of the February 22, 1985 issue of *Scânteia*.

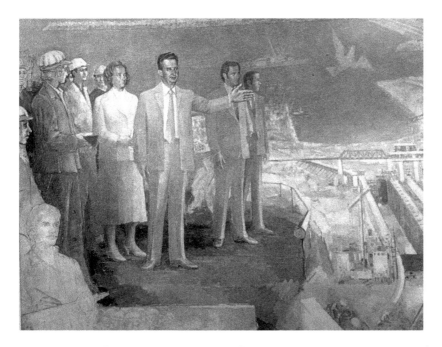

Figure 11.9 Vasile Pop Negreşteanu, *Working Visit*, painting, 1987. National Museum of Contemporary Art, Bucharest. (Courtesy of the Museum)

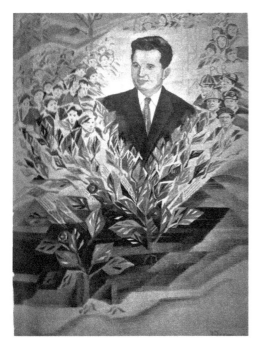

Figure 11.10 Ileana Balotă, *Homage*, tapestry, late 1970s. National Museum of Contemporary Art, Bucharest. (Courtesy of the Museum).

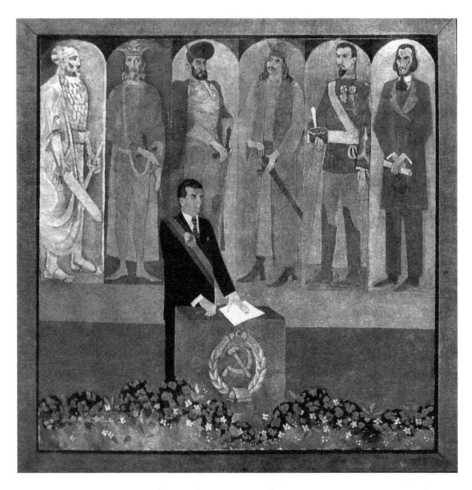

Figure 11.11 Constantin Piliuţă, *The First President*, painting, 1977. National Museum of Contemporary Art, Bucharest. (Courtesy of the Museum).

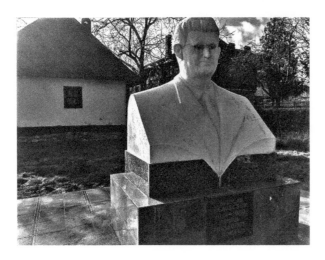

Figure 11.12 Bust of Nicolae Ceauşescu, sculpted by Dediu Georgescu, 2010, standing in front of the house where he was born, in Scorniceşti. (Photo: Stefania Matache).

Bibliography

LXXX. Mărturii orale. Anii' 80 și bucureştenii [LXXX. Oral testimonies. The 80s and people of Bucharest], edited by Şerban Angelescu and Ana Vinea. Bucharest: Paideia, 2003.

Câmpeanu, Pavel. *Ceauşescu, anii numărătorii inverse* [Ceauşescu, years of countdown]. Iaşi, Romania: Polirom, 2002.

Chelaru, Rodica. *Culpe care nu se uită. Convorbiri cu Cornel Burtică* [Guilts not to forget. Interview with Cornel Burtică]. Bucharest: Curtea Veche, 2001.

Cioroianu, Adrian. *Ce Ceauşescu qui hante les Roumains. Le mythe, les représentations et le culte du Dirigeant dans la Roumanie communiste* (2nd edition revised). Bucarest: Curtea Veche, L'Agence Universitaire de la Francophonie, 2005.

Cioroianu, Adrian. "Videologia lui Nicolae Ceauşescu. Conducătorul şi obsesia autoportretului." [Videology of Nicolae Ceauşescu. The leader and the self-portrait obsession]. In *Comunism şi represiune în România. Istoria tematică a unui fratricid naţional* [Communism and repression in Romania: Thematic history of a national fratricide], edited by Ruxandra Cesereanu, 251–265. Iaşi, Romania: Polirom, 2006.

Cioroianu, Adrian. *Pe umerii lui Marx. O introducere în istoria comunismului românesc* [On Marx's shoulders. An introduction to the history of Romanian communism]. Bucharest: Curtea Veche, 2007.

Deletant, Dennis. *Romania under Communist Rule*. Bucharest: Civic Academy Foundation, 1998.

Dobrilă, Constantin. *Entre Dracula et Ceauşescu. Le tyrannie chez les Roumains*. Bucharest: Institutul Cultural Român, 2006.

Drăguşanu, Adrian. "La commémoration des héros nationaux en Roumanie par le régime communiste de Nicolae Ceauşescu (1965–1989)." PhD diss., Université Laval, Canada, 2002.

Fischer, Mary Ellen. *Nicolae Ceauşescu. A Study in Political Leadership*. Boulder, CO: Lynne Rienner Publishers, 1989.

Gabanyi, Anneli Ute. *The Ceauşescu Cult*. Bucharest: The Romanian Cultural Foundation, 2000.

Marin, Manuela. *Nicolae Ceauşescu. Omul şi cultul* [Nicolae Ceauşescu. The man and his cult]. Târgovişte, Romania: Cetatea de Scaun, 2016.

Mocănescu, Alice. "The Leader Cult in Communist Romania 1965–1989: Constructing Ceauşescu's Uniqueness in Painting." PhD diss., Durham University, UK, 2007.

Preda, Caterina. *Art and Politics under Modern Dictatorships. A Comparison of Chile and Romania*. New York: Palgrave, 2017.

Shafir, Michael. *Romania. Politics, Economics and Society, Lynne Press*. Boulder, CO: Lynne Rienner Publishers, 1985.

Vasile, Cristian. *Viaţa intelectuală şi artistic în primul deceniu al regimului Ceauşescu 1965–1974*. Bucharest: Humanitas, 2015.

Verdery, Katherine. *National Ideology under Socialism: Identiy and Cultural Politics in Ceauşescu's Romania*. Berkeley: University of California Press, 1991.

12 The German Chancellors
Visual Strategies for the Image of the Head of State

Manja Wilkens

"If you are portrayed as a chancellor, then you should wear a navy blue suit, that should be enough",[1] stated Chancellor Helmut Schmidt (in office from 1974 to 1982) in July 1976 during the official opening of the *Galerie der Bundeskanzler* (Gallery of Chancellors), a collection of portraits of chancellors, established at the Federal Chancellery in Bonn (later moved to Berlin), twenty-seven years after the birth of the Federal Republic of Germany.[2] The photograph published by *Die Zeit* on November 12, 2016, in a special edition published on the occasion of Schmidt's death, is the perfect illustration of his view (Figure 12.1). The main purpose of the Gallery was to provide the young state with a collection of official portraits. This was in keeping with an old tradition. Schmidt's Gallery was in fact modelled on the *Nationale Bildnis-Sammlung* (National Portrait Collection), established in 1913, which in turn was inspired by the gallery that was created following the foundation of the German Empire in 1871.[3] The National Portrait Collection differed from conventional galleries of rulers or ancestors: the great men of Prussian history were chosen to be honored for their political achievements, not for their birth; moreover the collection was open to the public in order to bring its history closer to the people. This pedagogic function appealed to Schmidt and led him to create a gallery along the same lines.

The official portraits presented in this essay have at some point all been part of the constantly changing gallery (Figure 12.2). Paintings were often replaced because the authorities were not satisfied with earlier versions of the collection. However, the existence of a gallery as such has never been questioned.

The present investigation will illustrate some significant examples of portraits without dwelling on their vicissitudes: it will examine them in the context of official, party-controlled images, as well as of the photographs that have appeared in the press.

Modesty as Visual Strategy: Konrad Adenauer's Portraits

By electing Konrad Adenauer, a member of the Christian-Democrat Union (Christlich Demokratische Union, CDU), as Chancellor in 1949, in the first free election of the

1 Pater Sager, "Bonner Köpfe in Öl," *Zeitmagazin*, July 28, 1978, 16.
2 For a detailed account of the history of the Gallery, see: Manja Wilkens, *Die Galerie der deutschen Bundeskanzler* (Düsseldorf: Düsseldorf kunsthistorische Schriften 7, 2007).
3 For the Gallery's history, see Jörn Grabowski, "Die nationale Bildnissammlung," *Jahrbuch Preußischer Kulturbesitz* 31 (1994): 297–322.

post-war period, the young Federal Republic had chosen a politician who already had a successful political career as mayor of Cologne until the rise of the National Socialists, when he lost his office under Hitler.[4] As the three portraits we will consider will show, much care was taken to represent him using a visual language that contrasted strongly with that of Nazi propaganda.

The portrait of the first Federal Chancellor was painted by the modernist artist Hans-Jürgen Kallmann (1908–1991) in 1963, just after Adenauer resigned from the position he had held for fourteen years, and still hangs in the Chancellors' Gallery.[5] It is the only portrait to have been selected not by the sitter, but by his party. The painting was chosen by Helmut Schmidt, at the suggestion of the CDU, because Adenauer was no longer alive in July 1976 (he had died in 1967). Another portrait, realized in 1966 by Oskar Kokoschka[6] (Figure 12.3), was probably not even considered by the CDU. It had been sponsored by *Quick*, a popular weekly magazine which the CDU considered somewhat light-hearted. The painting began to be appreciated years later, when Angela Merkel hung it behind her desk, shortly after she assumed the leadership of her party in 2002.[7] It is a good example of the problems involved in visualizing the Federal Republic under Konrad Adenauer. The painting was the legacy of the Chancellorship, since when Kokoschka was given the commission Adenauer was no longer head of state.

Adenauer's portrait depicts him from the knees upwards, wearing the navy-blue suit Schmidt considered appropriate. One can identify some vague architectural elements of the room at Cadenabbia (Italy) that had been converted into a studio for the portrait sessions: the Chancellor stands with crossed hands in front of a fireplace that can only be glimpsed. The painting represents him looking into the distance, turned slightly sideways, without any decorations that might hint at his rank. Adenauer's facial expression – the closed mouth suggesting self-confidence and determination – reveals the personality of a man who stood his ground. However, his slight build and falling shoulders stand in sharp contrast to his facial expression: they evoke modesty.[8] This restrained depiction consciously subverts the body cult strongly promoted by National Socialism. The emphasis on the head and the silent restraint contrast with the vocal and shrill propaganda of the regime.

The idea of creating a portrait of Adenauer that is official yet also unassuming need not be attributed exclusively to Kokoschka. A picture which the CDU used for

4 On Adenauer's Cologne years, see the exhibition catalogue *Konrad der Große. Die Adenauerzeit in Köln. 1917–1933*, ed. Rita Wagner, Kölnisches Stadtmuseum, 2017 (Mainz: Nünerich-Asmus, 2017).

5 See https://www.bundeskanzlerin.de/Content/DE/StatischeSeiten/BK/oelbild-konrad-adenauer.html (this link and the following referred to in this essay were last accessed on February 17, 2019). Kallmann had been banned from working under the National Socialists, who considered non-representational art as "degenerate". After the war, he gained a certain reputation as a portraitist of well-known personalities.

6 Though Kokoschka belonged to the avant-garde of the early decades of the twentieth century, the absence of modernist art during the Nazi period makes him appear like an artist of the post-war art scene.

7 For the turbulent history of this painting, see Manja Wilkens, "Grenzgängerschaft im Herrscherporträt: Oskar Kokoschkas Adenauer-Bildnis und seine Instrumentalisierungen," in *Blickränder: Grenzen, Schwellen und ästhetische Randphänomene in den Künsten*, eds. Astrid Lang and Wiebke Windorf (Berlin: Lukas, 2017), 346–59.

8 Wilkens, "Grenzgängerschaft im Herrschaftsporträt," 348.

the election campaign of 1953, taken by its photographer Peter Bouserath,[9] represents the chancellor in a simple pose: Adenauer sits on an armchair, his head turned toward the beholder, with a notepad in his hand; the background depicts a bookshelf. The informality and approachability which the picture evokes – Adenauer looks like a friendly elderly man who welcomes his visitors into his living-room – appear not to have been considered effective in political terms. The photograph was used on the election poster in a substantially modified form: Adenauer featured in it only from the waist up, and the background was entirely removed.[10] The slogan states: "Deutschland wählt Adenauer" (Germany votes Adenauer) (Figure 12.4). The original photograph undoubtedly reflected the Chancellor's intention to distance himself from Hitler's propaganda imagery. Adenauer's modest appearance and his lifestyle were in keeping with the small and provincial town of Bonn that post-war Germany had chosen as a capital in order to project an understated image. Ludwig Erhard, who succeeded him as Chancellor (1963–1966), pursued the same subdued approach, as did, albeit to a lesser extent, Chancellor Kurt Georg Kiesinger (1966–1969).

Controlling Rhetorical Gestures: Willy Brandt

Initially, the sober and modest approach was approved by the general population. Over the years, while some found it reassuring, many became critical of it. The Social-Democrat Party (Sozialdemokratische Partei Deutschlands, SPD) sought to project an entirely different image. Its leader, Willy Brandt, who was to serve as Chancellor from 1969 to 1974, appeared on a poster produced for the federal election campaign of 1969 as a new type of politician (Figure 12.5, Left). Brandt confronts us with his head slightly tilted and his torso turned off its axial position to appear as a candidate who seeks direct contact with the voter. He is depicted in the act of delivering a speech: his mouth is open and reveals the lower set of teeth, and his right hand is raised to emphasize what he is saying (a device he was to use in the election campaign of 1972). While this image attempts to present him as a dynamic leader close to the people, the worm-eye view creates a respectful distance that older voters were especially likely to appreciate.

That Willy Brandt wished to appear as a new type of Chancellor became particularly evident when, on December 7, 1970, he travelled to Warsaw to honor the victims of the Ghetto and genuflected before the Memorial devoted to them. Numerous photographs of the *Warschauer Kniefall* (Warsaw genuflection), as it came to be known,

9 Ludger Derenthal, "'Finden Se dat so schön?' Porträtfotografien Konrad Adenauers," *Fotografie & Geschichte. Timm Starl zum 60. Geburtstag*, ed. Dieter Mayer-Dürr (Marburg: Jonas 2000), 152–3.

10 For the history of the political poster in the Federal Republic of Germany see: Doris Gerstl, "Die Wahlplakate der Spitzenkandidaten der Parteien bei den Bundestagswahlen von 1949 bis 1987," (Habilitationsschrift, Friedrich-Alexander-Universität Erlangen-Nürnberg 2016). A monograph based on this dissertation will shortly be published by Böhlau (Cologne).

were taken and disseminated in the media.[11] But which of them has become iconic?[12] The way Brandt approached the ceremony is worth describing in some detail. Usually, after laying down the wreath to commemorate the victims of wars and persecutions, politicians pause for a moment before turning away in order to provide reporters with an opportunity to take pictures. Brandt, standing a few steps ahead of the high-ranking officials who attended the ceremony, chose to kneel instead of turning away immediately, thus triggering numerous flashlights. Just before kneeling, Brandt held his hands entwined in front of his body. By looking at the footage of this moment, it can be seen that he changed his position after one to two seconds. Now his arms were no longer hanging down, but he moved them forward, taking up the position of a praying person.[13] Perhaps he recalled the posture of the grieving couple sculpted by Käthe Kollwitz for the German military cemetery in Vladslo (Belgium), a monument completed in 1932 that is well known in Germany.[14] Brandt is likely to have behaved spontaneously. His personal advisers would have probably discouraged him from assuming such a humble a stance, which many Germans would have considered inappropriate to the standing of a Chancellor.

The Warsaw Ghetto Memorial was guarded on both sides by armed soldiers. Polish and German politicians had gathered with a large number of journalists who were scattered around the area. As a result, there was no single picture: many were taken from different spots. Inevitably the impressions conveyed by the ceremony varied considerably. The problem of the variety of viewing points from which the scene could be photographed was an aspect that Brandt's advisers would have been concerned about: they would have advised him against assuming such an attitude. So we can presume that the genuflection was a spontaneous gesture. However, images cannot easily be manufactured in order to achieve specific effects. The plaque that was commissioned by the Polish government in 2000 to commemorate the event depicts Brandt alone, as a dignified politician during his moment of contemplation.[15] The German press, however, published photographs taken from all viewpoints: some pictures showed the chancellor silent and alone, kneeling in a manner that appeared both statesmanlike and humble; others depicted him with a jostling crowd of journalists, looking somewhat ridiculous. Some photographs featuring Brandt with the soldiers on duty made him appear like a secondary figure.

11 Christoph Schneider, *Der Warschauer Kniefall. Ritual, Ereignis und Erzählung* (Konstanz: UVK-Verl.-Ges. 2006). The pictures, taken by various photographers such as Engelbert Reineke, Hanns Hubmann and Sven Simon, are reproduced, for example, in: https://de.wikipedia.org/wiki/Kniefall_von_Warschau

12 On this issue see Detlef Hoffmann, "Der Kniefall des Kanzlers der Bundesrepublik Deutschland Willy Brandt," *Jahrbuch der Guernica-Gesellschaft* 14: *Kunst und Politik* (2012): 133–45, in particular 139, note 28.

13 The footage of the event on YouTube shows at minute 6:19 that his position changed after 1–2 seconds: https://www.youtube.com/watch?v=2rdiUDJYMwM.

14 On these sculptures see Ursula Lindau, *Der Schrei und die Stille. Trauer und Tod bei Künstlern der klassischen Moderne* (Husum: Ihleo, 2018), 86–9.

15 Reprinted in: https://de.wikipedia.org/wiki/Kniefall_von_Warschau#/media/File:Willy_Brandt_Square_02.jpg. For the Polish reception see: Lisa Bicknell, "Willy Brandt und Warschau. Denkmal, Symbol, Erinnerungsort?" in *Stadtgeschichten – Beiträge zur Kulturgeschichte osteuropäischer Städte von Prag bis Baku*, eds. Benjamin Conrad and Lisa Bicknell (Bielefeld: Transcript, 2016), 39–52.

Politics and Avant-garde: Willy Brandt

Shortly after Brandt became Chancellor in 1969, Georg Meistermann (1911–1990) – one of the leading representatives of abstract painting in West Germany – was commissioned his portrait. He produced several versions of it.[16] At that time no one was thinking of a creating a Chancellors' Gallery. Like the Warsaw kneeling, the painting prompted a variety of comments. The weekly magazine *Der Spiegel* described it as "an oil painting that has suffered an acid attack",[17] while another weekly magazine, *Der Freitag*, noted that the portrait had "captured something of Brandt's introversion".[18] Meistermann's picture is made up of brown, white and bluish spots of color. The white motif that appears to be stuck to the hand may be a sheet of paper. The vagueness of the representation (the figure is enveloped in a thick "fog") suggests that the sitter was shy and reserved. However, from a political standpoint the picture is unconvincing: it does not rely on standard political iconography to illustrate the chancellor's political virtues; indeed, it does not do justice to his achievements. It should also be noted that the shy attitude Brandt displays in it is put on, rather than real. Because none of Meistermann's versions of the portrait were found acceptable, preference was given to a picture by Oswald Petersen (1903–1992), a conventional portraitist appreciated by the Nazis. Helmut Kohl, who commissioned it, was keen to bring an uncontentious portrait of Brandt to the Chancellors' Gallery.

Creating a portrait of Willy Brandt that succeeded in celebrating his political virtues proved problematic even after he died in 1992. In 1996 Rainer Fetting (b. 1959), a member of Berlin's *Junge Wilde* (Wild Youth) movement, executed a monumental statue of chancellor for the SPD's new headquarters in Berlin (Figure 12.5, Right). Brandt is depicted making a dramatic gesture, one that was borrowed from his 1969 election poster. However, unlike the photographic one, which conveyed dynamism, the sculpted gesture is ambiguous: depending on the angle of viewing, it appears as an instruction or a threat made to the political heirs at his feet. Despite his raised right hand, his lowered head and sealed mouth suggest he is pausing during his speech. The sculpture was placed in the central foyer of the building and press photographers regularly use it as a backdrop when they depict party figures speaking.[19] (Figure 12.6). The speakers' positions in relation to Fetting's statue and the ways in which the photographers shoot them result in pictures that sometimes present the speakers in flattering terms, and sometimes in negative ones.

16 Kai Langhans, *Willy Brandt und die bildende Kunst* (Bonn: Dietz, 2002).
17 *Der Spiegel*, February 27, 1978, 211.
18 Ingo Arend, "Mit weißer Weste," *Der Freitag* 52 (December 19, 2003), 15.
19 See Manja Wilkens, "Der bronzene Hausherr und seine Gäste: Willy Brandt von Rainer Fettting," in *Vor-Bilder: Ikonen der Kulturgeschichte*, eds. Sandra Abend and Hans Körner (Munich: Morisel, 2015), 163–79, and Rüdiger Zill, "Transformationen: Willy Brandt oder die Metamorphosen eines Kanzlerbildes: Die Funktionsweise von Modellen in der Produktion und Wahrnehmung der Bildenden Kunst," in *Let's mix (all media) together & Hans-Dieter Huber*, ed. Hannelore Paflik-Huber (Berlin: Hatje, 2016), 116–32.

Mundanity without Pathos: Helmut Schmidt

Brandt's successor, Helmut Schmidt, in office from 1974 to 1982, dealt more effectively with the question of how to look modern and also succeed in conveying a political message. As his statement about navy blue suits suggests, he believed in sobriety as the best way of giving weight to one's political statements. His official portrait was painted by Bernhard Heisig (1925–2011), the most renowned artist of the German Democratic Republic (GDR), in 1986. Heisig was at the time the director of Leipzig's prestigious *Hochschule für Graphik und Buchkunst* (Academy of Graphics and Book Art). The choice of an artist from the "other" Germany was perceived as a subtle political statement. In fact, the idea did not come from Schmidt: the Ständige Vertretung der Bundesrepublik in der DDR (Permanent Representations of the Federal Republic of Germany), which also dealt with cultural matters, approached him and recommended the portraitist in question – a fact that has never been made public in West Germany.

The documents concerning the execution of the commission are a piece of "German-German" history. They reveal that the arrangement, which was looked at by the Stasi, the secret service of the GDR, with suspicion, was intended as a joint attempt to raise the iron curtain gently, despite the fact that the opening the border was still out of question.[20] Sittings for the portrait took place on both sides of the Iron Curtain, though the artist also relied on a photograph of the Chancellor. The result is a half-length portrait of Schmidt sitting at his desk and fixing the observer calmly. His glasses and various papers are scattered before him. He holds a cigarette with his right hand, resting his elbow on the desk. Heisig represented Schmidt as a democratic chancellor: he characterized him vividly with a pose that spells alertness and intelligence. As well as these general qualities, the portrait also conveys a concrete political message. Schmidt's preference for Expressionism[21] may have influenced his decision to commission the portrait from Heisig, for the latter's pictorial language was imbued with the style of that movement.[22] However the choice also reflected the SPD idea of *Wandel durch Annäherung* (Change through rapprochement [to the GDR]), a phrase coined by the SPD politician Egon Bahr. The portrait is possibly the most politically charged picture of the Gallery.

The somewhat prosaic depiction of Schmidt is in keeping with his distrust of propaganda, and of personality cults in particular. His attitude surfaced more clearly in the online Gallery of Chancellors, which was created in 2001.[23] The Bonn Gallery had been little known because it was not open to the general public. The press rarely discussed or even mentioned the paintings on display. This situation changed with Gerhard Schröder. During his chancellorship (1998–2005), the Internet began to gain influence; the decision was thus taken to put the Gallery on the web to make it accessible to all.

20 For a detailed account of this commission, see Kristina Volke, *Heisig malt Schmidt* (Berlin: Christoph Links, 2018), which also reproduces the portraits covering the period from Adenauer to Schmidt.

21 See Sinclair-Haus Bad Homburg et al., *Katalog der Ausstellung: Bernhard Heisig. Bilder aus vier Jahrzehnte* (Cologne: Wienand, 1998), 56.

22 It is known that he had initially contacted Kokoschka. See Volke, *Heisig*, 60–1.

23 The website was created by the Federal Government in 1997. The version discussed here was first made available in 2001. The Federal Press Office is responsible for the selection of texts and photographs. The parties have no say in this. I wish to thank the Press and Information Office of the Federal Government for this information.

On this occasion Kallmann's portrait of Adenauer was replaced with Kokoschka's. In addition to the oil paintings, the virtual gallery now also included photographs. Schmidt's photographic characterization is significant. He always appears in the act of performing his political functions: speaking in parliament, and conversing with the DDR leader Erich Honecker, with his Foreign Minister Hans Dietrich Genscher and with shipyard workers.[24] Adenauer features in one of the photographs as a rose-grower, while in a picture Helmut Kohl is shown with one of the aquariums he kept in the Chancellor's Office. Unlike them, Schmidt, both elegant and unostentatious, preferred to appear as a man of action.

Middle-Classness as a Public Relations Strategy: Helmut Kohl

In 1982 the CDU became the governing party and the idea of how a chancellor should be represented changed radically again. If Helmut Schmidt was dry and pro-saic, Helmut Kohl, who ran the country until 1998, fashioned himself as an ordinary, middle-class guy. He was criticized for that by the country's intelligentsia, and became the subject of satirical comments. In 1976, during the federal election campaign, a French cartoonist, Jean Mulatier, had drawn Kohl's head in the shape of a pear, to imply that he was simple-minded.[25] Those familiar with French history could imme-diately see a reference to Charles Philipon's famous caricature representing the head of the bourgeois king Louis Philippe as a pear. Satirists loved making fun of Kohl's massive physique, and equated his corpulence to political immobility. The party dealt with these satirical attacks through self-irony: in 1987 CDU campaigners wore "I like Birne" ("I like pear") pins.[26]

Kohl's pear caricatures implied that he was provincial – an image that contrasted with his ingenious Federal elections' campaigns. The posters depicting Kohl in the midst of a crowd that were produced for the election of 1994 attest it.[27] Their original version featured neither a party logo nor a slogan. The strategy worked because it was unusual. The poster imitated the advertisements of the Italian clothing company Benetton, which intrigued the public because they were text-less (and did not depict the products they were promoting).[28] The fact that someone put a Benetton sticker on one of the CDU posters shows that the similarity had been picked up.[29] This approach

24 In November 1977, during a state visit to Poland, Schmidt went to the Paryska dockyards (https://kfp.pl/zmarl-helmut-schmidt). I wish to thank Anna Ciszewska-Wilkens, Potsdam, for this information. The picture of this visit (https://www.bundeskanzlerin.de/bkin-de/kanzleramt/bundeskanzler-seit–1949/helmut-schmidt) was taken by the government's official photographer Engelbert Reineke. This explains how the photo later came to be part of the virtual Chancellors' Gallery.

25 *Der Spiegel*, Cover, 35, 1975. Kurt Koszyk, "Zur Genealogie der Birne,'" in *'Was sind wir Menschen doch! ...': Menschen im Bild: Analysen, Hermann Hinkel zum 60. Geburtstag*, ed. Dietrich Grünewald (Weimar: VDG, 1995), 227–33.

26 Christoph Gunkel, "Die Rache der Birne. Kohl-Karikaturen," *Spiegel online*. https://www.spiegel.de/geschichte/helmut-kohl-in-karikaturen-die-rache-der-birne-a-1037236.html

27 On this poster see Marion Müller, "Politisches Parfüm: Die visuelle Vermarktung de s Immateriellen," in *PR-Kampagne: Über die Inszenierung von Öffentlichkeit*, ed. Ulrike Röttger (Oppladen: Westdeutscher Verlag 1997), 202.

28 Wolfgang Brassat, "Benetton: Die 'imagerie populaire' und die Ikonographie," in *Im Blickfeld*, ed. Hamburger Kunsthalle, 2 (1997), 157–60.

29 Müller, "Politisches Parfüm," 202.

was intended to give the poster a "modern" feel. It is also true that Kohl's physical presence made texts superfluous: he filled the poster with his figure and was immediately recognizable. He was not of course the first politician to be represented with a crowd. Mention has already been made that the digital Chancellors' Gallery includes a photograph depicting Schmidt as working Chancellor, deep in conversation with some shipyard workers. Such a photograph could not have made a good poster because Schmidt, unlike Kohl, was a small man. This photograph is quite typical of the way Schmidt saw himself as Federal Chancellor, but was certainly unsuitable as a motif for an election poster. The convincing impression of a politician who is in the crowd, but does not drown in it, is exactly what the SPD tried to do on a poster produced to promote the candidature of Peer Steinbrück during the federal election campaign of 2013 (Figure 12.7). The result is quite disappointing for a number of reasons: the aspiring chancellor looks like a cut-out figure stuck in front of the crowd,[30] and people's individual faces are not recognizable. Moreover, Steinbrück curiously features behind an empty lectern, next to the campaign slogan "Das Wir entscheidet" (The we decide), his presence weakened by the SPD flags which clutter the picture. The words "Das Wir", which are meant to stress the idea of a community, stand in sharp contrast to an image that depicts the candidate as a figure emerging from the crowd, instead of being part of it. In Kohl's Benetton-style poster the absence of a slogan permitted a direct connection.

To return to the years of the Kohl government, one of the Chancellor's best-known public images concerns his meeting with President François Mitterrand in 1985 at the Douaumont cemetery in Verdun, the site of one of the most blood-stained battle of the First World War. The ceremony commemorated the seventieth anniversary of the beginning of the conflict. The photograph depicts him holding hands with the French leader – a gesture of reconciliation and friendship. The image was much commented on by the media. The hands motif is a political symbol with the left-wing associations: it recalls the peace movement and its human chains. Kohl's "borrowed" gesture consequently irritated both his supporters and his opponents.[31] Pictures can change meaning in the course of time and are occasionally even appropriated by the opposite camp, and the history of this photograph attests it. At first strongly criticized, it has now become a pictorial icon, a symbol of Kohl's strongly felt European beliefs and of the European idea in general.[32]

A few years later, another highly mediatized event became Kohl's trademark. In the summer of 1990, while the reunification of Germany was being planned, the

30 Another poster depicting a politician with a crowd worth mentioning is that produced by the CDU in 1983 to promote Kohl's candidature. The leitmotif of his election campaign was the idea that politicians and people should work together; the slogan was: "Miteinander schaffen wir's" (Together we can make it). The poster only hinted at a crowd, while Kohl's figure in the middle was clearly emphasized. His sharp outline stood out against an insignificant background, but at the same time the eye contact with his people convincingly conveyed a "we". See: https://commons.wikimedia.org/wiki/File:KAS-Kohl,_Helmut-Bild–1565–1.jpg and: Gerstl, *Wahlplakate*, 2, cat. 104.

31 Soeffner, "Geborgtes Charisma," 184.

32 See: Christoph Gunkel, "Geschichte zum Anfassen", *Spiegel online*, September 22, 2009, and Ulrike Hospes and Hans-Jürgen Küsters, "Bundeskanzler Helmut Kohl und Frankreichs Staatspräsident François Mitterrand reichen sich die Hände," https://www.kas.de/de/web/geschichte-der-cdu/kalender/kalender-detail/-/content/bundeskanzler-helmut-kohl-und-frankreichs-staatspraesident-francois-mitterrand-reichen-sich-in-verdun-die-haende, which reproduces the photograph.

Chancellor met the Soviet president Mikhail Gorbachev. The meeting took place in the latter's hunting lodge in the Caucasus. In view of the importance of the event, most of the participants were wearing formal attire, despite the setting where it was taking place. Gorbachev, as the host, took the liberty of renouncing his tie and suit. Kohl did the same, but unlike Gorbachev, who wore a dark blue sweater, he donned a much more conservative cardigan with a deep V-neck. The success of the exchanges with Gorbachev did not silence the usual criticisms that Kohl was provincial, but weakened them. Kohl continued to project an image of middle-class ordinariness in the following years, while succeeding in dispelling the fears of the other members of the European Union regarding an all-powerful united Germany.

In 2003, the Chancellors' Gallery was expanded to include the portrait of Helmut Kohl painted by Albrech Gehse (b. 1955), a pupil of Bernard Heisig's.[33] The calculated image of German provincialism is certainly only a marginal aspect of this painting, but it provided opportunities for some journalists to resume their attacks on the Chancellor. The fact that others referred to Kohl in favorable terms with phrases such as "the craftsman who has to manage a giant construction site" only encouraged accusations that he was provincial. Ultimately, the portrait painted by Heisig's pupil dealt with other aspects of the chancellorship. The painting provides a glimpse of Berlin's Brandenburg Gate in the background. The Chancellor is seated and wears a cardigan, which alludes to his Caucasus meeting with Gorbachev. The whitish area on Kohl's right side represents some papers he is holding under his arm.[34] Unlike Heisig, who tried to render Schmidt's intellectual liveliness, Gehse's main aim was to represent his subject as the maker of German unity. The blue color that dominates the painting alludes to the European Union. As modern as the CDU's election campaigns were, Kohl's painting for the Gallery is problematic. Unlike the portraits of Adenauer or Schmidt, Kohl's refers to his political achievements, but does not provide a representative image of a man who, after all, was Chancellor for sixteen years. Perhaps this was so because Gehse conceived the portrait as a résumé of Kohl's career at a time when the latter had already fallen seriously into disrepute due to the donations scandal, as a result of which the achievements of his years as Chancellor seemed to fade into the background.

"Neue Prächtigkeit"[35] (New Magnificence): Gerhard Schröder

The Social-Democrat Gerhard Schröder, who governed Germany from 1998 to 2005, brought a new look to the chancellorship. The photograph documenting the signature of his first coalition agreement – the government was to include the Bündnis 90/Die Grünen (Alliance 90/Green Party) – depicted Schröder with his new partners

33 It should be noted that Kohl was the only Chancellor to personally commission the portrait and also pay for it. He made it available to the Chancellery as a loan. See Albrecht Gehse, *Das Gemälde* (Berlin: Otto Meissners 2003), 22, and 5 for a reproduction of the portrait.

34 Albrecht Gehse confirmed this interpretation to me when I interviewed him in 2003.

35 This expression was borrowed from the *Schule der neuen Prächtigkeit*, which was established in the studio of Johannes Grützke in 1973.

celebrating with champagne glass in their hands.[36] None of the political figures wore knitted cardigans, and had they been photographed eating, we could be sure that *Saumagen,* the stuffed pig's stomach which Kohl was so fond of, would not have been served. The photograph attracted negative comments by the media because it suggested luxury. Criticism intensified when Schröder appeared wearing an elegant Brioni suit and smoking a cigar in the March 1999 issue of the fashion magazine *Gala.* Although this ostentated elegance lessened significantly over the years, accusations of superficiality and egocentricity continued to stick to him. In 2003 a photographer reduced the slogan of the party conference, "Das *Wich*tige tun" (Doing the important thing), to three letters that crown Schröder: "ich" (the German word for "me") (Figure 12.8).

In May 2001 Gerhard Schröder moved to the Chancellery in Berlin, and the Chancellors' Gallery was also brought there. Schröder added his portrait to it in 2007. This painting, which had been commissioned from the German artist Jörg Immendorff (1945–2007), was much debated.[37] It evokes Schröder's sense of style, as well as his egocentricity and self-confidence. It also ironically subverts traditional signs of power, and is rich in art-historical references.[38]

Soon after taking up office in 1998 Schröder showed a strong interest in art. He played an active part in the selection of the works (mostly contemporary) that were to decorate the Chancellery in Berlin, a building that was commissioned by Helmut Kohl, but actually completed during Schröder's term of office. The most prominent example – if the frequency with which the press mentioned it is anything to go by – was Georg Baselitz's *Falling Eagle,* which Schröder displayed behind his desk (the painting is now at the Museum Küppersmühle für Moderne Kunst, Druisburg).[39] The reason for such a choice is subtle: since the eagle is as an old symbol of power, its depiction in the act of falling could be interpreted ironically, as a reversal of its traditional meaning.

A few comments on the ways rulers are represented deserve to be made at this point. The pictorial genre of the statesman at his desk has been well established since Napoleon. The French leader was keen to prove his legitimacy through his actions. This approach led to a change in image policy: he had himself depicted working at his desk. Napoleon's example was followed by many leaders.[40] The chancellors of postwar Germany are no exception. The only difference is the new tendency to personalize the study by means of decorative elements of their choice, of private preferences, which become part of the chancellors' official photographs and of their public image. Adenauer had some framed photographs especially of his family and of important

36 Image in: Jürgen Leinemann, "Die Ära Kohl," *Der Spiegel*, May 17, 1999, 219. The photograph was taken by Roberto Pfeil.

37 Wilkens, *Galerie der Bundeskanzler*, 2007, 4–5.

38 See Horst Bredekamp, "Jörg Immendorff and the Anti-Pathos of the Chancellor Portrait," in *Inventing Faces. Rhetorics of Portraiture between Renaissance and Modernism*, ed. Mona Körte (Berlin and Munich: Deutscher Kunstverlag, 2013), 190–206.

39 See Eckard Fuhr, review: "Kunst und Macht" exhibition in: *Haus der Geschichte*, Berlin 2010). https://www.welt.de/kultur/article6467567/Wozu-Schroeder-einen-stuerzenden-Adler-brauchte.html

40 See Rainer Schoch, *Das Herrscherbild in der Malerei des 19. Jahrhunderts* (Munich: Prestel, 1975). Jacques Louis David's *Portrait of the Emperor in his study at the Tuileries*, painted in 1812 (National Gallery of Art, Washington, DC), is an early example of this genre.

visitors on display. Helmut Schmidt avoided giving a private touch to his study: he kept a portrait of the German Socialist politician August Bebel (one of the founders of the SPD in 1863) behind his desk. By contrast Kohl returned to a distinctly private, increasingly petty-bourgeois iconography. His study featured a collection of small elephants, and some aquariums. Schröder moved away from this political tradition.[41]

The Baselitz painting in Schröder's study is an aggressive renunciation of Kohl's habitus, but need not be interpreted as a return to Schmidt's sober reference to the history of his party. Immendorff's portrait, like Georg Baselitz's – both, incidentally, are artists who reverted to a figurative style – subverts traditional signs of power, although the irony is not immediately obvious.

Like his predecessors, Schröder chose the artist with much care: he had known Immendorff personally for several years. Immendorff was seriously ill, so the painting was mostly executed by his assistant. The portrait is rich in art-historical references.[42] Its frontality recalls Dürer's well-known self-portrait as Christ (Alte Pinakothek, Munich), the grid structure of the frame is a borrowing from garden architecture and the monochrome drawings in the grey background derive from Parmigianino's paintings. Moreover, Immendorff quoted elements from his own works on the lower part of the painting, and represented some monkeys as his alter ego in the portrait's oval. There is irony, on the one hand, and the artist's reference to himself, on the other. These elements seem to collide with conventional celebrative formulae: the marble-like pictorial ground and, above all, the monochrome gold tones of the bust itself. In other words, Schröder has been represented as a Chancellor far removed from his time, surrounded by monkeys, traditional symbols of artistic activity. Immendorff's portrait looks like a foreign body in the Gallery. It gives the impression that Schröder is turning away from democratic forms of representation. In fact, this picture, like the *Falling Eagle*, was chosen to make an ironic statement: it satirizes the solemn and serious ways in which politicians are expected to appear. Confirmation that the portrait's humorous connotations were intended by both sitter and painter was recently provided by Schröder himself.[43] Neither Kokoschka's Adenauer nor Meistermann's Brandt is displayed in the Gallery today. Placed in the proximity of other portraits painted by avant-garde artists, Immendorff's painting would have constituted a new and ironic attempt to illustrate modern democracy. The coexistence of Kokoschka's, Meistermann's, Heisig's and Immendorff's portraits would have considerably expanded the range of political expressions: the collection would not be just a series of portraits of old people hanging there because no other place could be found for them.

41 For the representation of politicians at their desks, see Gerstl, *Wahlplakate*, 2012, 667f; Manja Wilkens, "Der Rahmen der Macht. Zur Inszenierung der politischen Klasse," in *Format und Rahmen*, eds. Karl Möseneder and Hans Körner (Berlin: Reimer, 2008), 211–31.

42 For a first attempt of an analysis that goes beyond the sarcasm of the newspapers see: Stefan Kohldehoff in a radio interview (Deutschlandfunk "Kultur" (January 19, 2007). For a detailed analysis of the painting, see Bredekamp, *Immendorff*, 2013, 190–206.

43 Schröder made this point in the speech he gave during the opening of the exhibition *Jörg Immendorff: Für alle Liebenden in der Welt* (Haus der Kunst, Munich), on September 13, 2018. I am grateful to Gerhard Wohlmann, Munich, for this information.

The Media Chancellor: Angela Merkel

Angela Merkel, whose term of office began in 2005, is still in power, and we do not really know what her official portrait for the Gallery will look like. She is referred to as "Media Chancellor" especially on account of the way she uses the media, namely of her ability to control the presentation of issues.[44] Her own YouTube network, launched in October 2011, is almost a state television channel. Exploiting the absence of regulations, she has succeeded in legitimizing it by characterizing it as a channel of programs on demand. The official video broadcasts in which she features do not deserve film awards: the actress is stiff in appearance. The characterization provided by *Der Spiegel* on September 5, 2005, a few weeks before her first election, remains valid: "Again she [Angela Merkel] carelessly does everything wrong ... She continues as usual, talks calmly, and with a wry smile; she seems like an eternal contradiction to the media democracy." *Der Spiegel* was right with its prediction that she would be the next chancellor. Though she certainly knows how to use the Internet, she seems little concerned with her own physical appearance. It is difficult to imagine her on a portrait for the Chancellors' Gallery. A photograph depicting her as an ordinary person, such as those the German photographer Herlinde Koelbl took of Merkel from 1991 to 1998,[45] would not fit either. Koelbl tends to photograph politicians especially to show how power has changed them. Her portraits of Merkel no doubt convey a very humane image of her as a person, but one that would probably not be political enough for the Chancellors' Gallery.

An interesting way of picturing Merkel is suggested by a photograph taken by Andreas Mühe in 2008.[46] She stands near a tree in the Botanical Gardens in Berlin and turns her back on the observer. Mühe is re-interpreting and subverting a well-known photograph by Helmut Newton which represents Helmut Kohl before a massive oak tree looking into the distance. Merkel, in fact, never sat for the photograph: Mühe hired a model who looked like her. His picture is a game between the presence and non-presence of the Chancellor; at the same time it ironically refers to the dramatically staged image of her political "father", Kohl.[47]

44 For a critical account of the absence of regulations, see Benedikt Mahler, "Wenn es eiert, ist es roh," Sunday supplement of the *Frankfurter Allgemeine*, July 22, 2018, 43.

45 Herlinde Koelbl, *Spuren der Macht: Die Verwandlung des Menschen durch das Amt* (Munich: Knesebeck, 2010), 39–61. Over an extended period, Koelbl photographed and interviewed well-known German personalities (politicians, businessmen, etc.).

46 Andreas Mühe (born in 1979 in the GDR) has repeatedly photographed Angela Merkel. However, he refuses to be called a "Chancellor photographer". https://de.wikipedia.org/wiki/Andreas_Mühe. For a reproduction of the photograph, see: https://magazin.spiegel.de/EpubDelivery/spiegel/pdf/87818628 (109–10).

47 Manja Wilkens, "Muss man als Bundeskanzlerin schön sein: Selbstinszenierung und Fremdwahrnehmung von Angela Merkel," in *Der schöne Mensch und seine Bilder*, eds. Sandra Abend and Hans Körner (Munich: Morisel, 2017), 146–7. An article in *Der Spiegel*, May 13, 2017, 121ff, published after this essay was printed, reveals that Merkel was irritated by this photo. There is no doubt that Mühe's depiction is a convincing rendering of her personality. For a reproduction of Helmut Newton's photograph of Kohl see: http://rem-bond.livejournal.com/13435.html)

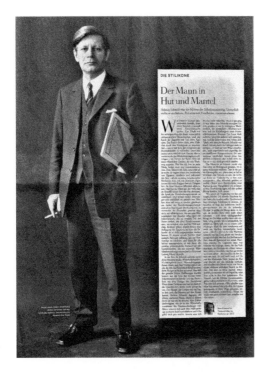

Figure 12.1 Helmut Schmidt, 1970. From: Peter Kümmel, "Die Stilikone. Der Mann in Hut und Mantel", *Die Zeit*, November 12, 2016. (Photo: Charles Wilp).

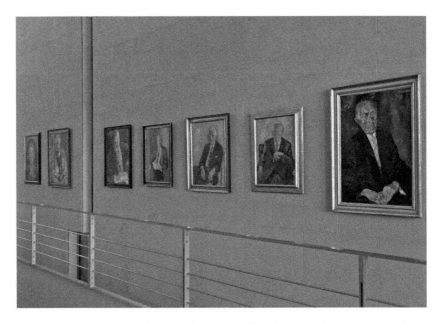

Figure 12.2 The *Galerie der deutschen Bundeskanzler* in the German Chancellery, Berlin, 2009. (Photo: Julian Herzog. https://de.wikipedia.org/wiki/Datei:Bundeskanzleramt_Be rlin_Kanzlergalerie.png).

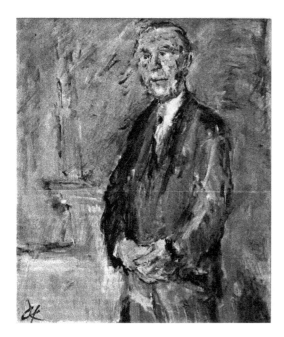

Figure 12.3 Oskar Kokoschka, portrait of Konrad Adenauer, 1966. The Chancellery, Berlin. (From: Stefan Koldehoff, "Das erste Bild im Staate", *Süddeutsche Zeitung*, January 28–29, 2006. Photo: VG Bild-Kunst, Bonn, 2006).

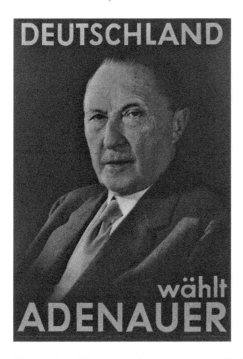

Figure 12.4 "Germany chooses Adenauer". CDU election poster featuring Konrad Adenauer, federal election, 1953. Archiv für Christlich-Demokratische Politik (ACDP), license: KAS/ACDP 10-001: 427 CC-BY-SA 3.0 DE. (Photo: Peter Bouserath).

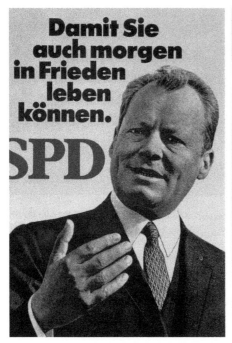
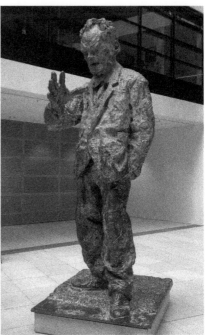

Figure 12.5 (Left) "So that you can live in peace tomorrow". SPD poster featuring Willy Brandt, federal election, 1969. From: *Katalog der Ausstellung: Bilder und Macht im 20. Jahrhundert* (Bonn: Haus der Geschichte 2004), 118. (Photo: Charles Wilp). (Right) Reiner Fetting, statue of Willy Brandt, 1996. National headquarters of the SPD, Berlin. (Author's photograph).

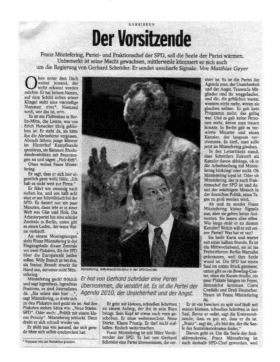

Figure 12.6 Franz Müntefering, federal president of the SPD, in front of Rainer Fetting's sculpture. From: Matthias Geyer, "Der Vorsitzende", *Der Spiegel*, May 24, 2004. (Photo: Action Press).

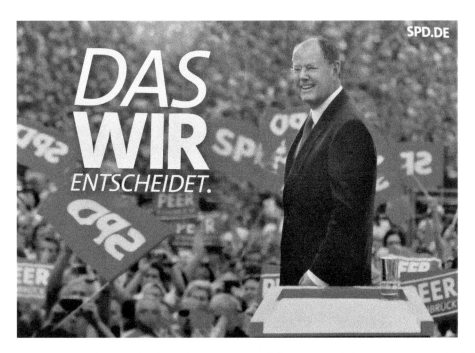

Figure 12.7 "The WE decide". Election poster of the SPD candidate Peer Steinbrück, federal election, 2013.

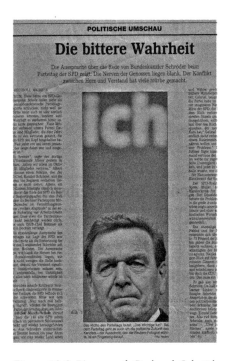

Figure 12.8 Picture of Gerhard Schröder. From: Reinhold Michels, "Die bittere Wahrheit", *Rheinische Post*, November 18, 2003. (Photo: Reuters).

Bibliography

Appel, Reinhard, ed. *Helmut Kohl im Spiegel seiner Macht*. Bonn: Bouvier, 1990.

Birkner, Thomas, ed. *Medienkanzler. Politische Kommunikation in der Kanzlerdemokratie*. Wiesbaden: Springer, 2016.

Bredekamp, Horst. "Politische Ikonologie des Grundgesetzes." In *Herzkammern der Republik. Die Deutschen und das Bundesverfassungsgericht*, edited by Michael Stolleis, 9–35. Munich: Beck, 2011.

Bredekamp, Horst. "Jörg Immendorf and the Anti-Pathos of the Chancellor Portrait." In *Inventing Faces: Rhetorics of Portraiture Between Renaissance and Modernism*, edited by Mona Korte et al., 190–207. Berlin: Deutscher Kunstverlag, 2014.

Deecke, Thomas. "Vom krachledernen Vorsitzenden zur schönen Rut. ProminentenPorträts in der Bundesrepublik seit 1945." *Das Kunstjahrbuch* (New Series, 1975 / 1976): 117–22.

Diehl, Paula. *Körper im Nationalsozialismus: Bilder und Praxen*. Munich: Paderborn, 2006.

Diehl, Paula Diehl, and Gertrud Koch, eds. *Inszenierungen der Politik. Der Körper als Medium*. Munich: Fink, 2007.

Diers, Michael. *Schlagbilder. Zur politischen Ikonographie der Gegenwart*. Frankfurt: Fischer, 1997.

Fleckner, Uwe, Martin Warnke, and Hendrik Ziegler, eds. *Handbuch der politischen Ikonographie*, 2 vols. Munich: Beck, 2011.

Hofmann, Viola. *Das Kostüm der Macht: Das Erscheinungsbild von Politikern und Politikerinnen von 1949 bis 2013 im Magazin Der Spiegel*. Berlin: Ebersbach, 2014.

Holtz-Bacha, Christina, ed. *Frauen, Politik und Medien*. Wiesbaden: Verlag für Sozialwissenschaft, 2008.

Hoppe, Günther, ed. *Das Porträt. Vom Kaiserbild zum Wahlplakat. Eine Ausstellung des kunstpädagogischen Zentrums im Germanischen National Museum*. Nuremberg: Germanisches Nationalmuseum, 1977.

Jung, Thomas. "Lafontaine / Weiße Frau: Zur, Exegese' einer öffentlichen Figur." In *'Wirklichkeit' im Deutungsprozeß: Verstehen und Methoden in den Kultur- und Sozialwissenschaften*, edited by Thomas Jung and Stefan Müller-Dohm, 379–408. Frankfurt: Suhrkamp, 1993.

Koch, Thomas. "Immer nur die Frisur? Angela Merkel in dem Medien." In *Warum nicht gleich? Wie die Medien mit Frauen in der Politik umgehen*, edited by Christina Holtz-Bacha and Nina König-Reiling, 146–66. Wiesbaden: VS Verlag für Sozialwissenschaffen/GW Fachverlages, 2007.

Koelbl, Herlinde. *Spuren der Macht. Die Verwandlung des Menschen durch das Amt: Eine Langzeitstudie*. Munich: Knesebeck, 2002.

Leggewie, Claus. "Fischer syne Frau und des Kanzlers neue Kleider: Inszenierungen des Politischen – Politik als Theater?" In *Erinnern, Agieren und Inszenieren. Enactements und szenische Darstellungen im therapeutischen Prozeß*, edited by Ulrich Streeck, 222–45. Göttingen: Vandenhoeck und Ruprecht, 2000.

Leinemann, Jürgen. *Höhenrausch. Die wirklichkeitsleere Welt der Politiker*. Göttingen-Munich: Blessing, 2004.

Macho, Thomas. "Das prominente Gesicht: Vom face-to-face zum Interface." In *Alle möglichen Welten: Virtuelle Realität – Wahrnehmung – Ethik der Kommunikation*, edited by Manfred Faßler, 121–35. Munich: Fink, 1999.

Marx Ferree, Myra. "Angela Merkel: What does it Mean to Run as a Woman?" *German Politics and Society* 24, 1 (2006): 93–107.

Munkel, Daniela. *Willy Brandt und die 'Vierte Gewalt'. Politik und Massenmedien in den 50er bis 70er Jahren*. Frankfurt: Campus, 2005.

Plum, Angelika. "Die Karikatur im Spannungsfeld von Kunstgeschichte und Politikwissenschaft: Eine ikonologische Untersuchung zu Feindbildern in Karikaturen." Doctoral thesis, Aachen: Shaker, 1998.

Pörksen, Uwe. *Weltmarkt der Bilder: Eine Philosophie der Visiotype*. Stuttgart: Klett Cotta, 1997.

Ronge, Tobias. *Das Bild des Herrschers in Malerei und Grafik des Nationalsozialismus*. Berlin: Lit, 2010.

Rosumek, Lars. *Die Kanzler und die Medien: Acht Porträts von Adenauer bis Merkel*. Frankfurt: Campus, 2007.

Scheurle, Christoph. *Die deutschen Kanzler im Fernsehen*. Bielefeld: Transcript, 2015.

Schmölders, Claudia. *Hitler's Face: The Biography of an Image*. Philadelphia: University of Pennsylvania Press, 2006.

Soeffner, Hans-Georg. "Geborgtes Charisma – Populistische Inszenierungen." In *Die Ordnung der Rituale: Die Auslegung des Alltags*, edited by Hans-Georg Soeffner, 177–202. Frankfurt: Suhrkamp, 1992.

Ulrich, Wolfang, ed. *Macht zeigen: Kunst als Herrschaftsstrategie*. Berlin: Deutsches Historisches Museum, 2010.

13 From Reticence to Excess

Political Portraiture in Italy, from the Fall of Fascism to the Present

Luciano Cheles

A Disincarnate Electoral Propaganda

After twenty years of fascism, in June 1946 Italians were able to vote for the Constituent Assembly, an election that was made to coincide with the referendum for or against the monarchy. Party leaders were little known: newspapers had small readerships and television had not yet come into existence. Posters featuring their effigies would have been the obvious way of introducing them to the public. Yet politicians totally eschewed this form of publicity: they did so to distance themselves from an approach that might evoke the propaganda of fascism, which was centered on the cult of Mussolini's charismatic leadership.[1] In 1946 the only personality who was featured on a poster was the king, Umberto II (Victor Emmanuel III had abdicated shortly before the election and referendum in an attempt to save the monarchy, which had been sullied by its association with fascism) (Figure 13.1). The unusual manner in which the king is portrayed deserves some comments. He does not stand alone, formally attired and posing hieratically, following a well-established royal iconography: he is shown wearing an ordinary suit, in a relaxed attitude, together with his wife and four children. Though his head tops the pyramid that structures the family group, he appears discreetly at the back. In every sense of the phrase, he keeps a low profile. The composition is in fact dominated by the queen, Marie José, shown, most unwontedly, sitting on the ground (a posture suggesting humility), and by her children, one of whom – six-year-old Maria Gabriella – holds a teddy bear. This picture of the royal household avoids solemnity to appear like an ordinary family snapshot. The portraits of politicians were equally absent from the campaign for the general election of April 1948, which virulently opposed Alcide de Gasperi, the leader of the Christian-Democrat Party (Democrazia Cristiana, DC), and Palmiro Togliatti, the General Secretary of the Communist Party (Partito Comunista Italiano, PCI).[2] The

1 Mussolini's portraits were ubiquitous and featured on a wide variety of media and expressive forms (posters, bill-boards, paintings, statues, mosaics, postcards, school books …). See Giorgio Di Genova, '*L'uomo della Provvidenza': iconografia del Duce, 1923–1945* (Bologna: Bora, 1997); Enrico Sturani, *Le cartoline per il Duce* (Turin: Edizioni del Capricorno, 2003); and Alessandra Antola Swan's essay "Manufacturing Charisma" in this collection.

2 On the propaganda for the elections of the early post-war period, see Pier Luigi Ballini, ed., *1946–1948. Repubblica, Costituente, Costituzione* (Florence: Polistampa, 1998), 124–79; Filadelfo Ferri ed., *1948 e dintorni. Manifesti politici. Immagini e simboli dell'Italia repubblicana* (Varese: Insubria University Press, 2008); Edoardo Novelli, *Le elezioni del quarantotto. Storia, strategie e immagini della prima campagna elettorale repubblicana* (Rome: Donzelli, 2008).

only figures that were featured on election posters were those representing categories of people: the partisan, the war widow, the peasant, the factory worker, the civil servant, children (symbols of the future generations), etc.

The Communists had an additional reason for rejecting a personality-centered propaganda: their idea of leadership was a figure capable of embodying collective values, rather than one with supernatural qualities that could sort out the country's problems, a "man sent by Providence", to echo the expression used by Pope Pius XI to refer to the *Duce* in 1929. However, Togliatti became the object of a real cult within his party after an attempt on his life by the right-wing activist Antonio Pallante, on July 14, 1948.[3]

The cult of Togliatti found expression in a number of celebratory posters. One of the most interesting, because of its complexity and subtlety, is the one that was issued to announce the leader's official return to active politics after his convalescence, which was to take place at a party rally held at the *Foro Italico* stadium in Rome (formerly *Foro Mussolini*) on September 26, 1948 (Figure 13.2). The event was made to coincide with the inauguration of the national *Festa dell'Unità*, the PCI's annual popular event providing cultural, musical, gastronomic and folkloric attractions. Togliatti is shown sitting at his desk lighting his pipe, with *l'Unità*, the party organ, before him. Although the portrait has an ordinary feel, it has been carefully staged. The leader's resumption of his political battles is only its most basic level of meaning. Togliatti has been photographed using two Soviet portraits as models. The first is a picture of Lenin reading the official Communist newspaper *Pravda* in his study, taken on October 16, 1918 (the eve of the first anniversary of the Revolution) by Pyotr Otsup, the Kremlin's official photographer (Figure 8.1). The second picture is a portrait of Stalin intent on lighting his pipe, taken in the 1930s by the celebrated photographer Max Alpert[4] (Figure 13.3). Both images were iconic: they were reproduced on different supports (postcards, posters, stamps, etc.) in the Soviet Union and countries of the Eastern Bloc. Several photographs, paintings and drawings depicting Stalin in his private study or at meetings attest that the Lenin picture was prominently displayed.[5] The communist parties of the Western world took care to disseminate the two photographs among their activists.[6] The Togliatti poster's concealed allusions to Lenin

3 Carlo Maria Lomartire, *Insurrezione. 14 luglio 1948: l'attentato a Togliatti e la tentazione rivoluzionaria* (Milan: Oscar Mondadori, 2007); Mario Avagliano and Marco Palmieri, *1948. Gli italiani nell'anno della svolta* (Bologna: Il Mulino, 2018), 299–347.

4 For an account of Lenin's and Stalin's portraits, see Graeme Gill's chapter "The Face of the Regime. Political Portraiture in the Soviet Union and Russia," 129–35 in this volume. On Otsup and Alpert: Sergei Morozov and Valerie Lloyd, eds., *Soviet Photography, 1917–40: the New Photojournalism* (London: Orbis, 1984), 16–27 and 124–35, respectively.

5 See, for instance, the front pages of the issues of the *Pravda* dated May 1 and June 27, 1945, November 7, 1948, and December 21, 1949.

6 The picture of Lenin in his study was published as a postcard in Italy: Marco Gervasoni, *La cartolina politica* (Milan: M&B Publishing, 2004), 194. The photograph of Stalin lighting his pipe was reproduced, for instance, in the French Communist Party annual *Almanach ouvrier et paysan: almanach de l'Humanité* (Paris: Bureau d'éditions, 1948), 98. For a detailed account of the visual fortunes of these two images, in the Soviet Union and elsewhere, see Luciano Cheles, "The Faces of Militancy. Palmiro Togliatti's Propaganda Portraits (1948–1964)," in *Words of Power, the Power of Words. The Twentieth-Century Communist Discourse in an International Perspective*, ed. Giulia Bassi (Trieste: Edizioni Università di Trieste, 2019), 115–55.

and Stalin, which some militants may have perceived, allowed the PCI to celebrate the Soviet leaders while avoiding accusations that the party was anti-Italian and anti-patriotic. It should also be noted that it would have been considered ill-appropriate to represent Togliatti together with Lenin and Stalin overtly, so great was the awe that the Soviet leaders inspired in Italian Communists. By associating Togliatti with his (albeit invisible) luminaries, the poster followed the traditional Soviet iconography that represented Marx, Engels, Lenin and Stalin in a sequence to suggest ideological continuity.[7]

The PCI subsequently produced other propaganda material bearing Togliatti's effigy. For instance, a poster featuring him with Antonio Gramsci, the co-founder and first General Secretary of the party, was issued in 1951 to commemorate the thirtieth anniversary of its foundation; another was printed in 1953 to celebrate Togliatti's sixtieth birthday. Postcards were also realized to mark these occasions, as well in response to tragic events: one issued in 1950 represents Togliatti giving a speech at the funeral of the Modena workers killed by the police during a demonstration in January that year. The posters were mostly intended for display in party branches and during communist rallies, and served to mobilize the supporters. The postcards were sold, and thus also fulfilled a fund-raising function.

Early Electoral Portraits

De Gasperi and Togliatti made a timid appearance on electoral propaganda for the first time in 1953. The posters that were designed to promote the two leaders are worth commenting on and comparing. The DC leader was represented with a grave and serious expression; the accompanying slogan stated "Senza forche, senza dittatura, quest'uomo semplice e grande ha salvato l'Italia" (Without gallows, without tyranny, this man both great and unassuming has saved Italy"). The emphasis on his modesty and reference to his alleged successes in re-starting the economy after the devastations of the war without resorting to violence and coercion were a reference to the regimes of the Eastern Bloc.[8] Togliatti's poster was devoid of aesthetic concessions. The image, which represented the leader smiling affably, looked like a casually taken photograph. It was complemented by an extended textual element with a strong political content, calling for peace and social reforms, and to an end to the Cold War and the rule of the clerical party. The approach was diametrically opposed to the graphic propaganda of fascism with its reliance on vacuous, high-sounding slogans and dramatic representations of the *Duce* with hard, sulking expressions.[9]

7 For numerous examples, see Anita Elizabeth Pisch, *The Personality Cult of Stalin in Soviet Posters, 1929–1953. Archetypes, Inventions and Fabrications* (Camberra: Australian National University Press, 2016).

8 The pro-government *Settimana Incom* newsreels and official documentaries also stressed De Gasperi's "ordinariness" and affability. On these films, see Augusto Sainati, ed., *La Settimana Incom. Cinegiornali e informazione negli anni '50* (Turin: Lindau, 2001); Maria Adelaide Frabotta, "Government Propaganda: Official Newsreels and Documentaries in the 1950s," in *The Art of Persuasion. Political Communication in Italy from 1945 to the 1990s*, eds. Luciano Cheles and Lucio Sponza (Manchester: Manchester University Press, 2001), 49–61.

9 Togliatti's and De Gasperi's 1953 portraits are analyzed in detail and illustrated in Cheles, "The Faces of Militancy," 140–3, figs. 36 and 39.

The parties' strong disinclination to depict their leaders, which lasted until the early 1980s, was not due exclusively to what has been termed *complesso del dittatore* (dictator's complex), namely the fear of evoking the ghost of Mussolini. It can also be explained by the presence on the political scene of numerous parties, and of factions within some of these parties (especially the DC, the largest party): the need to form electoral alliances discouraged the promotion of individual personalities since an imbalance in the way the various leaders of the center/center-right were depicted could have had serious repercussions on the formation of coalition governments.[10] Of course satirical representations of leaders always abounded in the propaganda of their opponents: before television broadcasting began in 1954 Italians were more likely to become acquainted with their politicians' appearance through these than through their official depictions.

Some categories of portraits, however, eluded the parties' self-imposed rule concerning the depiction of their political personalities on printed propaganda.

The first concerned the posters advertising the parties' political broadcasts. These programs, which bore the name of *Tribuna Politica*, were a considerable novelty when they were started in 1960. For the first time the television network RAI, which broadcast on a monopoly basis and was government-controlled, was allowing the leaders of all parties represented in parliament to address themselves to Italians directly. This especially benefited the oppositions, which had hitherto been deprived of any television visibility.[11] To draw attention to their leaders' interventions, parties made use of their portraits. Such posters followed a recurrent pattern: the politicians of various political tendencies were shown at half-bust, in spontaneous postures, framed by a stylized television screen or placed beside it, as if to stress that their function was not celebrative, but merely informative.[12]

Another genre is that of the posters honoring a newly elected President of the Republic, which were produced by his party of origin. The prestige enjoyed by the function and the political impartiality it presupposes (hence the absence of the party logo and the use of the tricolor, suggesting that he was the President of all Italians) legitimized the depiction of his effigy.[13]

The revered figures from a distant and recent past also featured frequently on printed propaganda. The image of the Risorgimento hero Giuseppe Garibaldi dominated the election of 1948: it was adopted as symbol by the Fronte Democratico Popolare, the Socialist-Communist alliance, and also used by other parties to claim that the left had misappropriated a personality who would not have

10 Tullio De Mauro, preface to Roger Gérard Schwartzenberg, *Lo stato spettacolo. Carter, Breznev, Giscard d'Estaign: attori e pubblico nel gran teatro della politica mondiale* (Rome: Editori Riuniti, 1980), vii-xvii; Gianfranco Pasquino, "Alto sgradimento: la comunicazione politica dei partiti," *Problemi dell'informazione*, 13, (1988): 487–9.

11 Edoardo Novelli, *Dalla TV di partito al partito della TV. Televisione e politica in Italia, 1960–1995* (Florence: La Nuova Italia, 1995).

12 For some examples, see Luciano Cheles, "Prima di Berlusconi. Il ritratto politico nell'Italia repubblicana (1946–1994)," in *Il ritratto e il potere. Immagini della politica in Francia e in Italia*, eds. Luciano Cheles and Alessandro Giacone (Pisa: Pacini, 2017), 104, figs. 4–6.

13 Ibid., 105, figs. 7–9.

supported its policies.[14] Giacomo Matteotti (1885–1924), the Socialist Member of Parliament murdered by fascists, was recurrently represented on his party's post-ers after the war. Such leading figures as Don Luigi Sturzo (1871–1959), the co-founder of the Partito Popolare Italiano, whose heir the DC was, De Gasperi, Togliatti and Aldo Moro, the Christian-Democrat leader murdered by the Red Brigades in 1978, featured on the posters commemorating them. It was obviously assumed that the veneration of a leader via his portrait did not carry any conno-tations of personality cult if paid posthumously. Their photographs were always chosen with considerable care to evoke specific characteristics of their personality or biography emblematically: Matteotti always appeared with a sad expression and eyes turned upwards following the iconography of the Christian martyr; the image of De Gasperi that was recurrently reproduced was one which depicted him with his face flooded by light[15] – a probable allusion to his piousness.[16] A poster issued by the DC just after Moro's death shows him with his head tilted down-wards and eyes half-closed, an image that attributed to him Christ-like overtones to evoke his "martyrdom".[17]

Lastly, mention must be made of the mini-cards bearing the effigy of candidates standing at national and local elections that were handed out during their campaigns by activists. Their diminutive format rendered them acceptable. This form of publicity, still popular today, was also legitimized by the Catholic Church's genre of the small, printed images depicting a religious figure together with a prayer or an invocation, which are distributed to the faithful. It is no accident that, like these, the political mini-cards are generally referred to as *santini* (holy pictures).

Political Personalization in the 1980s

Political portraits as a form of campaigning began to be more current in the early 1980s. The growth of this genre is tied to the phenomenon of the personalization of politics. Traditionally, the Italian political system was party-centered: parties repre-sented ideologies (the Catholic, Communist, etc.) and the subcultures in which they were rooted. The new emphasis on the leaders' personalities, which resulted in their depiction on posters and other printed materials, followed a trend established else-where in Europe. The "launch" of Margaret Thatcher in Britain in 1979 and François Mitterrand's presidential campaign in France in 1981, both of which were master-minded by marketing professionals (Saatchi & Saatchi in the first case and Jacques Séguéla in the second), acted as examples. The rise of private television networks also

14 See Ferri ed., *1948 e dintorni* and Novelli, *Le elezioni del quarantotto* for several examples. On the posthumous cult of Garibaldi: Omar Calabrese, *Garibaldi: tra Ivanohe e Sandokan* (Milan: Electa, 1982); and Silvia Barisione, Matteo Fochessati and Gianni Franzone ed, *Garibaldi, il mito. Manifesti e propaganda* (Florence: Giunti, 2007).

15 On the tendency to re-use the same portraits to celebrate political figures, see Luciano Cheles, "Iconic Images in Propaganda," *Modern Italy* 21 (2016): 460, 462–3 (figs. 15–20).

16 Light is a traditional symbol of spirituality. See Helene E. Roberts, ed., *Encyclopedia of Comparative Iconography: Themes Depicted in Works of Art* (Chicago: Fitzroy Dearborn, 1998), vol. 1, 504–12.

17 The poster is reproduced on the cover of the volume by Carlo Dané, ed., *Parole e immagini della Democrazia Cristiana in quarant'anni di manifesti della SPES* (Rome: Broadcasting and background, 1985).

contributed to the new propaganda approach. Unlike RAI, which strictly regulated its coverage of election campaigning, they enjoyed considerable freedom: politicians were often invited to their programmes to discuss issues in plain language. Because such programmes were frequently light-hearted shows, politicians often relied on gimmicks to appeal to their audiences. This gave rise to a spectacularization of politics that was to have an impact on the way candidates presented themselves on their publicity.[18]

The first general election to have been dominated by a candidate-oriented approach is that of 1983. The Socialist leader Bettino Craxi, who aspired to relaunch his party as a left-wing alternative to the PCI, led the way by having himself promoted like a star. He featured in numerous posters and leaflets in close-up, smiling broadly and wearing an open shirt – features that suggested approachability, informality and optimism (Figure 13.4). Indeed the slogan of the campaign was "Ottimismo della volontà" (Optimism of the will), which partially echoed Antonio Gramsci's famous quote "Pessimism of the intellect, optimism of the will". This extroverted and nonchalant style of presentation was inspired by American presidential campaigns. It should be pointed out that the beam, which is a standard element of American political portraiture, had hitherto been avoided by Italian politicians out of fear that it would confirm the general perception that they were a bunch of overpaid and corrupt profiteers. The Christian-Democrat leader, Ciriaco De Mita, and the leader of the small Republican Party (Partito Repubblicano Italiano, PRI), Giorgio La Malfa, followed suit and had themselves represented smiling on party literature.

The "dictator's complex" was never an issue for the neo-fascist Movimento Sociale Italiano, MSI, given its strong belief in charismatic leadership. Giorgio Almirante (1914–1988), who led the party he co-founded from 1946 to 1950, and again from 1979 to 1987, had another reason for being venerated by his adherents: he had known Mussolini personally, having been a Ministerial Private Secretary in the *Ministero della Cultura popolare*, or propaganda ministry, of the *Repubblica Sociale Italiana*, the German-supported puppet state established in central and northern Italy in September 1943, which ended with the surrender of the Nazi troops in May 1945. His posters and other types of party literature frequently represented him before a crowd of supporters (Figure 13.5) in order to evoke one of the canonical images of fascism: that of the *Duce* addressing a *folla oceanica* (sea of faces) – to use an expression dear to the state-controlled press, radio and newsreels – from the balcony of Palazzo Venezia, his headquarters and private residence in Rome.[19] So strong are the fascist connotations of this iconography that until Silvio Berlusconi entered politics

18 Gianni Statera, *La politica spettacolo. Politici e mass media nell'era dell'immagine* (Milan: Mondadori, 1986); Gianpiero Mazzoleni, "Emergence of the Candidate and Political Marketing. Television and Election Campaigns in Italy in the 1980s," *Political Communication and Persuasion* 8 (1991): 201–12; Filippo Ceccarelli, *Il teatrone della politica* (Milan: Longanesi, 2003).

19 On Almirante, see these partisan publications: Aldo Di Lello, *Almirante. Una storia per immagini* (Rome: Pantheon, 2008); and Gigi Montonato, *Almirante. L'Italiano d'Italia* (Massa: Eclettica, 2014), whose cover depicts the leader addressing his supporters. On Mussolini's ritual of speaking to cheering crowds and its iconography, see George L. Mosse, "Public Festivals: the Theatre and Mass Movements," in idem, *The Nationalization of the Masses* (New York: Howard Fertig, 1975), 109–10; Jeffrey T. Schnapp, "Mob Porn," in Jeffrey T. Schnapp and Matthew Tiews, *Crowds* (Stanford, CA: Stanford University Press, 2006), 1–45.

in 1994 Italian leaders never allowed themselves to be so depicted in their propaganda material.

Not all parties were affected by the phenomenon of personalization in the early 1980s. The PCI eschewed the practice, as did the small far-left movements. In the case of the PCI, the reasons were not exclusively ideological: Enrico Berlinguer, who led the party from 1972 to 1984, would have been loath to see his effigy plastered on walls, given his reserved character. Indeed such was his restraint that he was at times accused of pursuing a cult of *im*personality. His portrait was reproduced on posters only after his death, to commemorate him. The PCI succumbed to a practice that had become widespread for the first time in 1988: the effigy of its newly-elected General Secretary, Achille Occhetto, featured in full color on posters that advertised his party rallies. This turning point, which did not escape the attention of the left-wing press,[20] probably reflected the PCI's wish to abandon its *diversità antropologica* (anthropological difference), the projection of a "moral superiority" which so enraged its political opponents. It was probably also intended to boost the public image of a figure whom many perceived as lackluster.

The 1990s: *Mani pulite*, Berlusconi, Prodi

The portrait-centered approach to propaganda became more established in the campaign for the general election of 1992. On this occasion, for the first time, ordinary candidates were also portrayed on the posters. A change in the electoral system accounted for such a novelty. Multi-preference voting, which had lent itself to corrupt practices, was abolished by a referendum held on June 9, 1991, and was replaced with a system by which voters chose only one name from a ballot slip.[21] The intense competition among candidates led to striking images being produced in order to catch the public's eye. If politicians had tended to be represented in a fairly standardized way – at half-bust, set against a plain background – their style of presentation suddenly became quite diverse and elaborate: poses, gestures, garments, props and distinctive backgrounds were frequently used to refer to the professional status of the candidates, or to their alleged qualities and achievements.

The trend toward personalization was strengthened further in the campaign for the election of 1994, the first that took place after the judicial investigation into the corrupt practices of politicians known as *Operazione Mani pulite* (Operation Clean Hands), which had begun in 1992. The general disenchantment with politics and the demise of the parties that were most affected by the scandals (the DC, the PSI and the PRI) led the public to place greater emphasis on the would-be qualities of candidates, rather than on their ideological affiliations. Silvio Berlusconi (b. 1936), a wealthy entrepreneur whose empire ranged from television networks specializing in American sit-coms and shows with half-naked dancers, to publishing, banking, insurance, advertising and cinema, made his foray into politics with a newly-founded

20 See for instance Guido Moltedo, "Occhetto a Firenze," *Il Manifesto*, September 17, 1988.
21 On this referendum, see Patrick McCarthy, "The referendum of 9 June," in *Italian Politics. A Review*, eds. Stephen Hellman and Gianfranco Pasquino (London: Pinter, 1992), 11–28.

party, Forza Italia (Come On, Italy), and successfully contested the election in coalition with Alleanza Nazionale, AN (National Alliance), a political grouping open to the center launched by Gianfranco Fini, Almirante's heir to the leadership of the MSI, and with Umberto Bossi's devolutionalist Lega Nord (Northern League). Berlusconi's campaign, slick and professional, was spectacular and unabashedly centered on himself. Never before since fascism had political propaganda in its various forms been so totally dominated by the presence of a single person.[22] Berlusconi's main election poster set an approach that has remained fairly constant throughout his political career. It depicted him at half length, greatly rejuvenated (a special camera lens smoothed out his wrinkles), with his hair magically restored on his balding head, and smiling broadly (Figure 13.6). The self-confident smile alluded to his success as a businessman, but also acted as a reminder that he was the provider of scintillating TV entertainment. The portrait spelt *joie de vivre* and the promise of spectacular expansion. This buoyant image was endorsed by the slogan "Per un nuovo miracolo italiano" (For a new Italian miracle), which alluded to the strong economic growth of the 1950s and early 1960s. The campaign was visually coordinated: the image of the chief was used as a model for those of all the Forza Italia candidates (though their fainter smile established a hierarchical difference with him).

Berlusconi's poster produced for the European election that was to take place a few weeks later is even more ostentatious (Figure 13.7). The leader was represented set against a blue sky, with several microphones before him to allude to the huge media attention that his sudden rise to political stardom had attracted worldwide. The crown of stars (the symbol of the European Union) encloses the Forza Italia logo and brushes Berlusconi's head to represent his success in terms of an apotheosis.[23]

The propaganda of the Progressisti, the center-left alliance whose principal component was the Partito Democratico della Sinistra, PDS (Democratic Party of the Left), the party that evolved from the PCI, was insignificant in comparison with that of Berlusconi. Occhetto, who led the coalition, featured timidly on his campaign poster: he was portrayed in black and white, with two unidentifiable figures in the background, to suggest that the photograph was a casually taken snapshot. It was the first time since the 1953 that a party to the left of the PSI used his effigy on an election poster. This unemphatic approach in the representation of leadership has since become almost standard in the campaigns of the Left. Leaders like to be represented together with other people, who may be the members of the team they intend to work with if

22 On Berlusconi, see James Newell, *Silvio Berlusconi: A Study in Failure* (Manchester: Manchester University Press, 2019). On his political launch: Antonio Gibelli, *26 Gennaio 1994* (Bari-Rome: Laterza, 2018). On his visual propaganda: Luciano Cheles, "From Ubiquitous Presence to Significant Elusiveness: Berlusconi's Portraits, 1994–2005," *Journal of Contemporary European Studies* 14 (2006): 41–67; and Antonio Palmieri et al., *Come Berlusconi ha cambiato le campagne elettorali in Italia*, Preface by Silvio Berlusconi (Milan: Faber, 2012), of interest for its numerous color reproductions of the party's graphic output. On Berlusconi's carefully constructed public image in general: Federico Boni, *Il superleader. Fenomenologia mediatica di Silvio Berlusconi* (Rome: Meltemi, 2008); and Marco Belpoliti, *Il corpo del capo* (Parma, Italy: Guanda, 2009).

23 On the iconography of apotheosis, see Franz Matsche, "Apotheose," in *Handbuch der politischen Ikonographie*, eds. Uwe Fleckner, Martin Warnke and Hendrick Ziegler (Munich: Beck, 2011), vol. 1, 208–15.

they are elected, or figures representing specific categories (pensioners, women, students...) (Figure 13.8).

Berlusconi's 1994 government was short-lived: it collapsed in December of that year following the withdrawal from his coalition of the Lega Nord, and was succeeded by a caretaker government of technocrats headed by Lamberto Dini. When a new election was announced for April 21, 1996, the center-left coalition, l'Ulivo (the Olive Tree), which was led by the distinguished economist Romano Prodi, took the personalization of politics more seriously and featured him prominently on its posters and brochures. Prodi might have been depicted in his professorial study at the University of Bologna to impress voters. He was portrayed instead in close-up – a shot that emphasized his much-satirized "podgy face", the squint beneath the thick, old-styled glasses, his greying hair and five-o'clock shadow (Figure 13.9). His campaigners appear to have closely followed the advice Prodi received from the circle of semiologists of the Department of Communication of the University led by Umberto Eco: instead of being groomed and rejuvenated like Berlusconi, he was to exploit his physical imperfections to his advantage, to suggest ordinariness and authenticity.[24] This strategy may have played some part in Prodi's election victory.

The New Century: Berlusconi (again), "Post-Fascism", the Lega

Berlusconi's subsequent campaigns too have been monopolized by his image. In 2001, emboldened by the polls which indicated that a clear victory was at hand, he promoted himself through an extensive series of posters and giant billboards: his half-length portrait set against a blue sky was complemented by peremptory slogans, sufficiently vague to appeal to everyone, such as: "Un impegno preciso: città più sicure" (A clear pledge: safer cities); "Un impegno concreto: meno tasse per tutti" (A concrete pledge: lower taxes for everyone"); and "Un impegno concreto: un buon lavoro anche per te" (A concrete pledge: a good job for you too). If in 1994 Berlusconi's campaigning portrait acted as a model to those of the other candidates of his party, in 2001 the leader decreed that his effigy should be reproduced on all printed propaganda, with only the name of the prospective Members of Parliament accompanying it.[25] Images of Berlusconi – hundreds of them – also featured on the 132-page magazine-format color brochure *Una storia italiana*, which was printed in twelve million copies and sent to all households a few weeks before the election. The document illustrated in triumphal terms his career through photographs that depicted him alone, with his family and with leading personalities (Bill Clinton, Mikhail Gorbachev, Tony Blair, Pope John Paul II ...).[26]

24 Renzo Di Rienzo, "Vado in diretta, faccio una cassetta ... ," *L'Espresso*, February 17, 1995, 49–50; M.S. [sic], "Caro Prodi, non imitare Occhetto," *La Repubblica*, February 12, 1995, 7. See also the handbook his coalition produced for distribution to its campaigners: Omar Calabrese et al., *Orientamenti di comunicazione politica* (Bologna: Grafiche Damiani, 1996).

25 On the propaganda of this election, see Umberto Eco, "The 2001 Electoral Campaign and Veteran Communist Strategy," in idem *Turning Back the Clock. Hot Wars and Media Populism* (Orlando, FL: Harcourt, 2008), 121–7.

26 On this brochure, see William V. Harris "Letter from Rome," *The Times Literary Supplement*, June 8, 2001, 15; Alessandro Amadori, *Mi consenta. Metafore, messaggi e simboli. Come Silvio Berlusconi ha conquistato il consenso degli italiani* (Milan: Scheiwiller, 2002). A similarly produced, 162-page

The center-left coalition, led by the former mayor of Rome Francesco Rutelli, was unable to respond adequately to such an all-pervasive and self-centered campaign. The most effective vehicle of opposition proved to be derision. Many of Berlusconi's posters were daubed with satirical comments. A left-wing activist, Mark Bernardini, launched an Internet-based guerrilla warfare by creating a website to which the general public was invited to contribute with parodies of Forza Italia's imagery, and soon thousands of anonymous satirical photomontages became viral. One, for instance, made fun of the maxi-billboard that solemnly promised that cities would be safer if Berlusconi were elected by superimposing the bars of the prison on his original portrait. Another represented him as the Pope and carried the slogan "Un impegno concreto: diventare papa (e poi santo)" (A concrete pledge: to become Pope [then a saint]), to ridicule his limitless ambitions (Figure 13.10). Berlusconi must have been concerned by this form of counter-propaganda for he attempted to dismiss it through self-mockery: he launched a competition with prizes offered for the most amusing parodies, and included some of them in his website.[27]

It has already been mentioned that the portrait of Berlusconi's first election campaign was heavily retouched to rejuvenate him. His narcissism – the leader's hair transplants, face-lifts, dental improvements and heavy make-up are well known – also led him to re-use the same photographs years later, as if, like Oscar Wilde's character Dorian Gray, he did not age. The portrait that featured on his election poster of 1996 was also reproduced on giant billboards for the general election of 2001 and again on those for the European election of 2019.[28]

Berlusconi's well-staged appearances also merit some comments. When, in his capacity as Prime Minister, he addressed Italians on television, he sometimes had a religious painting in the background, as Popes do when they meet public figures before the cameras, to imply that his views had divine endorsement.[29] The settings of his public rallies are also thoughtfully planned. To cite one example: at the close of the campaign for the regional election of 2009, he addressed a large crowd in Rome framed by the Arch of Constantine, knowing full well that this triumphal image would be diffused by the media (Figure 13.11).

Berlusconi, who was accused of being incompetent and irresponsible in financial matters, faced trials on numerous occasions (for bribery, false accounting, embezzlement and other crimes), and found himself at the center of sex scandals, was savagely satirized by the media during his terms of office in order to debunk the smooth and august image he was so eager to project. Caricatures and unflattering photographs and

long brochure, entitled *La vera storia italiana*, was sent to households during the general election campaign of 2006. Other lavishly illustrated publications, such as the volume *Noi amiamo Silvio* (Sesto San Giovanni: Peruzzo, 2010) have followed. Pictures of Berlusconi and his family also regularly appear in the popular weekly *Chi*, which he owns.

27 Alexander Barley, "Battle of the Image," *New Statesman*, May 21, 2001, 45. The best photomontages were published in book form: Mark Bernardini, *www.cavalieremiconsenta.com* (Milan: Mursia, 2000); and anon., *Un impegno concreto. Un milione di poster* (Bologna: Alberto Perdisca, 2001).

28 Cheles, "From Ubiquitous Presence," 48, 52, figs. 7 and 12. The 2019 poster can be viewed by searching the keywords "Elezioni Europee 2019 Berlusconi poster" on Google Images.

29 Berlusconi declared in a speech on November 25, 1994 that he was "l'unto dal Signore" (the Lord's anointed). For his recurrent use of religious references and metaphors, see Giuliana Parotto, *Sacra Officina. La simbolica religiosa di Silvio Berlusconi* (Milan: FrancoAngeli, 2007).

photomontages also featured frequently on the covers of leading foreign magazines and front pages of newspapers.[30]

Gianfranco Fini dissolved the MSI, which had been politically marginalized for half a century, and established Alleanza Nazionale as a full-fledged party in 1995, presenting it as a modern and moderate right-wing force that could play a central role in political life. He was undoubtedly successful in persuading the general public and most informed observers that the ties with the fascist past, which was the essence of the identity of the organization it originated from,[31] had been severed for good. Fini soon became one of the most respected and popular political figures and his "post-fascist party" (as he referred to his new formation, somewhat ambiguously) grew to become one of the largest in parliament.[32] Yet, perusal of the party's publicity reveals that fascism was not repudiated. The posters, brochures, websites and front pages of the party organ, *Il Secolo d'Italia*, frequently represented him and other leading figures of the party (especially Gianni Alemanno, who was mayor of Rome from 2008 to 2013) in attitudes and situations evocative of Mussolini: e.g. addressing a large crowd, saluting with a raised and open hand (Figure 13.12) or standing with crossed arms.[33] Some propaganda material actually reproduced the effigy of Mussolini, albeit in subtly disguised form. For instance a poster advertising a conference on productivity depicts a worker whose effigy is closely modelled on one of the *Duce*'s best-known portraits (Figures 13.13). The reference to fascism is endorsed by the carefully thought-out association of images and texts: the leader's name in cubital characters is placed next to the doctored portrait of the *Duce* to permit the rhyme "Fini-Mussolini"; while the slogan "Con Fini per dar voce all'Italia che produce" (With Fini to give voice to productive Italy) has the word "produce" split by the diagonal line of the tube clutched by the worker to generate the pun "pro/Duce". AN merged with Berlusconi's Popolo della Libertà in 2009.[34] Fini disappeared from the political scene after a failed attempt

30 The headlines accompanying these images are equally irreverent: "Why Berlusconi is unfit to lead Italy" (*The Economist*, April 28, 2001); "Der Pate" [The godfather] (*Der Spiegel*, June 29, 2003); "Le bouffon de l'Europe" (*L'Express*, July 9, 2009); "The man who screwed an entire country" (*The Economist*, June 11, 2011); "The man behind the world's most dangerous economy" (*Time*, November 21, 2011); "Not just any old charlatan" (*Newsweek*, November 21, 2011); "Le retour de la momie" [The mummy's return] (*Libération*, December 12, 2012).

31 On the fascist identity of the MSI as reflected in the party's visual output, see Luciano Cheles, "'Nostalgia dell'Avvenire.' The Propaganda of the Italian Far Right Between Tradition and Innovation," in *The Far Right in Western and Eastern Europe*, eds. Luciano Cheles, Ronnie Ferguson and Michalina Vaughan (London – New York: Longman, 1995), 41–90.

32 Fini became Deputy Prime Minister in 2001, Foreign Minister in 2004 and Speaker of the Chamber of Deputies – the fourth highest institutional position – in 2008.

33 The folded arms were one of Mussolini's canonical postures: they were meant to give him a determined and intransigent appearance. Numerous official photographs so represented him. See Sturani, *Le cartoline*, 112–13, 154.

34 For a detailed account of AN's debt to the visual culture of fascism, illustrated by numerous examples, see Luciano Cheles, "Back to the Future. The Visual Propaganda of Alleanza Nazionale (1994–2009)," *Journal of Modern Italian Studies*, 15 (2010): 232–311; idem, "Il fascio dissimulato. Presenza dell'immaginario littorio nella propaganda della destra parlamentare," in *Mémoires du Ventennio. Représentations et enjeux mémoriels du régime fasciste de 1945 à aujourd'hui. Cinéma, théâtre, arts plastiques*, eds. Emilia Héry, Claudio Pirisino and Caroline Pane (Paris: Chemins de Tr@verse, 2019), 279–313. Both also deal with the portraits of AN personalities in detail.

to create a centrist party. A far-right splinter group called Fratelli d'Italia (Brothers of Italy) was launched in 2012 by Giorgia Meloni, whose approach to portraiture is quite different, as will be shown later.

Umberto Bossi, the leader of the Lega Nord (a party he founded in 1991), is a case apart. Though undoubtedly charismatic, he rejected the style of campaigning pursued by other political parties, a style that was becoming increasingly polished because propaganda was no longer produced internally by graphic designers who were first of all activists, but entrusted to advertising agencies. To campaign for greater regional autonomy and, at times, for the secession of "Padania", as Bossi called the wealthy northern stretch of Italy, the Lega relied on fiercely caustic cartoons, home-made and crudely drawn, that satirized an "idle South" allegedly exploiting the resources of the "industrious North" through the national fiscal system. Like the other alternative forms and styles of communication the Lega privileged (graffiti, crass language), the satirical drawings aimed to represent the party as an anti-establishment protest movement. Clearly, "respectable" portraits of the leader could have no place in such a propaganda. When Bossi featured on promotional materials, it was always in a self-mocking and provocative manner: some postcards depicted him wearing outrageously garish ties and jumpers; mock banknotes issued to mark the declaration of the independence of Padania on September 15, 1996 represented him with a loose tie occupying the space ascribed to such great figures as Michelangelo, Christopher Columbus and Giuseppe Verdi (Figure 13.14). Bossi relished being photographed by paparazzi wearing a vest and other informal garments, and gesturing offensively.[35]

New Leaders: Salvini, Grillo, Renzi

Bossi resigned in 2012 in the wake of a scandal. For a brief interim period his party was led by the much quieter Roberto Maroni, a former Minister of Labor and Welfare in Berlusconi's cabinets. Matteo Salvini was elected leader in December 2013, and served as deputy Prime Minister (with Luigi Di Maio, the leader of the 5 Star Movement, about which see below) and Minister of the Interior from May 2018 to August 2019. Salvini's Lega is considerably different from that of its founder: his policies focus on immigration, identity issues, law and order, national sovereignty and the traditional family. As a result, what was originally a federal/northern party has become a national party that has successfully campaigned in central and southern Italy too.[36] Salvini's manner of presentation is radically different too. His hallmark is the *felpa* (sweatshirt), a garment he began to wear in 2014 when he took up a populist stance and distanced himself from Bossi's independentism. The *felpa* provides him with the

35 Richard Barraclough, "Umberto Bossi: Charisma, Personality and Leadership," in *Charisma and the Cult of Personality in Modern Italy*, eds. Stephen Gundle and Lucy Riall, special issue of *Modern Italy*, 3,2 (1998): 263–9; Lynda Dematteo, *L'idiotie en politique. Subversion et populisme en Italie* (Paris: Maison des Sciences de l'Homme – CNRS, 2007); Marco Belpoliti, *La cannottiera di Bossi* (Parma: Guanda, 2012).

36 Daniele Albertazzi, Arianna Giovannini and Antonella Seddone, "'No regionalism, please, we are Leghisti!' The Transformation of the Italian Lega Nord Under the Leadership of Matteo Salvini," *Regional and Federal Studies*, 28 (2018): 645–71.

opportunity to show slogans such as "Basta Euro" (No to Euro) and with the names of the cities he visits ("Napoli", "Palermo", etc.) to signal his proximity to the people of those areas. As well as enabling him to appear like an ordinary person, rather than a member of the "caste", this clothing carries sporting connotations. Salvini has more recently taken up using military garments with weapons in his hands to express his solidarity with law enforcement and his belief in the liberalization of defense laws. In October 2018, for instance, he posed with a submachine gun at a police convention.[37] But he is a true man for all seasons, enjoying appearing in other guises too. He featured naked in bed on the pages of the popular weekly *Oggi* on December 2, 2014, to entertain its readership. In 2018 and 2019 he campaigned brandishing the Bible and a rosary to attract the Catholic vote – stunts that have been amply reported and illustrated by the national and international press,[38] and have aroused the anger of the Catholic authorities, who have always strongly condemned Salvini's hardline policies on immigration and treatment of immigrants. The front page of the July 28, 2018 issue of the magazine *Famiglia Cristiana* pictured Salvini with both hands placed across his face (a gesture expressing shock and incredulous disbelief), together with the headline "Vade retro, Salvini" (Back off, Salvini) (Figure 13.15),[39] which echoes the ancient formula for exorcism "Vade retro, Satana".[40] To woo the far-right electorate on May 4, 2019 Salvini addressed a crowd from the balcony of the Town Hall of Forlì (Emilia Romagna), the same from which Mussolini, who came from the nearby town of Predappio, had made a number of speeches and, in 1944, witnessed the execution of partisans by Nazi-fascists.[41]

The left-wing leaning Movimento 5 Stelle (5 Star Movement), founded in 2009 by comic actor and blogger Beppe Grillo, has also sought to project a rebellious and anti-establishment image – one that its very logo expresses cogently (the "V" it incorporates stands for "vaffanculo", fuck off).[42] Grillo, who led it until September 2017 (but was never a Member of Parliament), cultivated the image of the outspoken

37 Emma Johanningsmeier, "Italy Loosens Gun Laws as Matteo Salvini Polishes His Tough Guy Image," *The New York Times*, November 7, 2018, A, 10. On Salvini's rise and singular style of campaigning, see Giovanni Diamanti and Lorenzo Pregliasco, *Fenomeno Salvini: chi è, come comunica, perché lo votano* (Rome: Castelvecchi, 2019); Gianpaolo Pansa, *Il dittatore* (Milan: Rizzoli, 2019); and Giovanni Castiglioni ed., *Il Ducetto della Padania* (Milan: Kaos, 2019).

38 The strategy seems to work. A recent survey indicates that the number of Lega-voting Catholics is on the increase: Ilvo Diamanti, "Cresce il peso dei cattolici che votano Lega," *La Repubblica*, June 8, 2019, 6.

39 The photograph may have been chosen by *Famiglia Cristiana* because Salvini's gesture recalls that of one of the sinners being carried out by the devils in Michelangelo's *Last Judgement* frescoes in the Sistine Chapel.

40 The Catholic magazine's overt criticism of the Italian political leader was much commented upon by the foreign press, as well as by the Italian one. See, for instance, Miles Johnson and Davide Ghiglione, "Likening Salvini to Satan stokes fiery relationship," *Financial Times*, July 28, 2018, 3.

41 Coleen Barry, "Fascist symbols and rhetoric on rise in Italian EU vote," *The Washington Times*, May 23, 2019. (https://www.washingtontimes.com/news/2019/may/23/fascist-symbols-and-rhetoric-on-rise-in-italian-eu/). Salvini's nods to fascism appear to have paid dividends: the great majority of former supporters of the far-right organizations CasaPound and Forza Nuova voted for the Lega in the European elections. See Paolo Berizzi, "Così Salvini si è mangiato l'estrema destra," *La Repubblica*, June 9, 2018, 7.

42 Filippo Tronconi, *Beppe Grillo's Five Star Movement: Organization, Communication and Ideology* (London: Routledge, 2016). The 5 Stars allude to five key issues: public water, sustainable transportation, sustainable development, the right to Internet access and environmentalism.

buffoon who denounces and castigates the powers-that-be through his burlesque humor. At a time when most leaders strove to look well-groomed, he featured on the posters that advertised rallies and other spectacular events (such as his swim across the strait of Messina in October 2012, in support of his candidates in the Sicilian regional elections) grimacing and gesturing, with unkempt hair and a shaggy beard (Figure 13.16).[43]

Bossi, Salvini and Grillo have no doubt been extreme in the ways they have represented themselves. However, there is little doubt that, in the past few years, politicians in general have tended to eschew conventional forms of appearance. Male leaders now rarely wear a tie and often feature on their publicity in very informal poses. This is partly the result of the general rejuvenation of the political class. Matteo Renzi was 37 when he took part in the leadership contest of the Partito Democratico, PD, for the first time in 2012, winning it the following year. (His predecessor, Pier Luigi Bersani, was 62 when he fought his first election as leader of that party and of the center-left coalition in 2013). Luigi Di Maio was 31 when he succeeded Grillo as the head of the 5 Star Movement. Their casual styles are meant to affirm their intention to distance themselves from the old guards. Di Maio's portraits emphasize his youth and good looks.

Renzi is the most glaring example of the new approach to leadership. Bold and passionate like Tony Blair, who is one of his models[44] (he actually got to know the British Prime Minister during the latter's frequent holidays in Tuscany), he created for himself the image of the *rottamatore* (scrapper). Renzi aspired to reform the Italian political establishment by fighting its privileges, and overhaul an economic system based on patronage rather than true talent. When he campaigned, and throughout his tenure as Prime Minister (2014–2016), he relished appearing in his shirtsleeves and jeans, in spontaneous poses, signing autographs, taking selfies or riding a bicycle. The poster that was designed to promote his candidature to the leadership of the party in 2012, carrying the slogan "L'Italia cambia verso" (Italy turns around), perfectly illustrates his aims and style of presentation (Figure 13.17). Eager to appeal to a popular audience, he was featured wearing a white T-shirt and leather jacket on the cover of the May 22, 2013 issue of the magazine *Chi*, like Fonzie, the well-known character from the American television series *Happy Days*.[45] Renzi's boldness, ambition and over-confidence led to relentless opposition from leading figures of his own party, as

43 On Grillo's grotesque forms of self-promotion, see Giovanna Cosenza, "Grillo's Communication Style: from Swear Words to Body Language," in *The Five-Star Movement: a New Political Actor on the Web, in the Streets and on Stage*, eds. Maurizio Carbone and James L. Newell, special issue of *Contemporary Italian Politics* 6 (2014): 89–101; and Giuliana Parotto, "Usi del corpo nel linguaggio di Grillo," *Comunicazione politica*, 3 (2018): 413–32.

44 Renzi acknowledged this in an interview: Jim Yardley, "In Italy, Matteo Renzi aims to upend the old world order," *The New York Times*, March 31, 2015. (https://www.nytimes.com/2015/04/01/world/europe/in-italy-matteo-renzi-aims-to-upend-the-old-world-order.html). The admiration was mutual: a few months earlier Blair had declared to an Italian journalist that Renzi was the only way forward for Italy's Left. See Paolo Valentino, "'L'Europa ha bisogno di una sinistra nuova.' L'intervista a Tony Blair," *Corriere della Sera*, November 27, 2014, 19.

45 Sofia Ventura, *Renzi & Co. Il racconto dell'era nuova* (Soveria Mannelli: Rubbettino, 2015); Eugenio Salvati, "Matteo Renzi: a New Leadership Style for the Italian Democratic Party and Italian Politics," *Modern Italy* 21 (2016): 7–18.

well as from its traditional opponents. He became the favorite target of satirists who lampooned him for his would-be dogmatism and unscrupulousness, and in particular for signing a constitutional reform deal with Berlusconi.[46] In 2019 Renzi left the PD to form a new party, Italia Viva (Italy Alive).

Local Candidates

The present survey has mostly focused on the representation of party leaders and other major political figures. The distinctive features of the publicity promoting lesser-known candidates standing in local and regional elections also deserve some comments.

Generally speaking, local candidates are represented on posters, brochures, *santini* and websites in a less sophisticated manner than their national counterparts because their campaigns are fought on considerably smaller budgets and produced by local advertisers, rather than major advertising agencies. Though crudely executed, they can be quite imaginative and humorous, with slogans often written in a colloquial and playful style. This down-to-earth approach is pursued mostly by candidates of the right and center-right. The principal aim is not necessarily to persuade through argument, but to project a fun image that might make them appear close to ordinary people and attract attention. Indeed the media, both local and national, regularly comment on, and illustrate the more extravagant or outrageous images, which often have sexual connotations. For instance, in 2013 Davide Amadeo, who stood as city councilor in Milan with the Lega, appeared naked in his publicity to prove that he had "Niente da nascondere" (Nothing to hide), as his slogan stated. In 2014, the twenty-five year-old Mario Ferri, a Fratelli d'Italia candidate, had himself depicted in his boxer shorts to attest that "Questa politica ci ha tolto tutto" (This politics [the taxes introduced by Renzi's government] has taken everything from us). It should be noted that the tongue-in-cheek display of nudity or near-nudity for electoral purposes has concerned almost exclusively male candidates. Females candidates who promoted themselves in a similar fashion would lend themselves to accusations of perpetuating the role of women as sex objects, even if such images were meant to be taken jokingly. However, that does not mean that the portrayal of women in Italian propaganda is not gendered.

Representing Female Politicians

The number of women who have been actively engaged in politics has grown considerably over the decades. Suffice it to note that from 1996 to 2018 the number of female deputies has increased from 11.2 to 31.3 percent, and that of senators from 7.1 to 29.6 percent. Such a rapid surge gives reason to believing that number parity may be achieved in a relatively short time. This progression has not necessarily been matched

46 On Google Images, sub voce "Renzi satira", one finds an ample selection of satirical images on Renzi. See also Pietro Vanessi, *L'appaRenzi inganna. 30 autori di satira interpretano Matteo Renzi* (Villaricca, Naples: Cento Autori, 2016).

by an evolution in the attitudes of the political class toward female politicians.[47] The ways women are depicted depend to a large extent on their ideological affiliations.[48]

Female politicians of left-wing and libertarian parties are usually portrayed at half-bust and in a restrained way: they pose naturally, are lightly made up, wear soberly elegant garments in subdued colors, with a minimal amount of accessories, and their hair is brushed in an orderly and inconspicuous way. They are also shown in settings to allude to their engagement in their towns or constituencies.

On the opposite side of the political spectrum, since the early 1990s, women have tended to be presented in a glamorized way. They elicit the viewers' attention by means of a wide range of artifices. They are much more likely to be depicted from the waist, hips or knees up than male candidates. They emphasize their sex-appeal by taking up sexually suggestive postures, wearing heavy make-up, tight-fitting garments, often with low-cut tops, and ostentatious jewels. Unkempt hair, which evokes the loosening of sexual inhibitions, is another recurrent feature. The female politicians or aspiring politicians of the right and far right are also frequently shown at close range, a mode of representation that suggests intimacy and invites the appreciation of a perfect complexion. They may touch their faces delicately with their well-manicured hands or allow rebellious locks of hair to caress their cheeks. The absence of any background – a common feature of their propaganda – prompts one to focus exclusively on their bodies. It also contributes to the idealization of women by cutting them off the harsh realities of our imperfect world. Classy, alluring and impeccably depicted, the female candidates of the right and far right tend to look like stars of show business.[49] Indeed, they are often drawn from such a world.

Sex appeal was first used by a right-wing party for electoral ends in 1992, when the MSI, whose ultra-conservative views on women bordered on the misogynistic, launched the candidature of Alessandra Mussolini, the *Duce*'s grand-daughter and niece of world-famous actress Sophia Loren. Though lacking in administrative or political experience – she was a starlet and cover-girl who had disrobed for *Playboy* and other magazines – she triumphed in the parliamentary election and came close to winning the mayoral election in Naples the following year. Her physical appearance has continued to play a part in the national and European election campaigns she has subsequently fought under the aegis of different right-wing parties (Figure 13.18). Encouraged by Alessandra Mussolini's successes in the 1992 and 1993 elections, the MSI and its "post-fascist" heir AN fielded a number of other attractive female candidates to suggest "modernity" and disprove its traditional image of a party of old, black-shirt-wearing fascist diehards.[50] Berlusconi's populist Forza Italia party (which

47 On sexism in Italian politics, see Filippo Maria Battaglia, *Sta zitta e va' in cucina. Breve storia del maschilismo in politica da Togliatti a Grillo* (Turin: Bollati Boringhieri, 2015).

48 For a more detailed investigation on the representation of female politicians than what follows, see Luciano Cheles, "Donne manifeste. L'immagine femminile nella propaganda figurativa in Francia e in Italia," in *Il ritratto e il potere*, eds. Cheles and Giacone, 253–63, figs. 23–55 of the color insert.

49 This is a far cry from earlier approaches. As late as 1991, the consultant Maria Bruna Pustetto insisted in her *Manuale del candidato politico* (Milan: Bridge, 1991), 240, that aspiring female politicians should adopt a restrained appearance in order to avoid any suggestion of sexual availability and be taken seriously in the predominantly male world of politics.

50 On Alessandra Mussolini's triumphant foray into the world of politics, see Lesley White, "Mussolini in a Mini Marches on Rome," *The Sunday Times*, February 9, 1992, 3; Ed Vulliamy, "Fighter for the

was renamed Popolo della Libertà, PdL, People of Freedom, in 2007, but reverted to its original name in 2013) has also put up a number of showgirls to appeal to a public addicted to the glittering spectacles of his television networks, thus turning political life into an extension of the world of entertainment. The most striking case of a performer turned overnight into a politician is Mara Carfagna, a participant in the 1997 Miss Italia contest and showgirl who posed naked for the men's magazine *Maxim* in 2001 and an erotic calendar in 2005. Her political career began in 2004, when she was appointed coordinator of Forza Italia's women's movement in the Campania region. She was elected Member of Parliament in 2006 and was made Equal Opportunities minister by Berlusconi in 2008.[51] The electoral materials disseminated by parties to advertise the candidature of these television personalities provide eloquent illustrations of the visual artifices discussed above.

The importance given to youth and beauty compels the parties of the right and far right to make extensive use of photographic retouching when the candidates they are keen to field on account of their experience are less attractive, or not in their prime. Letizia Moratti (b. 1949), a member of Forza Italia and former businesswoman, was featured on her posters and leaflets rejuvenated by over twenty years when she sought re-election as mayor of Milan in 2011.[52] Iva Zanicchi, who was 74 when she stood as candidate for the same party in the European election of 2014, was depicted in her publicity with a photograph dating from the early years of her career as pop-singer. An arresting example is provided by the leader of Fratelli d'Italia Giorgia Meloni (b. 1977). Through image editing she appears in her propaganda as an attractive young lady, assuming, star-like, innumerable endearing expressions: romantic, thoughtful, sulking, carefree, cheeky, seductive... (Figure 13.19). The makeover is debunked and made fun of by the press and social media for it is so radical that Meloni often appears barely recognizable.[53]

The point has been made that left-wing and libertarian parties are at pains to represent female candidates in a restrained and dignified way. When, on occasion, they are promoted in an overtly erotic way, it is in order to provoke and shock. The porn-actress Ilona Staller, whose nom de plume is Cicciolina, appeared as such in her publicity when the Partito Radicale, a civil rights party whose past political battles included the liberalization of divorce and legalization of abortion, fielded her for the parliamentary election of 1987 to protest against the allegedly bigoted attitudes to sexuality of

Grand-Fatherland," *Week-End Guardian*, February 22–3, 1992, 4–7. On the evolution of the representation of women in the propaganda of the Italian far right: Luciano Cheles, "Dalla donna-angelo a Alessandra Mussolini. L'immagine femminile nella propaganda della destra parlamentare," in *La paura e l'utopia. Saggi sulla comunicazione politica contemporanea*, ed. Fabrizio Billi (Milan: Punto Rosso, 2001), 83–122.

51 https://it.wikipedia.org/wiki/Mara_Carfagna On Carfagna's glamorous look, see Robb Young, *Power Dressing. First Ladies, Women Politicians & Fashion* (London: Merrell, 2011), 134–5. On women's role in Berlusconi's personal life and political world, see Francesca Martinez Tagliavia, *Faire des corps avec les images. La contribution visuelle de la 'velina' au charisme de Berlusconi* (Paris: Institut Universitaire Varenne, 2016).

52 For Moratti's propaganda image and the original photograph on which it is based, shown side-by-side, see anon., "Europee col trucco. Ma questo si vede", *Il Tempo*, April 10, 2014. https://www.iltempo.it/politica/2014/04/10/gallery/europee-col-trucco-ma-questo-si-vede-935585/

53 A search on Google Images using the keywords "Giorgia Meloni Photoshop" generates numerous hilarious photomontages and caricatures.

the other parties.[54] Equally provocative was the propaganda of another star of X-rated movies, Emilia Cuccinello, alias Milly D'Abbraccio, who stood with the Socialist Party in the local election in Rome in 2008 as a living symbol of sexual liberation.[55] Also worth mentioning is the case of the transgender actress Vladimiro Guadagno, who stood in 2006 with the far-left party Rifondazione Comunista – part of Romano Prodi's center-left coalition – with the name of Vladimir Luxuria. She appeared in her campaign posters in the over-the-top guise of a vamp (long, black gloves, thick make-up, flashy jewels and organza dress) to denounce normative sexuality.

Unlike what happens in other Western countries, such as the United States, France and, albeit to a lesser extent, Britain, the First Ladies phenomenon is not widespread in Italy, and the companions of presidents and prime ministers, with some exceptions, such as Renzi's wife Agnese Landini, keep a low profile and receive little attention from the serious media.[56]

Conclusion

Political portraiture has evolved considerably in Italy since the end of the Second World War. The parties' reluctance to depict their leaders out of fear of recalling Mussolini's personality cult was followed by a strong reliance on the portraits for propaganda purposes when personalization and spectacularization came to dominate political life. The great diversity that characterizes these images is due to the different approaches to leadership which parties maintain, as well as to the contrasting attitudes to gender issues. It is also determined by the presence of a large number of parties, and within the same parties of candidates who are often in competition with one another: the necessity to present themselves in distinctive ways to catch the public's eye has led to increasingly emphatic depictions. In sharp contrast to the dramatic evolution in the representation of party figures, one portrait genre has changed remarkably little over the decades: the official photographs of the Presidents of the Republic. Simple and sedate to the point of appearing staid, these portraits distance themselves from the boisterous propaganda of the parties to assert the authoritative role that is expected from the highest official of the Italian Republic.[57]

54 On the Cicciolina phenomenon: Umberto Eco, "A Dollar for a Deputy: La Cicciolina," in idem, *Apocalypse Postponed*, ed. Robert Lumley (Bloomington: Indiana University Press, 1994), 196–9; the essay originally appeared in Italian in 1987); Bertrand Lavergeois, *Cicciolina: Ilona Staller, pornostar, députée* (Paris: Ledrappier, 1987).

55 One cannot help remarking that these parties, which consider themselves at the forefront of gender issues, have turned to well-known female porn stars, rather than male ones, such as Rocco Siffredi, to promote their cause. The choice of Milly D'Abbraccio, whose naked behind, represented in close-up, featured on one of her campaign posters, is especially surprising when we consider that she stood in support of the candidature of the leading gay activist Franco Grillini to the mayorship of the capital.

56 However, see Paola Severini, *Le mogli della Repubblica* (Venice: Marsilio, 2008).

57 On the official portraits of Italian Presidents, see Luciano Cheles, "Immagini presidenziali nel tempo presente : Francia e Italia," in *Presidenti. Storia e costume della Repubblica nell'Italia democratica*, ed. Maurizio Ridolfi (Rome: Viella, 2014), 157–64; and Alessandro Giacone's essay in this volume.

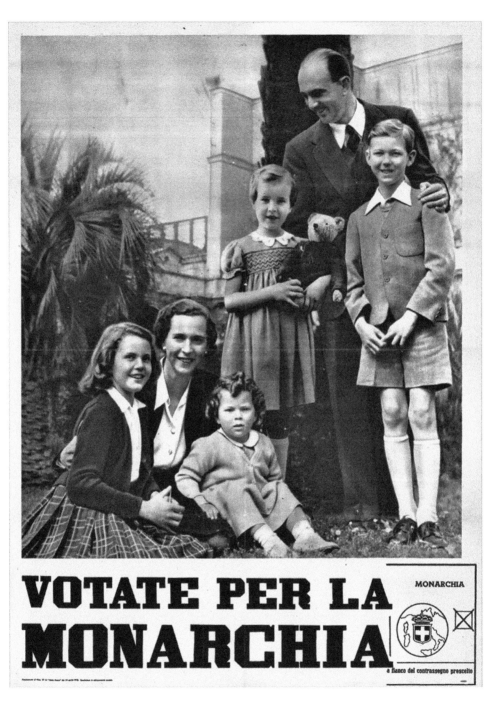

Figure 13.1 "Vote for the Monarchy". Poster, referendum for or against the Monarchy, 1946. (Fondazione Gramsci, Emilia-Romagna).

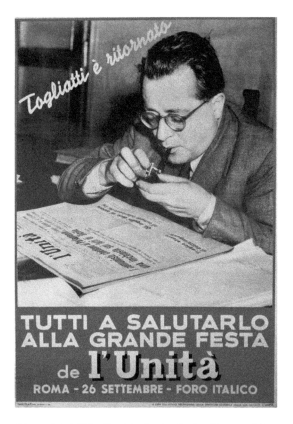

Figure 13.2 "Togliatti is back. Let's all greet him at the great *Festa de l'Unità*". Poster, Communist Party, Rome, September 1948. (Fondazione Gramsci, Rome).

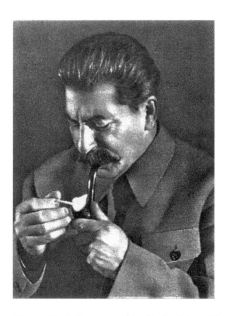

Figure 13.3 Portrait of Stalin by Max Alpert, 1930s.

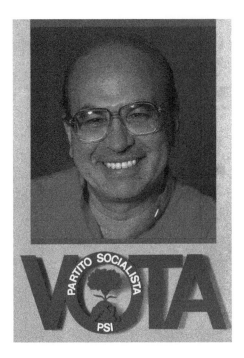

Figure 13.4 Bettino Craxi. Poster, Socialist Party, parliamentary election, 1983.

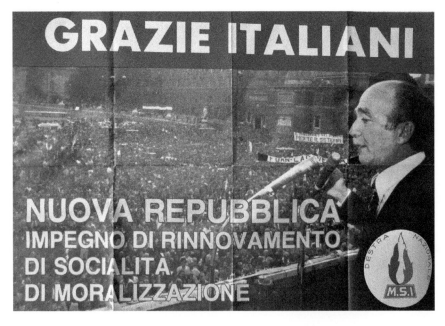

Figure 13.5 "Thank you, Italians. A New Republic. A pledge for renewal, sociability and morality". Giorgio Almirante at a party rally. Poster, Movimento Sociale Italiano, 1983.

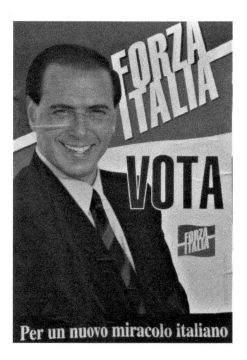

Figure 13.6 "Vote Forza Italia. For a new Italian miracle". Silvio Berlusconi. Poster, parliamentary election, 1994.

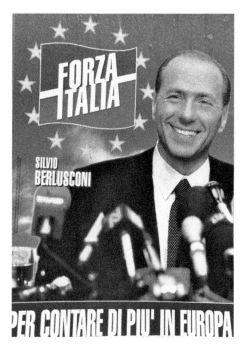

Figure 13.7 "Silvio Berlusconi. To count more in Europe". Poster, Forza Italia, European elections, 1994.

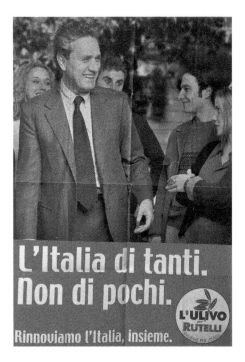

Figure 13.8 "Italy for the many. Not the few. Let's renew Italy together". Poster depicting Francesco Rutelli, leader of L'Ulivo (center-left coalition), parliamentary election, 2001.

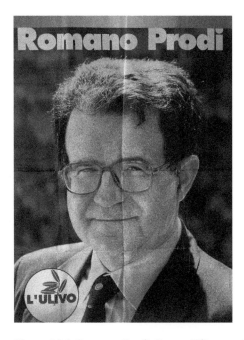

Figure 13.9 Romano Prodi. Poster, Ulivo, parliamentary election, 1996.

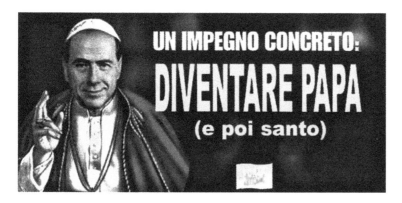

Figure 13.10 "A concrete pledge: to become Pope (then asaint)". Anonymous photomontage satirizing Silvio Berlusconi. From the "guerrilla warfare" website created by Mark Bernardini, parliamentary election, 2001. (From: Mark Bernardini, *www.cavalieremiconsenta*, Milan: Mursia, 2000).

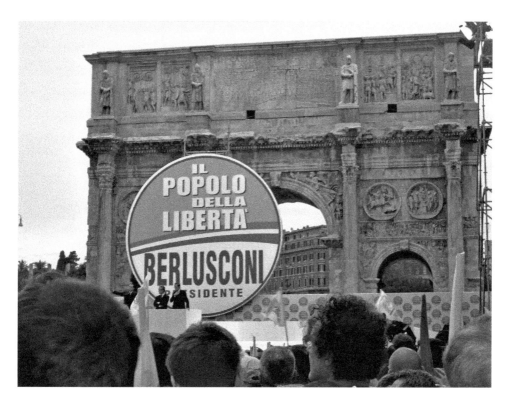

Figure 13.11 Silvio Berlusconi addressing a Popolo della Libertà rally, Rome, regional election, 2009. (Author's photograph).

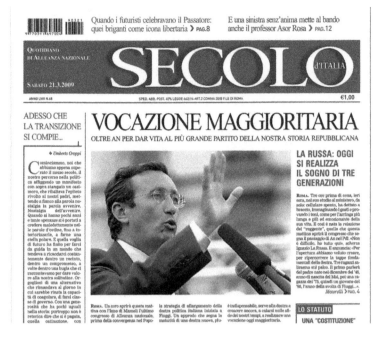

Figure 13.12 Gianfranco Fini "saluting". Front page of Alleanza Nazionale's organ *Secolo d'Italia*, March 21, 2009.

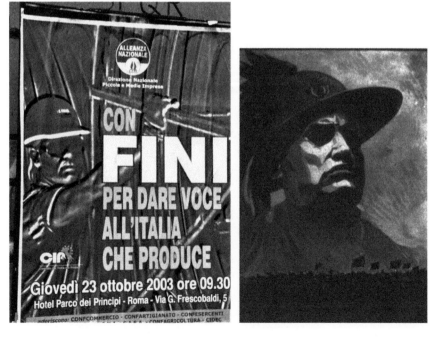

Figure 13.13 (Left) "With Fini to give voice to productive Italy". Poster, Alleanza Nazionale, advertising a conference on productivity, Rome, 2003. (Author's photograph). (Right) Mussolini wearing the hat of a *bersagliere*. Postcard, c. 1934.

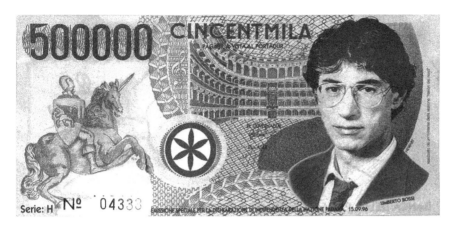

Figure 13.14 Mock Lega Nord banknote with the portrait of Umberto Bossi, issued to coincide with the declaration of independence of "Padania" on September 15, 1996. The text "Cincentmila" is written in the Milanese dialect.

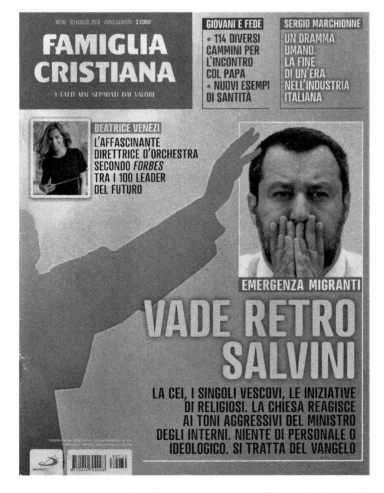

Figure 13.15 "Back off, Salvini". Front cover of the Catholic weekly *Famiglia Cristiana*, July 28, 2018.

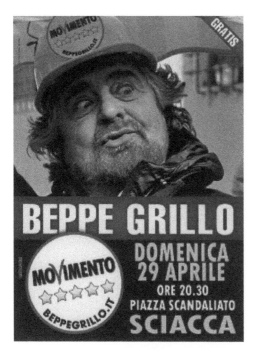

Figure 13.16 Poster, Movimento 5 Stelle, advertising Beppe Grillo's rally at Sciacca, Sicily. Regional election, 2012.

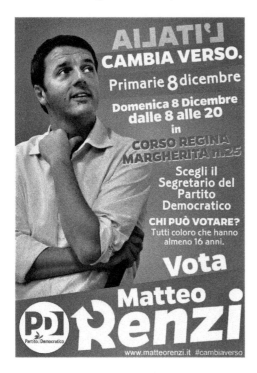

Figure 13.17 "Italy turns around". Poster promoting Matteo Renzi's candidature, primary election for the leadership of the Partito Democratico, 2012.

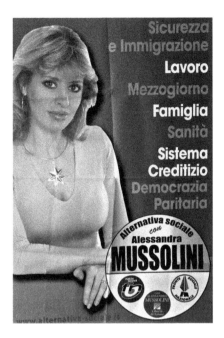

Figure 13.18 "Safety and immigration. Employment. The South. Family. Health. Credit system. Democracy and Equality". Alessandra Mussolini. Poster, Alternativa Sociale, parliamentary election, 2006. The party was founded by A. Mussolini in 2004 et dissolved in 2006.

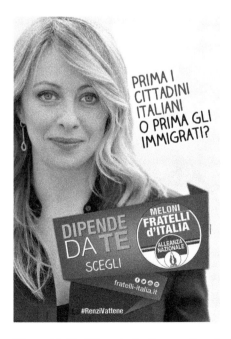

Figure 13.19 "First the Italians or first the immigrants? It's up to you. Choose Meloni. Fratelli d'Italia". Poster, mayoral election, Rome, 2016.

Bibliography

Archetti, Cristina. *Politicians, Personal Image and the Construction of Political Identity: A Comparative Study of the UK and Italy.* London and New York: Palgrave Macmillan, 2014.

Ballini, Pier Luigi, and Maurizio Ridolfi, eds. *Storia delle campagne elettorali in Italia.* Milan: Bruno Mondadori, 2002.

Cagianelli, Francesca, ed. *Il ritratto storico nel Novecento, 1902–1952.* Pisa: Pacini, 2003.

Ceccarelli, Filippo. *Invano. Il potere in Italia, da De Gasperi a questi qua.* Milan: Feltrinelli, 2018.

Cheles, Luciano, and Alessandro Giacone, eds. *Il ritratto e il potere. Immagini della politica in Francia e in Italia nel Novecento.* Pisa: Pacini, 2017.

Cheles, Luciano, and Lucio Sponza, eds. *The Art of Persuasion: Political Communication in Italy, from 1945 to the 1990s.* Manchester and New York: Manchester University Press, 2001.

d'Almeida, Fabrice. *La politique au naturel. Comportement des hommes politiques et représentations publiques en France et en Italie du XIXe au XXIe siècle.* Rome: Ecole Française de Rome, 2007.

De Luna, Giovanni, Gabriele D'Autilia, and Luca Criscenti, eds. *L'Italia del Novecento. Le fotografie e la storia.* Vol. 1, 2. *Il potere da De Gasperi a Berlusconi (1945–2000).* Turin: Einaudi, 2005.

Lucas, Uliano, and Tatiana Agliani. *La realtà e lo sguardo. Storia del fotogiornalismo in Italia.* Turin: Einaudi, 2015.

Luzzatto, Sergio. "Il corpo politico." In *Storia d'Italia. Annali 20. L'immagine fotografica, 1945–2000,* edited by Uliano Lucas, 523–47. Turin: Einaudi, 2004.

Mancini, Paolo. "Political Professionalism in Italy." In *The Professionalisation of Political Communication: Changing Media, Changing Europe,* vol. 3, edited by Ralph Negrine et al., 111–25. Bristol and Chicago: Intellect, 2007.

Martini, Fabio. *La fabbrica delle verità. L'Italia immaginaria della propaganda da Mussolini a Grillo.* Venice: Marsilio, 2017.

Mazzoleni, Gianpietro. "TV Political Advertising in Italy: When Politicians Are Afraid." In *The Sage Handbook of Political Advertising,* edited by Lynda Lee Kaid and Christina Holtz-Bacha, 241–57. London: Sage, 2006.

Mosca, Lorenzo. *La webpolitica. Istituzioni, candidati, movimenti fra situ, blog e social network.* Florence: Le Lettere, 2015.

Novelli, Edoardo. "Political Advertising in Italy." In *Handbook of Political Advertising,* edited by Christina Holtz-Bacha and Marion R. Just. New York and London: Routledge, 2017.

Novelli, Edoardo. *Le campagne elettorali in Italia. Protagonisti, Strumenti, Teorie.* Bari-Rome: Laterza, 2018.

Novelli, Edoardo. "Visual Political Communication in Italian Electoral Campaigns." In *Visual Political Communication,* edited by Anastasia Veneti, Daniel Jackson and Darren G. Lilleker, 145–63. Chan, Switzerland: Palgrave Macmillan, 2019.

Ottaviano, Chiara, and Paolo Soddu, eds. *La politica sui muri. I manifesti politici dell'Italia Repubblicana, 1946–1992.* Turin: Rosenberg & Sellier, 2000.

Ridolfi, Maurizio, ed. *Propaganda e comunicazione politica. Storia e trasformazioni nell'età contemporanea.* Milan: Bruno Mondadori, 2004.

Tampone, Francesca. "Mutamenti della rappresentazione femminile nei manifesti elettorali italiani, 1948–1979." Degree thesis, University of Turin, 2017–2018.

14 The Portraits of the Italian Presidents of the Republic, between Officialdom and Satire

Alessandro Giacone

In the referendum that took place on June 2 and 3, 1946 the Italian people were asked to choose between Monarchy and Republic. With 12.6 million votes the Republic won by a margin of two million votes over the Monarchy. The last king of Italy, Umberto II, left the country for exile in Portugal. Since 1861 Italians had lived under a monarchical regime and images of the royal family were in evidence throughout the country. Conversely, for the majority of the population, the idea of a republic was but an abstract concept and, as such, it was necessary to give it both a face and an image. Immediately a competition was held to create a new emblem: a star superimposed on a cogged wheel represented work, and two branches, one of oak and the other of olive, symbolized peace and brotherhood.[1] Contrary to what took place in most countries, the official portrait of the President was not widely used and this for reasons that could be easily understood: after the deluge of propaganda images that had characterized the Fascist period, the Republic wanted to promote an image of solemnity and avoid personalizing its representatives. This essay will analyze the portraits of the twelve presidents of the Republic and highlight in particular the subversion of official images through the use of caricature – a practice that has become increasingly widespread in the Italian press.

On June 28, 1946 the Constituent Assembly elected Enrico De Nicola (1877–1959)[2] as temporary head of state, a role he was to fulfill until the new constitution took effect. A man of mediation, he played an important part in the transition from monarchy to republic,[3] convincing King Victor Emmanuel III to delegate his powers to his son, Umberto. The election of De Nicola in 1946 was an attempt to unite a country split into two and to win over the allegiance of the South which had voted overwhelmingly for the Monarchy.

Since the establishment of the monarchy a decree had made obligatory the presence of the head of state's portrait in public offices and schools. As we shall see, this regulation was not respected during the first years of the Republic. In fact, it is difficult to classify the photograph of De Nicola, as featured on the website of the presidency of

1 Following two national competitions, the Piedmontese artist Paolo Paschetto was declared winner. The emblem that he designed was adopted officially on May 5, 1948.
2 During the interim period between the foundation of the Republic and the election of De Nicola, the role of the temporary head of state was filled by the head of government, Alcide De Gasperi.
3 See Alessandro Giacone, "Enrico De Nicola et la transition entre Monarchie et République," in *La vie intellectuelle entre fascisme et République. Italie 1940–1948*, eds. Antonio Bechelloni, Christian Del Vento and Xavier Tabet. *Laboratoire italien* 12 (2012), 279–96.

the Italian Republic,[4] as an official portrait given the poor quality of the image, which is more like a snapshot than a deliberate attempt to promote the temporary head of state.[5] It seems evident from this that the photograph was added only later to the series of presidential images (particularly on governmental sites): unlike the practice that exists in many other countries, in Italy there is no dedicated gallery of official portraits.[6] In this respect the only official initiative was made by the Socialist leader Bettino Craxi when he was Prime Minister (1983–1987): he commissioned Deanna Frosini[7] to paint a series of pictures of the first seven Italian heads of state.[8] While initially on display in Palazzo Chigi, the seat of the Italian Government, they have now been moved to a basement.[9] The artist depicted De Nicola in the courtyard of the Quirinal Palace, the former royal abode which became the official residence of Italian presidents, though he had never set foot there during his term of office (1946–1948): he made Palazzo Giustiniani, in the center of Rome, his abode. It was in the library of this building on December 27, 1947 that photographs were taken showing De Nicola signing the Italian Constitution. Many photographers and cameramen were present at the ceremony which took place within the library's narrow confines; the event was also filmed from above.[10] One photograph, which shows a front view of De Nicola seated at the table with his head bent in the act of signing, has achieved iconic status and is invariably reproduced in school textbooks to illustrate the founding act of the new Republic (Figure 14.1). De Nicola is in the center of the scene and is surrounded by four individuals on their feet: on the right, by his young secretary, Francesco Cosentino, and by the Prime Minister, De Gasperi, and on the left by the Minister of Justice, Giuseppe Grassi, and by Umberto Terracini, the President of the Constituent Assembly. De Nicola turned to De Gasperi and uttered a single sentence: "I've read it thoroughly. We can sign with complete trust".

In 2018, on the 70th anniversary of the enactment of the new constitution (January 1, 1948), a postage stamp and a commemorative two Euro coin were issued that bore the words "con sicura confidenza" (with complete trust) (Figure 14.2). The image used on the coin reproduces exactly some elements of the original photograph, but removes Grassi and Cosentino, so that the scene is dominated by the figures of De Nicola, De Gasperi and Terracini, namely "the institutional triumvirate". This composition

4 The official portraits of the presidents of the Republic from De Nicola to Napolitano can be viewed on the presidential website at http://presidenti.quirinale.it/ (accessed on July 9, 2019).

5 Luciano Cheles, "Immagini presidenziali nel tempo presente: Francia e Italia," in *I Presidenti. Storia e costumi della Republica nell'Italia democratica*, ed. Maurizio Ridolfi (Rome: Viella, 2014), 158–9. The front cover of this book features portraits of all the presidents (with the exception of Sergio Mattarella).

6 Official portraits are on display in the corridor of the Quirinal's Historical Archives and in the information center for visitors to the Presidential Palace.

7 Deanna Frosini (b. 1940) has worked in theatre, journalism and cinema. Her works have been displayed at the Quadrenniale d'Arte di Roma and in many other exhibitions. Other than the portraits of Italian presidents her work has featured many supporters of the socialist movement. See Federica Di Castro et al., *Deanna Frosini* (Milano: Prearo, 1991).

8 Enrico De Nicola, Luigi Einaudi, Giovanni Gronchi, Antonio Segni, Giuseppe Saragat, Giovanni Leone and Sandro Pertini (the president in post when the portraits were commissioned). Further evidence of the reserve that surrounds these portraits lies in the fact that they may not be found on any internet website.

9 I thank Luciano Cheles for this information.

10 "De Nicola, De Gasperi e Terracini firmano la costituzione italiana," *La Settimana Incom 00111 del 6 gennaio 1948*, accessed on March 30, 2019, https://www.youtube.com/watch?v=XUNOOms7oLM.

is also used, albeit seen from a different angle, on the postage stamp. The choice of figures was carefully calculated. Apart from holding the three most important offices of state in 1947, De Nicola, a member of the Italian Liberal Party, the Christian-Democrat De Gasperi and the Communist Umberto Terracini represent three different political tendencies, but at the same time symbolize the spirit of national unity that was evident during the drawing up of the constitution of the new Republic. Images of the head of state were often found on the front covers of popular weeklies such as *La Domenica del Corriere*.[11]

The presidents were also depicted by caricaturists. Following in the footsteps of Honoré Daumier, several satirical magazines appeared in Italy, though not before the end of the nineteenth century. The most important were *Il Guerin Meschino* (The Shabby Guerin, founded in 1882), *L'Asino* (The Donkey, 1892) and *Il Travaso delle idee* (The Decanting of Ideas, 1900) and the strongly anti-fascist *Il Becco giallo* (The Yellow Beak, 1924). Mussolini's regime curtailed drastically the activities of the satirical press, outlawing publications by other parties (1926) and making defamation of the state a crime (1930). *L'Asino* closed its doors in 1925 and a new general editor was imposed on *il Travaso delle idee*. *Il Becco giallo* was banned by the regime in 1926 but continued to be published clandestinely in France. With the return of democracy the last two publications were restarted with slightly different names: *Il Travaso* and *Il Merlo giallo* (The Yellow Blackbird).

Under the Monarchy it had been difficult to make fun of the head of state and it continued to be so after the birth of the Republic. However, although attacks upon the political class could be ferocious, the satire on heads of state was invariably good natured.[12] In 1946 a cartoon in *Il Travaso* depicted De Nicola in slippers, knitting in front of the fire. The title of the cartoon – "Pr-Pr-Pr" – presents the Primo Presidente Provvisorio (First Temporary President) as an essentially useless character who has nothing to do all day, especially when compared with Prime Minister De Gasperi.[13] A prominent lawyer and impartial by nature, De Nicola was a strange character with a hesitant personality. Throughout his long political career, when faced with difficulties, he preferred to resign, rather than commit himself. In February 1947 a peace treaty was signed that provided for Italy's withdrawal from its colonies and the redrawing of its borders with France and Yugoslavia. Many Italians found this humiliating and De Nicola himself did not want to ratify the measures. It was one of the reasons that induced him to resign, though officially he did so for health reasons. However, when re-elected by the Constituent Assembly De Nicola had no choice but to sign the act of ratification. In the summer of 1947 *Il Merlo giallo* depicted De Nicola as a patient who must *inghiottire il rospo* (literally "swallow the toad", i.e. bite the bullet) and sign the agreement presented as a diktat by the victorious Allied nations. Standing by him, De Gasperi and the Minister of Foreign Affairs, Carlo Sforza, are shown as two

11 Antonella Mauri, "*La Domenica del Corriere* e la rappresentazione dei Capi di Stato," in *Il ritratto e il potere. Immagini della politica in Francia e in Italia nel Novecento*, eds. Luciano Cheles and Alessandro Giacone (Pisa: Pacini, 2017), 57–81.

12 For some caricatures of the presidents of the Italian Republic, see especially Angelo Olivieri, *Sette anni di guai, I Presidenti della Repubblica nella satira* (Bari: Dedalo, 1992).

13 http://frame.technology/dev/vitepresidenti/de-nicola/la-satira/ (accessed on 9 July, 2019).

doctors telling him to "close [his] eyes and open [his] mouth" and swallow the bitter medicine (Figure 14.3).

De Nicola's successor was the leading economist Luigi Einaudi, president of the Republic from 1948 until 1955.[14] When offered the post, Einaudi's initial reaction was to refuse because, following an accident, he walked with a cane; in other words, he feared that his physical condition would prove a handicap during official ceremonies.[15] No official photographs were taken when he was elected President. However, in May 1950 a deputy asked a parliamentary question expressing regret that a presidential portrait was not displayed in public buildings. The secretary general of the Quirinal, Ferdinando Carbone, subsequently suggested to Einaudi that he choose one from a set of pictures taken by his friend Domenico Peretti Griva[16] or commission a new photograph.[17] Einaudi, a very thrifty person, chose the first option to avoid incurring expenses he considered unnecessary. Luciano Cheles has shown that, though the available photographs included a full-length portrait, he preferred a head-and-shoulder version of it that attenuated his distinguished appearance.[18] The portrait depicts him as a stern man with a bundle of papers in his hand: the image of a sober and respected economist. The walking stick, visible in the full-length portrait, has been cut out. Einaudi's photograph was sent to all who requested it, but was not exhibited in public places. Neither were the portraits of his successors: in 1965 the Minister of Education complained again about the absence of presidential portraits in schools.[19]

A statue of Einaudi was realized in 1949 by his friend Pietro Canonica (1869–1959), an internationally known academic artist who had been commissioned for celebrative sculptures by several European heads of state, including the Czar of Russia and the Turkish President Atatürk.[20] The work, now at the *Museo Canonica* in Rome, is realistic but with an element of stylization (Figure 14.4). A striking feature is the total lack of symbols related to Einaudi's presidential status. This contrasts with the bust of Victor Emmanuel III, which Canonica had executed in 1938 showing the king in military uniform with royal insignia (Figure 14.5). The representation of Einaudi is muted most probably at the request of the President himself, who was trying to affect a clean break with the pomp of the former regime. In 1952 Canonica was made a Life Senator for his contribution to art.[21]

Einaudi's effigy later featured on two commemorative postage stamps. The first was issued in 1974 on the hundredth anniversary of his birth: it is a rather simple image in which the economist is shown wearing a pair of round-framed glasses and without any

14 Riccardo Faucci, *Luigi Einaudi* (Turin: UTET, 1986).
15 The episode is described by Giulio Andreotti in *Visti da Vicino, Seconda Serie* (Milan: Rizzoli, 1983), 3–4.
16 Domenico Peretti Griva (1882–1962), an anti-fascist magistrate, was also an accomplished photographer. He was a leading exponent of the pictorialist movement in Italy. See Chiara Dall'Olio, *Domenico Riccardi Peretti Griva e il pittorialismo italiano* (Modena: Franco Cosimo Panini, 2012).
17 Carbone's letter to Einaudi, August 21, 1950, Torino Fondazione Einaudi, *Fondo Luigi Einaudi*, Einaudi/Carbone.
18 Cheles, "Immagini presidenziali," 159.
19 Letter from the Minister of Education, Luigi Gui, October 8, 1965, Archivio centrale dello Stato, PCM (1968–1972), *4.15/13554*, b.597.
20 The idea of sculpting a monument to Einaudi came from the artist. See *Stampa Sera*, March 8, 1949.
21 According to the Italian Constitution, the President of the Republic can nominate five citizens "for outstanding contributions to society, science, the arts and literature".

other distinguishing features. The second, issued in 2012, re-uses the official portrait, this time in color, superimposed upon an image of the Quirinal Palace, to allude to the fact that Einaudi was the first head of the Italian Republic to reside there.

Einaudi's presidency was also an important moment in the history of Italian political satire. When the law was passed that approved the establishment of presidential administration, the former Premier, Francesco Saverio Nitti, launched a campaign against "the mad expenses" of the presidency to discredit Einaudi who liked to appear as frugal. In 1948 a cartoon in *Il Guerin Meschino* depicted a rotund, well-fed Nitti remarking upon a very skinny Einaudi: "Now that he is President of the Republic, see how he's become fat!" In another cartoon the thrifty economist is harangued by his wife: "You've bought yourself some new braces! You must be mad! What will Nitti say!" These presidential caricatures were, however, the cause of a celebrated court case between Einaudi and Giovanni Guareschi, the author of the famous *Don Camillo* saga. In 1945 Guareschi founded the humorous weekly publication *Candido,* which had both royalist and anticommunist leanings. As well as articles and stories, *Candido* included satirical pieces often aimed at Einaudi who was also the owner of an important wine business.[22] In 1950 the Republic was depicted as a woman crowned with a tower (the symbol of the independent communes of medieval Italy[23]) next to a bottle of Nebbiolo wine[24] with the advertising slogan "Drink to Einaudi!" In the same year the humorist Carlo Manzoni published a cartoon in which the President's silhouette, tiny but still identifiable from his walking stick, is inspecting the *Corazzieri* (the presidential guards), who are in fact represented as two lines of bottles (Figure 14.6). On behalf of the President, Carbone pressed charges against both Guareschi, as editor of the publication, and Manzoni, as the creator of the offending cartoon. While awaiting a verdict Guareschi replied by representing Candido as a small mustachioed man chained to two huge bottles of Nebbiolo. Initially the two accused men were found not guilty by a court in Milan, but on appeal were given an eight-month suspended sentence by Italy's Supreme Court. A few years later Guareschi was found guilty in a different trial and spent nearly a year and a half in prison without any presidential pardon. The Einaudi/Guareschi affair belongs to a different epoch in which any expression of contempt toward the head of state could result in severe punishment. The *Candido* case explains why, for more than a decade, political satire in the press and on television almost always refrained from making fun of the nation's president.[25]

Einaudi's successsor, Giovanni Gronchi, was the first Christian-Democrat to hold the title of head of state (1955–1962)[26]. His official portrait (the photographer is

22 For a more detailed account, see Alessandro Giacone, "Caricature e vilipendio al Capo dello Stato. La vicenda Einaudi-Guareschi," in *Il ritratto e il potere*, eds. Cheles and Giacone, 113–21.

23 On turreted Italy, see Edoardo Novelli, "Il volto della Patria. Iconografia e narrazione simbolica della Nazione" in *Comunicazione politica* 1 (2011), 111–20.

24 Nebbiolo is a famous Piedmontese wine of which Einaudi was a producer.

25 In 1959, during a visit by Charles de Gaulle to Italy, a gala performance was staged at the Opera House in Milan. President Gronchi fell while his chair was being moved. Two famous comic actors - Ugo Tognazzi and Raimondo Vianello - re-enacted the scene on a television channel run by the state broadcasting company, RAI. As a result they were fired immediately.

26 Alessandro Giacone, "Giovanni Gronchi," in *I Presidenti della Republica. Il capo dello Stato e il Quirinale nella storia della democrazia italiana*, eds. Sabino Cassese, Giuseppe Galasso, Alberto Melloni (Bologna: Il Mulino, 2018), 159–83.

unknown) was taken in a photographic studio, as evidenced by the standard head-and-shoulders and three-quarter profile format.[27] The new President's slight smile and his modern spectacle frames differentiated him from Einaudi's solemn looks. In 2018, Gronchi's official portrait featured on a postage stamp that commemorated the 40th anniversary of his death.

Giovanni Gronchi was the first mass-media President: he gave many interviews and magazines frequently published images of his private life (a rare occurrence with Einaudi). Of the photographs taken during his seven-year presidency one of the most famous shows Gronchi kneeling before Pope Pius XII during an official visit to the Vatican (December 6, 1955). This gesture was not spontaneous but a part of the official arrangements: by kneeling the first Christian-Democrat President wanted to display his deference toward the Catholic Church. One cannot help be struck by this aesthetic photograph: the Pope in full regalia blesses the President who wears the Order of the Golden Spur, which he has been conferred, around his neck (Figure 14.7). As was to be expected, the gesture was widely criticized in Italy for it appeared as an act of subordination toward religious authorities. A few months later Gronchi made an official visit to the United States. *Il Merlo Giallo* carried a cartoon drawn by Livio Apolloni which showed the Italian President at the US Congress (where he was making an important speech) accompanied by a sarcastic comment from Uncle Sam: "I had prepared the usual *prie-dieu*, but, instead, he wanted to come to the rostrum instead" (Figure 14.8). Gronchi's interventions in Italian foreign affairs led to many clashes with the government, which treated them as interferences, an assault upon its powers. In another *Merlo Giallo* cartoon,[28] published during Gronchi's visit to West Germany in December 1956, shows him introducing his Foreign Minister Antonio Martino to Adenauer. The German Chancellor replies: "Well I never! You've actually got a Foreign Minister!"

Antonio Segni, a Christian-Democrat who was President from 1962 until 1964, had been the architect of the Agrarian Reform of 1950, but later swung toward a more conservative position.[29] Segni had been elected to the Quirinal for his moderate views, to counterbalance the recently formed center-left government to which he was personally opposed. The official portrait, again taken by an unknown photographer, shows nothing remarkable: the President's gaze is turned conventionally toward the left and his face stands out against a dark background.[30] Segni had the look of a physically weak man: a cartoon, drawn by Livio Apolloni in 1962, depicted him as a slender, emaciated man with a suspicious look. In fact, he had a tenacious character. The leading conservative journalist Indro Montanelli remarked of him that he had "an iron constitution". In August 1964 he suffered a stroke and was forced to resign four months later. During this time the Italian population displayed great affection toward him. Segni was perceived as the "nice President", a man who was above political squabbling, as illustrated by a cartoon published by *Il Corriere lombardo* just after his

27 Cheles, "Immagini presidenziali," 158. During his foreign visits this and other similar images of Gronchi were enlarged and displayed alongside those of the host nation's head of state.

28 The cartoon is by Giuseppe Russo, alias Girus (1888–1960). http://frame.technology/dev/vitepresidenti/gronchi/la-satira/ (accessed July 9, 2019).

29 See Salvatore Mura, *Antonio Segni, La politica e le istituzioni* (Bologna: Il Mulino, 2017).

30 As we shall see, these are the same characteristics that are found in the official portraits of Giovanni Leone and Sandro Pertini.

resignation (Figure 14.9): it shows him quietly walking away from the Quirinal Palace, leaving Italian politicians fighting among themselves. The reality was quite different: Segni had been the leader of one of the Christian-Democrat party's litigious factions. However, the cartoon is a good example of the respect that heads of state commanded at the beginning of the 1960s.

It is ironic that in the midst of the group of politicians brawling in *Il Corriere lombardo* cartoon one can see the man who was to become Segni's successor: Giuseppe Saragat, a member of the Resistance movement who had spent the Fascist period in exile, and was elected President of the Constituent Assembly after the war.[31] He quit the Socialist Party, of which he was a member, when this formed an electoral alliance with the Communist Party and founded what would become the Partito Socialista Democratico Italiano (PSDI). The official portrait of Italy's fifth president was the work of the well-known photographer, Ghitta Carell (whose signature is visible on the picture).[32] Saragat's presidency (1964–1971) coincides with the revival of the political comics in Italy.[33] One of the most important was *Linus*, founded in 1965, which featured comic strips such as Charlie Schulz's *Peanuts* and Elize Crisler Sagar's *Popeye*. It was the first Italian anti-establishment comic to be published in Italy, and was able to attract many talented cartoonists. They included Tullio Pericoli and Emanuele Pirella, who loved caricaturing Saragat and after his presidency ended, often represented him as a pensioner who spent his days sitting on a park bench.[34]

The events of 1968 unleashed a storm of irreverence: young artists no longer hesitated to attack the authorities, and the highest office of the State was not spared either. Coming from Piedmont, Saragat had a taste for wine, something that was not lost on cartoonists. The magazine *Marc'Aurelio*, founded during the Fascist period,[35] drew him in a dining room full of wine bottles: a good-natured joke, but something unimaginable only a decade earlier.[36] Saragat was often criticized for his habit of sending telegrams constantly, a habit which earned him the nickname of "Peppino O'Telegramma" ('Joe the telegram' in Neapolitan dialect). When in 1969 the astronauts Neil Armstrong and Buzz Aldrin set foot on the moon, the joke spread in Italy in which one asked the other: "What's that fluttering next to the American flag?" The other replied: "It's a telegram from Saragat". A cartoon published in the right-wing magazine *Il Borghese* in 1971 at the end of his first term of office shows the President from behind, recognizable by the glass of wine in his hand, declaring: "And then, if I don't get re-elected in December, I'll finally have the chance to publish a collection of all my telegrams" (Figure 14.10).

The presidency of Giovanni Leone (1971–1978) took place against the difficult background of the so-called *anni di piombo* (years of lead), which were marked by both left- and right-wing terrorism. Leone, a Neapolitan lawyer and jurist had twice

31 Federico Fornaro, *Giuseppe Saragat* (Venice: Marsilio, 2003).

32 In 2018 this portrait would also be reproduced on a postage stamp to commemorate the 30th anniversary of Saragat's death.

33 Franco Fossati, *Guida al fumetto satirico e politico* (Milan: Gammalibri, 1979).

34 See the following section, dedicated to the presidency of Leone.

35 Many future film producers and screenwriters, among whom Federico Fellini, Ettore Scola and Cesare Zavattini, worked at the magazine. The atmosphere in the editorial office of *Marc'Aurelio* is evoked in Scola's film, *Che strano chiamarsi Federico* (2013).

36 http://frame.technology/dev/vitepresidenti/saragat/la-satira/ (accessed July 9, 2019).

been Prime Minister. He had his official portrait photograph taken by his fifteen-year-old son Giancarlo.[37] After enjoying some initial popularity, Leone became the target of the press when he indulged in behavior considered unbefitting his position (singing Neapolitan songs during foreign visits, for instance). The photograph that best seems to sum up Leone's presidency was taken in 1975. During an official visit to Pisa, a group of extreme left-wing students shouted "Death to Leone!". The President replied with the "horn gesture", the clenched fist with the index and little finger extended that is supposed to ward off bad luck. He had done this on other occasions, but never before had the gesture been captured by photographers. The head of state eventually became a kind of comic stooge, lampooned by the press on a daily basis. The President's honesty was also placed doubt by a series of scandals, especially the Lockheed Affair, which involved many world politicians.

The far-left newspaper *Lotta Continua* published a series of cartoons entitled *Il Naso del presidente*[38] in which the President's nose was transformed into the shape of a Lockheed military aircraft.[39] The attacks culminated in 1978 when the journalist Camilla Cederna (later found guilty of libel) savagely attacked him in a pamphlet entitled *Giovanni Leone, la carriera di un presidente*.[40] Leone's period of office coincided with the rise of the cartoonist Giorgio Forattini, author of collections of cartoons that became undisputed national bestsellers. *La Repubblica* newspaper, founded in 1976, carried each day a Forattini cartoon on its front page that provided a scathing comment on current politics. A comic strip by Pericoli & Pirella, published on November 20, 1977, depicted Leone sitting next to his predecessor Saragat on a park bench and explaining to him that at the end of his term in office he would be free to do exactly what he wanted, like "singing with emigrants, defending small-time crooks in court and making the horn gesture". Saragat's response was: "This man must have really suffered."[41] The end of Leone's term was dramatic. The President looked on helplessly as the Red Brigades kidnapped the Christian-Democrat leader Aldo Moro, whose body was eventually found on May 9, 1978. One month later, politically isolated and abandoned even by his own party, Leone was forced to resign. Forattini's cartoon portrayed him swallowed up in a whirlpool: only his hand remains visible, determinedly making its famous horn gesture (Figure 14.11).

The presidency of Sandro Pertini (1978–1985) represents a key moment in the history of the Republic.[42] Pertini was a Socialist who had been a prominent figure of the Resistance and spent much of his youth in prison during Fascism. Elected at the age of 82, he enjoyed extreme popularity on account of the image of great probity he conveyed – an image that struck a chord in a period marked by numerous scandals – and of his informality and ability to communicate. His official portrait, the work of the

37 Cheles, "Immagini presidenziali," 160.
38 Vincino, *Il naso del Presidente* (Rome: Savelli, 1976).
39 During the years that followed his presidency the courts recognized Leone's total lack of involvement in the affair.
40 Camilla Cederna, *Giovanni Leone, La carriera di un presidente* (Milan: Feltrinelli, 1978).
41 Tullio Pericoli and Emanuele Pirella, *Falsetto. Cronache italiane dei nostri giorni* (Milan: Bompiani, 1982), 132.
42 Andrea Gandolfo, *Sandro Pertini dall'accesa al Quirinale allo scandalo della P2 1978–1981* (Rome: Aracne, 2017). Also Gandolfo, *Sandro Pertini. Dalla stagione del pentapartito agli ultimi anni 1981–1990* (Rome: Aracne, 2018).

Cantera photographic studio,[43] is in many ways conventional, though the strong light adds a dramatic quality to it. The intense gaze aptly expresses his determined character; the contrast of light in the photograph seems to cut the face in two. However, the images of Pertini that enjoyed the greatest popularity were the non-official ones that depicted him as a good-natured, smiling grandfather figure with a pipe in his hand (he was, incidentally, a keen pipe collector). It is one of these portraits, rather than the official one, that was chosen for the postage stamp issued in 1996 to commemorate the hundredth anniversary of his birth.[44]

Many consider Pertini to be the first "pop president" on account of his unconventional behavior, often tinged with a certain degree of populism, and of his constant presence in the mass media. His presidency coincided in fact with the media revolution of the early 1980s, which saw the development of private television networks. Pertini was interviewed, filmed and photographed on an almost daily basis; his appearance in the media ensured high audience numbers and newspaper and magazine sales. One of the most famous images of his presidency, which was to become an Italian icon of the 1980s, was taken at the 1982 World Cup Final held in Madrid: it shows Pertini celebrating the victory of the Italian team, a victory that united a politically divided nation, with the enthusiasm of a little boy (Figure 14.12). A friend of many artists, Pertini was the subject of numerous statues and pictures, some of which are kept at the Turati foundation in Florence and at the Sandro Pertini and Renata Cuneo museum in Savona, although they have never been exhibited publicly.[45]

Pertini was fond of political satire. Having been a newspaper editor who also dealt with its pictures, he was aware of the problems faced by cartoonists. In the lengthy interview that he gave to writer and semiologist Umberto Eco, published in a collection of satirical drawings by Pericoli & Pirella,[46] he remarked: "The first thing I do when I buy *la Repubblica* is to look at the cartoon." He confessed to collecting all the caricatures that featured himself. Pertini, a big fan of the French satirical weekly *Le Canard Enchaîné*, told Eco that he would have loved to see a similar publication in Italy. During an official trip to France in 1982, Pertini visited the magazine's headquarters in Paris. He is the only political figure to have ever been granted such a privilege by a weekly that has always been proud of its political independence and is well known for its iconoclastic attitude to authority. Cartoonists loved drawing Pertini. A Forattini drawing greeted Pertini's election on July 8, 1978 by representing him as a sprightly old gentleman, with his beloved pipe in mouth, flying toward his destiny on a broomstick shaped like a carnation, the symbol of the Socialist Party[47] (Figure 14.13). Even the far-right was benevolent toward him. *Il Secolo d'Italia*, the official organ of the neofascist Movimento Socialista Italiano, drew Pertini as the bowl of a pipe with

43 Cheles, "Immagini presidenziali," 160.

44 http://www.iboli.it/php/em-italia–2529-Ritratto%20Alessandro%20Pertini.php (accessed July 9, 2019).

45 Internet sites accessed April 25, 2019. http://www.fondazionestudistoriciturati.it/archivio/collez-pertin i1986–1990/ and http://www.comune.savona.it/IT/Page/t09/view_html?idp=423.Twelve pictures are kept at the Fondazione Turati in Florence. I thank Stefano Caretti for this information.

46 "Quando facevo le vignette anch'io" in Tullio Pericoli and Emanuele Pirella, *Falsetto, cronache italiane dei nostri giorni* (Milan: Bompiani. 1982), 5–9.

47 The carnation had been chosen by Socialist Party secretary, Bettino Craxi, as the official party symbol in memory of the Portuguese "Carnation Revolution" of 1974.

the caption "calumet della pace" (the pipe of peace).[48] Pertini's presidential mandate coincided with the appearance of *Il Male* (The Evil), a weekly magazine published between 1978 and 1982.[49] Inspired by the caustic and irreverent style of the French magazines *Hara-Kiri* and *Charlie Hebdo*, *Il Male* broke every taboo, viciously attacking even the Pope and Aldo Moro during his period of imprisonment in the hands of the Red Brigades. However, when it came to represent Pertini, a tamer approach was pursued: one cartoon shows him at the wheel of a sports car with a young woman at his side: "The Republic's 30th Birthday, Pertini's 80th."[50] Andrea Pazienza, one of the cartoonists of *Il Male*, built up a special relationship with the 'partisan-president': in a series of drawings representing "Pert e Paz", the artist imagines himself with Pertini during the Resistance. The image of two wary characters waiting for the enemy (the future President is shown sucking on his pipe while holding a rifle), was to be constantly reprinted after the artist died aged thirty-two.[51]

The Christian-Democrat Francesco Cossiga, elected president at the age of fifty-seven in 1985, was the first not to belong to the generation of founding fathers of the Republic. He had been Italy's youngest Minister of the Interior, Prime Minister and President of the Senate. His official portrait sought to give an impression of modernity:[52] Color was used for the first time and the image features the Italian flag together with a tapestry in the background. His presidency, which coincided with the fall of the Berlin Wall and the beginning of the collapse of traditional party system, is usually seen as being divided into two distinct phases: during the first five years he kept a low profile; then he started to intervene in public affairs more virulently, criticizing the government, the political parties and the magistrature.[53] Cossiga defined the views he expressed as *picconate* (pickaxe blows), as a result of which cartoonists represented him wielding the tool in question. Cossiga's term of office was marked a renaissance in political satire. *Cuore*, the satirical supplement of the Communist daily *l'Unità*, began to appear in 1988. Its editor, Michele Serra, assembled the cream of Italian cartoonists: Staino, Altan, Vincino, Vauro and Ellekappa. In 1991, *Cuore* became a periodical in its own right and enjoyed considerable success with weekly sales of up to 140,000, a record for any Italian satirical publication. Cossiga the pickaxe-man became one of its main targets. The front cover of May 27, 1991 depicted Cossiga in full-flow, surrounded by *Cuore*'s cartoon characters who, driven to desperation, are plugging their ears. The caption goes: "We give in. Just shut up!"

The last four presidents of the Republic will be dealt with more briefly. The Christian-Democrat Oscar Luigi Scálfaro was elected in dramatic circumstances in 1992 after the

48 http://frame.technology/dev/vitepresidenti/pertini/la-vita-privata/ (accessed July 9, 2019).

49 Oreste del Buono, cited in Franco Fossati, *Guida al fumetto satirico e politico*, 185.

50 https://www.dagospia.com/mediagallery/dago_fotogallery–44212/351281.htm

51 See the collection of comic drawings by Andrea Pazienza, *Pertini* (Rome: Fandango libri, 2010). This volume includes a memoir by Dario Fo.

52 From Cossiga onwards the task of photographing official portraits was no longer given to private studios but to the Istituto Poligrafico e Zecca dello Stato (State Printing Institute and Mint) under the supervision of Claudio Milza. See Cheles, "Immagini presidenziali," 160.

53 Ludovico Ortona, *La svolta di Francesco Cossiga. Diario del settennato (1985–1992)* (Turin: Aragno, 2016).

assassination of the anti-mafia judge, Giovanni Falcone.[54] His official portrait (which was reproduced in 2018 on the postage stamp commemorating the centenary of his birth) shows Scálfaro in the traditional head and shoulder, three-quarter pose with an Italian flag in the background. He props his face on his left hand to hide his double chin and wears the discretely small pin of the head of state (a feature that was to be copied by his successors) thus breaking with the tradition that the president should be indistinguishable from the ordinary citizen. Scálfaro's presidency (1992–1999) was troubled by investigations that led to the break-up of most of the political parties that had founded the Republic. Having been a magistrate in his younger days, Scálfaro backed the crusading efforts of the Milanese judges who discovered a web of corruption that came to be known as *Tangentopoli* (Bribesville), but at the same time condemned some judges for methods used to obtain confessions from politicians. In his end-of-year speech on December 31, 1997, the President described as "deplorable" the "jangling of handcuffs in the faces of those being questioned". This expression, which referred metaphorically to detainment in police custody, became well known, also thanks to satirical cartoons in which the President can be seen rattling a pair of handcuffs against the background of the presidential palace.

Carlo Azeglio Ciampi was the first President not to be a member of any political party (though in the immediate post-war period he briefly joined the Partito d'Azione, an antifascist liberal-socialist party). The Governor of the Bank of Italy from 1979 until 1993, Prime Minister from 1993 to 1994, and Minister of Economic Affairs from 1996 to 1999, Ciampi was a key figure behind Italy's adoption of the Single European Currency. His election to the presidency on the first ballot, in which he gained the approval of almost all political parties, was a clear recognition of his achievements in this area. During his term of office (1999–2006) Ciampi made efforts to relaunch the idea of national identity (he reinstated the celebration of the National Day which had been abolished in 1977) and to strengthen pro-Europeanism.[55] The background of his official portrait is similar to that of Cossiga: Ciampi is photographed before a tapestry, next to the national flag. The President has adopted a piercing, slightly frowning expression,[56] a sign of his authority. Like Pertini, Ciampi enjoyed great popularity and satirists always treated him well. In an interview, Forattini admitted that it was difficult to make fun of someone he liked: he depicted him as a good-natured, tail-wagging dog called Ciappi, playing on the similarity of the Head of State's name to that of a well-known dog food. Forattini devoted a series of cartoons to him that represented him as the "Pedigree President" intent on making a speech in front of the nation's flag (Figure 14.14). The volume is dedicated to the President "who for the first time, more than fifty years after the birth of the Republic, has officially used the word Motherland".[57]

The former Communist Giorgio Napolitano continued Ciampi's work of defending pro-Europeanism and the idea of the Motherland. His presidency (2006–2015) was the longest of the Republic's history: it stretched over two terms.[58] The official portrait

54 Giovanni Grasso, *Scalfaro, L'uomo, il presidente, il cristiano* (Milan: San Paolo, 2012); Guido Dell'Aquila, *Scalfaro, democristiano anomalo* (Florence: Passigli, 2018).

55 Umberto Gentiloni Silveri, *Contro scettici e disfattisti, Gli anni di Ciampi (1992–2006)* (Rome-Bari: Laterza, 2013).

56 Ciampi's thick eyebrows were the physical characteristic most frequently highlighted by cartoonists.

57 Giorgio Forattini, *Ciappi, un presidente di razza* (Milan: Mondadori, 2002).

58 Vincenzo Lippolis and Giulio Salerno, *La presidenza più lunga. I poteri del capo dello Stato e la Costituzione* (Bologna: Il Mulino, 2016).

photograph of 2006, re-used after his re-election in 2013, displays some innovations: Napolitano looks straight into the camera (only Gronchi had done so before), and the background includes the European flag and some shelves with books to indicate that the setting is the presidential library. These details portray Napolitano as a cultivated and fervently pro-European figure. Cartoonists often lampooned Napolitano: an exhibition of caricatures entitled *Napolitaneide*, organized at Forte dei Marmi in Tuscany in 2012, included more than one hundred drawings.[59] Of particular note is the work of Emilio Giannelli who, after Forattini's retirement, became the undisputed "prince" of Italian cartoonists. His drawings began to appear on the front pages of the *Corriere della Sera* newspaper in 1991. Due to a certain physical likeness to Umberto II, the last king of Italy, Napolitano was nicknamed "Re Giorgio" (King George). In 2013 Giannelli drew him wearing a crown and ermine cape together with a caption that mimicked Louis XIV's motto "L'État c'est moi" (I am the State): "L'État" has however been turned into "L'età" (The age) – a reference to the fact that Napolitano had been re-elected at the age of 88 (Figure 14.15).

The official portrait of the current President, the Christian-Democrat Sergio Mattarella (in office since 2015) features a tapestry and the Italian and European flags. In the background[60] Forattini celebrated Mattarella's election by playing with his name, which evokes the *mattarello* (rolling pin): he drew a *Mattarella* being flung at a turreted Italy (Figure 14.16). During his first years in office the current President has been notable for his great discretion, limiting his public declarations to a minimum, and this against the growing trend of employing social media. Giannelli's cartoon depicts Mattarella as Michelangelo's famous statue of Moses: legend has it that when the artist had completed his sculpture and gazed upon the perfection he had created, a perfection which lacked only the power of speech, he exclaimed: "Why don't you talk?"[61]

A number of conclusions can be drawn from this brief examination of the official portraits and cartoons of the Italian presidents. After the years of fascism and of the monarchy, during which images of both the Duce and the king were omnipresent, the Republic has preferred a more reserved approach, demonstrated by the absence of portraits in schools and public spaces. Shying away from pomp, the residents have presented themselves without any insignia of power. The presidents' official photographs are now in color and feature more symbolic elements, the principal ones being the Italian and European flags. However, the approach remains restrained to promote the idea of a Republic where the president is no different from any ordinary citizen.

Satire is a well-established art form in Italy. During the fascist period and just after the war, self-censorship and caution prevailed. Cartoonists later became savagely irreverent, particularly so during periods of social upheavals. Unlike party figures, Italian presidents are treated benevolently by cartoonists, mindful of Article 87 of the Constitution which declares that they represent national unity and cannot therefore be depicted in an undignified way.

59 http://www.affaritaliani.it/politica/al-via-la-mostra-satirica-su-napolitano280512.html (accessed April 25, 2019).
60 Exhibited in Italian public spaces, the official photograph of the President can be seen on the official website of the Quirinale: https://www.quirinale.it/page/biografia (accessed July 9, 2019).
61 https://www.corriere.it/foto-gallery/la-vignetta/18_ottobre_01/vignetta-giannelli-d37511e2-c53b-11e8-994e-6382a2ca0409.shtml (accessed July 9, 2019).

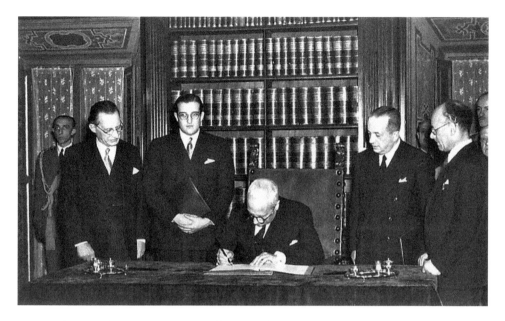

Figure 14.1 President Enrico De Nicola signs the Constitution, 1948. (Photo: Presidential Library and Archives).

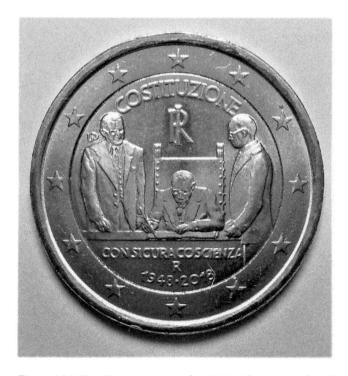

Figure 14.2 Two Euro coin, issued in 2018. The image is based on the photograph in Fig. 14.1.

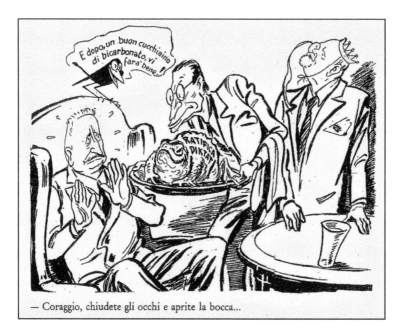

Figure 14.3 "Come along and close your eyes". Cartoon by Girus, *Merlo giallo*, 1947. (From: Angelo Olivieri, *Sette anni di guai, I Presidenti della Repubblica nella satira 1946-1992*, Bari: Dedalo, 1992).

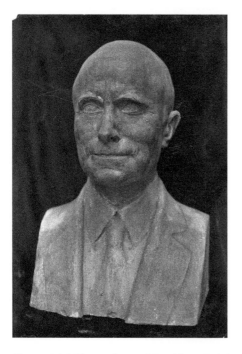

Figure 14.4 Plaster bust of President Luigi Einaudi by Pietro Canonica, 1948, *Museo Pietro Canonica*, Rome. (© Roma – Sovrintendenza Capitolina ai Beni Culturali).

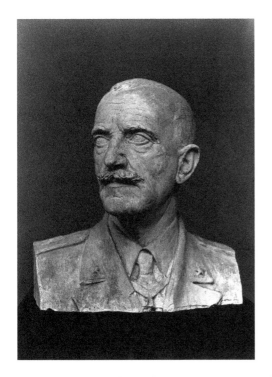

Figure 14.5 Plaster bust of King Victor Emmanuel III by Pietro Canonica, 1936, *Museo Pietro Canonica*, Rome. (© Roma – Sovrintendenza Capitolina ai Beni Culturali).

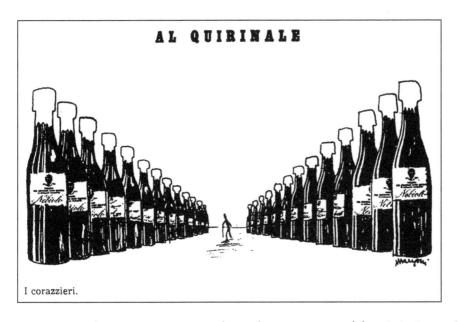

Figure 14.6 "The *corazzieri*". Cartoon by Carlo Manzoni, *Candido*, 1950. (From: Olivieri, *Sette anni di guai*).

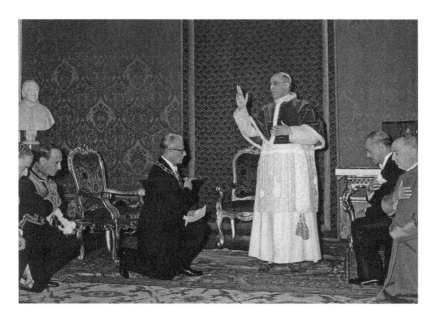

Figure 14.7 President Gronchi kneeling before Pope Pius XII, during a state visit to the Vatican, 1955. (Photo: Presidential Library and Archives).

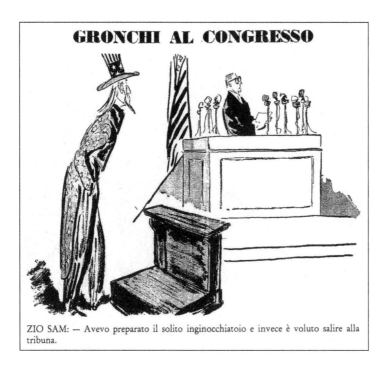

Figure 14.8 "Gronchi at Congress. Uncle Sam: 'I had prepared the usual *prie-dieu*, but he wanted to come to the rostrum instead'." Cartoon by Apolloni, *Merlo giallo*, 1956. (From: Olivieri, *Sette anni di guai*).

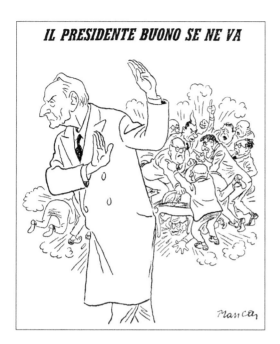

Figure 14.9 "The good President is leaving". Cartoon by Manca, *Corriere Lombardo*, 1964. (From: Olivieri, *Sette anni di guai*).

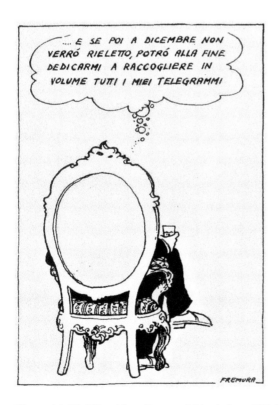

Figure 14.10 "[President Saragat:] 'And then, if I don't get re-elected in December, I'll at last have the chance to publish a collection of all my telegrams'." Cartoon by Fremura, *Il Borghese*, 1971. (From: Olivieri, *Sette anni di guai*).

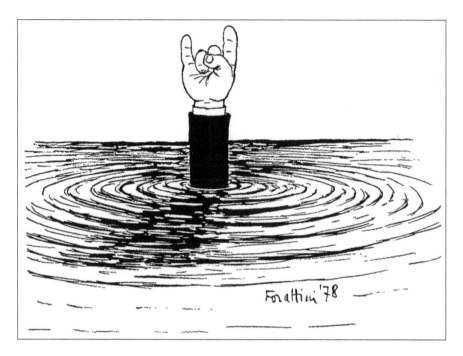

Figure 14.11 "[President] Leone resigns". Cartoon by Forattini, *La Repubblica*, 1978. (Scala, Florence).

Figure 14.12 Sandro Pertini rejoices at Italy's victory at the World Cup, 1982. (Photo: Presidential Library and Archives).

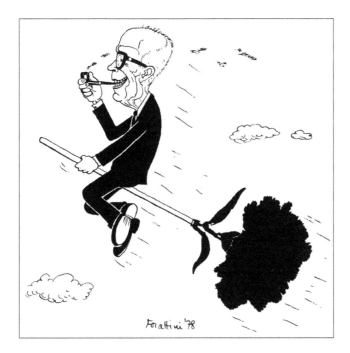

Figure 14.13 "Sandro Pertini elected President". Cartoon by Forattini, *La Repubblica*, 1978. (Scala, Florence).

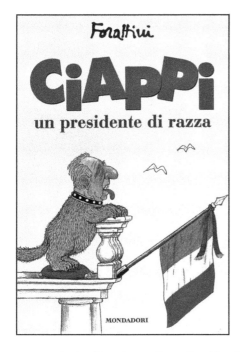

Figure 14.14 "Ciappi, a pedigree President". Cartoon by Forattini, *La Repubblica*, 2002 here reproduced from the cover of an anthology of his cartoons. (Scala, Florence).

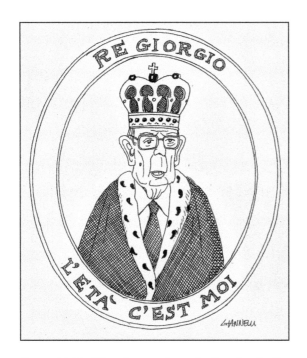

Figure 14.15 "King George, I am the State/age". Cartoon by Giannelli, *Il Corriere della Sera*, 2013.

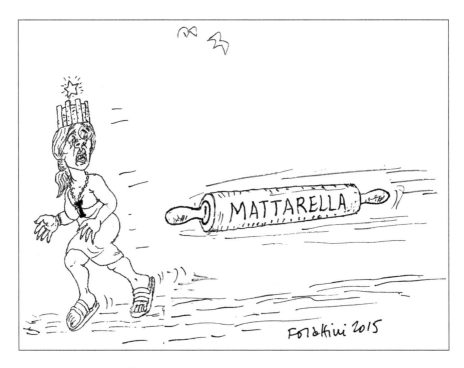

Figure 14.16 Mattarella/Rolling pin running after Italy. Cartoon by Forattini, *La Repubblica*, 2015. (Scala, Florence).

Bibliography

Cassese, Sabino, Giuseppe Galasso, and Alberto Melloni, eds. *I Presidenti della Repubblica. Il Capo dello Stato e il Quirinale nella storia della democrazia italiana*. Bologna: Il Mulino, 2018.

Cheles, Luciano, and Alessandro Giacone, eds. *Il ritratto e il potere. Immagini della politica in Francia e in Italia nel Novecento*. Pisa: Pacini, 2017.

Fossati, Franco. *Guida al fumetto satirico & politico*. Milan: Gammalibri, 1979.

Lumley, Robert. "The Last Laugh: *Cuore* and the Vicissitudes of Satire." In *The Art of Persuasion. Political Communication in Italy from 1945 to the 1990s*, edited by Luciano Cheles and Lucio Sponza, 232–57. Manchester - New York: Manchester University Press, 2001.

Mazzotta, Gabriele, ed. *Seduzioni e miserie del potere: visto da sinistra, visto da destra. Galantara, Scalarini, Sironi, Guareschi, Altan*. Vicenza: Mazzotta, 2005.

Moisio, Roberto. *Altan (Autobiografia non autorizzata)*. Milan: Skira, 2019.

Olivieri, Angelo. *Sette anni di guai. I Presidenti della Repubblica nella satira*. Bari: Dedalo, 1992.

Ridolfi, Maurizio, ed. *I Presidenti. Storia e costumi della Repubblica nell'Italia democratica*. Rome: Viella, 2014.

Rossi, Sergio, ed. *L'immaginazione al potere. Gli anni settanta tra fumetto, satira e politica*. Milan: BUR, 2009.

Pericoli, Tullio, and Emanuele Pirella. *Falsetto. Cronache italiane dei nostri giorni*. Milan: Bompiani, 1982.

Vincino. *Il Male. 1978–1982. I cinque anni che cambiarono la satira*. Milan: Rizzoli, 2007.

15 Staging Power in France

Political Portraiture from Mitterrand to Macron

Luciano Cheles

In the early years of the post-war period the use of portraiture for campaigning purposes was looked at with some suspicion in France. The personalization of political activity brought back memories of Marshal Philippe Pétain, whose effigy was ubiquitous when he governed the country from July 1940 to August 1944, the years of the Nazi Occupation.[1] Moreover, the parliamentary system of the Fourth Republic (1946–1958), strongly party-based, discouraged the promotion of the figure of the leader. The fragmentation of the vote produced by proportional representation led to coalitions that were formed on the basis of ideologies and programs, rather than around personalities; the figures in charge of parties acted mostly as chief administrators.[2]

However, some distinguished figures enjoying strong devotion among their supporters did not disdain personalization. Pierre Mendès France, who led a left-wing coalition government from 1954 to 1955, and Maurice Thorez, who was the General Secretary of the French Communist Party from 1930 to 1964, were often featured on printed publicity. In Thorez's case, the practice was legitimized by Stalin's example. Care was however taken to depict him in informal poses and smiling to stress that he was *un homme du people* (an ordinary man). A good example is the 1951 poster designed by André Fougeron, the party's artist-propagandist: Thorez is shown with an open shirt and rolled up sleeves facing the viewer and pointing his right arm toward a luminous point that stands for the future, as the slogan makes clear: "Vers l'avenir. Tous ensemble avec le Parti Communiste **Français**" (Toward the future. All together with the French Communist Party).[3] The image is most probably based on Iraklii Toidze's famous Second World War poster "The Motherland Calls!" which depicts a similarly-postured "Mother Russia" figure urging people to defeat fascism.[4]

1 Laurent Gervereau and Denis Peschanski, eds., *La propagande sous Vichy, 1940–1944* (Paris: BDIC, 1990); Dominique Rossignol, *Histoire de la propagande en France de 1940 à 1944. L'utopie Pétain* (Paris: Presses Universitaires de France), 1991.

2 On the question of personalization, see Christian Delporte, *Images et politique en France au XXe siècle* (Paris: Nouveau Monde, 2006), 279–98.

3 Philippe Bouton and Laurent Gervereau, *Le couteau entre les dents. 70 ans d'affiches communistes et anti-communistes* (Paris: Chêne, 1989), 138. On the iconography of Thorez in general, see Sante Cruciani, "L'immagine di Palmiro Togliatti e di Maurice Thorez nel movimento comunista internazionale," in *Il ritratto e il potere. Immagini della politica in Francia e in Italia nel Novecento*, eds. Luciano Cheles and Alessandro Giacone (Pisa: Pacini, 2017), 123–42.

4 On this picture, see Victoria E. Bonnell, *Iconography of Power. Soviet Political Posters under Lenin and Stalin* (Berkeley – Los Angeles – London: University of California Press, 1997), 244, 265, fig. 6.1.

Charles de Gaulle, the hero of the French Resistance against Nazi German, who presided as the country's interim government following its liberation, was also frequently portrayed on propaganda material, both during the war and in the early post-war years, albeit usually in an understated way to avoid accusations that he was power-hungry. One of his best-known posters is that released in 1947 to call the French to support his newly-founded Rassemblement du Peuple Français (Rally of French People): it shows him delivering a speech in a pose and facial expression echoing that of Marianne behind him.[5]

Another political figure who personalized his campaign is Pierre Poujade, the founder of the Union de Défense des Commerçants et Artisans (Union for the defense of shop-keepers and craftsmen), who claimed to fight for the small business and the small town, and called for revolt against government taxation, enjoying some popularity especially in the mid-1950s. An election poster disseminated for the parliamentary election of 1956 shows him with an open shirt to indicate his closeness to ordinary people, and beaming, an expression that conveyed enthusiasm, self-assurance and trustworthiness.[6] It was the first time the broad smile was used for political ends on a French poster.[7]

Electioneering and the Rise of the Political Consultant

The electoral system of the Fifth Republic, established by de Gaulle in 1958, greatly affected the nature of campaigning: the run-off voting for the election of the president of the Republic, who acquired strong executive powers, and for that of the members of the National Assembly personalized the contest. This led to a greater reliance on the candidates' portraits. Personalization was also the result of the growing role of television, which had been broadcasting political communiqués and interviews with party leaders since the mid-1950s. The mediatization of politics forced politicians to be conscious of the way they looked and behaved.[8]

The first personalities to have understood the great propaganda potential of television, and of images in general, are Jean Lecanuet and François Mitterrand. Lecanuet,

5 On visual representations of de Gaulle, see Jean-Pierre Guichard, *De Gaulle par l'affiche* (Paris: Institut Charles de Gaulle – Librairie Plon, 1980); Alain Gesnon, *De Gaulle: sur les murs de France* (Paris: CIRIP – Musée de l'affiche politique, 1991); and Zvonimir Novak, *Tricolores. Une histoire visuelle de la droite et de l'extrême droite* (Montreuil: L'Echappée, 2011), 177–218.

6 This and other posters of Poujade representing him in shirtsleeves and smiling can be seen by entering the keywords "Pierre Poujade posters" in Google Images. Interestingly, Guglielmo Giannini, the leader of the Italian populist Uomo Qualunque (Man in the Street) party that he founded in 1946, had also broken sartorial conventions by having himself represented in the so-called *Navicella*, the manual featuring the photographs and biographical details of all parliamentarians, with an open shirt to signal his anti-system stance. See Fabrice D'Almeida, *La Politique au naturel. Comportement des hommes politiques et représentations publiques en France et en Italie du XIXe au XXIe siècle* (Rome: Ecole Française de Rome, 2007), 292.

7 The smile – radiant, slight, sweet or mischievous – will feature with increasing frequency in the portraits of French politicians. (See below). On the impact of the smile in the domain of politics, see Michael Süflow and Marcus Maurer, "The Power of Smiling. How Politicians' Display of Happiness Affect Viewers' Gaze Behavior and Political Judgments," in *Visual Political Communication*, eds. Anastasia Veneti, Daniel Jackson and Darren G. Lilleker (Cham, Switzerland: Palgrave Macmillan, 2019), 207–24. This study offers interesting insights though it relates to a German context.

8 There is no doubt that the posture assumed by de Gaulle at the end of the speech he gave at Place de la République in Paris on September 4, 1958 to present the new Constitution – he outstretched his arms to form a "V" sign – was intended to be mediatized. The photograph quickly achieved iconic status.

a leading figure of the centrist Christian-inspired Mouvement Républicain Populaire, MRP, which was strongly critical of de Gaulle's hostility to European integration as a supra-national model, was a minor figure of the political landscape at the start of the presidential contest of 1965.[9] The marketing techniques used by Lecanuet's campaign manager Michel Bongrand, whose company Services et Méthodes had launched James Bond books and films in France, succeeded in turning him into one of the protagonists of the election. Young – he was forty-five at the time – sporty and personable, the candidate was presented as "le Kennedy français", and appeared on posters and brochures with an endearing broad smile, which earned him the nick-name *Dents blanches* (White teeth).[10]

The campaign of François Mitterrand, the forty-nine-year-old candidate supported by various left-wing parties, also emphasized his youth, but associated this feature with technological advances and the transformations they brought to France's economy, to imply that a country that aspired to be modern could not be run by an elderly states-man (de Gaulle, his main competitor, was seventy-five years old at the time). His poster, produced internally, depicted him gazing afar, toward the future, with a high-voltage pylon standing in the countryside and smoking factory chimneys in the background, to appeal to, and federate, both rural and urban France. The slogan urged people to vote for "Un Président jeune pour une France moderne" (A young president for a modern France) and stressed that he was "le candidat unique de la Gauche" (the candidate of the united Left). De Gaulle's poster depicted him against a fluttering tricolor that filled half of the picture, turned toward a group of people who extend their arms toward him adoringly (Figure 15.1). It is a triumphant image that celebrates him as a charismatic figure – "Confiance à de Gaulle" (Have faith in de Gaulle) declares the slogan – and reminds his compatriots that they owe their country's liberation to him. De Gaulle was eager to impose himself after his leadership had come under strong attack from the military and the French born in Algeria (the *pieds-noirs*, literally "black feet") for granting independence to that country.[11]

9 This was the first direct election of the Fifth Republic, since in 1958, under the first draft of the Constitution, De Gaulle had been elected President by an electoral college. The most informative and best illustrated volume on the graphic propaganda of the election of 1965, and that of the presidential and parliamentary elections of the following two decades, is Jean-Marc and Philippe Benoit and Jean-Marc Lech, *La politique à l'affiche. Affiches électorales et publicité politique, 1965–1986* (Paris: Editions du May, 1986).

10 Christian Delporte, *Une histoire de la séduction politique* (Paris: Flammarion, 2011), 155–8. On account of his youthful, telegenic and "nice guy" looks, President Emmanuel Macron has been compared with Lecanuet. See Olivier Pérou, "Emmanuel Macron, réincarnation de Jean Lecanuet?," *Le Point*, April 7, 2016 https://www.lepoint.fr/politique/emmanuel-macron-reincarnation-de-jean-leca nuet-07-04-2016-2030613_20.php (This link and the following cited in this essay were last accessed on October 10, 2019). By a strange coincidence, the name of Macron's party, En Marche, partly echoes the slogan of Lecanuet's campaign: "Un homme neuf ... Une France en Marche" (A new man ... A France moving forward).

11 Curiously, Mitterrand's poster (Benoit, Benoit and Lech, *La politique a l'affiche*, 41) and that of de Gaulle are reminiscent of certain propaganda images of Stalin's and Pétain's regimes respectively. The first recalls Fyodor Shurpin's well-known painting *The Morning of Our Motherland* (1948), which depicts Stalin looking into the distance before a rural landscape that includes some pylons – symbols of his country's modernity. On this painting, see Peter Burke, *Eyewittnessing.The Uses of Images as Historical Evidence* (Ithaca, NY: Cornell University Press, 2006), 30, who also reproduces it on the book's cover. De Gaulle's poster evokes some Vichy publications showing an elderly Pétain being cheered

Lecanuet's successful campaign encouraged other parties to appoint professional advertisers. De Gaulle, who had relied on his party's activists to fight the presidential race of 1965, from which he was to come out victorious, was happy to follow the growing trend: to campaign for the parliamentary election of 1967 he turned to no other than Michel Bongrand, who realized a poster that depicted him sitting behind his desk at the Elysée Palace, with both hands (natural symbols of power and action) resting conspicuously on it.[12]

Posters reproducing the effigy of the candidates played an increasingly dominant role, and because their conception was the result of marketing techniques, they tended to look like commercial advertisements. In Bongrand's view this was legitimate because both political communication and advertising "[aim to understand] public opinion in the widest sense, and, through the invention of words, sentences and images, touch people in their intimacy".[13] The advertisers' greater emphasis on images and the use of emotional messages changed political communication radically: the representation of ideals and values came to be replaced with gimmicky pictures that functioned as brand imagery intended to provide individual candidates with "corporate identities".

The image devised in 1974 by the advertising agency Havas for the first round of the presidential campaign of Valéry Giscard d'Estaing, leader of the center-right Fédération Nationale des Républicains Indépendants, FNRI, aptly illustrates the new approach. The candidate, who was to win the election, does not pose, but appears in a relaxed mood with his younger daughter against a nondescript background[14] (Figure 15.2). Made to look like an ordinary family snapshot, the picture, which was reproduced on giant billboards as well as posters, aimed to humanize the cold techno-crat image of a politician who had repeatedly been a minister of economy and finance: it spelled informality, youth and family values.

Giscard d'Estaing was to abandon the spontaneous and light-hearted approach when he fought the campaign of the presidential election of 1981. The poster of the first round depicted him at close range with a serious expression, against a dark back-ground – a more formal portrait that was deemed appropriate to his status of outgoing president. The slogan "Il faut un Président pour la France" (France needs a president) implied that he alone had a presidential stature, and therefore deserved to be entrusted with a second mandate.[15]

In marked contrast with Giscard, Mitterrand, who had become leader of the Socialist Party (Parti Socialiste, PS) in 1971, chose not to rely on professionals when he stood again as the candidate of the Left in 1974: his campaign was entrusted to his close friend Claude Perdriel, the general manager and owner of the left-wing weekly *Le Nouvel Observateur*. Posters and billboards featured a small photograph of the

by children. A good example is provided by the cover of Paluel-Marmont's children's book *Il était une fois un Maréchal de France* (Paris: Editions et Publications Françaises, 1941).

12 As Elias Canetti remarks in his seminal study *Crowds and Power* (New York: Continuum, 1973), 390: "We expect someone who is sitting to remain sitting. The downward pressure of his weight confirms his authority. [...] When a man sits it is physical weight which he displays." For an illustration of de Gaulle's poster, see Laurent Gervereau, *La propagande par l'affiche* (Paris: Syros-Alternatives, 1991), 134.

13 Michel Bongrand, *Le marketing politicien* (Paris: Bourin, 2006). Quotation cited from Barbara Atlan, *Politiques, affichez-vous* (Paris: L'Harmattan, 2012), 19.

14 Benoit, Benoit and Lech, *La politique à l'affiche*, 54–5.

15 For this and other posters that were produced to support his candidature, ibid., 76–9.

candidate's face and gave maximum visibility to the accompanying text printed in large characters – "'La seule idée de la droite est garder le pouvoir. Mon premier projet vous le rendre.' François Mitterrand" ('The right's sole concern is to hold on to power. My primary project is to put power back into your hands.' François Mitterrand).[16] The emphasis placed on the words to the detriment of the portrait suggested that ideology came before personalities and presented the Left as ethically rigorous and distrustful of politics as spectacle. However, the Socialist leader was soon to adopt a totally different strategy, one more akin to that which other parties were pursuing.

François Mitterrand and Jacques Séguéla

Mitterrand's turnaround occurred in 1976, when he approached Jacques Séguéla, co-founder of the advertising agency RSCG, to ask him to organize a campaign that was entirely personality-based for the local election of the following year. Billboards were produced that depicted the candidate wearing ordinary clothes (corduroy trousers, rather than a suit), walking alone along a beach at dusk.[17] It is an aesthetic and somewhat romantic picture that presents Mitterrand as a thoughtful, nature-loving personality (Figure 15.3).[18] The slogan "Le Socialisme, une idée qui fait son chemin" (Socialism, an idea that is gaining acceptance) evokes Mao's Long March: this event, which marked the beginning of the Chinese leader's ascent to power, as well as his reaching of the Great Wall, has come to mean that to achieve ambitious goals one must necessarily overcome difficulties. Iconographically, the image alludes to the famous poster *Chairman Mao goes to Anyuan*, based on a painting executed by Liu Chunhua in 1968, which represents the leader walking alone in the wilderness on his way to Anyuan in 1921 to mobilize the miners on strike and organize the workers' movement.[19] It is ironic that in order to present a moderate image Mitterrand should have sought inspiration from a picture representing Mao preparing his revolution.

The image of a pensive Mitterrand immersed in nature anticipated that of the poster "La force tranquille" (The quiet strength) which Séguéla devised for his campaign of 1981. Here the leader appears against an idyllic landscape, with the pink, white and light blue hues of the early morning sky evoking the French tricolor (Figure 15.5). The poster is rich in meanings and subtle allusions. Echoing the expression used by the Socialist Prime Minister Léon Blum in June 1936 when he announced in Parliament that his party had formed a *Front Populaire* with the Communists, the slogan's oxymoron sought to reassure the electors that his Socialist project would not be so radical as to upset well-established lifestyles and traditions. The rural landscape, which included a small church, was a celebration of the *douce France* (sweet France) extolled by many singers and writers, which also happened to be the *France profonde* (deep

16 Ibid., 52–3.

17 Ibid., 56–7.

18 This image was to be copied shamelessly by the conservative candidate Jacques Chirac (see below) in a brochure produced for the presidential election of 1995 (Figure 15.4).

19 On this poster, of which 900 million copies were disseminated in China during the Cultural Revolution, see Stefan Landesberger's chapter "Faces of Mao", in this volume, pp. 154–5, 165, Figure 9.7. Mitterrand visited China in 1960 and met Mao; he provided an account of his trip in the volume *La Chine au défi* (Paris: Julliard, 1961). The Chinese references in Séguéla's poster are probably due to him. The French leader was to meet Mao again in 1981, during a state visit he organized during his election campaign.

France, deep in the sense of profoundly provincial). The poster, which expressed pastoral calmness and beauty, patriotic sentiment and restraint, struck a sympathetic chord with the public at large, though it did not escape some observers that it bore an uncanny resemblance to a famous Vichy poster, which represented Marshal Pétain before a rural village complete with church, and bore the slogan "Patrie. Suivez moi! Gardez votre confiance en la France éternelle" (Fatherland. Follow me! Keep your trust in eternal France). Jacques Séguéla declared in a television interview that he hoped his poster campaign would contribute to Mitterrand's victory. The statement seemed over-optimistic given that in September 1980, six months before the election, polls had given the Socialist candidate's competitor Giscard a 28 percent lead in the second round. Mitterrand must have accepted that the propaganda devised by Séguéla did play a part in his triumph for he assigned him the organization of the election campaign of 1988.[20] The "Force tranquille" image was to be imitated repeatedly for decades, by parties of different ideological tendencies, as will be shown.

The Rhetoric of Informality

The formal style of representation was however being increasingly relinquished by politicians in favor of a more relaxed approach. Jacques Chirac, leader of the Rassemblement pour la République, RPR (Rally for the Republic), campaigned for the parliamentary election of 1986 with a poster, produced in two versions, that portrayed him smiling broadly, without a jacket, sporting a showy striped shirt and a tie that drifted sideways. A young girl affectionately puts her right arm around his shoulder in one version (Figure 15.6) (her presence evokes that of Giscard's daughter in his 1974 election poster), and in the second a young boy is portrayed in a similar attitude. These bright and happy images present him as a devoted father to imply by extension that he would be equally caring as head of the French nation. In another poster produced for the same occasion, Chirac appears with two women and nine men, all leading party figures (some were appointed ministers after he won the contest). They run beaming, arm in arm so as to form a human chain; the men wear rolled-up shirt sleeves, and – most of them – fluttering ties. The image spells dynamism and enthusiasm – attitudes which the slogan "Vivement demain!" (Rearing to go!) endorses; it is also a metaphor for the election campaign as a marathon or obstacle race.[21]

Jacques Chirac also avoided the serious, institutional approach when he fought the presidential election of 1988. The series of posters devised for the early stage of

20 For a detailed account of the making of "La force tranquille", which was only one of a series devised by Séguéla for the 1981 campaign, see Benoit, Benoit and Lech, *La politique à l'affiche*, 80–3, who also provide data from polls indicating that the poster received a high score in recognition tests and had a stronger appeal than those of the other candidates; it clearly succeeded in changing Mitterrand's "constant loser" image. For a scholarly analysis on the poster campaign and Séguéla's contribution to Mitterrand's victory, see Pierre Fresnault-Deruelle, "Le visage et le paysage. Quelques réflexions sur l'image de François Mitterrand en 1981," in idem, *Les images prises au mot* (Paris: Edilig, 1989), 159–70; and Philippe J. Maarek, "The Evolution of French Political Communication: Reaching the Limits of Professionalisation?" in *The Professionalisation of Political Communication. Changing Media, Changing Europe*, III, eds. Raph Negrine et al. (Bristol-Chicago: Intellect, 2007), 148–50.
21 For a semiotic analysis of these and other posters featuring politicians in shirtsleeves, see Pierre Fresnault-Deruelle, "Des hommes politiques en bras de chemise", in idem, *Les images prises au mot*, 171–80. On the visual propaganda of election campaign of 1986 in general, see René Rémond (introd.), *Législatives 1986. Les affiches de campagne* (Paris: BDIC, 1986).

the campaign showed him in a seductive mode: sun-tanned, without glasses, his head tilted slightly sideways,[22] he addressed the viewer with an engaging smile. The "Club Méditerranée" feel of these images, much satirized at the time, was mitigated by the telegraphic slogans that described his would-be qualities: "Le courage" (Courage), "L'ardeur" (The fervor) and "La volonté" (The will), etc.[23] The picture adopted for both rounds of voting by his competitor Mitterrand, who was to succeed in being re-elected, portrayed him in profile staring into the distance, namely as a charismatic figure confident that the French people will follow him again.[24]

Chirac continued to try and project a charming, affable and informal image in the presidential elections of 1995 and 2002, while the twice unsuccessful Socialist candidate Lionel Jospin appeared on his propaganda in a no-frills way that was entirely in keeping with his sober character.[25] Jospin was Chirac's main contender in 1995, and would have been in 2002 too (according to some observers with reasonable chances of winning the presidency) had the fragmentation of the left-wing vote in the first round not favored Jean-Marie Le Pen, the candidate of the far right Front National, FN, who achieved 16.9 percent, his highest score in a presidential election (the Socialist leader obtained 16.2 percent). Left-wing parties were forced to urge voters to support the conservative Chirac in the second round to keep Le Pen out.

Jean-Marie Le Pen: Rebel and Gentleman

When Le Pen first stood as presidential candidate, in 1974, he scored 0.75 percent. His party's fortunes grew considerably over time reaching 15 percent in 1995. Despite its relative strength in parliamentary elections too, the FN did badly in terms of deputies because of the majoritarian system. Le Pen's propaganda followed a two-pronged approach: he presented himself as a rebel, the tribune who fought the system to defend the rights of ordinary citizens, but also as a respectable figure embodying the traditional values and aspirations of the bourgeoisie.[26] A poster produced in the mid-1980s depicted him with a piece of cloth tied over his mouth together with the explanatory text: "Le Pen dit la vérité, ils le baillonnent" (Le Pen tells the truth, they gag him). The image, with some variations, was re-used for several years. In another poster, released in 1990, Le Pen appeared as an American Indian chief uttering the rallying cry "Sortons de nos réserves" (which translates both "Let's get out of our reservations" and "Let's come out and fight") to urge people to rebel against the marginalization of his party. On a Christmas card of 2009, which carried the slogan "Pour la France

22 Joseph Messinger remarks in *Ces gestes qui vous séduisent* (Paris: First Editions, 2004), 101: "[The head tilted toward our left], often coming with a serene expression, and even a faint smile, [can] be considered as a sign of seduction."

23 Delporte, *Images et politique*, 358–9.

24 Pierre Fresnault-Deruelle, "Têtes d'affiche. Chirac/Mitterrand: les présidentielles de 1988", in idem, *Les Images prises au mot*, 181–95.

25 For the posters promoting the principal candidates of the elections of 1995 and 2002, see france-politique.fr/affiches-presidentielle–1995.htm and france-politique.fr/affiches-presidentielle–2002.htm. For a semiotic analysis of the portraits of the candidates of the election of 2002, see Hugues Constantin de Chanay, "Pouvoir des images d'avant le pouvoir: de l'éthos dans les portraits des candidats à l'élection présidentielle 2002 en France," *Semiotica*, 159, 1–4 (2006), 151–77.

26 On Le Pen's visual propaganda, see Damien Bariller and Franck Timmermans, *Vingt ans au Front, 1972–1992. L'histoire vraie du Front National,* with an afterword by Jean-Marie Le Pen (Paris: Editions Nationales, 1993) and Novak, *Tricolores*, 76–105, which reproduce all the posters mentioned below.

à l'abordage!" (All aboard for France!) he represented himself as a pirate about to board a vessel pointing his gun at the observer. Yet other literature depicted him as a suit-wearing elderly gentleman with the charm and refinement of yesteryear (as symbolized by the pocket square) or as a loving grandfather. A poster of 1991 portrayed him with his two-year old grand-daughter Marion, who was to become a FN deputy at the National Assembly (2012–2017)[27]. The poster of the first round of the 2002 presidential election showed Le Pen posing in a classic navy blue suit and a white shirt, but featured the predictably harsh anti-immigration slogan: "La France et les Français d'abord" (Put France and the French first). The outcry provoked by the unexpected results of the first round led to innumerable satirical images being produced by civil rights organizations (anti-racist, ecological, etc.), political parties as well as ordinary individuals, that depicted Le Pen as Hitler, repulsive insects or fierce-looking bulldogs (Figure 15.7), images that were reproduced on placards and banners brandished by protesters at the mass rallies that took place throughout France or were disseminated via the internet.[28] Le Pen's portrait for the run-off of the election, taken by Franck Landouch, the FN's official photographer, depicted him in a casual posture, beaming and donning a trendy polo-necked jumper buttoned on the left shoulder[29]– a youthful and friendly image that was meant to have a supra-party appeal. Abandoning all polemical tone, the slogan simply stated: "Le Pen Président" (Figure 15.8).

Nicolas Sarkozy vs. Ségolène Royal

The election of 2007[30] saw as main protagonists Nicolas Sarkozy, who represented the Union pour un Mouvement Populaire, UMP (the party launched by Chirac to unite Gaullists and centrists) and the Socialist Ségolène Royal, the first woman to have qualified for the second round. Sarkozy, a former Minister of the Interior, and then Minister of Finance under Chirac's presidency, based his campaign, which was masterminded by the Boston Consulting Group, BCG, on the promise of a *rupture,* a radically new style of governing, closer to ordinary people. To construct his public image, he relied on television to a much greater extent that any of his predecessors had done: ensuring that TV cameras followed him wherever he went (schools, prisons, factories, mines …), he sought to appear as a dynamic and ubiquitous politician, in deliberate contrast with the sedate Chirac.[31] Two days before the run-off of the election, Sarkozy, who is city-born and bred, appeared wearing a red-checked shirt, jeans and Ray Ban sunglasses riding a white horse in the Camargue, the wetland south of Arles, like a perfect *gardian*, the traditional horseman of the region. This final electioneering event, which took place in the presence of around fifty journalists, photographers and cameramen, was

27 In 2018 Marion Maréchal (she no longer uses her maiden name) founded the high-sounding Institut des Sciences Sociales, Economiques et Politiques in Lyon, intended as her party's think-tank.

28 For an account of the different techniques used to attack Le Pen satirically in order to expose the threat he represented, see Christian Delporte's chapter "La menace Le Pen: images et Internet en 2002", in idem, *Images et politique,* 419–33.

29 The photograph was actually taken in summer 1999. On Le Pen's sudden change of image, see Michel Soudais, "La métamorphose de Le Pen. Adieu, le provocateur sulfureux. Bonjour, le leader policé et familial", *Le Monde,* May 12–13, 2002, 19.

30 On the official posters of the campaign: http://communipol.canalblog.com/albums/affiches/photos/ 13046207-affiches_des_candidats_a_la_presidentielle_francaise_en_2007.html

31 Donatella Campus and Sofia Ventura, "L'image et la communication de Sarkozy," in *La communication politique de la présidentielle 2007,* ed. Philippe Maarek (Paris: L'Harmattan, 2009), 31–51.

meant to attest the candidate's physical fitness and convey his love of traditions and of nature. The choice of the area was also politically motivated: the Camargue was a Front National stronghold.[32]

Sarkozy embodied what he himself termed a *droite décomplexée*, a new right that defended conservative beliefs overtly and without reservations. However, the posters promoting his candidature for the first and second round of the election imitated Mitterrand's "Force tranquille" poster of 1981: they depicted him at half-bust before a landscape that featured a meadow with the outline of some firs in the distance. He also used the oxymoron "la rupture tranquille" during his campaign. The text on the poster of the first round was equally indebted to the Left: "Ensemble tout devient possible" (Together everything becomes possible) partly echoed Mitterrand's 1972 slogan "Tout est possible, cela dépend de vous" (Everything is possible, it depends on you).

Female politicians in France, most of whom occupied relatively minor functions until the early years of this century, tended to adopt a sober appearance that attenuated their femininity (see below). Ségolène Royal (b. 1953), on the contrary, chose to turn her physical appearance into a political asset by pandering to the media. In the 1980s and 1990s, when she was an advisor to Mitterrand, then deputy in the Deux Sèvres constituency, in the mid-west, she seemed unconcerned about style: she wore a ponytail, large-frame spectacles and flowery dresses. Her look changed dramatically in 2004, when she campaigned for the governorship of the Poitou-Charentes region, which she was to win: advised by the film producer and talent manager Dominique Besnehard, she acquired a glamorous image. Royal's popularity rose meteorically as the press devoted numerous photo-reportages to her. The June 13, 2006 issue of the men's lifestyle weekly *FHM* published the results of a poll about the "100 sexiest women in the world" ranking her in 6th position – well before the film stars Laetitia Casta and Monica Bellucci.[33] The magazine *Elle* devoted the cover of its December 15 issue to her.

Two different portraits were used for the posters of her presidential campaign. The photograph for the first round, signed by Emanuele Scorcelletti, who had managed the launch of Dior, Gucci and Chanel perfumes and authored a book on Sharon Stone, is a close-up of Royal's face that draws attention to her flawless complexion and invites intimacy.[34] The use of black and white gave the picture a suggestive retro-look (it recalled the photographs of film stars of the 1930s and 1940s) and distinguished her poster from that of the other candidates. The slogan too was strongly gendered: "La France Présidente", printed in italics – a style of lettering regarded as "feminine" – is a syllogism in condensed form that goes as follows: since "France" is a feminine noun, the country requires a woman President, and Royal, being a woman, is the

32 Philippe Ridet, "Le candidat sur le cheval Univers et la presse en charrette pour une balade en Camargue", *Le Monde*, April 21, 2007, 8. Sarkozy's equestrian photo-opportunity was amply reported by the foreign media too. For the amused reactions of the American press, see for instance Craig S. Smith, "Ride 'Em, Cowboy. Well, Not Exactly," *The New York Times*, May 13, 2007: WK 14.

33 On Royal's rise and style of campaigning, see: Ben Clift, "The Ségolène Royal Phenomenon: Political Renewal in France?" *The Political Quarterly*, 78, 2: 282–92; and Donatella Campus, *Women Political Leaders and the Media* (Basingstoke: Palgrave Macmillan, 2013), 65–9.

34 As the film theorist Béla Balazs has remarked: "Good close-ups radiate a tender human attitude in the contemplation of hidden things, a delicate solicitude, a gentle bending over the intimacies of life-in-the miniature, a warm sensibility. Good close-ups are lyrical, it is the heart, not the eye that has perceived them". "The Face of Things", in Béla Balazs, *Theory of the film: Character and Growth of a New Art* (New York: Dover, 1970), 56.

natural choice for such a position.[35] The portrait for the second round of the election was realized by Oliviero Toscani, the world-famous photographer who had designed the controversial campaigns of the Italian brand Benetton. Royal is pictured smiling seductively, dressed in white to suggest a political virginity and the need to make *tabula rasa* of the traditional doctrines and organizational practices of the Socialist Party (Figure 15.9). Challenging the *éléphants,* the senior members of the party élite, she presented herself as an outsider to the French political system, though in truth she was herself part the "old guard", since she had attended the prestigious Ecole Nationale de l'Administration and held ministerial posts.

Having won the election of 2012, Sarkozy continued to cultivate the image of the omnipresent head of state. The website of the Elysée Palace was replete with images of his ceaseless activities. The strengthening of his own role, to the detriment of that of his prime minister and ministers, and his narcissism, earned him the title of *hyperprésident.*[36] On account of his taste for classy holidays, luxurious restaurants and expensive watches, and his association with celebrities (he even married one, the glamorous singer and song-writer Carla Bruni) – a glitzy lifestyle that glossy magazines delighted in illustrating – he came to be referred to as *Président bling bling.*

Nicolas Sarkozy vs. François Hollande (plus Marine Le Pen)

Sarkozy stood for a second term of office in 2012.[37] The image with which he campaigned for both the first and second rounds of the election is particularly interesting (Figure 15.10). Unlike all other candidates but one (the exception being the centrist François Bayrou), he does not face the onlooker but calmly directs his gaze toward our right to appear, like Mitterrand in 1988, as a man of vision. The blue sky that frames his head supports the concept because, being "limitless", it functions as a natural symbol of greatness.[38] So does the expanse of water because it evokes the image of the captain at helm, capable of steering the "ship of state" expertly even in the most turbulent waters.[39] Sarkozy's sea is perfectly placid because, associated with the slogan

35 The identification with France has always been a *leitmotif* of Royal's campaigns. In March 2007, asked in a pre-election television interview who was her favorite hero or heroine, she replied: "Joan of Arc". The identification was exploited chromatically in 2011, when she (unsuccessfully) attempted to be nominated by the Socialist Party for the presidential election of 2012: she was featured in her publicity wearing red and white garments against a blue background. She also posed in the guise of Marianne (the personification of the French Republic), modelling herself on the depiction immortalized by Eugène Delacroix's *Liberty Leading the People*, for *Le Parisien Magazine*, October 25, 2013.

36 Eric Maigret, *L'Hyperprésident* (Paris: Armand Colin, 2008). The cover of the book reproduces eighty identical smiling portraits of the President.

37 On the visual propaganda of the election of 2012: https://www.liberation.fr/france/2012/04/14/les-af fiches-des-candidats-dechiffrees_811536

38 Leaders of both dictatorial and democratic systems have had themselves represented in official portraits standing out against a vast sky to look charismatic. They include: Mussolini, Hitler, Stalin, Mao and Mitterrand.

39 Sarkozy's helm, not visible, is implied through the rhetorical device of the synecdoche. Woodrow Wilson, the Conservative Party leader Stanley Baldwin, Mussolini, Stalin, Mao ("the Great Helmsman"), Franklin Roosevelt and Argentina's former President Cristina Fernández de Kirchner are among the leaders who have featured on propaganda posters as "captains". On the political use of this maritime image, see Francesca Rigotti, "La nave dello Stato," in idem, *Metafore della politica* (Bologna: il Mulino, 1989); and Norma Thompson, "The Ship of State: the Political Metaphor and its Fate,"

"La France forte" (A strong France), it is intended to evoke the oxymoron "La force tranquille", as indeed the poster image of his 2007 campaign had done.

Sarkozy's principal antagonist in 2012 was the Socialist François Hollande, who campaigned pledging to be a *Président normal*, a Scandinavian-style head of state, close to his people, leading an ordinary life – the very opposite of the *Hyperprésident* that French people had increasingly been rejecting. His graphic propaganda was the perfect reflection of the normalcy he claimed to aspire to. Rejecting any form of narcissism, for the posters of the two rounds of the presidential election he chose a portrait that was almost identical to the one he had used when he campaigned for the primary election: it represented him at half-bust, turned slightly to our right, looking at the observer (Figure 15.11).

The 2012 electoral contest, which was won by Hollande, was also characterized by the strong performance of the FN candidate Marine Le Pen: her score (17.9 percent in the first round of the election) was the highest ever achieved by that party.[40] Just after taking over the leadership of the FN in 2011, Marine Le Pen set herself the task of de-demonizing its image. Exploiting the phenomenon of celebrity politics, she sought visibility by attending talk shows and featuring in the popular press. Marine Le Pen also used her physical appearance to build a positive image that would help normalize her party.[41] The two posters that were produced for the presidential campaign of 2012[42] attest it. They represented her looking us straight in the eye, with a mischievous smile. The close-up shots emphasize her smooth skin, and in particular her blue eyes and (dyed) blond hair – two features that are usually associated with ideal beauty.[43] Blue is also France's national color. In the first of the two posters the candidate rests

in idem, *The Ship of State. Statecraft and Politics from Ancient Greece to Democratic America* (New Haven: Yale University Press, 2008), 167–72, 207–8.

40 Hollande obtained 28.63 percent and Sarkozy 27.18 percent of the vote.

41 For a detailed analysis of the FN leader's attempt to forge a reassuring and appealing image, see Donatella Campus, "Marine Le Pen's 'Peopolisation': An Asset for Leadership Image-Building?," *French Politics*, 15, 6 (2017), 147–65. She remarks (p. 161) that a poll published in the October 20, 2011 issue of the tabloid magazine *Closer* indicated that Le Pen was the second "most-fancied" female politician, scoring 18.3 percent. She was preceded by Ségolène Royal who topped preferences with 52.1 percent. Campus explains that Le Pen later presented herself as a symbol of the generational struggle, as the daughter who tried to liberate herself from the influence of a cumbersome father, whose racist, anti-Semitic and colonialist views she professed to reject.

42 The two posters were not concurrent. During the official campaign period only one poster per election round can represent the candidate. Because the poster that was released initially featured the colors of the French flag in the background, therefore contravening electoral rules, it had to be withdrawn and replaced with another.

43 On the appeal of blond hair, see Joanna Pitman, *On Blondes* (London: Bloomsbury, 2014). In recent years several far-right/xenophobic parties have been led by young, blond and (in many cases) blue-eyed women. Among the names that come to mind are: Anke Van Dermeersch, Miss Belgium 1991 and president of the Vlaams Belang (Flemish Interest) party in the Belgian Senate; Céline Amaudruz, deputy-president of the Swiss ultra-nationalist Union Démocratique du Centre; Krisztina Morvai, prominent Euro-MP of the Jobbik (Movement for a Better Hungary); Siv Jensen, leader of the Norwegian Fremskrittspartiet (Party of Progress); and Alice Weidel, president of the parliamentary group of Alternative für Deutschland (Alternative for Germany) party. To this list we may add Jean-Marie Le Pen's ambitious grand-daughter, Marion Maréchal. The sex-appeal of these personalities conceals or attenuates the sinister ideologies they embody. It is indeed tempting to suggest that some may have been chosen by their respective parties for the electoral potential of their looks.

her chin on her folded arms (Figure 15.12), a coquettish posture that draws our attention to the face.[44]

The image that promoted Le Pen's candidature for the parliamentary election that followed a few weeks later represented her in a combative mode: she confronts us with a steely look, propping her head on her clenched fist, whose meaning is made clear by the slogan: "Marine à l'Assemblée! La seule à vous defendre" (Marine in the [National] Assembly! The only one who can defend you). The poster released in 2012 to advertise the FN's customary May 1 rally in Place de l'Opéra, in Paris[45] portrays Le Pen next to the silhouette of the equestrian monument to Joan of Arc that stands in the square, in an echoing posture, to present herself as a fighter, the guarantor of French nationhood and as a martyr (the victim of institutional prejudices that are responsible for her party's marginalization).[46]

Emmanuel Macron vs. Marine Le Pen

The presidential election of 2017[47] saw the collapse of the two political families that had governed France since the end of the Second World War: the conservative Les Republicains (as the UMP was renamed in 2015) and the Socialists. The two parties that scored the most in the first round were En Marche (Forward), the movement newly formed by a leader who had not yet turned forty, Emmanuel Macron,[48] and the FN. Both claiming to be anti-establishment, they based their campaigns on the need to make a clean sweep of old political methods.

Before focusing on Macron's and Le Pen's visual propaganda, a few words should be said about that of the sixty-three-year-old Republican candidate François Fillon. Fillon was expected to be elected president with a comfortable majority, given that the fifty-year-old Socialist candidate Benoît Hamon was handicapped by the negative image his party inherited from Hollande's massively unpopular presidency (an unpopularity that had led him to not seek re-election). He fell from grace following a political-financial scandal involving allegations that his wife and children were paid attractive salaries for doing little or no work. His campaign portrait, which depicted him at half-bust

44 Messinger, *Ces gestes qui vous séduisent*, 73. From the 1940s to the 1960s, female film stars frequently adopted this pose in the photographs that promoted them. Examples include Greta Garbo, Jane Mansfield and Sophia Loren.

45 The practice of commemorating Joan of Arc on the May 1, rather than on May 30 (the anniversary of her death by burning) was introduced by Jean-Marie Le Pen in 1988 to celebrate International Workers' Day in competition with the Left. On the cult of the Maid of Orléans in France and its appropriation by the far-right, see Michel Winock, "Jeanne d'Arc," in *Les Lieux de mémoire*, ed. Pierre Nora (Paris: Gallimard, 1997), vol. 3, 4427–73.

46 For a more detailed examination of Marine Le Pen's visual propaganda, see Luciano Cheles, "Immagini presidenziali nel tempo presente: Francia e Italia," in *Presidenti. Storia e costume della Repubblica nell'Italia democratica*, ed. Maurizio Ridolfi (Rome: Viella, 2014), 169–70, figs. 36–40.

47 On this election: Riccardo Brizzi and Marc Lazar, eds., *La France d'Emmanuel Macron* (Rennes: Presses Universitaires de Rennes, 2018). For the official posters of all the candidates: http://www.nouvelobs .com/galeries-photos/presidentielle–2017/20170404.OBS7531/en-images-les-affiches-des–11-candidats-a-la-presidentielle–2017.html

48 On Macron's meteoric rise and his propaganda machine, see Cécile Amar, *La fabrique du Président. Enquête sur les coulisses d'une ascension foudroyante* (Paris: Fayard, 2017); Sophie Pedder, *Révolution Française: Emmanuel Macron and the Quest to Reinvent a Nation* (London: Bloomsbury Continuum, 2018); and Arnaud Benedetti, *Le coup de com' permanent* (Paris: Cerf, 2018).

smiling faintly, strikes one for the conspicuous visibility of the wrinkles on his face and of the grizzled hair, carefully brushed in an old style. Confronted with such youthful and energetic contestants as Macron, Le Pen and Hamon, Fillon used the card of mature age to show that unlike them he was experienced. When the scandal erupted, the slogan that was originally intended for his campaign – "Le courage de la vérité" (The courage of truth) – was hastily changed to "Une volonté pour la France" (A will for France), fearing that the mention of "vérité" on the poster of a candidate who denied all the accusations of irregularities despite damning evidence would encourage sarcastic graffiti. However, the new slogan, which hinted at his *jusqu'au-boutisme*, namely his determination to go "all the way" despite being advised by senior party members to step down to allow a figure with better chances of winning the contest to stand, proved equally infelicitous: the posters were daubed with graffiti turning "Une volonté pour la France" into, for instance, "Une volonté pour la fraude" (A will to defraud) and "Un vol pour la France" (A theft for France) (Figure 15.13).

Marine Le Pen, who was widely predicted to make it to the run-off of the election, continued to pursue her strategy of softening her public image.[49] Shortly before the official start of the campaign, the FN disseminated a poster that portrayed her in a meditative mood against a bucolic landscape and featured the slogan "La France apaisée" (Serene France)[50] – another imitation of Mitterrand's "Force tranquille" campaign. The poster for the first round of the election represented Marine Le Pen smiling sweetly, with dimples on her cheeks (a feature that evokes innocence and charm), bending slightly toward the onlooker to signal that she is prepared to engage in dialogue. The loving quality of the image was counterpoised by the imperious slogan "Mettre la France EN ORDRE" (Putting France IN ORDER), whose disciplinarian message was emphasized by the capitalization of the last two words.

Marine Le Pen scored 21.3 percent in the first round, coming second after Emmanuel Macron who polled 24 percent. The poster of the final run-off was conceived with particular care (Figure 15.14). It represents the candidate in a study wearing a navy blue (*bleu marine* in French) jacket. She sits on the edge of the desk, to suggest that she is alert and able to move at any moment to connect with us, and her hands interlock at the front. When the hands are placed close to the belly, the posture characterizes feminine modesty: since the Renaissance, countless distinguished ladies, from Leonardo's *Mona Lisa* to Margaret Thatcher and Lady Diana, have been so represented in stately portraits. While apparently upholding such an established iconographic tradition, Le Pen's hands do not convey the same meaning because they are arranged slightly sideways, on account of her seating position. This position enables her in fact to defy, rather than adhere to the codes of feminine decorum because it causes her short dark skirt to reveal part of her right thigh. The exposure of so intimate a part, which has no precedent in formal representations of female leaders, was intended as a subtle dig at Islam which expects women to conceal their bodies.[51] The

49 Olivier Faye, "Marine Le Pen joue la carte de la moderation," *Le Monde*, September 17, 2016, 8–9.

50 The poster can be viewed by googling the words "La France apaisée."

51 This explanation was given by a member of Le Pen's campaign team to a journalist of the weekly *l'Express*: https://www.lexpress.fr/actualite/politique/elections/presidentielle-les-affiches-et-les-slogans-de-macron-et-le-pen-devoilees_1902600.html In displaying an intimate part of her anatomy as a quip Marine Le Pen seems to be following the example of her mother: fifty-two year old Pierrette Le Pen posed nude, engaged in house-cleaning, for the July 1987 issue of the French edition of *Playboy*, to

poster embraces the theme of femininity to the full: the slogan "Choisir la France" (Choose France) is superimposed across her chest and suggests that she is the embodiment of France. A final comment needs to be made about the setting. Le Pen is represented in a study that is probably intended to be that of her private residence, as the untidy arrangement of some of the books suggests. However, the image evokes official presidential portraiture[52] therefore acting as a prefiguration of the position she is determined to win.

Emmanuel Macron's official posters for the first and second rounds of the election are pictorially very similar: they both depict him at half-bust, frontally, fixing the observer with his gaze and smiling slightly (Figure 15.15, Left). The frontal and symmetrical pose hints at Macron's professed ideological equidistance, namely at his rejection of the traditional categories of right and left. The concept is endorsed by the dominant use of the color blue – the consensual color par excellence.[53] Frontality equally suggests courage (the will to face reality head-on), while looking someone straight in the eyes is considered to be sign of honesty and frankness. However, it is difficult to escape the impression that the young and blue-eyed candidate is also staring and smiling at us to try and seduce us.[54]

Macron was elected president with 66 percent of the vote. In contrast to Hollande, who had championed the image of normalcy, he pledged as early as October 2016 in an interview given to the magazine *Challenge* to be a *Président jupitérien* (Jupiter-like President). By this mythological reference he meant that he wished to give luster to the institutional role and restore its solemnity. It is a plan he put into practice immediately after the results of the election were announced: his victory march took place on the esplanade of the Louvre, by the scintillating glass pyramid, and to the sound of Beethoven's *Ode to Joy*, the official anthem of the European Union. Later, major events (meetings with foreign leaders, important speeches, etc.) have also been carefully stage-managed and held in such imposing settings as the Palace of Versailles, the Sorbonne and the Eiffel Tower. Naturally, the impressive images of the events have been widely reported by the international media. The emphasis on grandeur resulted in a boomerang effect especially in late 2018 and in the first half of 2019, when the government's introduction of tax reforms, which were thought to hurt especially the lower-paid, sparked the *Gilets jaunes* (Yellow vests) protest. Satirical images of Macron featured on posters, leaflets, the press and social media represented him in the guise of a haughty monarch, out of touch with ordinary citizens and thus unable to understand their everyday difficulties (Figure 15.15, Right).[55] To respond to the

ridicule her former husband's idea of a perfect housewife and retort to a statement he had made in an interview that if she needed money she should get a housecleaning job. See Rachel O'Donoghue, "French far-right leader Marine Le Pen's mum posed naked in Playboy pictures," *Daily Star*, September 24, 2018. https://www.dailystar.co.uk/news/latest-news/marine-le-pen-france-playboy-16898394.

52 On presidential iconography in France, see below.

53 Michel Pastoureau, *Blue. The History of a Color* (Princeton: Princeton University Press, 2001), 180–1.

54 The image of a frontal male figure with a penetrating stare and a faint smile is recurrent in the advertisements for designer goods that are supposed to make men more desirable (perfumes, underwear, etc.), such as those released by Dior, Lancôme, Prada, Ralph Lauren and Hom. It is worth recalling that the Latin word *fascinum* referred to the phallus.

55 For early humorous representations of Macron, see Régis Debray (foreword), *Alors, ça marche?* (Paris: Gallimard, 2017). The most scathing satirical portraits relating to the crisis period are found in the weeklies *Le Canard Enchaîné* and *Charlie Hebdo*.

crisis, the President launched a *grand débat national* which lasted two months and saw him discussing numerous topics with representatives of various categories of people (mayors, university students, school pupils, parliamentarians …), "humbly" sitting in his shirtsleeves among them, in town-halls across the country. These debates were broadcast live and much commented on by the media. Other debates have followed, and to show empathy with ordinary people, they have occasionally been held in work-places. On September 14, 2019, Macron met a group of workers at Bonneuil-sur-Marne (south of Paris) in a warehouse, again before the cameras.[56]

The Other Leaders' Portraits

This rapid survey has so far mostly focused on the portraits of the heavyweight figures of the presidential campaigns. However, the depiction of leaders of parties that have never made it to the run-off of the presidential election also merits some comments.

Environmental and anti-globalist candidates are usually represented in rural settings or against plain green backgrounds. Predictably, the propaganda of political organiza-tions to the left of the Socialist Party is dominated by the color red. The leaders are often featured in a small format to allow the text, i.e. the political message, to predominate. Their photographs tend to look like common snapshots and show them wearing every-day clothes. The campaign posters of Arlette Laguiller and Nathalie Artaud, successive leaders of the Trotskyist movement Lutte Ouvrière (Workers' Struggle), and those of the revolutionary communists Olivier Besancenot and Philippe Poutou (their party, originally called Ligue Communiste Révolutionnaire, was renamed Nouveau Parti Anticapitaliste in 2009) are cases in point. Poutou, a factory worker, appeared on his 2017 election poster unshaven and with unkempt hair. The texts complementing the photographs are usually roughly laid-out and printed in a no-nonsense typographical style to sug-gest authenticity and polemically reject "bourgeois good taste". This deliberately crude, homemade propaganda is also an act of rebellion against the parties' almost-generalized practice of seeking the assistance of spin-doctors to "market" candidates as attractive commercial products. However, not all far-left candidates are portrayed in unorthodox ways: politicians who have been members of a government at some point of their careers tend to feature well-groomed and respectably' dressed on well-designed posters. Two examples are provided by the Communist Marie-George Buffet, a minister of Youth and Sports in Prime Minister Lionel Jospin's left-wing coalition from 1997 to 2002,[57] who ran in the presidential election of 2007, and the leader of La France Insoumise (Rebellious France) Jean-Luc Mélenchon, a Junior Minister for Vocational Training in the same government, who fought the elections of 2012 and 2017.

Representing Women Politicians

In France, as in other Western countries, women's presence in politics has risen sub-stantially in the past few decades. If in 1997 only 10.9 percent of deputies were women, by 2017 their number had grown to 38 percent of the National Assembly.

56 Sylvie Corbet, "France's Macron tries the common touch to win back support." https://www.apnews.com/
 934518f7ccba446c8f61539daffbd0f0.
57 The Socialist Jospin became Prime Minister under the conservative Chirac – a period known as *co-habitation* – when the President called a snap election in 1997 in the hope of a personal endorsement.

The increase has been even more dramatic in the Upper Chamber: women represented only 5.92 percent of the total number of Senators in 1998; they obtained 29.3 percent of the Senate seats in 2017. Female politicians have tended to downplay their femininity out of fear that the excessive attention which the media traditionally give to their physical appearance trivializes them, thus affecting their credibility as competent politicians.[58] The outfits of the Socialist Edith Cresson, the first and only female Prime Minister of France, who was appointed by Mitterrand in 1991, were constantly scrutinized. After her resignation from office a year later, she declared with dismay:

> [Women in France are perceived as being] either too old or too young, too ugly or too beautiful, too much something or too little something else, and if she succeeds in something it's because she has slept with the man who is the key.[59]

Female candidates, like their male counterparts, are usually represented on their publicity at half-bust, rather than in full or from the knees up. They avoid ostentatious garments, and wear little or no make-up or ornaments.[60] This approach tends to cut across the political spectrum, unlike what happens in Italy, where the Left and Center-Left cultivates an unobtrusive look, while right-wing/populist parties tend to use sex appeal overtly for electoral ends.[61] But then in France the practice of fielding cover-girls, pop-singers, television presenters and porn-stars is virtually unknown. During the Sarkozy presidency, however, some young female members of government, such as Rachida Dati (Minister of Justice), Rama Yade (State Secretary for Human Rights and, later, for Sports) and Nathalie Kosciuzko-Morizet (Minister for Ecology and Information Technology) did wear close-fitting classy outfits and vertiginous high heels when performing official functions, and sought the attention of the popular press.[62]

The Presidential Portrait

A pictorial genre which is ascribed the utmost importance in France is the official presidential portrait, which is displayed prominently in such official buildings as town-halls, ministries, consulates, etc. Some town-halls hang the entire series of presidential portraits of the Fifth Republic in a separate hall to document the country's recent

58 On sexist attitudes toward female politicians in France, see Charlotte Rotman, *Retour à la maison! Les femmes politiques face au sexisme ordinaire* (Paris: Laffont, 2016).

59 Cited from Raylene L. Ramsey, *French Women in Politics: Writing Power, Paternal Legitimation and Maternal Legacies* (New York: Berghahn, 2003), 191.

60 On the representation of women politicians, see Emmanuelle Retaillaud, "Portraits de femmes dans la vie politique sous la Ve République" and Luciano Cheles, "Donne manifeste. L'immagine femminile nella propaganda figurativa in Francia e in Italia," in *Il ritratto e il potere*, eds. Cheles and Giacone, 207–27 and 253–70, respectively. More specifically on the female candidates of the election of 2007, see Cécile Girousse, "Femmes et politique en France. Photos des élections présidentielles de mai 2007," in *Le pouvoir et les images. Photographie et corps politiques*, ed. François Soulages (Paris: Klincksieck, 2011), 107–116.

61 See my chapter "From Reticence to Excess. Political Portraiture in Italy", 247–9, in this volume.

62 Retaillaud, "Portraits de femmes", 219. Rachida Dati featured on the cover of the December 8, 2007 issue of the popular weekly *Paris Match* donning a pink leopard-print Dior dress and high heeled boots.

history. The iconography of these portraits is devised with great care and is often elaborate, reflecting the emphasis which the French state is eager to place on the prestige of its highest institution.[63] The first two Presidents of the Fifth Republic – Charles de Gaulle (1959–1969) and Georges Pompidou (1969–1974) – followed the well-established tradition of the Third and Fourth Republic of portraying the head of state standing in his office, wearing his full regalia, with one hand resting on books. Their successors have modified this iconography, in some cases quite radically, to personalize the official portrait and turn it into a quasi-manifesto of the style of presidency they intend to pursue. To suggest closeness to ordinary citizens, all of Pompidou's successors have chosen to be depicted donning an ordinary suit, rather than the ceremonial attire. They wear the *Légion d'Honneur*, which the presidents, as Grand Masters of the order, are automatically awarded; however, the showy collar with medal that used to hang around their necks has been replaced with a small red badge pinned on the left lapel of their suits. The presidents no longer look away from the camera to maintain an awe-inspiring distance: they address their subjects directly.

Before commenting briefly on the individual portraits, it is worth noting that the pictures are not realized internally by an appropriate department of the Elysée Palace, but by highly reputed independent photographers chosen by the presidents themselves. This largely explains the considerable diversity of the portraits of the post-Pompidou era.

Valery Giscard d'Estaing, pictured by Jacques-Henri Lartigue, appears on his official photograph against a tricolor that has been represented in slanted form to give this patriotic symbol a modern and unconventional touch. Unusually, the format of the picture is horizontal, which recalls that of a television screen. François Mitterrand's photograph, taken by Gisèle Freund, shows him seated in his study with an open book in his hand, but looking at the viewer as if to suggest that he has interrupted his reading to receive someone who has just entered his study, in other words to show approachability. Jacques Chirac was represented by Bettina Rheims just outside the Elysée Palace, allegedly the abode of the French, like a good host who meets his guests at the gate. Nicolas Sarkozy's portrait, created by Philippe Warrin, represents him standing in his study, in a posture and setting that look back to de Gaulle's portrait of 1959, in order to place him in the General's illustrious lineage. Surprisingly, François Hollande's photograph, the work of the Socialist sympathizer Raymond Depardon, represents him, like Chirac, at the gate of the Elysée Palace – possibly, as has been suggested, to show gratitude to the former president, who had declared more or less

63 For good-quality color reproductions of all the official portraits of the presidents of the Fifth Republic, together with basic information about them, see https://www.pixopolitan.com/blog/portrait-presiden tiel-de-gaulle-macron/. The portraits are discussed extensively in the media as soon as they are made public, and there is also a substantial scholarly literature on them. See especially Pierre Fresnault-Deruelle, "Les portraits officiels des Présidents de la République," in idem, *Les images prises au mot*, 143–57; Yvan Boude, *Les portraits officiels des Présidents de la République. Histoire et sociologie d'une mise en scène* (Lille: ANRT, 2008); Laurence Girard, "Une «photo présidentielle, version people," *Le Monde*, May 28, 2007, 13 (on Sarkozy's photograph); Christian Losson and Luc Briand, "Des portraitistes jugent la photo officielle de Hollande", *Libération*, June 4, 2012. https://www.liberation.fr/france/2012/06/04/des-portraitistes-jugent-la-photo-officielle-de-hollande_823527. The comments that follow on Giscard, Chirac, Sarkozy and Hollande mostly draw from these publications.

facetiously to the magazine *Le Canard Enchaîné* that he would rather vote for the Socialist candidate than for Sarkozy.

By far the most elaborate official photograph is that of Emmanuel Macron, which was taken by Soazig de la Moissonnière and released on June 29, six weeks after his election[64] (Figure 15.16). The President appears in his study before the window over-looking the Palace gardens. Like Marine Le Pen, he is not ensconced in his seat: he leans against his desk to indicate that he is ready for action. Macron's attitude evokes determination and self-assurance: he transfixes the observer with a steely look and his hands grip his desk[65] – a posture and setting that have been compared to some iconic shots of Frank Underwood, the congressman of the popular American television series *House of Cards*. The similarity with the images of the ruthless and power-hungry fictional character is no doubt fortuitous; however, the portrait is indebted to the official depictions of some real-life politicians.

The most obvious source is the image of President Barack Obama's second term of office (2013–2017), which represents him standing in the Oval Office before his desk, framed by the window with the American and presidential flags on either side.[66] Macron's window, also bracketed by two flags (those of France and of the European Union), is more conspicuous than that of the American Head of State, and its shutters are flung open to reveal the gardens,[67] which function as a metonym for the Nation. The set-up is meant to convey the President's wish to be in touch with his people.

It is tempting to suggest that Macron's perfectly frontal depiction and fixed gaze may have been inspired by the official portrait of another young and blue-eyed states-man, that of the Canadian Prime Minister Justin Trudeau.[68] The common outlook and strong friendship that binds the two statesmen, a friendship that has led the media to speak of "bromance",[69] endorses this view.

A third source, one much closer to home, can be identified: it is the photograph of Prime Minister Edouard Philippe, which appeared in the press just after his appointment, on May 15, six weeks before Macron's official portrait was circulated. The picture represents him facing the viewer, propping himself up against the desk of his study

64 On this portrait, see for instance Bastien Bonnefous and Solenn de Royer, "Une photographie officielle où chaque détail compte," *Le Monde*, July 1, 2017, 10. Most unusually, a video illustrating the behind-the-scenes of the shooting was disseminated almost at the same time. It was posted on the website of Macron's communication advisor Sibeth Ndiaye and on the social network Twitter; it was also shown on several television channels. The video draws particular attention to the books Macron places on his desk: Stendhal's *Le Rouge et le noir*, André Gide's *Les Nourritures terrestres* and de Gaulle's *Mémoires de guerre*. It can be seen googling: "Le making of de la photo officielle d'Emmanuel Macron dévoilé."

65 Curiously, President Trump posed in a very similar way for the cover of the July 1, 2019 issue of the magazine *Time*. It would therefore appear that the American President has modelled himself on Macron's official portrait, which, as is argued below, was in turn based on the portrait of Obama's second presidential portrait.

66 For this portrait of President Obama, see Stephen Seidman's chapter on political portraiture in the United States, in this volume, p. 54, Figure 2.15.

67 It should be noted that the presidential desk's usual position is near the wall to the left of the window. It was moved temporarily to permit the *mise-en-scène* that was intended for the photograph.

68 https://pm.gc.ca/fr/premier-ministre-justin-trudeau

69 The widely disseminated series of photographs that showed Macron and Trudeau at the G7 summit in Taormina, Sicily, in May 2017, talking cheerfully in echoing poses against the background of the Mediterranean sea seemed to attest it.

at Matignon, the Prime Minister's residence, and clasping its edge with both hands.[70] Thus, in a world-turned-upside-down situation, the President's official portrait has been modelled on that of his Prime Minister, rather than vice-versa. Interestingly, though, when Philippe's picture was adopted as banner of his official website,[71] its lower edge was cut off, so that the hands, the attribute of action and power, are no longer visible, and Macron's supremacy has been re-established.

The point has been made that Macron's official portrait exudes confidence and resolve. The photograph of the President that *Time* reproduced on the cover of its September 30, 2019 issue, which includes a lengthy account of an interview with him, well illustrates his change of public image after the *Gilets jaunes* crisis. Macron poses resting on his desk, but without grasping its edges: he appears rolling one of his sleeves, to indicate that he is preparing to work to regain the trust of the people who had supported him. The title on the cover states: "Macron's Moment: France's leader is ready to reset his troubled presidency".[72]

Premières Dames

A brief mention should be made of the figure of the *Première Dame* (First Lady), who tends to be part and parcel of the public image of the French president, though she has no official status. Her role has varied a great deal, ranging from the simple one of the President's companion (representing together the "typical French couple"), to that of the charming hostess and living symbol of French *haute couture* who welcomes the illustrious guests to the Elysée Palace, to that of close collaborator. With the mediatization of political life the *Première Dame* has become more prominent. Carla Bruni-Sarkozy added glamour to the image of a President with a strong propensity for razzle-dazzle, while Brigitte Macron has provided the media with a story-telling (the mature woman who, defying all conventions and prejudices, falls in love and marries a former school pupil of hers) of indubitable appeal.[73]

70 For a reproduction, see Bastien Bonnefous and Solenn de Royer, "Edouard Philippe, Premier Ministre cerné et serein," *Le Monde*, July 4, 2017, 8. Though obvious, this source appears to have escaped the attention of the numerous media specialists who have analyzed Macron's photograph.

71 www.gouvernement.fr/ministre/edouard-philippe

72 https://time.com/5680174/france-emmanuel-macron-transcript-interview/. The picture was taken by a photographer appointed by the magazine, rather than the Elysée Palace, but the President must have chosen the posture and set-up. I am convinced that Macron adopted a mellowed version of the pose of his official portrait to show that he has relinquished the cocky attitude of the first two years of his presidency. In the *Time* interview he declares: "My challenge is to listen to people much better than I did at the very beginning." See Vivienne Walt, "Eye of the storm. After a turbulent year, Emmanuel Macron still dreams of a New France," *Time*, September 30, 2019, 25.

73 On the *Première Dame* phenomenon, which has no equivalent in Europe, see Joëlle Chevé, *L'Elysée au féminin de la IIe à la Ve République. Entre devoir, pouvoir et désespoir* (Monaco: Editions du Rocher, 2017). More specifically on Carla Bruni Sarkozy and Brigitte Macron, see Patrick Weber, *La Reine Carla* (Monaco: Editions du Rocher, 2010) and Ava Djamshidi and Nathalie Schuck, *Madame la Présidente* (Paris: Plon, 2019).

Concluding Remarks

After the Liberation of France and the fall of Pétain's regime, politicians tended to avoid having themselves represented on propaganda materials. The fear of accusations of personality cults only partly accounts for such reticence. Because before the advent of the Fifth Republic in 1958 the political system was largely party-based, the personality of the candidates played a limited role. The presidentialization of the electoral process, brought about by the new Constitution, radically changed the approach to electioneering. Posters featuring the candidates' effigies became the norm. They were first used extensively during the presidential election of 1965. This was also the first time a political consultant was employed in a campaign. The practice became increasingly widespread, though the Socialists objected to it until the mid-1970s, persuaded that political projects cannot be concocted following market research and advertised like consumer goods, and that the long-term quality of democracy came before conquering electors. They succumbed to political marketing when François Mitterrand hired the well-known consultant Jacques Séguéla to choreograph his local election campaign of 1976. Séguéla created suggestive images, entirely centered on the personality of the candidate, and pursued the same approach when he realized the "Force tranquille" posters for the presidential race of 1981.

The success of Séguéla's campaign has led parties across the political spectrum to imitate it. This is unsurprising. Because propaganda is now largely in the hands of marketing-oriented political consultants, it has become strongly homologized: the images and slogans adopted by parties no longer reflect their specific political identity.[74] Only the "home-made" graphic output of some small radical left and ecological organizations manages to be aesthetically in line with their ideologies.

Posters reproducing the effigies of candidates are a major feature of all election campaigns in France. Their display is regulated by the law: the posters are placed on boards that are temporarily put up close to polling stations, and are arranged in a random sequence that is determined by draw (before 2007 the sequence depended on the candidates' order of registration with the local authorities). Though the plastering of posters outside the designated spaces is a legal offence, punishable with heavy fines, the practice is followed by all parties, both "respectable" and anti-system. During election periods the effigies of the various candidates are stuck on barren-looking store windows, lamp posts and the fences of building sites to signal their territorial presence. Postering is indeed considered to be an essential feature of political activism.[75]

In discussing political portraiture in France this essay has mostly referred to the poster medium. In fact the effigies of candidates that are featured on official campaign posters are also reproduced on their *professions de foi* (professions of faith), the documents summarizing the program they pledge to implement if elected, which are sent to every voter by the local administrations, as a batch, prior to the election. It is commonly said that the advent of television and Internet has rendered printed forms of political communication largely irrelevant. This is clearly not the case in France.

74 The Communists, the Socialists and the far right had the strongest visual identities. See Romain Ducoulombier, *Vive les Soviets! Un siècle d'affiches communistes* (Paris: Les Echappés, 2012); François Hollande (introd.), *Des poings et des roses. Le siècle des Socialistes* (Paris: Editions de la Martinière, 2005); and Novak, *Tricolores*.

75 On the legal aspects of the placement of posters during election campaigns, and unlawful plastering as a generalized practice, see Dumitrescu, "French Electoral Poster Campaigns," 139–46.

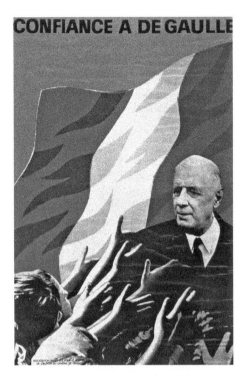

Figure 15.1 "Have faith in de Gaulle". Poster, presidential election, 1965.

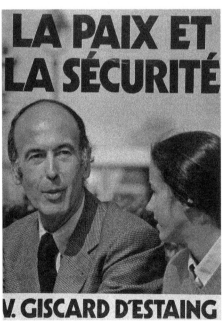

Figure 15.2 "Peace and safety". Valery Giscard d'Estaing with his younger daughter. Poster, Fédération Nationale des Républicains Indépendants, presidential election, 1965.

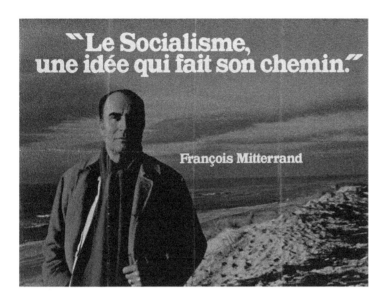

Figure 15.3 "Socialism, an idea that is gaining acceptance". François Mitterrand. Poster by Jacques Séguéla, Socialist Party, local election, 1976. (Collection Fondation Jean-Jaurès, Paris & Havas Groupe, Puteaux).

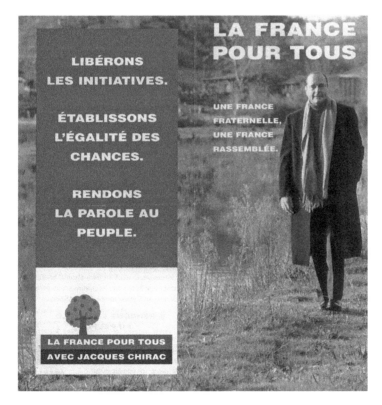

Figure 15.4 "France for all. A fraternal France, a united France". "Let's have freedom of initiative, let's have equality of opportunity, let's give their voice back to the people". Jacques Chirac. Brochure, Union pour un Mouvement Populaire, presidential election, 1995.

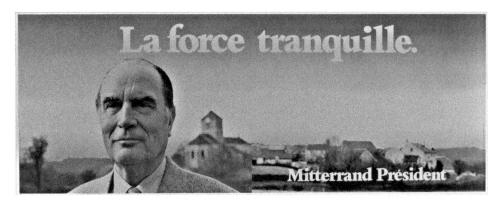

Figure 15.5 "The quiet strength". François Mitterrand. Poster by Jacques Séguéla, left alliance, presidential election, 1981. (Collection Fondation Jean-Jaurès, Paris & Havas Groupe, Puteaux).

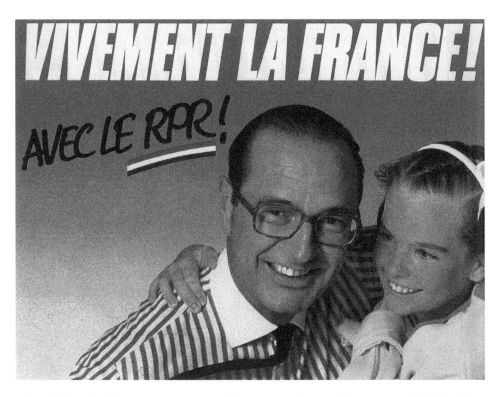

Figure 15.6 "Rearing to go!" Jacques Chirac. Poster, Rassemblement pour la République, parliamentary election, 1986.

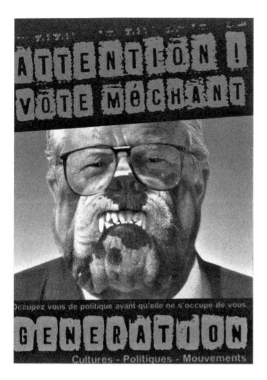

Figure 15.7 "Watch out! Vicious vote! Get into politics, before it gets you". Anti- Jean-Marie Le Pen poster produced by the private radio network Génération 2000, presidential election, 2002.

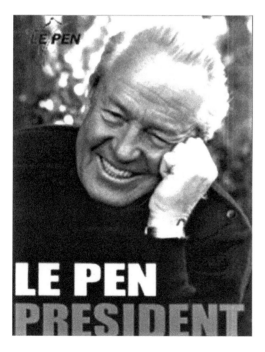

Figure 15.8 Jean-Marie Le Pen. Photograph by Franck Landouch. Poster, Front National, second round, presidential election, 2002.

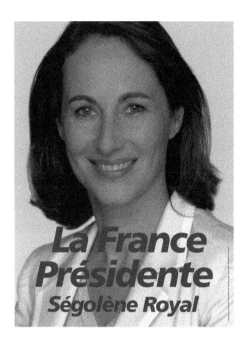

Figure 15.9 "A woman President for France". Ségolène Royal. Photograph by Oliviero Toscani. Poster, Socialist Party, second round, presidential election 2007. (Fondation Jean-Jaurès, Paris).

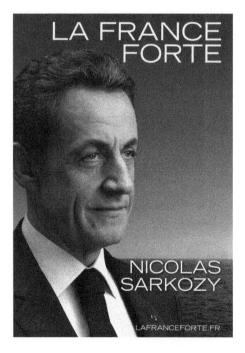

Figure 15.10 "A strong France". Nicolas Sarkozy. Poster, Union pour un Mouvement Populaire, first and second round, presidential election, 2012.

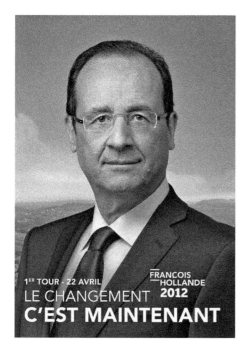

Figure 15.11 "Change, let's have it now". François Hollande. Poster, Socialist Party, presidential election, 2012.

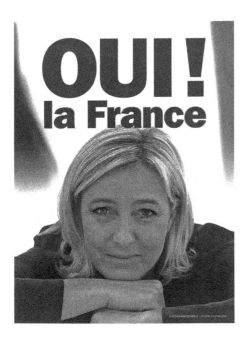

Figure 15.12 "[Say] Yes! to France". Marine Le Pen. Poster, Front National, presidential election, 2012. This poster was eventually replaced with another which also featured a close-up of the candidate.

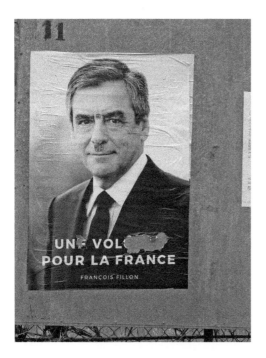

Figure 15.13 "A will for France" changed by graffiti into "A theft for France". **François** Fillon. Poster, Les Républicains, presidential election, 2017. (Author's phograph).

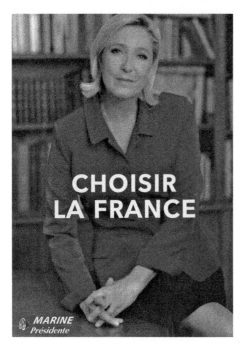

Figure 15.14 "Choose France". Marine Le Pen. Poster, second round, presidential election, 2017.

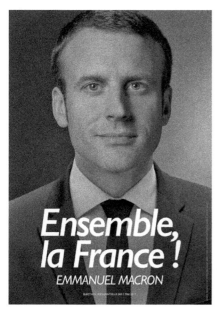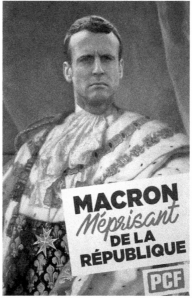

Figure 15.15 (Left) "Together, France!" Emmanuel Macron. En Marche, second round, presidential election, 2017. (Right) Anti-Emmanuel Macron poster, Communist Party, 2018 replacing "Président" with the assonant word "méprisant" (contemptuous).

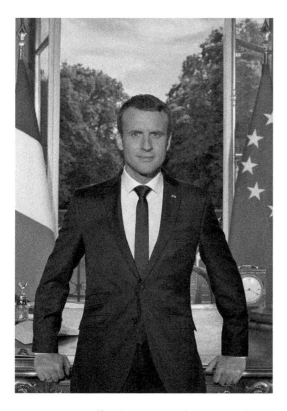

Figure 15.16 Official portrait of Emmanuel Macron, 2017. Photograph by Soizic de la Moissonnière. (DILA – La Documentation française).

Bibliography

Benassaya, Philippe. *Les années Giscard, 1974–1981*. Paris: Bourin, 2011.

Benoit, Jean-Marc, Philippe Benoit, and Jean-Marc Lech. *La politique à l'affiche. Affiches électorales et publicité politique, 1965–1986*. Paris: Editions du May, 1986.

Bernard, Agnès. *Musées et portraits présidentiels. Les sens cachés*. Paris: l'Harmattan, 2009.

Bernard, Richard, "L'image du Président de la République, clef de voûte symbolique," in idem *Les emblèmes de la République*, 277–301. Paris: CNRS Editions, 2012.

Borrell, Alexandre, and Jamil Dakhlia. "Political Advertising in France: the Story and Effects of a Slow Liberalization," in *Routledge Handbook of Political Advertising*, edited by Christina Holtz-Bacha, and Marion R. Just, 123–38. New York: Routledge, 2017.

Boude, Yvan, and Agnès Bernard. *Présidents de la République. Une mise en image du pouvoir*. Nevers: Conseil Général de la Nièvre, 2007.

Branca, Eric, and Arnaud Folch. *Les Présidents de la République*. Paris: Molière Valmonde, 2001.

Brefe, Fonseca, Ana Claudia, and Krystel Gualdé. *Pouvoirs. Représenter le pouvoir en France du Moyen Age à nos jours*. Paris-Nantes: Somogy – Château des Ducs de Bretagne, 2008.

Delporte, Christian. *La France dans les yeux. Une histoire de la communication politique de 1930 à nos jours*. Paris: Flammarion, 2007.

Doizy, Guillaume, and Pascal Dupuy. "De 1848 à nos jours: Le Président de la République face à son double caricatural." *Cahiers d'histoire* 131 (2016): 105–32.

Dumitrescu, Delia. "French Electoral Poster Campaigns in the Twenty-First Century." In *Election Posters Around the Globe: Political Campaigning in the Public Space*, edited by Christina Holtz-Bacha and Bengt Johansson, 139–57. Cham, Switzerland: Springer, 2017.

Gorius, Aurore, and Michael Moreau. *Les gourous de la com'. Trente ans de manipulations politiques et économiques*. Paris: La Découverte, 2011.

Maarek, Philippe J. "The Evolution of French Political Communication. Reaching the limits of professionalisation?" In *The Professionalisation of Political Communication*, edited by Ralph Negrine et al., 145–60. Bristol: Intellect, 2007.

Marzorati, Jean-Louis. *Les années de Gaulle, 1958–1969*. Paris: Bourin, 2012.

Marzorati, Jean-Louis. *Les années Pompidou, 1969–1974*. Paris: Bourin, 2012.

Milot, Grégoire. *La politique s'affiche. Un petit récit de nos murs politiques*. Clermont-Ferrand: De Borée, 2019.

Pigozzi, Caroline, and Philippe Goulliaud. *Les photos insolites des Présidents de la République*. Paris: Gründ, 2018.

Richard, Bernard. "L'image du Président de la République, clef de voûte symbolique." In *Les emblèmes de la République*, edited by Bernard Richard, 277–301. Paris: CNRS Editions, 2012.

Schwartznberg, Roger-Gérard. *L'Etat spectacle 2. Politique, casting et médias*. Paris: Plon, 2009.

Séguéla, Jacques, and Thierry Saussez. *La Prise de l'Elysée. Les campagnes présidentielles de la 5e République*. Paris: Plon, 2007.

Seidman, Steven A. "Politics and Posters in France." In *Posters, Propaganda, and Persuasion in Election Campaigns Around the World and through History*, edited by Steven A. Seidman, 101–24. New York: Peter Lang, 2008.

Tillier, Bertrand. *A la charge! La caricature en France de 1789 à 2000*. Paris: l'Armateur, 2005.

Various Authors. *Caricatures de Présidents, 1848–2012*, special issue of *Sociétés et representations* 36 (2013).

16 Political Portraiture in Early Republican Turkey

Christopher S. Wilson and Sinan Niyazioğlu

The Republic of Turkey, the secular nation-state established after the fall of the Ottoman Empire, was founded by Mustafa Kemal Atatürk (1881–1938), together with his right-hand man İsmet İnönü (1884–1973), following a War of Independence that took place between 1919 and 1923. After the war, Atatürk became Turkey's first president and İnönü its first prime minister.

Following the establishment of the Republic of Turkey, pictures of both Atatürk and İnönü were extensively used to represent and bolster the fledgling nation. Images illustrating key moments of their lives were widely disseminated both nationally and internationally through photographs, paintings, sculptures, posters, banknotes, stamps, magazine covers and textbook covers. In the end, it is quite difficult to separate the images of these two leaders from the actual nation-state of Turkey itself.

Atatürk the Soldier

Atatürk's revolutionary activities began shortly after his graduation from Istanbul's Ottoman Military College in 1905, but it was the occupation of the country by the Allied Powers following the First World War that propelled him to rally other similarly-minded military officers to support both the expulsion of the occupiers and the overthrow of the theocratic Ottoman Empire. In its place, Mustafa Kemal – who was granted the surname Atatürk ("Father of the Turks") after a 1934 Surname Law – along with İsmet İnönü created a secular, Western-oriented republic.

This new country was ruled by the *Cumhuriyet Halk Partisi* (Republican People's Party), which was virtually uncontested during the early years of the Republic. Other political parties existed at this time, but the Republican People's Party consistently held the majority in parliament from the declaration of the Republic of Turkey in 1923 until the second post-war election of 1950. Atatürk and İnönü ruled the young nation in a "top-down" manner, which partially explains the great number of reforms that they were able to introduce and maintain. Together, they abolished the Ottoman Sultanate (1922) and the Islamic Caliphate (1924), moved the capital from Istanbul to Ankara (1923), established a constitution (1924), created a national education system (1924), had the Quran translated into Turkish (1924), eliminated *sharia* courts (1924), prohibited religious clothing in public (1925), replaced the lunar calendar with a solar calendar (1925), adopted the Italian Penal Code (1925) and the Swiss Civil code (1926), instigated a national census (1926), replaced Arabic script with Latin letters (1928), introduced universal suffrage for women (1930 and 1934), passed land reform laws (1930s) and established a Monday-to-Friday work week (1935).

Mustafa Kemal's shift from soldier to statesman can be seen by the way he was represented during the early years of the Republic. Many photographs of Colonel Mustafa Kemal, particularly those representing him as a commander during the Turkish War of Independence, were reproduced and circulated in newspapers throughout the country to remind the fledgling nation that it was he who was responsible for its existence. The first photographs of Mustafa Kemal to ever appear in an Ottoman publication was published on October 29, 1915 in the Istanbul newspaper *Tasvîr-i Efkâr* (Picture of Ideas). However, a pre-revolution image that achieved true iconic status during Atatürk's presidency is a photograph taken by the army photographer Haydar Mehmet Alganer on June 17, 1915, at the battle at Gallipoli.[1] Shot at a low angle, this photograph depicts Mustafa Kemal standing upright and peering out at the enemy lines. Unlike the soldiers shown with him, the leader does not look at the camera – he is clearly focused on the battlefield, squinting into the distance. This picture, which seems to convey Mustafa Kemal's seriousness and determination, was later reproduced in numerous illustrated histories of the Turkish Revolution in order to establish his reputation as a great military leader.[2]

Also worth mentioning is a photograph taken during the Turkish War of Independence at Kocatepe Hill, near Dumlupınar, on August 26, 1922, by Etem Tem (1901–1971), an official military photographer. The image shows Field Marshal Mustafa Kemal walking uphill, alone, and deep in thought. It has been reproduced on postcards (Figure 16.1) and commemorative stamps, and features in all books about the Turkish Revolution. Several other pictures of Atatürk by Tem provided illustrations for Turkish primary school books for decades.[3] During the Turkish War of Independence, studio photographs of Mustafa Kemal were also shot for distribution to the press: they represent him with a piercing stare, suggesting concentration and determination, and wearing a *kalpak* – the traditional Turkish tall woolen hat (Figure 16.2).

After the war, monuments celebrating Atatürk as a military leader were also erected throughout Turkey. The *Ulus* (Nation) Monument in Ulus Square, Ankara (1927), and the *Cumhuriyet* (Republic) Monument in Taksim Square, Istanbul (1928), are among the most significant. The monument in Ankara was designed by the Austrian artist Heinrich Krippel,[4] one of about 200 foreign artists, architects, town-planners, engineers and other professionals who were invited to Turkey in the 1920s and 1930s

1 "Mustafa Kemalim," accessed October 20, 2019, https://mustafakemalim.com/canakkale-savasinda-mustafa-kemal–1915–1916.
2 The photograph features, for instance, in Celal Nuri İleri, *Türk İnkilabı* [The Turkish Revolution] (Istanbul: Ahmet Kamil, 1926); M. Şevki Yazman, *İstiklal Savaşı Nasıl Oldu?* [Did the Revolutionary War Happen?] (Istanbul: Akşam, 1933); Ali Rıza Seyfi, *Gazi ve İnkilap* [The Veteran and the Revolution] (Istanbul: Sinan Publishers, 1933); and Peyami Safa, *Türk İnkılabına Bakışlar* [Perspectives on the Turkish Revolution] (Istanbul: Kanaat, 1938).
3 Etem's entire portfolio of Atatürk photographs was published in album format in 1995: *Kemal Atatürk: Değişim ve Uluslaşma Hareketi* [Kemal Atatürk: Movement for Change and Nationalization], introduction by Bernard Lewis (Istanbul: Creative Publishers).
4 Heinrich Krippel (1883–1945), who trained at the Vienna Academy of Fine Arts and lived in Turkey between 1925–1938, created five other monuments to Atatürk in Ankara, Istanbul, Konya, Samsun and Afyon.

to contribute to its ambitious artistic and educational programs.[5] It is a bronze equestrian statue depicting a thoughtful and composed Atatürk in full military uniform, which is clearly indebted to classical models such as *Marcus Aurelius* on the Capitoline Hill in Rome and Renaissance ones such as Donatello's *Gattamelata*. The pedestal of this monument contains reliefs illustrating significant battles of the Turkish War of Independence, as well as Atatürk quotes from the same period. The Istanbul monument, designed by the Italian academic sculptor Pietro Canonica, is of particular interest because it represents Atatürk as a soldier on one side – in a pose similar to Etem Tem's Kocatepe photograph – and as a statesman on the other side.[6]

Atatürk, the Statesman

Following the Treaty of Lausanne, the Republic of Turkey was proclaimed on October 29, 1923. A parliamentary system was established with Mustafa Kemal as president with the official title of *Gazi Mustafa Kemal Pasha* (Veteran General Mustafa Kemal) and İsmet İnönü as prime minister. Both men then began to promote themselves as statesmen rather than soldiers.

By means of their social reforms, Atatürk and İnönü succeeded in changing the perception of "the Turk" as a Muslim subject of an emperor to a citizen of a modern, secular and democratic state. To illustrate this transformation, Mustafa Kemal adopted a new sartorial approach: he wore Western-style suits and stopped wearing the *kalpak*, replacing it with a European-style hat. In 1925, a Hat Law was introduced in Turkey that essentially outlawed the use of the *fez* and other religious headwear.[7] In August of that same year, Mustafa Kemal visited the towns of İnebolu and Kastamonu wearing a white, wide-brimmed straw hat, and informed a crowd that had come to welcome him: "This headwear is called a hat". The event caused quite a stir at the time, resulting in photographs that appeared in the press showing the president brandishing his new headgear. Following this episode, Atatürk would rarely be seen and photographed in public without a European-styled hat. On special days, he preferred top hat and tails, as commemorated by the Republic of Turkey in a postage stamp issued on the first anniversary of his death in 1939 (Figure 16.3, Left). On other public occasions, Atatürk could be seen wearing a Bowler, a Trilby or a Panama hat. In less formal situations, like relaxing at the beach or on a boat, he would wear a straw hat or flat cap. As the "father of the Turks", Atatürk was leading by example not only through his actions and words, but also through his wardrobe.

5 Most of these foreigners came from the German-speaking world. See Fritz Neumark, *Zuflucht am Bosphorous: Deutsche Gelehrte, Politiker and Kunstler in der Emigration* (Frankfurt: Knecht, 1980); Sinan Niyazioğlu, *Erken Cumhuriyet Dönemi'nin Otoportresi, 1923–1938* [A Self-portrait of the Early Republican Era, 1923–1938] (Istanbul: Mimar Sinan Fine Arts University, 2011), 77–91; and Aylin Tekiner, *Atatürk Heykelleri, Kült, Estetik, Siyaset* [Atatürk Sculptures, Cult, Aesthetic, Politics] (İstanbul: İletişim, 2010), 124–8.

6 Pietro Canonica (1869–1959) was responsible for three other Atatürk monuments: two equestrian statues, erected in Ankara and Izmir, in 1927 and 1929, respectively, and a statue that shows him standing wearing his uniform, which was put up in Victory Square, Ankara, in 1928.

7 Ironically, the *fez* was instituted in 1839 by Sultan Mahmud II as a modern replacement to the turban. By Atatürk's time, however, it was no longer perceived as being modern.

Another of Atatürk's reforms that resulted in an iconic photograph was the replacement of Arabic script with Latin letters, which was considered necessary by the new regime because the Arabic-based script that had been used during the reign of the Ottomans did not accurately and consistently represent the vowel harmony of the Turkish language. It was also (correctly) believed that literacy rates would improve in the country with the use of Latin script. Prior to the introduction of the new Turkish alphabet, Atatürk traveled the nation to advertise the novel concept. During a visit to the Central Anatolian town of Sivas in September 1928, Atatürk was photographed pointing to a blackboard on which an assistant had written various letters. This picture was repeatedly reproduced in the press and also featured on a commemorative stamp in 1938 on the tenth anniversary of both the alphabet change and the official designation of Atatürk as the nation's "Head Teacher" by the Turkish parliament (Figure 16.3, Right).

Another photograph presenting Atatürk as a teacher was taken in 1935 by Cemal Işıksel, who by 1929 had become the president's quasi-official photographer. This image, published in the newspaper *Cumhuriyet* (Işıksel's employer),[8] shows Atatürk, sitting, with his attention focused on his adopted daughter, Ülkü, who at the time was two and a half years old. Ülkü is concentrating on a piece of paper with one of her fingers pointing to the letters on the page. Atatürk seems to be teaching her the new Turkish alphabet. The graphic designer İhap Hulusi Görey[9] used this photograph as the basis of an *Alfabe* (Alphabet) poster, which later became the cover of the alphabet textbook all schools in Turkey adopted from 1936 onwards (Figure 16.4). In the background, Görey added a hill with a castle, alluding to the old regime, Ottoman Turkey, away from which the Republic of Turkey was moving by adopting the new alphabet.

Monuments celebrating Atatürk as a statesman were also erected throughout Turkey during his lifetime. The first of such monuments, designed again by Heinrich Krippel, was installed in 1926 in the Sarayburnu promontory in Istanbul – the site from which Atatürk departed on May 19, 1919 to begin the Turkish War of Independence. This sculpture depicts him standing with his fists clenched and right foot forward, looking east over the Bosphorus towards Anatolia. In 1927, in order to present himself as the embodiment of Turkey's liberation, Atatürk actually legally changed his birth date to make it coincide with the date of this famous journey out of Istanbul.[10]

Many other monuments celebrating Atatürk portray him in civilian clothes with a stern look on his face – an expression that was deemed appropriate to his status as war hero and founding father of the nation. The nineteen-foot high statue representing Atatürk with a furrowed brow and a heroic pose, accompanied by two muscular youths, part of the *Güven* (Trust) Monument erected in Ankara's Güven Park in 1935,

8 Cemal Işıksel (1905–1989) was one of the first professional photo-reporters in Turkey.

9 İhap Hulusi Görey (1898–1986) was one of the first professional graphic designers in Turkey, building his career on packaging designs, visual identities for governmental institutions, public service announcement posters, domestic and international travel posters, as well as Turkish Lottery tickets. Görey even designed his own professional logo – a triangle with his name and the word "Istanbul" – another first in Turkey.

10 Faik Gur, "Sculpting the Nation in Early Republican Turkey," *Historical Research*, May 2013, 360.

was the work of the Austrian-German sculptor Josef Thorak (1889–1952), coincidentally also one of the two official sculptors of the Nazi regime (Figure 16.5).

Indirectly, the Turkish government also commissioned artworks depicting Atatürk through their sponsorship of the *İnkılap Sergileri* (Revolution Exhibitions), held between 1933–1937. Artists were invited to submit works of art as long as they conformed to the theme of "revolution". One prominent example is the 1933 painting *İnkılap Yolunda* (On the Road to Revolution) (Figure 16.6), painted by Zeki Faik İzer (1905–1988), which currently hangs in the Istanbul Museum of Painting and Sculpture at Mimar Sinan Fine Arts University. İzer was educated at the Istanbul Academy of Fine Arts and also spent time studying in Paris, where he was able to acquaint himself directly with Eugène Delacroix's *Liberty Leading the People*. İzer's painting is clearly inspired by it, a fact that he never denied.[11] The central figure of İzer's canvas – the character corresponding to Delacroix's Liberty – portrays a modern Turkish woman waving the national flag from a plinth bearing the year of Turkish independence. On her left, bayonet-wielding soldiers attack bearded men (Ottomans). In front of the plinth, a dead man wearing a *fez* (an Ottoman) lies on the ground. Atatürk, standing next to the central female figure, raises his left arm to point toward the future – a gesture recalling that of the Lenin statue at Leningrad's Finland Station (1926) – while simultaneously embracing a man and woman with his right arm. Behind them is a woman in the process of removing her veil, symbolizing women's emancipation – one of the new Republic's reforms. The fortress to the left of the painting, like the castle in Görey's *Alfabe* textbook cover, represents old Turkey. The meaning of the composition is reiterated by the image of a youth raising a book bearing the title *Türk Dili ve Tarihi* (Turkish Language and History) and stepping onto a sheet of paper with a *tuğra*, the calligraphic monogram of an Ottoman sultan. The painting was obviously a reminder of the country's ongoing process of modernization, moving away from the past and stepping into the future.

As early as 1927, when the Turkish Lira was first introduced, Atatürk's image – dressed in a European-style suit – was also reproduced on banknotes (Figure 16.7). In fact, since 1952, all Turkish currency, both banknotes and coins, has contained an image of Atatürk on the face (and sometimes also on the reverse), despite the fact that Turkish law 701 of December 30, 1925 requires the current President of Turkey to be represented on its money.

İsmet İnönü: The National Chief

Atatürk died on November 10, 1938 and İsmet İnönü succeeded him to the presidency the following day. In addition, the Turkish Parliament bestowed the honorary title of *Milli Şef* (National Chief) upon him in order to emphasize the political role that he was expected to assume on the eve of the Second World War. İnönü served as President of Turkey and as National Chief until the general election of 1950, implementing a successful policy of active neutrality during the war and protecting the country from the threats of occupation from either Nazi or Soviet troops.

11 Gültekin Elibal, *Atatürk ve Resim Heykel* [Atatürk and Painting and Sculpture] (Istanbul: Türkiye İş Bankası Cultural Publications, 1973), 157.

Immediately after his appointment, İnönü posed for an official photograph for distribution to the press. At his request, a thoughtful set-up was devised: İnönü was photographed with the Prime Minister Celal Bayar beneath the picture of Atatürk that hung in parliament, demonstrating that he would not break away from the political line of his predecessor. The photograph visually asserted that Atatürk was the founder of the Republic, that the National Chief was its protector and that the new Prime Minister was its coordinator (Figure 16.8).[12] After being registered in Ankara's *Başvekalet Matbuat Umum Müdürlüğü Fotoğraf Arşivi* (Photographic Archives of the General Press and Publishing Directorate), the picture was sent to all newspapers for publication during Atatürk's funeral ceremonies in Istanbul and Izmir, and in Ankara a few days later.

Portraits of İnönü as National Chief

As the supreme embodiment of Kemalist authority, İnönü needed to project a more assertive image than that which he had conveyed as Prime Minister. İnönü's Turkey, like Atatürk's, was a one-party regime. The press supported him in order to encourage the people to do the same. Their propaganda machine attempted to create an effective public image for the National Chief. The main aim of photographers and artists at this time was to produce material that expressed Turkey's wartime policy of active neutrality within international and domestic diplomacy. Two pictures taken by Etem Tem, who became one of İnönü's official photographers, are worth highlighting. The first, which was displayed in all educational institutions and community centers around the country, depicts President İnönü wearing an ordinary civil servant's civilian clothes (Figure 16.9, Left). He confronts onlookers with a serious and solemn expression, forcing them to establish an emotional bond with him, but also suggesting that he is watching over them.[13] The second photograph, which was reproduced on postage stamps and on all official documentation aimed at international diplomacy,[14] shows İnönü wearing more formal attire – a tuxedo complete with a white bow tie – to emphasize his parliamentary identity (this was the outfit worn by Turkish MPs on ceremonial occasions) (Figure 16.9, Right). By choosing to be photographed in such a frock coat, rather than in a military uniform like Mussolini and Hitler, İnönü emphasized Turkey's wartime neutral position and conveyed the state's leitmotif *Yurtta sulh, cihanda sulh* (Peace at home, Peace in the world).[15] In this photograph, which was taken in 1939 when Nazi troops were close to the country's north-western border, İnönü looks west to suggest that Turkey does not want to enter a war, but would not hesitate to fight to protect itself. İnönü's tense facial expression and stern look directed toward the West were an open warning to the Axis Powers to refrain from attacking Turkey from the Balkans.

12 Sinan Niyazioğlu, *Irony and Tension, Perception of War in Istanbul and Ankara during the Second World War Years* (Ankara: Koç University-Vekam, 2016), 97.
13 Niyazioğlu, *Irony and Tension*, 98–9.
14 Niyazioğlu, *Irony and Tension*, 100–2. See also Ragıp Duran, *Savaş Yıllarında Dış İlişkilerimiz ve Türk Diplomasisi* [Turkish Diplomacy and Foreign Relations during the War Years] (Ankara: Kurtuluş, 1999), 33–5.
15 This phrase, first used by Atatürk on April 20, 1931 in a speech outlining the program of the Republican Peoples Party, became the official foreign policy of the Republic of Turkey.

Another portrait of İnönü as National Chief was realized by "court artist" Faruk Morel for a commemorative medal marking the twentieth anniversary of the foundation of the Republic of Turkey (Figure 16.10).[16] Here, Atatürk is depicted next to İnönü, both of them in profile and looking in the same direction.[17] Like the photograph that was taken just after İnönü assumed the presidency, this medal was meant to present him as the one who would continue Ataturk's policies.

As National Chief, İnönü faced the challenge of creating monuments in Turkey to himself just as Atatürk had done. In the 1940s, he commissioned artists to produce a range of sculpted busts and paintings that honored him and ensured that he appeared as the follower of Atatürk.[18] İnönü's favorite portraitists, all of whom were of a predictably academic type, were the sculptors Rudolf Belling[19] and Sabiha Bengütaş,[20] as well as the painters Feyhaman Duran[21] and İbrahim Çallı,[22] whose paintings, exhibited in the *Ankara Halkevi* (Ankara People's House), were often reproduced in poster format to be hung on the walls of public buildings.

The point has already been made that İnönü was frequently represented with Atatürk to stress that his policies were in line with those of his predecessor.[23] The reiteration of this idea was considered to be all the more necessary to project an image of political stability during the turmoil of the war years.[24] İnönü's monuments represented him as a calm and self-confident protector of the young.[25] Oil paintings, which hung in

16 Faruk Morel (1913–1985) was a Turkish poster artist, illustrator and painter of the Early Republican Era. He graduated from the Istanbul Fine Arts Academy in 1928, and taught graphic design at Istanbul's Chamber High School from 1934 to 1967. His book, *Afiş* [Poster] (1953) became a standard source book for a whole generation of Turkish poster artists.

17 This mode of presentation was clearly inspired by Soviet propaganda. Josef Stalin was frequently depicted with his profile echoing that of Vladimir Lenin. See Sinan Niyazioğlu, "Sert Yıkım,"*Arradamento Mimarlık ve Tasarım Kültürü Dergisi* ["Massive Destruction," Arradamento Magazine for Architecture and Design Culture], 2017, 313, 84–90.

18 Nihal Bayburtlu, *Milli Şef Dönemi Resim ve Heykel Kültürü* [Painting and Sculpture Culture in the National Chief Period], (Istanbul: Art Publications, 1996), 82–4, 89–93 and 102–4.

19 Rudolf Belling (1886–1972) was a German sculptor whose style was originally Expressionist. He was persecuted by the Nazis, who included some of his works in their 1937 *Entartete Kunst* [Degenerate Art] exhibition in Munich. In 1937, he immigrated to Turkey, where he lectured at the State Fine Arts Academy, Istanbul, for twelve years. Belling realized two monuments for İnönü: one at Taksim Gezi Park, Istanbul (1944) and another at the Faculty of Agriculture of Ankara University (1945). Out of necessity, his style became conventionally neoclassical and heroic.

20 Sabiha Bengütaş (1904–1992), the first female sculptor of the Early Republican Era, graduated from Rome's Academy of Fine Arts in 1927, where she met Pietro Canonica. When Canonica was invited to Turkey to realize the Atatürk monuments mentioned earlier, Bengütaş worked as his assistant.

21 Feyhaman Duran (1886–1970) studied painting at Paris's Ecole des Beaux-Arts and Académie Julian from 1910 to 1914.

22 Though essentially academic, the style of İbrahim Çallı (1882–1960) was also influenced by Impressionism.

23 Mahmut Gologlu, *Türkiye Cumhuriyet Tarihi, III, Milli Şef Dönemi 1939–1945* [History of the Republic of Turkey, III, National Chief Period 1939–1945] (Istanbul: Türkiye İş Bankası Cultural Publications, 2015), 67–9, 96–7 and 111–13.

24 Falih Rıfkı Atay, "Harbin Gölgesinde," *Ülkü Milli Kültür Dergisi* ["Under the Shadow of War," Ideal, A Magazine for National Culture] 10 (1942): 4–5 and Vedat Nedim Tör, "Harp ve Sulh," *Ülkü* ["War and Peace," Ideal] 175 (1944): 8–9.

25 "Abidelerimiz," *Ülkü Milli Kültür Dergisi* ["Our Monuments," Ideal, A Magazine for National Culture] 35 (1943): 13–14 and "Millet ve Anıt," *Ülkü* ["Nation and Monument," Ideal] 64 (1944): 17–19.

military institutions, hospitals and community centers, mostly depicted İnönü as a serious and distant leader, who, seated regally, watched over his people (Figure 16.11).

İnönü in the Popular Press

Photographs of the National Chief also circulated in the Turkish popular media, often featuring in full color on the covers of periodicals. The weekly magazine *7 Gün* (Seven Days) pictured İnönü on the covers of issues celebrating such national holidays as "Sovereignty Day", "Youth and Sports Day", "Victory Day" and "Republic Day". His portrait was usually decorated with torches or peace wreaths. At times, photomontage compositions combined İnönü's photographs with pictures of national monuments (Figure 16.12).[26] During İnönü's presidency, the two main propaganda organizations of the state – the *Başvekalet Matbuat Umum Müdürlüğü* (General Press and Publishing Directorate, Ankara) and the People's Houses – produced his wartime portraits and ensured that they were reproduced in the press. İnönü's effigy was prominently featured on front covers or in special inserts.

Managing İnönü's Propaganda

Though Atatürk and İnönü founded the Turkish Republic together and structured the modernist ideology of the Early Republican Era, they did not rely on visual propaganda to the same extent. İnönü made much greater use of it because during Atatürk's presidency the press organs and propaganda institutions of the fledgling state were not sufficiently organized to function effectively. Printed publicity suffered from paper shortage because imported paper was difficult to obtain after the 1929 worldwide economic crisis – Turkey only began to produce its own paper on an industrial scale in 1936, two years before Atatürk's death.[27] Moreover, the country lacked adequate printing equipment during Atatürk's presidency: official albums, banknotes, postage stamps and other such documents were mostly printed abroad. As has already been noted, there was also a dearth of local artists: in order for Atatürk to shape his public image as a Westernized leader, he was often forced to rely on European artists and architects. These individuals were independent, foreign professionals who mostly went back to their countries after the completion of their commissioned work. In order to create a contingent of local artists capable of promoting the new state through the use of imagery centered on his cult of personality, Atatürk sent a generation of students to art academies in Europe. These students returned to Turkey in the 1940s as skilled artists, ready to use their talents to exalt the National Chief İnönü.[28]

During the Second World War, İsmet İnönü reorganized the General Press and Publishing Directorate, developed its visual archives and reprographic department and arranged for photographers to be appointed to lecture at People's Houses throughout

26 Sinan Niyazioğlu, "İhap Hulusi Görey: Designer of the Early Republic's Visual Propaganda," *The Journal of Decorative and Propaganda Arts* 28 (2017): 143–5.

27 Uygur Kocabaşoğlu, *SEKA Tarihi* [The History of SEKA] (İzmit: SEKA Publications, 1996), 46–8. See also: Mehmet Sarıoğlu, *Bir Cumhuriyet Aydını: Mehmet Ali Kâğıtçı* [A Republican Intellectual: Mehmet Ali Kâğıtçı] (İstanbul: Türkiye İş Bankası Cultural Publications, 2008), 96–7.

28 Bayburtlu, *Milli Şef Dönemi Resim ve Heykel*, 89–93.

the country. Newly acquired and technically advanced equipment permitted the print-ing and diffusion of decent quality images.[29] İnönü's approach to image management was not much different than that pursued by Atatürk. However, thanks to İnönü's impulse, new technologies were used and new generations of young, foreign-trained artists were employed. The outcome was a visual propaganda that effectively con-veyed Turkey's wartime position of active neutrality.

The Afterlife of Atatürk's Image

Atatürk may have passed away on November 10, 1938, but his image is everywhere in Turkey. Statues of Atatürk in heroic poses grace the prominent public spaces of Istanbul and Ankara, and those of provincial capitals, in particular the towns asso-ciated with the Turkish War of Independence such as Samsun, Erzurum and Izmir. Busts of Atatürk are found in the main squares of smaller towns and villages, as well as in front of every school. An official Department of Education directive adopted on January 14, 1981 requires all schools – both state-funded and private ones – to "place, maintain and protect a bust of Atatürk in their gardens and forecourts". The regula-tions of the Association for Primary Education require that a portrait of Atatürk be hung above the blackboard, along with the national flag and a copy of the President's 1927 *Gençliğe Hitabe* (Address to the Youth). Rooms and offices in other state build-ings (hospitals, courthouses, police stations, town halls, public libraries and universi-ties) also display Atatürk's portrait. A 1950 document issued by the Prime Minister's Office states that "Only the portrait of the Great Atatürk, the Founder of the Republic of Turkey, may hang in official offices and establishments."[30] These depictions, how-ever, are not standardized: they vary to suit the nature and function of each location. The town hall room where marriage ceremonies are held may display a portrait of Atatürk that shows him dancing at a wedding, while a children's playground may have a photograph of Atatürk on a swing. Many commercial enterprises also enthusiasti-cally follow a similar practice: a calendar advertising the services of an optometrist may show Atatürk wearing glasses, and a taxi stand may have a bust of Atatürk, together with a quote from him praising the politeness of Turkish drivers. The website of the Presidency of the Republic displays a gallery of 100 of such Atatürk photographs.[31]

On major national festivities, government buildings in Turkey are decorated with the national flag and giant portraits of Atatürk covering large parts of their façades. Many Turks wear lapel pins with a picture of Atatürk and many television stations broadcast with a small Atatürk profile in the corner of the screen. Every edition of the newspaper *Hürriyet* (Freedom) features a picture of Atatürk along with the Turkish flag and a slogan on its masthead that reads "Turkey belongs to the Turks."

29 Falih Rıfkı Atay, *Cumhuriyetin 20.inci Yıldönümünde Ankara Halkevi Raporu* [Report on Ankara Peoples' Houses on the 20th Anniversary of the Republic] (Ankara: Ulus, 1943), 11–12.

30 Republic of Turkey Prime Ministry Archives, Group Code of 030–18-0–2, Ref: 124–92–6, File: 3/12229, Date: 23/12/1950.

31 "Türkiye Cumhuriyeti Cumhurbaşkanlığı" https://www.tccb.gov.tr/en/ata_special/photos, last accessed July 4, 2019.

Commercially-sold templates for primary school children that contain basic geometric shapes like squares, circles and triangles also feature the profile of Atatürk.[32]

Atatürk's seemingly ubiquitous effigies are intended to make the nation feel that he is still around; they act as reminders of a Turkish collective identity. The father of the nation's presence even extends to the natural landscape: it is claimed that Atatürk's profile can be perceived in various geological formations throughout Turkey, such as a mountain ridge near Gömeç, Balıkesir, and on a hill near the village of Gündeşli, Ardahan. Some landscapes also boast extra-large human-made portraits of Atatürk, such as the one which the artist Mustafa Aydemir (b. 1953) created in 1982 while completing his national service in Erzincan. With the help of 3,000 other servicemen, Aydemir painted a huge portrait of Atatürk on a local hillside – a portrait so monumental (176 × 43 m) that it can be seen from satellites.[33] The latest trend is the creation of massive sculpted portraits of Atatürk that protrude from hillsides – an idea possibly inspired by Mount Rushmore, in South Dakota. Several examples can be found in Buca, Izmir and Kepez, Antalya. Unlike the Mount Rushmore sculpture, however, the more recent Turkish versions are not carved out of stone, but made of light materials such as wire mesh sprayed with concrete.

Postwar Elections and the End of the Early Republican Era

After the Second World War, general elections were held in Turkey, as in other NATO European countries. The Republican Peoples Party won the 1946 election, but failed to do so in 1950, thus ending the virtual one-party rule that had begun in 1923. It lost to the Demokrat Parti (Democrat Party), which presented itself as a mainstream right-wing party and promised a "New Turkey", one that was free from war paranoia and looked confidently toward the future. The newly-elected President Celal Bayar and Prime Minister Adnan Menderes continued to immortalize Atatürk as the founding leader of modern Turkey. However, they disparaged İsmet İnönü, whom they treated as a *persona non grata*, blaming him for the policies he pursued as a National Chief during the Second World War – policies which, in their view, were too rigid and held Turkey back from developing its full potential.

In modern Turkey's political history, the general election of 1950 was a turning point. As well as concluding the political monopoly of Atatürk's Republican Peoples Party, it also marked the end of the Early Republican Era, and with that the Westernizing reforms that characterized it. The party continues to exist, but, surprisingly, it has never succeeded in returning to power; it has been relegated to the role of opposition party.

32 In addition, Atatürk's name graces at least one street or boulevard in most Turkish cities; Ankara's major north–south protocol axis, Atatürk Boulevard, is the most famous example. Many cultural centers, sports facilities, conference halls and hospitals also bear his name. The Yeşilköy International Airport in Istanbul, originally named after the neighborhood of its location, was re-named Atatürk International Airport in 1985. Interestingly, though, the new and larger airport, which was inaugurated in April 2019 to replace it, is not named after Atatürk.

33 Coordinates 3947'23" N, 3928'35" E.

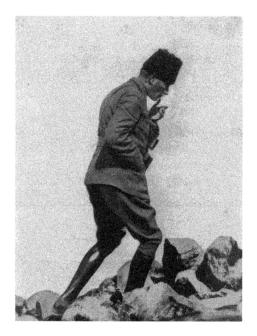

Figure 16.1 Field Marshal Mustafa Kemal photographed by Etem Tem, on August 26, 1922, at Kocatepe Hill, near Dumlupınar. Postcard, 1930s.

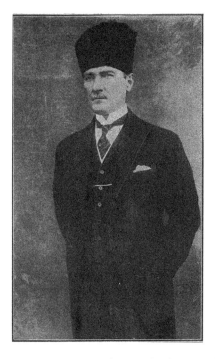

Figure 16.2 Mustafa Kemal, photographed by Etem Tem, early 1920s. From the propaganda album *Hakimiyet-i Milliyet* (National Authority), published in 1924 to promote Kemal's political authority in Anatolia.

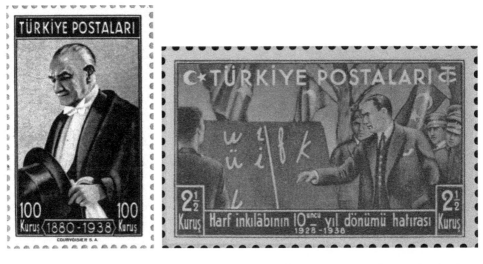

Figure 16.3 (Left) Postage stamp commemorating the first anniversary of Atatürk's death, 1939. (Right) Postage stamp, 1938, featuring Atatürk teaching in Sivas, September 1928.

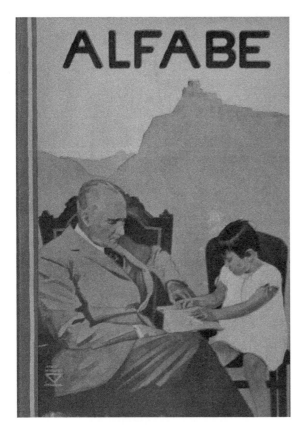

Figure 16.4 Cover of the school book *Alfabe*, designed by İhap Hulusi Görey, 1936.

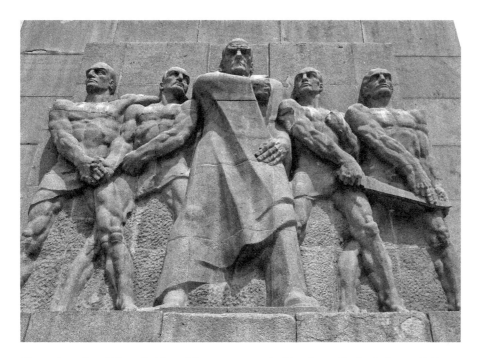

Figure 16.5 Josef Thorak, Trust Monument, north side, Güven Park, Ankara, 1935.

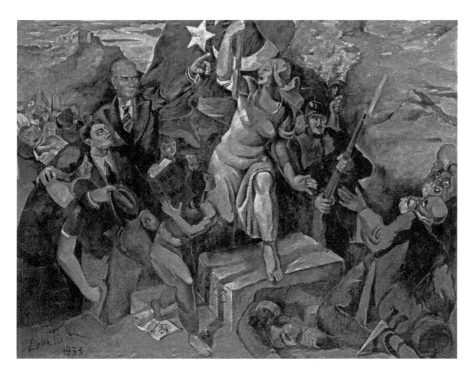

Figure 16.6 Zeki Faik İzer, *On the Road to Revolution.* Oil painting, 1933. Istanbul Museum of Painting and Sculpture, Mimar Sinan Fine Arts University, Istanbul.

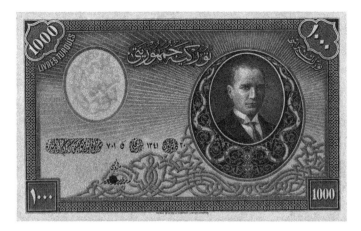

Figure 16.7 1000 Turkish Lira banknote, obverse, 1927. Printed by Thomas De La Rue & Company Limited, London. (Courtesy of Refik Mert Erdumlu).

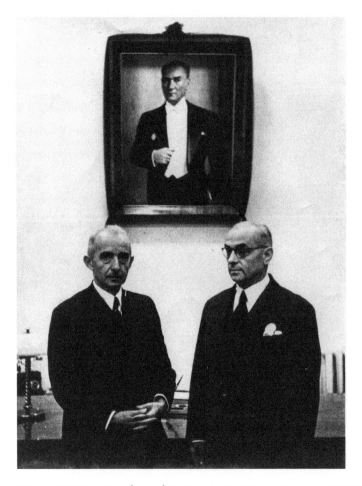

Figure 16.8 President İsmet İnönü with the Prime Minister Celal Bayar beneath a picture of Atatürk in parliament, November 11, 1938. Official photograph by the Press and Publishing General Directorate of Ankara.

Figure 16.9 (Left) İsmet İnönü as "National Chief" in civilian clothes. Photograph by Etem Tem, 1939. (Right) İsmet İnönü as "National Chief" in frock coat. Photograph by Etem Tem, 1939.

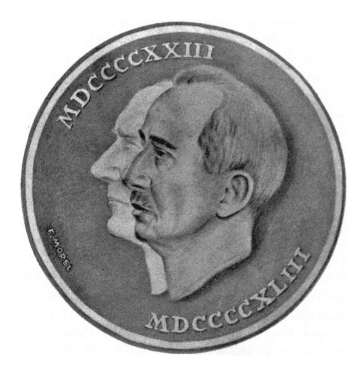

Figure 16.10 Medal commemorating the 20th Anniversary of the Republic, 1943. Designed by Faruk Morel.

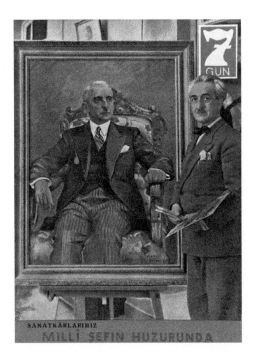

Figure 16.11 Cover of *7 Gün*, no. 379, 1940, showing the artist Feyhaman Duran in front of a portrait he painted of the "National Chief".

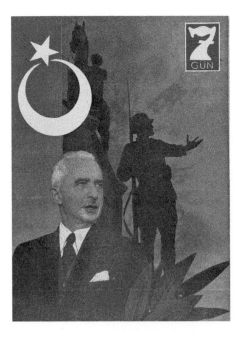

Figure 16.12 Cover of *7 Gün*, no. 454, 1941. Behind İnönü is the outline of Heinrich Krippel's Ulus Square monument to Atatürk. The holly branch in the foreground is a symbol of peace.

Bibliography

Bayburtlu, Nihal. *Milli Şef Dönemi Resim ve Heykel Kültürü* [Painting and Sculpture Culture in the National Chief Period]. Istanbul: Art Publications, 1996.

Bozdoğan, Sibel. *Modernism and Nation Building: Turkish Architectural Culture in the Early Republic*. Seattle: University of Washington Press, 2001.

Delaney, Carol. "Father State, Motherland, and the Birth of Modern Turkey." In *Naturalizing Power: Essays in Feminist Cultural Analysis*, edited by Sylvia Yanagisako and Carol Delaney, 177–99. London: Routledge, 1995.

Doğramacı, Burcu. *Kulturtransfer und Nationale Identität: Deutschsprachige Architekten, Stadtplaner und Bildhauer in der Türkei nach 1927*. Berlin: Gebr. Mann, 2008.

Glyptis, Leda. "Living up to the Father: The National Identity Prescriptions of Remembering Atatürk: His Homes, His Grave, His Temple." *National Identities* 10, 4 (2008): 353–72.

Gruber, Christiane, and Sune Haugbolle, eds. *Visual Culture in the Modern Middle East: Rhetoric of the Image*. Bloomington: Indiana University Press, 2003.

Gür, Faik. "Sculpting the Nation in Early Republican Turkey." *Historical Research* 86 (2013): 342–72.

Haskan, Filiz Aybike. *Karikatürler ve Şiirlerde Milli Şef* [The National Chief in Caricatures and Poems]. Istanbul: Nova Press, 2002.

Lewis, Bernard, and Halil İnalcik, with Etem Tem. *Kemal Atatürk: Transforming the Image of a Nation*. Istanbul: Yapı Kredi Publications, 1995.

Loğoğlu, Faruk. *İsmet İnönü and the Making of Modern Turkey*. Ankara: İnönü Foundation, 1998.

Mango, Andrew. *Atatürk: The Biography of the Founder of Modern Turkey*. London: John Murray, 1999.

Mogul, John, and Sibel Bozdoğan, eds. *Journal of Decorative and Propaganda Arts*, Special issue on Turkey. Miami: The Wolfsonian-Florida International University Publications, 28, 2017.

Niyazioğlu, Sinan. *Irony and Tension, Perception of War in Istanbul and Ankara During the Second World War Years*. Ankara: Koç University-Vekam, 2016.

Niyazioğlu, Sinan. "İhap Hulusi Görey: Designer of the Early Republic's Visual Propaganda." *The Journal of Decorative and Propaganda Arts* 28 (2017): 132–53.

Özyürek, Esra. *Nostalgia for the Modern: State Secularism and Everyday Politics in Turkey*. Durham: Duke University Press, 2006.

Türkoz, Meltem. "Fathering the Nation: From Mustafa Kemal to Atatürk." *Traditiones* 43 (2014): 53–64.

Volkan, Vamık, and Norman Itzkowitz. *The Immortal Atatürk: A Psychobiography*. Chicago: University of Chicago Press, 1984.

Wilson, Christopher. "Representing National Identity and Memory in the Mausoleum of Mustafa Kemal Atatürk." *Journal of the Society of Architectural Historians* 68, 2 (2009): 224–53.

17 Burning United States Presidents

Protest Effigies in Iraq, Iran and Afghanistan

Florian Göttke

Introduction

Effigy protest is a truly visual medium of communication, a practice that uses and manipulates images for specific goals. In Iran, Iraq and Afghanistan, protesters portray the US presidents, the representatives of their country, as perpetrators who deserve to be convicted, degraded and punished. They create active and activating images that make the result of US politics – the injustice, the violence and pain inflicted on the people of Iran, Iraq and Afghanistan – visible, and demand rectification.

Because the data of this research stem largely from Western media sources, they are presented in a biased way: journalists, photographers and editors provide news in accordance with the ideological and cultural framework of Western audiences. But it is exactly these Western audiences that the protesters aim to reach, as the regular appearance of English language placards in protest scenes make clear. The photographs of the protests, distributed by Western news media can therefore be seen as instances of successful communication between communities caught on opposite sides of serious political conflicts. The analysis of these events through the perspective of the Western news media can shed light on attitudes and strategies in cross-cultural visual communication.

Before dealing with effigy-burning in Iran, Iraq and Afghanistan, it is worth looking at this form of protest as it is perceived in Europe. Effigies are a rather specific kind of image: they are usually three-dimensional, life-size representations of an individual that emphasize the social, political and judicial aspects of a person.[1] Such images can be used to celebrate figures of power – for instance on coins and monumental graves – or to denigrate.[2] Effigy punishment was also a common practice in popular justice all over Europe and in many European colonies, with mobs parading effigies to shame and ostracize fellow citizens who had transgressed community norms.[3] These practices have often been appropriated for political purposes.

It is in first instance not the private, physical body that is punished, but the public body – a person's honor, good name and social standing – that is injured through insult,

1 Colloquial use of the English word has narrowed to the quickly made scarecrow-like dummies that are paraded, hanged and burned to denounce the person they represent. Oxford English Dictionary, s.v. "effigy," www.oed.com.; Florian Göttke, "Burning Images: Performing Effigies as Political Protest" (Phd Dissertation, University of Amsterdam, 2019), 39–41.

2 Image punishment was enshrined in European formal justice systems in the fifteenth century and practiced up into the nineteenth century for crimes such as treason, desertion or counterfeiting, if the perpetrator could not be apprehended.

3 Göttke, "Burning Images," 48–9.

ridicule and social exclusion. Especially in more traditional societies where honor is an important resource, this punishment can have serious consequences for the convict, because the survival and well-being of the individual and his/her family depends on the preservation of the social status.[4] While Iran, Iraq and Afghanistan have of course developed their own image cultures, their people are familiar with some aspects of Western European visual traditions and use images in comparable ways, as will be shown.

Iraq: Re-toppling the Tyrant

In Iraq, portraits of Saddam Hussein were omnipresent, on coins and paper bills, in public spaces, in public offices and private homes, in newspapers and on TV. His images were signs of sovereign power. They were quickly destroyed once that power was gone – most famously, when US soldiers and Iraqi civilians toppled Saddam's monumental statue on Firdous Square in Baghdad in front of the international news media on April 9, 2003. This event marked the end of his regime.[5] Between 2005 and 2009, the square was used for a series of protests against the US occupation, organized by followers of Muqtada al Sadr, a Shia cleric from a prominent family and one of the most influential politicians in post-Saddam Iraq.

On April 9, 2005, the second anniversary of the toppling, life-size dummies of US President George W. Bush, British Prime Minister Tony Blair and Saddam Hussein were set up on a pedestal in front of the plinth on which the dictator's statue once stood.[6] They were dressed in the red prison jumpsuits that had become infamous from Guantanamo Bay and Abu Ghraib prisons, shackled and with nooses tied around their necks. The faces were transformed into those of werewolves.

Three-and-a-half-years later, on October 18, 2008, protesters burned effigies of Bush and US Secretary of State Condoleezza Rice in protest of the planned security agreement between Iraq and the United States. Bush was depicted wearing blue pants, a white shirt and a red tie. His head and right arm were dressed in bandages and he seemed mangled from the years of occupying Iraq. Rice was dressed in an insulting array of clothing: a skimpy skirt, long stockings and a handbag. She wore pink slippers for earrings with soles adorned with Stars of David – considered defamatory in an anti-Israel context. The faces of these figures were made from photographs of the two politicians.

A month later, on November 21, 2008, another Bush effigy appeared on Firdous Square. A photograph (Figure 17.1) shows a figure approximately four-meters high, dressed in a black suit, white shirt and a tie; the head, made of cloth, is covered with a photo of the President. The figure holds a whip in one hand, and a black briefcase featuring the Arabic text "US-Iraq security agreement" in the other. It is tied to the plinth of Saddam's statue, and a protester on the plinth can be seen hitting the effigy with a shoe, waving the Iraqi flag, and hiding from the barrage of bottles and shoes that are thrown at the effigy. At the culmination of the performance, participants pull the effigy with a rope, turning it upside down until it tumbles to the ground. In this way the protesters literally re-staged the toppling of Saddam's statue with the effigy of Bush.

4 Karl Härter, "Images of Dishonoured Rebels and Infamous Revolts: Political Crime, Shaming Punishments and Defamation in the Early Modern Pictorial Media," in *Images of Shame. Infamy, Defamation and the Ethics of Oeconomia*, ed. Carolin Behrmann (Berlin: De Gruyter, 2016), ch. 1, ebook.
5 Florian Göttke, *Toppled* (Rotterdam: Post Editions, 2010), 53–5.
6 The plinth was at this moment occupied by a sculpture installed a few month after Saddam's statue fell. See Göttke, *Toppled*, 46.

The last in this series of protests was staged on April 9, 2009, on the sixth anniversary of the toppling (by this time Bush was no longer in office). Photographs indicate that this "portrait" was even bigger than the one before. The former President appears wearing a blue collared shirt with a red tie, black pants and shoes, but no jacket. The enlarged photo of a grumpy Bush is molded onto the stuffed head. Photographs taken a little later show the effigy standing upright attached to the plinth on Firdous Square engulfed in flames.

Common to these effigies is the use of photographs for the faces and an emphasis on the cultural identity of the depicted. The figures' Western attire strongly contrasts with the traditional clothes of a cleric worn by Muqtada al Sadr in the many portraits that are carried during the protests. Except for the dummies with werewolf features, these protest effigies are rather realistic. The protesters express their contempt by hitting the effigies, throwing shoes and bottles at them and finally destroying them. Appropriating the media images that shaped the memory of the Iraq war, the protesters re-interpreted the toppling of Saddam's statue, and provided the news media with new spectacular and symbolic images.

Iran: From Revolution to Commemoration

Resistance against the corrupt and brutal regime of the Shah Reza Pahlavi, who had ruled Iran since 1941, was followed by protests, which intensified from January 1978 onwards, and was supported by a wide coalition of religious and nationalist groups.[7] Iranian students abroad participated in the protests, burning effigies of the Shah in India, Italy, Germany, Great Britain, Libya and the United States. In January 1979, the Shah was forced to leave the country and Ayatollah Khomeini returned from his exile in Paris, striving for dominance in post-revolution Iran.

Building on Shia Islam's position of resistance in relation to power, Khomeini had framed the revolution in religious terms. The processions of *Ashura,* commemorating the martyrdom of Imam Hussein ibn Ali, the grandson of the Prophet, were transformed into mass protests against the Shah. A minor event in these commemorations was the "killing" of Umar, the second Caliph in Sunni tradition. At this event, people burned effigies made from wood and cloth, stuffed with straw, and filled with firecrackers and donkey turds.[8] The revolution appropriated this practice and Umar's effigy was replaced by those of US President Jimmy Carter and the Shah.[9]

The United States attempted to maintain their influence on Iranian politics after the Shah's ouster. Frustrated by the continuing interference and the refusal to extradite the exiled Shah, Iranian students stormed the US Embassy in Tehran on November 11, and took the embassy personnel hostage. The occupiers staged continuing protests in front of the international news media, who had assembled at the embassy. According to one journalist, protesters paraded and burned effigies of the Shah, President Carter or Uncle Sam almost daily.[10] The protests gained wide media coverage, especially in

7 Rouhollah K. Ramazani, "Iran's Revolution: Patterns, Problems and Prospects," *International Affairs* 56, 3 (1980): 446.

8 Michael M. J. Fischer, *Iran: From Religious Dispute to Revolution* (Madison: University of Wisconsin Press, 1980), 177.

9 Peter Chelkowski, "Popular Entertainment, Media and Social Change in Twentieth-Century Iran," in *The Cambridge History of Iran*, eds. Peter Avery et al. (Cambridge: Cambridge University Press, 1991), 7:766.

10 James Yuenger, "U.S. Embassy: Where it all started," *Chicago Tribune*, Jan. 21, 1981. I have collected photographs of seventeen effigies being paraded in Tehran in November and December 1979, six representing the Shah, seven President Carter and four Uncle Sam.

the United States, where counter-protests with effigies of Ayatollah Khomeini were staged in response.

A photograph taken on November 8 (Figure 17.2) shows a smoking effigy above a celebratory crowd. Made from cloth and paper, the figure wears a high hat with the stripes of the American flag. The Arabic language sign on the chest is undecipherable. At a November 25 protest, the portrait simply consisted of a strangely shaped cut-out figure dangling from a gallows in a crowd also carrying a portrait of Ayatollah Khomeini. The name "Carter" was written in Arabic and Latin scripts; three Stars of David, a dollar sign and a Swastika were drawn onto the figure.

These images do not have a consistent style, and most seem to have been made very quickly. While some of the drawn faces do attempt a visual likeness to either the Shah or President Carter, others look nothing like their prototypes. Many show names, signs or the usual distinguishing features (dollar symbol, Swastika, etc.). All effigies of Uncle Sam wear a high hat adorned with the stars and stripes.

Many photographs show large crowds carrying the effigies of the leaders on sticks or on improvised gallows made up of a few wooden beams, as well as banners and signboards with slogans such as "Down with Carter and imperialism", written in Persian and occasionally in English. On December 15, a figure made from white cloth, stuffed but rather flat, was proudly presented to the cameras by a crowd consisting of men of different ages. It featured the caricature of the Shah on one side and that of Carter on the other. Sign-boards reading "corruptor on earth" were drawn around their necks. Afterwards, the effigies were set on fire, and the photographs show crowds chanting and waiving their fists to express their anger.

In the years following the revolution, protest effigies of Uncle Sam and consecutive sitting US presidents became a fixture in Iranian memorial culture. They still feature in demonstrations celebrating the anniversaries of the Iranian revolution of February 1979 and the embassy takeover in November of that year.[11] The style of these images has not changed much during the years. The effigies are homemade, scarecrow-like figures consisting of stuffed clothes, or sculpted heads on a wooden stick with the American flag as the body. More recently, photographs have been attached to the representations of Barack Obama and Donald Trump, and clownish figures have been used to ridicule the presidents, instead of demonizing them. In the picture of a 2016 demonstration (Figure 17.3), a young woman almost hides behind a stuffed cloth effigy of President Obama that she carries on a stick: a piece of foam rubber in the shape of a rocket carrying the words "Iran's Rocket" written in Persian has been attached to the belly. The face is black and consists of a large nose, big red lips and blue eyes with a rather sheepish expression. Once props in violent performances that expressed popular anger at a time when Iranian society was being redefined, these images have been turned into harmless accessories for state-sponsored rallies that commemorate the past in order to cement current power structures.

11 Effigies of Uncle Sam and the US President are also paraded on *al Quds* Day (Jerusalem Day), a holiday instituted by Khomeini in 1979 in support of the Palestinians' claim to a homeland and their demand that Jerusalem be the capital of their state.

Afghanistan: Insult and Anger

In Afghanistan, the use of images representing power in the European tradition seems rare. Only once, in 1961, was an Afghan coin issued bearing the portrait of the ruler, Mohammed Zahir Shah. The first documented effigy protests occurred in 1999, when likenesses of President Bill Clinton were set on fire to protest his country's pressure to extradite Osama bin Laden for his involvement in the US embassy bombings in East Africa. However, when the Soviet Union invaded Afghanistan in 1979, Afghan emigrants and students in Tehran protested the invasion with life-size cut-out drawings of the Soviet leader Leonid Brezhnev and Afghan President Babrak Karmal dangling from improvised gallows – most likely inspired by the Iranian revolutionaries who had demonstrated with burning effigies in front of the US embassy just a few weeks earlier. Until the Soviet Union withdrew its troops from Afghanistan in 1989, Afghans held rallies in many countries they lived in, both Western and Eastern, and burned effigies of Brezhnev and his successors Yuri Andropov, Konstantin Chernenko and Mikhail Gorbachev, to remind international opinion of the ongoing war and occupation of Afghanistan.

Again, after the attacks on the World Trade Center on September 9, 2001, when the United States threatened with war if Afghanistan did not expel bin Laden, protesters burned dummies of George W. Bush. The practice became current during demonstrations that took place in Afghanistan between 2005 and 2015 to denounce the country's occupation by the US-led International Alliance and military operations that caused civilian casualties.[12] Even more effigy protests were triggered by incidents perceived as Western insults to Islam. These included Quran desecrations by American soldiers, the publication in the Western press of cartoons ridiculing the Prophet Mohammad, and the release in the West of two anti-Islamic films.[13] The conflict between Palestine and Israel also led to effigy protests featuring US presidents.

The effigies of George W. Bush and Barack Obama that were produced in Afghanistan for protest purposes were made very simply from old clothes draped over a wooden frame, and stuffed with flammable material. While a few had photographic portraits attached to the head, most faces were crudely drawn without attempting a resemblance: they were essentially caricatures with foolish expressions or monstrous features. The effigies appear as mere props in the performance of punishment, which draws the attention to the anger of the protesters, and the apparent violence of the performance. The photographs show chaotic scenes: figures engulfed in flames, angry crowds chanting and protesters hitting the burning effigies on the ground.

12 My records show nine effigies depicting President Bush between May 2005 and March 2008 and as many as 29 effigies depicting President Barack Obama between October 2009 and November 2013. Other politicians burned in effigy during these years include Israeli Premiers Olmert and Netanyahu, Geert Wilders, the Pope, Iranian President Ahmadinejad, the American Pastor Jones, French President Hollande, Pakistan's President Zardari and, on one occasion, also Afghanistan's President Karzai.

13 The films in question are *Fitna* by the Dutch right-wing politician Geert Wilders (2008) and a trailer to the movie *Innocence of Muslims* (which was never produced) by the American self-proclaimed filmmaker Nakoula Basseley Nakoula (2012).

Conclusion

The protest effigies that are produced in Iraq, Iran and Afghanistan differ in style, but have common features too. The Iraqi examples have a somewhat distinct, realistic style and show that they have been made with some effort. Their sculptural form, the choice of garments, the use of photographs molded onto the heads as faces, reveal some concern with verisimilitude. In contrast, the effigies produced in Iran and Afghanistan seem more improvised, made from old clothes stuffed with flammable material. As a result, they look like grotesque figures with distorted bodies and dangling limbs.

What matters most is that the figures are clearly identifiable. This is achieved in the three countries under consideration in a number of ways. The identity of the US presidents is indicated by the names and photographs attached, drawings that attempt a visual likeness, or features such as skin color. Equally recurrent are attributes that serve as indicators of cultural identity: the Western suit, shirt and tie, and in Afghanistan the Christian cross. Symbols of political identity are also frequently added to the effigies: the American flag, the CIA acronym and the US dollar sign. In Iran in particular, the figure often depicts Uncle Sam, instead of the president. Signs are also used for disparaging purposes: the Star of David, the Swastika, shoes (considered dirty in Arab culture), vilified animals (dogs, donkeys, apes) and demonizing attributes (werewolf faces, demons' teeth). These signs and traits are transferred from the image (the effigy) to the prototype (the person depicted) for ridiculing and denigrating ends.[14] As in the European Renaissance tradition of defaming portraiture, the emphasis is very much on the public body. The images depicting the office-holders, the representatives of the US government, are punished in order to express contempt for the country.

It should be pointed out that effigy punishment is not quite the same as political iconoclasm, which is the destruction of images representing power. While the "portraits" that have been considered in this chapter mostly concern the public body, the connection with the private body is close. The presence of a vulnerable material body, together with the possibilities to manipulate and obliterate it, make effigy punishment a practice quite unlike the toppling of a statue: it is more closely aligned with the ritual of capital punishment. As Michel Foucault explains in his essay "The Spectacle of Punishment", in the seventeenth century this ritual was the theatrical enactment of violence performed on the convict to affirm and make visible the power of the sovereign.[15] The procedure served to strip the convicts of their political and social status and reduce them to a pure physical presence, to their biological state of pain and death. Effigy punishment is also a theatrical demonstration of power, expressing either the existing power – as in effigy punishments in formal law – or the rightful and righteous power that has yet to be established or re-established in protests against occurred injustices.

Because of the absence and inaccessibility of the real perpetrator, a substitute body is created for the ritual of punishment. It consists of a material body with added signs and attributes representing the figure's social and political body. The image replaces the person, in a mechanism Horst Bredekamp calls "substitutive image act", one that is particularly relevant in the social, political and judicial realm.[16] Bodies are treated

14 For a more exhaustive account of the forms and effects of grotesque denigration, see the chapter "Resemblance and the Grotesque" in Göttke, "Burning Images," 233–68.

15 Michel Foucault, *Discipline and Punish: The Birth of the Prison* (New York: Vintage, 1977), 48–9.

16 Horst Bredekamp, *Theorie des Bildakts* (Berlin: Suhrkamp, 2010), 173.

as images and images as bodies: the image (the effigy) takes the place of the perpetrator, so that the deserved punishment can be carried out and made public. The body of the effigy is punished – insulted, spat at, beaten, punched or hanged – to strip away the public body. Finally, the effigy is burned, in order to obliterate the effigy's material body as well, until only unrecognizable debris is left over.

The protesters communicate through the manipulated images of their enemies. In the first instance, the grotesque effigies announce the debased nature of the depicted. Then these "bodies" are subjected to further denigrating treatment as they are ridiculed, insulted, beaten, hanged and burned. These visual spectacles are staged for the benefit of the public actually present at the demonstrations, and to produce photographs to be distributed by the media to distant audiences.

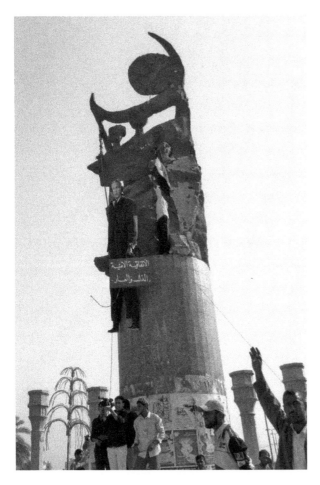

Figure 17.1 An effigy of President Bush hanging on the pedestal where a statue of Saddam Hussein once stood in Firdous Square, in Baghdad, November 21, 2008. (Photo: Adam Ashton).

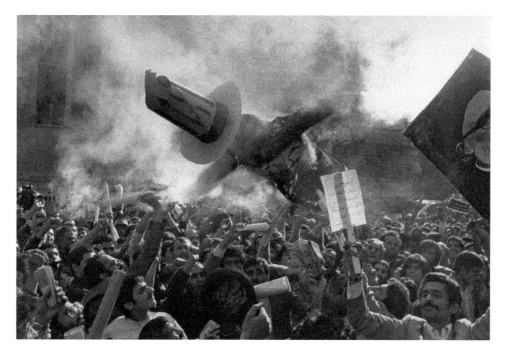

Figure 17.2 A scarecrow symbolizing the United States being burned during a demonstration, Tehran, November 8, 1979. (Photo: Philippe Ledru).

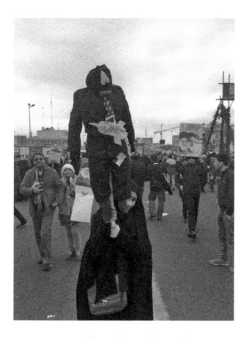

Figure 17.3 Effigy of President Obama at a rally held in Tehran, February 10, 2016. (Photo: Thomas Erdbrink).

Bibliography

Afary, Janet. "Shi'i Narratives of Karbalâ and Christian Rites of Penance: Michel Foucault and the Culture of the Iranian Revolution, 1978–1979." *Radical History Review* 86 (2003): 7–35.

Behrmann, Carolin, ed. *Images of Shame: Infamy, Defamation and the Ethics of Oeconomia.* Berlin: De Gruyter, 2016.

Belting, Hans. "Image Medium Body: A New Approach to Iconology." *Critical Inquiry* 31, 2 (2005): 302–19.

Bredekamp, Horst. *Image Acts: A Systematic Approach to Visual Agency.* Berlin: De Gruyter, 2018.

Brückner, Wolfgang. *Bildnis und Brauch: Studien zur Bildfunktion der Effigies.* Berlin: Erich Schmidt Verlag, 1966.

Didi-Huberman, Georges. "The Molding Image." In *Law and the Image: The Authority of Art and the Aesthetics of Law*, edited by Costas Douzinas and Lynda Nead, 71–88. Chicago and London: Chicago University Press, 1999.

Eder, Jens, and Charlotte Klonk. *Image Operations: Visual Media and Political Conflict.* Manchester: Manchester University Press, 2017.

Edwards, Justin D., and Rune Graulund. *Grotesque.* London: Routledge, 2013.

Mitchell, W.J.T. "Image, Space, Revolution." *Critical Inquiry* 39, 1 (2012): 8–32.

Schlosser, Julius von. "History of Portraiture in Wax." In *Ephemeral Bodies: Wax Sculpture and the Human Figure*, edited by Roberta Panzanelli, 171–303. Los Angeles: Getty Publications, 2008.

Index

Page numbers in *italics* reference images.